BERNARD BLISTENE

HISTORY OF 20TH-CENTURY ART

Flammarion **Beaux**Arts
magazine

Acknowledgments

I would like to thank the whole *Beaux Arts magazine* team that has seen this project through with great understanding, especially chief executive Charles-Henri Flammarion, my friend commissioning editor Fabrice Bousteau—who was the driving force behind both the idea for the book and its realization—and designer Nicolas Hoffmann.
I would like to express my gratitude to my editor Christophe Perez, without whose assistance this publication would never have seen the light of day.
I also wish to acknowledge all those who offered help and support during the preparation of the book, notably Sophie Blasco, Hervé Derouault, Jean Poderos, Philippe Bissière, Jean-Michel Bouhours, Céline Chevrier, Olivier Cinqualbre, Fabrice Crélerot, Catherine Fröchen, Raymond Guidot, Alain Guiheux, Alain Sayag, Christine Sorin, Nicole Toutcheff and Christine van Assche.
Finally, I wish to thank Marie-Laure Verroust for her kind and touching support. The following work is dedicated to her.

Bernard Blistène

DEALING WITH THE UNKNOWN

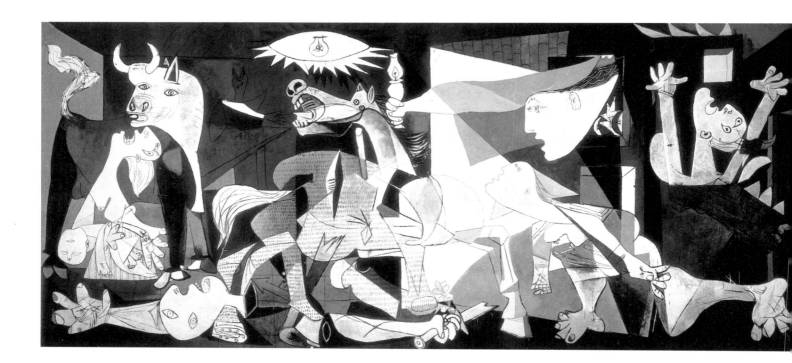

Two works. Two images selected from among the many that comprise our "history." Images from two different worlds with different sets of expectations that highlight an unbridgeable gap and define the limits of our task. These two images conjure up others—those of works by the artists discussed in this book, and those that each of us calls to mind. Inevitably, given the impossibility of any taxonomy, this is also a history of artists who have been neglected or forgotten.

As our subject has unfolded, each chapter has presented tough decisions. Constrained by the limited space available, we have had to cut and condense. Nonetheless, we have kept to the basic history of twentieth-century art and its principal movements (although art is an essentially individual concern), and it is this aim that has remained paramount.

In spite of the many different perspectives and points of view on offer, this volume is not intended to be a "book" as such, still less an encyclopedia. Instead, it seeks to present a few pointers, an overview of the tangled web of contradictions and hypotheses that make up narratives of this kind. Our undertaking, however modest and practical its ambition, can hardly be described as unusual. Although we are all too aware of the absurdity of such classifications, our fins de siècle cannot avoid the curse of the "survey." And what can we say of the present one, since the demands made on creativity have had to measure up to its tragedies and disillusionment, since its various utopias (fenced in by norms and, worse still, by pragmatism) have suffered the ordeal of countless false starts and reworkings, since the geography of our histories has proved to be inadequate, and since what we still call "contemporary art" appears to be nothing more than the construction

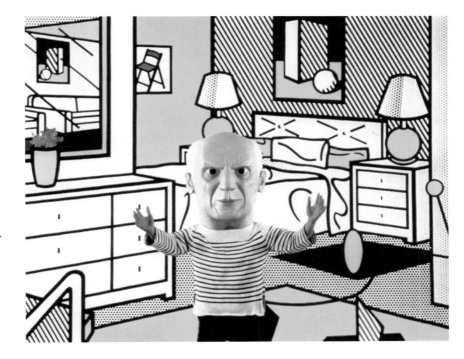

of an imaginary space containing all those who—after the arbitrary exclusions and banning orders—simply fit in with our ideas.

As is still and as always has been the case, whole areas come into view that make old regimes and linear readings of history seem outmoded. In an age of the global circulation of visual media and the constant development of new techniques, in an age of mutation in the senses and of transformations in meaning resulting from the ever-increasing impact and speed of communication and technology, hackneyed traditions and time-honored divisions soon lose their legitimacy.

As an art history is first and foremost a work on history, as its working procedures are unclear and its categories unstable, the present text is more in the way of a workshop: risks have been taken in the choices made and there is something of "ourselves" in it. We willingly accept that its inclusions may well appear rudimentary in some cases and too allusive in others, and we are doubly conscious that an illustrated book, however many pictures it contains (and we have often attempted to summarize the work of an artist in a single example), can never claim to be exhaustive.

The concise bibliographies and chronologies at the end of each chapter stem from a desire to see art in its context. They seek to bring out parallels between the history of civilization and art history, as well as providing useful chronological signposts.

It is to be hoped that the material presented here will inspire readers to compile their own histories, in the full knowledge that conclusions are impossible and that it is better to deal, as Rimbaud put it, "in the unknown so as to find something new."

Bernard Blistène

CONTENTS

FAUVISM 15

"from objects to signs"

At the dawn of the twentieth century, with Impressionism and Symbolism waning and with the Neo-Impressionists and the Nabis engaged in a reassessment of the fundamentals of painting, a new generation emerged that broke decisively with convention. Abandoning local color and adopting a rich palette, they produced intensely vivid images of lasting significance to modern art. With the Fauves was born the inevitable distinction between the real and its depiction.

23 | CUBISM

"from image to language"

Hailing Cézanne and rejecting Matisse's elegiac style, Picasso and Braque invented Cubism. Turning their backs on the work of Lautrec, Degas, the Fauvists and the old masters that had inspired their early canvases, they looked to African sculpture to discover the visual and symbolic elements for a new idiom. In the winter of 1906-7, Picasso created the emblematic work of the twentieth century — *Les Demoiselles d' Avignon* — and supplied the enduring model from which an analysis of the form and structure of painting reached full critical potential.

CUBISM 31

"from static to dynamic"

Cubism, following on from Impressionism and Fauvism, signaled the first break with traditional forms of representation, but the sheer number of styles that followed in its wake makes any inventory impractical. Cubism laid the foundations of modern art for the many artists who came into contact with it in Paris or through international exhibitions. This chapter attempts to outline the questions the movement posed for artists.

SCULPTURE 1880-1914

39

"from monument to readymade"

From Rodin to Brancusi, from Picasso to Duchamp, artists questioned the principles of sculpture, undermining the very basis and purpose of the art. The subject matter of the artwork was replaced by the work of art as subject. The rejection of sculpture's commemorative function led to the development of an autonomous language. Form in space was no longer the result of technical or stylistic mastery, but instead a process of redefining the art's rules and functions.

47 | # ARCHITECTURE 1890-1914

"from ornamentation to simplicity"

At the end of the nineteenth century, new technology and growing urbanization led to profound transformations in architecture. As a counterpoint to the early innovations of the Arts and Crafts Movement and the Glasgow School, architects and designers embarked on the construction of the modern utopias. Throughout a variety of centers, from the Vienna Sezession to Chicago and California, from Munich to Brussels, from Paris to Nancy, a new idiom emerged: Art Nouveau.

EXPRESSIONISM

55

"between figure and abstraction"

Developments on the German artistic scene, centered around Die Brücke and Der Blaue Reiter, contrasted with events occurring simultaneously in Paris. The members of these groups hailed from all over Europe and the alternative vision they presented opened up a deep aesthetic rift on the eve of World War I.

61 | # DADA

"between war and peace"

Rather than a movement proper, Dada was more a frenzied state of mind. Emerging from and during World War I, it burned like a wildfire from Zurich to New York and was to leave lasting scars even after it burned out around 1922. Anarchistic, revolutionary, even censorious it certainly was; but it was also indifferent, dilettante and poetic. From buffer states and battlefields, Dada radiated from many centers, and its bright fire still rages.

SURREALISM

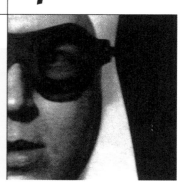

"from *The Manifesto* to exile"

Building on the ruins of a culture it later helped to bring to grief, Surrealism strove to "change life" and to create a genuine humanism through the celebration of the true measure of man. As Aragon put it, Surrealism's "vice is the unreasonable and impassioned use of astounding images" and it bequeathed to twentieth-century art an infinite variety of artworks of every kind that proclaimed the "originating power of the mind."

CLASSICISMS AND REALISMS

"between order and model"

Between 1919 and 1939, with the rise of abstraction and the revolutionary movements centered around Surrealism and Dada, a confused, heterogeneous situation emerged. New types of work were created that lay outside these categories, works that, as Jean Clair has written, "bypass the theology of the avant-garde" and force us to call its very significance into question.

ABSTRACTION AND CONSTRUCTIVISM

"geometry and utopia"

In the mid-1910s, the "invention" of abstraction echoed throughout Europe in the form of various currents and approaches whose common characteristic was the refusal to regard art as the mere representation of reality. Wedding spiritualism to social program, Russian Suprematism and Constructivism, Dutch Neo-Plasticism and De Stijl, the Bauhaus in Germany, and the groups and movements that sprung from the emigration to France of numerous artists, constituted one of the most important episodes in the forging of the avant-garde credo.

SCULPTURES, ASSEMBLAGES, CONSTRUCTIONS

"spatial languages"

Sculptures, assemblages, constructions: a triangle that attempts to circumscribe the diversity of the avant-garde approach to space in the wake of the break between monumental forms and the readymade that occurred at the beginning of the century. From Tatlin's *Corner Constructions* to Brancusi's *Endless Column,* from the welded sculptures of Julio González and Picasso to the Surrealist objects hailed by André Breton, these multiple experiments went beyond the classic interwar model and opened the way to more diffuse reflections on form and meaning.

ARCHITECTURE 1914-1939

95

"rationalism and modernism"

"Architectural Expressionism," a trend centered around Rudolf Steiner, Bruno Taut, Heinz Pölzig and Erich Mendelsohn, heralded the end of nineteenth-century utopianism. In the interwar period, the International Style triumphed, poised between rationalism and modernism.

THE UNITED STATES

103

"from Abstract Expressionism to Minimalism"

With Abstract Expressionism and Minimalist abstraction, the United States began to extend its economic and industrial dominance into the sphere of ideas. Enthused by a dream of self-purification, "American painting," as defined by Clement Greenberg, could now join the modern art community, becoming the dominant force to an extent that hitherto it could scarcely have dared expect.

EUROPE 1939-1970

115

"painting: from image to tool"

To cover a whole continent over such a long period in a single overview is to invite disaster. It presupposes and indeed encourages the idea of a rivalry between Europe and the United States, as well as neglecting art produced in other regions. The hypothesis, however, helps to account for the various often contradictory postwar trends emerging at a time when "modern art" was experiencing (almost) official consecration.

THE REAL IN QUESTION

127

"Pop art, Nouveau Réalisme, Fluxus and the Happening"

Although very different from each other, these movements all share, not so much a rejection of the traditional principles of painting, as a steadfast willingness to remain open to other disciplines and to be receptive to practices from other very different fields. Pop art, Nouveau Réalisme, Mec art, Fluxus, the Happening and Lettrism together countered Clement Greenberg's opinion expressed in 1939 that mass culture could only ever produce phony art.

137 | SCULPTURE 1939-1970

"between form and gesture"

The term "sculpture" seems inappropriate to define the various practices and movements that arose in the first half of the twentieth-century avant-garde, clearing the way for a complete overhaul of its function and purpose. As sculpture embraced instability, pared itself to the essential or incorporated the amorphous, it edged toward installation, environment, or mechanical contraption. The few examples taken from a host of movements are intended to summarize the evolution and variety of what amounted to a totally new language.

ARCHITECTURE 1944-2000

145

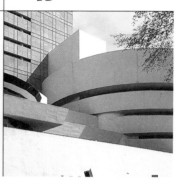

"after modernism"

It is impossible to provide a complete inventory of the movements and figures that have left their mark on half a century of architecture, but these few milestones indicate the challenges it posed and provide evidence of its on-going metamorphosis. As François Chaslin reaffirmed in an editorial for *Architecture d' aujourd' hui* (December 1990), there is still some point in "trying to sort it all out."

155 | ART TODAY

"the situation and its risks"

For this chapter, we were tempted to co-opt Christian Boltanski's notion of the *Inventory* for our own devices; a cruel yet entirely safe choice for the art historian, since it can mention everything and signify nothing—save perhaps the vanity and the inability of sitting in judgement over a history which requires constant rewriting. After Arte Povera, Supports/Surfaces, after the various incarnations of Minimal and Conceptual art, and after Vito Acconci's Body art, the 1970s pointed the way to fresh areas and disciplines, opening the door to a pressing crowd of competing utopias.

DESIGN

167

"things—a user's guide"

As the century became mechanized, it witnessed the birth of a consumer culture with its attendant products, consumer durables and logos. Decade after decade, these became indicative of our different ways of living and of "being in the world." As soon as the borders between the various genres broke down and they became porous to every branch of knowledge, design made its impact and triggered an irreversible process of production that affects our daily lives as well as the diverse forms of contemporary aesthetics.

PHOTOGRAPHIES

177

"the memory of the gaze"

In an image-based society, reproduction techniques occupy pride of place. Among these, in what Walter Benjamin called "the age of mechanical reproduction," photography has contributed to the broadening of both our ideas and techniques. In a time of new technology and virtual reality, photography still affirms its usefulness as a way of looking at the world and of grasping, in countless forms and styles, the real in all its guises.

187 | # CINEMA, VIDEO

"moving image: projections and installations"

Born with the century, cinema has since imposed itself as one of the paramount models for contemporary art. In its confrontation with social, political and economic realities, it has applied its own codes that an image-conscious world recognizes as holding up a mirror to our very peculiar struggle. With their projections and installations, the visual arts too have cinema in their sights, and—in the era of television and video, of communication technologies and multimedia—are putting it through a series of tests which will expand its horizons and extend its field of operations.

Flammarion,
26, rue Racine, 75006 Paris
France

All rights reserved.
No part of this book may be reproduced in any form or by any electronic or mechanical means, including information storage and retrieval systems, without permission in writing from the publisher.

Originally published as
«Une histoire de l'art du XXe siècle»
© 1999 Beaux-Arts S.A.

This english-language edition
© 2001 BeauxArts S.A.
© 2001 Flammarion.
© 2001 Adagp for the works by its members
© 2001 Succession Matisse
© 2001 Succession Picasso
© 2001 L & M Services B.V. Amsterdam

ISBN: 2 08010 564 7
Book n°: FA 0564-01-V
Dépôt légal: 05/2001

Chief editor: Fabrice Bousteau
Editorial coordination: Isabelle Canals-Noël,
Sophy Thompson
Translation: David Radzinowicz Howell
Copy-editing: Bernard Wooding
Design: Nicolas Hoffmann
Typesetting: Vincent Bernière, Barbara Torgoff

BeauxArts magazine, tour Montparnasse
33, avenue du Maine, 75755 Paris Cedex 15, France

FAUVISM
"from objects to signs"

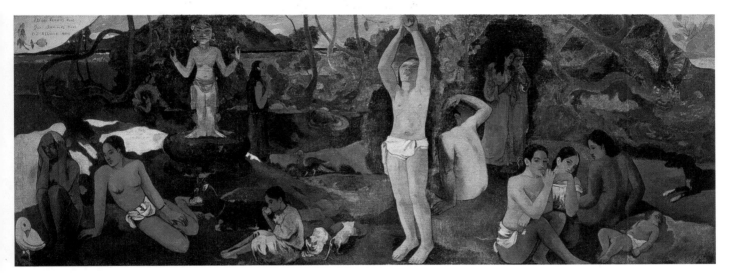

"I sometimes hear someone say: this arm is too long . . ."

PAUL GAUGUIN
Where Do We Come From?
What Are We? Where Are
We Going To?
1897. Oil on canvas,
141 x 411 cm.
Museum of Fine Arts, Boston.
© Bridgeman-Giraudon.

"I sometimes hear someone say: this arm is too long, etc. Yes and no. Mostly no, since, as you lengthen it, you move away from resemblance and move toward fable, which is no bad thing . . . If Bouguereau made an arm too long, then yes! What would he have left? since his vision—his artistic will—is confined to that feeble-minded exactitude that binds us to the chains of material reality." So wrote Paul Gauguin to H. de Monfreid in March 1898. *Where Do We Come From?* represents a synthesis of the painter's aes-

thetic and spiritual credo, a testament that condenses his ambitions as a visual artist and his metaphysical questions, with Tahiti serving as an idyllic, pantheistic backdrop. A month before his death (on May 8, 1903) Gauguin wrote to Charles Morice in the same vein: "You were mistaken the day you told me that I was wrong to say I was a savage. It's true all the same: I am a savage. And the civilized can sense it: the only thing that surprises them, that puts them off in my works is the savage-in-spite-of-myself. That's why it is inimitable." It was Matisse who organized his 1906 retrospective. Later he was to write: "For Gauguin to be placed among the Fauves, he lacks spatial construction through color, employing it instead to express feelings."

The dawn of the twentieth century, like its close, was characterized by a complacent assumption that it was a time of irreversible decadence. Never had the chasm between the creative arts and the savage reactions they provoked been so wide. This paradoxical situation doubtless stemmed from the simultaneous appearance of works of patently antagonistic expressiveness and of a spirit that rendered pre-existing classifications unsatisfactory. Up until World War I, there was a continual tension between enthusiasts for the past and innovators. A gaping chasm opened up between the diktats of the old academies and new creative fields bent on experiment. It was true that the burden of the institutions, with their art schools and hallowed figures, weighed like an albatross around the necks of those desiring to question its teachings > > >

15

>>> and the very *raison d'être* of art itself.

First Impressionism blazed a trail of dissent, followed by Neo-Impressionism, which sought to give its findings systematic form. But the question remained whether art should still conform to time-honored models. Should it open itself up to the radical changes and the hopes of the century to come? Against the servile mimicking of reality in an age of photography and cinematography, against the dream of a lost golden age rooted in the archaic and nostalgia, against hackneyed and worn-out forms, a living, creative force strove to work out and give expression to subjective and unmediated visions.

In a world which was changing and founding its hopes as well as its illusions on experimentation, Rimbaud's precept that one has to "deal in the unknown to find something new" resounded loud and clear. When the disaster precipitated by World War I put paid to the utopian vision, the old models persisted, dragging on for one last stand. In an ever-changing world in which technological and mechanical progress held considerable fascination, the modern credo was gradually ousting that of the past.

Faced with outmoded official arenas, creative artists—aided and abetted by a handful of critics and art dealers—were coming up with new ways of disseminating their work. As early as 1880, independent artists were getting organized; in 1903, the first Salon d'Automne was held in Paris, followed in 1904 by the Salon des Artistes Décorateurs. Both were to become regular events. Like artists, society in general was looking for ways of going beyond convention. Never had cultural exchange attained such intensity: people flocked, for example, to the World Fairs of 1878, 1889, and 1900. Devotees of the past, however, continued to issue nationalist, xenophobic and anti-Semitic critiques of every hue: against the backdrop of increasing internationalism, the Dreyfus affair split French society down the middle. In the 1910s, in the French parliament it was mooted that Cubism had close links with a plot fomented in a foreign land. The Libre >>>

"Stenciled confetti"

HENRI MATISSE
Luxe, Calme et Volupté
1904. Oil on canvas,
98.3 x 118.5 cm.
Musée d'Orsay, Paris
(on indefinite loan to the
Centre Georges Pompidou,
MNAM).
© Centre Georges Pompidou,
MNAM.

"**S**tenciled confetti by a painter who has had the far from inspired idea of associating his talent with the group [of Neo-Impressionists]"—the tone was set by the *Mercure de France* critic Charles Morice. Matisse executed this painting at Signac's who, once it had been shown at the Salon des Indépendants in 1905, was to purchase it. In a 1898 issue of *La Revue blanche*, Signac had already published "De Delacroix au néo-impressionisme," in which he concluded: "Although we have yet to see an artist among the Neo-Impressionists who is capable, through his genius, of imposing this technique, they have at least made his task that much easier. The triumphant colorist has only to show himself: his palette has already been prepared." *Luxe, calme et volupté* surely heralds a new kind of art, as well as being the final instance of a synthesis between a Symbolist subject and the Divisionist technique. Maurice Denis, spokesman for the Nabis, gave a concise and subtle account of the work and of the dilemma it poses: "It is in truth a search for the absolute. And yet, by a strange contradiction, this absolute is limited by the most relative thing in the world: personal emotion."

HENRI MATISSE
Interior at Collioure, Siesta
1905. Oil on canvas,
59 x 72 cm. Private collection,
Zurich. © Giraudon.

In Collioure, Matisse was to abandon Divisionism and discover "Gauguin's theory." "I've tried to replace vibrato with a single chord whose simplicity and sincerity alone could give me a less troubled surface. Breaking up color brought with it a break-up of form and outline. The result is a surface that dances. Retinal sensations alone remain, but they demolish both surface and contour." Light-space is here replaced by color-space. Fragmentation is supplanted by diffuse blotches and colored planes. The theme of the window developed by Matisse led him to reduce what Maurice Denis termed "noumena" to a set of visual and chromatic cues. "If I have been able to unite what lies

"I don't have to do anything to establish links between interior and exterior"

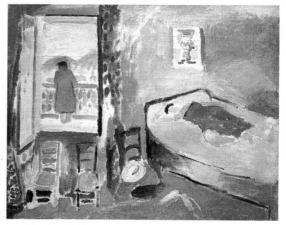

outside, the sea for example, to the interior in my painting, it is because the atmosphere of the landscape and the room are one and the same ... I don't have to do anything to establish links between interior and exterior." In 1935, keen to explain his approach (that André Gide had already described as "contrary"), Matisse remarked: "A painting is made from an accretion of differently colored surfaces that result in the creation of an expression."

"ARRANGE THINGS IN THE LIGHT AND MAKE THEM

"The most baffling of all these crazy brushes"

HENRI MATISSE
Woman with the Hat
1905.
Oil on canvas, 80.6 x 59.7 cm.
Museum of Modern Art,
San Francisco.
Bequest of Elise S. Haas.

"The most baffling of all these crazy brushes—a mixture of wax bottle tops, parrot feathers, and shapeless daubing: blue, red, yellow, green, flecks of a color scheme juxtaposed every which way." When exhibited at the 1905 Salon d'Automne, the present work simultaneously provoked anger and laughter. The journal *L'Illustration* poured oil on the fire in publishing the pic-

ture among others in the context of an "enquiry into contemporary painting." Beyond being a portrait of the painter's wife, the model is subordinated to color, thereby destroying representation. Francis Carco, the future critic of *Gil Blas*, was to write: "I had at the time no firm opinion about modern painting ... And I was wondering whether Picasso, in spite of his astonishingly persuasive powers, did not derive more pleasure from mystifying us than in painting, when the famous *Woman with the Hat* taught me more in a split-second than all these paradoxes. At last I understood what it was that my friends called a portrait.

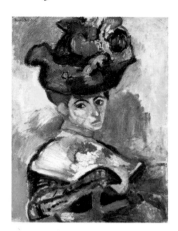

Nothing there was physically human. It seemed as if the artist was more concerned with his own personality than that of his sitter."

"Nature already exists. It is not to be added to"

GEORGES ROUAULT
Girl in a Mirror
1906. Watercolor, 72 x 55 cm.
Centre Pompidou, MNAM,
Paris. © Centre Pompidou,
MNAM.

PIERRE BONNARD
Nude against the Light
1908. Oil on canvas,
124 x 109 cm. Musées Royaux
des Beaux-Arts, Brussels.

The worlds of Pierre Bonnard and Georges Rouault (who, like

some other Fauves, was a pupil of Gustave Moreau) seem poles apart. A Christian and a moralist, Rouault is an observer of human misery and his cortege of lonely, lapsed beings express a disillusionment not dissimilar to that felt by his friend, the Catholic apologist Léon Bloy. Bonnard, after joining with the Nabis and collaborating on *La Revue blanche*, depicts a brightly lit, tactile world, where light plays over the surface of figures, dissolving them into a sensual, evanescent flux.

Bonnard usually created vivid, warm pictures which, as Jean-Christophe Bailly has suggested, in no way oppose the world, but instead "dissolve into it," and adopt as their own Symbolist poet Stéphane Mallarmé's contention that "Nature already exists. It is not to be added to." Rouault applies an impasto to his canvases which brings darkness and suffering, gradually transforming the rough-hewn paint surface into the structure of a stained-glass window.

"Intentional disharmonies"

ANDRÉ DERAIN
Waterloo Bridge
1905–6.
Oil on canvas, 80 x 100 cm.
Thyssen-Bornemisza
Collection, Madrid.

In his hunt for "intentional disharmonies," Derain made two trips to London, at the end of 1905 and in the spring of 1906. There, he found new subjects and a light different from the "blond, golden light that eliminates shadow" at Collioure. The paintings he produced in London were unique in their chromatic intensity. In a push for Monet-like atmospherics, Derain opted for a schematic design where the outlines of the build-

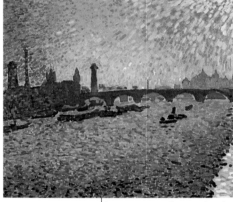

ings set monochrome density against iridescent colors. The picture's fiery brightness shows Derain indulging in an "acrobatic exercise" and manifests a desire to treat nature as the locus of subjective, lyrical drives. In advancing the idea that the subject should be a pretext for reinventing reality, Derain is celebrating the power of painting as well as that of the imagination. His subsequent oeuvre shows the extent to which one of the most idiosyncratic Fauvists, in expressing what is an uncommon tension between color as constructive value and emotional effect, drew closer to Cézanne and blazed, as did Picasso, his own distinctive trail.

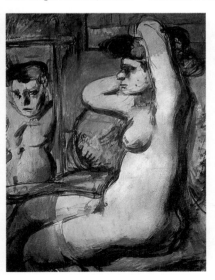

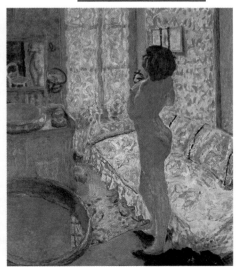

HARMONIZE WITH THE MATERIALS AVAILABLE" Matisse

> > > Esthétique and the Salon des XX in Brussels, Die Brücke after 1905 and Der Blaue Reiter in Germany, along with the sudden growth in periodicals, soon made the movement toward change more widely known and gave it fresh impetus. Picasso and Kees van Dongen arrived in Paris in 1900; Brancusi settled there in 1904; Derain, like the aging Monet, visited London in 1906; Gauguin left for self-imposed exile in the Marquesas Islands, where he died in 1903. The Austrian Adolf Loos built was designing the Villa Karma near Montreux, while his compatriot Josef Hoffmann was creating the Palais Stoclet in Brussels. This is partly why art at the turn of the century is so eclectic and difficult to label: the various currents conflicted with one another, before petering out. Before the emergence of Fauvism, there was no single dominant vision. As well as the hopes inspired by new techniques and by the inventions of the time, the discovery of "primitive" art was to quicken the rejection of time-worn *fin de siècle* forms that an unfocussed and ornamental Symbolism continued to dilute, giving new impetus to this aesthetic revolution. After almost a century, the full extent of the new departure inaugurated by those a critic at a loss for a witticism pejoratively dubbed "les fauves" (the wild beasts) is still being gauged. In many ways, it was Fauvism that sounded the death knell of the old order. The Symbolist Gustave Moreau, who was succeeded by the grim Cormon as professor at the École des Beaux-Arts in Paris at his death in 1898 and who had taught Matisse, Marquet and Rouault, grasped the fact perfectly. It took a totally unintentional scandal at the fledgling Salon des Indépendants in 1905 for this break with the old to be ratified by events, while the retrospective exhibitions dedicated to Seurat (1900 and 1905), van Gogh (1901), Gauguin (1906) and of course Cézanne (1907)—amidst jeers and taunts— presented the upcoming generation with models they could ill have done without. The structuring of space through intense and arbitrary color displaced optical realism and with it the imitation of appearances, thereby leaving the way clear for a total and traumatic transformation. <

"Matisse was preparing his first large-scale decoration"

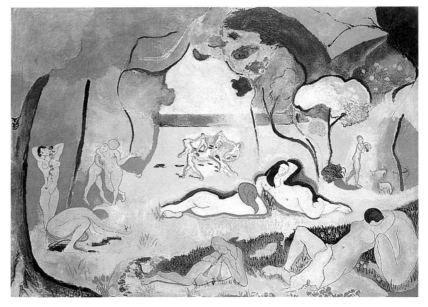

HENRI MATISSE
Le Bonheur de vivre
1905–6. Oil on canvas,
174 x 238 cm. The Barnes
Foundation, Merion.

Gauguin's friend and accomplice Charles Morice not only lamented the "poverty of imagination" of a canvas that showed "distressing indigence," he also joined with Louis Vauxcelles in expressing disappointment in its "abuse of systematic abstraction." Matisse painted *Le Bonheur de vivre* at the end of 1905 in the old convent of "Les Oiseaux," where he was to open an art school. It is a seminal work that juxtaposes pastoral themes and that of *Luxe, calme et volupté* with the Bacchanalia and Virgil's bucolic ideal, with Dance and Music both making an appearance. Though the subject remains wedded to the classical tradition of a serene elegiac Arcadia, the piece is also a glorious application of the principles of Fauvism. Divisionism has been abandoned, while the synthetic approach to drawing and the arabesque are suggestive of outlines and sketches. Its sumptuous chromatic values show the abandonment of local color, Matisse constructing the new system on which he was to base his entire oeuvre. Louis Vauxcelles wrote: "Simplification and insufficiency, the schematic and the vacuous, should not be confused," a statement countered, however, by Gertude Stein's observation that Matisse was for the first time putting into practice in a conscious way his desire to deform the human form so as to harmonize and intensify the pictorial values of the colors.

"COLORS SERVED AS STICKS OF DYNAMITE.

"The earliest paintings of L'Estaque were already in my mind's eye before I left"

GEORGES BRAQUE
L'Estaque
1906. Oil on canvas,
59.9 x 73.3 cm. Centre Georges Pompidou, MNAM, Paris.
© Centre Georges Pompidou, MNAM.

"It was in the South of France that I felt my exultation rise to a peak." Braque spent the winter of 1906 at L'Estaque, poaching studiously on Cézanne's preserve. Jacques Lessaigne even asked him whether this was his purpose in going. "Yes," the artist replied, "and with the idea already in my head. I can say that the earliest paintings of L'Estaque were already in my mind's eye before I left. I have worked hard though to subject them to the influence of the light and atmosphere and to the rain effects that have enlivened the colors." With the effect of what poet Francis Ponge has termed in this connection "frontalization and confrontation," the almost tactile landscapes that Braque painted at L'Estaque attempt to fuse Fauvist vehemence and Cézanne-like structure. Color, raised to maximum intensity, illuminates the canvas and heightens it to a point of incandescence. In 1929, Georges Duthuit in *Les Cahiers d'art* seeks to bring out connections between this movement and the early middle ages, identifying "the same simplification of mass and outline, less grandiose in style in the modern than in the historical example, but freer in the energetic manner it rejects geometry; the same fulgurat-

ing color scheme dominated by chromium, ultramarine, emerald and vermilion...; the same drive to face the sun's blaze, to resist the tempering quality of shadow, to collaborate with light and supplement its vibrations with orchestrated colors that organize and humanize daylight."

"How to convey, not what I see, but what is there?"

RAOUL DUFY
The Posters at Trouville
1906.
Oil on canvas, 65 x 81 cm.
Centre Georges Pompidou, MNAM, Paris.
© Centre Pompidou, MNAM.

At Trouville in 1906, Dufy painted similar motifs as his companion, painter Albert Marquet. As he would later

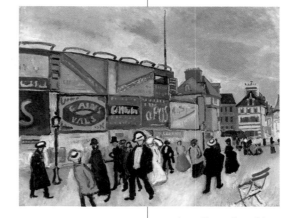

"Fauvism was to be our baptism of fire"

ANDRÉ DERAIN
Bend in the Road at L'Estaque
1906. Oil on canvas,
130 x 195 cm. Private collection. All rights reserved.

"Fauvism was to be our baptism of fire. I had never lost contact with the masters and, at eighteen, I was acquainted with all available reproductions of their masterpieces. For what can one gain if one lacks culture? There were doubtless hidden reasons for our disquiet at the time, a need to do something different from what everybody else could see. It was the era of photography. That might well have been a pivotal influence and played a part in our reaction against anything looking like a snapshot. We couldn't gain sufficient distance from things to be able to look at them and transpose them in our own time. Colors served as sticks of dynamite. They had to be made to explode with light. In its novelty, the idea that everything might be transported to a higher reality was an attractive one. And serious, too. Using flat planes, we showed a willingness to conserve the masses, endowing, for example, a blot [representing] sand with a weight it did not possess in order to bring out the fluidity of the water and the lightness of the sky." Back from London, Derain went to paint in L'Estaque where Cézanne had worked twenty years earlier. In this grand landscape, Gauguin's influence together with the breadth of the composition led him to strive for synthesis.

remark to Pierre Courthion, "How, with these," gazing on his brushes and paint tubes, "can I convey not what I see, but what is there, what exists for me, my reality? That's the whole problem. And I know that's where it lies, and nowhere else." In the summer of 1905, at a time when his work was still following the example of Eugène Boudin, Dufy encountered Matisse's *Luxe, calme et volupté*. In a search for a sensitive and picturesque lyricism, Dufy painted from life, adopting themes linked with the immediate and unmediated nature of his sensations. He adopted a free form of "Tachism" that quickly veered away from Divisionism. Some critics have seen in his choice of landscape subjects and themes the echo of a certain branch of Impressionism.

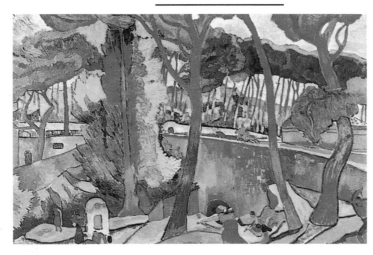

"THEY HAD TO BE MADE TO EXPLODE WITH LIGHT" Derain

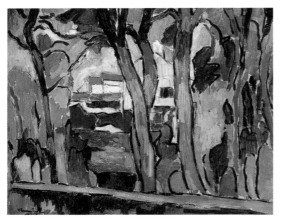

"Emerald green becomes black— pink, flaming red"

MAURICE DE VLAMINCK
Landscape with Red Trees
1906. Oil on canvas, 65 x 81 cm.
Centre Georges Pompidou,
MNAM, Paris. © Centre Georges
Pompidou, MNAM.

Owing a debt to the work of
Cézanne, whom he dubbed
"the sad companion,"
Vlaminck moved from the
lyricism of the years 1904–5
to produce more highly con-
structed works. "Working
directly from paint tube to
canvas, one soon achieves
extraordinary facility and
then finally mathematical
transpositions: emerald
green becomes black—pink,
flaming red, etc." Unlike his
friend Derain, however,
Vlaminck did not feel the need
to call his entire oeuvre into
question. Although he was
probably the first Fauve to
become interested in the arts
of Africa, this does not appear
in his works produced be-
tween 1905 and 1907. His
interest in the human figure
and his way of dramatizing
the subject led him to reject
the analytical dimension
toward which his contempor-
aries were progressing.

"I went from surprise to surprise"

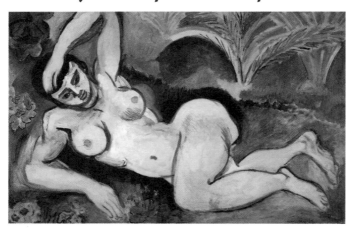

HENRI MATISSE
Blue Nude: Memory of Biskra
1907.
Oil on canvas, 92.1 x 140.4 cm.
The Baltimore Museum of Art,
Cone Collection.
All rights reserved.

The crucial year of 1906 saw
Henri Matisse's first journey
to North Africa. He later
recalled: "I went from sur-
prise to surprise. I couldn't
tell whether my astonishment
resulted from the customs of
the new types of people I saw
or from purely pictorial emo-
tions." Both the pose and
model here seem to hark back
to *Luxe, calme et volupté* and
to *La Joie de vivre*. Though
Vauxcelles could only see "a
mannish nymph," an "ugly
naked woman, lying down on
the opaque blue grass
beneath the palm trees,"
Matisse's fanciful divinity in
fact demonstrates the
increasing ascendancy of
Cézanne over the decorative
and allegorical influence of
Gauguin. As Fauvism reached
its limits and Expressionism
returned with renewed power,
the result was the emergence
of Cubism. As Jean Leymarie
has stressed: "Supremely
controlled tendencies clash
in this formidable *Blue Nude*
... that Matisse produced at
the very moment when
Picasso (and it is significant
that Derain was moving in
the same direction) was
putting the finishing touches
to *Les Demoiselles d'Avignon*,
and thus laying down a new
direction for painting."

"Unable to do anything decent"

ANDRÉ DERAIN
The Bathers
1907. Oil on canvas,
132.1 x 195 cm.
The Museum of Modern Art,
New York. All rights reserved.

While in London in 1906,
Derain had discovered the
African art collections of the
British Museum. The following
year, however, he underwent
a profound crisis: "Unable to
do anything decent. Very tired
physically and emotionally."
Did Derain paint his *Bathers*
after seeing studies for *Les
Demoiselles d'Avignon* in
Picasso's studio in the winter
of 1906–7? He had certainly
had it in mind to break with
the Fauvist system and was
now trying manfully to con-
struct solid, monumental,
hieratic figures. "There's a
lot left to do with drawing, fol-
lowing on from what we have
already managed with color."
Synthetic geometrization and
the mask of the central figure,
in conjunction with the cylin-
drical treatment of the
composition as a whole, turn
The Bathers into a synthe-
sis in which Cézanne, Gau-
guin and early art have
impacted on the artist and
pushed him beyond physi-
cal reality as conveyed in his
Fauvist creations.

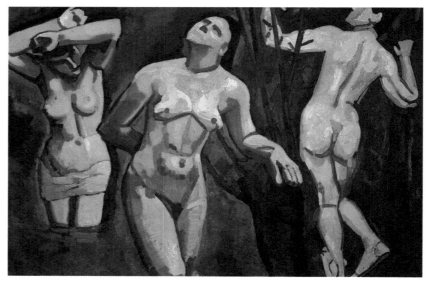

Chronology 1895–1907

In keeping with the subject of the chapter, this chronology is largely devoted to events in France and the rest of Europe. Sections in bold refer to artists mentioned in the main text and captions.

1895

- Invention of the cinema by the Lumière brothers.
- Berlin: first appearance of the journal *PAN*.
- Venice: first Biennale.
- Gauguin's second visit to Oceania.
- Cézanne exhibition at Ambroise Vollard's gallery.

Matisse studying in the studio of Gustave Moreau, where he will be joined by Charles Camoin, Manguin and Marquet.

1896

- Georges Méliès's first films.
- Brussels: first Salon de la Libre Expression.
- Munich: publication of the review *Jugend*.
- Alfred Jarry: satirical, absurdist play *Ubu Roi*.
- Deaths of poet Paul Verlaine and art critic and diarist Edmond de Goncourt.
- Bonnard's debut exhibition at the Galerie Durand-Ruel.
- Opening of the Art Nouveau gallery (Siegfried Bing), Paris.

1897

- Serious loss of life at a fire in the Bazar de la Charité store, Paris.
- Vuillard, *Large Interior*.
- Vienna: first president of the Sezession elected (founded 1892).
- Scandal erupts at the French state's refusal of Caillebotte's Impressionist painting collection.

Van Dongen arrives in Paris.

1898

- *J'accuse*, Émile Zola's open letter on the Dreyfus affair.
- Auguste Rodin: *Balzac*.
- Hector Guimard: Castel Béranger, Paris.
- Paul Signac publishes his *De Delacroix au néo-impressionnisme*.
- Deaths of Puvis de Chavannes, Aubrey Beardsley and Gustave Moreau.

Matisse in London (January) to see Turner; then to Corsica and Toulouse region. Friesz and Jean Puy arrive in Paris. Matisse returns to Paris (February), living at 19, quai Saint-Michel; meeting with Derain and Puy. First stirrings of Fauvism.

1899

- Dreyfus affair: Dreyfus wins initial pardon after French army retrial.
- Branly and Marconi invent telegraphy.
- Nabis exhibition at the Galerie Durand-Ruel.
- Maurice Ravel: *Pavane for a Dead Infanta* (piano or orchestra).
- Berlin: first Sezession exhibition.
- Death of Alfred Sisley.

1900

- World's Fair in Paris.
- Max Plank's quantum theory.
- Maurice Denis: *Homage to Cézanne*.
- Seurat retrospective exhibition at the *Revue blanche*.
- Construction of the Petit Palais and Grand Palais exhibition halls in Paris.
- Picasso's first trip to Paris.

Vlaminck and Derain meet at Chatou. Braque and Dufy arrive in Paris.

Dufy joins Friesz at the École des Beaux-Arts.

1901

- Gauguin in the Marquesas Islands.
- Van Gogh retrospective exhibition at the Galerie Bernheim-Jeune.
- Nobel prize for physics goes to Roentgen for the discovery of X-rays.
- First Nobel prize for literature goes to French establishment figure Sully-Prudhomme.
- Death of Toulouse-Lautrec.
- Decorative arts: École de Nancy (Jean Prouvé, Émile Gallé, Louis Majorelle) forms into an association.
- Tony Garnier: plans for the "Cité Industrielle."

Matisse and Marquet exhibit at the Salon des Indépendants (to 1908). Derain introduces Vlaminck to Matisse at the van Gogh retrospective exhibition at Bernheim-Jeune's.

1902

- Death of novelist and champion of progressive art, Émile Zola.
- Georges Méliès's film, *Le Voyage dans la lune*.
- Claude Debussy's opera, *Pelléas et Mélisande*.
- Picasso and Matisse exhibitions at Berthe Weill's gallery.
- Alfred Stieglitz: the "Photo-Secession" and the journal *Camera Work* set up in New York.

1903

- Auguste Perret: building on the rue Franklin.
- Bertrand Russell: *The Principles of Mathematics*.
- Salon d'Automne founded in Paris: Gauguin retrospective.
- Deaths of Gauguin, Pissarro and Whistler.

1904

- Anton Chekov: *The Cherry Orchard*.
- Giacomo Puccini: *Madama Butterfly*.
- First Salon des Artistes Décorateurs.
- Neo-Impressionist and Post-Impressionist exhibition in Munich.
- Matisse exhibition at Vollard's gallery.
- Picasso at the Bateau-Lavoir studios.

Matisse spends summer at Saint-Tropez in the neighborhood of Post-Impressionists Paul Signac and Edmond Cross.

Derain returns from military service and joins Vlaminck at Chatou.

"Cézanne strives to give things solidity"

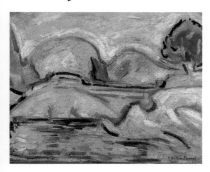

OTHON FRIESZ
Landscape at La Ciotat
1905 or 1907.
Oil on canvas, 33.5 x 41 cm.
Centre Georges Pompidou, MNAM, Paris.
© Centre Georges Pompidou, MNAM.

As the works he sent to the Salon des Indépendants demonstrate, Friesz remained committed to what had now become traditional principles, but also to the rejection of van Gogh and even Gauguin, deploring the "sensual turbulence" of the former and the "exoticism" of the latter. To them, Friesz preferred Cézanne who "strives to give things solidity," an observation that this *Landscape at La Ciotat,* probably painted in 1907 and incorrectly dated 1905, brings to mind. The color masses and the sinuous line privilege solid construction over dissolution of form. The architecture of nature is still conveyed through volume. In the summer of 1906, Friesz was at Antwerp with Braque. If the pictures he painted there betray a desire to replace local color with a more arbitrary palette — "if it heightens the key" — he falls short of actually constructing space through color. His later canvases would display still more obviously their kinship with those of Cézanne.

Chronology 1895–1907

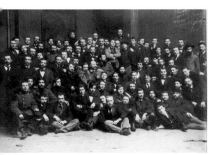

1895. Louis Lumière, *Train arriving at La Ciotat.* Document, *Cahiers du Cinéma.*

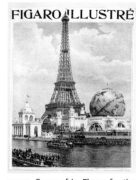

1897. Anonymous. Gustave Moreau's studio at the École des Beaux-Arts. Musée Gustave Moreau, Paris. © RMN/R. G. Ojeda.

ALFRED JARRY

Ubu Roi

PARIS
Édition du Mercvre de France

1896. Alfred Jarry. *Ubu Roi.* Mercure de France edition, Paris. © Roger-Viollet.

Le Petit Journal

1897. *Le Petit Journal.* The fire at the Bazar de la Charité. © Roger-Viollet.

FIGARO ILLUSTRÉ

1900. Cover of *Le Figaro* for the Paris World's Fair. Musée des Art Décoratifs, Paris. © Dagli Orti.

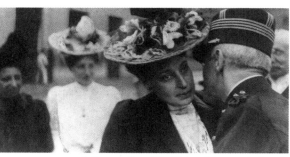

1906. Presentation of the Légion d'Honneur to Captain Dreyfus accompanied by his wife. © Keystone.

1905

- Salon d'Automne: the "cage aux fauves" ("wild beasts cage") with Derain, Marquet, Matisse, and Vlaminck. Manet exhibition.
- Salon des Indépendants: Seurat and van Gogh retrospective exhibitions, as well as 4,270 entries by contemporary artists.
- Die Brücke founded in Dresden. Van Gogh exhibition at the Galerie Arnold.
- Josef Hoffmann: Palais Stoclet, Brussels.
- Frantz Jourdain: "La Samaritaine," department store, Paris.

Matisse and Derain at Collioure.
Marquet, Camoin and Manguin in the Saint-Tropez region.
Friesz at Antwerp and La Ciotat.
Vlaminck and Derain make contact with van Dongen. African sculpture is a revelation to many artists.
Matisse and Friesz set up their studios in the former convent of Les Oiseaux, rue de Sèvres, Paris.

1906

- Captain Dreyfus exonerated.
- Santos-Dumont flies in an airplane.
- Mahler: 6th Symphony.
- Claude Monet: first of the *Waterlilies.*
- Salon d'Automne: Gauguin retrospective exhibition.
- Juan Gris and Modigliani arrive in Paris.
- Death of Cézanne.

Matisse's *Joie de vivre* at the Salon des Indépendants.
Matisse's first journey to North Africa (Biskra); summer sojourn at Collioure.
Derain in London (views of the Thames) and in Provence.
Marquet and Dufy in Normandy.
Braque exhibits at the Salon des Indépendants, adopts Fauvism, and spends autumn at L'Estaque.

1907

- France, Great Britain and Russia join in the Triple Entente.
- Opening of Daniel-Henri Kahnweiler's gallery in Paris.
- Picasso completes *Les Demoiselles d'Avignon* in the autumn.
- Cézanne retrospective at the Salon d'Automne and Galerie Bernheim Jeune.

Matisse travels to Italy. The Académie Matisse opens its doors. Marquet, Camoin and Friesz in London. Braque at La Ciotat and L'Estaque. Derain at Cassis and Avignon in the South of France. Dufy at Le Havre and Marseille. Camoin in Spain. Puy at Talloires (Haute-Savoie).

Studies on Fauvism

W. Bohn. *Apollinaire and the International Avant-Garde.* Albany, 1997.
G. Diehl. *Les Fauves.* Paris, 1971 [1943].
G. Duthuit. *The Fauves.* New York, 1950.
J. Elderfield. *The "Wild Beasts." Fauvism and its Affinities.* New York, 1976.
M. Giry. *Le Fauvisme.* Neuchâtel, 1981.
J. Herbert. *Fauve Painting: The Making of Cultural Politics.* New Haven, 1992.
J. Leymarie. *Fauvism.* Geneva, 1959.
E. C. Oppler. *Fauvism Reexamined.* New York and London, 1976.
L. Vauxcelles. *Le Fauvisme.* Geneva, 1958.
S. Whitfield. *Fauvism.* London, 1991.
B. Zurcher. *Les Fauves.* Paris, 1995.*

Main exhibitions and catalogues

1951 June–Sept., Paris. *Le Fauvisme.* MNAM (preface J. Cassou).

1952–53 Oct.–May, New York, Minneapolis, San Francisco, Toronto. *The Fauves* (preface J. Rewald).

1966 Jan.–March, Paris; March–May, Munich. *Le Fauvisme français et les débuts de l'expressionnisme allemand* (prefaces B. Dorival and L. Reidemeister; catalogue M. Hoog). Haus der Kunst.

1976 March–June, New York. *"The Wild Beasts." Fauvism and its Affinities.* MoMA.

1990 Oct.–Dec., Los Angeles. *The Fauve Landscape.* Los Angeles County Museum.*

Where works can be seen

France
Musée d'Orsay, Paris.
Musée National d'Art Moderne, Paris.
Musée d'Art Moderne de la Ville de Paris.
Musée de l'Annonciade, Saint-Tropez.
Musée d'Art Moderne, Troyes (donation Pierre Lévy).
Musées Matisse, Cateaux-Cambresis and Nice.

United States
MoMA, New York.
Barnes Foundation, Merion.

Europe
Tate Gallery, London.
Statens Museum for Kunst, Copenhagen (Rump collection).

*** Essential reading**

CUBISM
"from image to language"

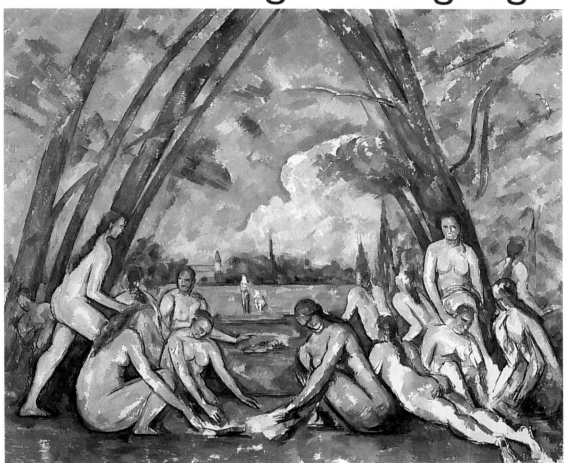

"Pictures that can teach"

PAUL CÉZANNE
Large Bathers
1899–1906.
Oil on canvas, 208 x 249 cm.
Philadelphia Museum of Art.
W. P. Wilstach Collection.
© AKG Paris.

"A painter should devote himself entirely to the study of nature and strive to create pictures that can teach." In these words, Cézanne set out his credo; since then, the aura surrounding his work has only intensified. *The Large Bathers* cycle is composed of three monumental canvases in which the pointed arches representing a pantheist nature are flanked by thick foliage. Cézanne here undermines both Fauvist chromaticism and the construction of form through color. The bodies are rendered geometrically, form being constructed through pictorial space. Though remnants of empirical optics may survive, as Louis Vauxcelles noted, "Cézanne's marbleized forms turn green on bathers' torsos immerged in what are fearsomely indigo waters." Cézanne proved to be the artist to whom a whole new generation would turn, Matisse himself acquiring a small canvas from the art dealer Ambroise Vollard. Meanwhile, in a far cry from the empathy that characterized the works he had painted up to then, Picasso was soon to be working on his *Demoiselles d'Avignon*.

No movement in the early part of the twentieth century was to give rise to such profound changes as Cubism. In this initial overview, the decision to limit ourselves to Picasso and Braque is symbolic: Cubism was not so much a movement as a meeting of these two minds. Their collaboration had been furthered by poet and critic Guillaume Apollinaire, and, like a climbing team roped together, they would interact daily to the point that, for the inexperienced eye, their works can be difficult to tell apart.

On October 1, 1907, at the inauguration of the > > >

> > > fifth Salon d'Automne in Paris, critic Charles
Morice noted with concern how Cézanne's
influence had gained the upper hand. In fact,
Cubism was invented as a response to Cézanne's
self-appointed mission to deconstruct the world
of appearances. The term, however, is but a
vague and generic one coined in an attempt to
discredit its exponents and it now hampers true
appreciation of the variety of the movement.
Cubism no more began with *Les Demoiselles
d'Avignon* in 1907 than it ended with World War I
in 1914. As Juan Gris, one of its most important
protagonists, put it some time later, it was "not a
practice, but a state of mind." Of course, Cubism
first emerged in painting, but it was to extend
far beyond into sculpture, literature and music.
To understand its genesis and evolution, it is
helpful to divide the movement into three
periods. The first phase was openly indebted to
Cézanne, while in the case of Picasso it was
marked by the influence of "primitive" art. The
second, from 1910 to 1912, marks an essential
stage in the process of the deconstruction, the
splintering of figures in space. This is Analytical
Cubism, that mistreats and pulls apart the rules
of perspective, establishing a syntax that
overturns conventional imagery. The final
period, that of Synthetic Cubism, began in 1912
and ended when the war scattered its key
exponents. It was characterized by the intrusion
of reality in the form of *papiers collés* (pasted
papers affixed to the canvas) and a multiplicity
of technical means intended to reconstruct the
puzzle in pieces.

It is difficult to overstress the precarious nature
of such a division, however, since Cubism has all
the appearance of a process of eternal
recurrence, a project without end that cannot be
reduced to systematic classifications. As Jean
Laude has demonstrated, "Fauvism, just like
Cubism, should not be considered as a definitive
style . . . but as presenting provisional solutions
to a problem which broadened in scope as it
progressed. They form part of a process of > > >

24

"This Spaniard torments us like a sudden chill"

PABLO PICASSO
The Family of Acrobats
1905.
Oil on canvas, 212.8 x 229.6 cm.
National Gallery of Art,
Washington D.C. Chester Dale
Collection.
© AKG Paris.

For the period from 1893 to
1906, J. E. Cleriot refers to the
"birth of a genius," while
Pellicer, discussing the artist's
work up until his visit to Gosol
in the summer of 1906, speaks
of "Picasso before Picasso."
The social and psychological
bitterness of the Blue Period
was (once he settled perma-
nently at the Bateau-Lavoir in
Paris in April 1904) succeed-
ed by, as Christian Zervos put
it, "a need to refresh his eyes
and senses with new visions
and to portray beings, which,

if not exempt from nervous
shivers, would not convey
them by quite such visible
signs." Thus began the Rose
Period. Picasso's peculiar fas-
cination with the character of
Harlequin, the artists he was
then meeting and the fact that
the circus Médrano was in the
neighborhood all played a part
in its making. In this large can-
vas of acrobats, El tio Pepe
Don José is the central figure.
Zervos sees the piece as the
first large-scale composition
by Picasso, "who [until that
time] had contented himself
with portraying single figures
or couples." But *The Family
of Acrobats* also recalls
Velázquez' *Las Meninas*. As
early as 1905, the poet Guil-
laume Apollinaire could write:
"This Spaniard torments us
like a sudden chill."

"I'M SURPRISED AT HOW THE WORD 'EVOLUTION'

"Eighty or ninety sittings"

PABLO PICASSO
Portrait of Gertrude Stein
1905–6.
Oil on canvas, 99.6 x 81.3 cm.
Metropolitan Museum of Art,
New York.
© Giraudon.

In the spring of 1906, an important exhibition at the Louvre of Iberian sculpture unearthed during excavations at Osuna brought Picasso into contact with a new language, and it was as he was preparing this portrait of Gertrude Stein (who had been introduced to him by Matisse) that his style underwent a profound transformation. Picasso only finished the portrait, however, after returning from Gosol. "Gertrude Stein took up her pose, and Picasso, seated on the edge of his chair, his nose to the canvas, holding in his hand a tiny palette covered in a grayish brown, would begin to paint." Unlike Matisse, who saw in his discovery of "primitive" forms a lyrical manner of suggesting movement, Picasso tried to imprint on the face a sculptural intensity close to that of a mask. Cézanne, once again, understood well enough that, as Jean Leymarie has noted, "all pre-existing criteria of illustration or of feeling have to be dissolved and converted into plastic energy."

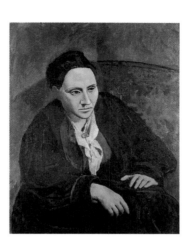

"I interpret my own subjective impressions"

GEORGES BRAQUE
Study for *The Large Nude*
1907–8.
Ink drawing on paper.
Photo after *The Architectural Record,* New York, 1910.

Apollinaire introduced Braque to Picasso in late 1907. *The Large Nude* (now in a private collection), which was exhibited at the 1908 Salon des Indépendants, dates from the same period. As Braque explained to the American critic G. Burgess: "I couldn't depict woman in all her natural beauty . . . I haven't the skill. So I had to create a new kind of beauty, the beauty which appeared to me in terms of volume, line, mass and weight, and, through this beauty, I interpret my own subjective impressions." In an effort to assimilate the lesson of Picasso whose endeavors were all directed at interlocking surface and depth, Braque recorded that he had to first sketch out three figures each representing a single physical aspect of a woman, "like a house that has to be drawn in ground-plan, elevation and cross-section."

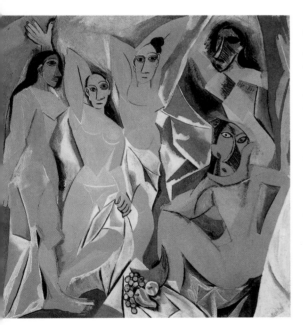

"What barbarian sculptors were striving to do"

PABLO PICASSO
Les Demoiselles d'Avignon
1907.
Oil on canvas,
243.9 x 233.7 cm.
© Museum of Modern Art,
New York.

A seminal work, *Les Demoiselles d'Avignon* presented a new way of treating space and of expressing emotion. "The picture he'd painted looked insane and monstrous to everyone," the dealer Daniel H. Kahnweiler noted at a later date. Picasso countered Matisse's elegiac style with tragedy. Braque even declared that "painting in that way made him feel like he was drinking gasoline." The story of this emblematic work, begun in the winter of 1906–7, and its erstwhile title, *The Philosophic Brothel*, is well known. Its gestation was a lengthy one, the composition continuing to evolve until the final state was arrived at in July 1907. The initial violence of the subject was in the end eclipsed by that of the painting itself: a deliberately unfinished piece, it is a list of thorny questions with no neat answers. André Salmon, who saw it at an early stage, noted in 1912: "So, Picasso wants to provide us with a global representation of man and things. This is what the barbarian sculptors were striving to do. But this is painting, an art confined to the surface; this is why (casting aside academic rules and anatomy) Picasso has to balance these figures within a space that conforms rigorously to an unexpected freedom of movement."

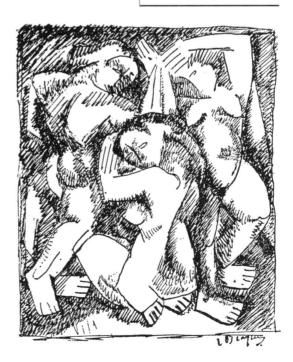

IS SO USED AND ABUSED. I DON'T EVOLVE. I AM" Picasso

> > > integrating art into a society for which they also created some of the ideals."

Situating Cubism historically requires an understanding of the profound changes in attitude toward the world that were then in full swing. In a parallel with the philosophy of the time, we could say that the distance separating Cézanne from Picasso is comparable to that separating the ideas of Henri Bergson and Edmund Husserl: no more axiomatic knowledge, but instead a direct experience of the world linked to the visual sense. Picasso's aphorism (told to Leo Stein, Gertrude's brother, before 1914) comes to mind: "A head . . . is made up of eyes, nose, mouth that can be arranged however you please—the head will still remain a head." And not only philosophy, but also music, since the parallel could be extrapolated to embrace Schoenberg's compositions. If Cubism's heritage today is most evident in its formal principles, whereas the specifically phenomenological character of its intentions seems to have escaped its contemporaries, it has to be stated that the abandonment of visual illusion, the idea of the picture as an object in itself and the multitude of technical means it exploited have proved of enduring value to twentieth-century art as a whole. In common with all those who continued along their path, Picasso and Braque, in reacting against the vanity of illusion and against outdated spiritual and symbolic precepts, strove for a new interpretation of the external world that only new-found formal means were to render possible. <

26

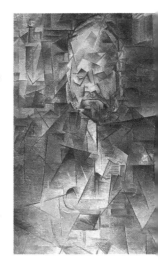

"The picture is no longer a dead zone in space"

PABLO PICASSO
Portrait of Ambroise Vollard
1909–10. Oil on canvas, 92 x 65 cm. State Hermitage Museum, Saint Petersburg. © Giraudon.

Probably begun around the end of 1909, the *Portrait of Ambroise Vollard* was only terminated in the spring of the following year. A comparison with the portrait of the same dealer Cézanne had painted in 1899 shows just how far Picasso had come in the space of ten short years. Vollard sits facing us. On a table behind him stands a bottle and, to his left, a book. A handkerchief sticks out of his jacket pocket. The fragmented surface of the canvas is multifaceted, suggesting, in the way the light plays over it, the splintering or atomization of the subject. But the true subject matter no longer resides in portraiture but in the elaboration of a formal "analytic" language. Perceptive experiences would lead Picasso to increasingly degrade the picture's readability, without, however, ever totally abandoning the "subject." In his "Notes on Painting" published in *Pan* in French (1910), fellow artist Jean Metzinger wrote: "Whether he paints a face or a piece of fruit, the whole image radiates in duration: the picture is no longer a dead zone in space."

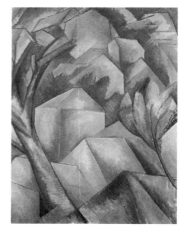

GEORGES BRAQUE
House at L'Estaque
1908.
Oil on canvas,
73 x 60 cm. Ruph Foundation, Bern. © Giraudon.

In 1908, while Picasso was working on the banks of the Oise, Braque, back in the

"Braque paints little cubes"

South of France, was following in Cézanne's footsteps and trying to synthesize his own recent work. Volumes became more geometric while nature and architecture began to interlock. The jury of the Salon d'Automne rejected this piece and it was the dealer Kahnweiler who finally presented Braque's works with a preface by Apollinaire (November 9–28). It might have been on this occasion that the word "cube" first appeared. Matisse is meant to have suggested the term to Vauxcelles, who in turn wrote that "Braque paints little cubes" (*Gil Blas*, November 14, 1908). The same critic was to reuse the expression in a commentary he provided for the 1909 Salon des Indépendants.

"M. BRAQUE IS A BOLD YOUNG MAN INDEED... HE DISDAINS

"Appearances are a result"

GEORGES BRAQUE
Le Portugais (The Emigrant)
1911–12.
Oil on canvas, 117 x 81.5 cm.
Kunstmuseum, Basel.
© Giraudon.

"Appearances are not to be imitated. Appearances are a result." In the summer of 1911, Picasso and Braque were staying together in Céret in southwest France where they laid the foundations for what proved a decisive step. *Le Portugais* itself is a monumental composition in which stenciled numbers and fragmentary words provide a few clues: the word *bal* ("dancehall") hints at music, while "0.40" was doubtless lifted from a poster advertising the

place where the Portuguese is to have played. Yet this is merely an attempt to reconstitute the origins of a reality which the principles behind the painting have shattered. What we have with *Le Portugais* is essentially a picture that defies description. The few signs one struggles to decipher are mere analogies that prevent the image from dissolving totally. They help in naming the subject, in recomposing it mentally, and provide it with a resonance in space and time. Painting is tangible space. Like Picasso, Braque here hints at the tactile dimension that they will soon achieve through the incorporation of paper cut-outs.

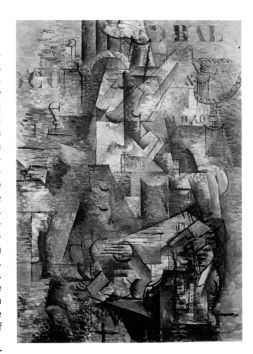

"A dauber in landscape"

HENRI ROUSSEAU
(KNOWN AS LE DOUANIER ROUSSEAU)
The Snake Charmer
1907.
Oil on canvas, 169 x 189.5 cm.
Musée d'Orsay, Paris. © RMN.

"We are the two great painters of the time, you in the Egyptian genre and myself in the modern." This famous quip—made by Rousseau to his host on the occasion of a banquet thrown in his honor by Picasso in 1908—strikes one as puzzling at the very least. It is an acknowledgement of the Catalan painter's roots precisely at a time when Rousseau was drawing inspiration from published albums of *Les Bêtes sauvages* (Wild Beasts). If Cézanne had admired Bouguereau, then

Rousseau venerated another academic painter, Gérôme. He readily admitted that he had acquired his manner through "sheer grind." However, Paul Reboux saw him as a mere "dauber in landscapes fit for a rifle shoot," while Tarabant said his work was "bumbling scrawl." Though he had been tenaciously exhibiting at the Salon des Indépendants since 1886, it took Vallotton, Louis Roy and absurdist playwright Alfred Jarry who compared the painter to the Renaissance master Memling) to put Rousseau on the map. Picasso, Delaunay and Brancusi, as well as the poets Blaise Cendrars and Apollinaire, also defended his work, since he provided a break with the Impressionist obsession with motif, opting for a more intellectualized approach to art.

"Express reality through materials"

GEORGES BRAQUE
Violin and Pipe, Le Quotidien
1913. Chalk, charcoal, pasted paper, fake-wood paper, and newspaper glue-mounted on paper, 74 x 116 cm. Centre Georges Pompidou, MNAM, Paris. © Centre Georges Pompidou, MNAM/CCI.

PABLO PICASSO
Bottle, Glass and Violin
1897. Pasted papers and charcoal, 47 x 62.5 cm.
© Moderna Museet, Stockholm. Photo T. Lund.

"We were trying to express reality through materials which we did not know how to handle and which we appreciated precisely because they were not indispensable and because they were neither the best nor the most suitable." Picasso's remarks echo Braque's: "The role of color was fixed definitively by the use of *papiers collés* [pasted papers]. Color became clearly dissociated from form and this independence was made visible—since that was

the essential point." Cut-out fragments of printed texts, wallpaper imitating the texture of wood, newsprint underlined or retouched here or there, a pencil sketch: here, space no longer plays with illusion. The *papier collé* is at once concretely and absolutely flat. It is an infinite open space where meaning can be formed and yet remain in abeyance, allowing the artist's absolute right over his chosen subject to be assumed. "Painted proverbs..."

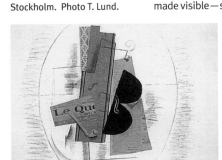

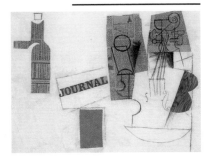

FORM AND HAS REDUCED EVERYTHING... TO CUBES" Vauxcelles

"One can paint with whatever one likes"

PABLO PICASSO
Still Life with Chair Caning
1911–12. Oil on waxed canvas surrounded with rope, 29 x 37 cm. Musée Picasso, Paris. © RNM/Ojeda.

"**S**o as to mimic the wicker seating of the chair, Picasso introduces a piece of paper, painting over the areas showing the wood parts of the chair. He first found it senseless to slavishly parrot something which had already been imitated, and then to imitate something when it was possible to put the object itself in its place. He also liked to stick on a bit of old newspaper and add a few lines of charcoal and leave the picture at that... The extreme, the arrogant poverty of the materials always enchanted him." So wrote Louis Aragon in a preface to the catalogue of the 1930 exhibition "La Peinture au défi," his text seeming to echo one published some two decades previously, in 1913, by Guillaume Apollinaire entitled *Les Peintres cubistes.* "Surprise gives a wild laugh at the purity of the light; it is quite in order for molded numbers and letters to appear as picturesque elements that are new to art but which have long since been impregnated with humanity... One can paint with whatever one likes—with pipes, postage stamps, postcards, playing cards, candelabras, pieces of waxed cloth, detachable collars, wallpaper, newspapers." *Still Life with Chair Caning* is the first collage, and marks, wrote Pierre Daix, "the irruption of industrial representation in painting."

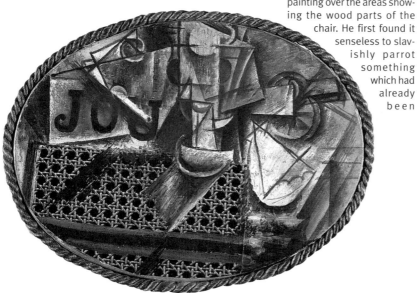

"I like rules that adjust emotion"

GEORGES BRAQUE
Man with a Guitar
1914. Oil and sawdust on canvas, 130 x 73 cm. Centre Georges Pompidou, MNAM, Paris. © Centre Georges Pompidou, MNAM/CCI.

This work was begun as early as 1911 (at the same time as *Le Portugais* discussed above), when Braque was something of Picasso's apprentice in Céret. Like the latter's *Portrait of a Girl,* painted in 1914, this work is a monumental synthesis of the discoveries of Cubism. It was finished prior to the artists' separation in August, when Braque went to the front, where he remained until January 1917. Unlike Picasso's work, however, the dominant effect is of a brown-hued cameo, even if a few motifs enliven the overall tone. The material is sometimes granulated, at others fluid, the sawdust mixed in with the oil giving the surface an abrasive appearance. In "Pensées et réflexions sur la peinture," published in the journal *Nord-Sud* in December 1917, Braque summarized the Cubist experience before its interruption by the war. "The charm and the strength of primeval painting often derive from its limited means... The pasted paper, the fake wood and other elements of a similar type which I employed in a number of drawings also appealed through their factual simplicity, and it is that which led people to confuse them with trompe l'oeil, of which they are the exact opposite. They are simple facts, but they are created by the mind and they are evidence of a new way of placing figures in space... I like rules that adjust emotion."

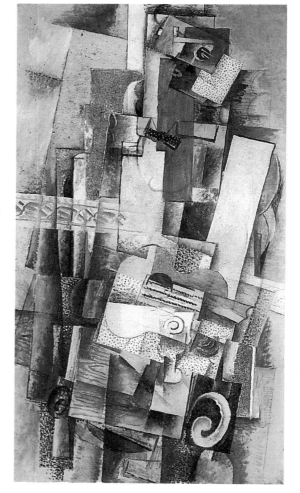

"WE WORK RATHER LIKE

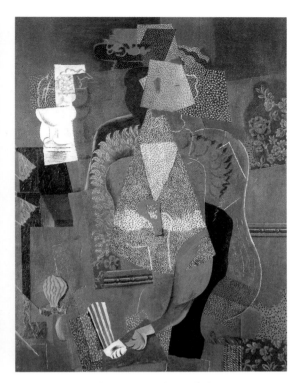

"A miscellany of Cubism's decorative motifs"

PABLO PICASSO
Portrait of a Girl
1914. Oil on canvas, 130 x 97 cm.
Centre Georges Pompidou,
NAM, Paris.
© Centre Georges Pompidou,
MNAM/CCI.

In the *Portrait of a Girl,* Picasso offered a magnificent synthesis of all his discoveries since 1912. Painted in Avignon in the summer of 1914, it provides what amounts to a "miscellany of all Cubism's decorative motifs." Is it a *papier collé* or a painting? As Marie-Laure Bernadec has rightly emphasized, its illusionism is striking. Marbling, fringes from an armchair, and pieces of molded paper are juxtaposed with, and even interlock with, various parts of the girl's body, as well as with the diverse objects that make up the pictorial space. The whole painting is a virtuoso puzzle, unity being imparted by a greenish hue that spreads over the entire surface. Here the asceticism and sparseness of earlier works has been supplanted by a profusion of ornament. The pleasure Picasso experiences in painting and in freely controlling a vocabulary and a syntax that he himself developed has encouraged him to push ornament and decoration to their limits, thereby entering a whole new area in which the power of pictorial illusion is given a new lease of life.

Chronology 1907–1914

In keeping with the subject of the chapter, this chronology is largely devoted to events in France and the rest of Europe. Sections in bold refer to artists mentioned in the main text and captions.

1907
Picasso paints *Les Demoiselles d'Avignon*. He meets Braque, Derain and Kahnweiler, who opens a gallery in Paris.
Manet's *Olympia*, previously thought scandalous, enters the Louvre.
Salon d'Automne: Cézanne retrospective exhibition.
Munich: Werkbund association created.

1908
• Salzburg: first international congress of psychoanalysis.
• Émile Zola ashes are transferred to the Panthéon, Paris.
• France: laws protecting intellectual property extended to cover the domain of film.
• Dresden: exhibition by painters from the Brücke group.
• American Ashcan School of painting has its beginnings with an exhibition by The Eight.
• October: Austria-Hungary proclaims the annexation of Bosnia-Herzegovina.
• Founding of the prestigious literary journal *La Nouvelle Revue française* (the "NRF") by André Gide among others.
A banquet in honor of Le Douanier Rousseau is organized at Picasso's.

1909
• Munich: establishment of the Neue Künstlervereinigung ("New Artists' Association," NKVM).
• Paris: publication in February of Filippo Tommaso Marinetti's "Futurist Manifesto" in French in *Le Figaro*. First issue of the *Nouvelle Revue française* published.
• Paris: first season of Sergei Diaghilev's Ballets Russes is a triumph.
• Taking off from Calais at dawn on July 25, Louis Blériot flies across the English Channel.
• Couturier Paul Poiret opens an outlet at 107, rue du Faubourg Saint-Honoré.
• Manufacturer of the first artificial fiber.
• Man reaches the North Pole.
The Salon d'Automne shows furniture and furnishings from Munich. Picasso moves to 11, boulevard de Clichy and spends the summer at Horta de Ebro. First Picasso exhibition in Germany.

1910
• Second season of the Ballets Russes stages Igor Stravinsky's *Firebird* (decor and costumes by Leon Bakst and Aleksandr Golovin).
• Death of the photographer Félix Tournachon, known as Nadar, and of painter Winslow Homer.
• September 2: death of painter Henri Rousseau, known as Le Douanier Rousseau.
• November: death of Russian writer Leo Tolstoy.
• Marie Curie isolates radium.
• Moscow: avant-garde Knave of Diamonds group created, with Larionov and Goncharova.
Kandinsky completes his essay "On the Spiritual in Art."
Chagall arrives in Paris.

1911
• Man reaches the South Pole.
• *Mona Lisa* stolen from the Louvre (recovered 1913).
• Dresden: premiere of *Der Rosenkavalier*, opera by Richard Strauss with a libretto by Hugo von Hofmannsthal.
• May: death of Gustav Mahler, composer and conductor.
• Paris: *Martyr of St. Sebastian* by Claude Debussy receives its first performance at the Châtelet theater. Nijinsky dances the title role in Stravinsky's *Petrushka*.
• Nobel prize for chemistry goes to Marie Curie. Nobel prize for literature awarded to the Belgian Symbolist Maurice Maeterlinck.
• First film studio opens in Hollywood.
• Larionov and Goncharova leave the Knave of Diamonds to set up the more "Russian"-orientated Donkey's Tail.
• Die Brücke leaves Dresden for Berlin.
Munich: Der Blaue Reiter founded.

1912
• China is declared a republic.
• The liner *Titanic* sinks after hitting an iceberg.
• First issue of the Russian paper, *Pravda*.
• Strongly worded criticism of Nijinsky's "erotic and extremely lewd" style. Paris society is divided for and against the dancer into "faunistes" et "antifaunistes."
• Maurice Ravel's *Daphnis and Chloe* performed.
• Air postal service starts between Paris and London.
• Death of the opera composer Jules Massenet.
• Schoenberg's *Pierrot Lunaire* inaugurates atonal Expressionism in music.

MOUNTAINEERS ROPED TOGETHER" Braque

October 2, 1908. Blériot flies in an airplane. © Roger Viollet.

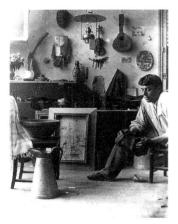

1910–11.
Georges Braque in his
studio. Archives Laurens.
Centre Georges Pompidou,
MNAM, Paris.
© Centre Georges Pompidou,
MNAM/CCI

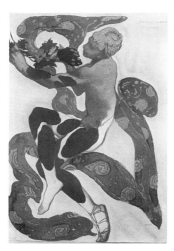

1912.
Léon Bakst,
Nijinsky in *L'Après-midi
d'un faune* by Debussy.
Poster for Diaghilev's
Ballets Russes, watercolor.
Bibliothèque de l'Arsenal.
© Giraudon.

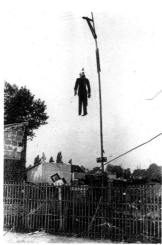

1914.
Effigy of Wilhelm II
hanged at Bécon-les-
Bruyères.
© Roger-Viollet.

Chronology 1907–1914

• September 30: general mobilization in Serbia,
Greece and Montenegro.
• Gleizes and Metzinger, *Du Cubisme.*
• Kandinsky publishes the *Almanach der Blaue
Reiter* and the essay "On the Spiritual in Art."
**Cubist Section d'Or exhibition at the Galerie
de la Boëtie. Mondrian stays in Paris.
Duchamp paints *Nude Descending a
Staircase.* Picasso leaves Montmartre for
Montparnasse. Picasso's first exhibition in
England.**

1913

• February: "Armory Show" opens in New York,
with a special section for Cézanne, van Gogh and
Gauguin.
• Stravinsky's *Rite of Spring* ballet with Nijinsky
receives its uproarious first performance in Paris.
• Cinema : *Fantômas* series by Louis Feuillade.
• Apollinaire's anthology of poems *Alcools* and
his essay "Les Peintres cubistes" published in
French. Marcel Proust's *Du Côté de chez Swann*
comes out, the first part of *A la Recherche du
temps perdu.*
**Paris: Futurist and Cubist works fill four
rooms in the Salon des Indépendants.**

1914

• June 28: Archduke Franz Josef of Austria and
his wife are assassinated at Sarajevo. Outbreak
of World War I.
• Panama Canal opens.
• Dresden: Impressionism triumphs at an
exhibition of French art.
• Rimsky-Korsakov's opera *The Golden Cockerel*
first performed with sets by Goncharova.
• Founding of Vorticism and its review *Blast* in
England.
• Stéphane Mallarmé's typographical poem *Un
coup de dés jamais n'abolira le hasard* published
by the *Nouvelle Revue française.*
• Apollinaire's anthology of typographical poems
Calligrammes published.
• Appearance in the American press of "daily
strips," an early form of cartoon.
• The Italian-produced film *Cabiria* employs
Segundo de Chomon's invention of the traveling
shot.
• Léger and Braque called up to the front.
**Picasso spends the summer in Avignon with
Braque and Derain. *Les Bateleurs* is sold for
11,500 francs at the Hôtel Drouot auction
house in Paris.**

Studies on Cubism
G. Apollinaire. *The Cubist
Painters.* New York, 1944
[Paris, 1913].
A. H. Barr, Jr. *Cubism: an
Abstract Art.* New York,
1936.*
W. Bohn. *Apollinaire and
the International Avant-
Garde.* Albany, 1997.
D. Cooper. *The Cubist
Epoch.* London, 1971.
P. Daix. *Cubism and
Cubists.* London, 1983.
E. Fry. *Cubism.* London,
1966.
J. Golding. *Cubism—A
History and an Analysis,
1907–1914.* London and
New York, 1959.*
G. Habasque. *Le Cubisme.*
Geneva, 1959.
J. Laude. *La Peinture
française et l'art nègre.*
Paris, 1968.
N. Lynton. *Cubism: The
Disrupted and Constructed
Image.* London, 1976.
J. Paulhan. *La Peinture
cubiste.* Paris, 1971.
R. Rosenblum. *Cubism and
Twentieth Century Art.*
London and New York,
1959.

*Main exhibitions and
catalogues*
1936, New York. *Cubism
and Abstract Art.* MoMA.
1953 Jan.-April, Paris. *Le
Cubisme, 1907–1914.*
MNAM.
1973, Paris, Bordeaux. *Le
Cubisme.* MAMVP and
Musée des Beaux-Arts,
Bordeaux.
1990 Sept.-Jan., New York.
*Picasso and Braque:
Pioneering Cubism.* MoMA
(curated by William
Rubin).*

*Where works can be
seen*
France
Musée d'Art Moderne,
Villeneuve d'Ascq.
Musée National d'Art
Moderne, Paris.
Musée d'Art Moderne de la
Ville de Paris.
Musée Picasso, Paris.
United States
The Art Institute of
Chicago.
MoMA, New York.
Solomon R. Guggenheim
Museum, New York.
Philadelphia Museum of
Art.
Europe
Kunstmuseum, Basel.
Kunstmuseum, Bern.
Hermitage, St. Petersburg.
Staatsgalerie, Stuttgart.
Peggy Guggenheim
Foundation, Venice.
Kunstmuseum, Winterthur.

* **Essential reading**

CUBISM
"from static to dynamic"

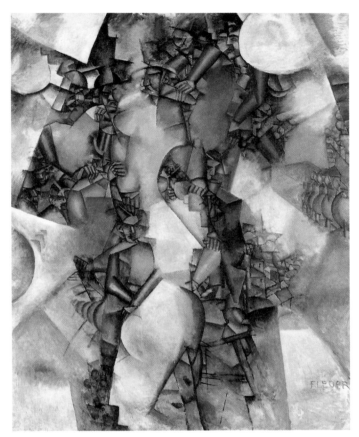

"A tubist"

FERNAND LÉGER
The Wedding
1911. Oil on canvas,
257 x 206 cm. Centre Georges
Pompidou, MNAM, Paris.
© Centre Georges Pompidou,
MNAM/CCI.

"A tubist": Louis Vauxcelles's term vividly captures the dismay he felt on first encountering Léger's work at the Salon des Indépendants in 1911. The following year, Apollinaire voiced similar misgivings: "Léger's picture originates in pure painting. No subject; a great deal of talent. It is to be feared, however, that the artist's manner, if it is not nourished by thought, will soon peter out." The Cubist movement was at the time looked down upon by French intellectuals, though it attracted great interest in Germany and Italy. *The Wedding* was purchased by Albert Flechtheim, a celebrated Berlin art dealer, who was eventually to present the work to the French state in 1937. The decomposition of the figures and the wedding procession, the various points of view and the indistinct effects all suggest movement. "Cubism," as Léger himself noted in 1931, "born of a necessary process of reaction, started out in gray tints and it took a number of years for color to appear." In a letter of December 1919 addressed to Kahnweiler, the artist had already written: "Once I had gained possession of my form [i.e. of modeled volume], then color reappeared, firstly in the grays like Cézanne's, then, little by little, it increased in importance." *After Nudes in a Forest, The Wedding* marked an important turning point. As Picasso wondered: "This guy must be on to something new as he hasn't been given the same name as us."

The 1911 Salon des Indépendants, like the Salon d'Automne of the same year and the Section d'Or in October 1912, ushered in public recognition of the Cubist movement. Picasso and Braque, however, did not take part. Cubism was now a doctrine that could serve as a rallying point for the younger generation. Albert Gleizes and Jean Metzinger thus noted that the two cofounders became Cubists "as if by ricochet" and that they watched the movement developing despite them: only the pair's preoccupation with the geometrical and with simplification could form the basis for a "school."

> > >

> > > Unlike numerous other European capitals, such as Berlin and Moscow, Paris witnessed the advent of a whole new generation of Cubists, while Picasso and Braque themselves remained poorly known. At the very moment Cubism was becoming an international movement whose influence was to extend rapidly east and west alike, Picasso and Braque started working in an analytical way which their disciples and immediate followers were not in a position to fathom. If it is true that Cubism became not only a movement but also a model that allowed its exponents to express rejection of the "old world" order, a closer reading of the chronology of the fast-moving events on the art scene shows how, from 1909, the trail Cubism had blazed split into numerous, often contradictory, sidetracks. Today, for example, there can be no justifiable reason for assimilating the work of Robert and Sonia Delaunay after the *Simultaneous Contrasts* to orthodox Cubism. Similarly, the term is inapt when referring to the Section d'Or, the salon organized by the Duchamp brothers in 1912. For innovative minds, Cubism was never an end in itself, but more a pretext, marking the moment, at the dawn of the modern period, when it was possible to reflect on the finality of painting. For instance, a few years later, although he was himself a pioneer of Cubism as a system, Albert Gleizes recognized that the "idea, as it developed, had burst out of the flimsy envelope of the word 'Cubism.'" In 1919, the modernist poet Blaise Cendrars, an early ally of Fernand Léger as well as of Robert and Sonia Delaunay, remarked for his part: "The day can already be foreseen when the term 'Cubism' will, as regards the history of contemporary painting, only serve as a name for the various investigations undertaken by certain painters between the years 1907 and 1914." After Léger, who exhibited at the 1909 Salon d'Automne, and Robert Delaunay, who like Léger had a predilection for cityscapes, Juan Gris's specific investigations aimed to "lay bare not only the relationship between the > > >

32

"A multiplicative state"

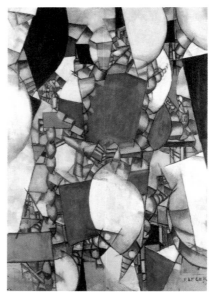

FERNAND LÉGER
Woman in Blue
1912. Oil on canvas,
194 x 130 cm. Öffentliche
Kunstsammlung, Basel.

"I wanted to bring out each tone in isolation; a really red red, and a really blue blue. Delaunay was going in for nuances while I went for a forthright use of color. In 1912, I came up with pure color inscribed within geometrical forms. Example: *Woman in Blue*." Like *The Wedding*, it is a monumental work. Its "large dimensions," as Jean Cassou explained, "allow Léger to encompass images from his universe," drawing him close to a "multiplicative state." "I juxtaposed," as the artist put it, "curved and straight lines, flat and molded surfaces, pure local color and nuances of gray. Whether these initial plastic forms are inscribed on objective elements or not is irrelevant to me. That is a mere question of variety." The *Woman in Blue* has been seen as analogous to Cézanne's *Woman with a Coffee Pot,* although Léger was actually searching for a system of mechanical organization: "a dry, tough relationship... between dead surfaces... and sprightly forms." The image can thus be seen as a field of investigation and conflict.

"It was a battle to get away from Cézanne"

FERNAND LÉGER
The Alarm Clock
1914. Oil on canvas, 100 x 81 cm.
Centre Georges Pompidou,
MNAM, Paris.
© J. Faujour/Centre Georges
Pompidou, MNAM/CCI.

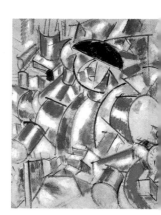

"In 1912 –13, it was quite a battle to get away from Cézanne. His influence was so strong that to escape it I had to turn to abstraction." Yet, if the series of *Contrasts of Forms* led Léger to develop what Douglas Cooper described as a syntax for a new pictorial language, *The Alarm Clock,* like most of the works he was producing at the time, still relied on the pretext of a subject. Painted on jute, the *Contrasts of Forms* that the artist produced up to 1914, and in which Jean Cassou thought he could discern "powerful golems," commingle human experience with the world of the machine and everyday life. The poet Blaise Cendrars comes to mind: "With him we became entangled," as Léger would say, "in the modern world."

"THE VALUE OF AN ARTWORK IN TERMS OF ITS REALISM

"A conception of art that has perhaps been lost since the great Italians"

ROBERT DELAUNAY
The City of Paris
1912. Oil on canvas,
267 x 406 cm. Centre
Pompidou, MNAM, Paris.
© Centre Pompidou,
MNAM/CCI.

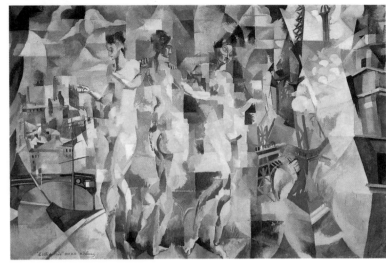

The City of Paris was the dominant presence at the 1912 Salon. Apollinaire's enthusiasm reached new heights: "Decidedly, Delaunay's picture is the most important of the whole Salon. *The City of Paris* is not just another artistic event: the picture marks the advent of a conception of art that has perhaps been lost since the great Italians. It condenses all the effort that went into its execution as well as summarizing, without trickery, all the scientific achievements of modern painting." The work was produced in three short weeks; the dates inscribed along its lower edge refer to the various stages of research from which it resulted. Following the principles of a mosaic, it juxtaposes three paintings that combine debts to Le Douanier Rousseau and Jean Metzinger as well as to the School of Fontainebleau in the "Three Graces," worked up from a photograph of a fresco from Pompeii. Delaunay himself explained his intentions: "Having broken with line, with a line that came from very far off, we are no longer able just to stick it back together or to fiddle with it, since there remained something else to do: a new state of mind to discover. Historically, it marked a shift in understanding and hence in technique and ways of seeing... Contortions were no longer enough for me."

"From red to green, all the yellow dies"

ROBERT DELAUNAY
Windows Open Simultaneously (1st section, 3rd motif)
1912. Oil on canvas, 57 x 123 cm. Peggy Guggenheim Collection, Venice.
© D. Heald/The Solomon R. Guggenheim Foundation.

"At that moment, I had the idea for a type of painting that technically would derive from color alone, from color contrast, but evolving through time and perceived simultaneously, in a single instant. I employed Chevreul's scientific term: simultaneous contrast. I played with color as one might express in music colored phrases through the use of fugue... Certain formats of canvas were much broader than high. I called them 'windows' and hence the 'windows series.'" The fragmentation accentuated by the oval format and the organization of space into colored planes, eliminating chiaroscuro in an intersecting lattice of kaleidoscopic lines that seem tangible, diaphanous and prismatic, do not altogether obscure the image of the Eiffel Tower, a trademark image that reappears on a cycle of thirteen canvases painted between 1912 and 1913. "These windows that open on to a new reality" were supposed to have been suggested to Delaunay while he was reading a poem by Mallarmé. They in turn inspired one of Apollinaire's most famous poems in *Calligrammes*. "From red to green, all the yellow dies/.../The window opens like an orange/Beautiful fruit of the light."

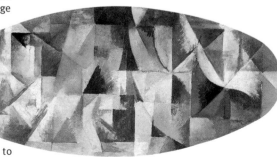

"Complete Cubism"

JUAN GRIS
Still Life in front of an Open Window (Place Ravignan)
1915. Oil on canvas, 116 x 89 cm. Arensberg Collection, Museum of Art, Philadelphia.

As a nineteen-year-old advertising draftsman, Juan Gris arrived in Paris in 1906. When he exhibited his Homage to Picasso at the 1912 Salon des Indépendants, Apollinaire had spoken of "complete Cubism." An intellectual and theoretician, he read mathematicians such as Poincaré and Einstein. The war having drawn him to Matisse at Collioure, in 1915 he widened his scope and developed his approach: "My canvases possess a unity they have lacked until now. They are no longer

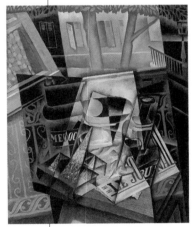

33

those lists of objects which have so disheartened me in the past." His work, previously static and measured, yielded to lyricism and rhythm. Through the device of the open window, interior and exterior spaces interconnect. The angle of view and shifts in scale literally tip the subject over. Gris concluded a lecture he gave at the Sorbonne in 1924 with the following affirmation: "The only possibility for painting is to express certain relationships between the painter and the external world... The picture results from the close association of these connections with the confined surface that contains them."

IS TOTALLY INDEPENDENT OF ITS IMITATIVE QUALITY" Léger

> > > object and oneself, but also that between objects." The very definition of Cubism, however, was becoming waylaid in the inventory of minor masters and marginal figures, who as often as not retained solely Cubism's system of spatial division. It is still more intriguing to note how from that time—aside from the efforts of Apollinaire, who was committed body and soul to reconstituting the scattered remnants of Cubism proper—all attempts to produce a linear history foundered. Continuations and ventures as diverse as those of the Futurists, Francis Picabia and Marcel Duchamp, as well as simultaneous developments in Russia (such as Rayonism and shortly afterward Suprematism), and in Germany and the Netherlands in the footsteps of Mondrian, ran parallel to Picasso and Braque's, who themselves remained wedded to the idea of confining their explorations to a more realist domain.

One can only concur with critic Pierre Daix's assertion that "Cubism's enduring repercussions" lay not so much in the formal continuation of the plastic and analytical models it inaugurated as in the fact that it became, in parallel with its own evolution, both "abstraction's antechamber" and the system from which other areas—from architecture and industrial aesthetics, from literature to the cinema—were to draw the sustenance from which to begin anew. The increasingly rapid circulation of novel ideas and, as a consequence, the elimination of the forms of the past, came to an abrupt halt with the outbreak of war. The confrontation between the partisans of an impossible reconciliation with the notion of progress and the advocates of a revolt against the contemporary world remained in abeyance. Duchamp, for his part, had already sensed this in 1912, preferring to satirize the society of the machine rather than enthuse over modern life. <

34

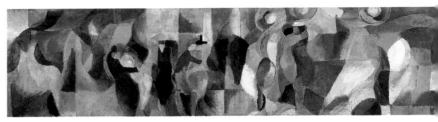

"We start off from the element of pure color"

SONIA DELAUNAY
La Bal Bullier
1913. Oil on ticking, 97 x 390 cm. Centre Georges Pompidou, MNAM, Paris.

"We start off from the element of pure color, and create planes, forms, depth, perspective with this element alone." The work was inspired by the Bal Bullier, a Montparnasse nightspot where Sonia, together with husband-to-be Robert, who had arrived in Paris in 1905, was to meet many an artist or writer friend. Exhibited in Berlin at the gallery of *Der Sturm* in 1913, *Le Bal Bullier* is the equivalent of Renoir's earlier *Moulin de la Galette* or Seurat's *Circus* in modern dress. Referring to the painting's immediate predecessors on similar themes, Michel Hoog notes that "it is surely closest to Degas. But... Sonia Delaunay remains more faithful to sensory impressions, conflating planes and allowing the poses to overlap." *Le Bal Bullier* is a seminal work of Orphism. Its unusual format resembles that of *La Prose du Transsibérien* (an artist's book realized in collaboration with Blaise Cendrars). The painting has a cinematographic quality and can also be likened to a music score: an interdisciplinary fusion of space-time and space-movement.

"Nonexistent anatomies"

MARCEL DUCHAMP
The Chess Players
1911. Oil on canvas, 50 x 61 cm. Centre Georges Pompidou, MNAM, Paris.
© Centre Georges Pompidou, MNAM/CCI.

As a member of the Puteaux group, Duchamp was engaged on developing a radically different conception of Cubism. Whereas most of the Section d'Or painters invoked the name of Cézanne, Duchamp considered himself as a descendant, artistically speaking, of Odilon Redon. His works tend to combine a number of different viewpoints of an object or a figure on the same canvas without fusing them into a single image. If *The Chess Players* constitutes an obvious transposition of Cézanne's *Card Players* and thus betrays a rapport with Cubism, the underlying approach is surely quite distinct. Space is merely hinted at and left undefined, while the handling results in effects of superimposition that render the anatomies of the figures "nonexistent." The pair of black vertical bands reduces the piece to the dimensions of a chessboard. Executed in the greenish glow of gas lighting (an Auer lamp), the piece sweeps away all remnants of realism and develops a configuration dependent on artifice.

"LIGHT IS THE

"Not as abstract as it would like to be"

FRANCIS PICABIA
Udnie
1913. Oil on canvas,
300 x 300 cm. Centre Pompidou,
MNAM, Paris.
© Centre Pompidou,
MNAM/CCI.

Picabia exhibited with the Cubists for the first time at the Salon de Juin, before showing *Dancer at the Spring* at the Salon d'Automne and the Section d'Or. The surface is here composed of a jigsaw puzzle of colored shapes, the subject being almost unidentifiable. In 1913, the year of the *Manifeste amorphiste* and the year he painted *Udnie* and retreated from his brief incursion into "Cubism," Picabia explained: "To enjoy my art,

one needs, it is true, a particular education and training of the eye. As I used to say, it is not of the common-or-garden variety." While Apollinaire sensed that "the young painters of the extremist school had the unspoken aim of producing pure painting," in New York ("the only Cubist city in the world") Picabia was showing abstract canvases "whose only reason for existing is to exist." Standing before them, viewers "felt the movement of boats upon the water... the crowds in the streets." *Udnie* is one of the three large-scale paintings he produced on his return. Its enigmatic title is a reference to a Spanish dancer he had met on a transatlantic

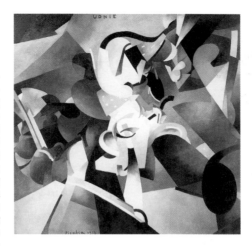

liner. The forms appear disjointed, while the signs are scattered about all four corners of the picture. "This is an entirely novel plastic art," Apollinaire opined. "It is still only in its infancy and is not yet as abstract as it would like to be."

"Vibrations precipitated into space"

GIACOMO BALLA
Abstract Speed + Noise
1913–14. Oil on panel,
54.5 x 76.5 cm. Peggy
Guggenheim Collection, Venice.
© D. Heald/The Solomon
R. Guggenheim Foundation.

On February 20, 1909, the Parisian newspaper *Le Figaro* published a long text by the thirty-three-year-old poet and theoretician Filippo Tommaso Marinetti, *The Founding and Manifesto of Futurism*, which declared war on the old world, on tradition and museums, comparing the latter to graveyards. Marinetti appealed to modernity, to speed and to the poetry of the city. A number of painters rallied to his cause: their premiere Paris exhibition in February 1912 juxtaposed their works with a Cubism they were committed to reinter-

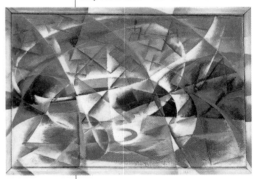

preting. They opposed the static organization of space with a successive representation of snapshots of motion and countered the unity of form and object by "prolonging the rhythms which objects impress on [their] sensitivity." Balla, around whom the movement coalesced, was moving away from the Divisionism of his early work, producing from 1912 canvases infused with speed and acceleration. The subject is not so much the object depicted as the expression of its dynamism and of the impossibility of conveying it. Forms are reduced to oblique beams, "vibrations precipitated into space" that boldly bleed over onto the picture frame, thereby serving as an analogy to the limits of representation.

"The abstractive search for a method of multiplying movement in space"

MARCEL DUCHAMP
Nude Descending a Staircase 2
1912. Oil on canvas, 146 x 89 cm.
Arensberg Collection, Museum
of Art, Philadelphia.

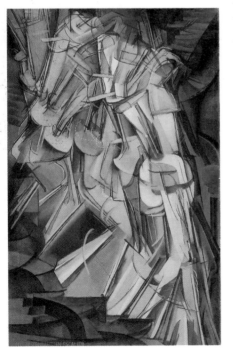

The "abstractive search for a method of multiplying movement in space" evoked by the two versions of *Nude Descending a Staircase* corresponds to the "remnants of beings" that Apollinaire had discerned in one or two of Duchamp's earlier exhibits. The artist himself, however, while referring to Futurism as merely "the Impressionism of the mechanical world," was more forthcoming: "My goal was the static representation of movement—a static composition of static indications of the various positions taken up by a form as it moves—with no attempt to create cinematic effects through painting." *Nude Descending a Staircase* flies in the face both of the Futurist diktat that "the nude should be totally excluded from art for a period of ten years" and of the pervasive enthusiasm of the Italian movement for all things modern. It is first and foremost a reflection on the paradox of movement in the static space of the picture and, in so doing, on how to convey three dimensions onto the two planes of a painting.

ONLY REALITY" R. Delaunay

"An esoteric rebus"

MARC CHAGALL
Homage to Apollinaire
1911–12. Oil on canvas,
200 x 189.5 cm. Stedelijk van
Abbemuseum, Eindhoven.
© AKG Paris.

Chagall discovered Cubism on his arrival in Paris in the summer of 1910. He frequented the Académie de la Palette and settled at the Grande Chaumière, where he struck up friendships with Robert Delaunay and the poet Blaise Cendrars. From them, as well from Albert Gleizes, Jean Metzinger and Léger, he learned the lessons of Cubism. Keen to absorb no more than the essentials, he quickly countered Cubism with a pictorial space that he envisioned as "magical," shying away from the "rationalism" of a movement that he considered tainted by "realism." As early as 1912, he participated in the Salon d'Automne and the Salon des Indépendants, and detached himself from the avant-garde that he imagined he could reinvent through a lyrical and mystical poetics sustained by Hassidic imagery. Like many other famous pictures completed at the time in Paris, this *Homage to Apollinaire* is the expression of a personal quest in which the Delaunays' *simultanéisme* and their principles of circles is pressed into the service of a "primitivist" and esoteric rebus. Above the figures of Adam and Eve one can first read Chagall's signature in full then "Chgll," without the vowels, as in Hebrew. Conjoining Roman and Hebrew letters, "one would have expected Chagall to 'Cubistify' his *Homage to Apollinaire* a little since," as a sour-faced commentator noted, "his intention was to sing the praises of the poet who was both the exegete and the high priest of Cubism."

"Rayonism is painting concerned with objects in collision"

MIKAEL LARIONOV
A Sunny Day
1913–14. Oil, paper pulp and size on canvas, 89 x 106.5 cm. Centre Georges Pompidou, MNAM, Paris. Photo P. Migeat/Centre Georges Pompidou, MNAM/CCI.

By 1909, seconded by Natalia Goncharova and Vladimir and David Burliuk, Larionov had developed his "Neo-Primitivist" style. By 1913 in Moscow he was organizing the "Target" exhibition, in which he and Goncharova presented the Rayonist works that they had been working on since 1910. The same year, he published a pamphlet of the same title: "Rayonism is painting concerned with objects in collision in addition to being the dramatized representation of the conflict between plastic emanations radiating from all things." *A Sunny Day* was given to Apollinaire as a thank-you for the preface the poet had written for Larionov's first show at Paul Guillaume's gallery. A picture-poem that combines material effects, textual fragments and musical notation, the painting is also a synthesis of the artist's principles and those of his companion (the couple were by this time living in Paris). "Painting is autonomous. It has its own forms, color and tones. Rayonism's primary goal is to reveal the spatial forms that may arise from rays reflected off various objects as they intersect."

"Cubo-Futurism has fulfilled its mission"

KASIMIR MALEVICH
The Englishman in Moscow
1913–14. Oil on canvas,
88 x 57 cm. Stedelijk Museum,
Amsterdam.

In June 1915, Malevich wrote: "Within the principle of Cubism, a commendable task remains: not to depict objects, but to make a picture." This statement gives an essential clue for understanding the painter's development, from the rejection of Neo-Primitivism to the elaboration—based on the principles of Synthetic Cubism—of what he was to call, at the end of 1913, "Alogism." The equivalent in painting of the "transrational" language of *zaum* invented by his friend the poet Khlebnikov, Alogism led Malevich to combine in his pictures figurative objects—heterogeneous in terms of both dimension and meaning—with words and letters. The artist replaced the process of Cubist fragmentation with the juxtaposition of painstakingly rendered forms and signs. *The Englishman in Moscow* refers to the way languages and cultures interconnect, and is a metaphor for the relationship between man and the diversity of the surrounding world. Malevich, "of the opinion that Cubo-Futurism has fulfilled its mission," was soon framing a conception of image and of reality that, by the spring of 1915, had led him to ponder the very principles of painting and move on to develop Suprematism.

36

"THEY SHARE WITH THE ARTISTS OF ACADEME

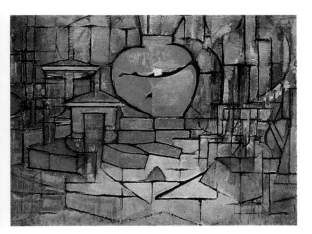

"Breaking with the natural appearance of things"

PIET MONDRIAN
Still life with Ginger-Pot
1912. Oil on canvas,
91.5 x 120 cm.
Gemeentemuseum,
The Hague.

The first exhibition held by the Moderne Kunstkring took place in October 1911 in Amsterdam. As well as seeing a homage to Cézanne, Mondrian also took the opportunity of viewing Cubist works in the flesh for the first time. "I immediately found myself attracted to the Cubists, to Picasso and Léger above all. Of all the abstracts... I felt that the Cubists alone were on the true path and, for a time, I was strongly influenced by them." At the end of the same year, Mondrian left for Paris, stay-ing on there until 1914 when he found himself trapped in Holland. Two still lifes betray this Cubist influence. If the first, probably painted in Holland, still bears traces of a "descriptive" style, the second is closer to the tonal values and to the "grid" used in the works Mondrian painted shortly after his arrival in France. The subject and iconography remain dependent on Dutch seventeenth-century tradition, but the formal stylization and simplification of the volumes manifest both the purposeful manner in which Mondrian adopted the Cubist idiom and "his majestic struggle to break with the natural appearance of things and, in part, with limited form."

Chronology 1907–1914

A chronology of events from the Cubist period appears at the end of the chapter "Cubism, from image to language." The list here refers in the main to artists belonging to the movement and to those who were at one point associated with the trend until the "cube" began to dissolve in 1914.

1907
Delaunay meets Léger and Henri Le Fauconnier. Picasso acquires two Iberian heads, and—according to Kahnweiler—also owns a statue from the Marquesas Islands.
Autumn: Picasso completes *Les Demoiselles d'Avignon*. Apollinaire introduces Braque to Picasso.

1908
Derain exhibits *The Bathers* (1907) at the Salon des Indépendants.
Braque and Picasso see each other on a daily basis. Braque spends the summer at L'Estaque. Picasso stays a few weeks at Rue-des-Bois.
Braque paints *The Bather (Large Nude)*.
Salon d'Automne: the jury refuses a series of Braque's paintings.
November: Braque shows at Kahnweiler's gallery. First appearance of the word "cube" in the artistic sense in a piece by critic Louis Vauxcelles in *Gil Blas*.

1909
Delaunay abandons Pointillism: *Saint-Séverin* series followed shortly after by the *Tour Eiffel*. Gleizes meets Le Fauconnier.
February 20: Marinetti publishes the first Futurist manifesto in *Le Figaro*.
Picasso moves to 22, boulevard de Clichy. He passes the summer at Horta de San Juan, in Spain. Braque stays at La Roche-Guyon.
Salon d'Automne: Le Fauconnier exhibits his portrait of the poet Pierre Jean Jouve.

1910
Chagall arrives in Paris. Picasso spends the summer at Cadaquès with Derain.
April: (first) *Manifesto of Futurist Painting*, Milan. First Futurist exhibition at Famiglia Artistica, Milan.
Picasso shows works at the Tannhäuser gallery, Munich. Cubist exhibition at the Neue Künstlervereinigung, Munich.
Salon des Indépendants: works by Archipenko.
Salon d'Automne: Metzinger, Gleizes and Le Fauconnier exhibit in the same room. Léger meets Picasso.

1911
In *Le Portugais (The Emigrant),* Braque stencils in the letters "B A L."
Braque and Picasso spend the summer together at Céret in the French Pyrenees.
Salon des Indépendants: room 41 shows the first exhibition of works by the Cubist group. Léger exhibits *Nudes in a Landscape,* and Delaunay three Paris cityscapes. Le Fauconnier and Gleizes exhibit in one room and La Fresnaye and Lhote in another.
Salon d'Automne: Metzinger shows *Le Goûter,* and Gleizes a portrait of Jacques Nayral.
Autumn: Gleizes and Metzinger begin writing their book on Cubism that will be published in March of the following year. Second Futurist exhibition at the Padiglione Riccordi, Milan.
Marinetti, Boccioni, Carrà and Russolo make a trip to Paris.
Larionov creates Rayonism.
Mondrian's first stay in Paris.

1912
January: Delaunay at Laon.
February: Futurist exhibition at the Galerie Bernheim.
March: Gleizes and Metzinger publish *Du Cubisme,* which is promptly translated into English, Russian and Czech.
Picasso and Braque spend the summer at Céret, before going on together to Sorgues near Avignon.
Sonia Delaunay begins her *Simultaneous Contrasts*. Robert Delaunay goes to the Chevreuse valley for the summer: *Windows* and "Orphic" works.
Gris incoporates a piece of mirror glass into *Le Lavabo*.
Picasso paints *Still Life with Chair Caning*. In the autumn of this year he moves to Montparnasse. Braque completes the first *papier collé* (pasted paper), *Fruit Dish and Glass*. Picasso and Braque execute a number of sculptures and paper constructions. Gris exhibits at the Clovis Sagot gallery. He also sends his *Homage to Picasso* to the Salon des Indépendants. The Cubists exhibit at the Salon de Juin in Rouen. La Section d'Or group begins to form.
Salon des Indépendants: Delaunay exhibits *The City of Paris*.

THE SAME MANIA FOR PAINTING STATES OF MIND" Apollinaire

Around 1900. The "Bal Bullier" in Montparnasse, Paris.
© Roger-Viollet.

Around 1910. Russian artists at the "Bal Bullier," with, at
the center in profile, Mikhail Larionov. © Roger-Viollet.

1914.
André Derain. *Portrait of
Iturrino*, oil on canvas.
Centre Georges Pompidou,
MNAM, Paris. All rights
reserved.

Around 1920. The dance floor at the "Bal Bullier." © Roger-Viollet.

Chronology 1907–1914

André Salmon publishes *La Jeune Peinture
française*, given over for the most part to Cubism.
October: Salon de la Section d'Or,
Galerie La Boëtie, Paris.
Presentation of 180 ostensibly Cubist works.
December 3: the Cubists are barracked in the
French Chambre des Députés. Marcel Sembat
quips, "This doesn't call for the gendarmes!"

1913

June: Boccioni exhibition at the Galerie La
Boëtie. Léger produces some of his "contrasts in
form." Picasso spends spring at Céret while Gris
spends the summer there.
Delaunay goes to Louveciennes near Paris for
the summer; circular canvases and the first
Disques.
Apollinaire publishes *Les Peintres cubistes,
méditations esthétiques,*
an anthology of articles taken from
Les Soirées de Paris.
Maurice Raynal brings out
Qu'est-ce que le cubisme?
Blaise Cendrars and Sonia Delaunay
issue the first book of "Simultanéisme,"
*La Prose du Transsibérien
et de la petite Jehanne de France*.
Salon des Indépendants:
four rooms are devoted to Cubism and Futurism.
Moscow: Larionov and Goncharova
organize the "Target" exhibition. Larionov
publishes "The Rayonist Manifesto."
Malevich creates Suprematism.
Milan: Apollinaire publishes
L'Anti-Tradizione futurista.
Robert Delaunay exhibits at Herwarth Walden's
gallery in Berlin.

1914

June: Léger gives a lecture on contemporary
painting at the Académie Wassilieff,
"Réalisations picturales actuelles."
Braque spends the summer in Sorgues and
Matisse in Collioure, where he paints
French Window at Collioure.
Picasso divides his time between Sorgues and
Avignon, where he works with Derain,
who is based in nearby Montfavet.
Derain returns to the classic model:
Portrait of Iturrino.
August 2: Picasso takes Braque and Derain,
who have been mobilized,
to Avignon train station.
Salon des Indépendants:
"This year, they say,
Futurism has begun to invade the Salon."
Gris begins to make serious use of
papiers collés.
November: Picasso returns to Paris.

Studies on Cubists

Braque
Centre Pompidou (exh.
cat.). *Braque, les papiers
collés*. Paris, 1982.
W. Hofmann. *Georges
Braque—His Graphic Work*.
London, 1962.
J. Richardson. *Georges
Braque*. London, 1952.
B. Zurcher. *Georges
Braque: Life and Work*.
New York, 1988.

Robert and
Sonia Delaunay
S. Baron and J. Damase.
*Sonia Delaunay: the Life of
the Artist*. London, 1995.
S. A. Buckberrough. *Robert
Delaunay, the Discovery of
Simultaneity*. Ann Arbor,
MI, 1982
*Sonia Delaunay: a
Retrospective*. Buffalo, 1980.
MAMVP (exh. cat.). *Robert
et Sonia Delaunay, le
centenaire*. Paris, 1985.*

Duchamp
P. Cabanne. *Les Trois
Duchamp*. Paris, 1975
(exh. cat.).
R. Lebel. *Sur Marcel
Duchamp*. Paris, 1996
[1959].*
Marcel Duchamp. Paris,
1977 (4 vols.).*

Gris
D. H. Kahnweiler. *Juan Gris:
His Life and Work*. London,
1947.

Léger
Centre Georges Pompidou
(exh. cat.). *Léger*. Paris,
1998.*
C. Green. *Léger and the
Avant-Garde*. New Haven,
1976.
D. Kosinski (ed.). *Fernand
Léger 1911–1924: The
Rhythm of Modern Life*.
Munich, 1994.

Picabia
U. Appolonio (ed.). *Futurist
Manifestos*. London, 1975.
M.-L. Borràs. *Picabia*.
London, 1985.

Picasso
H. B. Chipp (ed.). *Pablo
Picasso: a Catalogue
Raisonné of His Works*. San
Francisco, 1995–98.
P. Daix. *La Vie de peintre de
Pablo Picasso*. Paris, 1977.*
P. Daix and J. Rosselet. *Le
Cubisme de Picasso.
Catalogue Raisonné de
l'œuvre, 1907–1916*.
Neuchâtel, 1979.
R. Penrose. *Picasso: His
Life and Work*. Berkeley,
1981.
MoMA (exh. cat.). *Pablo
Picasso: a Retrospective*.
New York, 1980.

For general studies and
information as to where
works can be seen, refer to
the previous chapter.

* Essential reading

SCULPTURE
"from monument to readymade"

"Dance, winged child, on the grass in the woods"

EDGAR DEGAS
Little Fourteen-year-old Dancer

1880–81. Bronze, tulle, satin, wood, height 95.2 cm. Musée d'Orsay, Paris. Photo R. G. Ojeda/RMN.

"Dance, winged child, on the grass in the woods,/Your thin arm placed on the line you follow/In equilibrium balances your flight and weight./I wish you, I who know, a famous life." This sonnet by Degas pays tribute to a subject that he was to explore consistently throughout his life. From 1860 to his death in 1917, Degas completed some 150 sculptures modeled in wax or clay. Seventy of these were cast in bronze, among them this *Little Fourteen-Year-Old Dancer*, the only sculpture Degas was to present during his lifetime in its original version, on the occasion of the Sixth Impressionist Exhibition in April 1881. As ever, the critics were severe, Henri Trianon for example seeing it as, "the very epitome of horror and bestiality." Only Joris-Karl Huysmans, confronted with what he called "the tremendous realism of a statuette that makes the public uneasy," praised "the most truly modern thing ever attempted in sculpture." Two-thirds life-size, the girl is dressed in real clothes that

Degas, in order to unify the object, partly coated in wax. They increase the realism of a sculpture that the artist intended as the culmination of naturalism: for the history of sculpture at the dawn of the twentieth century, *The Dancer* constituted an exceptional work as well as a model to follow.

Statuary in France was never again to enjoy the same number of commissions it had under the Third Republic (1870–1940). During the nineteenth century, sculpture fulfilled a commemorative role in a society addicted to self-congratulation, but by the end of the century it had started to undergo profound changes. The man most responsible for this was Auguste Rodin, an artist who reinvented the art many times before his death. No oeuvre synthesized in such a powerful way the shift from the old order to modern ways of thinking; never was opposition to the Académie and the École des Beaux-Arts—which stipulated both the subject and the manner in which it was to be executed—so forcefully expressed.

The anthropomorphic precision of the 1877 *Age of Bronze*, shortly to be followed by the monumental *Burghers of Calais*, abolished the distinction between real and virtual space, as did the destabilized monolith of his *Balzac* (commissioned in 1891 and exhibited initially at the Salon in 1898). All three pose awkward questions for an art form that had

39

> > >

> > > become hamstrung by convention, and it is in Rodin, more than in any other artist of the period, that the bases for a redefinition of sculpture should be sought. Rodin, by inverting the accepted norms of statuary, opened the way, figuratively and literally, to an infinite space. Even a brief sketch of the history of twentieth-century sculpture must first acknowledge its primacy over all preceding forms. Hence, if the classical impulse persists in the work of Emile-Antoine Bourdelle and Astride Maillol, they appear somewhat marginalized in respect of the field opened up by sculptors working around 1900. For the notion of sculpture suffers from fewer restrictions than that of any other art form. It presupposes neither a preexisting technique nor a means of production; it does not conform to any particular logic of imagery nor to a commemorative function. Shaking off the diktats of the schools, it develops through autonomous creation, and turns its back on external reality to develop conceptions that belong solely to the artist creating the piece. It is interesting therefore to note that, in the twentieth century, in parallel with Rodin and after him Brancusi, it was painters who give sculpture a new lease of life: from Degas to Gauguin, from Matisse to Picasso—leaving to one side for a moment Duchamp's notion of the readymade—the most thoroughgoing transformations were undertaken by artists whose initial experiences had been with painting and who had questioned the precepts of that art too in the most radical manner.

In this context, sculpture can be seen as the most significant expression of modernity, of its challenges and conflicts, but it remains relatively unknown to the public and is most often confined to the margins of the long history of twentieth-century art. Along with Rodin and > > >

"Deliverance toward space"

MEDARDO ROSSO
Carne Altrui
1883.
Wax over plaster,
23.5 x 22.5 x 16 cm.
Galerie de France, Paris.
Photo J. Losi.

Born in Turin, Rosso only turned definitively to sculpture after 1889, by which time he had settled in Paris. In 1894 he met Rodin, with whom he exchanged sculptures. Their friendship was to be soured, however, when the "Master of Meudon" unveiled his *Balzac*, which Rosso felt plagiarized his work. Today, Rosso's pieces appear undemanding, his subjects—the face of a child or woman in private or everyday situations—are entirely free of monumental and heroic effects. Boccioni, however, was keen to promote his work as "revolutionary, very modern, more profound, and necessarily restrained. There are scarcely any heroes or symbols in his sculpture, but the plane representing the forehead of his female figures and children introduces and indicates a deliverance toward a space that will one day have far higher importance in the history of the human spirit than the critics of our time have so far credited it with, though unfortunately the Impressionist drive for experiment means that Medardo Rosso's investigations were limited to the area of high- or bas-relief."

"A sack of coal"

AUGUSTE RODIN
Honoré de Balzac
1897. Plaster,
height 300 cm.
Paris, Musée d'Orsay.
Photo Giraudon.

It seems probable that the germ of all modern sculpture lies in the sculptures Rodin unveiled at the end of the nineteenth century and in the scandal they occasioned. Although commissioned by the Société des Gens de Lettres, the association was to reject the monumental *Balzac* the artist exhibited at the 1898 Salon. Draped in a dressing gown, and seemingly on the point of overbalancing, Rodin's figure threatens to metamorphosize into an autonomous work divested of all mimetic properties. As Benjamin H. D. Buchloh writes: "Volume had acquired too great an independence." As early as 1876, the excessive anthropomorphic precision of *The Age of Bronze* had fuelled suspicions that some artistic trickery was afoot. Classical ideals though were in for yet another battering twenty-two years later! Rodin's *Balzac* could hardly fail to be the butt of criticism, since what some dubbed the "sack of coal" simply jettisoned the two prime functions of sculpture: monumentality and representation. Medardo Rosso, on the other hand, for whose work Rodin had been vociferous in his enthusiasm as early 1894, felt personally betrayed, remaining convinced that he had had a profound impact on the statue, both because it showed impression ousting representation and because the distance it maintains from its supposed model makes *Balzac* into a figure of great elusiveness.

"The great error lies in the Greek"

PAUL GAUGUIN
Oviri
1894–95. Stoneware partially enameled,
75 x 19 x 27 cm.
Musée d'Orsay, Paris.
Photo J. Schormans/RMN.

Gauguin started painting in 1871, but he only began working in three dimensions some fifteen years later in Ernest Chaplet's studio. There, he discovered a new technique, but one which remained for the most part ancillary to the decorative arts. By 1886, Gauguin had produced his first ceramic objects. In 1893–94 and again in 1895–99 (the years covering his second trip to Tahiti), he was to execute numerous wooden carvings. Here, his contemporaries were struck by his use of direct carv-

ing, a process that Western sculpture had in the main abandoned, and the frontality and immobility of his hieratic figures. The unnaturalistic proportions and stylization of the figures seem to highlight how sculpture not only represents but can also be the incarnation of a spirit or divinity. It is in fact spirit made matter, an idea that, as Margit Rowell has emphasized, had been absent from Europe since the Roman period and which was to exert a considerable influence over modern sculpture, especially after the Gauguin retrospective staged at the Salon d'Automne in 1906. The artist preferred idols to heroes: "The great error lies in the Greek," he wrote, "no matter how beautiful it is."

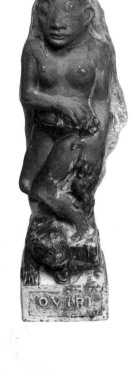

"Sculpture... is presence"

PABLO PICASSO
Figure
1907. Carved wood with traces of pencil and paint on the top of the head, 32.5 x 12.2 x 12 cm.
Musée Picasso, Paris.
Photo B. Hatala/RMN.

Picasso's early work in the round, which includes the *Seated Woman* (1902) and the larger wood sculptures dating from 1906–7, coincided with his discovery of Iberian sculpture and African art. William Rubin believes Picasso's interest in the tribal betrayed a need to appropriate a new repertory of forms

and a spiritual resonance independent from Western traditions. It is not surprising that Picasso was interested in Gauguin's work, an interest reflected in works such as this *Figure* of 1907, a year that also witnessed the gradual gestation of *Les Demoiselles d'Avignon*. The predominant frontality and the sharp facial features (the nose treated in the same way as the "quarter-Brie noses" of mask-figures

from the same year) evoke both Mali statuary and the helmet-masks of the Gabon. However, Picasso also borrowed elements from the noble severity of some of Cézanne's paintings (elements also evident in his first Cubist *Woman's Head* made in 1909). Sculpture was no longer confined to representation: it was presence and, rather than being subjected to space, it imposed itself within it.

"Direct carving"

ERNST LUDWIG KIRCHNER
Woman Dancing
1911. Painted wood,
87 x 35.5 x 27.5 cm.
Stedelijk Museum, Amsterdam.

It is an open question as to whether the sculpture produced by Kirchner and some of his contemporaries, such as Jacob Epstein or Henri Gaudier-Brzeska, should be seen as a challenge to the avant-garde because of its attachment to traditional techniques such as direct carving and its stylized naturalism close to that of the "primitive" arts. Were such works anachronistic or were they instead a genuine expression of a resistance to the ideals of progress as voiced by their contemporaries? Intimately associated with Die Brücke, a group he founded with Erich Heckel and Karl Schmidt-Rottluff in 1905, Kirchner was involved in a search for a pre-industrial world. Kirchner was deeply impressed by Dürer's woodblocks and by the African and Oceanic sculpture he had seen at the ethnographic museum in Dresden. His pieces were entirely unrelated to developments in art at the time, drawing on folk art and primitive figurines. He carved directly in wood in an almost exaggerated manner. In fact, Kirchner attached scant importance to the purely sculptural lessons that his contemporaries were to draw from such art. The *Woman Dancing* of 1911 is archetypal in this respect: an object that Kirchner infused with life, energy and power, and a liberating potential comparable to that of a fetish.

41

> > > Medardo Rosso, exalted figures who transcended both the Romantic and Symbolist ideals, the key figure for understanding the origins of modernity is Degas. His sculptures are plastic forms in space, designed to transcend detail and anecdote, and to become nothing less than a tactile sign devoid of ornament. One can already sense the world of Matisse, of whose sculpture it was said for a long time that it was merely an excuse to break off temporarily from painting, which, it is true, sometimes directly inspired his three-dimensional pieces. With Picasso, however, the break was still more fundamental. From the earliest pieces to the prismatic figures that preceded his 1912 constructions, the very language of sculpture was put to the test. Traditional materials were replaced by a deft form of "do-it-yourself" which was wholly at the beck and call of his imagination: sculpture could now be cobbled together out of pieces of string and from anything else the artist had to hand. If the subjects remained those of his painting, in sculpture they provided a pretext for endless formal games and were pressed into the service of an entirely novel artistic syntax. The still lifes and guitars made of corrugated iron, wood and cardboard applied the *coup de grâce* to an artistic discipline that had until then remained in the thrall of time-worn materials and techniques. Single-handed, Picasso paved the way for all the radical reevaluations and mutations of twentieth-century sculpture, to the extent that we are inclined to think that Picasso's contemporary Marcel Duchamp—who for his part had explored the entire range of painting and "freed himself from the Cubist straitjacket"—in his skepticism vis-à-vis the modernist creed of Futurists of every stripe wanted to rid himself of sculpture completely by substituting for it a totally new category: the readymade. According to its original definition, the readymade conforms to no preexisting order: it is an art form in itself that the "anartist" Duchamp invented so as distinguish himself—with no inkling that, in the future, it would become one of the most fertile sources of misunderstanding in all twentieth-century art. <

42

"Put my sensations into order"

HENRI MATISSE
La Serpentine
1909.
Bronze, height 56.5 cm.
Musée Henri Matisse, Nice.
© Galerie Maeght.

Having met Picasso through Gertrude and Leo Stein in 1905, a year later Matisse was discovering "colonial" art. At the 1908 Salon d'Automne, he exhibited thirteen sculptures which demonstrated his desire to liberate form from both Western convention and idealized imagery. This work shows Matisse's readiness to model and stretch shapes and, even at this early juncture, to treat form in the way of a cut-out in space, comparable to the flattened effects and arabesques of his paintings. *La Serpentine*, together with the series of busts of Jeannette (1910–13), was a striking departure for an artist that his contemporaries regarded as being primarily a painter. "I made sculptures when I was tiring of painting. To change medium. But I sculpted as a painter does... [when] I took clay... it was always to organize it. It was to put my sensations in order, to devise a method that would satisfy me totally."

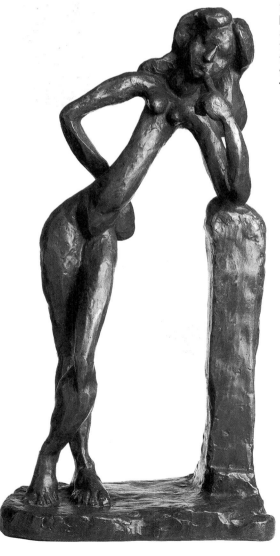

"AVOID INTRODUCING EMPTY SPACES

"An experience of the real"

PABLO PICASSO
Guitar
1912. Sheet metal and wire,
77.5 x 35 x 19.3 cm.
Museum of Modern Art,
New York.

In an effort to solve problems of a pictorial nature, Picasso began producing assemblage sculptures in 1912. Using wood, cardboard, sheet steel and string, and starting out from the still-life themes which up until then he had been exploring in painting, Picasso cobbled together fragile constructions that resulted in a wholly original method and syntax. The objects he produced always seem to have something of the model about them: the form is cut out or folded and is organized in various planes that serve to convey the subject. The color derives from the rusted material itself, a fact that opened a new field of investigation that "sculpture" as previously defined had never addressed and that extended its very signification. It is modern sculpture itself that springs ready formed from this sheet-metal *Guitar* (donated by the artist in 1971 to the Museum of Modern Art, New York). A new sculptural idiom was born that "allowed new attitudes." Transcending the accepted ideas of the block, of carving and of modeling, and reveling in its possibilities for invention and play, Picasso here offers what Dominique Bozo has characterized as a new "experience of the real."

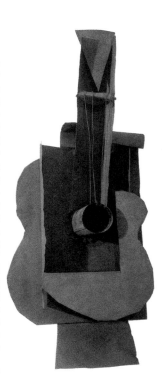

"Sculpto-painting"

ALEXANDER ARCHIPENKO
Pierrot Carousel
1913. Painted plaster,
61 x 48.6 x 34 cm.
Solomon R. Guggenheim
Museum, New York.
Photo Guggenheim Museum.

Archipenko recalls that the idea for this sculpture came to him while he was looking at a merry-go-round complete with horses, gondola-seats and airplanes mimicking the earth's rotation. The inscription "come and laugh" on one of the figure's sides was as much a reminder of the origin of Archipenko's subject matter as a way for him of identifying with the Cubists he was associating with at the time. Arriving from Russia in 1908,

Archipenko completed his earliest sculptures in 1910. He exhibited regularly at the Salon des Indépendants, but he was often refused at the Salon d'Automne. Abandoning the kind of investigations he had embarked on in the course of his innumerable visits to the Louvre, Archipenko started work on assemblages of sometimes unusual materials. In these works, modeling was replaced by the rhythmic interchange of polychrome planes that he described as "sculpto-painting." By reintroducing color in its most decorative guise, Archipenko was recovering a lost tradition in the same way as Gauguin and Kirchner were, though not surprisingly the work also owed much to the ornamental tendencies of Russian art.

"The sculptor was slowly dying in him"

AMEDEO MODIGLIANI
Woman's Head
1912. Stone, 58 x 12 x 16 cm.
Centre Georges Pompidou,
MNAM, Paris.
Photo P. Migeat/Centre
Georges Pompidou.

Executed between 1909 and 1914, Modigliani's sculpture has for the most part simply vanished. Twenty-five pieces survive today, all but two in stone, one in wood and another in marble. Following Brancusi, Modigliani opted for direct carving over modeling. He used surplus wooden beams from the Metro and stone blocks found on construction sites, materials which give his works their column-like form and powerful severity. The tops and bases of these *Heads*, begun around 1911, are often unfinished, hinting at an architectural, ornamental function. They are a highly distinctive continuation of the work Brancusi had begun three years earlier on the theme of the kiss, presenting, as Henri de Cazals noted, "the same lightly incised, block-like appearance, the same geometric simplification of the features." Numerous influences on Modigliani's three-dimensional work have been postulated, from the Gothic sculptor Tino di Camaino to Kauroi, archaic Greek male nudes. But it was the discovery of Baule carving from the Ivory Coast that led him to sculpture on his return to Livorno shortly before the war. Once back in Paris, Zadkine could only concur: "The sculptor was slowly dying in him."

43

THAT JEOPARDIZE THE WHOLE" Matisse

"The total renovation of this mummified art form"

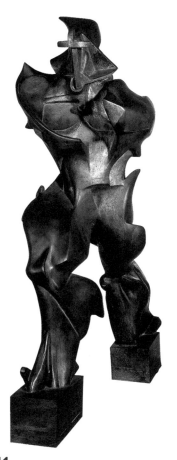

UMBERTO BOCCIONI
Unique Forms in the Continuity of Space (Dynamism of a Running Man)
1913. Bronze, height 115 cm. Galleria d'Arte Moderna, Milan. © Lauros/Giraudon.

The first two manifestos of Futurist painting that Boccioni had drafted with Marinetti, whom he had got to know in 1909–10, were to be followed by the publication of the *Manifesto tecnico della scultura futurista* in 1912. The critics were scathing, with Marcel Boulenger (in the October 8 issue of *Gil Blas*) coining the disparaging term "Cubo-Futurism." That same year, Boccioni exhibited his sculpture at the Salon d'Automne, declaring to an art collector friend: "In recent days, I have become obsessed by sculpture! I think I can glimpse a total renovation of this mummified art form." As with many of his acolytes, Boccioni's intention was to exalt the dynamism of the modern world. He thus tried to find a way of suggesting the displacement of volume in a fluid, unstable continuity. "A primary dynamic element might be obtained by decomposing this unity of matter into a certain number of different materials that each might characterize, by its very diversity, differences in weight and expansion of molecular volume." And, in a brief note, Boccioni added: "The renewal of sculpture depends on sculpture that itself becomes architectural."

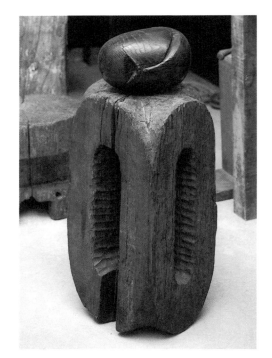

"Sculpture now extends toward the base"

CONSTANTIN BRANCUSI
Head of a Child
1913. Wood, 16.5 x 25.6 x 18.4 cm. Centre Georges Pompidou, MNAM, Paris. Photo B. Prevost/Centre Georges Pompidou.

Born in Romania, Brancusi arrived in Paris in 1904 after studying in a number of art schools in his native land. At the 1906 Salon d'Automne, he met Rodin, but turned down an offer to work with him, commenting famously: "No other trees can grow in the shadow of an oak." Shortly after, he took up direct carving, going on to produce a body of work that was crucial to the development of modern art. His early wood pieces, a blend of "archaic figuration and organic abstraction," reveal his fascination for African art. The later sculpture, starting in the 1920s, combined metal and marble. Brancusi favored extreme simplification in a quest for absolute form. He sought to invert the "monumental" logic around which the whole art of sculpture had been centered. "Simplicity is not an objective in art, but one achieves simplicity despite oneself by entering into the real sense of things."

"The power of the machine makes itself felt"

RAYMOND DUCHAMP-VILLON
Horse
1914.
Plaster, 100 x 110 x 100 cm. Centre Georges Pompidou, MNAM, Paris. Photo A. Rzepka/Centre Georges Pompidou.

Intended for the 1914 Salon d'Automne, Duchamp-Villon's *Horse* was designed to fuse vital force and mechanical power. In a letter to Walter Pach in 1913, he wrote: "The power of the machine makes itself felt and we can no longer imagine living beings without it, and we are moved by the strange way beings and things brush past each other quickly, and we are becoming used, if only unconsciously, to perceiving the forces of the former through the forces that they subjugate. From this point it is only a short step to acquiring an outlook in which life appears in the form of a superior dynamism." This work owes something to his knowledge of anatomy, which he studied as a medical student, except that Duchamp-Villon transforms his subject by "mechanizing" it, replacing the animal's limbs by crankshafts, gears, axles and other moving parts. As an allegory of the industrial age, the work is not particulary celebratory — anatomy becomes mechanical, the sculpture morphing into "horsepower" in a search for a fusion between the mechanical and the organic worlds. Duchamp-Villon never saw this work cast in bronze — neither did he live to see the monumental version of it he had planned to execute in steel. Called to the front in 1915, he contracted typhoid fever and died at Cannes in 1918.

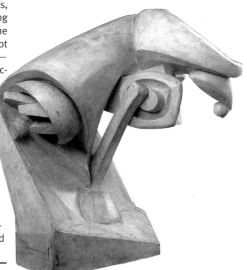

44

"THE MODEL'S FOOT ON THE DAIS MAKES A LINE

"Beauty of indifference"

MARCEL DUCHAMP
Bicycle Wheel
1913. Bicycle wheel mounted on a kitchen stool,
height 126.5 cm.
Centre Georges Pompidou,
MNAM, Paris.
Photo Centre Georges
Pompidou.

Is the term "sculpture" still appropriate here, or should one already be applying the notion of the readymade that Duchamp, in his eagerness to do away with all categories, decided to substitute for it in 1915? Is it right, as many have, to link Duchamp to the history of sculpture when this artist did his utmost to short-circuit the discipline? Ultimately, the readymade belongs more to the world of inventions than to that of "sculpture" as it had hitherto been defined. The bottle rack readymade (bought at the Bazar de l'Hôtel-de-Ville in 1913) and this bicycle wheel fixed to a kitchen stool both belong above all to the realm of thought. They form a separate category, a program that Duchamp devised for himself, detached from all aesthetic considerations: "A beauty of indifference" that broke with "modern beauty." A New York critic noted as early as 1915 that the young Duchamp was also strangely unimpressed by the numerous controversies to which his work gave rise, neither speaking nor behaving like an artist: it was mooted that perhaps Duchamp was not an *artist* as such at all, since he oozed disrespect for the accepted meanings of every word in the "artistic" dictionary.

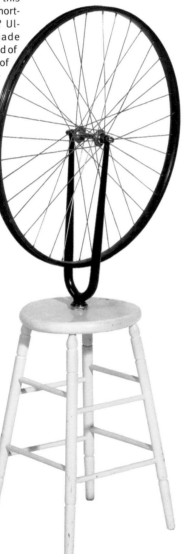

Chronology 1890–1914

In keeping with the subject of the chapter, this chronology is largely devoted to events in France and the rest of Europe. Sections in bold refer to artists mentioned in the main text and captions.

1890
• Paris, Galerie Bing: Salon de l'Art Nouveau opens.
Matisse takes up painting.

1891
On the advice of Odilon Redon's wife, who was from the island of La Réunion, Gauguin decides to leave for Tahiti. March 23, poet Stéphane Mallarmé presides over the painter's farewell dinner. Through the good offices of his friend Zola, Rodin receives a commission from the Société des Gens de Lettres for a monument to Balzac.

1892
• July: the anarchist Ravachol is executed.
• Berlin: scandal erupts at an exhibition of around twenty works by Edvard Munch.
Gauguin carves wooden statuettes and cylinders.

1893
• A wave of anarchist attacks hits France.
• June: the painter Maximilien Luce is arrested.
Copenhagen: exhibition of paintings by Gauguin, together with works in ceramic and sculptures.

1894
• April: the review *L'Artiste* lambasts Gustave Caillebotte's gift of Impressionist works to the state as "A pile of rubbish... that publicly dishonors French art."
• June: assassination of President Sadi Carnot.
Matisse's earliest sculpture, *Deux Profils de Femme*.

1895
• First Venice Biennale.
Gauguin's second voyage to Tahiti.

1896
• Brussels: first Salon de la Libre Expression.
• Edvard Munch exhibits at the Salon de l'Art Nouveau organized at Bing's gallery.

1897
Gauguin's journal *Noa-Noa* appears, illustrated with a series of wooden carvings.

1898
• September 10: death of Mallarmé.
Rodin presents his monument to Balzac at the Salon. It is attacked by everyone except the young sculptor Bourdelle.

1899
• Paris: under the impetus of architect Frantz Jourdain, the Syndicat de la Presse Artistique is set up, a professional association that issues a subscription offer enabling Rodin's *Thinker* to be presented to the City of Paris.

1900
• Loïe Fuller dances in Paris.
• Munich: the Phalanx association is founded, spearheaded by Kandinsky.

1901
• Maillol, *La Méditerranée*.
• The École de Nancy is founded (decorative arts).

1903
• Islamic art exhibition at the Musée des Arts Décoratifs, Paris.
• May: Gauguin dies. Within a short time, his property is auctioned off at Papeete. Victor Segalen, author of "On Exoticism," acquires a number of works.
• Foundation of the Salon d'Automne under the presidency of Frantz Jourdain. It immediately opens its doors to the upcoming artistic generation.

1904
**Rodin: *Romeo and Juliet*.
Following a stay in Munich, Brancusi settles in Paris. He declines an offer from Rodin to work with him.**

1905
Matisse meets Maillol and they quickly become friends.

1906
• Daniel de Monfreid stages a Gauguin retrospective at the Salon d'Automne.
Matisse purchases his first piece of African art. Vlaminck buys a Fang mask from Africa, which he sells to Derain shortly after. Modigliani comes to Paris, renting a studio near the Bateau-Lavoir where Picasso works.

1907
• Derain executes the sculpture *Crouching Man* that will be exhibited in September by Kahnweiler in Paris.
Brancusi moves to Montparnasse. Raymond Duchamp-Villon (Marcel Duchamp's brother) becomes a member of the jury of the sculpture section at the Salon d'Automne. With another brother, Jacques Villon, Duchamp-Villon founds the Puteaux group, together with other

AS STRAIGHT AND CLEAR-CUT AS AN INCISION" Matisse

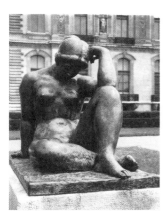

1902–3.
Aristide Maillol.
La Méditerranée. Bronze,
Jardin des Tuileries, Paris.
© Roger-Viollet.

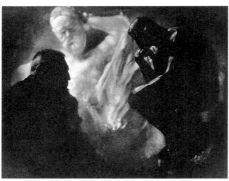

1903. Edward Steichen. Photograph of Auguste Rodin.
Musée d'Orsay. © RMN.

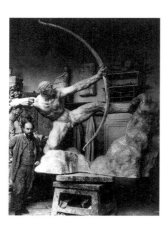

Around 1910.
Antoine Bourdelle in
his studio, standing
next to *Heracles the
Archer*.
© Harlingue-Viollet.

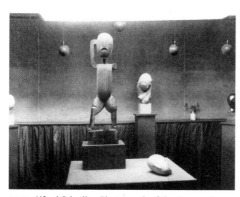

1914. Alfred Stieglitz. Photograph of the Brancusi
exhibition at Gallery 291, New York.

Chronology 1890–1914

painters, sculptors and writers.
Picasso discovers the ethnographical museum at
the Trocadéro and its primitive art collections. He
produces the sculpture *Figure*.

1908

Matisse exhibits thirteen sculptures at the Salon
d'Automne. Brancusi regularly exhibits in the
Salons. He meets Le Douanier Rousseau, Léger,
Modigliani, Matisse and Apollinaire. Archipenko
settles in Paris, where he is joined by Modigliani.

1909

• Bourdelle: *Heracles the Archer*.
Brancusi completes *Sleeping Muse*.
Picasso executes *Woman's Head: Fernande,* as
well as other Cubist sculptures.
Modigliani asks his first client, Paul Alexander, to
introduce him to Brancusi.

1910

Archipenko opens his own art school in Paris and
exhibits at Le Salon des Indépendants. Modigliani
devotes his efforts to sculpture. Matisse
commences the series *Heads of Jeannette* that he
will continue working on up until 1913.

1911

Archipenko exhibits at the Salon d'Automne.
Boccioni travels to Paris, where he encounters
Apollinaire and the Cubists and produces his
earliest sculptures. Modigliani exhibits seven
sculptures in Amadeo de Souza Cardoso's studio.

1912

First exhibition of sculptures by Matisse in New
York at the 291 Gallery. Archipenko creates his first
"sculpto-paintings" and participates at the Cubist
exhibition staged by the Puteaux group, that
subsequently turned into the Section d'Or.
Publication of the *Manifesto tecnico della scultura
futurista*.
Picasso makes constructions and assemblages
from cardboard, sheet metal and wire.

1913

• Bourdelle makes low reliefs for the facade of the
Théâtre des Champs-Élysées.
• Tatlin travels to Paris, where he meets Picasso.

Brancusi, Archipenko and Matisse exhibit at the
Armory Show, New York.
Marcel Duchamp, whose *Nude Descending a
Staircase* is also exhibited, makes the first
readymade: *Bicycle Wheel*.
Kirchner splits from Die Brücke, which dissolves
later in the year.

1914

• The photographer Alfred Stieglitz organizes the first
Brancusi exhibition in New York, at the 291 Gallery.
• The Russian painter Matvei-Markov writes the first
known study of the aesthetics of African art, published
in 1919. In 1915, the philosopher Carl Einstein brings out
"Negerplastik," the first published essay on the subject.
Picasso completes the series of painted bronzes,
the *Glass of Absinthe*.

Studies on sculpture

Dictionaries and general works

A. Elsen. *Origins of Modern Sculpture*. New York, 1974.

R. Goldwater. *What is Modern Sculpture?* New York, 1969.*

A. M. Hammacher. *Modern Sculpture: Tradition and Innovation*. New York, 1988.

R. E. Krauss. *Passages in Modern Sculpture*. London, 1977. *

R. Maillard. *New Dictionary of Modern Sculpture.* New York, 1971.

A. Pingeot (et al). *Sculpture: The Adventure of Modern Sculpture in the Nineteenth and Twentieth Centuries.* New York, 1986.

H. Read. *A Concise History of Modern Sculpture.* London, 1968.

M. Rowell. *Qu'est-ce que la sculpture moderne?* Paris, 1986.

W. Tucker. *The Language of Sculpture.* London, 1974.

Monographs and exhibition catalogues on the sculptors mentioned

G. Balla. *Umberto Boccioni, la Vita e l'opera.* Milan, 1964.

Constantin Brancusi. Paris, 1995.

A. Elsen. *In Rodin's Studio.* London, 1980.

A. d'Harnoncourt and K. McShine (eds.). *Marcel Duchamp.* New York, 1973.

D. E. Gordon. *Ernest L. Kirchner.* Cambridge, 1968.

R. Kendall. *Edgar Degas and the Little Dancer.* Yale, 1998–99.

K. J. Michaelsen. *Alexander Archipenko.* National Gallery, Washington, 1986.

I. Monot-Fontaine. *The Sculpture of Henri Matisse.* New York, 1984.

G. Moure. *Medardo Rosso.* 1996.*

C. Parisot. *Amedeo Modigliani.* Paris, 1992.

Raymond Duchamp-Villon. Musée des Beaux-Arts, Rouen, 1976.

P. Schneider. *Henri Matisse.* London, 1984.

Sculpture du XXe siècle, 1900–1945: tradition et ruptures. Saint-Paul-de-Vence, 1981.

W. Spies. *Pablo Picasso. Das plastische Werk.* Berlin, 1983–84.

A. Werner. *Modigliani the Sculptor.* New York, 1962.

* **Essential reading**

ARCHITECTURE
"from ornamentation to simplicity"

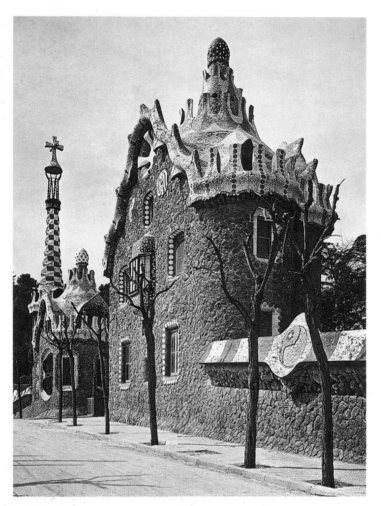

"Man does not create, he discovers"

ANTONI GAUDÍ
*Entrance Pavilion,
Parque Güell, Barcelona*
1900–14.

In a career spanning half a century, Gaudí created around fifteen works fusing tradition and Art Nouveau which were far too personal in style to leave many followers. An admirer of the German Nazarenes and of medievalism in general, he spent much of his life building the church of the Sagrada Família. Gaudí was also, however, the architect of the industrial bourgeoisie in buildings that juxtaposed influences from Mudéjar ornament to Berber architecture. Gaudí planned and directed the construction of the park for the industrialist Eusebio Güell, for whom he had already designed a large residence in the city shortly before the Barcelona World's Fair (1885–89). He worked on the park between 1900 and 1914, seeking a synthesis of form, construction and structure. His imaginative approach and experimentation with exposed parabolic arches led him to reject historicism and to shift gradually from a sculptural approach to three-dimensional form to an architectural one. "Mediated by man, creation continues unabated," maintained Gaudí, adding "But man does not create: he discovers. Those that delve into the laws of nature so as to nurture original works collaborate with the Creator. Copyists do not collaborate. That is why originality consists in a return to the origin."

Following on from "medievalists" such as Viollet-le-Duc, who created a repertory of ornament derived from natural forms, a "new art" emerged at the end of the nineteenth century: Art Nouveau. A last throwback to Romanticism, as individualistic as it was antihistoricist, it spread throughout Europe. At its heart was the idea of the *Gesamtkunstwerk* (total work of art) that extended to the most basic details of everyday life. Known as the "Modern Style"

> > >

> > > in England, "Paling Stil" (eel style) for the Flemish, "Style des Vingt" in French-speaking Belgium (after the group of that name), "Jugendstil" (Young Style) in Germany, "Sezessionstil" in Austria, "Liberty" in Italy and "style nouille" (noodle style) or "style Guimard" in France, Art Nouveau reached its zenith at the turn of the century, a period which it is now felt to epitomize. It would continue developing for many years to come, however, being prolonged in the singular and magnificent oeuvre of the Catalan Antoni Gaudí and as an offshoot in the Wiener Werkstätte, founded in Vienna by Koloman Moser and Josef Hoffmann in 1903.

A reaction to industrialization and progress, Art Nouveau remains a paradox. Inspired by theoreticians of society and aesthetes such as John Ruskin and even Oscar Wilde, it countered modern technology with craftsmanship, but its attempt to impart a social dimension to art and architecture became waylaid in the ornamental and the decorative. Although an early Art Nouveau project consisted of working-class housing, the movement's formal repertory became reactionary and in the end it was the living embodiment of middle-class society. Early on, the American Louis Sullivan—who designed the Schlesinger and Mayer department stores in Chicago (1894–1904) —lambasted its excessive decorativeness. In 1902, the architect and theoretician Hermann Muthesius declared that only machine-made objects could ever exist in harmony with the prevailing social and economic conditions. In October 1907 at Munich, the Werkbund, with its connections to industry, represented a desire to bridge the gap between the principles underlying the creative arts and the reality of a new world. This contrasted with the concern of Henry van de Velde, apostle of Jugendstil, to preserve the idea of handicraft. Just a few years later, the Austrian Adolf Loos was denouncing in

48

"Precious yet severe, elegant yet unyielding"

CHARLES RENNIE MACKINTOSH
Glasgow School of Art, Scotland
1897–1909.
© Bridgeman/Giraudon.

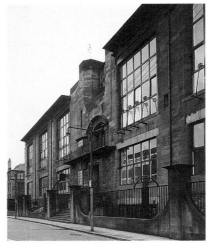

In the 1890s and the early 1900s, Mackintosh was a member of the group known as "The Four," also known as the "Glasgow School" (1895–1900), along with Herbert MacNair and the Macdonald sisters. Influenced by both Japonaiserie and Symbolism, they created a series of pieces that were to be popularized by early magazines devoted to interior decoration. Mackintosh also designed public buildings for his home city. The style can best be summed up as a cross between Arts and Crafts and "Scottish feudal" vernacular. From 1897 to 1899, and from 1907 to 1909, one of his projects marked the high point of his career, the Glasgow School of Art. The facade, which is placed off-center, displays masterly sophistication. The large uncased windows, like the skylights that illuminate the studio space, can be traced to the vocabulary of industrial architecture. Combining attention to detail with monumentality, the Glasgow School of Art, "precious yet severe, elegant yet stiff," marries formal simplicity to a search for genuine economy in construction.

"A sound constructive logic"

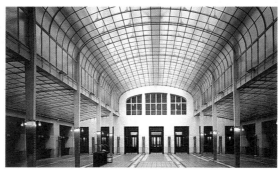

OTTO WAGNER
Banking Hall, Post Office Savings Bank, Vienna
1903–6.

After twenty years of conventional eclecticism and designing buildings which to this day have not all been clearly identified, Otto Wagner won the 1893 competition for the Vienna urban redevelopment scheme. Appointed director of one of the two architecture schools at the city art academy, Wagner then published an essay entitled *Moderne Architektur* (1896) which laid stress on the dialectical relationship between technical and architectural imperatives. Close to the rationalism of Jugendstil and to the style of the Sezession, which he joined in 1899, his numerous designs display a synthesis between graphic and ornamental concerns. The Post Office Savings Bank, whose trapezoid plan opens onto a central courtyard, has eschewed all ornament. Thanks to a generous use of glass and steel, in addition to countless details that marry tradition and modern processes, Wagner turned this edifice into a major milestone in the development of industrial era architecture.

> > >

"ONLY THE USEFUL

"A geometrical aesthetic... bordering on the decadent"

JOSEF HOFFMANN
Palais Stoclet, Brussels
1905–11.

Josef Hoffmann was strongly influenced by the Rationalist theories of Otto Wagner (of whom he was a pupil) and Mackintosh. Unlike Loos, he was not highly critical of ornamentation and remained a stalwart defender of craftsmanship. A founder member of the Wiener Werkstätte in 1903, he began designing the Purkersdorf Sanatorium the same year and was to become one of the central figures of Rationalism. The Palais Stoclet was commissioned from him by the coal and railroad magnate Adolphe Stoclet, and has been described as a "major work of Post-Impressionism and Symbolism, already entirely orientated to an aesthetic of

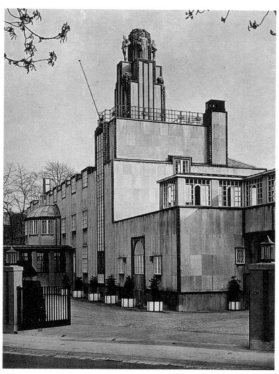

geometry, though rich in ornaments and detailing bordering on the decadent." A monument dating from the "Indian summer" of the bourgeoisie, its plan is directly inspired by Mackintosh's project for an art-lover's house, but its layout is based on a proportional system governed by the square. Exterior and interior alike feature subtle details that counteract the massiveness of the structure.

"Nature is a great book in which we look for inspiration"

HECTOR GUIMARD
Castel Béranger, Paris
1894–97.
© G. Dagli Orti.

This first commission in 1893 enabled Guimard to develop his half-rustic half-suburban vocabulary, with its anti-classical, asymmetrical idiom. A number of trips in Europe enabled him to become acquainted with Art Nouveau and, on his return in 1895, he completed the Castel Béranger. This is only a small building, but one which stood the conventions of Parisian residential architecture on their

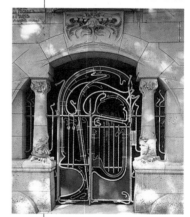

49

head. The diversity of materials employed on the facade and the accentuated curves were to become hallmarks of Guimard's work, and, in spite of the numerous campaigns waged against their "limp inflections," the architect continued to play a major role until the outbreak of war. "Above all, it seemed necessary in my eyes to abandon the classical tradition and to stop trying to work in 1899 as in 1829. It occurred to me that art should be based on science and that, in respect of artistic composition, one should strive for the unity which is in nature herself—since the logic of nature is infallible."

"Architecture derives from life"

FRANK LLOYD WRIGHT
Robie House, Chicago, United States
1900–10.
Photo R. Bryant.
© Archipress/Arcaid.

Son of a Unitarian preacher, Frank Lloyd Wright was heir to a Romantic vision of divine order and universal values. After studying civil engineering, he settled in Chicago and became assistant to Louis Sullivan. He designed a house for himself which displayed a taste for simple, geometric forms. He worked on the Guaranty Building in Buffalo, which gave him early experience in large-scale architecture. In the Charnley House in Chicago (1891–92) he exploited for the first time the decorative value of unadorned surfaces and the flat wall. In 1893, he set up on his own account, concentrating on residential architecture until 1909. He began to develop the Prairie House type, characterized by long, horizontal forms with low roofs and overhanging eaves. These designs were influenced by both Japanese architecture and "machine art." Wright saw the house as a complex composition of interrelated elements, designing everything from light fixtures to textiles.

"I believe architecture to be the humanizing of building. The more humane, the more rich and significant, inviting, and charming your architecture becomes, the more truly is it the great basis of a true culture."

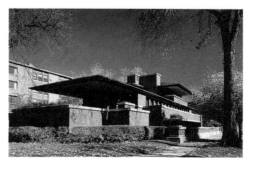

CAN BE BEAUTIFUL" Otto Wagner

> > > *Ornament and Crime* (1908) what he saw as Art Nouveau's ornamental delirium, to which he preferred the glass-and-steel functionalism of Otto Wagner.

What became known as Rationalism initially arose in reaction to such whim and asymmetry, since Art Nouveau had seen itself as a style that acted as an extension of the hand and that sought to re-establish the link with nature that had been lost during the rush toward industrialization. Rationalism was initially a search for functional solutions whose philosophical, political and social implications were informed by innovations already underway at the turn of the century. It was both a moral and an ethical project. Opposed to individualism in general, it advocated collective and international research, which it promoted with industrial techniques, countering formal idiosyncrasies with economic and technological vocabularies of its own. After seething ornamentation which claimed descent from organic and biological principles came sparseness and the imperatives of rigor, together with the heightened importance accorded to public spaces and social housing. The pressing need for city planning and new building programs simply overtook the isolationist view of architecture. Wedding form to function and exalting structure over decoration, Rationalism seemed to adopt Vitruvius's notion of a "reasonable science." This opened the way, as a side effect of both liberalism and the creation of housing projects of the type first conceived by people like Tony Garnier, for a recognition of the industrial city and of the "art of engineering."

<

"Classical architecture was an aberration. Only truth is beautiful"

TONY GARNIER
Design for a station,
Cité Industrielle
1904.

In 1889, Tony Garnier, an established architect in Lyon, entered the École des Beaux-Arts in Paris. After winning

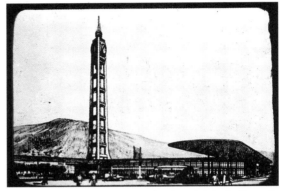

the Grand Prix de Rome in 1898, he found himself at the Villa Medici at a time when some were trying to overthrow the stale traditionalism of the French Academy in Rome. Garnier, a virtuoso draftsman, set about planning a com-

plete town, but his "study for an industrial city" was lambasted as a "vast doodle in pencil" and caused an uproar back in Paris. His scheme for a huge, secular and "municipalist" modern-day city turned a blind eye to ideas of property and to the centers of political power and the law. In 1905, Garnier, who had been associated with the radical Socialist circles around Jean Jaurès and with Emile Zola following the Dreyfus affair, was appointed by Édouard Herriot as director of the "Grands Travaux de la Ville de Lyon." His scheme for the "industrial city," which he continued to develop and publish up until 1917, served as a basis for all his subsequent designs. Totally at odds with his period, Garnier wrote: "Modern architecture might draw inspiration from the beauties of Antiquity, without making it the unique basis of teaching, since social imperatives demand other studies too."

"A laboratory of modernism"

PETER BEHRENS
AEG Turbinenfabrik, Berlin
1908–9. © AKG Paris.

Behrens was a founder member of the Munich Sezession (1892) and went on to set up the Vereinigte Werkstätten für Kunst im Handwerk (United Workshops for Art in Handicraft) in the same city (1897). A self-trained architect, his first design was for a house for himself at the artists' colony of Mathildenhöhe. He was subsequently appointed director of the Düsseldorf School of Arts and Handicraft. He was a founder of the Deutscher Werkbund in 1907 and in the same year was appointed coordinating architect for the electrical company AEG (1907–18), where he

exerted considerable influence. Such notable figures as Walter Gropius, Mies van der Rohe and Le Corbusier worked in his studio, that was dubbed a "laboratory of modernism." His work for AEG included the famous Turbinenfabrik, a sort of monument to German manufacturing might. A glass-and-steel construction, the Turbinenfabrik fused up-to-date materials with the lines of a classical temple. The facade is of steel and brick-faced reinforced concrete. The vast glazed skylights are counterbalanced by sturdy corner piers coursed with brick in a rusticated arrangement. Behrens drew inspiration from the Neo-Classicist Karl Friedrich Schinkel, a

dominant figure in Berlin architecture. The logo of the firm appears on the pediment, whose profile evokes agricultural architecture and harks back to the human solidarity that came from tilling the soil and that industrial work was expected to perpetuate.

"THERE IS NO PERMANENT DISTINCTION

"The role of the walls . . . is restricted to that of mere screens . . . to keep out rain, cold and noise"

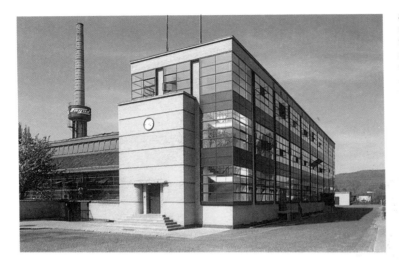

WALTER GROPIUS AND ADOLF MEYER
Fagus factory, Alfeld an der Leine
1910–11.
© AKG Paris/Hilbich.

The son of a Berlin architect, Walter Gropius joined Peter Behrens's practice in 1907. Three years later he embarked on a solo career, becoming active in areas ranging from interior design to the design of factories. Between 1910 and 1911 (in collaboration with Adolf Mayer), he designed a shoe-last factory for the Fagus company. This revolutionary factory consists of a three-storied steel-framed structure combined with glass curtain walls. The wall piers are recessed to emphasize the transparency and weightlessness of the walls. The window bars, brick moldings and joints serve to highlight the principal proportions. In 1919 he became head of both the Kunstgewerbeschule and the Hochschule für Bildende Kunst in Weimar, which he amalgamated under the title of Das Staatliche Bauhaus Weimar.

"Concrete is enough on its own"

AUGUSTE PERRET
Théâtre des Champs-Élysées, Paris
1911–13. © Roger-Viollet.

Auguste Perret was the son of a prosperous French builder who had sought refuge in Belgium following the upheavals of the 1871 Paris Commune. Together with his brother Gustave, he set up Perret Frères, an unusual firm which combined architectural consultancy with construction business. From 1896 on, they erected buildings all over France. In 1899, they began experimenting with reinforced concrete, creating joists with a 15-meter span over a floor area covering 300 square meters. Fascinated by the properties of this material, in 1903 they constructed their first reinforced-concrete multistory building on rue Franklin in Paris, one of the seminal works of modern architecture. In 1905 they designed a garage on rue de Ponthieu (destroyed), leaving the concrete exposed. In 1911, they were asked to implement a design by Henry van de Velde for the new Théâtre des Champ-Élysées. They overhauled the existing plans and proposed integrating the three auditoriums and suspending the foyer over eight main pilasters, creating a unified monolithic structure. The facades, however, were based on van de Velde's elevations and were decorated with bas-reliefs by the influential sculptor Émile-Antoine Bourdelle. The architecture of the theater itself, however, stemmed from new construction principles and was one of the century's most significant milestones. Perret noted: "Whoever conceals any part of [a building's] framework deprives themselves of the finest and only legitimate ornament in architecture. Whoever hides a post commits an error. Whoever erects a fake post commits a crime."

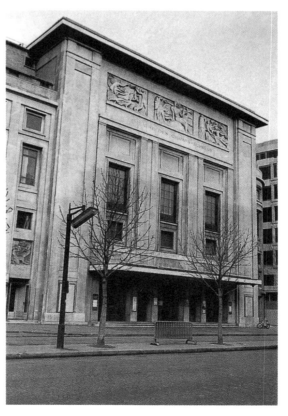

BETWEEN A TOOL AND A MACHINE" Hermann Muthesius

" We have overcome ornament"

ADOLF LOOS
Steiner House, Vienna
1910. Photo R. Schezen.

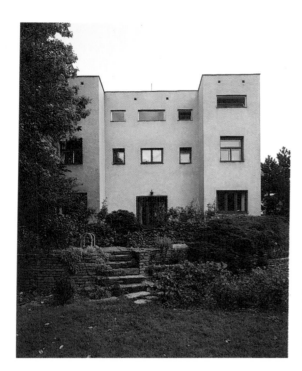

After a study trip to the United States (1893–96), Loos returned to Vienna at a time when the modernist Sezession movement was gaining ground. Loos took an active part in the intellectual debate raging at the turn of the century. Unlike the leading exponents of Jugendstil, he refused to reduce architecture solely to an art form and he was opposed to the notion of the *Gesamtkunstwerk*. In his own work, he strove to avoid decorative excess. "The grandeur of our time lies precisely in the fact that it is no longer prepared to turn out new ornaments. We have overcome ornament; we have learned how to do without it. A new century is coming in which the greatest promise of all will be fulfilled. Soon, walls in cities will glow, great white walls. The twentieth-century cityscape will be dazzling, unadorned—like Zion, the Holy City and capital of heaven." The house Hugo and Lily Steiner commissioned from Loos in 1910 consists of a symmetrical design and embodies an opposition between an "anonymous" exterior and an interior as "a place of distinction." It also illustrates the architect's search for what he dubbed the *Raumplan* (space or "volume" plan), resulting in a complex structure with living areas whose volumes differed according to their function and meaning. "After a care-worn day, we turn to Beethoven and *Tristan*. My cobbler can't do that. I shouldn't deprive him of his joys since I have nothing to replace them with. But whoever listens to the *Ninth* and then sets off to design wallpaper is either a rogue or a degenerate."

52

"Interior decor alien to and in conflict with the architecture is an absurdity"

ANTONIO SANT'ELIA
Plan for an electricity generating plant
1914. Black, green and red ink. Private collection, Milan.

" The point… is not to establish formal differences between old and new constructions, but rather to create *ex nihilo* a New Dwelling that exploits all the resources of science and technology and which would satisfy with all due nobility the requirements of our spirit and habits… devising new forms, new lines and a new raison d'être that are rooted in the specific conditions of modern life… In contemporary life, the ongoing process of architectural stylistic development has been cut short. Architecture has broken free from tradition and has to start afresh from the beginning." Sant'Elia worked as an architect in Milan, where he became friends with the Futurists. Initially influenced by Otto Wagner, he worked on the scheme for the new Milan railway station and created a number of designs for factories, hangars and hydroelectric plants that he christened "architectural dynamisms." Together with several other architects, he set up the Nuove Tendenze group and in May 1914 exhibited a number of plans on the theme of the city of the future. Sant'Elia no longer thought of architecture as comprising isolated constructions, but as an integral part of a complex urban landscape and of the communication networks that comprise it. As he assimilated the Futurist aesthetic, Sant'Elia came to think of the city in terms of idealized theater design, the underlying framework for which was provided by the industrial landscape.

"MAKING ORNAMENTS IS NOTHING BUT A WASTE OF

September 19, 1896. Cover of issue 36 of the journal *Jugend*. © AKG Paris.

1900. Pont Alexandre III and the Grand Palais, Paris. © AKG Paris.

1899. Entrance to the Dauphine Metro station, Paris. © AKG Paris.

Chronology 1890–1914

In keeping with the subject of the chapter, this chronology is largely devoted to events in France and the United States. Sections in bold refer to artists mentioned in the main text and captions.

1890
• St. Louis: Wainwright Building by Louis Sullivan.

1892
• The Frenchman François Hennebique applies for a patent for reinforced concrete.

1893
• The World's Colombian Exposition, Chicago: Japanese pavilion, the Ho-o-den Villa, designed by Kuru.
• Foundation of the Arts and Crafts journal *The Studio*.
• Brussels: Tassel House by Victor Horta.
• Adolf Loos goes to the United States, where he stays until 1896.

1894
• Vienna: Otto Wagner starts work on replanning the city (1894–1900) and publishes the first volume of *Moderne Architektur*.
• Brussels: Hôtel Solvay by Victor Horta. Guimard travels to Brussels, where he discovers the work of Paul Hankar and Victor Horta.
• Paris: Castel Béranger by Hector Guimard (1894–98). Church of Saint-Jean de Montmartre by Anatole de Baudot (1894–1904).

1895
• Uccle: Villa Bloemenwerf by Henry van de Velde.
• Buffalo: Guaranty Building by Louis Sullivan.
• Brussels: work starts on Maison du Peuple by Victor Horta (1895–99; demolished).

1896
• London: Whitechapel Art Gallery by Charles Townsend (1896–1901).
• Glasgow: Charles Rennie Mackintosh wins the competition for the Glasgow School of Arts.
• Munich: creation of the journal *Jugend* and of the Vereinigte Werkstätte.

1897
• Glasgow: Miss Cranston's Tea Rooms by Mackintosh, MacDonald, and MacNair.
• Brussels: Hôtel Eetvelde by Victor Horta.
• Berlin: Henry van de Velde settles in the city.
• Vienna: foundation of the Sezession round Gustav Klimt.

1898
• Brussels: Maison du Peuple and the Maison Horta by Victor Horta.
• Vienna: Majolica House, an apartment block, by Otto Wagner. Art Gallery by Joseph Maria Olbrich.
• Englishman Ebenezer Howard publishes *Tomorrow, a Peaceful Path to Real Reform* setting out his conception of the Garden City.

1899
• Budapest: Post Office Savings Bank by Ödön Lechner.
• Darmstadt: creation of the Mathildenhöhe artists' colony, instigated by Prince Ernst Ludwig and with the collaboration of Joseph Maria Olbrich.
• Berlin: first Sezession exhibition.

1900
• Paris: Metro entrances by Hector Guimard.
• Paris: construction for the World's Fair of the Pont Alexandre III and the facades of the Petit and the Grand Palais by Charles Girault.
• Paris: first concrete building by François Hennebique.
• Sèvres: Castel Henriette by Hector Guimard (demolished).
• Prague: Peterka House by Jan Kotera.

1901
• Paris: Tony Garnier starts work on his Cité Industrielle.
• Nancy: founding of the École de Nancy (Daum, Gallé, Majorelle).
• Brussels: L'Innovation department store by Victor Horta (demolished).
• Darmstadt: Ernst Ludwig Haus by Joseph Maria Olbrich.
• Barcelona: Lluís Domènech i Montaner starts work on the San Pablo hospital (1901–12).
• United States: Frank Lloyd Wright starts to evolve his Prairie House type.

1902
• Vienna: beginning of the Steinhof psychiatric hospital by Otto Wagner (1902–7; interior decoration by Koloman Moser).
Publication of *Moderne Architektur* by Otto Wagner continues.

MATERIALS, MONEY AND HUMAN LIVES" Loos

Chronology 1890–1914

1903
• Barcelona: facade of the Casa Battlo by Antoni Gaudí.
• Frankfurt: department store by Victor Horta.
• Amsterdam: Stock Exchange by Hendrik Petrus Berlage.
• Vienna: Post Office Savings Bank by Otto Wagner. Foundation of the Wiener Werkstätte by Joseph Maria Olbrich and Koloman Moser.
• Paris, "Exhibition de l'Habitation": working-class housing by Hector Guimard and Jules Lavirotte.
• Paris: apartment building at 25 bis, rue Franklin by Auguste Perret. Eugène Hénard publishes *Études sur la transformation de Paris* (1903–9).
• Pasadena: bungalows by Charles and Henry Greene (1903–9).

1904
• Scottish town planning theorist Patrick Geddes publishes *City Development*, that laid the groundwork for his later *Cities in Evolution* (1915).
• Weimar: interiors for the Grand-Ducal Saxon Schools of Art and Arts and Crafts by Henry van de Velde (1904–11).
• Paris: La Samaritaine department store by Frantz Jourdain.
• Bourg-la-Reine: Villa Hennebique by François Hennebique.
• Buffalo, New York: Larkin Building by Frank Lloyd Wright (demolished).

1905
• Brussels: Palais Stoclet by Josef Hoffmann (interior mosaics by Klimt).
• Barcelona: Casa Mila by Antoni Gaudí.
• Barcelona: Lluís Domènech i Montaner starts work on the Palau de la Musica Catalana (1905–8).
• Switzerland: Swiss engineer Robert Maillart builds the reinforced-concrete bridge at Tavanesa.

1906
• Paris: garage on rue de Ponthieu by Auguste Perret.

1907
• Foundation of the Deutscher Werkbund.
• Berlin: AEG program by Peter Behrens.

1908
• Stuttgart: Tietze department store by Joseph Maria Olbrich.
• Adolf Loos publishes *Ornament und Verbrechen* (Ornament and Crime).

1909
• Chicago: Daniel Burnham draws up his plans to extend and develop the city.

1910
• Paris: Hôtel Guimard by Hector Guimard.
• Vienna: Goldman & Salatsch building by Adolf Loos (1909–11).
• Vienna: Steiner House by Adolf Loos.

1911
• Paris: creation of the city-planning association, the Société Française d'Urbanisme.
• Paris: Théâtre des Champs-Élysées by Auguste Perret (1911–13).
• Alfeld-an-der-Leine: Fagus Factory by Walter Gropius.

1912
• Paris: building at 26, rue Vavin by Henri Sauvage.
• New Delhi: British architect Edwin Lutyens is appointed architect for the planning of New Delhi.

1913
• New York: Woolworth Building by Cass Gilbert.

1914
• Cologne: Werkbund exhibition. Public debate between Muthesius and van de Velde on standardization and craft.
• Milan: first exhibition by the Nuove Tendenze group, "Milano l'anno duemille."
• Sant'Elia presents his project for a "città nuova." Manifesto of Futurist architecture.

54

1889.
Adler and Sullivan.
Auditorium Building,
Chicago.
© F. Eustache/Archipress.

Studies on architecture

Dictionaries and general works
L. Benevolo. *History of Modern Architecture*. Cambridge, 1971 (2 vols.).*

W. Curtis. *Modern Architecture Since 1900.* London, 1982.

Dictionnaire de l'architecture du XXe siècle. Paris, 1996.*

H-R. Hitchcock. *Architecture, Nineteenth and Twentieth Centuries.* London, 1958.

R. Julian. *Histoire de l'architecture en France de 1889 à nos jours. Un siècle de modernité.* Paris, 1984.

M. Ragon. *Histoire de l'architecture et de l'urbanisme modernes.* Paris, 1986 (3 vols.).

General works
J. Dethier and A. Guiheux (eds.). *Paris. La Ville, art et architecture en Europe, 1870–1993.* Paris, 1994.

H. F. Mallgrave (ed.). *Otto Wagner: Reflections on the Raiment of Modernity.* Malibu, 1993.

Paris et La Rochelle. Chicago, 150 ans d'architecture 1833–1983. Art Center/ Musée-Gal. de la Seita/IFA, Paris, 1984.*

J. Russell. *Art Nouveau Architecture.* New York, 1979.

Antoine Picon. *L'Art de l'ingénieur.* 1997, Paris.*

Monographs on the architects studied
J. Abram. *Perret et l'école du classicisme structurel.* Nancy, 1985 (2 vols.).

L. Caramel. *Antonio Sant'Elia: l'Opera completa.* Milan, 1987.

G. R. Collins and J. B. Nonell. *The Designs and Drawings of Antonio Gaudí.* New York, 1983.

Frank Lloyd Wright Architect. The Museum of Modern Art, New York, 1994.

B. Gravagnuolo. *Adolf Loos, Theory and Works.* Milan, 1982.

Hector Guimard. Musée d'Orsay, Paris, 1992 (exh. cat.).

W. Nerdinger, *Walter Gropius.* Berlin, 1985.

R. Macleod. *Charles Rennie Mackintosh. Architect and Artist.* London, 1983.

H. F. Mallgrave (ed.). *Otto Wagner: Reflections on the Raiment of Modernity, Issues and Debates.* Malibu, 1993.

B. Rukschcio and R. Schachtel. *Adolf Loos. Leben und Werk.* Salzburg, 1982.

E. F. Sekler. *Josef Hoffmann: L'œuvre architecturale.* Liège, 1986.

Tony Garnier: L'œuvre complète. Paris, 1989.

A. Windsor. *Peter Behrens. Architect and Designer, 1868–1940.* London, 1981.

*Essential reading

EXPRESSIONISM
"between figure and abstraction"

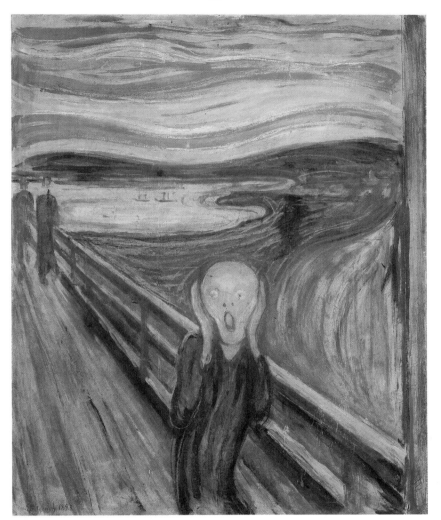

"An appalling scrawl"

EDVARD MUNCH
The Scream
1893. Tempera and pastel on cardboard, 91 x 74 cm. Nasjonalgalleriet, Oslo. © AKG.

Munch was strongly influenced by van Gogh, Gauguin and Lautrec, whose work he discovered in Paris. After returning to Oslo in 1898, he initially met with success. At his exhibitions in Berlin, he had forged close links with Symbolist circles, while the expressive violence of both his subjects and his palette made him an exemplary if controversial figure for the young Die Brücke generation. His technique and his interest in wood engraving left an enduring mark on the Expressionist movement, although some of its adherents at first took him for more of a Jugendstil artist. It is noteworthy, however, that Paul Cassirer once let it be known that he had employed the term "Expressionism" precisely to distinguish Munch's work from that of his contemporaries. Whether true or not, Cassirer's assertion underscores the extent of the Norwegian painter's sway over certain artistic milieus in German-speaking countries at the turn of the century. On this score, *The Scream* is an icon bedeviled by anguish, solitude and death. Its pessimistic vision of human destiny and the rhythmic violence of what a scathing critic at the Berlin Sezession dubbed "an appalling scrawl" amply justify its presence at the beginning of an introduction to Expressionism.

More than a movement or a school, Expressionism was a state of mind. In this respect, its roots lie further back in the past than its accepted historical definition. The word itself, however, was first used in 1911 to describe artists who were involved in all areas of the creative arts and who were reacting to the hegemony of Impressionism and Fauvism. It was a reaction that was both aesthetic and moral. It was also the recognition of a specific cultural situation

> > >

> > > and context. But the history of Exprssionism is also the history of a word and its various meanings. Did the critical heritage of the term begin in 1908, with the art historian Wilhelm Worringer, author of *Abstraktion und Einfühlung (Abstraction and Empathy)*, or with Paul Cassirer discussing Max Pechstein's work, or in the midnineteenth century, or at the 1901 Salon? By 1911, the term Expressionism was so vague that it was applied to anything and everything. However there was a distinct movement, which was accompanied—as an undercurrent—by the history of the relationship between France and the part of Europe to its east. In this regard, van Gogh and van Dongen, among others, although associated with Impressionism and Fauvism since they lived and exhibited in Paris, seem ultimately to be closer in spirit to Die Brücke. Expressionism was not an art that imitates nature, but a liberation with respect to the real. Its central tenet was that true reality lies within oneself. Although no more a concept than it was a monolithic style, it was a reaction against naturalism. Although it remained representational, it distorted reality so as to augment its own expressive power. There was a crucial distinction between Die Brücke and Der Blaue Reiter: members of the latter went beyond the anguished and convulsive pathos of the former in an attempt to express spiritual feelings in art, striving to free painting from its submission to the depiction of reality. Expressionism's plethora of means and techniques mirrored the many-sided nature of the world and of people. Expressionism was also a protean movement; there was never any question of a "program." On a woodblock carved for the cover of what would serve as the manifesto of Die Brücke in 1906, Ernst Ludwig Kirchner stated: "Anyone who directly and faithfully reproduces their creative source is one of us." With their preoccupation with group work, the members of Die Brücke also asked Emil Nolde to join with them; in their quest for unprecedented sensations, they exalted the New Man in Nietzsche's *Also Sprach Zarathustra*. Shortly before > > >

56

"The great thing about man is that he is a bridge"

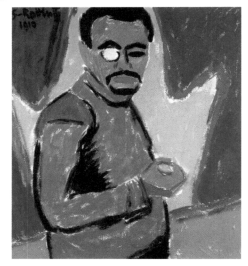

KARL SCHMIDT-ROTTLUFF
Self-Portrait with Monocle
1910. Oil on canvas, 84 x 76.5 cm. Nationalgalerie, Berlin.

Schmidt-Rottluff was born at Rottluff in Saxony in 1884. In 1901 he met Erich Heckel and followed courses in architecture in Dresden (1905–6), where he came into contact with Kirchner. Schmidt-Rottluff was hugely cultured, versed in poetry and profoundly interested in the philosophy of Nietzsche. Inspired by the prologue to *Also Sprach Zarathustra*, it was he who coined the term Die Brücke: "The great thing about man is that he is a bridge and not an end in himself. The thing that can be loved in man is that he is at once transition and decline." Although involved in the birth of the movement and associated with the various events Die Brücke staged in Berlin, where he had settled in 1911, Schmidt-Rottluff preferred the "bracing air of the Baltic Sea" to the capital. There he found he could express all "the tension between the beyond and the here and now." He was mobilized in 1915 and did not resume painting until 1919. Some twenty years later, his works hung once more in Berlin, though this time at the Nazis' anti-modernist show of "degenerate art." His *Self-Portrait with Monocle* is an example of the artist's mature style: a black contour provides the figure with its outline, while the flat planes of color and the schematic representation display the links between painting and the art of printmaking that Schmidt-Rottluff practiced throughout his career.

"Creating out of disorder"

ERNST LUDWIG KIRCHNER
Street Scene in Berlin
1913. Oil on canvas, 121 x 95 cm. Brücke-Museum, Berlin. © AKG.

"**W**e accept as one of us all those who transcribe, immediately, spontaneously, without counterfeit or sophistication, whatever it is that compels them to create..." Kirchner's program for Die Brücke may not have been very explicit, but he did at least cast some light on its goals. Influenced in Munich by the Jugendstil designer Hermann Obrist, Kirchner discovered Rembrandt and then the wood engravings of Vallotton and Munch. He terminated his stud-

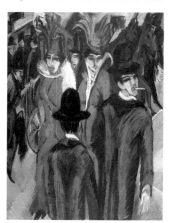

ies in architecture in 1905. Exalting collective studio work above all else, he founded Die Brücke with Heckel and Schmidt-Rottluff. By 1906, the group was expanding and becoming known through exhibitions all over Germany. In Berlin in 1910, on the occasion of the Neue Sezession, Die Brücke emerged at the forefront of the German avant-garde. Kirchner settled in the capital, where he produced many street scenes and works showing circuses or music halls in an exaggerated or distorted graphic style that he himself dubbed "hieroglyphic." The experience of the modern conurbation with its noise and violence, and the desire to "strip anti-nature bare" induced him to try to "create a picture of the time out of its disorder." In 1917, following illness and an accident, Kirchner retreated to Davos, where he was to commit suicide in 1938.

"HARMLESS-LOOKING OR STRAIGHTFORWARD

"Storms of color"

EMIL NOLDE
The Dance around the Golden Calf
1910. Oil on canvas, 90 x 105.5 cm. Bayerische Staats-gemäldesammlungen, Munich.

Nolde trained in wood carving and technical drawing at Karlsruhe. Between 1892 and 1898, he taught decorative arts at the school of industrial design at St. Gallen, Switzerland. There he encountered the Symbolist work of Ferdinand Hodler and Arnold Böcklin, and completed a series of grotesque masks, as well as a first oil painting, *The Giants of the Mountain*. After a number of trips through Europe "to pay tribute to its storms of color," Nolde was invited to join Die Brücke. He left the group in 1907, however, and joined the Berlin Sezession. His first religious paintings date from 1909 and, in 1910, he issued a vitriolic attack on the president of the Sezession, the Impressionist painter Max Liebermann, with whom he soon parted company. During a voyage to Holland and Belgium, he became familiar with the work of van Gogh and met the painter James Ensor. He then embarked on a *Life of Christ* and showed at the second Blaue Reiter exhibition in Munich. A painter of the visible world until 1909, he then strove to "add new values to nature by projecting on to it his own emotional and intellectual life." Though he conveys the seething tumult of the town, he also expresses, through pure color applied with brush and finger, a fervent mysticism in dramatic pictures with more than a hint of caricature. The ecstatic and Dionysiac *Dance around the Golden Calf* bears witness to the artist's fascination with Primitivism. In 1913, Nolde took part in an anthropological expedition to the German colonies in the Pacific.

"Strident clashes of color"

KEES VAN DONGEN
The Indian Dancer
1907. Oil on canvas, 100 x 81 cm. Private collection, Lausanne.

Van Dongen was born near Rotterdam and attended the city's Academy of Art. He was an ardent admirer of the work of Frans Hals and Rembrandt. He started pro-

ducing drawings for a number of magazines and his studies of port scenes or prostitutes created something of a stir. He arrived in Montmartre in 1897 and contributed numerous watercolors to journals such as *L'Assiette au beurre, L'Indiscret,* and *Le Rabelais.* He became associated with the powerful Symbolist critic and "anarchist" Félix Fénéon, and discovered both the Nabis and Divisionism (Pointillism). Even before the "cage aux fauves" scandal that gave the movement its name, the stylistic and thematic characteristics of his oeuvre were firmly in place: strident clashes of color, voids surrounding the subject like a halo, an affection for subject matter inspired by the Médrano circus, as in this *Indian Dancer.* At fellow painter Max Pechstein's initiative, in 1908 van Dongen sent some drawings to Die Brücke. His style at that time presented greater affinity with German Expressionism than with Fauvism and in some ways it offers an insight into the fragility and tension underlying relations between the two movements.

"Nostalgia for a lost Eden and disillusioned eroticism"

OTTO MUELLER
Two Female Nudes in a Landscape
Around 1924. Oil on canvas, 100 x 138 cm. Thyssen-Bornemisza Collection, Madrid.

Otto Mueller was a lithographer, before studying at the Dresden Academy (1894–1996). He led an unsettled life until 1908, when he moved to Berlin. In 1910 he became a member of Die Brücke and his style changed as he abandoned the nature-orientated Symbolism of his early work for a sharper, angular line. The nude soon became his preferred theme. In adopting a natural, relaxed position, his bodies defy the stiff poses of the academy and incarnate a life free of the shackles of bourgeois morality. Once again, it was Gauguin who served as both the artistic and spiritual model. Mueller, who had inherited gypsy blood from his mother's side, was especially drawn to Bohemian models. His work combines disillusioned eroticism with a nostalgia for a lost Eden. Often working in tempera on a loosely woven canvas, his oeuvre testifies to his interest in Egyptian art and its matt surfaces. "Untroubled... and as if unaffected by the stress and terror of the times," Wold-Dieter Dube contends, "Mueller went his own way, his work providing a haven for the sensuous harmony of his life."

PICTURES ARE RARELY WORTHWHILE" Nolde

> > > 1914, while still believing in the necessity of joint programs, the members of Die Brücke themselves split up. In 1913 in Berlin, where the harsh realities of daily life had thrown them together, the declaration of faith that had bound them together eventually fell apart and the war finally led to a complete dissolution.

In December 1911 in Munich, forty-three works, gathered together on the initiative of Franz Marc, Gabriele Münter and Wassily Kandinsky, showed precisely "how the artist's desire is expressed in many different guises." Following from the dissension of the Neue Künstlervereiningung München (the NKVM, or "New Association of Munich Artists"), this event constituted the Blaue Reiter's first "counter exhibition." In March 1912, a few more names were added to the list, and an exhibition was held under the auspices of the critic and art dealer Herwarth Walden, marking the first of *Der Sturm's* many events. The Blaue Reiter show was the culmination of Marc and Kandinsky's efforts, and they were soon joined by many other artists. Both were edging toward nonfigurative painting and were searching for a form of "synthesis." After Kandinsky and Münter's encounter with nature at Murnau, where color had been freed from its mimetic role, and after the dissolution of the NKVM in December 1912, the bases of abstract art had become clearer. Kandinsky wrote: "At some unknown hour, and from a source which is today shut to us, the work nonetheless comes, ineluctably, into the world." Franz Marc, for his part, could sense "the entirely spiritualized and dematerialized inwardness of sensation." In 1910, Kandinsky finished his text, *On the Spiritual in Art* (published in 1912). The title specifies at the outset the extent to which "inner necessity" alone dictates the duty of the artist. Kandinsky began to free himself completely from representation, producing a succession of *Impressions, Improvisations, and Compositions* which progressively erased all remnants of reference to the real, leading in 1913 to totally abstract works. The viewer too discovers abstraction. <

58

"Harmonies shot through with dissonance"

ALEXEI VON JAWLENSKY
Young Girl with Peonies
1909.
Oil on cardboard,
101 x 75 cm.
Von der Heydt Museum, Wuppertal.
© AKG.

In 1890, Jawlensky left St. Petersburg for Germany and France where, through the good offices of Sergei Diaghilev, he exhibited at the Salon d'Automne. There he met Matisse, whom he dubbed "the greatest living painter." Once back in Munich in 1907, he was initiated into the dark outlines and clear colors of Cloisonnism and struck up a friendship with Kandinsky and the painter Gabriele Münter. They worked together at Murnau, Upper Bavaria, where Jawlensky produced landscapes imbued with a tragic and vigorous symbolism. With Kandinsky, he was instrumental in setting up the Munich Neue Künstlervereinigung ("New Artists' Association," or NKVM), remaining a member until 1912. Close to Emil Nolde, he also exhibited at the Sonderbund in Cologne, and at the first Blaue Reiter show in the gallery of *Der Sturm*. Whereas from 1911, Jawlensky was mainly concerned with portraiture redolent of Russian icons, the "harmonies shot through with dissonance" that he produced during his NKVM period testify to a desire to translate the ideals of the group's manifesto. "We start out from the idea that the artist, beyond the impressions that he receives from the external world, from nature, constantly accumulates other experiences from his internal world and is engaged in a quest for artistic forms that have to be divested of subsidiary elements so as to express only the essential."

"Absolutely wretched work"

FRANZ MARC
The Yellow Cow
1911. Oil on canvas,
140 x 190 cm. The Solomon R. Guggenheim Museum, New York.

Franz Marc first studied theology before moving on to painting at the Munich Academy of Fine Arts. In 1903, he went to France, where he encountered Impressionism and became friends with the progressive landscapist August Macke, who initiated him into Fauvism. A member of the NKVM with Kandinsky, he went on to cofound Der Blaue Reiter. In October 1912, he once again left with Macke for Paris to meet Robert Delaunay, in whose work he admired "the absolute rhythm of nature." Marc was to perish at Verdun in 1916. *The Yellow Cow* figured at the first Blaue Reiter exhibition. Animal subjects had been a favorite of Marc's since 1907. Its dancelike motion is suggestive of the animal's joy in the unbreakable laws of nature and the cosmos. Yellow, dominant in the composition, was characterized by Kandinsky as a "typically earth-bound" color. This canvas gave rise to a lively debate within the ranks of the NKVM which forced Marc to resign. One of the association's members, the painter Alexander Kanoldt, branded *Yellow Cow* and *Deer in a Forest* as "absolutely wretched work."

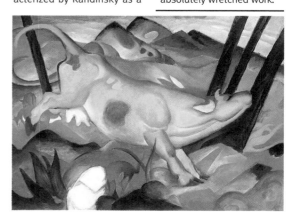

"CONTRAST AND CONTRADICTION:

"Fullness of color"

WASSILY KANDINSKY
Murnau with Church
1910. Oil on canvas, 96 x 105 cm. Stedlijk van Abbemuseum, Eindhoven.

Kandinsky initially studied law in Moscow. In 1895 he discovered the Impressionists and became fascinated by Monet's haystacks cycle because at first sight the subject had not been obvious to him. He henceforth devoted himself to tackling the problems of nonrepresentational painting. In 1896, he settled in Munich where many artists were preparing the ground for a new art "that should signify nothing, represent nothing, evoke nothing." After register-ing at the Academy of Fine Arts, he began teaching at the Phalanx school, acting as dean from 1902 to 1904. Jugendstil and Neo-Impressionism were to determine the direction of his work. He traveled through-out Europe from 1903 to 1908, exhibiting at the Sezession, at the Salon d'Automne and at the second show to be held by Die Brücke, in Dresden in 1906. Back in Munich in 1908, he set up an artist's colony with Gabriele Münter, Jawlen-sky and Marianne von Were-fkin at Murnau, Upper Bavaria. During this period he pro-duced a large number of land-scapes which, beyond their debt to Cézanne and Matisse, show his keenness to liber-ate his art from representa-tion through the strength and fullness of color. Bavarian folk art provided additional tools that helped him simplify his subjects. He was then edging toward the "realization of a synthesis between external reality and the artist's interior world."

"I have a liking for abstract forms"

WASSILY KANDINSKY
Untitled
1910. Lead pencil, watercolor and Indian ink on paper, 49.6 x 64.8 cm. Centre Georges Pompidou, MNAM, Paris.

This watercolor has been involv-ed in the dispute over whether Kandinsky was in fact the "inven-tor" of abstract art. Recent stud-ies suggest that it was signed after the event. Is it a purely abstract work? Kandinsky for his part always laid great stress on the polarity between "pure ab-

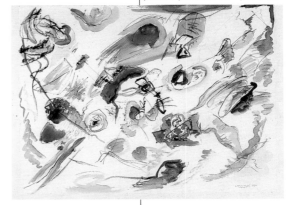

straction" and "pure realism." Two quotations from the artist provide further enlightenment: "My book *On the Spiritual in Art,* like the *Blaue Reiter* almanac itself, sought above all to awaken what would become in the future the abso-lutely indispensable capacity, and one which was to facilitate innu-merable experiments, of experi-encing the spiritual through mate-rial and abstract objects." And in April 1912 he wrote to Hans Bloesch: "As everything in the world acts from inside, in the depths of the soul, any material at all can serve an artistic pur-pose... Personally, I have a liking for abstract forms. It also seems to me that in the final analysis—let us say in some indeterminate future—painting will progress in the direction of 'pure' pictorial (that is to say, nonfigurative) art."

"The representation of conflicts"

WASSILY KANDINSKY
With Black Arch
1912.
Oil on canvas, 189 x 198 cm. Centre Pompidou, MNAM, Paris © Centre Pompidou, MNAM/CCI.

According to Christian Der-ouet and Jessica Boissel, the starting point for this excep-tional work was a little pen-cil sketch entitled *Mit Reiter von links unten* (With horse-man from bottom left), which Roethel thinks was a study for a woodcut intended for Kandinsky's book *Klänge* (sonorities, noises). Johannes Langner has devoted a thor-ough analysis to this paint-ing, which bears a title adapted from Kandinsky's *On the Spiritual in Art:* "Contrast and contradiction: such is our harmony." Langner explains that the main subject of the work is the "representation of conflicts." The themes of cataclysm, confrontation, and struggle had already appeared in 1901, when Kandinsky organized the first exhibition of the Phalanx group. In its evocation of forces in motion, *With Black Arch*—completed between the end of August and the early days of September 1912—amounts to a synthe-sis of preceding work and a program for future endeavor.

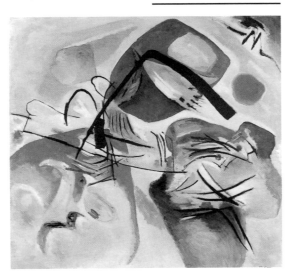

THEREIN LIES OUR HARMONY" Kandinsky

Chronology 1896–1914

In keeping with the subject of the chapter, this chronology is largely devoted to events in Germany and the rest of Europe. Sections in bold refer to artists mentioned in the main text and captions.

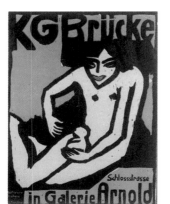

1905–7. Ernst Ludwig Kirchner. Poster for the Brücke exhibition at the Galerie Arnold. © AKG Paris.

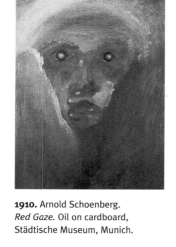

1910. Arnold Schoenberg. *Red Gaze.* Oil on cardboard, Städtische Museum, Munich.

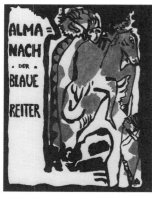

1911. Wassily Kandinsky. Cover for the *Almanach Blaue Reiter.* Firmengruppe Ahlers Collection. © AKG Paris.

1896
Kandinsky, of Russian origin, moves to Germany. Five years later he creates the Phalanx group and school, which breaks up in 1904.

1900
• Death of philosopher Nietzsche.

1905
• Heinrich Mann publishes the satirical novel *Professor Unrat.*
Dresden: strongly influenced by the ideas of Nietzsche, Kirchner, Fritz Bleyl, Heckel and Schmidt-Rottluff form the group Die Brücke.

1905–6
Dresden: van Gogh and Munch exhibitions.

1906
• Georg Trakl stages his dramas *Totentag* (Day of Death) and *Fata Morgana.*
• Ernst Cassirer publishes *The Problem of Knowledge.*
• Frank Wedekind publishes *Totentanz* (Dance of Death).
Kirchner writes the short manifesto for Die Brücke, making a woodcut of it for publication. Nolde and Max Pechstein join the Brücke group, the former for eighteen months, the latter for six years.
Opening of a Brücke exhibition in Dresden.

1906–7
Nolde paints a series of *Gardens.*
Kandinsky moves to Paris and discovers the art of Matisse and Picasso. September: opening of a further exhibition in Dresden.

1908
Kees van Dongen joins Die Brücke.
Kandinsky moves once more to Murnau in Bavaria, where he is joined by two other Russian painters: Alexei von Jawlensky and Marianne von Werefkin.
In Murnau, Kandinsky and his companion Gabriele Münter discover Bavarian folk art. Kandinsky abandons his use of Russian myth in his art.
The art historian Wilhelm Worringer publishes *Abstraktion und Einfühlung (Abstraction and Empathy)* in Munich.
Joint Fauvist and Brücke exhibition at the Richter gallery.

1909
Following Heckel's lead, Kirchner and Pechstein produce wood carvings.
Kandinsky, Munter, Jawlensky and Werefkin found the Neue Künstlervereinigung München (NKVM).

1910
Otto Mueller becomes a member of Die Brücke. A member of the Berlin Sezession since 1908, Max Pechstein creates the Neue Sezession. Nolde paints his *Autumn Seas* series. Herwarth Walden sets up the journal *Der Sturm* (The Storm) that will continue publication until 1932. Kandinsky writes *Of the Spiritual in Art* (published 1912).

1911
• Franz Pfemfert begins the political and literary weekly *Die Aktion.*
Kirchner, Heckel and Schmidt-Rottluff leave Dresden for Berlin, where they join up with Pechstein, who is back from a trip to France. Munich: Kandinsky, Munter and Marc organize an anti-NKVM exhibition under the title "Der Blaue Reiter" at the Tannhauser gallery.

1912
• Gottfried Benn publishes *Morgue und andere Gedichte.*
• Thomas Mann publishes *Tod in Venedig* (Death in Venice).
Pechstein is excluded from Die Brücke by Kirchner for showing at an exhibition held by the (old) Sezession. Publication of the *Almanach der Blaue Reiter.* Jawlensky leaves NKVM and, from 1914, lives in Switzerland. Kandinsky publishes *Of the Spiritual in Art* and establishes close links with the Viennese composer and painter Arnold Schoenberg. Marc and August Macke meet Robert Delaunay in Paris. Marc, mobilized in 1914, will be killed at Verdun in 1916. Munich: second and last exhibition under the auspices of Der Blaue Reiter at the Galerie Goltz.

1913
Berlin: Kirchner publishes the *Chronik der Brücke.* Since other members refuse to sanction parts of the text, the group dissolves. Nolde paints his *Seas* series. He leaves for the South Pacific, returning in 1914.
Kandinsky publishes *Rückblick* and *Klange.*

1914
April: Macke spends two weeks in Tunisia with Swiss painter Louis Moilliet and Klee (he will lose his life at the front on August 8).
Kandinsky returns to Russia, where he will occupy important functions at the end of the Revolution.
The *Almanach der Blaue Reiter* is reissued, plans for a second volume having come to nothing.

Studies on Expressionism
S. Barron and W-D. Dube (eds.). *German Expressionism: Art and Society.* Munich, 1997.

W. D. Dube. *Journal de l'expressionnisme.* Geneva, 1983.

D. Elger (et al). *Expressionism: A Revolution in German Art.* Munich, 1998.

D. E. Gordon. *Expressionism: Art and Idea.* New Haven and London, 1987.

H. Jähner. *Die Brücke. Naissance et affirmation de l'Expressionnisme.* Paris, 1992.

J.-E. Muller. *A Dictionary of Expressionism.* London, 1983.

J.-M. Palmier. *L'Expressionnisme et les arts, portrait d'une génération.* Paris, 1979.

M. Priester (et al.). *Inner Visions: German Prints from the Age of Expressionism.* New York, 1993.

L. Richard. *Encyclopédie de l'expressionnisme.* Paris, 1993.*

S. Sabarsky. *La Peinture expressionniste allemande.* Paris, 1990.

R.-C. Washton (ed.). *German Expressionism: Documents from the End of the Wilhelmine Empire to the Rise of National Socialism.* New York, 1993.

A. Zweite and R. Gollek. *Der Blaue Reiter im Lembachhaus München.* Munich, 1982.

Main exhibitions and catalogues
1968, New York. *Fauves and Expressionists.* Leonard Hutton Galleries.

1978 July-Nov., Paris. *Paris-Berlin, rapports et contrastes France-Allemagne.* MNAM/Centre Georges Pompidou.

1986 Nov.-Feb., Bern. *Der blaue Reiter.* Kunstmuseum.

1992, Paris. *L'Expressionnisme.* MAMVP.*

Where works can be seen
United States
MoMA, New York.
Solomon R. Guggenheim, New York.

Europe
Brücke-Museum, Berlin.
Nationalgalerie, Berlin.
Museum Ludwig, Cologne.
Lehmbrück Museum, Duisburg.
Kunstsammlung Nordrhein-Westfalen, Düsseldorf.
Museum Folkwang, Essen.
Sprengel Museum, Hanover.
Staatsgalerie Moderner Kunst, Munich.
Städtische Galerie im Lembachhaus, Munich.
Musée National d'Art Moderne, Paris.
Von der Heydt Museum, Wuppertal.
State Hermitage Museum, St. Petersburg.

* Essential reading

DADA
"between war and peace"

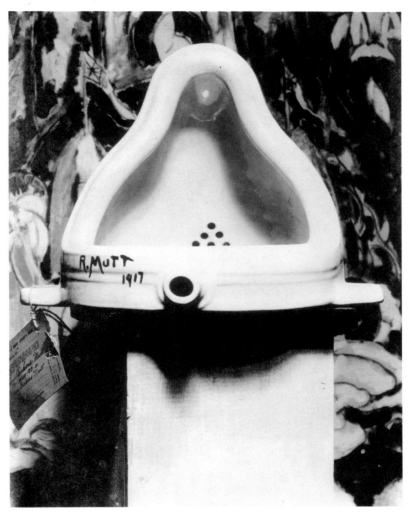

"Your female's a urinal — and you get on fine"

R. MUTT (MARCEL DUCHAMP)
Fountain
1917. China urinal photographed by Alfred Stieglitz for *The Blind Man,* no. 2, May 1917. Private collection, Paris.

"Whether Mr. Mutt with his own hands made the fountain or not has no importance. He CHOSE it. He took an ordinary article of life, placed it so that its useful signification disappeared under the new title and point of view—created a new thought for that object." So ran an editorial in the second issue of *The Blind Man,* probably written by Duchamp himself. There was what was called a "Richard Mutt Case" that was indeed covered by the press, Exhibit A being photographed by Alfred Stieglitz, whose status as an artist and a mainstay of modern art showed just how seriously it was all taken. Duchamp's entry to the Society of Independent Artists might well never had such far-reaching consequences since the association in principle rejected censorship and was committed to unjuried admis-sion. Their refusal to show R. Mutt's *Fountain* thus hoisted the organizing committee on its own petard. The object itself, apparently, was not the most shocking thing; it was the "artist's" name—with its dual meaning of "sap" and "mongrel"—that put various backs up. By way of protest, Duchamp promptly resigned from the committee, since he could not accept that "in the name of the law" an object which he (albeit with tongue in cheek) had entered "in the name of art" be thrown out in this way.

A pacifist, international movement, Dada was an attempt to stigmatize stupidity, a denunciation of nonsense and vanity. Essentially anarchic, it fought on more than one battlefield: with Arthur Cravan, the boxer-poet, Dada was aggressive and irreverent; with Francis Picabia, it became the total refusal to synthesize; for Marcel Duchamp, it was a paean to certain forms of behavior; with Hugo Ball, it became a form of conscientious objection, mystical and

> > >

>>> mystificatory; a militant for Richard Huelsenbeck; for Max Ernst, it was all poetry and inventiveness… And Tristan Tzara added: "Dada is our intensity. Dada is art without slippers or parallels, that is for and against unity, and decidedly against the future." For Dada want wanted to live for the present. Born on February 5, 1916, at the Cabaret Voltaire in Zurich, it quickly rallied to its side both artists and intellectuals in exile in the city. Two Germans, Hugo Ball and Richard Huelsenbeck, two Romanians, Tristan Tzara and Marcel Janco, and Jean (Hans) Arp from Alsace constituted the hard core of the group. It arose "so as to remind people that, above and beyond the war and the homeland, there exist independently minded men who live for other ideals." They all shared a horror for the war and a feeling for the absurd. From 1916 to 1919, Tristan Tzara, leading and coordinating the movement and organizing evening events that often degenerated into pitched battles, fomented a *tabula rasa:* his experiments advocated methodical doubt. Some twenty years later, Richard Huelsenbeck was to reproach Tzara his attitude: Dada should have held onto its militant and revolutionary dimension.

But Dada simply packed its bags and was reborn in Berlin, where, in a defeated Germany, it pressed itself without further ado into the service of the proletarian revolution. Tracts and petitions swelled to a flood. Raoul Hausmann, sound poet and photomontage artist, joined the field of operations. In a new *Manifesto*, the Berlin Dadaists asked what the purposes of Dada were exactly. "Dada," they replied, "is German Bolshevism." George Grosz sent in caricatures of a Germany on crutches, John Heartfield and Hannah Höch their censorious collages. In Berlin, Dada rejected "art for art's sake" and advocated total revolution. The First International Fair in June 1921 was the culmination of the political revolt, which finally absorbed Dada so completely that it withered in Berlin, only to surface again in Cologne, where Johannes Theodor Baargeld and above all Arp and Ernst constructed absurdist *FaTaGaGas* together, opposing the politicization of the movement and reconciling Dada to the poetical act through the >>>

62

"I'd do nothing much—then I'd sign it"

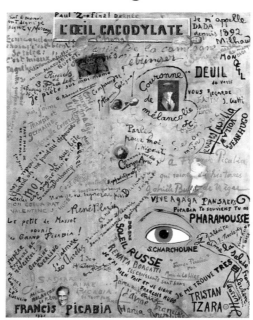

FRANCIS PICABIA
L'Œil Cacodylate
1921. Oil and ink on canvas with collage, 146.8 x 117.4 cm. Centre Pompidou, MNAM, Paris. Photo MNAM/CCI.

One of Picabia's most significant works is in fact one with which his handiwork had only a very vague connection. Afflicted with herpes of the eye (not exactly a boon to a painter), Picabia gathered together a motley crew of fellow conspirators to compose an "anti-picture." After first painting the organ that was causing him so much pain on an unprimed canvas in best Egyptian style, Picabia invited a crowd of troublemakers and firebrands to add their own scribbles. The surface was then peppered with photos, one being a humorous portrait of the man behind the whole joke. Dadaist Tristan Tzara was one of the many who invested this "eye in cacodyl" with the significance of a group tract. A year later, however, the *rastaquouère* (an injurious term for "rich foreigner"), as Picabia was known in Dada circles, crashed out of the movement. The poet who wrote *La Fille née sans mère* (A daughter born without a mother) rejected (as Arp later recalled) every "trace of the dried-out sponges of rhetoric, no more twinkly phrases, no more visual trickery in a bra."

"Disdain and scandal set to squabbling over him"

FRANCIS PICABIA
Danse de Saint-Guy (Tabac-Rat)
1919–20/1946–49. Cardboard, ink and string in a frame, 104.4 x 84.7 cm. Centre Pompidou, MNAM, Paris. Photo MNAM/CCI.

Of the three works Picabia presented at the Salon des Indépendants in 1922, only the "St. Vitus Dance (Tobacco-Rat)" was accepted. Does what we see in its gilt frame have any interest as an artwork? Do the pieces of string have anything to say about the visual? Do the textual fragments invest the work with a poetical aura? Picabia maintained that he had wanted the piece to be suspended and appear weightless. There was also a plan for white mice to be placed in a wheel installed in the back of the weird machine. *The Danse de Saint-Guy* was damaged and the picture-poem's string and words replaced by new ones at its postwar "hanging." The original inscription ran (in translation): "Tobacco I go to bed/ What beautiful sunshine." The new stated instead: " St. Vitus Dance/Tobacco-Rat/Francis Picabia." Exploring the space of language and the language of space, and at a time when Picabia was returning to a highly individual type of figuration, "disdain and scandal," as Serge Lemoine put it, "set to squabbling over him."

"THERE IS NOTHING TO UNDERSTAND—

"You piss me off!"

MARCEL DUCHAMP
Tu m'
1918. Oil on canvas with bottle brush and safety pins, 70 x 312 cm. Yale University Art Gallery, gift of Katherine Dreier, New Haven.

Five years after his last oil painting, Duchamp seemed to return to the medium simply to take his leave of it forever. *Tu m'* is a long, narrow composition executed for the library of his friend Katherine Dreier in Connecticut. The title (an abbreviation of *Tu m'emmerdes*—and not *Tu m'aimes*) perfectly encapsulates the attitude of a man who refused to "get tipsy on turpentine." Co-opting the principles of optic illusion on which the kind of artworks he boycotted are based, Duchamp executed a perfect trompe l'oeil. A color scale stretches like a chronophotograph across the canvas, with shadows of his readymade sculptures viewed from various angles, and a fake "hole." In addition, real safety pins and a bottle brush are primed to cause injury to anyone misguided enough to "approach the eye for a closer look." *Tu m'* is a complex piece of machinery in which mechanical know-how (represented by the "precision optics") and craftsmanship (in the shape of the sign-painting executed on the canvas by a specially invited artist) are at loggerheads. Duchamp, formerly an *anartiste* (nonartist), now turns "engineer." *Tu m'* is not so much directed at the collector friend who commissioned it as to certain goals of art that were henceforth best relegated to the "novelty store."

"The Ray Man"

MAN RAY
Woman
1920. Vintage silver print, 38.8 x 29.1 cm. Private collection, Milan.

Man Ray joined Dada after seeing works by Duchamp at the ground-breaking New York Armory Show in 1913. Born in Philadelphia, he studied in New York, notably at the Ferrer Center that had been set up by sympathizers to anarchist and libertarian causes. Cherishing the ideas of Henry Thoreau and Walt Whitman, Man Ray was a key figure in the American avant-garde. Between 1913 and 1915 at Ridgefield, New Jersey, he joined other poets and theoreticians and was soon turning out and exhibiting collages and paintings. As he had to provide photographs for the shows, he soon observed that "no-one is better placed for such a task than the painter himself." It was in this way that Man Ray became a photographer for himself and for others, though his life's work as a whole remained directed toward experimentation. The almost accidental discovery of the airbrush, of the rayograph (objects placed directly on photographic paper) and of the intense exposures of solarization should not obscure the fact that Man Ray was first and foremost concerned with the investigation of the fundamental ambiguity of the world. Eschewing the conventions of classical perspective, his early pre-1920 photographs stress both the "indeterminacy of photographed reality" and a desire to distort it.

"A readymade in perpetual motion"

MARCEL DUCHAMP
The Bride Stripped Bare by Her Bachelors, Even (The Large Glass)
1915–23.
Oil, varnish, lead foil and lead wire on two (cracked) panes of glass, 277 x 175.5 cm. Philadelphia Museum of Art, gift of Katherine Dreier.

A total synthesis of Duchamp's speculations and thoughts since 1915, the *Grand Verre* was left incomplete—or in abeyance—in 1923. Accidentally cracked, it was left unrestored, somewhere between transpar-

ency and obscurity, like a photographic plate. Surrealist leader André Breton was moved to describe it as suggestive of "a mechanicist, cynical interpretation of the phenomenon of love." Executed in lead materials in addition to paint, its enigmatic nature has given rise to a flood of commentaries that revolve around its combination of erotic and visual themes. Unfinished, incomplete, the *Large Glass* makes up for its stationary nature with an openness to the moving world beyond that the viewer can see through it. Robert Lebel has characterized it as "a readymade in perpetual motion."

LIVE FOR PLEASURE ALONE" Picabia

> > > invention of a "parallel reality" in collage.

When Arp and Ernst left and fell under the spell of Paris, Dada morphed itself once again in the hands of Kurt Schwitters in Hanover. In order to counter the now anti-aesthetic position of the movement, Schwitters invented *Merz*, a form of myth synthesizing plastic space and poetical art. Working in the margins, he sought to objectivize chance and to create a total work of art, his *Merzbau* (a cross "between a cathedral and the Cabinet of Doctor Caligari").

Dead in Germany, Dada flourished once more in the Paris of the 1920s. Poets Louis Aragon, André Breton and Philippe Soupault took up Dada "like one goes on a diet." Before founding their own review, *Littérature*, in 1919, they sensed in Dada, quite apart from a way of behaving, a reflection on language and its usefulness. Following on from Rimbaud, Jarry and the "Incohérents," Paris Dada became a matter of language—of words and of writing—and an anti-bourgeois offensive. At the Salon des Indépendants, Dada encountered just the kind of (anti-)victory it had always courted as riots and scandals came thick and fast: Dada was a way of being as much as a way of life. On January 12, 1921, the movement evaporated in the following spasm: "Dada knows everything. Dada spits it all out . . . Dada does not speak. Dada has no fixed idea. Dada doesn't catch flies . . . The Ministry is overthrown. By whom? By Dada. A girl commits suicide. Because of what? Of Dada . . ."

Dada could not help replacing art for art's sake with confusion for confusion's sake. Breton searched for a way out and tried to change direction. There followed the mock "trial" of the voguish conservative writer Maurice Barrès. At that point, Picabia, the *loustic* ("funny man"), threw in the towel. Once it started taking itself seriously, Dada signed its own death warrant. Duchamp, keeping out of every movement except the movement of the mind itself, had it about right. He certainly had some "sympathy for metaphysical Dada," and collaborated with them when the fancy took him, but he was never sufficiently biddable to actually join a group. <

"Destructive reconstruction"

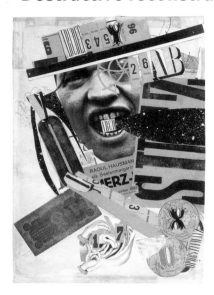

RAOUL HAUSMANN
ABCD (Portrait of the Artist)
1923–24.
Collage and Indian ink on paper, 40.4 x 28.2 cm.
Centre Georges Pompidou, MNAM, Paris.
Photo Centre Georges Pompidou, MNAM/CCI.

Just as the movement was sprouting wings in Paris but losing height in Berlin, Raoul Hausmann declared: "Dada is just a word." His role in the movement's growing international scope, however, was a singular one, combining as it did political activism with research in the fields of visual art, photography and typography. His practice of "destructive reconstruction" created new meanings through the use of untoward materials, through conflating genres, and by inventing novel techniques. Soon acquiring a reputation as "the most aggressive destroyer of prefabricated images," Hausmann's pet techniques were photomontage and assemblage. *ABCD* is a "portrait" that harks back to a time in the early 1920s when the artist and his friends were Dada partisans. A gaping mouth screams the first four letters of the alphabet amid a scattering of snippets of paper, cut-out scraps of typeface, tickets for the Kaiser's Jubilee, a Czech banknote that recalls a "performance" by fellow Dada Kurt Schwitters in Prague, and a flier for a Merz event at Hanover in 1923 at which Hausmann read his own concrete poetry.

"I wanted to expose the spirit of our times"

RAOUL HAUSMANN
The Spirit of our Times (Mechanical Head)
1919. Assemblage, wooden dummy head and mixed technique, 32.5 x 21 x 20 cm.
Centre Georges Pompidou, MNAM, Paris.
Photo Centre Georges Pompidou, MNAM/CCI.

"Long ago, I noticed that people have no character and that their face is just an image got up by their hairdresser. Why not in that case just take one of those heads made by simple, innocent souls on which trainee hairdressers practice wigmaking. The idea of it!

I wanted to expose the spirit of our times, the spirit of everyone in its most rudimentary state... So I took a fine wooden head... and crowned it with a collapsible metal cup. On the back I stuck a pretty-looking billfold. I took a little jewelry box and attached it next to the right ear. I then put a photographic roll inside with a stem from a smoker's pipe... I stuck a bronze component from an antiquated camera to a wooden ruler and then I looke... Ah yes, I was missing the little piece of white cardboard inscribed with the number '22,' since of course the only meaning the spirit of our time has is a numerical one."

"LOGIC IS A

64

"A laboratory for inventing new forms"

HANS-JEAN ARP
Trousse d'un Da
1920–21. Polychrome driftwood, 38.7 x 27 x 4.5 cm. Centre Georges Pompidou, MNAM, Paris, gift of Christophe Tzara. Photo Centre Georges Pompidou, MNAM/CCI.

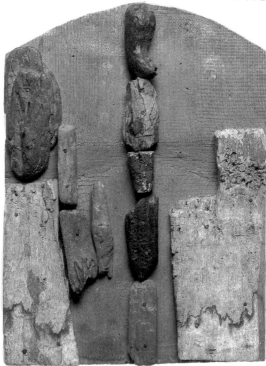

Member of the Blaue Reiter and of Der Sturm, and a friend of Max Ernst in Cologne, Arp's work only truly matured in the orbit of Sophie Taueber, whom he met in Zurich in 1915 and married in 1922. Highly flexible in his approach and called by some a "walking laboratory for inventing new forms," Arp was the very epitome of a Dadaist — creative, inventive and multifaceted, transcending every category. He was drawn to biological forms and developed a pure type of sculpture, eschewing systems and making ample use of play, chance and spontaneity. His work "distances itself from aesthetics, in a search for a new relationship between man and nature." In Berlin in 1918, Arp took part in the campaign Dada was waging against the army of Cubist and geometrical painters of the Section d'Or and railed against art professionals. Close to Kurt Schwitters, with whom he collaborated on building the installation-like *Merzbau* that grew out of the relief sculptures both were producing at that time, Arp also had a hand in various weird objects (like this "case/bag of a Da[da?]"), cobbled together out of pieces of driftwood found on the island of Rumen, where, in the company of his artist friend, he was unsuccessfully trying to finish a novel.

"Now I call myself MERZ"

KURT SCHWITTERS
Das Arbeiterbild
1919.
Collage of wood and pasted papers, 122.5 x 90 cm. Moderna Museet, Stockholm.

"I just couldn't see why old tickets, driftwood, cloakroom tokens, pieces of thread and bits of wheel, buttons and any old thing found in the attic or in the trash can couldn't be used for a picture as well as manufactured paint. The way I see it, this was a social attitude and, artistically speaking, my personal hobbyhorse, in fact mostly that... I called my new works that employed materials of this kind, *Merz*.

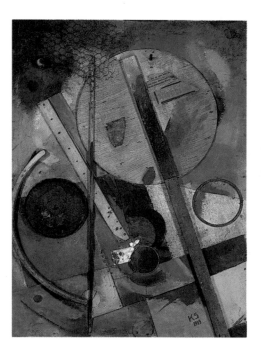

It is the second syllable of 'KOMMERZ'. It appeared in the picture *MERZ*, a work in which, beneath some abstract shapes, the word itself appeared, cut out from an advertisement for the KOMMERZ UND PRIVAT BANK and then glued... You'll appreciate that I called a picture with the word 'MERZ' in it MERZ Picture in the same way as a picture with the word 'and' in it was called 'and Picture' and one with the word 'worker' in it 'Worker Picture'... I later extended the use of the word MERZ, first to poetry, since I was writing poems by 1917, then to all my other diverse activities. Now I call myself MERZ."

"Contradictory images"

MAX ERNST
Two Ambiguous Figures
1919–20.
Collage and gouache, 60 x 40 cm. Private collection.

If it is indeed true that without Ernst Surrealism might never have existed, Dada too would have lacked an explorative and philosophical dimension without "DadaMax." Ernst unquestionably stands in the middle of various crosscurrents in European culture, but his oeuvre — which has common elements with the technique of free association as

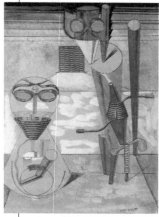

envisaged by psychoanalysis — is a process of ceaseless discovery, "a hallucinatory succession of contradictory images, double, triple, multiple that are superimposed one over the other, as long-lasting and as rapid as a memory of love or a half-sleeping vision." Ever on the lookout for the unknown, Ernst was engaged in a search for "a meeting of two distant realities on a plane alien to both." His hybrid pre-1922 works were influenced by Picabia and de Chirico. Ernst's poem-pictures demonstrate his delight in the juxtaposition of text and image. The visual character of his collages depended on the sources he chose and the shapes he cuts from them. His joint works with Arp, to which they gave the absurd title *Fatagaga* (from "Fabrication de Tableaux Garantis Gazométriques"), were also tools with which to build a new poetic space, lying halfway between the world of the machine and biological form.

65

COMPLICATION" Tzara

Chronology 1916–1924

In keeping with the subject of the chapter, this chronology is largely devoted to events in Europe and the United States. Sections in bold refer to artists mentioned in the main text and captions.

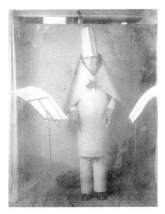

1916. Hugo Ball reciting his poem "Karawane" at the Cabaret Voltaire in Zurich. Photo Fondation Arp, Clamart.

1917. Cover of the first issue of the journal, *The Blind Man.* Photo Centre Georges Pompidou, MNAM/CCI.

1923–36. Kurt Schwitters. The artist's photograph of his *Merzbau.*

1916

• February: beginning of the Battle of Verdun, during which Franz Marc will be killed.
Zurich: birth of the Dada movement.
February 5: Jean Arp, Hugo Ball and Tristan Tzara found the Cabaret Voltaire.
April: coining of the word "dada."
The first and only issue of the review *Cabaret Voltaire,* featuring contributions from Apollinaire, Arp, Cendrars, Huelsenbeck, Kandinsky, Modigliani, Picasso and Tzara.
Picabia moves to Barcelona for a few months and publishes the first issues of his own review *391.*

1917

• Russia: Bolsheviks seize power.
April: boxer-poet Arthur Cravan and Picabia arrive in New York. Initial exhibition held by the Society of Independent Artists at which Duchamp's—alias Richard Mutt's—*Fountain* is refused. He resigns from the society.
May: appearance in New York of the two issues of *The Blind Man.* First performance of Erik Satie's ballet *Parade.* The word "sur-réalisme" appears in the text of the program written by Apollinaire. First number of Pierre Reverdy's literary periodical *Nord Sud.*
Zurich: opening of a Dada gallery.

1918

• March: the Brest-Litovsk Treaty puts an end to hostilities between Russia and Germany.
• Paris: death of Apollinaire in November.
Duchamp completes *Tu m'* for Katherine Dreier. Duchamp, Dreier and Man Ray will go on to found the Société Anonyme, Inc. in 1920.

1919

• Treaty of Versailles signed.
• Zurich: Sophie Taeuber (later married to Arp) makes Dada "heads" shaped from hat blocks
Paris: Louis Aragon, André Breton and Philippe Soupault create the journal *Littérature.* Paul Valéry and André Gide contribute to early issues.
In its April issue, *Littérature* publishes *Les Poésies* of Isidore Ducasse (a.k.a. the Comte de Lautréamont).
Using a reproduction of the *Mona Lisa,* Marcel Duchamp makes the irreverent *L. H. O. O. Q.*

1920

• Society of Nations established.
• Austro-Hungarian empire broken up.
• Brussels: Magritte's debut exhibition at the Centre de l'Art.
• Ballets Suédois directed by Rolf de Maré on tour.

New York: Duchamp, cross-dressing as "Rrose Sélavy," is photographed by Man Ray.
Paris: the journal *Littérature* becomes the chief organ of the Dada movement.

1921

Berlin: Berlin Dadaists on trial. After writing and printing the portfolio *Gott mit uns!* Johannes Baader, Grosz, Rudolf Schlichter and the publisher Wieland Herzfelde are charged with aggravated libel of the armies of the Reich.
Paris: Max Ernst's first exhibition of collages.
April: opening of the "Grande Saison Dada."
New York: Man Ray invents the rayograph cameraless photo. With Duchamp he also sets up the journal *New York Dada.*

1922

Paris: split between Breton and Tzara, the latter refusing to participate at an international meeting organized by Breton in Paris designed "to set out the purposes and the defense of the modern spirit."
April: Tzara publishes a pamphlet, *Le Cœur à barbe.*
The new series of *Littérature* edited by Breton opens its pages to Picabia. Now distributed by the powerful publisher Gaston Gallimard, it also receives funding from collector and dress-designer Jacques Doucet.
Rome: Hannah and Matthew Josephson bring out the review *Broom* on the Dada and Constructivist model. They will later move it to Berlin.
Weimar, September: Dadaist and Constructivist Congress arranged by van Doesburg.

1923

• Munich: Hitler's putsch foiled.
Paris, July: the "Cœur à Barbe" evening, with a performance of Tzara's *Le Cœur à Gaz* at the Théâtre Michel with costumes by Sonia Delaunay. A violent reaction on the part of the Surrealists ends in a scuffle which only breaks up with the arrival of the police.
Hanover: Schwitters creates the review *Merz* and travels around Holland.

1924

• Death of Lenin.
• Weimar: the authorities close the Bauhaus for the first time.
Paris: Breton publishes *Le Manifeste du surréalisme.*
First issue of the review *La Révolution surréaliste* edited by Pierre Naville and Benjamin Péret.
Picabia's ballet *Relâche.* His periodical *391* comes out for the last time.

Studies on Dada

T. O. Benson. *Raoul Hausmann and Berlin Dada.* Ann Arbor, 1987.

M. Dachy. *The Dada Movement.* New York, 1990.

M. Dachy. *Journal du mouvement Dada 1915-1923.* Geneva, 1995.*

S. C. Foster and R. Kuenzli (eds.). *Dada Spectrum: The Dialectics of Revolt.* New York, 1978.

J. Freeman. *The Dada & Surrealist Word-Image,* Cambridge, Mass., 1989.

R. Huelsenbeck. *Almanach Dada.* Paris, 1980.

R. Huelsenbeck (ed.). *DADA Almanac.* London, 1993.

S. Lemoine. *Dada.* Paris, 1986.*

R. Meyer (et al.). *Dada Global.* Zurich, 1994.

R. Motherwell (ed.). *The Dada Poets and Painters: An Anthology.* Cambridge, Mass., 1989.

F. M. Naumann. *New York Dada, 1915–23.* New York, 1994.

G. Ribemont-Dessaignes. *Dada.* Paris, 1974 (2 vols.).

M. Sanouillet. *Dada à Paris.* Paris, 1995.

W. Verkauf. *Dada. Monograph of a Movement.* New York and London, 1975.

Main exhibitions and catalogues

Dada. Exposition du cinquantenaire. MNAM, Paris, 1996.*

Dada in Europa. Werke und Dokumente. Akademie der Künste, Berlin, 1977.

Dada à Zurich. Kunsthaus, Zurich, 1985.

Where works can be seen

United States
The Art Institute of Chicago.
The Menil Collection, Houston.
Yale University Art Gallery, New Haven.
MoMA, New York.
Solomon R. Guggenheim Museum, New York.
Philadelphia Museum of Art.

Europe
Kunsthaus, Zurich.
Moderna Museet, Stockholm.
Peggy Guggenheim Foundation, Venice.
Zayas Archives, Seville.
Bibliothèque Littéraire Jacques Doucet, Paris.
Musée National d'Art Moderne, Paris.
Musée d'Art Moderne de la Ville de Paris.

* Essential reading

SURREALISM
"from *The Manifesto* to exile"

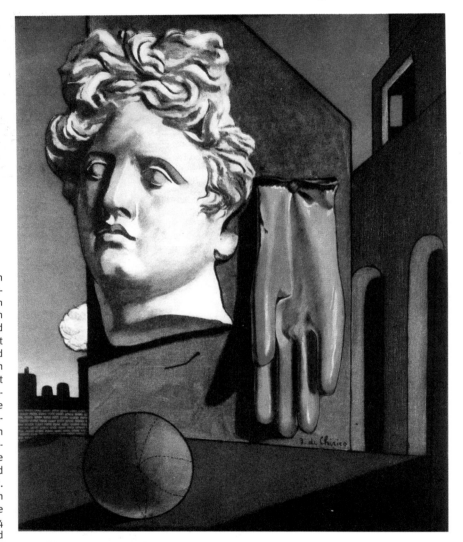

"An internal model"

GIORGIO DE CHIRICO
Love Song
1914.
Oil on canvas, 73 x 59.1 cm.
Museum of Modern Art, New York. All rights reserved.

"**B**etween you and me, and in a lowered voice, in the growing uncertainty of the mission with which we have been entrusted, we often had recourse to this fixed point just as previously to the fixed point of Lautréamont, which has often been enough to set our course straight." By placing de Chirico on the same footing as Surrealism's emblematic poet, André Breton invested him with a responsibility commensurate with the abrupt change that occurred in the painter's work in 1917. De Chirico settled in Paris in 1911, where his paintings were noted by Apollinaire. By 1914 his craft was being compared to "the calm application of an old master." De Chirico created an oeuvre that hovers halfway between past and present, rejecting certitudes, and imbued with a dream-like and "metaphysical" power. A kind of Surrealist talisman, de Chirico drifted like a sleepwalker, propelled by his hallucinations. His repetitive use of certain motifs, his outsized perspectives and shadows, the principle of irrationally juxtaposing figures and disparate signs "devoid of common sense and

logic alike" all corresponded to the "internal model" that Breton advocated and that the painter himself mentioned in 1913. "It has to be that the revelation we have of an artwork, the conception of a picture representing something that has no meaning in itself, that has no subject matter, that, from the point of view of human logic has no sense at all, it has to be, I repeat, that such a revelation or conception becomes so strong in us... that we feel compelled to paint it."

Still alive and kicking some thirty years after the death of its instigator, André Breton, Surrealism continues to stand for a "bid for freedom," appealing to all those who have wanted, through the use of "imaginary solutions," to resist the rationalism of the twentieth century. Surrealism was born in the 1920s under the threefold sign of Love, Poetry and Liberty, when André Breton, Louis Aragon,

> > >

67

> > > Philippe Soupault and, soon after, Paul Eluard created a journal, *Littérature,* and distanced themselves from Dada's "whims." Under the auspices of the marvelous—as represented by writers and poets from the Marquis de Sade to Gérard de Nerval, from Baudelaire to Rimbaud and on to Apollinaire (from whom they borrowed the word itself)—Surrealism broke with destructive nihilism, adopting instead a taste for insolent provocation. It quickly got organized, setting up a "research bureau" and head office. It was difficult to tell whether it was a movement or a militant reworking of the parties it abhorred. Originating in and with writing, Surrealism spurned artistic disciplines and wanted to exist "in the absence of all rational controls, and above and beyond all aesthetic and moral preoccupations." In the *Champs magnétiques* (The Magnetic Fields), the first text to follow Surrealist methods, Breton and Soupault exalted "automatic writing." The movement found sources for its investigations in the long-forgotten nineteenth-century poet Lautréamont, as well as in Freud, Hieronymus Bosch and Gustave Moreau. Determined "to conquer the irrational" through "automatism," "sleep experiments," dream narratives and language games, the Surrealists lent an ear to the cavernous maw of the unconscious.

The 1924 *Manifesto* detailed Surrealism's intentions, stating that it wanted no less than to draw up a "new Declaration of the Rights of Man." Seeking to break down the barriers between dream and reality, Breton gathered around him all those who found order and reason repugnant, and together they launched an appeal for the "complete emancipation of humanity." Seeing themselves as "stealing fire," they traced their family tree back as far as the outlandish *fatrasie* poems of the Middle Ages and acknowledged Lautréamont as a "synonym for courage unto death." Surrealism, though initially "outside all aesthetic preoccupations," did not arise nonetheless ex nihilo. Breton was responsible for the discovery of many an obscure text and creative figure; his movement formed part > > >

68

"Who will solve the conundrum?"

MAX ERNST
The Elephant Celebes
1921.
Oil on canvas, 125 x 107 cm.
Tate Modern, London.

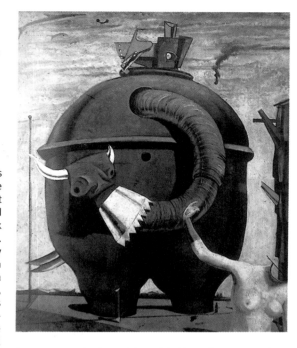

The space of this painting is surely ambivalent—there are green fish swimming about at the surface! Max Ernst lifted the central motif in this work from an anthropology journal. From out of what was a clay corn bin, Ernst made addition after addition until he had a monstrous beast, half animal, half machine. The title refers to a rude rhyme that school-boys used to sing about the supposed unnatural sexual practices of various elephants, including one from the Indonesian island of Celebes (Sulawesi) with "yellow on its bottom." The headless woman in the foreground seems to be enticing the beast, while the low vantage point is reminiscent of de Chirico's Metaphysical interiors, though everything else leads one to the conclusion that, like the various collages and "overpainted" works he made the same year, *Celebes* inhabits a deep sea environment. Referring to this anti-aesthetic juxtaposing of air and water, Ernst noted: "Outside and in, both at the same time. Free and yet a prisoner. Who will solve the conundrum?"

"A persuasive force"

MAX ERNST
Woman, Old Man and Flower
1923–24.
Oil on canvas, 95 x 127.5 cm.
Museum of Modern of Art, New York.

For André Breton, the collages Ernst made on his arrival in Paris were able, "by dint of images, to establish very unusual connections between beings and things. Everything he has released from the absurd pledge of appearing or of not appearing at the same time... is just as I wanted to see and have seen." Stimulated by the resonance between German Romantic painting and poetry, as well as by de Chirico, Max Ernst soon painted his first large-scale pictures, transferring to the domain of canvas another reality endowed with "a persuasive force rigorously proportional," as Breton again put it, "to the violence of the initial impact that caused it." In a version of *Woman, Old Man and Flower* which has since vanished, the father figure was morphed into a huge spinning-top, at once whip-like genitalia and pencil, thereby appearing as the perfect translation of visions the artist might have seen when half-asleep. In this version, the bizarre spinning top has disappeared and with it its inherent symbolic content: the power of paternal authority and the sexual act that in the painter's fantasies is intimately bound up with creative potential.

"WHO'S THERE? VERY WELL,

"Arrested at the infantile stage..."

JOAN MIRÓ
Harlequin Carnival
1924–25.
Oil on canvas, 65 x 90 cm.
Albright-Knox Art Gallery,
Buffalo. All rights reserved.

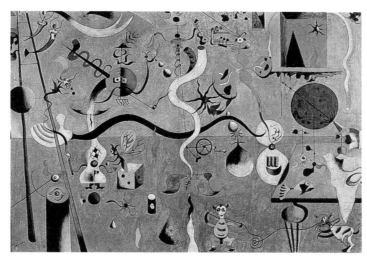

Miró joined Surrealism shortly after the appearance of Breton's Manifesto (1924). The Catalan was to forge a synthesis between childhood images and others from folk art, with the addition of naivety and grotesque humor. Combining his own obsessions with the philosophical interest of the Surrealists in the erotic, from 1924 his repertory of imaginary figures, strongly influenced by the line of Art Nouveau, underwent a transformation. Developing what poet and critic Jacques Dupin has called a "detailist" painting style populated by schematic and sensual motifs that scatter over the surface of the canvas, Miró's works were progressively abbreviated to calligraphic and ornamental signs. Spatial perspective and modeling receded in the face of a swarm of ebullient, biologically derived forms. André Breton saw Miró's personality as having been as it were "arrested at the infantile stage." The artist transfigured nature by filling it with playful and hybrid signs from a lively if secret language, his art turning into a combination of hallucination and metamorphosis.

"Words and images"

RENÉ MAGRITTE
The Living Mirror
1928. Oil on canvas, 54 x 73 cm.
Private collection. All rights reserved.

By 1925, Magritte was endeavoring to unpack the task of representing objective reality from the art of painting. Between 1927 and 1930 (the year he fell out with Breton), he produced a series of austere-looking "alphabet paintings" or "word paintings" with similar themes to Conceptual art. Though entirely different from the icons which brought him his notoriety, the magnificent works of this brief period did provide a sort of blueprint for many of the artist's concerns. Echoing the illustrated

demonstration he provided for the journal *La Révolution surréaliste* in 1929 under the title "Les Mots et les Images" (Words and Images), his painstakingly painted pictures such as *Le Miroir vivant* (which belonged to a fellow Belgian Surrealist, E. L. T. Mesens) were intended to bring out the ambiguous and haphazard nature of the connections between pictorial and linguistic systems of representation. Following the idea that "in a picture, words are made of the same stuff as images," Magritte inscribed in a childish italic hand little snippets of text, free-floating words intended to combine into a random and insoluble rebus. In this group of silent yet voluble works, Magritte no longer felt that the word, as it becomes image, requires the accompaniment of a visual equivalent.

69

"Understanding the void"

JOAN MIRÓ
Stars in the Snail's Sexes
1925.
Oil on canvas, 129.5 x 97 cm.
Kunstsammlung
Nordrhein-Westfalen,
Düsseldorf.
All rights reserved.

Between 1925 and 1927, Miró restricted his palette to broad, fluid areas of monochrome color. Only a few tangential signs survive in works which, as Michel Leiris suggested, "look less painted than soiled." Working directly on the canvas, Miró switched from what Breton characterized a "pure automatism" to what the painter himself described as a second phase based on a "carefully calculated" approach. In a joyous marriage of word and image, spindly, weightless marks find echoes here and there in the swirling, intertwined words. Using graphic signs and poetical clues that "supplant the age-old quarrel over the sex of angels with one concerning that of the stars," Miró structures these "Stars in the snail's sexes" (the meaning is ambiguous) like a free-verse poem that can thus achieve an "understanding of the void." "There are no connections," Dupin writes, "between the image and the word, or between the sex of stars and of snails, other than the ones the artist himself forges."

LET INFINITY IN!" Aragon

> > > of the continuous line from Romanticism and Symbolism. It celebrated idealism as well as the necessity of political *engagement*, for, as Breton wrote, "art is in the service of the Revolution." With "automatic writing" and cadavre exquis (exquisite corpses), with *frottage* and *grattage* (invented by Ernst in 1925), with the "paranoia-critical" method initiated by Dalí and its "symbolically functioning objects," Surrealism bubbled away like a vast laboratory. Hijacking reality in the name of high jinks and high comedy, its flickering brilliance wavered between gravity and Breton's *Anthology of Black Humor.* In his *Second Manifesto*, published in the 1930s, Breton multiplied admonishments and excommunications. He assigned a Promethean function to poetry, while, ranged against him, Georges Bataille (a scholar of the extreme in all its guises from economics to the erotic) and his collaborators, denounced in their turn Breton's "Icarian" and "idealist" morality. For Bataille, creativity was only of value if it gave the spur to a continuous state of revolt. "I invite," he wrote, "everyone who feels he still has stream of blood in his throat to spew it with me into the face of André Breton."

By his refusal to subsume Surrealism with Marxism, Breton split with the Communists as well, just as a number of his former friends became party dignitaries. In Mexico in 1938, however, he met up with Trotsky, the same year organizing a huge exhibition that combined—two examples among many—Dalí's *Rainy Taxi* and Duchamp's 1,200 hanging coal sacks. Though the movement was showing its solidarity by rallying round its figurehead, Surrealism gave the impression of being "caught between two wars." Born out of Dadaist revolt, it unraveled without having attained its self-proclaimed goal of changing life. Though still an apostate, Surrealism was undergoing a diaspora. Breton left France for the United States in 1941. Thus although it did not change life, thanks to its "active contradiction," Surrealism did leave it "reasonably well oxygenated" (Julien Gracq), and it went on to reinvent itself in the guise of a thousand splinter groups. <

70

"Feelings of heightened urgency"

ANDRÉ MASSON
Lancelot
1927. Oil, size, sand, paint and ink on canvas, 46 x 21.5 cm. Centre Pompidou, MNAM, Paris.

In 1912, aged sixteen, Masson started studying at the École des Beaux-Arts in Paris. He was seriously wounded during World War I. After living in the South of France, he returned to Paris in 1922. Close in spirit to poets Robert Desnos and Georges Limbour, anthropologist and writer Michel Leiris, playwright Antonin Artaud and theoretician Georges Bataille, he collaborated with them when, following their violent condemnation of Surrealism, they went on to found the review *Documents*, and later, *Acéphale*, for which he did the cover colophon. He was acquainted with Elizabethan and Romantic literature, as well as with Nietzsche's ideas. Masson's early post-Cubist work, that he exhibited at Kahnweiler's in 1924, explored erotic, esoteric subjects. He subsequently experimented with unconscious automatic drawing. Through its angular lines, he conveyed "feelings of heightened urgency and conflicting impulses" very different from his friend Miró. After first daubing the surface of the canvas with size and then sifting sand over it, Masson populated the seismic and "disquieted" space with mutants created at the behest of gesture and of some furtively traced ink lines. "I begin with no image or plan in mind, but as I start drawing or painting rapidly, following my impulses... gradually, within the marks I make, I begin to make out figures or objects."

"An obsession with sex murder"

ALBERTO GIACOMETTI
Man and Woman
1928.
Bronze, unique piece, 40 x 40 x 16.5 cm. Centre Pompidou, MNAM, Paris.

Giacometti moved to Paris in 1922. He attended the studio of the famous sculptor Émile-Antoine Bourdelle for three years, producing a number of pieces that reveal a familiarity with Cubism, "primitive" art and the slender, stylized figures of the Greek Cycladic Islands. He then began crafting hollowed-out forms that became increasingly distanced from the model. He moved into the workshop on rue Hippolyte-Maindron that he was to keep all his life, and joined Surrealism, but was expelled in 1934 by Breton, who denounced him for returning to the model and for betraying his "symbolically functioning objects" that had possessed, in the Surrealist leader's eyes, "the same virtue as dreams." With these two tense, arched forms facing one another, Giacometti has created an image of coitus in which the depiction of desire and the sexual act is envisioned as a taboo flouted. In 1929, in an issue of the review *Documents*, Michel Leiris published the first study of the artist which stressed the "archaic fetishism [that] continues to beat within every civilized man." An icon of desire and fulfillment, *Man and Woman* is a forerunner of the other "symbolically functioning objects" where sexuality is portrayed in the form of aggression.

"ANNIHILATING GOD

"The discredit of reality"

SALVADOR DALÍ
The Persistence of Memory
1931.
Oil on canvas, 22.5 x 32.5 cm.
Museum of Modern Art,
New York. All rights reserved.

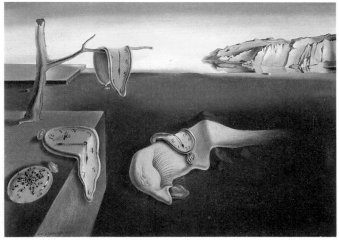

Dalí was heir both to the Catalan Symbolist José A. Inglada and to nineteenth-century battle-painter Mariano Fortuny. In his early years, he was receptive to influences as diverse as de Chirico's Metaphysical paintings, Picasso's Cubism, Max Ernst's collages, Miró, the landscapes of Yves Tanguy and Leonardo da Vinci's well-known text on exciting the imagination. After 1929, he started working on paintings in a willfully "outdated" technique that incorporated complex images he felt presented a challenge to his own time. "For three or four years," Breton was to recall, "Dalí was the very embodiment of the Surrealist spirit and made it blaze in glory as only someone who had not been involved in the sometimes painful episodes of its gestation could have." Dalí defined his work as a form of "critical paranoia": "A spontaneous method of irrational knowledge embedded in the critical and systematic objectivization of delirious phenomena." Keen to contribute "to the total discredit of the world and of reality," up until 1931 Dalí developed a visual idiom filled with personal imagery that borrowed from the ideas of the sexual-defiance scientist Krafft-Ebing, as well as Freud, whom he briefly met in London in 1939. In his quest "to conquer the irrational," Dalí, magnifying glass at the ready, crafted pictures he characterized as "hand-painted photographs of dreams," peopling them with rubbery-looking biological forms. In these "soft" constructions behind which Dalí hid, Surrealist historian Marcel Jean thought he could glimpse the terrible symbol of a penis despairing in its impotence.

"Exquisite corpses"

ANDRÉ BRETON
MAX MORISE
MAN RAY
YVES TANGUY
Cadavre exquis
May 17, 1927. Pen and ink, colored crayons and lead pencil on folded paper, 31 x 20 cm. Centre Pompidou, MNAM, Paris. All rights reserved.

71

In the name of an egalitarian approach to imagination and language, one Surrealist ambition was to pool and dissolve personal differences. The Surrealists reveled in collective experience and sought to produce what poet Paul Eluard called "poetry invented collectively." One of their inventions was the game *cadavre exquis* (exquisite corpse): a sheet of folded paper is passed round on which each player continues the picture begun unseen by his predecessor. Once unfolded, the hybrid image is revealed, the outcome of what Breton called "objective chance." The "exquisite corpse," however, is first and foremost the expression of thoughts issuing from more than one mind. It stimulates the unconscious and mocks verisimilitude, demonstrating, as Gaëtan Picon put it, "like sketches by the insane and mediumistic drawings, that painting, and poetry too, can be made by all."

"Between deep-sea abyss and desert"

YVES TANGUY
L'Armoire de Protée
1931.
Oil on canvas, 60 x 50 cm.
Private collection, Paris.
All rights reserved.

With spatial illusion and handling comparable to late medieval Flemish painting, Tanguy's "style might be realist but his poetry is abstract." From 1926, among the menhirs and megaliths of his native Brittany, Tanguy, a friend of the popular poet Jacques Prévert and an avid reader of Lautréamont's powerful works, created a dream world populated by fragmentary images that seem to float halfway between submarine and terrestrial worlds. Space plunges deep, while the initially organic forms seem to liquefy. Breton indeed specifically praised "the great subjective light that floods [his] canvases." In the early 1930s, Tanguy journeyed to Africa, the pictures following this trip being laid out in strata-like plains. The mineral gradually took over from the vegetal in his work, "between deep-sea abyss and desert." Silence rules over a waxen space that seems slowly to dissolve into a world which predates, or perhaps survives, organic life.

IS A BEAUTIFUL DREAM" Breton

"An emblem of universal demolition"

VICTOR BRAUNER
*Mr. K's Powers of
Concentration*
1934. Oil on canvas with dolls
and artificial plants made out
of paper, 148.5 x 295 cm.
Centre Georges Pompidou,
MNAM, Paris.

This work, completed during Brauner's first stay in Paris (1930–34), figured in the artist's debut exhibition at the Galerie Pierre with a preface by André Breton. The sheer size of the picture and the incorporation of artificial materials invest the piece with a strange, haunting character. Didier Semin has explained that, "in Brauner's personal mythology, Monsieur K. is an allegory of the triumph of idiocy" in the style of Alfred Jarry's obese *King Ubu* in the play of thirty years before. The critic adds, however, that it is probably less valid to draw parallels between this satirical K. and the narrator of Franz Kafka's *The Trial*. Breton saw the seriousness of an image which, "in becoming more explicit, has long since stopped making us laugh." Semin, for his part, maintains that "*Mr. K.* is no caricature: it is an emblem of universal demolition." William Rubin, in his book on the impact of "primitive" art on modern art, compared the work to a Polynesian statuette from the Tubuai (Austral) Islands. *Mr. K.* is a dual figure, a hybrid that exemplifies all the potent archetypes of Brauner's art.

72

"Modern-day mannequin"

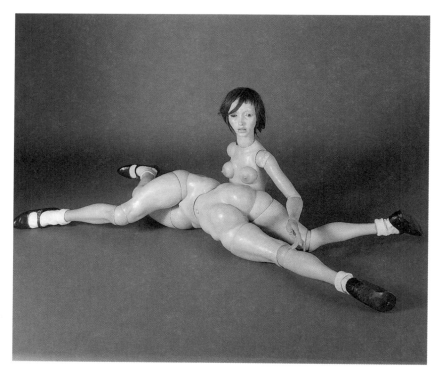

HANS BELLMER
The Doll
1932–45. Painted wood,
hair, shoes and socks,
61 x 170 x 51 cm.
Centre Georges Pompidou,
MNAM, Paris.
Photo Centre Georges
Pompidou, MNAM/CCI.

The Surrealists first became interested in Bellmer's work in 1934. After working as an illustrator and advertising artist in Berlin, in 1938 he settled in Paris. He was interned as an enemy alien with Max Ernst in the Milles camp near Aix-en-Provence in the South of France. In 1941 he moved to the unoccupied zone and after the war returned to Paris, where he lived until his death. The quintessence of the artist's work, the doll *(La Poupée/Die Puppe)* constantly recurs in Bellmer's art and writings. As the affirmation of a highly personal and yet social rebellion, *The Doll* harks back to ETA. Hoffmann's Olympia, the "artificial girl whose anatomic possibilities are capable of 'rephysiologizing' the vertigo of passion to the point of exciting new desires." Throughout the 1930s, the life-size doll underwent a series of transformations. Several photographs of her multifarious metamorphoses were reproduced in issue 6 (December 1934) of *Minotaure*, thereby showing the ongoing Surrealist fascination with Bellmer's "modern-day mannequin." The very year the artist arrived in Paris, Paul Eluard composed fourteen poems that were published in the review *Messages*, before appearing ten years later under the title *Jeux de la Poupée* (games with a doll).

"LET'S GET RID OF THE

1924. Man Ray. A "waking dream" séance, with Max Morise, Roger Vitrac, J.-A. Boiffard, Breton, Paul Eluard, Pierre Naville, de Chirico, Philippe Soupault, Robert Desnos, Jacques Baron and Simone Breton-Collinet. © Centre Pompidou, MNAM/CCI.

1924. Man Ray, *André Breton.* © Centre Georges Pompidou, MNAM/CCI.

1930. Luis Buñuel and Salvador Dalí. A still from the film *L'Age d'Or.* Collection *Cahiers du cinéma*/D. Rabourdin.

Chronology 1924–1939

In keeping with the subject of the chapter, this chronology is largely devoted to events in Europe and the United States. Sections in bold refer to artists mentioned in the main text and captions.

1924
• Thomas Mann: *Der Zauberberg* (The Magic Mountain).
Paris: Surrealist evenings at the Café Cyrano. Louis Aragon: *Une vague de rêves.* Joan Miró joins the *Surrealists*. Masson meets Eluard and Aragon. Yvan Goll: one and only issue of *Surréalisme*. Breton: *Manifeste du surréalisme*. Picabia attacks the Surrealists in *391*. Pierre Naville and Benjamin Péret, *La Révolution surréaliste*.

1925
• Franz Kafka: *Der Prozess* (The Trial).
**Several issues of *La Révolution surréaliste* appear, featuring: "Is suicide a solution?" and announcements to the Pope, the Dalai Lama, Buddhists generally, university rectors and the heads of mental institutions.
Joan Miró exhibition at the Galerie Pierre. Tanguy, Jacques Prévert and Marcel Duhamel participate in Surrealist activities.
The first "cadavres exquis" (unconscious drawings made by more than one person). Ernst starts using the technique of *frottage*. "La Peinture surréaliste" exhibition, Galerie Pierre. Brussels: Magritte and E. T. L. Mesens publish the one and only issue of *Œsophage*.**

1926
• Italy governed by the Fascists.
• Fritz Lang's futuristic film, *Metropolis*.
First exhibition at the Galerie Surréaliste, rue Jacques Callot, centers around objects and works by Man Ray and objects from the Pacific Islands owned by Surrealists. Naville leaves the group and founds the Communist review *Clarté*. Artaud and Soupault banned from the group.

1927
• USSR: Stalin's purges begin.
• Martin Heidegger: *Sein und Zeit* (Being and Time).
**Ernst begins a number of series, including *Hordes, Forêts, Fleurs coquillages and Monuments aux Oiseaux*.
Breton: *Introduction au Discours sur le peu de réalité*. He addresses the question of the Surrealist object. Aragon, Breton and Eluard: *Lautréamont envers et contre tout*. Masson: first paintings incorporating sand. First exhibition by Tanguy at the Galerie Surréaliste with a preface by Breton. The sole issue of *La Révolution surréaliste* to appear that year includes a defense of**

the work of Charlie Chaplin, some *cadavre exquis* and the conclusion of Breton's study on Surrealism and painting. Brussels: Magritte exhibition at Galerie Le Centaur.**

1928
• Stalin draws up the first Five Year Plan.
**Breton: *Nadja*, then *Surréalisme et la peinture*. Break with de Chirico. Giacometti becomes a friend of Masson, Michel Leiris and a number of other Surrealist "dissidents."
Buñuel and Dalí: film *Un chien andalou*.**

1929
• Leo Trotsky exiled.
• United States: Black Thursday on Wall Street.
**Georges Bataille founds the review *Documents*.
After *L'Étoile de Mer,* Man Ray makes *Les Mystères du Château de Dé*. Giacometti joins the Surrealist circle. Masson proclaims himself a "Surrealist dissident." Buñuel, Dalí and poet René Char join the group. Breton: *Second Surrealist Manifesto* in the final issue of *La Révolution surréaliste*. In the name of a "purification of Surrealism," several hitherto acceptable precursors, such as Baudelaire, Rimbaud, Poe and Sade are excluded. The alchemist Nicolas Flamel is lauded, whereas Artaud, Roger Vitrac, Masson and Soupault are criticized.**

1930
• Germany: the Nazi Party celebrates its election victory.
• Josef von Sternberg: *The Blue Angel*.
Breton the butt of vituperative attacks after his manifesto. Max Ernst: *Rêve d'une petite fille qui voulut entrer au carmel*. First issue of *Le Surréalisme au service de la révolution,* that replaces *La Révolution surréaliste*. *L'Age d'or* by Buñuel and Dalí shown at Studio 28. Banned by the police. Aragon participates in the "Second International Congress of Revolutionary Writers" in the USSR. Publication of the *Front Rouge*.

1931
• Republicans elected in Spain.
Hartford, Connecticut: first large-scale Surrealist exhibition in the United States.

1932
• Trotsky: *The Permanent Revolution*.
• Louis Ferdinand Céline: *Voyage au bout de la nuit* (Voyage to the End of the Night).

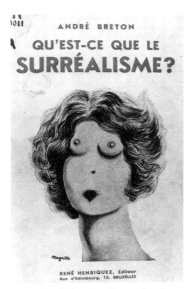

1934. René Magritte. Illustration for the cover of André Breton's *Qu'est-ce que le Surréalisme?* Brussels, René Henriquez. © Roger-Viollet.

1936. René Magritte painting *La Clairvoyance.*
C. Hercovici Collection, Brussels.
© René Magritte/Giraudon photo library.

1938. "The International Exhibition of Surrealism," Galerie des Beaux-Arts, Paris.
© Roger-Viollet.

Chronology 1924–1939

Breton: *Les Vases communicants.*
Giacometti: first exhibition, at the P. Colle gallery.

1933
• Germany: Adolf Hitler becomes chancellor.
• Malraux: *La Condition Humaine* (The Human Condition).
Final issue of *Le Surréalisme au service de la révolution.* *Le Minotaure* review, edited by Albert Skira and Tériade.
Dalí publishes a piece in praise of the nineteenth-century academic painter Meissonier.

1934
New York: Dalí and Giacometti exhibitions at Julien Levi's gallery. Dalí condemned by the Surrealists for his interest in Nazism. Breton, *Qu'est-ce que le surréalisme?* Ernst's collage novel *Une semaine de bonté.*

1935
• China: Mao Zedong becomes president of the Communist Party.
• Publication of *After Picasso* by J. T. Soby, the first American book on Surrealism.
"Joan Miró 1933–1934" exhibition at Pierre Matisse's gallery. Dalí's lecture on "Critical Paranoia." Breton creates his first "poem-objects." Giacometti returns to model-based work and is excluded from the Surrealist group.

1936
• Italy and Germany offer their support to Franco in Spain.
• New York: Alfred H. Barr Jr. organizes "Fantastic Art, Dada, Surrealism" at MOMA.
Paris: exhibition of Surrealist objects, Galerie Ratton. Publication of *Surrealism* by Herbert Read. London: "International Surrealist Exhibition" at the New Burlington Galleries.

1937
• Spain: bombing of Guernica.
• Munich: Nazi exhibition of "degenerate art."
Paris: Breton opens the Galerie Gradiva. Chilean Roberto Matta joins the Surrealists. Artaud is sectioned in Rodez. Breton becomes editor-in-chief of *Minotaure.* Georges Hugnet excluded and Eluard leaves the group.

1938
• Germany: Munich agreement and *Anschluss* (annexation of Austria).
• Artaud: *Le Théâtre et son Double.*
• Jean-Paul Sartre: *La Nausée* (Nausea).
Surrealist exhibition, Galerie des Beaux-Arts. Breton meets Diego Rivera and Leo Trotsky in Mexico.

1939
• Spain: Franco's forces win Civil War.
• Nazi-Soviet nonaggression pact. Invasion of Poland.
• Outbreak of World War II.
Breton and Péret mobilized. Ernst and Bellmer interned as enemy aliens.
London: Dalí visits Sigmund Freud.

Studies on Surrealism
C. Abastado. *Introduction au surréalisme.* Paris, 1971.
S. Alexandrian. *Le Surréalisme et le rêve.* Paris, 1975.
F. Alquié. *Philosophie du surréalisme.* Paris, 1956.
G. Bataille. *The Absence of Myth: Writings on Surrealism.* London/New York, 1994.
A. Breton. *Manifestoes of Surrealism.* Ann Arbor, 1972.
A. Breton. *Surrealism and Painting.* Oxford, 1973.
A. Breton. *Le Surréalisme et la Peinture.* Paris, 1965.
M. Carrouges. *André Breton et les données fondamentales du surréalisme.* Paris, 1967.
W. A. Camfield. *Max Ernst: Dada and the Dawn of Surrealism.* Munich, 1993.
R. Descharnes. *Dalí.* London, 1985.
J. Dupin. *Miró.* New York, 1993.
G. Durozoi. *Histoire du mouvement surréaliste.* Paris, 1997.*
P. Gimferrer. *Giorgio de Chirico.* New York, 1989.
M. Nadeau. *History of Surrealism.* Harmondsworth, 1971.
R. Passeron. *Histoire de la peinture surréaliste.* Paris, 1968.
G. Picon. *Surrealists and surrealism, 1919-1939.* New York, 1977.
G. Picon. *Journal du surréalisme.* Geneva, 1988.*
J. Pierre. *André Breton et la Peinture.* Lausanne, 1987.
W. S. Rubin. *Dada and Surrealist Art.* New York, 1968.*
S. Stick. *Anxious Visions: Surrealist Art.* New York, 1990.
P. Waldberg. *Chemins du surréalisme.* Brussels, 1965.

Main exhibitions and catalogues
1986, Marseille. *La Planète affolée. Surréalisme. Dispersion et influences, 1938–1947.* Musées de Marseille.
1991, Paris. *André Breton, la Beauté convulsive.* Centre Pompidou.*

Where works can be seen
United States
Albright Knox Art Gallery, Buffalo.
The Art Institute of Chicago.
The Menil Collection, Houston.
MoMA, New York.
Yale University Art Gallery, New Haven.

Europe
Bibliothèque Littéraire Jacques Doucet, Paris.
Musée National d'Art Moderne, Paris.
Musée d'Art Moderne de la Ville de Paris.
Palais des Beaux-Arts, Brussels.
Kunsthaus, Zurich.
Miró Foundation, Barcelona.
Peggy Guggenheim Foundation, Venice.
Kunsthaus, Zurich.
Kunstmuseum, Basel.
Kunstsammlung Nordrhein-Westfalen, Düsseldorf.
Staatsgalerie Moderner Kunst, Munich.
Tate Gallery, London.
Wallraf-Richartz Museum, Cologne.

* Essential reading

CLASSICISMS & REALISMS
"between order and model"

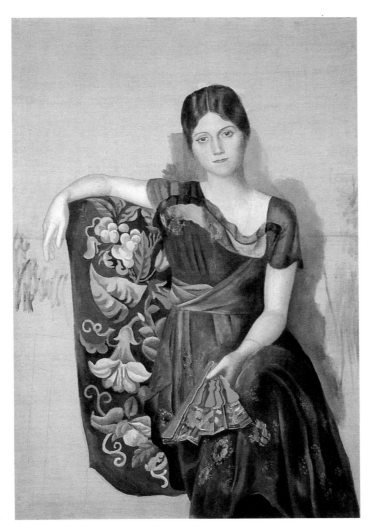

"Between transition and order"

PABLO PICASSO
*Portrait of Olga
in an Armchair*
1917.
Oil on canvas, 130 x 88 cm.
Musée Picasso, Paris.

Picasso met the ballerina Olga Kokhlova while working for Diaghilev's Ballets Russes in Rome in 1917. For this picture of her, he reverted to realism, thereby pursuing his "return to the model" that he had begun in January 1915 with a portrait of Max Jacob. "Between transition and order"— for Picasso the "cult of the true" was simply part of his on-going investigation of the art of painting, an intimate journal in which the achievements of Cubism and the questioning of reality met head on. At the very time his contemporaries were becoming bogged down in academicism and nostalgia, Picasso was already busy elsewhere, reveling in the boundless interplay of transformation and experiment that were more important to him than poaching or quoting from others. As

Wilhelm Uhde remarked at the unveiling of *Olga*: "I found myself in the presence of a large portrait in what is termed the 'Ingres style'; its conventional attitude, its willful sobriety seemed to be trying to repress some unspoken pathos; the baroque only emerged a little in the line and in the balance between the main masses. What did such pictures mean? Were they marking time, a beautiful but aimless game in which [Picasso's] hand had taken pleasure, while the soul, weary after all its travels, rested a while?"

"Between the wars": an easy division tailor-made to highlight the utopian ideals and disappointments of a period that clung to the precept that modern art carried within it a promise of future happiness. It was a time when, as Jean Laude has observed, "the artist was of a mind to warn against the vagaries of the past" and, recovering his calm, return to the virtues of a time which seemed so far away: the nostalgia for a golden age.

> > >

> > > This analysis obviously calls for greater subtlety. At best, it can be applied to a specific geographical area, the one where the avant-garde arose and exerted an influence. This return to the figure and to the models of the past varied according to the different countries concerned. To speak of "realisms"—even with the nuance given by the plural—remains imprecise since the word is invested with a meaning which art history restricts to a given moment in the nineteenth century.

The term "classicism" is just as allusive, in that the notion seems far removed from the motivations and careers of artists as varied as the representatives of German Neue Sachlichkeit (New Objectivity), Magic Realism or the Italian members of Valori Plastici, not to mention all the groups who rallied behind the "return to order" to which Roger Bissière referred around this time. Seeing the past as offering guarantees of a sustainable level of skill or of a type of subject is essentially a facile notion, and one with a hint of melancholy. Thus there should be no confusion between the "rule and emotion," as Braque and Gris envisioned it, and the nationalist tendencies of young French painters nailing their colors to the mast of the *Nouvelles Bucoliques*. The Italian dream that condemned Futurism's revolutionary modernism and advocated a rehabilitation of the great pictorial tradition cannot be assimilated to the situation in conquered Germany, where Neue Sachlichkeit countered escapist art with a ferocious critique of present-day reality.

This amounts to an overhasty judgment of a complex period that groups under a single "-ism" or label diverse individuals and tendencies. Defying categorization, these individuals and tendencies arose in a variety of sometimes contradictory contexts. In 1923, Nikolaia Tarabukin wrote in

> > >

"The great book of the Italian primitives

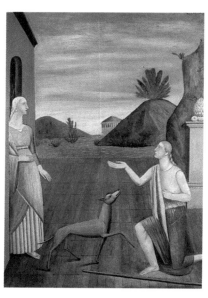

CARLO CARRÀ
Lot's Daughters
1919. Oil on canvas,
110 x 80 cm. Private collection,
Bolzano. All rights reserved.

Although he was a joint signatory of the first two Futurist manifestos, Carrà retained an interest in naïve and folk art, and also published essays on Giotto and Uccello (1915). Through his desire to "reintegrate the history of Italian art," Carrà broke with Futurism and became committed to merging tradition and revolution. He rejected imitation and advocated "identification" instead, fashioning a regressive figurative style with Metaphysical accents. Spurning the archeological and deliberately "mythological" bent of some of his Italian contemporaries, Carrà aimed for a "plastic reality" suggested to him by the great fourteenth-century painters he had studied. Wilhelm Worringer's essay on Carrà in 1925 testifies to the increasing influence he exerted over the border in Germany after World War I. "One can rest assured that, beneath Carrà's stylistic concentration which developed out of abstract Synthetism and Constructivism, there lies an underlying, implicit message taken from the great book of the northern Italian Primitives."

"Ego pictor classicus"

GIORGIO DE CHIRICO
Self-Portrait
1924. Tempera on canvas,
61 x 76 cm. Kunstmuseum,
Winterthur. Photo AKG Paris.

Although de Chirico's Pittura Metafisica was intended as an alternative to other avant-garde tendencies of the 1910s, by 1918 he was turning back to the masters of the past. On seeing the Titians in Rome's Villa Borghese, he experienced a "revelation," and went on to complete a series of classical self-portraits peppered with Latin tags that amount to a manifesto for a return to tradition. The 1919 publication by the traditionalist Valori Plastici of the first monograph on his work extended his influence to Neue Sachlichkeit and Magic Realism in Germany. "Condemned" by the Surrealists for the work he produced after 1918, de Chirico became a leading figure in the revival of "grand style" painting. An eclectic figure who maintained that Italian seventeenth-century painting was decadent and who was not afraid of polemics (witness his *Pro Tecnica Oratio* declaration), de Chirico appealed to "the architectural sense" of classical painting and to a necessary "return to craft." The ambiguity and complex irony of these highly intellectual speculations have since become more apparent.

"THAT'S QUITE ENOUGH

OTTO DIX
Der Großstadt
1927–28. Triptych, mixed technique on panel, central panel 181 x 201 cm, side panels 181 x 101 cm. Galerie der Stadt, Stuttgart. Photo AKG Paris.

"**M**y ideal had always been to paint like the Renaissance masters... Everything is already there... In the scarcely creditable simplicity of Cranach." Dix trained in Dresden between 1909 and 1914. He studied the techniques of fifteenth-century Italian

"Paint like the Renaissance masters"

painters, and those of German artists such as Lucas Cranach, and developed a distinctive "Old Master" manner. World War I horrified him and he fashioned a macabre, ironic style that combined a search for psychological and social truth with an acute sense of caricature. The ambitious *The Big City* typifies his use of acerbic outlines and severe forms. Although his use of the triptych is an implicit reference to religious

painting, the central section denounces middle-class pleasures which marginalize those in the left panel and make victims of those on the right. In allegorical renderings of great foreboding, Dix captured, as E. Roters put it, "the image of a great city as an incarnation of anti-paradise which reflects in shimmering colors the illusion of earthly felicity while, behind the facade, lie the emptiness and misery of disillusion."

"Italy opened my eyes"

CHRISTIAN SCHAD
Self-Portrait with Model
1927.
Oil on canvas, 76 x 62 cm.
Private collection, Hamburg.

The shift from Dada-inspired nihilism back to the masters of the past meets with a singular example in the case of Christian Schad. In exile in Zurich between 1915 to 1920, he participated in Dada's Cabaret Voltaire and invented a type of camera-less photography ("Schadography"). After the war, Schad withdrew from the avant-garde. In 1927, he moved to Vienna and in 1928 to Berlin, where he took part in the Neue Sachlichkeit exhibi-

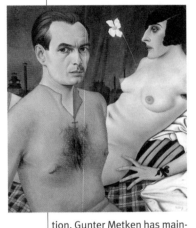

"A three-act drama"

MAX BECKMANN
Departure
1932–33. Triptych, oil on canvas, central panel 215.3 x 115.2 cm, side panels, 215.3 x 99.7 cm. The Museum of Modern Art, New York. Photo AKG Paris.

After moving to Berlin in 1933 to enjoy its anonymity, Beckmann painted his first large-scale allegorical triptych, *Departure*, which has the structure of a three-act drama. In 1937, the artist commented at length on the work. "Life appears on the left and the right... Life is torture, suffering of every sort—physical and mental. Men and women are equally vulnerable. On the right, dragging behind as if tied to you, you can see the corpse of your memory, of your

failings and mistakes, searching for a path in the blackness... And in the middle? The King and Queen, man and woman, are conveyed to the other side by a mask-wearing ferryman they know not, a mysterious figure who conducts us to a mysterious land...

The King and Queen are free from the torments of life. They have triumphed over themselves. The Queen carries the greatest prize of all—Freedom—clinging to her like an infant. Liberty is the important thing. It is a departure, a new beginning."

tion. Gunter Metken has maintained that Schad uses iconographic types which explain the "fascination that these portraits still (or, rather, once more) exert on us. They are records of human solitude and self-absorption. The naked woman in his *Self-Portrait* is possessed by man and likened to an object, adorned and arranged in the way of a still life... Painter and model both appear outside reality, while Schad's self-regard as a man and as an artist reveals itself in the flower chosen—a narcissus. Real connection between man and woman is out of the question: never will they surmount the metaphysical antagonism that divides them."

DIONYSIAC DAUBERS" Einstein

> > > *From the Easel to the Machine:* "Today's world presents the artist with an entirely new set of demands: it requires of him, not 'pictures' or 'sculptures' for museums, but objects that are socially justifiable in terms of form and purpose." Painters and sculptors of this period who focused on the depiction of the figure and the human condition were not necessarily regressive artists of the "return to order." History has much to teach us of the fate of utopias in totalitarian regimes. The nationalist leanings of people such as Dunoyer de Segonzac or Mario Sironi and Felice Casorati should not obscure the richness of the ideas put forward by Picasso and (whatever the Surrealists might say) de Chirico, or indeed, for quite different ends, by Max Beckmann, Otto Dix and Edward Hopper, for instance.

By 1923, Picasso, cutting through all arguments about style, drew the whole debate to a close: "For me," he wrote, " in art there is neither past nor future." As for any other moment in history, a clear distinction should be drawn between masters and epigones, between proponents of a defiant heritage and the slavish imitators of the past. As Christian Derouet has rightly said, to speak of "realisms" is not to refer to a given category of painting but to a mode of artistic behavior. To call the work of Giacometti, Balthus or Hopper academic or even reactionary and to tar these artists with the same brush as a host of artists who were never more than mere illustrators is to conflate art history and reduce its scope to that of a "two-party state." The very diversity of the works in question is in fact a manifestation of the complexity and many-sidedness of our period. Today, it is no longer sufficient to simply reject out of hand work which falls outside the all too reassuring dichotomy between figure and abstraction. <

"Heir apparent to all the great artists"

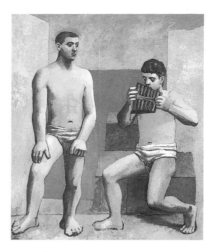

PABLO PICASSO
The Pan Flute
1923. Oil on canvas,
205 x 174 cm.
Musée Picasso, Paris.
Photo RMN.

A few months before his death at the beginning of 1918, Apollinaire uttered these final, prophetic words: "Picasso," he wrote, "is heir apparent to all the great artists… He changes direction, retraces his steps, then starts off again with firmer tread, growing in stature, fortified by his contact with uncharted nature and any examination by—or comparison to—his peers of the past." In these antique forms, the inventor of Cubism rediscovered the images and myths of the ancient world. By the summer of 1923, subversion seemed to have taken a back seat, or rather seemed, as Pierre Daix put it, to have "turned against 'official' Cubism." Showing an awareness of variations in modeling (with or without shadows) and an understanding of a painter for whom the reversion to classical values was but a return to his sources, the "Cubist" poet Pierre Reverdy wrote of the *Flûte de Pan*: "Every attitude, every gesture is nothing but the pictorial result of his chosen means. There is not a head, not a body or hand that—by dint of form or position—is anything other than a unique element in the service of the expression, with no meaning outside the overall constitution of the picture."

"Raphael is the most misunderstood of us all"

ANDRÉ DERAIN
Pierrot and Harlequin
Around 1924.
Oil on canvas, 175 x 175 cm.
Musée de l'Orangerie,
Walter Guillaume Collection,
Paris. Photo RMN.

By 1912, Derain, who was strongly influenced by Sienese painting, seemed "to have left off the euphoria of Fauvist splashes." He started out on a "Gothic" (or "archaizing") period that foreshadowed, in a unique and paradoxical way, all those who were later to turn to the painting of former ages. His unique position meant that some of his contemporaries admired him, while others stared in blank incomprehension. Derain did indeed sing the praises of Raphael as "the most misunderstood of us all" and explored historical models; but he was in turn to become an example for younger artists. Alberto Giacometti and, soon after, Balthus both found a critical power in his practice that facilitated their own return "to sobriety and measure." The composition for *Pierrot and Harlequin* is taken from a print showing figures from the Commedia dell'Arte—improvised eighteenth-century Italian theater. "This allusive eclecticism," wrote C. Derouet, "was tailor-made to inveigle those art lovers brought up on the prejudices of the museum and for whom the art of painting had to be based on cast-iron principles."

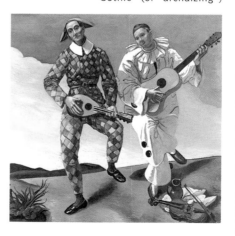

"DERAIN IS THE MOST DESPERATE,

"An 'uncanny' scene"

BALTHUS
The Mountain (Summer)
1936.
Oil on canvas,
250 x 369.5 cm.
MoMa, New York.

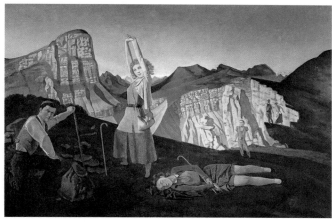

In 1926–27, the young Balthasar Klossowski de Rola, known as Balthus, was copying Piero della Francesca's frescoes in Arezzo. Encouraged by the German poet Rilke and French writers Pierre Jean Jouve and André Gide, and stimulated by Surrealism, Balthus developed a synthesis of modernism and a respect for the past. Although he never belonged to any group, Balthus has some features in common with the verism of German Neue Sachlichkeit. This is particularly evident in the peculiar and quiet works he produced over the following years, which are characterized by a brutal and almost hallucinatory realism. One of the first to write about Balthus's work was the creator of the "theater of cruelty," playwright Antonin Artaud. On the occasion of the artist's debut exhibition at the Galerie Pierre, Artaud wrote in the prestigious *Nouvelle Revue française:* "It now seems that painting, tired of depicting wild animals [*fauves*] and extracting embryos, wants to revert to a sort of organic realism, which, far from fleeing the poetic, the marvelous or the fabulous, is more attached to them than ever, but with tried and tested means." Balthus's architectural, almost theatrical approach to space led to large-scale compositions reminiscent of the nineteenth-century myth painter Puvis de Chavannes. Painted a year after his notorious *Street, The Mountain* exudes a feeling of motionless expectation as in an open-air game of "statues," while time is suspended in what Freud would have called a scene of the *Unheimliche*—the "uncanny."

"The present silenced"

Regionalists, and the desolation of the American Scene Painting generally, Hopper depicts a hard-boiled America where the light is certainly bright, but not warm. His work, shorn of picturesque effects, has since become known for being a census of the American landscape that bears witness to the pain of emptiness and to the immobility of time. Unwavering and unaffected by technical innovations, his paintings fixed as if in aspic images of everyday life. Hopper said it took him ten years to get used to the chaos of America's ugliness. Yet in fact, as if by a kind of conjuring trick, his work shows life ranged against dreams and reality against cloud-cuckooland: things simply are as they are. At this level, painting, though still unassuming and full of wonder, makes evident its distaste for stylized forms.

"One apple ... was still too much to paint"

ALBERTO GIACOMETTI
Apple on a Sideboard
1937. Oil on canvas,
72 x 75.5 cm.
Private collection, New York.

By 1935, Giacometti had become weary of Surrealist orthodoxy and, abandoning his earlier practice, began to observe reality with new eyes. The true face of the real thus became an obsession that he tried to convey for the rest of his life. The isolated figures and objects he painted and sculpted in the privacy of his own studio seemed to embody a haggard, dislocated world. Painted the same year as *The Artist's Mother,* this still life presaged a clear break with Surrealism and provided the starting point for a further eight years of similar work in the form of sculpture, prints, drawings and paintings. In their subject matter and restrained palette, some of these new works carry echoes of Cézanne. Giacometti's highly personal draftsmanship was a way of directly transcribing his visual explorations: "So," he wrote, "I removed the cup, the plates, the flowers. But have you ever tried to observe three apples at the same time from three meters? So I took away two of them. And as for the third, I had to make it smaller, since it was still too much to paint."

79

EDWARD HOPPER
Hotel Room 1931.
Oil on canvas, 152.5 x 166 cm.
Thyssen-Bornemisza Collection, Madrid.

As John Soby has implied, although the hour of day captured in Hopper's work is always precisely indicated, it only serves, as it were, to stop the clock. He also refers to the interesting comparison between Hopper and de Chirico made by Lloyd Goodrich. Though of very different temperaments and styles, both painters evoke a world in which time stands still, and their imagery alludes to "deep time," but only in its contrast with the hush of the present. Unlike the machines and still lifes of the Precisionists, the provincialism of the

THE MOST COURAGEOUS OF PAINTERS" Giacometti

Paul Poiret and André Derain (left). © Roger-Viollet.

Around 1930. Soup kitchen in Berlin. © Roger-Viollet.

Weimar Republic (1919–33). Young Germans playing with a kite made out of devalued Deutschmark bills. © Harlingue-Viollet.

Portrait of Mussolini on the facade of a building in Italy. © Harlingue-Viollet.

Chronology 1919–1939

In keeping with the subject of the chapter, this chronology is largely devoted to events in Europe and the United States. Sections in bold refer to artists mentioned in the main text and captions.

1919
• Abel Gance: *J'accuse*.
Italy: La Ronda (literary movement).
Picasso works for the theater and the ballet: de Falla's *Three-Cornered Hat* followed by, among others, *Pulcinella* (1920), Cocteau's *Antigone* (1922) and *Le Train Bleu* (1924).

1921
• Paul Valéry: *L'Âme et la Danse*.
• Luigi Pirandello: *Six Characters in Search of an Author*.

1922
• Mussolini's "March on Rome."
• James Joyce: *Ulysses*.
Milan: founding of the Italian group Novecento with support from the Fascist regime.
Westheim publishes an enquiry into the "new naturalism" in his journal *Das Kunstblatt*. Last issue of the review *Valori Plastici*.

1923
• Munich: Hitler's attempted putsch. He is imprisoned and writes *Mein Kampf*.
• Valéry: *Eupalinos ou l'architecte*.
• Rilke: *Sonnets to Orpheus* and *The Duino Elegies* first published in German.

1924
• Thomas Mann: *Der Zauberberg* (The Magic Mountain).
Picasso: sets for Satie's *Mercure*.

1925
• Franz Kafka: *Der Prozess* (The Trial).
Mannheim: G. F. Hartlaub curates an exhibition of Neue Sachlichkeit (New Objectivity) works.
Galerie Druet: "Néo-Humanistes" group.

1926
• Italy under Fascist control.
• Georges Bernanos: *Sous le soleil de Satan*.
Italy: the review *900* set up.

1927
• Stalin begins his "purges."
• Martin Heidegger: *Sein und Zeit* (Being and Time).
• Elie Faure: *L'Esprit des formes*

1928
• Stalin draws up the first Five Year Plan.
• Brecht: *Threepenny Opera*.
Julio Gonzalez teaches Picasso the techniques of welding.

1929
• Paul Claudel: *Le Soulier de Satin*.
• United States: Wall Street Crash.
Amsterdam: Neue Sachlichkeit exhibition at the Stedelijk Museum.

1930
• Germany: the Nazi Party victory.
• Josef von Sternberg: *The Blue Angel*.
• Freud: *Civilization and its Discontents*.
Pierre Jean Jouve and Pierre Klossowski translate Romantic poet Hölderlin's poems of his madness.
Galerie Billiet-Worms: Forces Nouvelles group.

1931
• Republicans elected in Spain.
• Pierre Drieu La Rochelle: *Feu Follet*.
• William Faulkner: *Sanctuary*.

1932
• L. F. Céline: *Voyage to the End of the Night*.
• René Clair: *À nous la liberté*.
Artaud: *The Theater of Cruelty*.

1933
• Germany: Hitler becomes chancellor. Reichstag fire. Closure of the Bauhaus.
• Malraux: *The Human Condition*.

1934
• Hitler becomes Führer.
• Berlin: "Night of the Long Knives."
• Henri Focillon: *La Vie des Formes*.
• Michel Leiris: *L'Afrique Fantôme*.
Italy: Venice Biennale, "Discussions on art and contemporary reality."

1935
• Germany: anti-Semitic laws.
• Jean Giraudoux's play: *La Guerre de Troie n'aura pas lieu*.
• Paris: Valéry writes a preface for the exhibition of "Italian Art from Cimabue to Tiepolo" at the Petit Palais.

1936
• France: Front Populaire victorious at elections.
• Spain: beginning of the Civil War. Execution of García Lorca.
• Berlin: Olympic Games.

1937
• France: Léon Blum resigns.
• Paris: World's Fair.
Munich: "Degenerate Art" exhibition.
Picasso, *Guernica*. Dufy, *La Fée Électricité*.

1938
• Germany: Munich agreement and *Anschluss*.
• Artaud: *Le Théâtre et son Double*.
• Jean-Paul Sartre: *La Nausée* (Nausea).

1939
• Erwin Panofsky: *Studies in Iconology*.
• Spain: end of the Civil War.
• Nazi-Soviet nonaggression pact. Invasion of Poland. Outbreak of World War II.
Paris: Réalités Nouvelles created.

Studies on Realism and Classicism
P. Adam. *The Arts of the Third Reich*. London, 1992.

E. de Chassey, S. Guégan, and J. B. Minnaert. *L'ABCdaire des années 30*. Paris, 1997.*

B. Fer, D. Batchelor, and P. Wood. *Realism, Rationalism, Surrealism: Art Between the Wars*. New Haven/London, 1993.*

C. Green. *Cubism and its Enemies: Modern Movements and Reaction in French Art, 1916–28*. New Haven and London, 1987.

C. Green (ed.). *The European Avant-Gardes: Art in France and Western Europe, 1904–45*. London and New York, 1995.

R. Kiterding. *Realism: To Venture Independence*. New York, 1991.

P. Milza and F. Roche-Pézard. *Art et fascisme: Du totalitarisme et résistance au totalitarisme dans les arts*. Actes du colloque de l'Université de Paris I. Brussels, 1989.*

L. Richard. *D'une apocalypse à l'autre*. Paris, 1998.

E. Roters. *Berlin 1910–33*. Freiburg-Paris, 1982.

W. Schmied. *Edward Hopper. Portraits of America*. Munich, 1999.

Le Retour à l'ordre dans les arts plastiques et l'architecture, 1919–25. Actes du second colloque d'histoire de l'art de l'Université de Saint-Étienne. Saint-Étienne, 1975.

Main exhibitions and catalogues
1967, Berlin. *Deutsche realistische Bildauerkunst im XX. Jahrhundert*. Nationalgalerie.

1978–79, Berlin. *Revolution und Realismus: Revolutionäre Kunst in Deutschland 1917 bis 1933*. Altes Museum.

1980–81, Paris. *Les Réalismes, entre révolution et réaction, 1919–39*. Centre Georges Pompidou.*

1997, Paris. *Années 30 en Europe: le temps menaçant, 1929–1939*. Musée d'Art Moderne de la Ville de Paris.*

Where works can be seen
United States
The Art Institute of Chicago.
The Menil Collection, Houston.
The Whitney Museum of American Art, New York.

Europe
Musée National d'Art Moderne, Paris.
Musée d'Art Moderne de la Ville de Paris.
Musée de l'Orangerie, Paris.
Pinacoteca di Brera, Milan.
Galleria d'Arte Moderna, Milan.
Galleria Nazionale, Rome.
Museum Boymans-van Beuningen, Rotterdam.
Staatsgemäldesammlungen, Munich.
Tate Gallery, London.
Von der Heydt-Museum, Wuppertal.
Kunsthaus, Zurich.

* Essential reading

ABSTRACTION & CONSTRUCTIVISM
"geometry and utopia"

"Follow me and fly through endless space"

KASIMIR MALEVICH
Composition:
White on White
1918.
Oil on canvas,
79.4 x 79.4 cm.
The Museum of Modern Art,
New York.

"Suprematism is the semaphore of color in the infinite. I have emerged into whiteness, my pilot comrades, follow me and fly through endless space." Some three years after "o.10. The Last Futurist Painting Exhibition" in Petrograd (St. Petersburg) that laid the foundations for Suprematist painting, Malevich developed a method of thinking that would go "beyond the zero of form" and have its being in what his book termed a *"Non-Objective" World*. Like other entities that appeared subsequently (the *Black Circle*, the *Black Cross)*, the first *Black Square on a White Ground* initiated a sequence of phases during which the forms gained in complexity and even began to overlap. In the years 1917 and 1918, outlines also dissolved, culminating logically in the white-on-white pictures, such as *White Square on a White Ground,* exhibited at the Tenth State Salon in Moscow. Form vanishes into the boundlessness of vision. A few years later, Malevich explained just how hard it had been "to liberate art from the pointless weight of objects" in spite of his "despairing efforts." His theories, that appeared in a dozen or so pamphlets penned in the prophetic style of manifestos, are still not widely available. The interpretation of Suprematism depends on the period: the black square stands for economy in general, the red, "a signal for revolution," while the white is "pure movement," an intuitive presence opening out to the cosmos.

Abstract art is not, of course, a school, but rather a rupture in history whose salient characteristic is to have remained a path that can be explored even today. Thus to restrict it to a specific period of art when it has been the dominant force of the century could be misleading. The history of abstract art in its simplest definition is—in contradistinction to all other "movements"—not yet closed. Although it was born in the heart of

> > >

> > > the avant-garde and nurtured by the work of those who shunned the mere replication of the external world, abstract art was at the outset a sufficiently broad notion to embrace movements and artists that appeared distinct from, and even at odds with, one another. Early on, be it lyrical or geometrical, abstract art—in its search for spiritual essence—opposed expression through color with the cult of form. Abstraction was an earnest and ambitious project that created new possibilities and whose goal was to change the world. A great leap forward, it was part and parcel of a revolutionary utopia and of the scientific and technological upheavals of modernity. In their efforts to make themselves heard, Kandinsky, Malevich and Mondrian, in common with many others, devised and disseminated through manifestos and theoretical treatises new conceptions and new perspectives on a world they thought they glimpsed. The artist thus became a critic of his own art, as well as of the situation into which his works were propelled. Writing a history of abstract art presupposes the synchronic analysis of the different movements and groups that constitute it: the history of Suprematism, for instance, does not draw to a close with the "objective" version created by El Lissitzky in what he called *Prouns*. The birth of Constructivism around the Pevsner brothers, the evolution of Neo-Plasticism and of De Stijl under the auspices of Theo van Doesburg, and, at the same time, the unfolding ideas of the Bauhaus underscore just how complex, and even how divergent, each movement was, even if they sometimes overlapped. Ideas were diffuse and contrasted with one another like a chorus of single voices: abstract art gained ground and ended up becoming the epitome of the modern project and its diverse and contradictory spirit. Abstraction should not be reduced, however, to a chapter in the story of easel painting. If abstraction and the infinite possibilities it offers arose from painting, many of its exponents—from Rodchenko to > > >

82

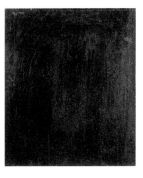

"Art is dead!"

ALEXANDER RODCHENKO
Last Painting (Pure Red, Pure Yellow, Pure Blue)
1921. Oil on canvas. Three canvases each 62.5 x 52.7 cm. A. M. Rodchenko and V. F. Stepanova Archives, Moscow.

On September 18, 1921, the Constructivists held their "5 x 5 = 25" exhibition showing works representing an ultimate stage that heralded the fact that painting was soon to become obsolete. Three of the five works by Rodchenko, collectively entitled *The Last Painting,* were pure monochromes. Some twenty years later, Rodchenko explained: "I reduced painting to its logical conclusion and exhibited three canvases: red, blue, and yellow. I maintained that it is uniform. Basic colors. Each plane is a plane, and there must be no more representation." For a number of Constructivists, the art of painting was seen to have lost its usefulness and, above all, it could no longer impact directly on real life. Through a critique of Malevich's principles of composition, Rodchenko extended Suprematism logically to the relinquishment of painting *per se.* "Art is dead. Let us cease all speculative activity... The domain of reality is that of practical construction."

"Dynamic Suprematism"

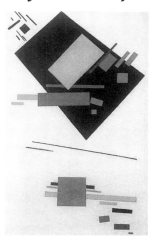

KASIMIR MALEVICH
Suprematism
1915–16.
Oil on canvas, 101.5 x 62 cm. Stedelijk Museum, Amsterdam.

If "man is an energized being," Suprematism resides in the "expression of an intuitive, universal motion of energy forces." This was the basis for Suprematism's fundamental definition: "Universal energy aims for economy ... The Revolution is nothing other than a new economic energy powering universal revolution." By 1918, at the invitation of Chagall, Malevich started teaching at the art school in Vitebsk. He soon shouldered his mentor to the sidelines, and, surrounded by a crowd of disciples, proclaimed the "Suprematist Academy" of UNOVIS, displacing the school's "center of gravity toward the architectural front." He designed *arkitektons* (Suprematist design "dwellings") for the "inhabitants of the earth" (which he called *Planits)*. In 1922, he was made director of Inkhuk (Institute of Artistic Culture) in Petrograd (St. Petersburg), where he decreed that painting and architecture were the expression of a new conception of "creative inventiveness" that modified and even generated the world. Although the Suprematist picture immersed humankind in the "vast spaces of cosmic calm," for Malevich painting was "out-of-date, the painter nothing but a hangover from the past."

"AT THE PRESENT TIME, MAN'S PATH

"A step forward is an adventure"

OSKAR SCHLEMMER
Dancer
1922. Oil on canvas, 199 x 123 cm.
Neue Pinakothek, Munich.

"**S**tart from the positions of the body, from its sheer presence, then its position standing, walking, and finally jumping and dancing. A step forward is an adventure, and raising one's hand, or wagging a finger are no less so." At the Bauhaus (1923–29), where he taught in the mural painting, sculpture and set-design departments, Schlemmer was the great exponent of the theater. He devel-oped prototypes which vehi-cled an abstract vision of the human body and he bridged genres, devising a collective pro-gram that was based on the model put forward by the founder of the Bauhaus, Walter Gropius, and was centered on the whole human being. Among other projects, Schlemmer pro-duced a *Triadic Ballet* in which he proposed analyzing the elementary movements of the human body. It was performed by dancers wearing costumes that were, in common with the many stage sets he designed, a projection of the dimensions of the figure and of its rhythm and motion in space. Lying beyond both painting and ar-chitecture, the history of the-ater was, for Schlemmer, the "history of the transfiguration of human form."

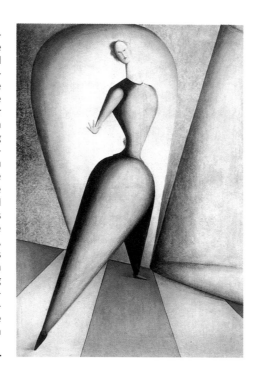

"The experience of a new-found unity"

LASZLO MOHOLY-NAGY
Composition AXX
1924.
Oil on canvas, 135.5 x 115 cm.
Centre Pompidou, MNAM, Paris. Photo P. Migeat.

Painter, sculptor and pho-tographer, the Hungarian-born Moholy-Nagy was called to the Bauhaus in 1923 by Gropius to teach the "cul-ture of materials," replacing Johannes Itten. Along with color theorist and painter Josef Albers and typographer Herbert Bayer, he played a key role in the onset of geomet-rical abstractionism at Dessau. As the director of the metal-working department, he researched the differences between materials by com-bining, for instance, alumin-um and synthetic products. He edited a series of Bauhaus publications *(Bauhausbücher)* and wrote a number of books, such as *Malerei, Photogra-phie, Film* (Painting, Pho-tography, Film; 1925) and *Von Material zu Architektur* (1929; translation: *The New Vision,* 1932). In these, he set out his process of enquiry, that remained receptive to all forms of experimentation. His factory-made *Telephone Pictures* (1922) marked a turning point in his system-atic approach that was inured to the cult of the craftsman. Research work in photogra-phy and cinema led him (1923–30) to create a series of *Light-Space Modulators,* whose mechanized compon-ents produced kinetic images and shadows. Contrary to appearances, they do not refer to "machine culture" but instead permit the "expe-rience of a new unity" through "art and technology."

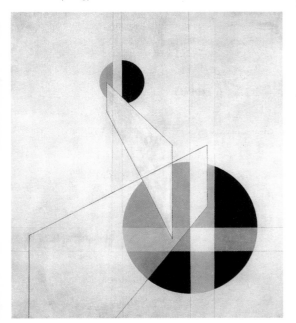

"Abstract, but with memories"

PAUL KLEE
Senecio
1922.
Oil on canvas remounted on panel, 40.5 x 38 cm.
Kunstmuseum, Basel.

Like Kandinsky, Paul Klee was first and foremost a painter, so did not really fit in with the spirit of the Bauhaus. The two artists were seen as Romantics of an Expressionist bent. In 1924, to-gether with American-born Lyonel Feininger and Alexei von Jawlensky, they founded the Blauen Vier (the Blue Four), thereby underscoring their dif-ferences with the "artist-engineers" of the Bauhaus. Klee had been appointed professor at the Bauhaus as early as 1920. In his attempts to fuse the architectonic and poetic sides of painting, he preferred the term "construction" to "composition." Developing apart from any specific movement,

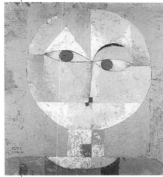

Klee described his art as "abstract, but with memories." His paint-ings and drawings drew their inspiration from various sources, such as ideograms, theater and opera. Some of his figures resem-ble puppets hovering between comedy and tragedy and his paint-ings contain an element of pan-tomime, just as those of his con-temporaries were characterized by discipline. Similarly, while his fellow Bauhaus artists were mov-ing toward architecture, Klee pre-ferred small formats on fragile supports that facilitated a more intimate relationship in keeping with his "credo".

83

LEADS THROUGH SPACE" Malevich

> > > El Lissitzky and Tatlin, from Moholy-Nagy to Oskar Schlemmer, from Theo van Doesburg to the various members of De Stijl—never envisaged picture-making as an end in itself. Abstraction was the place where experiment and speculation met. In Constructivism and De Stijl, and at the Bauhaus, the synthesis that took place between the various artistic disciplines contributed every bit as much as painting did to the redirecting of art from individualism toward the universal. Thus abstraction concerned sculpture, architecture and everyday life as much as it did painting. It was the fruit of their fusion and aimed at the abolition of the distinction between "fine" and "applied" art, striving, as in the case of Walter Gropius at the Bauhaus, to bind art to industry, or, with De Stijl, to build an architecture receptive to plastic values. Abstract art was a "laboratory" art. Stalinism, Nazism and the other totalitarian regimes in Europe forced some artists to stop painting and obliged others to emigrate. The Bauhaus was shut down in 1933 and the Vkhutemas (the Higher Technical Art Studios in Moscow) was abandoned and its artists dragooned into producing propaganda art. Although Paris was unaware in the 1920s of the work of Mondrian (who had settled there), or of developments in the Eastern European avant-garde, the French capital was once again, almost without realizing it, about to serve as a forum for the interchange of ideas. There, movements, groups and journals such as Cercle et Carré and Abstraction-Création reconfigured themselves into veritable international groupings. Annual exhibitions and manifestos promoting "man's reconciliation with the cosmos" were evidence of great confidence in the future and of an enduring opposition to Surrealism.

But, as war approached, this founding utopia faced annihilation, while the enforced exile of those who survived shattered the twentieth-century avant-garde's dreams of community and idealism. <

84

"Point, Line, Plane"

WASSILY KANDINSKY
Study for *In the Black Square*
1923. Watercolor, gouache and Indian ink on paper, 36 x 36 cm. Centre Pompidou, MNAM, Paris.

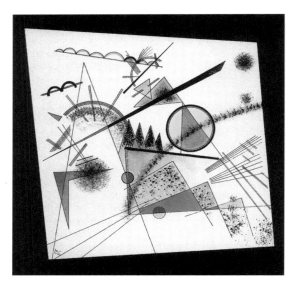

Declaring his opposition to revolutionary Soviet ideology in artistic matters, Kandinsky repaired to Germany in 1922 to teach at the Bauhaus. There he adumbrated theories which no longer relied on the "spiritual in art," but on precision. "Conscious," as he put it, "of his rights and responsibilities," he gradually developed a more geometric pictorial vocabulary. In 1926, he published *Point, Line, Plane*, a grammar of forms that he continued to amplify and enrich through methodological and pedagogical research until his death in Parisian exile. As he searched for the scientific perfection that would "result from a formal dialectical reflection" far removed from the impulsive lyricism of his earlier works, Kandinsky adopted an exuberant if calculated geometricism. Using ruler and compass, he produced endless variations on geometry dictated by an alphabet of autonomous signs that were preceded by rigorously elaborate drawings. The canvases that followed his move from the Bauhaus incorporated instead a poetical language that mixes arabesques with zoomorphic and decorative shapes in what was envisaged as "pure pictorial storytelling."

"Intuition remains something positive"

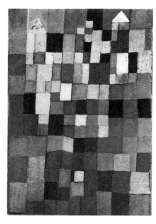

PAUL KLEE
Architecture
1923. Oil on canvas, 57 x 37.5 cm. Staatlichesmuseum, Berlin.

Klee was initially influenced by Cézanne and Robert Delaunay, whose essay on light he translated for the journal *Der Sturm*. In 1914, he visited Tunis, a journey that proved a turning point in his career. He noted: "Color possesses me. I no longer need to pursue it... Color and I are one—I am a painter." During his years at the Bauhaus (1920–31), where he taught theory of art and then glass-painting and tapestry-making, Klee seemed to be somewhat peripheral to the unfolding history of abstract art. An instinctive personality, he was convinced that what he was doing was teaching him what he was looking for. In the teeth of his more methodical colleagues, he maintained that "intuition remains something positive." In Weimar, he painted a series of abstracts consisting of a "mosaic" of colors suggestive of both a stained-glass window and a randomly arranged checkerboard. In 1924, he provided a summary of his beliefs to date: "Art does not reproduce the visible: it makes visible... An artwork is in creation's image. It is a symbol... Art extends through things, going farther than the real and than the imaginary alike."

"THE CENTRAL OBJECTIVE

"Flat planes and pure colors"

BART VAN DER LECK
Still Life with Wine Bottle
1922. Oil on canvas, 40 x 32 cm.
Rijksmuseum Kröller-Müller,
Otterlo.

In common with other painters whose work was centered on the gradual decomposition of reality, Bart van der Leck's methodical deconstruction of representation issued from an initial figurative approach to the subject. As early as 1916, his works, composed from "flat planes in pure colors," were already impressing Mondrian, with whom he was also to have lengthy discussions on the nature of abstraction. Van der Leck, whose works often formed series, investigated various motifs— workmen, animals, still lifes— which were all treated to the same process of schematic and fragmentary reduction, so that they were pared down to a rhythmic arrangement of primary-colored planes and orthogonally organized lines over a white ground. Bart van der Leck's abstraction developed incrementally by a process of heightened stylization. Built up from a system of grids, his art was a search for the essence of reality and its ultimate connections. In this respect, his approach was similar to that of Mondrian. In 1918, van der Leck quarreled with Theo van Doesburg and left De Stijl; soon after he reintroduced recognizable motifs into his work.

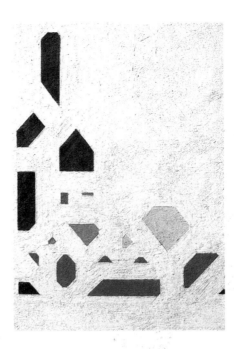

"A work of art of pure plasticity"

GEORGES VANTONGERLOO
Composition
1917.
Oil on canvas, 36 x 54 cm.
Centre Georges Pompidou,
MNAM, Paris.

The Belgian Georges Vantongerloo was a contributor to the first issue of *De Stijl* (The Style; October 1917), along with the architects J. J. P. Oud, Jan Wils and Robert van t'Hoff, the poet Antony Kok, Piet Mondrian, Theo van Doesburg, Bart van der Leck and the Hungarian Vilmos Huszar. Up until 1937, Vantongerloo, in both his sculpture and his painting, remained basically faithful to the Neo-Plasticism of De Stijl, employing in the latter the principle of complementary colors. "De Stijl wishes to unite within it all currents of thought as applied to the plastic arts today, currents which, though essentially similar, have developed independently... Any genuinely modern artist fully aware of his actions has to fulfill a dual mission. First, he has to produce a work of art of pure plasticity; then he has to open the public's eyes to such a pure art." Vantongerloo, in common with others in the movement, produced a host of models for buildings, airports and bridges, while his easel works, like the mathematical laws underpinning his sculptures, were all directed toward preparing for a period in which the art of painting would be surpassed.

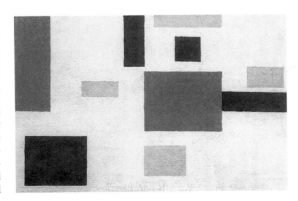

"In equilibrium"

JEAN HÉLION
Balance
1933–34.
Oil on canvas, 97.4 x 131.2 cm.
Peggy Guggenheim
Collection, Venice.

Hélion exhibited his first abstracts in 1929. It was during this process of eliminating figurative elements in his work that he encountered van Doesburg's Neo-Plasticism. Although he signed the *Art Concret* manifesto in 1930, he quickly rejected the austere geometrical principles he had adopted and the following year he introduced curves. Together with Jean Arp, Albert Gleizes, Auguste Herbin, Franz Kupka and Georges Vantongerloo, among others, he created the Abstraction-Création association that gathered together abstract artists from various countries, replacing the Cercle et Carré group that had been set up in "a sort of despairing rage " by critic Michel Seuphor and Uruguayan painter Joaquín Torres-García. Hélion's works of the years 1933–34 superseded

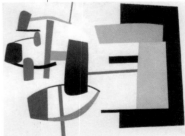

the strictly orthogonal compositions that had adhered to the decrees of the various movements arising from the rejection of figuration. His new works consisted of multiple forms and rhythmical interlocking elements to form balanced and harmonious compositions. In 1944, however, he reintroduced the figure and still-life themes that were to dominate his painting until the end of his life. The latter half of his career thus ran counter to the credo of abstraction.

ALWAYS REMAINED MAN HIMSELF" Moholy-Nagy

"Counter-compositions"

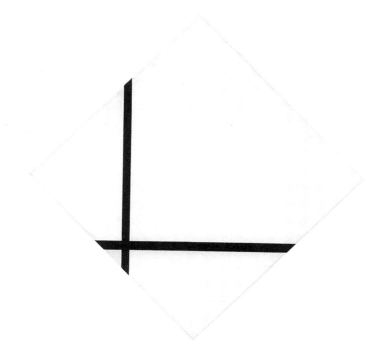

THEO VAN DOESBURG
Arithmetical Composition
1930. Oil on canvas, 101 x 101 cm.
Private collection, Switzerland.

In 1915, van Doesburg—painter, architect, musician, theoretician and critic under a panoply of pseudonyms—wrote an article on Mondrian for the review *De Eenheid* (Unity). In October 1917, as the Bolshevik Revolution was raging, he began to produce a journal entitled *De Stijl* (The Style), which was followed a year later by the movement of the same name. Whereas Mondrian returned to Paris in 1919, van Doesburg disseminated his ideas at the Bauhaus and in Russian Constructivist circles. De Stijl ceased publication in 1928, while its founder died prematurely aged 47. Van Doesburg devised a pure visual language in which only the cube and the square were permitted and all planar surfaces were uniform and unmodulated. He advocated a functionalist art with social and collectivist implications that were intended to synthesize the ideas of Frank Lloyd Wright and Neo-Plasticism. The resulting black-and-white easel compositions and the designs for flooring and stained-glass windows for J. J. P. Oud's house are quite distinct from the more metaphysical Neo-Plasticism of Mondrian, which van Doesburg had criticized for being doctrinaire. In what he called "Counter-compositions," van Doesburg produced dynamic arrangements that made extensive and varied use of 45-degree angles. "The goal of Nature is Man. The goal of Man is Style," he declared. In 1926, he published the "Manifesto of Elementarism," as well as a Dada supplement to *De Stijl* entitled *Mécano*. In 1930, he edited the one and only number of the *Revue de l'art concret*. An energetic and many-faceted figure, van Doesburg bestowed on abstract art a social role it had lacked in pure Neo-Plasticism.

"A new image of the world"

PIET MONDRIAN
Composition with Two Lines
1931.
Oil on canvas, 112 x 112 cm.
Stedelijk Museum, Amsterdam.

By 1915, Mondrian was developing a new approach to pictorial space based on pure perpendicular rhythms where "+" and "-" generated proportional ratios based on relationships between vertical and horizontal lines. By 1917, he was using right-angles to determine the structure of his pictures. An example of timeless and absolute equilibrium, Mondrian's work opens the door to a syntactical architecture that is imbued with spiritual and visual plenitude, the pure expression of deep-seated interrelations. In a series of articles that appeared in Paris in 1920, dedicated to the "men of the future," and also in a brochure in which he defined Neo-Plasticism, Mondrian stated: "The truly modern artist consciously experiences abstraction in an emotion of beauty, he consciously recognizes that the emotion of beauty is cosmic, universal. This conscious realization has its corollary in abstract Plasticism, since Man can only put his faith in the universal." Under the impact of De Stijl, Mondrian did make use of the three primary colors, though in his most uncompromising pieces the right-angles and the planar areas they describe endow them with the highest degree of rigor and convey what his friend the Theosophist Schoenmaeker called a "niewe Werebeld"— a new image of the world.

"TO DENATURALIZE MEANS TO MAKE ABSTRACT;

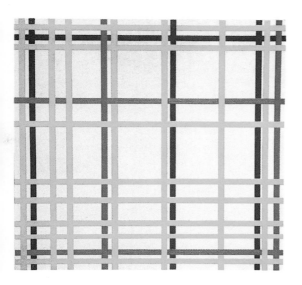

"Pure, unadulterated vitality"

PIET MONDRIAN
New York City 1
1942.
Oil on canvas, 119.3 x 114.2 cm.
Centre Georges Pompidou,
MNAM, Paris.

In the autumn of 1940, Mondrian, who had been staying in London with Naum Gabo, and Ben Nicholson and Barbara Hepworth, settled in New York, encountering for the first time the rhythm, geometry and sheer scale of Manhattan. Motion, light and life now filled works which until then had been ascetic. The tight grid of black lines that had been modulated in countless variations over many series of canvases was superseded by a colorful lattice that allowed for an interplay of chromatic rhythm and contrast. A paean to the syncopated cross-rhythms of Mondrian's beloved jazz, *New York City, Boogie Woogie, Broadway Boogie Woogie,* and *Victory Boogie Woogie* contrast strikingly with the contemplative and theoretical leanings of his earlier Neo-Plasticist works. He explained: "Only now do I see that my works in black and white and a few colors were simply drawings in oil." He grew increasingly critical of his own dogma and was receptive to the idea of rethinking its very foundations. His life was cut short on February 1, 1944, although not before he had embarked on a radical switch from the static forms of the Paris years to a fresh dynamism. Painted or composed directly with the aid of adhesive tape, and striving not so much to express perfect equilibrium as to depict "pure, unadulterated vitality," the canvases of his last four years brought about a fusion between color and drawing. The art of painting was given a new lease of life, reinventing itself as Mondrian's startling new titles make clear. In a New York that provided him with the themes of his last years and convinced him that painting was condemned to disappear, to be replaced by a kind of generalized aesthetic, Mondrian maintained: "Art will gradually vanish as life acquires its balance... We will have no need of painting and sculpture because we will be living in the midst of actualized art."

Chronology 1915–1939

In keeping with the subject of the chapter, this chronology is largely devoted to events in Europe and the United States. Sections in bold refer to artists mentioned in the main text and captions.

1915
Petrograd, February: Vladimir Tatlin presents his *Constructions* and a *Corner-Relief* at the "Tramway V" exhibition organized by Ivan Puni.
Amsterdam, October: Theo van Doesburg notices Piet Mondrian's canvases at the city museum.
Petrograd, December: "0.10" exhibition. Malevich exhibits *Black Square* and thirty-five other abstract works. He publishes *From Cubism to Suprematism*.

1916
Moscow: "The Store" exhibition. Tatlin exhibits *Corner Counter-Reliefs*.
The Hague: Mondrian discovers works by Bart van der Leck.

1917
• Russia: October Revolution.
Moscow: Tatlin and Rodchenko provide the interior decoration for the Café Pittoresque.
The Hague, October: first issue of the review *De Stijl,* followed a year later by the movement's manifesto.

1918
USSR: Anatoly Lunacharsky, People's Commissar of Education, founds IZO (Department of Fine Arts at the Commissariat for People's Education). Thirty-six museums are created in three years.
Malevich paints *White Square on a White Ground*.

1919
Paris, February: return of Mondrian.
USSR: Soviet government commissions a Monument to the Third International from Tatlin.
Malevich begins teaching for three years at Unovis, Vitebsk.
Weimar: Bauhaus founded.
Moscow: retrospective exhibition with 150 works by Malevich.

1920
Mondrian publishes a leaflet on Neo-Plasticism.
Antoine Pevsner and his brother Naum Gabo publish the *Manifesto of Constructivism*.
Tatlin submits the maquette of the Monument to the Third International.

1921
At Lunacharsky's request, Kandinsky presents an arts program for the Academy of Sciences.
September: "5 x 5 = 25" exhibition with Rodchenko, Alexandra Exter, Liubov Popova, Varvara Stepanova and Aleksandr Vesnin.

1922
Kandinsky, Pevsner and Gabo all leave the USSR.
Civil war in USSR ends with a Bolshevik victory.
Critic and historian Michel Seuphor meets Mondrian.
Schlemmer stages his *Triadic Ballet*.
Moholy-Nagy devises his *Light-Space Modulator* (up to 1930).
Van Doesburg devotes his review *Mecano* to Dadaism and spends time at the Bauhaus.
El Lissitzky organizes a meeting of progressive artists at Düsseldorf and a "Constructivism-Dada" congress at Weimar.
Hanover: the Provinzialmuseum is the first museum to acquire abstract works. Its director Helmut Dorner commissions an "abstract cabinet" from El Lissitzky.

1923
Van Doesburg sets out his sixteen points on "plastic architecture."
Petrograd: Malevich directs a laboratory of experimental art (until 1928).
Poland: Vladislav Strzeminski founds Unism. With Henryk Stawewski and Henryk Berlewi, he founds the group and journal *Blok*.
Weimar: "Art and Technology: a New Unity" exhibition.
Paris, October-November: De Stijl exhibition, L'Effort Moderne gallery.

1924
Kandinsky, Klee, Feininger and Jawlensky set up Die Blauen Vier (The Blue Four) so as to distinguish themselves from the Bauhaus "artist-engineers."
Utrecht: Gerrit Thomas Rietveld completes the Schröder House.

1925
Bauhaus moves to new buildings at Dessau designed by Gropius.
Paris: "L'Art d'aujourd'hui" exhibition.
The USSR pavilion designed by Constantin Melnikov and Rodchenko exhibits furniture models.

TO DENATURALIZE MEANS TO MAKE MORE PROFOUND" Mondrian

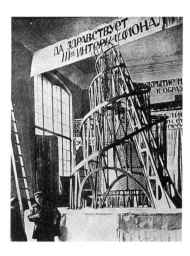

1920.
Vladimir Tatlin in front of the model for the Monument to the Third International.

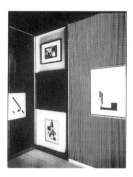

Around 1928.
View of the "abstract cabinet" commissioned from El Lissitzky by the Provinzialmuseum, Hanover.

1924.
Gerrit Rietveld. Color scheme for the Schröder House at Utrecht.

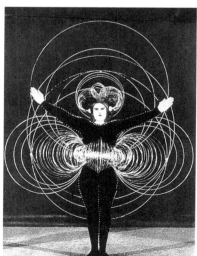

Around 1922.
Performance of Oskar Schlemmer's *Triadic Ballet.*

Chronology 1915–1939

1926
Breaking with Mondrian, van Doesburg publishes "The Elementarist Manifesto."

1927
Strasbourg: van Doesburg, Arp and Sophie Taueber design L'Aubette.
Hanover: formation of the association Die Abstrakten Hannover (DAH), bringing together Schwitters, Friedrich Vordemberge-Gildewart, Carl Buchheister and César Domela.

1928
Gropius leaves the Bauhaus.

1929
Marcel Seuphor and Joaquin Torrès-Garcia set up the group and the journal Cercle et Carré.

1930
Paris: Cercle et Carré exhibition at the Galerie 23.
April-May: van Doesburg, with Hélion's assistance, publishes the only issue of *Art Concret.*

1931
•Paris: Calder exhibits his first mobiles (so christened by Duchamp) at Marie Cuttoli's gallery.
Davos: death of van Doesburg.
Kandinsky publishes the review *Les Cahiers d'Art,* and his *Reflections on Abstract Art.*

1932
Two years after a visit to Mondrian in Paris, Calder meets Miró in Spain.

1933
Bauhaus closed.
October: Kandinsky settles in Paris.
Josef Albers emigrates and teaches at Black Mountain College, North Carolina, until 1949.

1935
Death of Malevich. Official funeral in Petrograd.

1936
Solomon Guggenheim and Baroness Hilla Rebay start assembling a collection that leads in 1939 to the creation of the Museum of Non-Objective Art.

1937
Paris: World's Fair. The Delaunays exhibit large-scale decorations for the "Chemins de Fer" pavilion and the Palais de l'Air.
New York: founding of the Abstract American Artists association (AAA).
Chicago: Moholy-Nagy founds the New Bauhaus.

1938
• New York: Amédée Ozenfant arrives.

1939
• Paris: creation of the Réalités Nouvelles and debut exhibition at the Charpentier gallery organized by Sonia Delaunay.

Studies on Abstract Art
J. Albers. *Despite Straight Lines.* Cambridge, Mass., 1977.
J. Baljeu. *Theo van Doesburg.* New York and London, 1974.
L. S. Boersma. *0. 10 - The Last Futurist Painting Exhibition.* Rotterdam, 1993.
C. Gray. *The Great Experiment: Russian Art, 1863–1922.* London, 1962.*
M. Jaffé. *The De Stijl Group: Dutch Plastic Art.* Amsterdam, 1964.
S. Lemoine. *L'Art constructif.* Paris, 1992.
K. Malevich. *Essays on Art* (ed. T. Anderson). Copenhagen, 1968 (2 vols.).
A. Moszynska. *Abstract Art.* London, 1990.
A. Nakov. *L'Avant-garde russe.* Paris, 1985.*
K. Passuth. *Les Avant-gardes de l'Europe centrale, 1907–1927.* Paris, 1988.
M. A. Prat. *Cercle et Carré: peinture et avant-garde au seuil des années 30.* Lausanne, 1984.
M. Ragon. *Journal de l'art abstrait.* Geneva, 1992.*
L. Richard. *Encyclopédie du Bauhaus, école du design.* Paris, 1985.*
M. Seuphor. *L'Art abstrait.* Paris, 1974–88 (5 vols.).*
N. Troy. *The De Stijl Environment.* Cambridge, Mass., 1983.
D. Vallier. *L'Art abstrait.* Paris, 1980.

Main exhibitions and catalogues
1978, Paris. *Abstraction Création 1931–1936.* Musée d'Art Moderne de la Ville de Paris.
1988, Lyon. *Le Monochrome. La couleur seule.* Musée des Beaux-Arts.
1996, New York. *Abstraction in the Twentieth Century: Total Risk, Freedom, Discipline.* The Solomon R. Guggenheim Museum.*

Where works can be seen
United States
The Art Institute of Chicago.
Solomon R. Guggenheim Museum, New York.
The Menil Collection, Houston.
MoMA, New York.
The Menil Collection, Houston.
MoMA, New York.

Europe
Musée National d'Art Moderne, Paris.
Musée d'Art Moderne de la Ville de Paris.
Musée de Strasbourg.
Stedelijk Museum, Amsterdam.
Kunstmuseum, Basel.
Kunstmuseum, Bern.
Museum Ludwig, Cologne.
Landesmuseum, Hanover.
Gemeentemuseum, The Hague.
Museum Sztuki, Lodz, Poland.
Thyssen-Bornemisza Collection, Madrid.
Rijksmuseum Kröller-Müller, Otterlo.
Tretyakov Gallery, Moscow.
State Russian Museum, St. Petersburg.
Peggy Guggenheim Collection, Venice.
Stedelijk van Abbemuseum, Eindhoven.

"spatial languages"

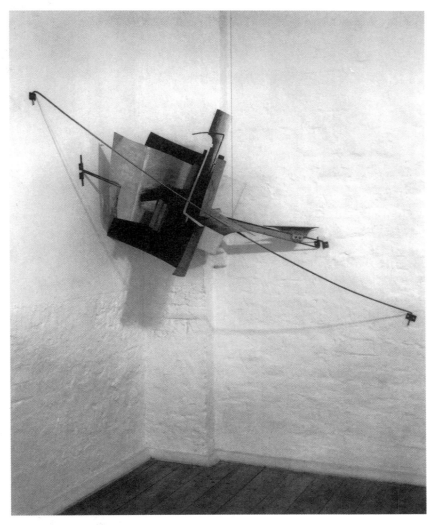

"An authentically real object"

VLADIMIR TATLIN
Corner Counter-Relief
1915. Replica by Martyn Chalk (1966–70) after historical photographs. Iron, zinc and aluminum, 78.7 x 152.4 x 76 cm. Fischer Fine Art, London. Photo Cuming Wright-Watson Associates.

Tatlin's interest in the "culture of materials" can be traced back to his exposure to Cubist collage during his stay in Paris in 1913. Constructions such as this *Corner Counter-Relief*, few of which have survived, stemmed also from his dissatisfaction with Suprematism's pictorial concerns. The components of a Cubist still life are here transposed through various formal devices into three-dimensional space, with the rhythms being imparted by tension cables. Elements in aluminum, flat, bowed or cut out and sawn, planks of wood drilled and screwed together, glass and tensioners all enhance the piece's structural dynamism and foreshadow (as did Tatlin's famous project for a *Monument to the Third International*) utilitarian prototypes such as Letatlin (a human-powered flying machine) that he designed with utopian and political ambitions in the 1920s. The *Counter-Relief* marked a radical departure because it was directly fixed to the wall, rejecting transcendental and illusionistic space alike, and thus incorporating an architectural dimension. This "authentically real object," analyzed by Nikolaia Tarabukin in *From the Easel to the Machine* (Moscow, 1923), is the work of an artist-engineer in full command of a "Productivist mastery" that heralds the collapse of the time-honored distinction between genres and disciplines.

It is no longer worthwhile wondering, as Walter Benjamin argued in connection with photography, whether the readymade belongs to the field of sculpture or not. It is more profitable to assess how it modified the codes and disciplines intrinsic to artistic endeavor. The readymade heralded throughout Europe a plethora of ideas committed to enlarging the scope and definition of the relationship between the artwork and space. > > >

89

> > > Certainly, the term "sculpture" seems ill suited to works whose very nature was above all to go against convention. Following the monuments and statues of the nineteenth century, and the work of Rodin, a sense of vacuity and instability developed, accompanied by the emergence of an aesthetic based on fragmentation and montage, in which the language and practice of sculpture was reinvented. In this respect, the life-long friends and co-conspirators Brancusi and Duchamp appear as two antithetical and symmetrical representatives of a complementary field of research: the former strove to redefine and reconfigure the very language of sculpture and go beyond the "figuration/abstraction" dichotomy by dint of an archaic practice, while the latter sought to neutralize artistic conventions and to call a complete halt. Paradoxical as it may seem, both Brancusi and Duchamp paved the way for all kinds of discoveries, while Picasso too was constantly reinventing himself.

The latter's work stretches categories and perspectives to breaking point: the word "sculpture" evokes the sumptuous works in the round he made at Boisgeloup; the term "assemblage" brings to mind the painted sheet-steel or wood pieces that the artist produced at various stages in his career using objects to hand; the term "construction" conjures up the magnificent spindly figures or the projects for the Apollinaire monument that, rejecting the Surrealists' "cage-space," amounted to a deliberate defiance of Constructivism. With Picasso, everything vacillates, everything emerges in a new perspective: he is a one-man history of twentieth-century sculpture, embracing all its contradictions as well as its U-turns, transgressing movements and disciplines. Picasso cleared a path for many successive trends, even for those which refused the notion of the object as an end in itself and appropriated space and site for other purposes. > > >

90

"Developable Surface"

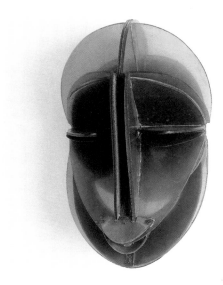

ANTON PEVSNER
Mask
1923. Metal and celluloid,
33 x 20 x 20 cm.
Centre Georges Pompidou,
MNAM, Paris.
Photo Centre Pompidou.

In 1920, Pevsner co-signed the *Realistic Manifesto* with his brother Naum Gabo and posted it in the streets of Moscow. In 1923, during his third trip to France, he settled in Paris. He became a French citizen in 1930 and joined the Abstraction-Création movement. In 1946, together with Albert Gleizes and Auguste Herbin, he formed the Réalités Nouvelles group. Like his brother, he was very conscious of the specificity of materials. Integrating Analytical Cubism with forms derived from industrial design, Pevsner evolved the concept of "developable surfaces" constructed from elements soldered together. These works were calculated to sculpt space itself. The masks he produced in the 1920s demonstrate his assimilation of both Cubism and African sculpture. They fuse contrasting materials like plastic and metal and unite opposing qualities such as opacity and translucence. Beyond their essential classicism, Tatlin's works were the products of a particular formal logic and used contemporary materials.

"A spatially open work"

NAUM GABO
Column
1923. Plexiglas, wood, metal and glass,
105.3 x 73.6 x 73.6 cm.
Solomon R. Guggenheim Museum, New York.

The Pevsner brothers (Gabo was born Naum N. Pevsner) drew up their *Manifesto of Constructivism* (first entitled *Realistic Manifesto*) in 1920. It affirms their desire to set free "kinetic rhythms, the essential forms of our perception of the real." Praising the "modern beauty" of the Eiffel Tower, Gabo declared: "The ambition of Constructivism is not to create pictures or sculptures but constructions in space." Gabo initially studied medicine, followed by natural sciences and engineering. He read Kandinsky's *Of the Spiritual in Art* and met its author in Germany, before returning to Russia after the Revolution. Between 1920 and 1922, he produced his first "kinetic constructions," in which form determines rhythm and motion in space-time. Gabo nonetheless rejected the idea that sculpture should necessarily mimic the machine. His *Project for a Monument for an Observatory* (1922), like the *Column* the following year, is constructed in lightweight, semitransparent materials that bring into the equation effects of mass and void, resulting in what is intended to be a "spatially open work." Gabo made many small models that he hoped to develop on an architectural scale. His work prefigured important developments in sculpture.

"WE REJECT THE IDEA OF VOLUME

"Functional utilization of the material"

ALEXANDER RODCHENKO
Suspended Oval Construction 1919–20.
Painted plywood and wire, 83.7 x 51 x 47 cm. Indiana University Art Museum, Bloomington.

The designer with Tatlin of the Café Pittoresque in Moscow in 1917, Rodchenko distanced himself from Malevich's theories and adumbrated an objectivist theory of art. "The construction," he wrote, "in its unambiguous and exact sense, that is to say, as an organization of real objects, can only be made

from matter. That is why the adequate use of materials has become such a crucial problem. We define a construction as an object that relies on the functional utilization of materials and that is systematically executed. Hence, through such efforts in the area of construction, the artist has been led, by way of spatial constructions, to the construction of real objects." Mobile about its axis, the *Suspended Oval Construction* partakes both of object and visual tool. Rodchenko's intention was not so much to produce an intriguing structure as to develop dynamic and cinematic forms. The artist here demonstrates his commitment to a program in which each element forms an integral part of a redefinition of the purposes of art.

"The interplay of light and shadow"

LASZLO MOHOLY-NAGY
Spatial Modulator
1922–30 (reconstruction 1970).
Metal, plastic, glass and wood, 151 x 70 x 70 cm.
Stedelijk van Abbemuseum, Eindhoven. Museum photo.

In the 1920s, Moholy-Nagy began exploring differences between materials. This type of work, produced in parallel with his photography, revealed to him the immense importance of light. In 1925, he started using celluloid and bakelite in his reliefs, and evolved the concept of "painting with light." This was the inspiration for his *Light-Space Modulator,* an object that had a decisive influence on Op

and Kinetic art. Light is captured in its capacity for transformation. It modulates space through movement in a way that is comparable to film-making and theatrical work, which Moholy-Nagy was also involved in. Designed to be installed at the center of the Raum der Gegenwart (Contemporary Space) in the Hanover museum, the modulator was financed by the firm AEG and was eventually presented in Paris in 1930. Exploiting to the full every technical resource of the time, the *Modulator* surprised even its creator. "In 1930, when the *Light Prop* was started up, I felt like the Sorcerer's Apprentice. The appearance of the contraption was so astonishing in the coordination of its movements and in the interplay of light and shadow that I took it for something almost magical."

"Sculpture encloses space"

KATARZYNA KOBRO
Spatial Composition
Around 1926.
Welded and painted steel, 44.8 x 44.8 x 46.7 cm.
Centre Georges Pompidou, MNAM, Paris.
Photo Centre Pompidou.

With her husband Vladislav Strzeminski, Kobro was co-director of the IZO studio (an offshoot of Malevich's UNOVIS) at Smolensk. Both were influenced by Malevich and Tatlin. By 1924, the couple were in Poland. They became members of the Blok and Praesens groups. In 1929, they formed a new group, known as a.r., that was linked to Abstraction-Création. They published theoretical texts, including Kobro's own "Sculpture and Volume" in 1929. Kobro's unenclosed volumes made out of painted steel were arranged in accordance with extremely accurate calculations of numerical ratios. These works amounted to a "total," organic

systemization of space. In the tract "The Composition of Space: Calculations of Spatial-Temporal Rhythm," she elaborated on her work: "Each sculpture encloses within its bounds a

clearly delimited portion of space... Every sculpture poses the crucial problem: the relationship between the space contained within the sculpture and the space situated beyond it."

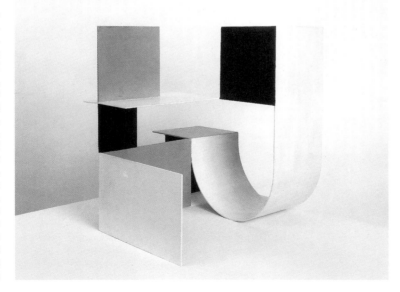

AS A PLASTIC FORM OF SPACE" Gabo and Pevsner

> > > The rationalism of a Rodchenko, the architectural drive of a Malevich, Gabo or Pevsner, the spatial utopias of Tatlin, projects by engineer-cum-inventors such as Moholy-Nagy or Kobo can now be seen as presenting politically and socially aware alternatives. In contrast to the Surrealist "object," and in the wake of Duchamp's nihilism and Picasso's heroic stance, these interrogate, not so much the relationship between the work of art and its space, but rather the possibility of an enhanced notion of space itself, henceforth to be understood as much as a territory as a piece of architecture or environment. Sculpture, assemblage, construction... to these categories should be added one more, dreamed up by that great manipulator of language, Duchamp, which playfully defies gravity as well as other conventions —the notion of the "mobile" as developed by Alexander Calder.

Between the wars, the field of "sculpture" expanded to include "found" and "natural" objects—monstrous entities fashioned directly by nature—"disrupted" objects and other incongruous forms that the Surrealists delighted in. These intersected not only with the realm of creativity but also with that of the "mystery of man," and what Breton, in his search for a new focus for psychic automatism, described as "certain objects that are approached only in dreams." <

"Drawing in space"

JULIO GONZÁLEZ
Woman with Basket
1930–33.
Welded iron, 194 x 63 x 63 cm. Centre Georges Pompidou, MNAM, Paris. Photo Centre Georges Pompidou.

Julio González, a leading pioneer of welded-iron sculpture, went to Paris in 1900, where he met poet Max Jacob, writer André Salmon and critic Maurice Raynal. He taught Picasso welding techniques, and executed numerous metal sculptures in collaboration with the Catalan. For González, these works were a homage to the great sculptor's "lessons." His "drawings in space" were initially inspired by natural forms. His sculptures were preceded by innumerable drawings, which formed a process of "clarification." His work in the 1930s was a celebration of iron as a living and malleable material. He produced linear structures made up of metal plates or scrap welded together and hot-worked. These pieces amounted to the first few steps in a new language that broke radically with the traditional precepts of sculpture. Unlike the precise, carefully planned pieces in which Picasso and his craftsman had collaborated, this image of an elongated and allusive female body looks more like an impromptu sketch, an open, loose gesture with sharpened spikes that suggest—should anyone care to search for the subject designated by the title—the hair on top of a spindly silhouette in delicate equilibrium.

"A modern parody of the Charioteer of Delphi"

PABLO PICASSO
Construction
1928. Figure for a monument to Guillaume Apollinaire. Wire and sheet-metal (iron), 60.5 x 15 x 34 cm. Musée Picasso, Paris. Photo B. Hatala/RMN.

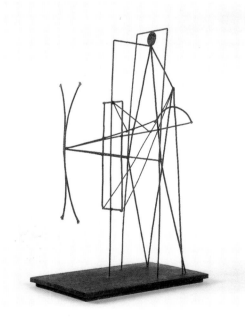

Starting in 1928, Picasso created a series of openwork assemblage *Constructions* based on drawings he had made earlier. The use of rigid iron wire gives volume to and structures space, delineating what Dominique Bozo has called "transparent matter." Here, matter and line are integrated, and the human figure, which survives through a scattering of identifiable signs, attains a paradoxical and ironic monumentality. A variation on the Constructivist concept of immateriality, wire suggests the presence of volume through its edges, such as here the internal "backbone" that seems to be holding "reins" at the end of its arms. Rosalind Krauss sees the piece as a modern parody of the *Charioteer* of Delphi and an implicit critique of the monolithic nature of sculpture materials. Several major pieces dating from the same period, such as *Woman in the Garden, Head* and *Woman's Head*, are closely linked to Picasso's paintings of the same period.

"REAL MATERIALS

"Mobile and silent object"

ALBERTO GIACOMETTI
Suspended Ball
1930–31. Metal, wood and wire, 60.5 x 36.5 x 34 cm. Centre Pompidou, MNAM, Paris. Photo Centre Pompidou.

Formerly part of André Breton's private collection, the *Suspended Ball* belongs to Giacometti's Surrealist period. Dalí saw it as the "extra-plastic" prototype of the "symbolically functioning object" that was soon to be dubbed the "Surrealist object" as envisaged by Breton. Giacometti himself christened the piece a "mobile and silent object," although he later neutralized its obvious erotic connotations, observing simply that it

showed a "ball with a cleft suspended in a cage that rides on a crescent." Agnès de Baumelle has remarked that, "once placed in the context of the optical problems that permeated Giacometti's work... the true change of direction that occurs with the *Suspended Ball*—the horn-cum-crescent can be thought of as the exterior equivalent of the missing section of the ball—comes from the fact that it impacts on the eye, carrying within it the potential for wounding and killing, being equipped with what is a 'separative' power (as the psychoanalyst Jacques Lacan would have said). The yoking together of a pair of opposite yet complementary terms reveals a dual ocular function that underlies the essential visual tension of Giacometti's sculptural oeuvre."

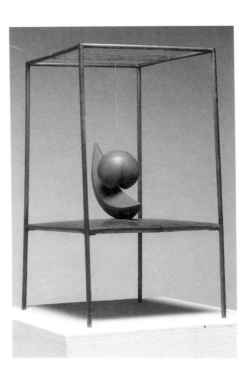

"Fascinated by a magnetic force"

JOAN MIRÓ
L'Objet du couchant 1935–36.
Painted wood, metals and string, 68 x 44 x 26 cm. Centre Pompidou, MNAM, Paris. Photo Centre Pompidou.

In the early 1930s, prompted by Breton, Miró began constructing strange, crude objects that allowed him to "escape into the absolute of nature." This work consists of a chunk of wood painted red, decorated with an eye/sex and topped with springs tied with string, a chain and handcuffs and another metal object christened "Sunset Object." It drew on a similar source as a contemporary series of drawings and collages. Reproduced in 1938 "Abridged Dictionary of Surrealism," it may have appeared under the vaguer title of *Objet* at the exhibition of Surrealist works held by Charles Ratton in the same year. In a letter written in 1975, Miró explains: "It was made and painted at Montroig [northeast Spain] from a section of carob trunk, a tree of

great beauty cultivated in that region of the country... I came across the other objects on my walks. I should make it clear to you that when I find something, no matter what it is, I am always first attracted and fascinated

by a magnetic force that I can't resist... I also inform you that the object was of course considered farcical by all and sundry, except Breton, who immediately grasped its magical side."

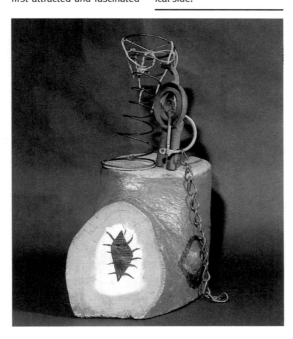

"Like Vulcan in his forge"

CONSTANTIN BRANCUSI
Endless Column II
Around 1925.
Wood, 301.5 x 29 x 29 cm (view of the reconstructed studio taken in 1997.)
Centre Pompidou, MNAM, Paris. Photo Centre Pompidou.

Like Schwitters and Mondrian, Brancusi designed his house-cum-studio as what the mystic critic Mircea Eliade called "his own personal world." It was on the same grand and varied scale as his work. Brancusi, who was soon to become, as Jean Cassou put it, an "extraordinary old man shut away in a magic workshop like Vulcan in his forge," had always dreamed of making monumental sculptures and installing them in the open, as he did for the public park at Tirgu Jiu in his native Romania (1937–38). Marielle Tabart has commented that it was "within the walls of his studio that [Brancusi] succeeded in impos-

ing a vision of a total environment that allowed the visitor an experience of what was his last creation—the actual place where he worked and lived." Half tree trunk, half temple pillar, the column motif first appeared in 1917 and became the basic module for his later oeuvre. It was seen by Brancusi as a metaphor for the absolute.

93

IN REAL SPACE" Tatlin

1923. View of Oskar Schlemmer's studio at the Bauhaus, Weimar. © AKG Paris.

Around 1926. Alexander Calder playing with his *Circus* in his Paris studio.

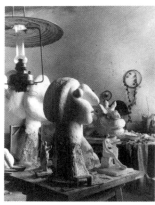

1932. Picasso's sculptures in the studio at Boisgeloup, photographed by Brassaï. © Musée Picasso, Paris.

1937–38. Constantin Brancusi. *The Table of Silence.* Tirgu Jiu, Romania.

Chronology 1915–1939

In keeping with the subject of the chapter, this chronology is largely devoted to events in Europe and the United States. For additional information on the same period, reference should be made to the previous chapter. Sections in bold refer to artists mentioned in the main text and captions.

1915
• June: Duchamp arrives in New York.
Petrograd: Tatlin presents constructions and a *Corner-Relief* at the "Tramway V" exhibition.

1916
Moscow: "The Store" exhibition. Tatlin exhibits *Corner Counter-Reliefs.*

1917
• Duchamp's *Fountain*, signed R. Mutt, is rejected by the Society of Independent Artists.
Moscow: Tatlin and Rodchenko provide the interior decoration for the Café Pittoresque. The Pevsner brothers return.

1918
• El Lissitzky begins his series of *Prouns*, followed from 1923 by *Proun Spaces*.

1919
• Weimar: Bauhaus founded.
USSR: Soviet government commissions a Monument to the Third International from Tatlin. Development of the "laboratory art" works.

1920
Antoine Pevsner and his brother Naum Gabo publish the *Manifesto of Constructivism*.

1921
Moscow, January: first Constructivist exhibition; works in metal by Kasimir Medunetsky. The Stenberg brothers, Vladimir and Georgii, exhibit *Spatial Structures*. Moholy-Nagy's early sculptures.

1922
Moholy-Nagy: *Light-Space Modulator*. Kandinsky, Pevsner and Gabo all leave the USSR.

1923
• Hanover: Schwitters begins designing the Merzbau.
Poland: Vladislav Strzeminski founds Unism. With Henryk Stawewski and Henryk Berlewi, and joins the Praesens group.

1924
• Breton, *First Surrealist Manifesto*.

1925
• Bauhaus moves to Dessau.
Brancusi travels to the United States. Paris: "L'Art d'Aujourd'hui" exhibition. The USSR pavilion designed by Constantin Melnikov and Rodchenko exhibits models for furniture.

1926
• Calder moves to Paris.

1927
• Breton, *Introduction au Discours sur le peu de réalité*. He addresses the question of the "Surrealist Object."

1928
Picasso works in iron with Julio González.

1929
Michel Leiris publishes a text on Giacometti in the journal *Documents*. Christian Zervos publishes "Projet de Picasso pour un Monument" in *Cahiers d'art*.

1930
• Jean Arp takes up sculpture.
• Henri Laurens returns to modeling.
Picasso settles at Boisgeloup.

1931
• Paris: Calder exhibits his first mobiles (so christened by Duchamp) at Marie Cuttoli's gallery.
Giacometti produces his *Disagreeable Objects* and "Surrealist" sculptures (to 1935).

1932
• Henry Moore executes *Mother and Child* based on a pebble with a hole in it.
• Hans Bellmer begins his *Doll* series.
Calder meets Miró in Spain.

1933
• Calder in the United States.

1934
• Ben Nicholson: reliefs.

1935
Brancusi commissioned to provide a monument at Tirgu Jiu (Romania), inaugurated in 1938.

1936
**Paris: exhibition of Surrealist objects at the Galerie Ratton.
Meret Oppenheim produces Objet: *Déjeuner en Fourrure* (a fur-lined teacup now in the MoMA).**

1937
• Calder produces his first stabiles.
Chicago: Moholy-Nagy founds the New Bauhaus.

1938
• Barbara Hepworth: "threaded string" sculptures.

1939
Brancusi's last trip to the United States. Plan for an *Endless Column* the height of a skyscraper.

Studies on Sculpture and Constructions
Dictionaries and general works

S. Barron and M. Tuchman. *The Avant-Garde in Russia.* Los Angeles, 1980.

J.-P. Breuil (ed.). *Dictionnaire de la sculpture.* Paris, 1992.

G. Conio. *Le Constructivisme russe.* Lausanne, 1987 (2 vols.).

D. Elliott. *New Worlds, Russian Art and Society 1900–1937.* London, 1986.

K. Passuth. *Les Avant-gardes de l'Europe centrale, 1907–1927.* Paris, 1988.

S. Zhadova, A. Nash, and J. Merkert (eds.). *Naum Gabo: Sixty Years of Constructivism.* Munich, 1985.

Monographs and exhibition catalogues on the sculptors mentioned

1980, Los Angeles. *The Avantgarde in Russia 1900–1930. New Perspectives.* Los Angeles County Museum of Art.

1983, Paris. *Présences polonaises.* C. Pompidou.

1979, New York. *The Planar Dimension: Europe 1912–1932.* The Solomon R. Guggenheim Museum.

1995, Paris. *Constantin Brancusi.* Centre Pompidou.

1997, Paris. *L'Atelier Brancusi.* Centre Georges Pompidou.

1971, Grenoble. *Naum Gabo.* Musée de Peinture et de Sculpture.

1999, Paris/Saint-Étienne. *Alberto Giacometti, La collection du Centre Georges Pompidou.* Centre Georges Pompidou.

1983, New York. *Julio González: a Retrospective.* The Solomon R. Guggenheim Museum.

1991, Mönchengladbach. *Katarzina Kobro.* Städtisches Museum Abteiberg.

W. Strzeminski and K. Kobro. *L'espace uniste.* Lausanne, 1977.

Y. A. Bois. "Strzeminski et Kobro: en quête de la motivation." *Critique*, no. 440–41. Paris, 1984.

1991, Marseille. *Laslo Moholy-Nagy.* Musées de Marseille/RMN.

P. Peissi and C. Giedion-Welcker. *Antoine Pevsner.* Neuchâtel, 1961.

1983–84. Berlin /Düsseldorf. *Pablo Picasso. Das Plastische Werk* (cat. W. Spies). Nationalgalerie/Kunsthalle.

S. O. Khan-Magomedov. *Alexander Rodtchenko. The Complete Work.* London, 1986.

L. Zhadova. *Vladimir Tatlin.* London, 1989.

*Essential reading

ARCHITECTURE 1914–1939
"rationalism and modernism"

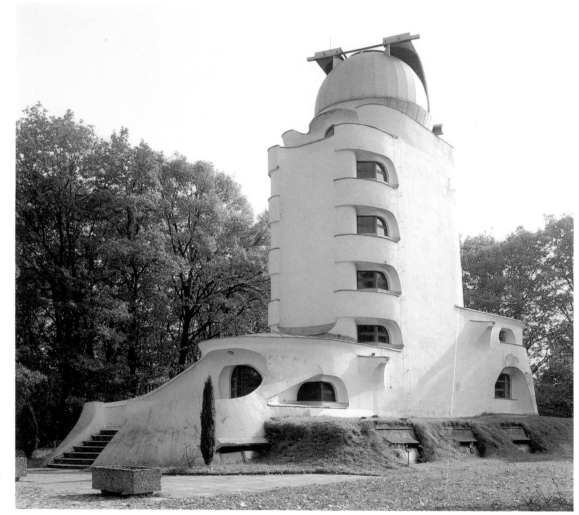

"Fleeting visions"

ERICH MENDELSOHN
The Albert Einstein Observatory, Potsdam
1919–21. © AKG Paris.

From 1908 to 1912, Mendelsohn studied architecture and political economy, first in Berlin then in Munich. Active mainly in Berlin from 1912 to 1933, Mendelsohn was familiar with Der Blaue Reiter, as well as with the Futurist theories of Antonio Sant'Elia. While in the trenches, he made some extraordinary sketches for different building types. In Berlin in 1917, he took part in an exhibition of concrete and steel architecture. In 1919 he was commissioned to design an observatory at Potsdam: the Einstein Tower. The resulting tower gave concrete form to the "fleeting visions" captured in his wartime sketches. The observatory was a state commission designed to test Einstein's Theory of Relativity and quantify some of the phys-

ical relations between space and time and between energy and matter. It also houses an underground laboratory dedicated to spectrometric analysis. A metaphor for the organic, the whole building evokes a moving and flexible "thorax," while the curves of its walls suggest wind-blown sand dunes. Though Mendelsohn hoped to build the tower in reinforced concrete using curved molds, thereby freeing it entirely from the straight line, he had to be content with a brick construction faced with cement.

The end of World War I was followed by a period of reconstruction and the enforced reorganization of the cityscape. New industrial techniques applied to architecture and town planning held the promise of a better world. After the October Revolution, the Russian avant-garde, for instance, developed a vast program based on Malevich's *Arkitektons* and Tatlin's Constructivism. Architects such as Constantin Melnikov were appointed to Vkhutemas and

> > >

> > > put in place the structures required to modernize the country. Although Constructivism had spread throughout Europe by the end of the 1920s, the advent of Stalinism saw it on the back foot in the USSR itself. After traveling extensively throughout Asia and Europe, Le Corbusier finally settled in Paris in 1917 where, together with Amédée Ozenfant, he developed the concept of Purism in an attempt to transcend the conflict between technical progress and artistic invention. In the journal *L'Esprit nouveau*, as well as in the polemical and theoretical texts he wrote at the time, Le Corbusier constructed a veritable formal grammar. He also devised a prototype for mass-produced living units, the Maison Dom-Ino.

During this period Rationalism flourished, while in a different domain the decorative arts were undergoing developments of their own, particularly in France, where industry was being restructured. From 1915, the Compagnie des Arts Français, heirs to the Munich Werkbund, organized what was to become ten years later the famous Exhibition of Modern Decorative and Industrial Arts. A formal and decorative variant or scion of Art Nouveau, whose origins lay somewhere between the French rational tradition and English Arts and Crafts, the 1925 exhibition signaled a desire for a fresh start "to which no copying or pastiche of olden styles would be admitted." The anger of Auguste Perret, and all those who rejected ornament, was understandable, since the modern movement, committed to solving the concrete problems thrown up by the avant-garde, was striving to create "objective" architecture and an "objective" urban fabric. Standardized production and the construction of large-scale social-housing projects at the end of the 1920s led to the concept of the "minimum-income dwelling" and to the rationalism of serial production at the Bauhaus. The creation of the Weissenhofsiedlung (a development of workers' housing) at Stuttgart in 1927, and the founding of the International Congress of Modern Architecture (the French acronym is CIAM) in 1928 provided further evidence of the importance attached to the > > >

"A reinforced-concrete Sainte-Chapelle"

AUGUSTE PERRET
*Notre Dame du Raincy,
Le Raincy*
1922–23.
Photo F. X. Bouchard/Archipress.

With Auguste Perret's Théâtre du Champs-Élysées, reinforced concrete had come of age. His Church of Notre Dame du Raincy, however, is more like its radical manifesto. Following on from a number of industrial buildings, Le Raincy manifests the mastery Perret had acquired in utilitarian architecture. Built in thirteen months to a tight budget, the church comprises a 53-meter nave, vaulted toward the choir, flanked by two nar-rower aisles vaulted transversally, the whole carried on fluted columns without base or capital. The structure is encased in openwork *claustra* built in concrete and tinted glass brick. The latter reinterpret Gothic stained-glass windows, earning the church the nickname the "reinforced-concrete Sainte-Chapelle" after Paris's medieval masterpiece. Perret designed several other churches along similar lines, before reverting to plans of a Neo-Classical stamp, such as the timber-built Theater for the 1925 Paris Exhibition of Decorative Arts. He also produced numerous constructions, such as the Paris museum of civil engineering. He was involved in the celebrated postwar redevelopment of Le Havre, whose monumental character was instrumental — through its powerful aesthetic of reinforced concrete — in breathing fresh life into the Classical French tradition.

"Kiosks" against "Organisms"

MARCEL CHAPPEY
*Project for a
confectionery kiosk*

CONSTANTIN MELNIKOV
*Soviet Pavilion. 2 projects for
the Exposition Internationale
des Arts Décoratifs et
Industriels Modernes, Paris.*
1925. © Harlingue-Viollet.

Marcel Chappey, who won a first prize at the competition for "kiosks adapted to various uses" (never built), was just one of a host of little-known architects who participated in the 1925 Paris Exhibition of Decorative Arts. His design exemplifies a style which became omnipresent, notably in the field of decorative arts, while the spirit of the international avant-garde was making itself felt next door in Le Corbusier's "Esprit Nouveau" pavilion, as well as in the Russian design here. The Soviet pavilion earned Konstantin Melnikov, who taught at the Vkhutemas (Higher Technical-Artistic Studios), world renown. The whole building is traversed by the diagonals of the staircase and the roofs are pitched in diverse directions. After the exhibition, the dismantled pavilion was re-erected to serve as a club for workers' associations.

COUPE. PLAN.

FAÇADE PRINCIPALE

"THE MOST EFFECTIVE MEANS OF PRODUCTION DERIVE

"A modern city"

ROBERT MALLET-STEVENS
Rue Mallet-Stevens, Paris
Opened 1927.
© Harlingue-Viollet.

Mallet-Stevens, an architect and interior designer who was related to the Brussels Stoclet family (for whom Josef Hoffmann designed the famous Palais), graduated from the École Spéciale d'Architecture in Paris in 1906. By 1911 his studies and plans were being published and he exhibited at the Salon d'Automne from 1912. The war interrupted his work, but in 1921 he issued a selection of plates entitled *Une Cité Moderne* (A Modern City) inspired by Josef Hoffmann and other Austrian models. From 1924 on, Mallet-Stevens' plans were responses to concrete programs and he began to advance toward a synthesis of modern technology and fashionable aesthetics. Associated with Fernand Léger and receptive to the lessons of De Stijl's

1923 exhibition in Paris, he worked on many projects for private individuals (such as the art-loving Noailles family) and became a prominent figure on the international avant-garde scene. The project that he completed in Paris, named with a hint of vanity for himself, is the archetype of a modern, spare, refined style, with its elegant, graphic combination of vertical and horizontal lines. Rob Mallet-Stevens also built a house and workshop for himself, as well as a house-cum-studio next door for the sculptor brothers Jan and Joël Martel. In 1924, he taught at the École Spéciale d'Architecture. Mallet-Stevens also designed industrial furniture and participated with Le Corbusier, Charlotte Perriand and others in the founding of the Union of Modern Artists.

"A machine for living"

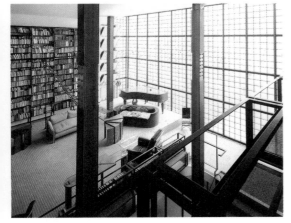

PIERRE CHAREAU
Living room,
Maison de Verre, Paris
1928–32. Photo
G. Meguerditchian/Centre
Georges Pompidou, Paris.

Pierre Chareau, who worked for some time as a designer in an English interior decorating firm, did not establish his own practice until after the war. In 1919, Doctor Jean Dalsace and his wife commissioned him to redecorate the interior of their Paris apartment. At the 1925 Exhibition of Decorative Arts, Chareau presented two suites of furniture. With the wrought-iron craftsman Louis Dalbet, he made a number of objects in alabaster and metal, designing the Delsaces's "modern living space with professional premises" on rue Saint-Guillaume in Paris in collaboration with the Dutchman Bernard Bijvoet. The glass wall and the subtle use of internal space make the "Glass House" a veritable "machine for living." The floors were covered in wood for the private apartments, ceramic for the semi-public areas and rubber for the public spaces. The fittings consisted of mass-produced elements that are an integral part of the structure. The load-bearing skeleton facilitates an open interior, with swing-doors, hanging screens and sliding partitions allowing the spaces to be configured in various ways.

"Metropolis"

WILLIAM VAN ALEN
Chrysler Building, New York
1927–30. © Archipress.

A symbol of modernity and progress, the skyscraper appeared in New York and Chicago around 1870 and continued to evolve in the United States throughout the 1930s. It marked the collaboration between architect and engineer, an example being the utilization of steel and mechanical construction equipment that enabled the installation of elevators. It was the very essence of a modern construction, perfectly captured in the charcoal drawings executed by Hugh Feriss for "Metropolis." It suffered from the aftershocks of the 1929 Wall Street Crash, though the 1930 Chrysler Building, with its mix of Art Deco and modernism, and the Empire State Building completed the following year, remain its greatest achievements. Subjected to the tightest regulations, the Chrysler Building is constructed in sections gradually set back from each other as the construction ascends. Up until the 1950s, when Mies van der Rohe transformed its structure, the skyscraper underwent a com-

plex evolutionary process that was linked to the overall planning of the city. A quintessential example was the Rockefeller Center (1931–39), built just as the International Style emerged.

FROM RATIONALIZATION AND STANDARDIZATION" CIAM

> > > unifying of art and industry. At the fourth meeting of the CIAM in 1934, Le Corbusier drafted the Athens Charter, in which the notions of the contemporary city and of his own *Ville Radieuse* presuppose a vision of the cityscape on a nationwide scale. The International Style established itself, via the United States, as an international movement. In 1932 (at the suggestion of the critic Henry-Russell Hitchcock, together with the architect and Le Corbusier promoter extraordinaire Philip Johnson), the Museum of Modern Art in New York, a mere three years after moving to new premises, staged its first exhibition of European architecture, thus presenting a viewpoint that had material repercussions on the development of a specific style. A canon was established that gave primacy to composition in terms of space and module rather than mass. The International Style, however, neglected town-planning, economic and social considerations and was preoccupied solely with the aesthetic aspects of architecture. Deliberately turning a blind eye to these topics, the movement opened the door to the advent of the skyscraper and to the growth of an American architecture furthered by exiles such as Walter Gropius and Ludwig Mies van der Rohe. Classicism and regionalism alike each sought to dictate their own laws, however. In contrast to the rationalism which attained perfection in a geometric architectural aesthetic devoid of ornament (Perret for example wanted to "ban Art Deco"), the 1930s also saw the emergence and proliferation of often contradictory styles and forms. Traditional values were espoused in reaction to the excesses of modernism. The monumental nature of many architectural projects undertaken in various nations oscillated between the lure of the "lost model" and the development of other, more typically totalitarian programs. In Berlin, Albert Speer started laying out the design of the major axis of the Reich's capital with Hitler. In Paris, German and Stalinist projects could be compared at the 1937 World's Fair. Architecture and town planning were to leave far behind the successive dreams of the various members of the CIAM and the Union of Modern Artists. <

98

"It's impossible to progress if you look backwards

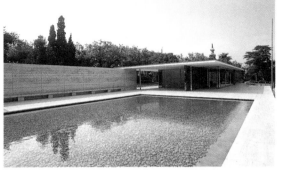

LUDWIG MIES VAN DER ROHE
German Pavilion, International Exhibition, Barcelona
1929. © AKG.

The undisputed master of the Modern Movement, Mies van der Rohe is one of the major figures of twentieth-century architecture. Eager to combine Viollet-le-Duc's rationalism with the eclectic Neolassicism of Karl Friedrich Schinkel, he established his own practice in 1913. In his 1924 manifesto *Baukunst und Zeitwille* (Architecture and the Will of the Times), he stated: "It is impossible to make progress if you look backwards." In 1923, he became president of the Novembergruppe, an important militant artistic group. He was a co-founder of The Ring, an organization of radical architects. Mies condensed the ideas of De Stijl and Suprematism in his quest for order, be it structural or monumental. He was vice-president of the Deutscher Werkbund industrial association, for which he organized the important exhibition in Stuttgart in 1929. He designed the master-plan for the Weissenhofsiedlung project for low-cost housing and was director of the Bauhaus from August 1930 to August 1932. The German Pavilion for the 1929 International Exhibition in Barcelona had worldwide repercussions. Constructed according to a grid of eight chromium-cased steel columns, it has freestanding panels, thereby creating a separation between post and wall. The Pavilion, like Frank Lloyd Wright's Prairie Houses, was clearly influenced by Constructivism. With its combination of colored marble and metal, tinted screens, swimming pool and pond, the Pavilion, which also contained furniture designed by Mies, was tantamount to a manifesto.

"Promenades architecturales"

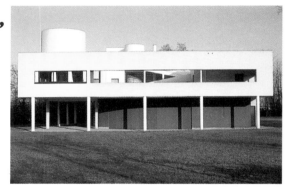

LE CORBUSIER (CHARLES-ÉDOUARD JEANNERET, KNOWN AS)
Villa Savoye, Poissy
1929.
Photo Franck Eustache/ Archipress.

After a first major study trip to Italy in 1907, in the years 1908–9 Le Corbusier worked for the brothers Perret in Paris, familiarizing himself with the uses of reinforced concrete. There then followed a number of private residential accounts and a collaboration with Peter Behrens in Berlin. He made a further research trip to the Far East and then traveled throughout Europe. Greatly struck by his discovery of the Mediterranean and of Athens, Le Corbusier returned to study painting under the future Purist, Amédée Ozenfant. Together with Paul Dermée, the two men founded the journal *L'Esprit nouveau,* of which twenty-eight issues were published between 1920 and 1925. There then followed the "laboratory years" and the publication of his early theoretical works, among them *Vers une architecture (Towards a New Architecture;* translated 1931), in which he laid down a number of the precepts he was to develop in later years. The principle of the *plan libre* (free plan), that allowed for considerable fluidity in the use of space, the conception of *promenades architecturales* (architectural walkways), and the possibility of separating structure and wall thanks to concrete made it possible to divide up the various spaces. After designing the Villa Savoye, he was invited by the Deutscher Werkbund to write the "Five Points of a New Architecture," in which he expanded on ideas which were to be put into practice in numerous later projects.

"Gravity-defying"

FRANK LLOYD WRIGHT
Edgar Kaufmann House,
"Fallingwater," Bear Run,
Pennsylvania
1934–37.
Photo P. Cook/Archipress.

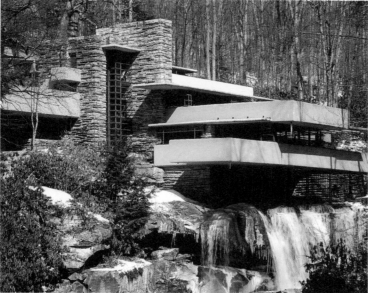

From 1913, influenced by Cubism, Frank Lloyd Wright's style evolved. After a period of relative obscurity in the 1920s, Wright returned to prominence in the 1930s with the house known as Fallingwater for the Kaufmann family at Bear Run, Pennsylvania. Unifying the site and the technology of architecture in what was a gravity-defying construction, Wright pushed the findings of Richard Neutra and Mies van der Rohe to a logical extreme in a rhythmical contrast that sought to highlight differences between materials, such as white concrete and local brick and stone. In the fullness of the New Deal,

Wright developed low-cost "Usonian" houses based on vernacular American architecture. These were intended to improve the social habitat and to be adapted to both the site and locally available materials. Inspired by the

English garden suburb, similar concepts emerged at the end of the 1930s in other contexts, notably in the ideas of Richard Buckminster Fuller with his Dymaxion House, a "machine for living" initially conceived in 1927.

"An organic principle"

ALVAR AALTO
Villa Mairea,
Noormarkku, Finland
1938–41.
Photo Guimault/Centre
Georges Pompidou, Paris.

Alvar Aalto's oeuvre falls into three phases. The borrowings from Nordic Classicism in his early career were rooted in Finnish "national Romanticism." This was succeeded by a Functionalist period, and finally by the affirmation of the "organic" principle that was to "create a more intimate relationship between man and nature." Throughout, Aalto's work is stamped with a desire to overcome the conflict between Rationalism and Romanticism. Standing in the middle of a clearing bordered

by pines, the Villa Mairea, built with the assistance of his wife Aino, demonstrates Aalto's desire to unite highly contrasting materials in a sensitive, tactile way. The Villa—built at a time when concrete was highly popular—was also intended to bring out the value of wood, and is constructed in a sub-

tle blend of brick, faced stonework and pine timber. The building, which seems to be in osmosis with the surrounding site, suggests a multiplicity of contrasting images, from the organic and geological volume of the whole, to the monolithic and artificial form of the sauna and the prowlike studio.

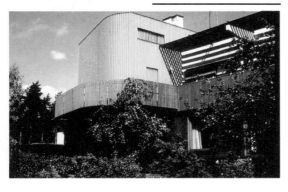

"A Regionalist Bible"

CHARLES LETROSNE
Murs et toits pour les pays de chez nous, Paris
1923–26. (Preface by Léandre Viallat, Éditions Dan Niestlé).

Regionalist architecture is a twentieth-century invention. Though claiming to be a break with the centralized outlook, Regionalism in France actually gained ground not so much in the provinces directly, but more as a result of shifts in population brought about by mass tourism, social change and even armed conflict. Regionalism is all too often confused with a penchant for folklore, but in truth it is a paradox vehicling an architectural history of its own that combines the written word with the image and blends eclectic reference with quotation. This is the backdrop to the publication in three volumes of the rustically if polemically entitled "Walls and Roofs for Our Country's Regions"

by Charles Letrosne, "a substantial and succulent attempt to define the regions of France through the buildings of France." In this veritable "Regionalist Bible," traditional values confront international Modernism head on. Initially a marginal phenomenon, Regionalism was little in evidence at the 1925 World's Fair in Paris. By time of the 1937 World's Fair in Paris, Regionalism had become a broader movement and received greater media coverage. Despite being adopted as the official line by the pro-German regime of Vichy, the debate over Regionalism continued to rage.

THE FOREMOST PRIORITY OF OUR TIME" Mies van der Rohe

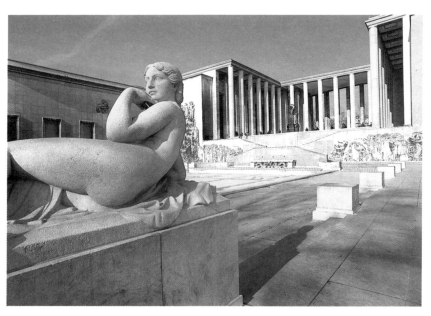

"Between classicism and modernity"

**JEAN-CLAUDE DONDEL,
ANDRÉ AUBERT,
PAUL VIARD,
MARCEL DASTUGUE**
*The Two Museums
(Musée d'Art Moderne,
Musée d'Art Moderne
de la Ville de Paris)*
1934–37.

Following a competition marked by Le Corbusier's attack on the academic style of the winning projects for the 1937 World's Fair in Paris, the design of the state museum of modern art and the museum for the City of Paris was awarded to J.-C. Dondel, A. Aubert, P. Viard and M. Dastugue. The specifications stipulated that the two museums were to be erected in close proximity, and the architects decided to link the buildings by means of a portico and a stepped esplanade that could be used for the open-air display of sculpture. Built in reinforced concrete, both edifices were faced with stone and their sobriety contrasts with Pierre-Georges Jeanniot's stone reliefs that adorn the wall of the monumental staircase. The antique Classical spirit is counterbalanced by the sparseness of frontages that seem to be something of a sop to Modernism. Combining monumentality and rationalism, the "Two Museums project," like the Palais de Chaillot that was the dominant presence at the 1937 World's Fair, hark back to both the Roman epoch and to the "splendid periods of French Renaissance and seventeenth-century architecture."

"Freed from the subjugation of weight"

**GIOVANNI MICHELUCCI
(AND THE GRUPPO
TOSCANO)**
New Station, Florence
1933–36.
Photo F.-X. Bouchart/
Archipress.

In 1933, Giovanni Michelucci won the competition for the new Stazione Santa Maria Novella in Florence. The project was completed with the assistance of the Gruppo Toscano. A storm of protest was stirred up at the time at the prospect of a modern building in the heart of historic Florence and so near the great fourteenth-century Dominican church of the same name. The station was, however, the essence of discretion and attempted above all to blend in with the surroundings. Extensive use was made of stone and the building was given a low-slung profile with a glazed roof supported by a large metal skeleton. Michelucci continued to work in a similar vein, a very 1930s amalgam of Classicism and Rationalism, designing the Palazzo del Governo at Arezzo (1936) and a number of villas. He was also heavily involved in the reconstruction of Florence after the German bombing of the city at the end of World War II. A contemporary of Rationalist architect Giuseppe Terragni, who described architecture as a "sign of a civilization rising up in clarity, simplicity and perfection," Michelucci here purposefully illustrates an alliance between Modernism and Classicism which modern architect Alberto Sartoris has described as "nimble architecture, freed from the subjugation of weight."

"ARCHITECTURE IS DESIGNED IN THE WAY

1924–30.
J. J. P. Oud. Kiefhoek quarter, Rotterdam.
Documentation Générale, Centre Georges Pompidou, Paris.

1925.
Walter Gropius.
Bauhaus, Dessau.
AKG Paris.

1926.
Hugh Ferriss.
View of the Business Sector, imaginary plan. Charcoal drawing. Documentation Générale, Centre Georges Pompidou, Paris.

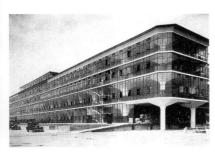

1930–32.
Sir Owen Williams.
Boots Factory, Beeston, Great Britain.
© RCHM, Crown.

Chronology 1914–1939

In keeping with the subject of the chapter, this chronology is largely devoted to events in Europe and the United States. Sections in bold refer to artists mentioned in the main text and captions.

1914
Cologne: Deutscher Werkbund exhibition
Le Corbusier invents the Dom-Ino system.

1917
• Bruno Taut sets up the Arbeitsrat für Kunst.
• Berlin: Max Reinhardt's theater by architect Hans Pölzig.
• Weimar: Bauhaus founded.
Paris: Le Corbusier settles in the city. With Amédée Ozenfant and Paul Dermée, he develops the concept of "Purism."

1919
Potsdam: Albert Einstein Observatory (1919–21) by Erich Mendelsohn.

1920
• Malevich designs *Planits* and *Arkitektons*.
• Tatlin designs the Monument to the Third International.
Le Corbusier, Ozenfant and Dermée set up the journal *L'Esprit nouveau*.

1921
• At the request of interior designers Louis Süe and André Mare, poet Paul Valéry publishes *Eupalinos ou l'Architecte*.
Robert Mallet-Stevens issues a collection of plates entitled *Une cité moderne*.

1922
Le Raincy: Notre-Dame du Raincy by Auguste Perret.

1923
Le Corbusier publishes – and designs the La Roche-Jeanneret House in Paris.

1924
• Utrecht: Schröder House by Rietveld.
Robert Mallet-Stevens designs the decor for Marcel L'Herbier's *L'Inhumaine*.
Emergence of Regionalist architecture.

1925
• Rotterdam: Café de Unie by J. J. P. Oud.
• Newport Beach, California: Lovell Beach House by Rudolph Schindler (1925–26).
Paris: Exposition des Arts Décoratifs et Industriels Modernes.

1926
• Fritz Lang makes *Metropolis* with its vision of a future city.
Dessau: Bauhaus school, administrative building by Walter Gropius.

1927
• Richard Buckminster Fuller produces sketches for the Dymaxion House.
Le Corbusier sets out his *Five Points for a New Architecture*.
Italian architects found Gruppo 7.
Stuttgart: Weissenhofsiedlung workers' housing development by the Deutscher Werkbund.

1928
• Los Angeles: Health House by Richard Neutra for Philip Lovell.
• Henry-Russell Hitchcock writes about the International Style in the journal *Hound and Horn,* and then in *Modern Architecture, Romanticism and Regeneration,* published in 1929.
• Prague: Bata Department Store by Ludvik Kysela.
Brno (now Czech Republic): Tugendhat House (1928–30) by Ludwig Mies van der Rohe.
Garches: Stein-de-Monzie (Les Terrasses), villa by Le Corbusier.
Paris: Maison de Verre by Pierre Chareau (1928–32).
Switzerland: CIAM (Congrès Internationaux d'Architecture Moderne).

1929
• The Soviet government takes the decision to build the mining city of Magnitogorsk.
• Barcelona: creation of the GATEPAC group (Group of Catalan Artists and Technicians for the Progress of Contemporary Architecture) centered around José Luis Sert.
• New York: Daily News Building (1929–30) by Raymond Hood and John Mead Howells.
Paris: Salvation Army Hostel (1929–33) by Le Corbusier and Pierre Jeanneret.
Helsinki: Paimio Sanatorium (1929–33) by Alvar Aalto.
Barcelona: German pavilion by Mies van der Rohe.
UAM (Union des Artistes Modernes) founded.

OF THE SLEEP OF REASON" Terragni

1930–31.
Eileen Gray.
Entrance to the
bathroom in a
studio-flat,
rue Chateaubriand,
Paris.
Documentation
Générale, Centre
Georges Pompidou,
Paris.

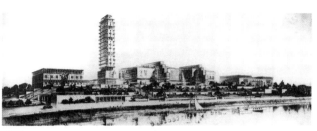

1934.
Aleksandr, Leonid, and Victor Vesnin. Urban rehabilitation plan,
Kotelnitcheski Quay, Moscow. Architecture Museum, Moscow.

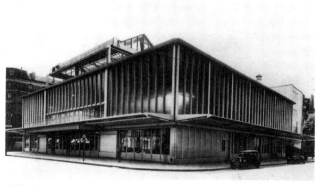

1937–39.
Eugène Beaudouin, Vladimir Bodiansky, Marcel Lods
and Jean Prouvé. Maison du Peuple, Clichy.
Documentation Générale, Centre Georges Pompidou,
Paris.

1937.
Overall view of the
Paris World's Fair.
© Cap-Viollet, Paris.

Chronology 1914–1939

1930
• Villejuif: Karl-Marx School by André Lurçat.
• Beeston, England: Boots Factory (1930–32) by
Sir Owen Williams.
**Dessau: Mies van der Rohe appointed head of
the Bauhaus.**

1931
• Bagneux: Champ des Oiseaux estate by Eugène
Beaudouin and Marcel Lods.
• Italian architects found MIAR (Movimento
Italiano per l'Architettura Razionale).
New York: Rockefeller Center (1931–39).

1932
• Publication of Alberto Sartoris' *Gli Elementi
dell'Architettura funzionale.*
• Como: Casa del Fascio (1932–36) by Giuseppe
Terragni.
• USSR: Stalin sets up the Union of Soviet
Architects.
**New York, MoMA: "Architecture in Europe Since
1922" exhibition.**
**Philip Johnson and Henry-Russell Hitchcock
publicize the term "International Style."**

1933
•Drancy: Cité de la Muette estate by Eugène
Beaudouin and Marcel Lods.
• London: MARS (Modern Architectural Research
Group) established.
Le Corbusier draws up the Athens Charter.

1934
• United States: National Housing Act furthers
subsidized building of social housing projects.

1937
• Germany: Albert Speer is named inspector
general of buildings. Greater Berlin project.
**Paris: international exhibition of art and
technology.**
**Clichy: Maison du Peuple (1937–39) by Jean
Prouvé, Eugène Beaudouin, Marcel Lods and
Vladimir Bodiansky.**

1938
**Noormarkku, Finland: Villa Mairea by Alvar
Aalto (1938–41).**
**A year after Walter Gropius and Marcel Breuer,
Mies van der Rohe leaves Germany for the
United States.**

1939
• New York: World's Fair at Flushing Meadow,
Queens.

**Studies on Architecture
Dictionaries and
General Works**

Y. Brunhammer. *1925.* Paris,
1976.*

P. Collins. *Splendeur du béton.*
Paris, 1995.

W. J. R. Curtis. *Modern
Architecture since 1900.* London,
1996.

K. Frampton. *Modern
Architecture: A Critical History.*
New York, 1992.*

W. Gropius. *Scope of Total
Architecture.* New York, 1975.

H. R. Hitchcock and P. Johnson.
The International Style. New
York, 1996.

H.-U. Khan. (ed. P. Jodidio).
*Le Style international, le
modernisme dans l'architecture
de 1925 à 1965.*
1998, Cologne.

Le Corbusier. *Essential Le
Corbusier: L'Esprit Nouveau
Articles.* London, 1998.

Le Corbusier. *The City of
Tomorrow and Its Planning.*
New York, 1987.

L. Munz and G. Kunstler (eds.).
*Adolf Loos, Pioneer of Modern
Architecture.* London, 1966.

T. Smith. *Making the Modern.*
Chicago, 1993.

R. Stern. *New York, 1930.* New
York, 1987.

M. Tafuri and F. Dal Co.
Architecture contemporaine.
Paris, 1991.*

The International Style (exh.
cat.). Exhibition 15 and The
Museum of Modern Art. New
York, 1992.*

J. C. Vigato. *L'Architecture
régionaliste.* Paris, 1994.

J. Walker. *Glossary of Art,
Architecture and Design since
1945.* Boston, 1992.

**Monographs and
catalogues on the
architects mentioned**

1998, New York. *Alvar Aalto.*
The Museum of Modern Art. *

1993, Paris. *Pierre Chareau.*
Centre Georges Pompidou.*

Le Corbusier, une encyclopédie.
Centre Georges Pompidou,
Paris, 1987.*

J.-L. Cohen. *Ludwig Mies van
der Rohe.* Paris, 1994.*

D. Deshoullières. *Robert
Mallet-Stevens architecte.*
Brussels, 1980.*

S. Khan-Magomedov.
Konstantin Melnikov. Moscow,
1970.*

B. Zevi. *Erich Mendelsohn,
opera completa.* Milan, 1970.*

F. Borsi. *La Città di Michelucci.*
Pistoia, 1976.*

J. Abram. *Auguste Perret et
l'école du classicisme structurel.*
Nancy, 1985 (2 vols.).*

1994, New York. *Frank Lloyd
Wright Architect.* The Museum
of Modern Art.

* Essential reading.

UNITED STATES

"from Abstract Expressionism to Minimal art"

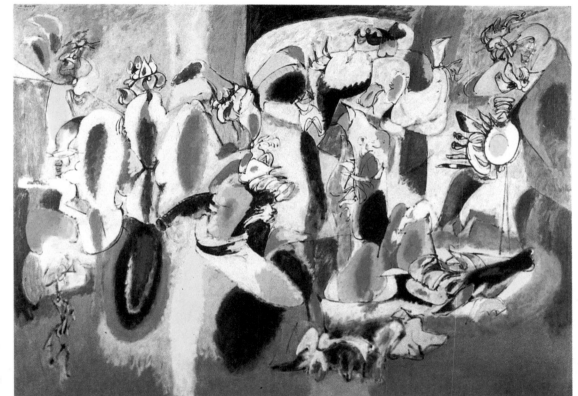

"Hybrid cryptograms"

ARSHILE GORKY
The Liver is the Cock's Comb
1944.
Oil on canvas, 180 x 249 cm.
Albright-Knox Art Gallery,
Buffalo.
© Albright-Knox Art Gallery.

Whether he is considered as the last Surrealist or the first Abstract Expressionist, Armenian-born Arshile Gorky certainly provided a crucial link between the Europe he fled in 1920 and his new home in the United States. A protégé of André Breton, who coined the term "hybrid" to describe images that swing from figuration to abstraction and back again, Gorky is the painter of forms which "result from the contemplation of a natural event as it conjoins with the flux of memories from childhood and elsewhere." He met the Surrealists (initially the Chilean Roberto Matta and André Masson, both refugees in New York) and adopted the principles of automatic drawing, shaking off the thrall of Chagall, Kandinsky, Picasso and Miró. Rectilinear structure was supplanted by a subtle type of biomorphism in a blend, as William Seitz has put it, of thoracic projections, sensual masses and floating membranes. His canvases became "luxuriant," meaning being transmitted by a tangle of signs and expressive twists in what Breton termed "cryptograms." The brilliant handling of canvases such as *The Liver is the Cock's Comb* was followed by more dilute works introducing "dying" forms. In this way, Gorky undertook the leap from Surrealist imagery to an abstract aesthetic that allowed for the freeing of concealed energies.

It has been customary to treat American art of the first half of the century only in so far as it relates to developments in Europe. After the first really independent group, the realist Ashcan School, significant figures such as Georgia O'Keeffe, Arthur Dove and Charles Demuth sought to define American painting, but the close links between Alfred Stieglitz's gallery "291" and his journal *Camera Work* fostered—up to and >>>

> > > beyond the Armory Show organized in 1913—a cult of European artistic supremacy. Large-scale collections of European avant-garde art, such as those of Walter Arensberg, Katherine Dreier, Dr. Barnes and the Paris-based Steins, numerous exhibitions and the formation of groups like the Synchromists (with Stanton Macdonald-Wright and Morgan Russell), as well as the presence of Man Ray whom Marcel Duchamp had encouraged to go to Paris in the 1920s, were all early harbingers of a recognition of American art in its own right. After World War I, two currents dominated an American artistic scene in which the notions of avant-garde and academicism as well as the relationship between fine and applied arts already operated on a different footing from that in Europe. Charles Demuth, Stuart Davis and Gerald Murphy developed a suitably "American" iconography, while Morton Schamberg and Man Ray exalted the selfsame "beauty of indifference" as Marcel Duchamp. Meanwhile, Charles Sheeler forged a Precisionist imagery lying halfway between painting and photography that developed into a form of realism influenced by Shaker designs. Ben Shahn and above all Grant Wood, on the other hand, celebrated the agrarian values of the Midwest and fostered through a nationalist message the furtherance of "American painting." In his large-scale murals of the 1930s, Thomas Hart Benton presented a vibrant image of life in the United States, but it was Edward Hopper alone who, through a subtle blend of reality and artificiality arranged in a cinematographic or theatrical manner, created an image for the nation instead of merely mirroring the American scene.
In 1929 the Museum of Modern Art in New York was founded and in the 1930s the Federal Arts Project, employing Arshile Gorky, William Baziotes, Adolf Gottlieb, de Kooning and Jackson Pollock. But it was only with World War II and the mass arrival of artists from all > > >

104

"Two totemic figures"

JACKSON POLLOCK
Male and Female
1942.
Oil on canvas, 186 x 124.4 cm.
Philadelphia Museum of Art.

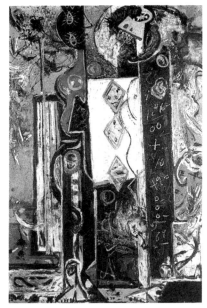

In the works in his early shows at the Art of the Century Gallery, Pollock had put into practice a number of Surrealist precepts: anatomical parts, heads, ideographs, Kabalistic symbols, totemic personae occupied canvases which grew ever larger in scale. A student of Jung's theory of the collective unconscious, Pollock sought to create a visual and symbolic order in which a pulse of free-floating signs dictated the disposition of the entire canvas. A former student of muralist David Siqueiros and of Regionalist Thomas Hart Benton, Pollock forged a synthesis between rhythm and psychic automatism. *Male and Female* is organized in vertical planes with the two archetypal beings standing among what were for the most past indecipherable "graffiti." "The vehement handling," as Denys Riout has written, "makes the two totemic figures appear barbarously violent ...The graffiti or 'gestural' marks, far from running counter to the expression of the subject, are evidence of the personal appropriation of a 'myth' adopted by an individual who devotes the best of his energies to making it appear."

"My paintings have no center"

JACKSON POLLOCK
Number 1
1949.
Enamel, metallic paint on canvas, 160 x 259 cm.
Museum of Contemporary Art, Los Angeles.
© Museum of Contemporary Art/SPADEM.

Pollock's career from 1947 to 1951 was characterized by two radical shifts. One was of a structural nature and was linked to the principle of all-over painting; the other was connected to the wholly novel painting technique of dripping. Pollock thus broke totally with the primacy of the center of the image over the edges, as well as with the effects of perspective and the hierarchy between ground and form that have dominated the history of Western painting. He himself declared in 1951: "My paintings have no center," and hence painterly interest is equally distributed over all areas. The scattering of skein-like signs "all over" the surface of a canvas painted flat on the ground, and the lack of direct contact between painter and canvas through the practice of free and dance-like Action painting, resulted in the recognition of the artist with his trailblazing new technique. Although Pollock still thought of his paintings as having a top and a bottom and a right and a left, and even continued to sign them so as to indicate how they should be hung, "dripping" was still a practice of great immediacy, accentuated by the use of industrial fluid paints projected with "sticks, trowels or knives" to literally inseminate the waiting vessel of the canvas.

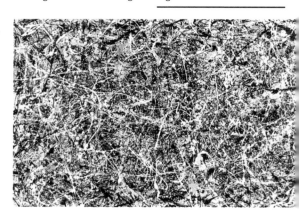

"ON THE FLOOR I AM MORE AT EASE. I FEEL . . .

"The figure resurfaces"

JACKSON POLLOCK
The Deep
1953. Enamel paint and metallic paint on canvas, 220.4 x 150.2 cm. Centre Georges Pompidou, MNAM, Paris. Photo Centre Georges Pompidou.

Around 1951, Pollock temporarily interrupted his classic dripping period in a most radical way by reintroducing figurative elements in pictures executed on raw canvas. Keen once more to confront the image of Picasso, Pollock returned to the figure. The paintings that followed bear witness to a process of unrelenting self-interrogation. In a way that short-circuits the misguided reading of his art as a purposeful progression,

Pollock in fact produced work whose style and handling vary widely. Similar in theme to his turbulent early works and, like them, reconnecting with the subject (albeit diffuse), Pollock's idea was that since painting had become more direct, more ways of producing interesting results had appeared. *The Deep* is an unusual later work. Here Pollock returns to a more "classic" organization, in which form and ground can be readily distinguished. Color too has become metaphorical, a milky white substance contrasting with a black abyss suggestive of a space beyond the surface. The work reaffirms the power of illusion and uncertainty in what is not so much the exemplification of a method Pollock had arrived at five years before as the enactment of all the doubts and questions concerning being that arise from his art.

"The impact of a Social Realism"

JOSÉ CLEMENTE OROZCO
Landscape of Peaks
1948. Tempera and oil on masonite. Museo de Arte Alvar and Carmen T. de Carrillo, Mexico City. © B. Hatala/Centre Georges Pompidou.

In the 1930s, certain American artists such as Ben Shahn incorporated a political dimension into their art. In this regard, it is difficult to exaggerate the impact of the major exponents of American Social Realism at the time. These were known as the Mexican Muralists and included José Clemente Orozco, David Alfaro Siqueiros and Diego Rivera. The commitment of Mexican muralists to the ongoing revolution taking place in their native land meant that they were invited to undertake many mural decorations, and these were an important inspiration to North American painters. Some, like Orozco, were given important public commissions in the United States, such as the *Epic of American Civilization* cycle at Dartmouth College, New Hampshire (1934). The decoration of the Rockefeller Center, New York, was entrusted to Diego Rivera in 1933, though it was removed because of its explicit

"One's own being is revealed"

ROBERT MOTHERWELL
Elegy to the Spanish Republic, 34
1953–54. Oil on canvas, 202 x 253 cm. Albright-Knox Art Gallery, Buffalo. © Albright-Knox Art Gallery.

With Pollock, Motherwell was instrumental in reshaping the relationship between American and European painting. A student of aesthetics, Motherwell brought to the New York art scene a vivid awareness of its historical context and a conscious effort to resituate the history of modern American art in the "history of modern freedom." Finely attuned to the radical nature of the European avant-garde, he declared that the "psychic improvisation" of automatism was less fruitful as an unconscious impulse than as an artistic tool. As an expression of his unease with the civilized world, Motherwell embarked on a cycle of canvases on the revolutionary figure of Pancho Villa that were forerunners to the *Elegies* he commenced in 1949. "The Spanish elegies are not 'political,' they are my own unwavering reference to a dreadful death." In their deliberate massiveness, the "Stonehenge"-like blocks in the many *Elegies* provide a marked contrast to the aerial dimension of Pollock's work. Broad swathes of pigment are evocative of the Mediterranean landscape and culture that were such a profound source of visual and symbolic inspiration for Motherwell.

support for Marxist-Leninism. Both the work of these Mexican artists and their political engagement provided stylistic examples that proved significant at the dawn of truly American painting. Their path was followed by Pollock and it allowed him to achieve exactly the formal and symbolic synthesis he was searching for at the time.

MORE A PART OF THE PAINTING" Pollock

> > > over the world that America began, as it were, to purloin the idea of modern art. The younger generation began to experience the impact of avant-garde masters whose work, if still vigorous, had been diluted through the slavish copying prevalent in interwar America. This new generation of American artists tried to address head on questions of the meaning and purpose of art in a domestic context. Clement Greenberg, in striving to provide a basis for the New York artistic experience, sparked off a critical, formalist and pragmatic analysis of the European arena, urging the avant-garde to defend itself against any deterioration into kitsch. The émigré Russian painter John Graham, in his *System and Dialectics of Art* published in 1937, advocated a notion of modern art in which thought, feeling and automatic writing would prevail over more traditional approaches. There thus arose the somewhat paradoxical term, "Abstract Expressionism," in which the content of a work of art was to have no relation to the motif (i.e. to the thing represented). Gorky, de Kooning, Pollock, Motherwell, Franz Kline, Barnett Newman, Clyfford Still and Rothko among others gradually built up a nonrealistic pictorial language that was to treat of those universal concerns that they considered (with to say the least ambivalent concision) had been unduly neglected by European modern art. Between 1930 and 1947, Jackson Pollock combined influences from Picasso and Masson with an interest in Native American art and the Mexican Muralists in an effort of redefine both the subject and the practice of painting. It was from Pollock's drippings—the result of an immediate and direct engagement with space and time—that Action painting stemmed. Much vaunted by the critic Harold Rosenberg, such work contrasted with post-Pollock Color Field (with Newman, Rothko and Still) as defended by Greenberg. In the depths of the Cold War, Abstract Expressionism itself was promoted by the American administration > > >

106

"One of the mythmakers"

CLYFFORD STILL
1947-H nº 2
1947.
Oil on canvas, 162 x 104 cm.
The Menil Collection, Houston.
© Centre Georges Pompidou.

By the end of the 1940s, in common with many other Abstract Expressionists, Clyfford Still was undertaking work of mural-like proportions. Still used heavy impasto and his works are reminiscent of strips of material peeled off a surface over which a single color predominates. As with Motherwell, Still's space is scenically lit in vivid colors and forms suggestive of a conflagration. A cofounder of Color Field painting with Newman and Rothko, Still belongs to the generation of so-called "mythmakers" of American painting. Spontaneity was an important ingredient in Still's pictures, which are largely monochromatic, and the artist dedicated his work to anyone who "accepts total responsibility for what he executes." Still was keen to emphasize the physical presence of the picture. "When I expose a painting I would have it say: 'Here I am, and this is my presence, my feeling, myself.'"

"Tabula rasa"

FRANZ KLINE
New York
1953.
Oil on canvas, 200.6 x 125.5 cm.
Albright-Knox Art Gallery,
Buffalo.
© Albright-Knox Art Gallery.

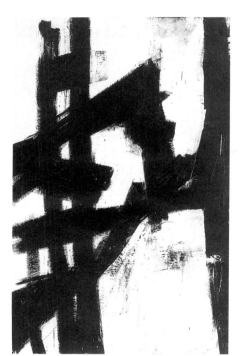

At the beginning of the 1950s, Franz Kline rejected figuration and developed a form of abstraction based on the technique of enlarging his own tiny sketches through a projector. A celebration of the dynamic urban environment in the same vein as Manhattan's metal-clad architecture, the suggestive power of these large black and white canvases derives primarily from the intense, broad sweep of their handling. After many brush drawings evocative of vague contours drifting through space, Kline's crucial step was to blow up his abstract ideograms and repaint them on to large canvases in quick-drying industrial paint. Although the black forms are allusive of sturdy outlines, Kline did not approach the white area as a ground in the accepted meaning of the term. In fact the white zones are also painted in the same way as the black, and in places the light color intersects with or partially covers the dark mass.

In his search for a *tabula rasa*, Kline approached painting as a direct practice and eschewed metaphysical interpretations: for him painting was a celebration of the act of painting and an outpouring of the energy it harnesses.

"EVEN ABSTRACT SHAPES

"I am an eclectic artist by choice"

WILLEM DE KOONING
Black Friday
1948. Oil and enamel paint on panel, 122 x 96.6 cm.
The University Art Museum,
Mrs. H. Gates Lloyd Collection,
Princeton.

By the end of the 1930s, notions such as the tangible and the immediate already lay at the core of de Kooning's work. Unlike his contemporaries, he remained attached to the human figure, although in his hands it proved sufficiently porous for form and background to melt, or shatter, into one another, creating an ambiguous and dislocated picture space that he dubbed a "no-environment." As Barbara Rose has noted, tension arises from the difficulty the viewer experiences in determining where the subject is actually located, although it is clear that *something* is emerging from the surrounding chaos. At the end of the 1940s, de Kooning embarked on a series of "positive-negative" paintings, many of which are in black and white. Rhythm has the better of any attempt to decipher the subject, while the turbulent surface rejects both the spirit of geometry and that of pure abstraction, running counter to the demarcation line on which all readings and interpretations of twentieth-century art are dependent. De Kooning's work subverts at one and the same time the reading of modern history and any meaning its interpretation may find.

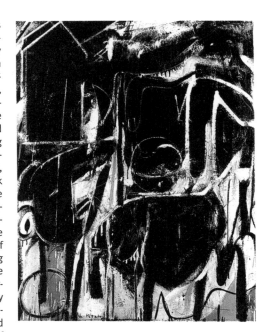

"Female idol"

WILLEM DE KOONING
Woman and Bicycle
1952–53.
Oil on canvas,
194.3 x 124.5 cm.
Whitney Museum of Modern Art,
New York.

De Kooning declared that "flesh was the reason why oil painting was invented" and the *Women* he produced during the 1950s laid down a challenge to the predominance of abstraction. Grotesque and often murderous variations on the theme of the female idol, de Kooning's *Women* are also a metaphor for the very act of painting. "Painting and living," as Denys Riout has remarked, "form an existential unity. The picture emerges through a process of self-revelation. It is by no means sure, moreover, that the content, which is only to be discovered at the end of the process, can be termed an actual, visible entity." Rather it is an encounter, a "bolt from the blue, an illumination." The *Women* series also exemplified the the-

107

"Composition -landscapes"

WILLEM DE KOONING
Parc Rosenberg
1957. Oil on canvas,
203.2 x 177.8 cm.
Private collection.

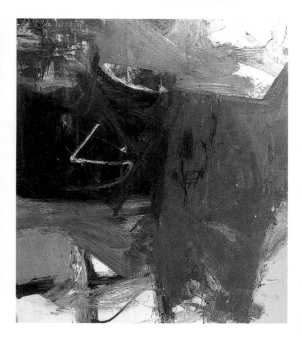

Around 1955, de Kooning abandoned the representation of the melting or dissolving figure in his large-scale "composition-landscapes." Advancing beyond the biomorphic phase of Abstract Expressionism, the surface began to be swept by generous brushstrokes that he applied with the help of a swivel easel on which the canvas could be rotated. The dislocated image is nonetheless redolent of the landscapes of de Kooning's native Holland, and the distraught chromatic scheme of earlier works was restructured into a surface of colored wedges. In 1963, de Kooning settled on Long Island. As Robert Hughes put it, "What mattered most in his paintings at the time was the experience of getting there... fast movement through unscrolling American space." From this period, de Kooning's work moved toward ever greater evanescence.

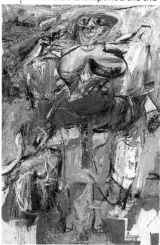

oretical dispute that opposed Clement Greenberg and Harold Rosenberg at this time. Greenberg's essentially formal approach was countered by an analysis of the process of art and of the hand-to-hand struggle between the creative artist and his work in which Action painting occupied the same metaphysical plane as the existence of the artist.

MUST HAVE A LIKENESS" de Kooning

> > > through the organization of a vast Europe-wide exhibition in 1958. The United States had thus found a tool well adapted to carving out a place in the history of modern art. The influence of journals, art teaching and committed dealers and collectors was soon to elevate Abstract Expressionism to a position of pre-eminence that it took Pop art to overthrow. The work produced by Robert Rauschenberg and Jasper Johns in the early 1950s is impossible to label, but it is nonetheless important to remember that they were contemporaneous with Abstract Expressionism, and with the ongoing development of de Kooning's oeuvre, Color Field, Hard-Edge painting and Abstract Impressionism. They should not therefore be bracketed with Pop art or Neo-Dada: both, beyond the imagery they employed, were committed to a critical approach to the medium of paint. In this connection, their position was quite distinct from the principles of mechanical reproduction which became prevalent a few years later and thus did not oppose the existentialist conception of painting in itself, instead extending and transmogrifying it.

The history of American painting up to Pop art at the height of the consumerist age is not so much that of a succession of art movements as an interconnected construct. For instance, Frank Stella, in exhibiting his *Black Paintings,* furthered a new form of abstraction that should be seen either as a continuation of modernism through which Greenberg could interpret Abstract Expressionism, or else as a critique of the latter's agenda. Still more patently, at the turn of the 1960s, the paintings of Robert Ryman and Brice Marden, in advancing findings of an epistemological and theoretical nature, introduced a new dimension and fresh forms of experience of precisely the kind that "Duchamp-style" Pop art had seemed to have disposed of once and for all. <

108

"Both the finite and the infinite"

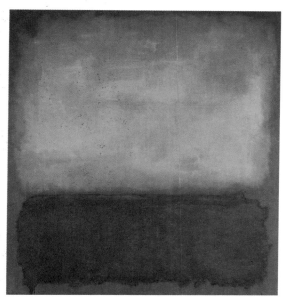

MARK ROTHKO
Number 14
1960. Oil on canvas,
289.6 x 266.7 cm. San Francisco
MoFA. All rights reserved.

In Color Field painting, color became subject and constructive means, giving the paintings the character of a "living organism." Rothko centered his early approach around figuration and Expressionism, and treated of "timeless and tragic subject matter." Gradually, however, representation retreated in the face of two-dimensional space and an opaque, submarine abyss emerged through which biologically derived forms would pass. By 1947, Rothko was producing *Multiforms* in which the pigment seems to float over the surface of the canvas, "pulverizing the familiar identity of things." In 1950, he listed the constituent parts of his work: the ground pigment and a mythical, plastic surface that emerges from the picture, providing its sole subject. Rothko's work attempts to grasp "both the finite and the infinite" in what he called "the simple expression of the complex thought."

"The fertility of white space"

SAM FRANCIS
Other White
1952.
Oil on canvas, 205.5 x 190.5 cm.
Centre Georges Pompidou,
MNAM, Paris.
Photo Centre Georges
Pompidou.

American Sam Francis's first exhibitions were staged in Paris, where he lived between 1950 and 1958. He was involved in a number of major shows organized by the critic Michel Tapié, such as "Signifiants de l'Informel" and "Un art autre." In his studio on rue d'Arcueil, he executed his first large-scale mural composition (for the Kunsthalle in Basel) with broad, fluid colors. In 1957, he made exploratory trips to Japan, before moving to California in 1962. During his first two years in the French capital, Francis favored white and gray in "floating" monochromes that are typical of Art Informel. While in the South of France, he discovered Cézanne and completed a series of white pictures in blatant opposition to Abstract Expressionism proper. A nebulous work redolent of late Monet or Bonnard, *Other White*, like many of his paintings, was "a celebration of the fertility of the white space."

"THE SELF, TERRIBLE AND CONSTANT, IS FOR ME

"The Sublime is Now"

BARNETT NEWMAN
Shining Forth (to George)
1961.
Oil on canvas, 442 x 290 cm.
Centre Georges Pompidou,
MNAM, Paris. Gift of the de la
Scaler Foundation.
Photo Centre Georges
Pompidou.

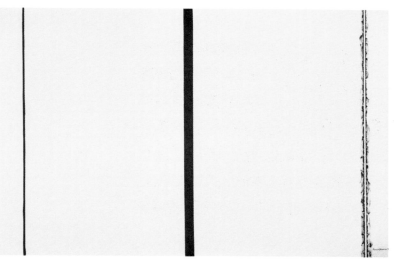

Around 1946–47, Newman began giving his works titles expressive of his spiritual and symbolic intentions. *Onement 1* (1948) was the first of his picture's to feature a single bisecting vertical strip that he christened a "zip." This format of the divided rectangle suggests a fundamental instability within the act of creation. "The image we produce is the self-evident one of revelation, real and concrete, that can be understood by anyone who will look at it without the nostalgic glasses of history." In adopting a simplicity that relinquishes expression in the face of the unknowable, Newman confronted the unrepresentable and its metaphysical imperatives. The surface is plain, and split by three "zips" that provide an illusory symmetry. *Shining Forth* was painted for his dead brother, its dedication to George carrying a secondary connotation: in Hebrew, the name means "shine."

"Art-as-Art"

AD REINHARDT
Ultimate Painting no. 6
1960.
Oil on canvas, 152.5 x 152.5 cm.
Centre Georges Pompidou,
MNAM, Paris.
Photo Centre Georges Pompidou.

A student of Meyer Schapiro at Columbia University, Reinhardt joined the American Abstract Artists group in 1937. Under the influence of the Bauhaus, he executed a series of geometrical paintings that were almost monochrome. At the same time, however, he was publishing cartoons lampooning both the history of art and the art scene. With his taste for controversy, he was one of the Irascibles that

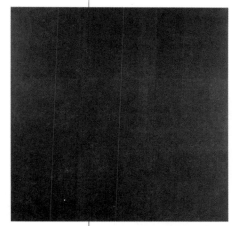

109

famously boycotted an exhibition at the Metropolitan Museum, and he aired his opinions on aesthetics in numerous publications such as *Art as Art* and *Twelve Rules for a New Academy*. By 1950, Reinhardt was producing canvases based on a single tone, and from 1953 his quest for the absolute led him to limit his palette to black alone. From 1960 to his death, Reinhardt produced only square canvases, identical in format, whose apparently uniform surface—of one single color or hue, black, blue, red—was, on closer inspection, seen to be almost imperceptibly graduated. "I am simply making the last paintings that can ever be made," he averred. "Art is art and everything else is everything else."

"Metaphysical understanding"

BARNETT NEWMAN
Chartres
1969.
Acrylic on canvas, 305 x 290 cm.
Private collection.
All rights reserved.

Barnett Newman used to refer explicitly to Edmund Burke's eighteenth-century theory of the Sublime, as well as to Spinoza's pantheism: the sublime is the elevation of the spirit, and painting should aim for "metaphysical understanding." In *Chartres*, the meaning of the "zips" with which Newman divided his flat surfaces in blocks of flat unmodulated color is clearly revealed. The idea for a triangular painting came to him while he was involved on his sculpture *Broken Obelisk* (1963–67), which comprises two pyramidal structures one on top of the other facing tip to tip. In a painting which would avoid all perspective "traps," the allusions to Gothic architecture inherent in the format are of course seconded by the title. Newman thus offers his contribution to the important debate with the historian of the Gothic aesthetic Edwin Panofsky on the nature of the sublime in this type of painting.

THE SUBJECT MATTER OF PAINTING" Newman

"Avoids grasping anything"

CY TWOMBLY
Untitled
1970. Oil and wax crayon on canvas, 345.5 x 405 cm.
The Menil Collection, Houston.
© B. Hatala/Centre Georges Pompidou.

A contemporary of Rauschenberg and Jasper Johns, Twombly is also heir to the mantle of Abstract Expressionism. He differs from the Abstract Expressionists in his willful abandonment of skill, which, as critic Roland Barthes put it, "avoids grasping anything." He was a student at the Boston Museum School and then at the famous Art Students League of New York, and discovered the work of Giacometti and Jean Dubuffet. He spent the summer of 1951 at that hotbed of modernism, Black Mountain College. Twombly settled in Rome in 1957, and sought inspiration in Antiquity. Hovering between nostalgia and emotion, as well as between gesturality and the unconscious, Twombly's work has unfolded in phases of violence and lascivi-

110

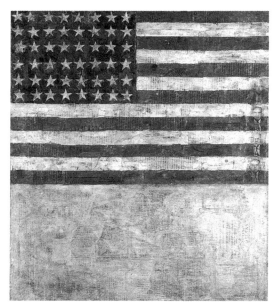

"The nature of painting"

JASPER JOHNS
Flag on White with Collage
1955.
Encaustic and collage on canvas, 57.2 x 48.9 cm.
Öffentliche Kunstsammlung Basel, Kunstmuseum, Basel. Gift of the artist in memory of Christian Geelhaar.
© B. Hatala/Centre Georges Pompidou.

With quintessentially modernist flatness, although without totally losing figurative illusionism, Jasper Johns, in his series of variations on the Stars and Stripes, targets, numbers, and letters, proposes a critical yet allegorical synthesis of Clement Greenberg's appeal for a genuine "American" painting style. The "nature of the painting" that Leo Steinberg referred to in *Other Criteria* (1972), allied to Johns's per-

sonal technique—which involved wax-based techniques, pasted papers, rich color schemes and a handling that emphasized a subtle distance from the motif—demonstrated the nature of the gap that Johns had prized open between the "work" and the thing it "depicts." While others where extolling painting as a search for self-identity, Johns renegotiated, albeit in ironic mode, the relationship between artwork and model. By identifying the painted image with the surface of the painting itself, the proponents of Abstract Expressionism, who were preoccupied with originality and individuality, found via traditional subjects and techniques elements of a critical analysis of the myths on which a whole dimension of American art was based.

ousness, of quivering and renunciation, quite unlike the all-conquering heroics of the preceding generation. The stain paintings and graffiti from around 1955 were succeeded later by arrays of numbers and words inscribed in a spiky, hesitant hand. Executed at the end of the 1960s, the chalk *Blackboard Paintings* are "parables of light and shade," traced in a series of loops like arbitrary signs covering the surface.

"Act in the gap between art and life"

ROBERT RAUSCHENBERG
Bed
1955. Oil and crayon on objects, 191 x 80 x 20.3 cm.
The Museum of Modern Art (partial gift of Leo Castelli in honor of Alfred H. Barr, Jr.) New York.

The true significance of the symbolic ramifications that Rauschenberg laid before the Abstract Expressionist generation only emerged when he erased a drawing de Kooning had given him. After the empty spaces of the 1949 works that Leo Steinberg characterized as "flatbed picture planes," and a stay in the progressive Black Mountain College where he studied with Josef Albers, Rauschenberg produced a series of white paintings, where the only image present is that of the shadow cast by the viewer. These works were

too hastily seen as Neo-Dada gestures, whereas in fact for the artist, as for his friends composer John Cage and choreographer Merce Cunningham, they were more like planes of silence. Rauschenberg followed these "whites" with composite works in mixed media—from pictures covered in screwed up newspapers and black enamel paint to constructions built out of urban trash, rusty nails and strands of rope. They herald the celebrated Combine Paintings that were built from found images: pieces of printed fabric (like the patchwork *Bed*), photographs or postcards, arranged and glued into the picture like clues to some metaphoric puzzle. They offer a commentary on the physical and technical processes involved in de Kooning's work, and were explained by Rauschenberg as an effort to "act in the gap between art and life."

"MY PAINTING IS BASED ON THE FACT THAT

"What you see is what you see"

FRANK STELLA
Mas o Menos
1964. Metal powder in acrylic emulsion on canvas,
300 x 418 cm.
Centre Georges Pompidou,
MNAM, Paris.
Photo Centre Georges Pompidou.

In 1965, the art historian Michael Fried proposed a reading of modern art, from Manet to Pollock and Stella, which saw it as a continuous process of reduction. As William Rubin has noted, however, Stella is above all one of the first major painters of the modern school to have received his training entirely within abstract art. From the 1950s, he was engaged on a method-ical analysis of the basic con-stituents of painting and ques-tioned the egocentricity inher-ited from Abstract Expres-sionism. Directly influenced by Johns' *Flags*, Stella's *Stripe Paintings* divide the canvas into congruent parallel bands. Later works were the fruit of a compositional method Fried termed "deductive structure," where the motif is dependent on the shape of the surround. By 1960, Stella was inferring the internal dynamic of the image directly from its perimeter and focusing on structural prob-lems: he "notched" the cor-ners or pierced the centers of aluminum paintings in an extrapolation of the severe, crisp lines of Hard Edge. *Mas o Menos* is a member of the *Running V* series that Stella executed in 1964, the same year in which he famously declared: "What you see is what you see."

"A progressive surrender"

MORRIS LOUIS
Delta Iota
1960. Acrylic on canvas,
292.7 x 445.2 cm.
Musée de Grenoble. Gift of Marcela Louis-Brenner.
© Musée de Grenoble.

From the *Veils* series of the mid-1950s to the *Unfurleds* of 1960–61, Morris Louis gave free rein to autonomous color by pouring paint over the canvas, allowing it to soak in. Through what he termed "cropping" the painted surface, Louis gradually freed the central area of all motifs and left the viewer with a vast open space. Louis, like Helen Frankenthaler and Kenneth Noland, adopted Greenberg's notion of a flat, all-over painting style that would, like Pollock's, unify line and color. By 1940, in a famous text

III

"Abolish allusion"

ELLSWORTH KELLY
Two Panels: Red and Green
1968. Oil on canvas,
284.5 x 330.2 cm.
Collection David Robinson, California.
© B. Hatala/Centre Georges Pompidou.

In 1948, Kelly embarked on a six-year stay in Paris where he discovered Monet's late *Waterlilies*, visited Brancusi, Arp and the De Stijl artist Vantongerloo, and became friends with François Morellet. Melding the teachings of Mondrian and Matisse, he sought to synthesize European and American painting and other seemingly contradictory principles. His earliest reliefs were obtained from architec-tural photographs he took in Paris and transposed into ab-stract paintings. By 1950, he was executing anonymous, unsigned objects which pro-gressively increased in size.

Returning to the United States in 1954, he developed a purist abstract style on a truly "American" scale. Engaged in an ongoing critique of Abstract Expressionism, his crisp, mul-tiple monochrome panels were devised to enter into a dia-logue with the environment and incorporate something of sculpture's three-dimensional-ity into painting. "Instead of making a picture that was an interpretation of a thing seen, or a picture of invented content, I found an object and 'pre-sented' it as itself alone." "If figure and ground are indeed interchangeable," in Kelly's work, Claire Stoullig has writ-ten, "the fact that linear marks no longer appear on the sur-face abolishes allusion."

entitled "Towards a Newer Laocoön," Greenberg wrote: "The history of avant-garde paint-ing is that of a progressive sur-render to the resistance of its medium; which resistance con-sists chiefly in the flat picture plane's denial of efforts to 'hole through it' for realistic perspec-tival space." Twenty years later, he summarized his position in *Modernist Painting*, a rallying cry for a whole generation of artists and theoreticians: "Realistic, illu-sionist art had dissembled the medium, using art to conceal art. Modernism used art to call attention to art... Whereas one tends to see what is in an Old Master before seeing it as a pic-ture, one sees a Modernist paint-ing as a picture first. This is, of course, the best way of seeing any kind of picture."

ONLY WHAT CAN BE SEEN THERE IS THERE" Stella

"What is to be done with paint"

ROBERT RYMAN
Untitled
1962. Oil on linen canvas, partially glued to cardboard, 31 x 31 cm.
Centre Georges Pompidou, MNAM, Paris.
Photo Centre Georges Pompidou.

In 1952, Ryman started working as a warden at MoMA, where he became familiar with the works of Matisse and Rothko, both of whom he considered as painters of method. From 1957 to 1962, he exe-cuted pieces that experimented with a variety of supports and techniques, such as oil, gouache and casein. Ryman was soon working solely on square canvases in the belief that it represented both the ideal space and a perfect shape that obviated the problem of specific proportions. Ryman's art does not address so much the structure of an individual picture as the components of painting itself. White is used to the exclusion of practically all other hues, as a "neutral color... that makes other aspects of painting visible that would not be so clear with other colors." Between 1958 and 1962, Ryman composed small-scale canvases on unstretched linen. The canvas is partially covered by a plain area of white satu-rated in a thick network of white brushstrokes through which a blue undercoat shows through, making the surface pigment vibrate intensely. A subtle artist intent on an experi-ence he called "illumination," Ryman reminds us that "what is to be done with paint is the essence of all painting."

"An organ of touch"

BRICE MARDEN
Thira
1979–80.
Oil and wax on canvas, 18 panels, overall dimensions: 244 x 460 cm.
Centre Georges Pompidou, MNAM, Paris. Gift of the Georges Pompidou Art and Culture Foundation.
Photo Centre Georges Pompidou.

A student of Josef Albers, Marden emerged in 1964 with monochromes in a near "all-over" technique that left a sin-gle narrow strip of canvas bare along one edge. In 1965, he began hanging oblong can-vases in pairs, exploiting the interplay between dissonant colors which he laid on with a spatula in beeswax, tur-pentine and encaustic pig-ment. This technique confers a matt and receptive density on the painting, transforming the surface into what J. C. Lebensztejn has called "an organ of touch." Marden's work, however, runs counter to a Minimalism that he regards as over-reductive. Marden has maintained that painting is and has always been akin to religion in its mystery. Like figure and ground, drawing and color structure the composition, and in *Thira* combine to convey, through the religious monu-mentality of the construction of the triptych, the theme of a gate to a sacred realm. The colors and arrangement of identical rectangles leave no room for decorative effects in what is an austere abstraction.

112

"WHAT IS DONE WITH PAINT

Chronology 1945–1970

This chronology is largely devoted to events in the United States. Sections in bold refer to artists mentioned in the main text and captions.

1945
• Yalta Conference.
• Atomic bomb dropped on Hiroshima and Nagasaki.
• Japanese capitulation.
• New York: Mondrian retrospective exhibition.

1946
Jackson Pollock adopts the technique of dripping.
New York: birth of Abstract Expressionism.

1947
• Marshall Plan begins operation.
• Beginnings of the Cold War.

1948
• State of Israel created.
Ashile Gorky commits suicide.
Willem de Kooning, *Black Paintings*.
Short-lived The Subject of the Artists set up (William Baziotes, Clyfford Still, Robert Motherwell, etc.), followed by Studio 35 and the Artists' Club.
Barnett Newman, *Onement I*.

1949
Life magazine asks whether Jackson Pollock is the "greatest living American painter."

1950
• MacCarthy anti-Communist witch hunts.
Venice Biennale: New York School.
Rothko: first Color Field paintings.
De Kooning, *Woman I*.
The Irascibles send a protest to the Metropolitan Museum against the jury at the "American Painting Today 1950" exhibition.

1951
• New York: Living Theater founded.
Pollock, *Black Pourings* (enamel paint).
Motherwell: *The Dada Painters and Poets* anthology.
Rauschenberg: *White Paintings*, and collaboration with John Cage.
New York: "The Ninth Street Show."

1952
Harold Rosenberg: "American Action Painters" (*Art News*, December).
Black Mountain College: Cage, *The Event* (sets by Rauschenberg and choreography

by Merce Cunningham).
Paris: first Pollock exhibition, Studio Fachetti.

1953
• USSR: death of Stalin.
Rauschenberg: *Erased De Kooning; White Paintings* at Betty Parsons Gallery.
Ad Reinhardt's palette is reduced to black.

1954
Jasper Johns: *Flags* and *Targets*.
Motherwell: first *Elegy to the Spanish Republic*.

1955
• Duchamp becomes an American citizen.
Clement Greenberg tries to forge a definition of truly "American painting."
Rauschenberg: *Bed*, first Combine Painting.
Jasper Johns: *White Flag*.

1956
• Jack Kerouac: *On the Road*.
New York: opening of Leo Castelli gallery.
Death of Pollock.

1958
• Allan Kaprow: *The Legacy of Jackson Pollock*. First happenings.
Barnett Newman starts producing the *Stations of the Cross-Lema Sabachtani* (to 1966).
Frank Stella produces twenty-three *Black Paintings* in two years.
European showing of the exhibition "The New American Painting in 1958."

1959
• Cuba: Fidel Castro becomes prime minister.
• New York: Claes Oldenburg, *The Street*. "Sixteen Americans," MoMA.
Irvin Sandler's enquiry into the "new" academic painting in *Art News*.
Over the next two years, Clement Greenberg organizes numerous exhibitions at French & Co.

1960
• John F. Kennedy becomes president.
• Tinguely: *Homage to New York*, MoMA.
A. Reinhardt: *Ultimate Paintings*.

"Beyond painting"

Apart from a spell in Hans Hoffmann's class in 1956, Flavin was self-taught. He painted, wrote poems and produced numerous drawings. He also executed a number of small-scale constructions, all of which failed to satisfy his own exacting standards. He then began to make notes on an art form that would use electric lights, and between 1961 and 1963 realized eight "Icons," painted wooden or masonite square supports with at-tached electric lightbulbs. In 1963, Flavin made his first use of industrial fluorescent tubing fixed directly to the wall as a "dynamic and plastic object-image." From this point on, Flavin's work was liberated from all sub-servience to pre-existing models. His significance is thus primarily as the figure with whom art beyond painting and sculpture begins. In these "object images" the space is bathed in light and color, transforming it into a sensitized and phenomeno-logical environment in which the traditions of the two arts dissolve into architecture. The selection of the various fluorescent lights, the arrangement and the titles of Flavin's works "appropriate," in Minimalist Donald Judd's words, "the results of in-dustrial production" for aesthetic purposes.

IS THE ESSENCE OF ALL PAINTING" Ryman

1946.
Ad Reinhardt.
*How to Look at
Modern Art in
America,* published
June 2, in *P.M.*

1951.
The group of
Irascibles, including
Pollock, Rothko,
Newman,
Motherwell,
de Kooning, Kline
and Reinhardt.

1964.
Robert
Rauschenberg.
Elgin Tie
performance at the
Moderna Museet,
Stockholm.

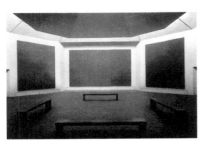

1964–70.
Mark Rothko, Chapel
at the Institute for
Religion and Human
Development,
Houston (architect
Philip Johnson).
© Hickey & Robertson.

Chronology 1945–1970

1961
• Cuba: "Bay of Pigs."
• New York, MoMA: "The Art of Assemblage."
• Warhol: *Campbell Soup Cans.*
• Tom Wesselmann: *Great American Nudes.*
• Maciunas: Fluxus.
Greenberg: *Art and Culture.*
Cage: *Silences.*
Frank Stella: *Black Paintings.*

1962
• W. Burroughs: *Naked Lunch.*
• New York, Sidney Janis Gallery: "New Realists."

1963
• Assassination of Kennedy.
• Warhol starts up the Factory.
• Pasadena: first great Duchamp retrospective.
Jewish Museum: "Toward a New Abstraction."

1964
• Arthur Danto on the "end of art."
**Venice: Rauschenberg, Grand Prix at the Venice
Biennale.**
**Los Angeles: "Post-Painterly Abstraction"
exhibition.**
**Rothko begins the Houston Chapel, completed
in 1970.**

1965
• Vietnam War intensifies.
• Roy Lichtenstein: *Little Big Picture.*
• The term "Minimal art" first appears.
• Donald Judd: *Specific Objects.*
**New York: Op art exhibition "The
Responsive Eye."**
**Harvard: Michael Fried, *Three American
Painters.***

1967
• Death of Che Guevara.
• Sol LeWitt, *Paragraphs on Conceptual Art*
(Art Forum, June).
Death of Ad Reinhardt.

1968
• Student uprisings in Europe and the
United States.
• Wilhelm Reich, *Sexual Revolution.*
• Death of Marcel Duchamp. Discovery of *Étant
donné: 1. la chute d' eau, 2. le gaz d' éclairage.*
• Hyperrealism gains ground.
• New York, MoMA: "The Machine as Seen at the
End of the Mechanical Age."

1969
• Man first steps on the Moon.
• Development of Body art.

1970
• New York: "Conceptual Art" exhibition.
•Robert Smithson, *Spiral Jetty.*
**Mark Rothko's suicide and death of
Barnett Newman.**

Studies on American Art
D. Ashton. *American Art Since 1945.* New York, 1982.

M. Auping. *Abstract-Expressionist.* Buffalo, 1982.

G. Battcock. *Minimal Art: a Critical Anthology.* New York, 1968.

D. Crane. *The Transformation of the Avant-Garde. The New York Art World, 1940–1985.* Chicago, 1987.

A. Danto. *The Transfiguration of the Commonplace.* Cambridge, Mass., 1981.*

M. Fried. *Three American Painters.* Cambridge, Mass., 1965.

C. Gintz (ed.). *Regards sur l'art American des années 60, anthologie critique.* 1979, Paris.*

C. Greenberg. *Clement Greenberg: The Collected Essays and Criticism.* 4 vols. Chicago, 1986–93.*

S. Guilbaut. *How New York Stole the Idea of Modern Art.* Chicago, 1983.*

R. Hughes. *American Visions.* London, 1997.

L. Lippard. *Art as Art: The Selected Writings of Ad Reinhardt.* New York, 1975.

B. Rose. *American Art Since 1900. A Critical History.* New York, 1989 (new ed.).

H. Rosenberg. *The Anxious Object.* New York, 1969.

I. Sandler. *The Triumph of American Painting: A History of Abstract Expressionism.* New York, 1976

L. Steinberg. *Other Criteria, Confrontations with 20th Century Art.* New York, 1972.

Where works can be seen
United States
Albright-Knox Art Gallery, Buffalo.

The Menil Collection, Houston.

MoCA, Los Angeles.

The Metropolitan Museum, New York.

MoMA, New York.

The Solomon R. Guggenheim Museum, New York.

The Whitney Museum of American Art, New York.

Philadelphia Museum of Art, Philadelphia.

National Gallery, Washington.

Europe
Musée National d'Art Moderne, Paris.

Musée de Grenoble.

Stedelijk Museum, Amsterdam.

Guggenheim Museum, Bilbao.

Museum Ludwig, Cologne.

Kunstsammlung Nordrhein-Westfalen, Düsseldorf.

Moderna Museet, Stockholm.

Peggy Guggenheim Collection, Venice.

Tate Gallery, London.

*** Essential reading**

EUROPE 1939-1970

"painting: from image to tool"

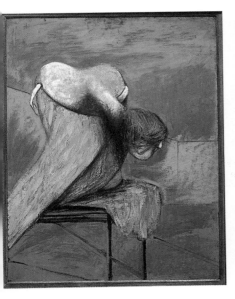
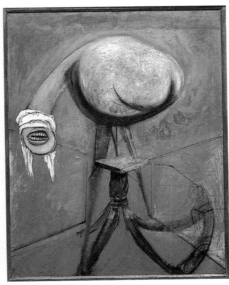
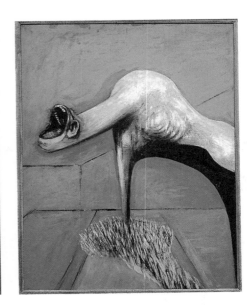

"Art is a method for opening up areas of feeling"

FRANCIS BACON
Three Studies for Figures at the Base of Crucifixion
1944. Oil on chipboard. Triptych, each panel 95 x 73.5 cm. Tate Gallery, London. Gift of Eric Hall.

Seeing Bacon's first triptych at the end of the war, some commentators were of the opinion that it was more than simply a symptom of recent tragic history. Bacon himself thought of these *Three Studies* as preparatory sketches for a large-scale crucifixion. He talked of the image of the Crucifixion as an "armature" on which to hang "feelings about behavior and the way life is." The ground here is orangey, a foretaste of a long line of works by Bacon in acidulous and strident colors. The sculptural figures—their "anatomy, half-human, half animal," as John Russell described them (1971)—contort themselves, at once unreal and grotesque. In words from one of the numerous texts anthropologist and autobiographer Michel Leiris has devoted to the artist, Bacon here almost adheres to "an order of reality of flesh and blood."

After 1945, the notion of modern art was being positively trumpeted through its identification with freedom from tyranny, and the historical avant-gardes were being feted at countless retrospectives at which its heroes were duly acclaimed. The 1944 Salon d'Automne provided an opportunity for a celebration of the masters of the first half of the century, and in particular for a homage to Picasso, who was considered, with his *Guernica* and *The Charnel House,* as the supreme painter of the Resistance. Braque, Bonnard, Léger, Rouault and Matisse (who had been hard at work since 1941 on *papiers* > > >

> > > *découpés,* and who was soon to begin on the Chapel of the Rosary at Vence), as well as Chagall and Miró, were heralded in the name of the "French tradition," and were soon to receive major accolades at biennial exhibitions and shows the world over. In 1947, Jean Cassou, with the assistance of Georges Salles, established the collection which was to become—twenty-five years after Hanover, eighteen after New York, and sixteen after Lodz in Poland—the core of the Musée de l'Art Moderne in Paris. In spite of yawning gaps, the numerous donations made possible a clearer perception of the art of the first fifty years of the century.

Nonetheless, Europewide analysis of the period is a complicated affair and it is reductive to view it as a tussle between the abstract and the figurative, or as a tug-of-war between Paris and New York. In the 1950s, against political backdrops as diverse as Spain, Italy, Holland and Germany, numerous trends were unfolding. In 1948 in Barcelona around the Dau group; in the same year, with "Cobra" shuttling between COpenhagen, BRussels and Amsterdam; in 1957 with the Madrid El Paso group; in 1947 in Milan around Lucio Fontana, as well as in northern European countries—a flood of manifestos and events provided ample evidence of the desire to return to a measure of intellectual freedom. In a disenchanted postwar ambiance, the notion of modern art became closely identified with utopian ideals. The very diversity of the movements concerned, however, renders any such approach extremely intricate. In the context of such quandaries, it is worthwhile quoting a text by Jean Leymarie concerning the post-1945 art scene: "In the years after War World II, after the wholesale slaughter, the concentration camps, and the bomb on Hiroshima, all confidence in the machine age and on a technology-based society evaporated. There then arose in Europe . . . an art that was no longer merely international but of global scope, a kind of organic, nonfigurative art that was profoundly opposed to the geometric constructivism of the earlier Bauhaus." Taking this up, Laude recalls the unfeasible inventory of all > > >

"Dead stars"

JEAN FAUTRIER
Tête d'otage no. 16
1944. Oil on paper glue-mounted on canvas, 27 x 22 cm. Private collection. Photo J.-C. Mazur

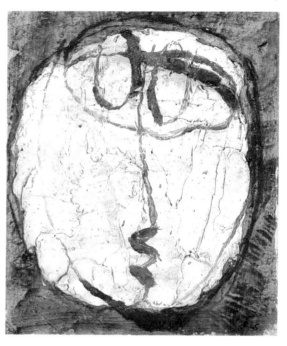

The exhibition of Fautrier's *Hostages* series in the autumn of 1945 was one of the most significant artistic events of the immediate postwar period in France. It showed around fifty works that he had started producing in 1942–43, although the conditions in which they were painted remain somewhat unclear even today. Some of the "heads" seemed to have been painted in the Vallée des Loups, a place filled with memories of the idylls of Chateaubriand, and the site of several executions in 1943. Others were apparently made in Paris as a shocked reaction to the public executions being carried out by the occupying forces. The violence of the subject matter is counterbalanced by the physical fragility of a disintegrating body or face drawn in faint outline and reduced to being what Michel Ragon has called "dead stars." In his preface to the original catalogue, critic André Malraux stressed that Fautrier represented "the earliest attempt to strip away the pain we feel today and lay it bare in the form of ideograms filled with pathos—until it is forced to percolate, as it does now, through to an eternal realm."

"Inner space"

HENRI MICHAUX
Untitled
1949. Watercolor and gouache on paper, 38.7 x 54 cm. Centre Georges Pompidou, MNAM, Paris. Gift of Daniel Cordier. Photo Centre Georges Pompidou.

Although, as Mexican poet Octavio Paz has stressed, "in Michaux's work painting and poetry intersect without ever becoming confused," both arts led to what the artist himself called "inner space." Long considered a sideline to his poetry, fifty years of uninterrupted work in watercolor or gouache, of *frottages*, oils and mescaline-induced drawings offer an intriguing if circuitous counterpoint to his written oeuvre. Following on from the wartime *Landscapes*, ghostly figures and uncertain silhouettes emerged. "I pour on water so as it attacks the pigments that dissolve, contradicting one another, intensifying or turning into their opposite, flouting the forms and lines sketched out—such destruction, mocking all permanence and all design, is brother and sister of my state of mind that leaves nothing standing."

Panic-stricken faces, "faces of the sacrificed," in which some commentators have detected the more tragic periods in the artist's life, Michaux's motifs are experimental and result from a quest as much as from a watchfulness—a sense of "shortcomings of which the work is a confession," as Alain Bonfand puts it.

"DRAG THE SPIRIT

l disobedience"

JEAN DUBUFFET
Dhôtel nuancé d'abricot
1947. Oil on canvas, 116 x 89 cm.
Centre Georges Pompidou,
MNAM, Paris. Photo Centre
Georges Pompidou.

"**I**nsisting upon his special position 'on the edge,' his absolute individuality," Jean Beauffet has written on Dubuffet, "we have finally had to accept the 'legend' of an oeuvre that is a 'work apart.'" Keeping a watchful eye on all the various disputes of the time, receptive to "primitivism" in the arts and to their democratization, resistant to formalism and to the power of all kinds of cultural systems, Dubuffet tried to reassert the meaning and signification of an artistic practice freed from all restrictions. Anthropology, archeology, prehistoric art, the art of the insane (that had

already been feted by Breton), graffiti and children's drawings served, as Dubuffet saw them, as calls to rebellion, to artistic "civil disobedience." *From Puppets of Town and Country* and *Métro* to *Plus beaux qu'ils croient* (More beautiful than they think) and *Corps de dame* (Lady's body), unifying the "metaphysical and grotesque triviality," from the *Mental Landscapes* to *Texturologies* and *Matériologies*, as well as the *Hourloupe* cycle begun in 1962 as an "objection to received values," Dubuffet's agenda combined a campaign against conformity with a search for works uncontaminated by ideological conditioning. In 1942, in what was a deeply thought out and celebratory reworking of his tools and materials, Dubuffet started to move toward a new idiom akin in spirit to the graffiti Brassai was photographing in the streets of Paris. His anticultural stance led

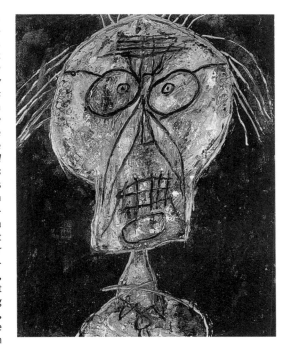

to the creation in 1945 of the subversive notion of Art Brut (raw art), art outside all norms.

"Journey to an in-between world"

return to Paris, where he was given encouragement by Henri-Pierre Roché, Jean-Paul Sartre and René Drouin, the last being responsible for organizing a debut one-man show in 1947, an exhibition which Georges Mathieu acknowledged as a "remarkable event." Searching for a fusion of Expressionism and Surrealism through painting, watercolor, and photography, Wols was inspired by Far Eastern mysticism. He explored a "miniature world (butterfly, horse, cockroach, violin, etc.), by which he is assailed from within, unseen, and which inflicts on him its sleepwalking habits." His eye on the sea, bewitched by the poet Rimbaud's travels, Wols, wrote art historian Werner Haftmann, created "thousands of watercolors that constitute a logbook on a journey to an in-between world where the imagination and the real are no longer in contradiction."

"A modern rustic painter"

GASTON CHAISSAC
Personage
1960. Oil on wood, 63.5 x 30 cm.
Private collection, Paris.
All rights reserved.

Starting out as a saddler's apprentice, two chance events determined Chaissac's artistic vocation: his friendships with Otto Freundlich and Jeanne Kosnick-Kloss in Paris and the meeting, in 1939 at the Clairvivre sanatorium, with Camille Guibert, a primary-school teacher who was to become his wife and whom he was to follow on various postings all over the Vendée. Chaissac's work was soon noticed by contemporaries such as Jean Dubuffet, philosophical writer Jean Paulhan, novelist Raymond Queneau and critic Michel Ragon. He remained outside artistic groupings, even—since he was sensitive to its internal contradictions—Art Brut, although his work is often wrongly subsumed within that tendency. He himself preferred to call himself a "modern rustic painter," letter-writer and author. He published a collection of writings, selected with the assistance of Dubuffet, under the absurdist title *Hippobosque au bocage.* Although he took part in the memorable exhibition devoted to "Art Brut preferred to the cultural arts" in October-November 1949 at René Drouin's, he stood apart, an "esthete in a leather apron," detached from a world in any case somewhat hostile to his background and to the power of an imagination that was rooted in a rural and pious upbringing which remained the stage for his daily life. As Henri Claude Cousseau remarked, it was the artist himself "who, for the most part, stares out at us" from all the faces and abstract signs in his works.

117

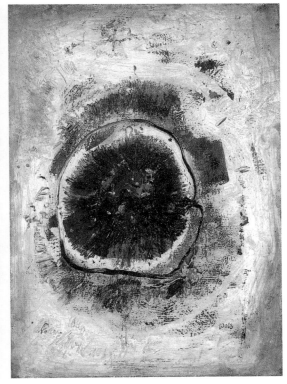

WOLS
Grenade bleue
1946. Oil on canvas, 46 x 33 cm.
Centre Georges Pompidou,
MNAM, Paris. All rights reserved.

Interned as a German citizen and freed at the French Armistice, Wols took refuge at Cassis and Dieulefit. Only at the Liberation could he

OFF ITS BEATEN PATH" Dubuffet

> > > the art movements to have arisen since 1945 assayed at the "72/72" exhibition. The situation is in truth an inextricable cat's cradle that makes any classification impossibly involved.

The debate between figuration and abstraction in the 1960s seemed to elevate the disciplines of painting and sculpture and invest them with an authority that remained unchallenged. The following decade, however, saw the absorption by an upcoming generation of elements in the historical avant-garde which were to expand the scope of creativity in the plastic arts. This in turn heralded the dream of a *Gesamtkunstwerk* and opened the door to a host of ideas that were to percolate down from other disciplines.

The arguments between the advocates of a return to the values specific to defining the "modern tradition" and the undermining of that very continuity were wide-ranging and contradictory. The tragedy of the postwar situation was embodied by artists such as Jean Fautrier, Francis Gruber and Bernard Buffet, as well as by all those painters who, like Francis Bacon, put the stress on empathy. But the early 1950s were nonetheless the period of abstraction. Abstract art had appeared in France even during the war at the "Vingt Jeunes Peintres de Tradition Française" exhibition. Lyrical, often red, white and blue—a nationalist tone that was paralleled by the articles of Jean Bazaine in the famous *Nouvelle Revue française* at the time—the style strove to encapsulate modernity and served as a rallying point for a new generation.

In Abstraction Lyrique (in which Manessier, Bazaine and Jean Le Moal revived religious themes), in Tachisme (for which Charles Estienne presented a virulent critique of the very different vitality of a "constructed art" based on geometric shapes promoted by Léon Degand and the Galerie Denise René), in critic Michel Tapié's notion of the "Informel" in his advocacy of an "art autre" (other, different)—the producer of art manifested his or her need to rejoice in gesture and pure form alone. Nicholas de Staël, Olivier Debré and Hans Hartung all worked in this vein, as did Pierre Soulages, who, in terms no one else could have bettered, wrote: "Art is necessarily a > > >

"Stripped naked—like life"

ROGER BISSIÈRE
Black Venus
1945. Oil on canvas with painted stucco reliefs, 100 x 80 cm. Centre Georges Pompidou, MNAM, Paris. Photo Centre G. Pompidou.

In 1920–21 Roger Bissière wrote articles for Le Corbusier's *L'Esprit nouveau*. From 1925 to 1938, he taught at the influential Académie Ranson. Shortly before the war, he fulfilled a slightly ambivalent role as the main proponent of the Paris School's "return to order." In 1938 he retired to the Lot, where he made a few assemblages. Struck by the ingenuity of his son's earliest paintings, he sought to liberate himself from the constraints of his own skill in a series of works combining painting, mixed media and sewn fabric. Determined henceforth to "tell all," "naked—like life," he was persuaded to exhibit these pieces at René Drouin's gallery: *Black Venus* appeared on the cover to the catalogue. Although such works were reminiscent of Dubuffet's pictures, Bissière, unlike the unruly apostle of Art Brut, sought to express humility through his painting. He was indebted to Georges Bataille's radical rereading of Surrealism, Henri Focillon's history of form and Émile Mâle's surveys of medieval art. After initially being influenced by archaic motifs, he moved on to an investigation of spatial and plastic qualities, the results of which later served as a crucial spur to a certain pictorial idiom in postwar France.

"An appeal to imagination"

KAREL APPEL
Children Asking Questions
1948. Oil-painted wood relief nailed to panel, 83 x 56 cm. Centre Georges Pompidou, MNAM, Paris. Photo Centre Georges Pompidou.

Isolated in a postwar Amsterdam wholly under the spell of abstraction, Appel turned instead to African art. He tried, like Dubuffet and French painter Jean-Michel Atlan, whom he had met with in Brussels and Paris, to reconnect with the power of "primitive" totems. He started painting left-handed, his calling card being what he called the "powerful, primeval" theme —"stronger than African art and Picasso"—of *Children Asking Questions*. Appel was cofounder with Constant and Corneille in Paris of Cobra, a movement for whom the theme of the child had great attraction, its impact being enhanced here by Appel's vehement palette and deliberately rudimentary construction techniques. Receptive to the notion of free play (as pre-

sented in Johan Huizinga's book *Homo Ludens,* 1939), Appel's works caused an uproar. When his frescoes for the Amsterdam city hall were unveiled, there were calls for them to be censored. In his defense, architect Aldo van Eyck wrote a tract that amounted to an "appeal to the imagination" and Cobra's official spokesman Christian Dotremont intervened (stressing that "Appel has done something violent, but his violence is just, popular. Appel is one of the people, the meaning is not that of the old Surrealist scandals"), but Appel's work was eventually covered up. Shortly after, in 1950, Appel, Constant and Corneille all decided to leave the city.

"THE TYPE OF PAINTING THAT DOES WITHOUT REPRESENTATION IS

"A nondescriptive manner"

PIERRE SOULAGES
Painting on Paper 1948-1
1948. Walnut stain on paper glue-mounted on canvas, 65 x 50 cm.
Centre Georges Pompidou, MNAM, Paris. Gift of the artist.
Photo Centre Georges Pompidou.

Any approach to the art of Pierre Soulages finds itself referring unavoidably to the prehistoric carved stones and monuments of Romanesque art that recall the artist's attachment to his native Aveyron. Trapped in Montpellier during the war, Soulages met Joseph Delteil who in turn introduced him to Sonia Delaunay. During a short stay in Paris when he was eighteen, Soulages had already discovered Cézanne and Picasso, in addition to the kind of abstract art soon to be banned by the Nazis. Independant of pre-existing models, and in a "nondescriptive manner," he started painting broad black or brown lines which deliver up their form "immediately, abruptly." He exhibited several works at the radical Salon des Surindépendants in 1947. Up until 1950, he produced walnut-stain drawings in a style that prefigures the monumentality of his subsequent oeuvre. By 1948, Soulages was one of the very few French artists to have earned genuine international recognition. The format of his canvases grew and black remained dominant, enriched by a subtle use of other hues (ocher, blue or red).

"A redoubtable precedence"

HANS HARTUNG
T. 1956-14
1956. Oil on canvas, 180 x 136 cm.
Centre Georges Pompidou, MNAM, Paris.
Gift of the Galerie de France.
Photo Centre Georges Pompidou.

From 1954 to 1960, Hans Hartung developed and expanded a concept of painterly graphics that had been gestating in his work from the 1920s and 1930s. During this early period, Hartung had become interested in astronomy and photography, and had discovered the old masters in the museum at Dresden. The violence of his line and the extreme tension it engenders convey the impression of being painted through movements executed by the entire body. With what René de Solier recognized as his "redoubtable precedence," Hartung has asserted himself as a precursor of Action painting and as a major exponent of Lyrical Abstraction, though in truth his method differs from both of these tendencies. The organization of

"A ceaseless interplay of forces"

NICOLAS DE STAËL
The Roofs
1952. Oil on hardboard, 200 x 150 cm.
Centre Georges Pompidou, MNAM, Paris. Gift of the artist.
Photo Centre Georges Pompidou.

The *Roofs* followed on from the large-scale abstract compositions of the 1940s and the 1951 *Walls* sequence. Initially entitled the "Sky over Dieppe," it demonstrates de Staël's determination—in defiance of those he called the "forward to abstraction gang"—to return to subjects with direct input from the real. As his formats grew larger, and as *matière* turned to genuine impasto, his paintings appeared increasingly frontal, and thus undermined classical perspective. Starting off from abstraction, and although he destroyed most of his pre-1941 oeuvre, de Staël was now unquestionably raising once again the problematic of the subject of painting and of the real objects that serve as its motifs. In a discussion of the nature of the dilemma with Roger van Gindertael in 1950, the artist noted: "A picture is organically disorganized and inorganically organized." De Staël mixed matter with transparency and brick-like construction with fluidity of color.

With their "ceaseless interplay of forces," his works (like those of the Portuguese-born French painter Maria Elena Vieira da Silva) are an appeal to reconsider the figuration/abstraction dichotomy.

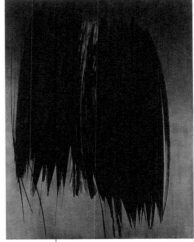

space as a relationship between form and ground led to a highly unorthodox approach in relation to the dominant forces of geometric abstraction and Surrealism in the 1930s. Hartung's avowed intent to "no longer represent anything" gave rise to a reflection on the purposes of painting. "What I enjoy," he said, "is *acting* on the canvas."

SURROUNDED BY THE WORLD AND OWES IT ITS MEANING" Soulages

> > > humanization of the world, and it should not be thought the world is absent from it simply because its image—or one of its images—is absent from the canvas."Abstraction, no matter of which kind, opened the way to a reflection on the "irreducible" nature of painting itself. From Bram van Velde to Yves Klein, from Martin Barré to Supports/Surfaces, from Simon Hantaï's methodology to the analytical criticism of BMPT, abstract art was bent upon becoming the ethic of modernity. On the opposing shore, however, Bacon, Balthus, Jean Hélion and Picasso (in one of his many guises) remained impossible to pigeonhole and their quality, in the eyes of their contemporaries at least, seemed to reside in their very isolation. Today, however, the reasons behind the return to the subject in the work of Hélion, Giacometti, de Staël and even, in his way, of Yves Klein, as well as the enduring desire felt by some painters to remain faithful to avatars of figuration, call for deeper investigation. The rejection of a teleology based on the universal triumph of abstraction made figuration inevitable, although the result was not inescapably a descent into melancholia. Figures skeptical of the utopia of abstraction, such as Jean Dubuffet, Gaston Chaissac, Bissière and the Cobra group, opted instead to delve into forms and figures derived from the so-called "primitive" arts. By 1945, Dubuffet had provided a definition of Art Brut as a term covering "all types of production… that present a spontaneous and highly inventive character and which owe as little as possible to the normal run of art and cultural cliché." With Christian Dotremont as the driving force, between 1948 and 1951 Cobra also united various groups under one umbrella and, by going beyond the Paris art scene, proclaimed "the internationalization of the avant-garde." As is clear in confronting the complex relations between what are interconnected strands, any "cataloguing," any distinction between abstract and figurative is a vain enterprise. Unless 'of course' abstraction as it is normally defined has never existed and is instead a particular and decidedly unique way of perceiving the real. <

120

"A touch of reality"

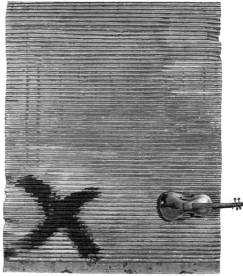

ANTONI TÀPIES
Metal Shutter and Violin
1956. Painting and assemblage,
200 x 150 x 13 cm.
Private collection, Barcelona.
Photo B. Hatala/CNACGP.

Reading the works of Sartre and Heidegger forced Tàpies to "distinguish between an inauthentic existence (banal, everyday reality, the madding crowd) and an authentic one (the true locus of being)." After the war, through his friend the poet Joan Brossa, Tàpies encountered the Catalan avant-garde and was part of the group that set up the journal *Dau al set*. At the October salon in Barcelona in 1948, he exhibited a painting and, already, a collage with cross motifs. His work immediately began to show the impact of the art and thought of the East, of its "mix of mysticism, philosophy and an art of living." In 1950 in Paris, he experienced a "new feeling of freedom" and, shaking off the persistent lure of Surrealism, tried to imbue his work with a "social content." Through contact with the review *L'Art d'aujourd'hui*, Tapiès became associated with Art Informel, which had profound repercussions on his oeuvre. His pictures transmuted into "sediments," their "poor" surfaces proffering a "touch of reality," loaded with memory and history.

"Reach out and touch it"

ALBERTO BURRI
Sacco e Bianco
1953.
Sackcloth and oil on canvas,
150 x 250 cm.
Centre Georges Pompidou,
MNAM, Paris. Photo Centre
Georges Pompidou.

The work of Alberto Burri is a masterful interrogation of the nature of painting as applied to all the constituents and materials of the picture-making act. The series of burlap *Sacchi* (sacks) produced in 1950 is an exercise in imposing order on matter. The darned sacks are a metaphor for a vision of painting ripped from the ruins and sewn back together: they try to reconstitute a reality torn asunder. In this connection, G. C. Argan notes that "Burri's painting is not embedded in symbols, but in signs; it neither desires, nor forewarns, nor does it announce a situation, but wants to make it possible to *reach out and touch it.*" Predating Yves Klein's *Combustions*, as early as 1955, in his *Legni*, Burri was flaming and charring wood. As Daniel Abadie has highlighted, however, "Whereas Yves Klein nurtured cosmic intentions, Burri's scope is first and foremost pictorial." The *Cretti* that followed, and the intentional crocodiling that the artist exploited in them, confirmed that Burri's focus was on the status of the painting as physical object and on its continuing existence at a certain stage of our history.

"BLUE HAS NO DIMENSION,

"Cosmic abstractions"

LUCIO FONTANA
Concetto Spaziale
1960.
Oil on canvas, 150 x 150 cm.
Centre Georges Pompidou,
MNAM, Paris.

Fontana is a major figure in twentieth-century art. In the 1930s, he was in contact with the Abstraction-Création movement. The Futurist leader Marinetti had already praised his "cosmic abstractions" in 1938, but up until his return from a six-year exile in Argentina in 1947, Fontana in fact exemplified the internal conflict between interwar Italian Classicism and adherence to the international avant-garde. The *Primo Manifesto Blanco* that he co-signed the same year consecrated him as one of the most significant supporters of an aesthetic utopia firmly rooted in a multifaceted experience of modernity. Intrigued by the logic of materials, and pursuing his desire to bridge the gap between sculpture and painting, Fontana envisioned everything he did in the context of a single overarching program, which led him to the *Secondo Manifesto Spaziale* in 1949. In the later manifesto, he expressed a new willingness to produce work that would link more closely to the site and to the environment. He began work on *Bucchi* (holes punched in the surface of the canvas), followed by *Inchiostri* (Inks), and finally the famous *Attese* ("Waiting" works), where the generally monochrome canvas is precisely slashed. A number of other manifestos followed, larded with declarations in which Fontana expressed his intention, for example, to "find a

style in which form is inseparable from the notion of time and in which the images seem to detach themselves from the flat surface and extend the motion they suggest into space."

"Pure materials"

PIERO MANZONI
Achrome
1959. Kaolin on pleated canvas,
140 x 120.5 cm.
Centre Georges Pompidou,
MNAM, Paris.

Artist, poet and theorist, from 1956 Piero Manzoni got involved in artistic activism and published numerous texts. A meeting with Klein and Burri led to the manifesto *Per una Pittura organica* (Toward an organic painting) distributed in Milan by the Movimento Nucleare, with which he broke in 1959. Using what he dubbed "pure materials," Manzoni developed the concept of the one-color *Achrome*, and completed the first of his *Lines*. He also began to sign people's bodies and issue certificates of authenticity to that effect, and worked on a project for shutting up corpses in transparent boxes. Associated with the Zero group, he produced a series of inflatable sculptures called *Bodies of Air,* the ones he blew up himself being subtitled *Artist's Breath.* The first *Magic Bases* followed in 1961—for the time a person stands on such a base they are transformed into a work of art. The *Merda d'Artista* were produced at the same time: 30 grams of the artist's own excrement in boxes stamped "Made in Italy" sold at the rate of the gold standard. Manzoni also created a *Pneumatic Theater* and built the first of his upside-down *Bases of the World,* one of which was dedicated to Galileo.

"Living brushes"

YVES KLEIN
Grande Anthropométrie bleue Hommage à Tennessee Williams (ANT 76)
Around 1960. Pure pigment and synthetic resin on paper stretched on canvas, 276 x 418 cm.
Private collection.

In 1948, Klein signed *the sky over Nice,* thus claiming it as his own. He met with François Dufrêne (linked at the time to the Lettrists). In his early years, he earned his living as a judo instructor and traveled to Japan (1952–53), where he became a black belt. He also became interested in the Rosicrucians. In Paris in July 1955, the *orange monochrome* he presented at the Salon des Réalités Nouvelles was rejected. He did, however, successfully exhibit a group of *Monochromes* of various hues at Colette Allendy's

gallery a year later, before selecting a particular tint of blue that he patented and baptized "International Klein Blue" (IKB). In 1957 at Milan, and then in Paris at Iris Clert's and Colette Allendy's, he presented both IKB *Monochromes* and *Objects,* and the following year exhibited the empty white space of *The Void* at Iris Clert's. In 1959 he worked on various architectural projects (including *Monogold),* followed in 1960 by *Cosmogonies* and *Anthropométries,* imprints of the human body painted with "living brushes." On November 27 of the same year, the *Journal d'un seul jour* published the photograph of the "painter of space" throwing himself into emptiness.

IT LIES OUTSIDE DIMENSION" Klein

"The instant of crystallization"

MARTIN BARRÉ
67 z 23
1967. Spraycan paint on canvas, 73 x 54 cm.
Private collection, Paris.

"**F**inding his own personal path," writes Jean Clay, "as far away from 'cold abstraction' as from 'Parisian Tachism,'" Barré adopted "ordinal" serial methods. Reflecting on the status of easel-painting, and scrupulous as to the formats used, Barré created works resulting from a steady process of reduction that ended only with what he referred to as the "instant of crystallization"—the moment when, for him, a picture was finished. As early as the 1960s, Barré had arrived at a systematic simplification of means, applying pigment either by squeezing paint directly from

122

the tube, or spreading it with the finger, or by spraying black paint from an aerosol on to specified areas of the canvas. In 1972, Barré returned to the brush proper and started using acrylic. The methods behind these works oscillate between elaborate geometrical principles and palimpsest-like transparency. Color too gradually made a reappearance, becoming steadily more dominant in later works. A marginal, little-known figure, Barré's demanding and masterful presence in fact represents one of the high points of contemporary painting. His work heralds Minimalist abstraction but also appears as a highly unconventional "system" that switches back and forth between the use of rules and instinct.

FRANÇOIS MORELLET
A Random Arrangement of Triangles Generated by the Even and Odd Numbers in a Telephone Directory
1958.
Oil on wood. Three parts, each 80 x 80 cm.
Musée de Grenoble.

Unencumbered by ideology, the highly influential figure of François Morel-

let appears today as one of the most original creative artists of the second half of the twentieth century. He was able to synthesize and frame a far-reaching critique of some of the most contradictory experiments of modernity. Although sometimes mistakenly assimilated to Kinetic art and a cofounder of the Groupe de Recherche Visuel (GRAV) in 1960, he was a lone wolf. Morellet had began teaching

himself in the late 1940s, soon adopting principles that allied rigor to play, system to chance. Fascinated by the calculations behind the mosaics at the Alhambra, Granada, and receptive to the Constructivist avant-garde and to the work of Max Bill (which he saw as offering a way out of the constraints of the Neo-Plasticist idiom), by the beginning of the 1950s Morellet was producing systematic and delib-

"I like messing things up"

erately reductive works that relied on iterative and deductive formulae which for the time were strikingly advanced. A freebooting and disrespectful figure, Morellet was both heir to the rigorist formalism of Concrete art (he confessed "I like messing things up") and forerunner of Conceptual art. Chance and a dizzying use of language joined forces with the aim of deconstructing the imperious order of geometry.

"Kinetic art"

VICTOR VASARELY
Mindoro 2
1958. Oil on canvas, 155 x 130 cm. Centre Georges Pompidou, MNAM, Paris.
Photo Centre Georges Pompidou.

Spiritual son of the Bauhaus and of its urbanist and social repercussions, Vasarely emigrated from Hungary in 1930. Until 1956, he worked as a commercial artist managing an advertisement company. He started painting in an abstract mode in 1952, gradually reducing his palette to a more limited range of colors. A stay at Belle-Île-en-Mer, Brittany, in 1947, during which he became fascinated by the local pebbles, confirmed him in the idea that "languages of the spirit are only supervibrations of the physical world in the wider sense." Seeing himself essentially as a plastic artist and as the creator of works he considered as "starting points for prototypes," Vasarely published the *Yellow Manifesto* in 1955. He intervened crucially in the activities of the Galerie Denise René, and in the development of Kinetic art and of the "multiple," of which he was a major exponent. The exhibition "Mouve-

ment"—which brought together Yaacov Agam, Pol Bury, Alexandre Calder, Marcel Duchamp, Robert Jacobsen, Jésus-Rafael Soto, Jean Tinguely and Vasarely himself on April 6, 1955—marked the earliest appearance in public of an aesthetic based on the idea of "transformable works." A "brief summary of kinetic art," a text entitled *Movement-time or the Four Dimensions of a Kinetic Plastic* by Pontus Hultén and a piece by Roger Bordier explained the ideas behind these transformable works. "Be it through the motion of the work itself, through optical movement, or through intervention by the viewer, the work can—by dint of its substance and in its very nature—be constantly and perhaps indefinitely re-created." At this time, Vasarely began to imagine a total work of art released from the contingencies of picture-making which would, through an implicit relationship with the city, renew with what Vasarely himself termed the "plasticity" and spirit of the Renaissance.

"A SENSITIVE MAN OR ARTIST CAN ONLY BE ILL

"A Western calligrapher"

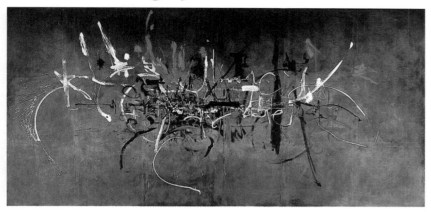

GEORGES MATHIEU
Capetians Everywhere
1954. Oil on canvas,
295 x 600 cm. Centre Georges
Pompidou, MNAM, Paris.
Photo Centre Georges
Pompidou.

As early as the Salon des Réalités Nouvelles in 1947, Mathieu presented three canvases he had executed flat on the ground. These works showed him to be a Tachist, gestural exponent of Art Informel opposed to the domin- ant geometric trend. In 1948, he organized the "HWPSMTB" and "White and Black" shows, while various articles published in 1949, as well as the "Véhemences confrontées" exhibition staged by Michel Tapié in 1951, brought out the differences separating true Action painting from Art Informel. In 1953, Mathieu brought out the first issue of the *United States Paris Review,* a journal that he was to edit for a further ten years. At the same time, he was painting large-format can- vases on "historical" themes, embracing Merleau-Ponty's philosophical approach to the notion of the body as described in *The Phenomenology of Perception* (1945). "Using oil paint directly from the tube, working 55,482 times faster than Utamaro," Mathieu was seen by André Malraux as "a Western calligrapher whose work shows the painter physically wrestling with the canvas as he strives to fuse practices originating in the Orient with performance in a public forum."

"Transcending of Western signs"

JEAN DEGOTTEX
Aware II
1961. Oil on canvas,
202 x 350 cm. Centre Georges
Pompidou, MNAM, Paris.
Photo Centre Pompidou.

In 1952, Degottex joined Charles Estienne in setting up the Salon d'Octobre. He also benefited from support from André Breton, who wrote a pref- ace for his show at the Étoile Scellée gallery in 1955. Degottex was strongly influ- enced by Zen painting and phi- losophy. Concerned with space and the void, as well as with the dynamism of brushwork, his work introduces "minimized" structures. "All writing systems attract me, but I think that, with the less decipherable ones, things can take on a different meaning. In Sumi or Zen cal- ligraphy, the sign is tran- scended; but how can one start to transcend Western signs?" The English title of this paint- ing also refers to the East and alludes to one of the four suc- cessive fundamental states of the individual faced with an artwork. As Degottex describ- ed: "As far as the people of the East are concerned, control is also physiological. Here, since there is a dearth of spiritual teaching and training...[control] is also as much of the intellec- tual as of the empirical order. In Zen, people also use what have been translated as 'stratagems.' This shows that sometimes one has to play tricks on habits that might threaten to adulterate our deepest impulses."

"Unveiling without end"

BRAM VAN VELDE
Untitled
1965. Oil on canvas,
199.5 x 250.5 cm.
Centre Georges Pompidou,
MNAM, Paris.

Dutch-born Bram van Velde first settled in Paris in 1925, before moving the following year to Corsica. In 1932 he moved to Majorca, but fleed from the island at the outbreak of the Spanish Civil War. In 1943 he met with Jacques Put- man, critic Georges Duthuit, and then with Édouard Loeb and Samuel Beckett, but he was only to attract public attention at an exhibition orga- nized by Michel Warren in Paris in 1957. According to Jacques

Putman, it is senseless to approach van Velde's work chronologically, since it must be thought of as a single sys- tem of interconnecting levels. "Bram van Velde," as Beckett put it, "paints extension." Characterizing himself as a "dilute being," he dilutes the forms he inscribes on the sur- face of the canvas and thus tends toward what Jean Starobinksi termed "super- fluous interpretation." A type then, in Jean-Pierre Pincemin's words, of "ungainly" painting. "An endless unveiling, veil behind veil, plane after plane of imperfect transparencies, light and space themselves veils, an unveiling towards the unveilable, the nothing, the thing again."

123

IN OUR CIVILIZED WORLD RIDDLED WITH LIES" Bram van Velde

"A practice"

CLAUDE VIALLAT
Untitled no. 40
1968.
Canvas, red ground, blue forms, 280 x 194 cm.
Centre Georges Pompidou, MNAM, Paris.
Gift of Daniel Cordier.
Photo Centre Georges Pompidou.

A painter through and through, from 1966 Viallat developed a unique stenciling technique that was to become his signature. An intentionally prolific artist, he produced a radical critique of both the geometric and lyrical strands of abstraction, substituting for artistic conventions an infinity of possibilities that combine enjoyment of painting with systematic rigor. His agenda at this time formed part of the pictorial materialism typical of Supports/Surfaces. A central figure in this French group, he exhibited with them in 1970 at the ARC space, only to resign in May 1971. Viallat went on to produce pieces in a broad spectrum of media that reflected his inquisitive interest in archaic and primitive techniques, and in a kind of *bricolage* which paralleled his ever-growing corpus of paintings. Unstretched canvases

124

were followed by highly colorful works on supports of every kind in which paint was subjected to extreme treatment.

"Retinal silence"

SIMON HANTAÏ
Mariale M A 3
1960.
Oil on canvas, 296.6 x 209.5 cm.
Centre Georges Pompidou, MNAM, Paris.
Gift of M. Marcel Nahmias.
All rights reserved.

From the 1940s, Hantaï produced works influenced by Surrealism (exhibition at the Étoile Scellée gallery, 1953, prefaced by André Breton). These were followed by numerous monumental canvases assembled for a 1956 show at Kléber's entitled "Sexe-Prime." A large pink picture covered in writing dating from 1958-59, and described by the critic Marcelin Pleynet as "the final act of drawing," provided a springboard for a new beginning. In 1960, Hantaï stopped using the "time-worn surface" (as Jean-Paul Ameline called the conventional support), and began to work "eyes closed" on a canvas first folded, then doubled back on

itself, screwed up or knotted, and coated uniformly in paint from edge to edge. The painting was then unfolded and flattened out: the areas painted blind thus appeared colored, while the "missed" ones were left untreated. "Painting," Ameline continued, "is no longer a screen on which objects are projected, but its own object. It comes into being on its own, the painter assisting in the event." From *Mariales* in the 1960s to the *Tabulas* of the 1980s, as well as in more recent works (though the rules and objectives have remained the same), Hantaï's methods have varied greatly. The philosopher-critic Maurice Blanchot has exerted a crucial influence on the artist: "Folding is that neutral voice that lets the work speak from a place without a place wherein the work can stay silent." A wall of color, this canvas belongs to a sequence called "The Wall Says: Mantels of the Virgin Mary." Hantaï himself defines it as "retinal silence."

"A form which has never existed"

NIELE TORONI
Imprints With a No. 50 Paintbrush Repeated at Regular (30 cm) Intervals.
1967.
Acrylic paintbrush marks on white waxed canvas, 475 x 140 cm.
Centre Georges Pompidou, MNAM, Paris.
Photo Centre Georges Pompidou.

Toroni's methods have not altered since 1967. They consist in applying the marks left by a no. 50 paintbrush at regular 30-cm (1-foot) intervals to a predetermined surface. Toroni's work thus runs counter to the very idea of originality, although the colors and supports he uses do vary according to the project. The artist has employed this unique "logo" to cover—or invade—many types of support: he has worked simultan-

eously on wall, canvas and other surfaces, and thus tackles the question of the locus and status of painting. Toroni is also a generous commentator on the reasons behind his art. In a lengthy interview with Catherine Lawless for *Les Cahiers du Musée national d'art moderne* in 1988, for instance, he noted: "My great utopia, my great mistake, is in thinking there is anything left to do after Pollock without employing some pre-existent form (either by deviating from it or making it more sophisticated). What I call 'marks with a no. 50 paintbrush' is a form which has never existed before. I called them that because they result from working with paint: from placing the hair end of a brush, the end that is used for painting, on a given surface, so that pigment is applied and becomes visible."

"ALL CONTEMPORARY PAINTING IS

"A tool for seeing"

DANIEL BUREN
Painting, Manifestation III
1967. Acrylic on canvas,
250 x 250 cm.
Centre Georges Pompidou,
MNAM, Paris.
Photo Centre Georges
Pompidou.

In January 1967, four young painters—Daniel Buren, Olivier Mosset, Michel Parmentier and Niele Toroni—organized a protest they dubbed "Manifestation I" at the Salon de la Jeune Peinture. They handed out fliers emblazoned with the words "We are Not Painters," and executed works on the spot which they then took down and replaced with a banner running, "Buren, Mosset, Parmentier, Toroni are not exhibiting." A number of other protests followed until a final event in September 1967, at which they declared that "art is a distraction, art is false. Painting begins with Buren, Mosset, Parmentier, Toroni." Such collective actions may have given the impression that a group was about to form, whereas the four artists themselves always refused to be lumped together as a movement, admitting at the most that they might be a collaborative demonstration or association that united politics, aesthetics and criticism. Back in 1965, Buren had won a prize at the Paris biennial exhibition. The same year he had started painting white over an increasing proportion of the two edges of a piece of industrial fabric striped vertically in equal bands 8.7 cm (32/5 in.) wide. The absence of any specific motif and the constitution of a sign, or a "tool for seeing," allowed Buren to tackle head on the question of painting at its limits—and the limits of painting. At the end of 1967, Buren had reduced his working practice to a "degree zero," to what a critic called "semantic asepsis." Painting was no longer an end in itself. The impersonal, the neutral mark provided the artist, as he put it, with a method of "becoming extremely personal," depending on the locality and position the mark is allotted. Buren then turned theoretician, and began to address more closely the notion of "site-specific" projects. Identifying himself with the "genius of the place," Buren propelled his work from the private situation to the public arena. At the same time, he assumed the paradox of a body of work which weds critical analysis to a renewal of a decorative dimension—something he clearly accepts as being one of the challenges of contemporary art.

Chronology 1939–1970

This chronology is largely devoted to events in Europe. Sections in bold refer to artists mentioned in the main text and captions.

1939
• September: outbreak of World War II.

1941
• Derain, Vlaminck, van Dongen, Friesz, Belmondo and Despiau travel to Germany.
• Matisse: cut-out gouaches.
Paris, Galerie Braun: "Jeunes Peintres de tradition française."

1942
• Paris: Arno Breker exhibits his heroic sculptures.
Jean Paulhan takes Bazaine to meet Braque.

1943
• Foundation of the Salon de Mai.
• Jean-Paul Sartre: *Being and Nothingness*.

1944
• The Salon d'Automne consecrates modern art.
Francis Bacon: *Three Studies for Figures at the Base of a Crucifixion*.

1945
• The Armistice. Yalta Conference. UN set up.
• Paris, Galerie René Drouin: "Art Concret" exhibition.
Jean Dubuffet uses the term "art brut."

1946
• Isidore Isou founds Lettrism.
• Paris, Galerie René Drouin: Kandinsky retrospective exhibition. Galerie Louis Carré: Delaunay retrospective exhibition; Calder exhibition with a preface by Sartre.
Paris: Galerie Denise René opens.
First Salon des Réalités Nouvelles.

1947
• André Malraux: *Le Musée imaginaire*.
• Antonin Artaud: *L'Art brut*.
• Paris: inauguration of the Musée National d'Art Moderne.
Paris, Galerie Lydia Conti: Schneider (1947), Hartung (1948), Soulages (1949). Paris, Salon des Surindépendants: Wols and Soulages gain exposure. Georges Mathieu: "Abstraction lyrique" exhibition.
Jean-Paul Riopelle: "Automatisme" exhibition. Returning from Brazil, Maria Helena Veira da Silva and Arpad Szenes join up in Paris. Lucio Fontana founds Movimento spaziale.

1948
• Braque wins Grand Prix at the Venice Biennale.
• Salon des Réalités Nouvelles: exhibition by the Argentine-Uruguayan group Madi.
• Michel Seuphor prepares the publication of *Art abstrait, ses origines, ses premiers maîtres*.
Paris, Galerie Allendy: "HWPSMTB" exhibition.

J. Bazaine, *Notes sur la peinture d'aujourd'hui* published. Barcelona: Dau al set group formed. Amsterdam: birth of the Cobra group. Bram van Velde meets Samuel Beckett.

1949
• Auguste Herbin: *L'Art non figuratif, non-objectif*.
• Paris, Galerie Breteau: "Musicalistes" group.
Foundation of the Salon de la Jeune Peinture. Léon Degand sets up the journal *Art d'aujourd'hui*.

1950
Italian group Origine, around Burri.

1951
• Ulm: Max Bill, Hochschule für Gestaltung built.
Charles Estienne: article on the academic nature of abstract art.
Galerie Dausset: "Véhémences confrontées."

1952
• Samuel Beckett: *Waiting for Godot*
Michel Tapié: "Un art autre." Art "informel."

1953
• Review *Cimaise* founded.

1954
• Beginning of the Algerian War.
Pierre Guéguen's "Tachisme" appears.

1955
• Foundation of "Comparaisons" and of the Kassel documenta.
Paris, Galerie Denise René: "Le Mouvement." Vasarely: *Yellow Manifesto*. Op art appears.

1956
• Marseille: opening festival of avant-garde art.
Yves Klein presents the monochromes refused at the Salon des Réalités Nouvelles and, in 1957, his blue monochromes that resemble the *Achromes* of Piero Manzoni.

1957
• Madrid: formation of the El Paso group.
• Georges Bataille: *L'Érotisme*.
• Roland Barthes: *Mythologies* on consumer society.
Internationale Situationniste.
Düsseldorf: Zero group set up.

1958
• De Gaulle returns. Fifth Republic.
• Alain Robbe-Grillet: *Les Gommes*, novel.
Venice Biennale gives pride of place to Mark Tobey, Tàpies and Chillida.
Paris, Galerie Iris Clert: Yves Klein, "Le Vide."

ALREADY IN LASCAUX AND IN THE PREHISTORIC" Viallat

1948.
Denise René's gallery, rue La Boétie, Paris. Gilioli, Schneider, Degand, Dewasne, Jacobsen, Denise René, Odile Degand, Poliakoff, Vasarely, Piaubert, Mortensen, Lucienne Kilian, Charles Estienne. Archives D. René.

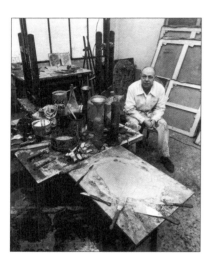

1951.
Jean Dubuffet in his studio, Paris. Photo Doisneau/Rapho.

1960.
Pierre Soulages in his studio on rue Galande, Paris. Photo Izis.

1962.
Timothy Behrens, Lucian Freud, Francis Bacon, Frank Auerbach, and Michael Andrews at Wheeler's Restaurant, Old Compton Street, London. Photo J. Deskin.

Chronology 1939–1970

1959
• Paris biennial exhibition founded.

1960
• Birth of Nouveau Réalisme.
Paris: G.R.A.V. (Groupe de Recherche d'Art Visuel) set up, with J. Stein, Morellet, Garcia-Rossi, Julio Le Parc, F. Sobrino and Yvaral. Paris, Musée des Arts Décoratifs: "Antagonistes" exhibition.

1961
• Paris, Galerie J.: "À 40° au-dessus de Dada."
• Berlin Wall erected.
• Amsterdam, Stedelijk Museum: "Movement in Art."
• Balthus named director of the French Academy at Rome in the Villa Medici.
• Düsseldorf: Beuys begins teaching at the Kunstakademie.

1962
• Paris: Groupe Panique founded.
• Manessier and Giacometti, prizes at the Venice Biennale.
Dubuffet creates *L'Hourloupe* (to 1974).

1964
• Paris, Musée des Arts Décoratifs: "Nouvelle Tendance."
• Galerie Daniel Cordier closes.
• Saint-Paul-de-Vence: Fondation Maeght.
• Jacques Lacan founds the École Freudienne in Paris.
• Alain Robbe-Grillet: "Manifesto" for the New Novel.

1965
• Sixteenth Salon de la Jeune Peinture: "Salle Verte." G. Aillaud, E. Arroyo, H. Cueco, etc.
Bern and Paris: "Lumière et Mouvement."

1966
• Paris, Galerie Stadler: first Gutai exhibition.
• Paris, Grand Palais and Petit Palais: "Hommage à Picasso."
• Saint-Paul-de-Vence: "10 ans d'art vivant 1945–1955."
• Michel Foucault, *Les Mots et les Choses* first published
Paris: various events staged by BMPT.

1967
• Six-Day War. Death of Che Guevara.
• Guy Debord: *La Société du spectacle*.
• Paris: ARC, CNAC and FNAC all created.
Paris: Salon de la Jeune Peinture (January), Musée des Arts Décoratifs (June): BMPT events and exhibits.

1968
• Europe: Student uprisings.
• Prague Spring of temporary freedom.
• London ICA opens. Death of Marcel Duchamp.

1969
• Paris, ARC: "Salle Rouge" for Vietnam.
• President de Gaulle resigns. New president Georges Pompidou announces the project for Beaubourg.
Hartung wins Grand Prix at the Venice Biennale.

1970
• Paris: foundation of the Coopérative des Malassis.
Paris, ARC: Supports/Surfaces exhibition.

Studies on Post-War European Painting
A. Bonfand. *L'Art en France, 1945–1960*. Paris, 1995.

E. Braun (ed.). *Italian Art in the Twentieth Century*. London and Munich, 1988.

B. Ceysson. *L'Art en Europe: les années décisives 1945–1953*. Geneva, 1987.*

S. Compton (ed.). *British Art in the 20th Century: The Modern Movement*. London and Munich, 1986.

C. M. Joachimides, N. Rosenthal, and W. Schmied (eds.). *German Art in the Twentieth Century*. London and Munich, 1985.

G. Mathieu. *Au-delà du tachisme*. Paris, 1963.

C. Millet. *L'Art contemporain en France*. Paris, 1987.

J. Paulhan. *L'Art informel*. Paris, 1962.*

F. Popper. *Origins and Development of Kinetic Art*. London, 1975.

M. Ragon. *Journal de l'art abstrait*. Geneva, 1992.

M. Seuphor. *L'Art abstrait, ses origines, ses premiers maîtres*. Paris, 1974–88 (5 vols.).*

Vingt-Cinq Ans d'art en France. Paris, 1986.*

Main exhibitions and catalogues
1972, Paris. *Douze Ans d'art contemporain en France*. Grand Palais.*

1981, Paris. *Paris/Paris, 1937–1957*. MNAM.*

1982, London. *Aftermath: France, 1945–1954*. Barbican Centre.

1988, Paris. *Les Années 50*. MNAM.*

1990, Paris. *Une histoire parallèle, 1960–1990*. Centre Pompidou.

1991, Saint-Étienne. *Supports/Surfaces, 1966–1974*. Musée d'Art Moderne.*

1993, Saint-Étienne. *L'Écriture griffée*. Musée d'Art Moderne, RMN.

Where works can be seen
United States
The Menil Collection, Houston.

MoMA, New York.

Solomon R. Guggenheim Museum, New York.

France
Musée de Peinture et de Sculpture, Grenoble.

Musée d'Art Contemporain, Lyon.

Musée Cantini and MAC, Marseille.

Musée des Beaux-Arts, Nantes.

Musée National d'Art Moderne, Paris.

Fondation Maeght, Saint-Paul-de-Vence.

Europe
Antoni Tàpies Foundation, Barcelona.

Nationalgalerie, Berlin.

Kunstsammlung Nordrhein-Westfalen, Düsseldorf.

Stedelijk van Abbemuseum, Eindhoven.

Louisiana Museum, Humlebaek.

Tate Gallery, London.

Moderna Museet, Stockholm.

*** Essential reading**

THE REAL IN QUESTION

"Pop art, Nouveau Réalisme, Fluxus and Happenings"

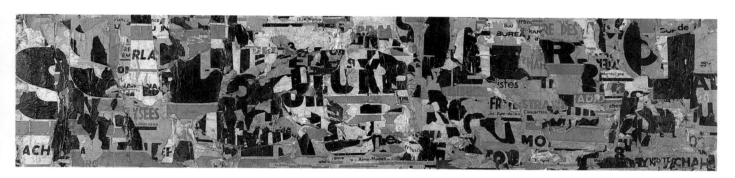

"A modern-day Bayeux Tapestry"

RAYMOND HAINS AND JACQUES DE LA VILLEGLÉ

Ach Alma Manetro
1949. Slashed posters pasted on to paper glue-mounted on canvas, 58 x 256 cm. Centre Georges Pompidou, MNAM, Paris. Photo Centre Georges Pompidou.

After the end of the war, two Breton-born conspirators started working together, using new media, on an oblique critique of pictorial methods. Hains, who had learned about photography by Emmanuel Sougez, with whom he worked on *France-Illustration,* had already turned his back on the École des Beaux-Arts. Villeglé, for his part, after two years spent completing his architectural studies, adopted an approach based on recycling urban waste (wire, fragments of the German Atlantic defenses, etc.). In 1948—the year he exhibited *Hypnagogic Photographs* (objects taken through a lens placed in front of a reflector that thus produces multiple images) at Colette Allendy's gallery—Hains shot some short films with Villeglé that made use of the serried ranks of advertisements they had seen on their city wanderings. While they were making *La Loi du 29 juillet 1881* (in reference to an old anti-flyposting law), they started poaching from posters, peeling them away and revealing fragments of words (such as *Ach Alma Manetro* here) that recall the meaningless phonemes that Isidore Isou and the Lettrists were reciting and the "crirythme ultralet-triste" declaimed by François Dufrêne in his *Cantate des mots camés* a few years later. These torn posters are a kind of mod-ern-day Bayeux Tapestry. Unlike collage, they are not "the result of addition or composition," as Pierre Restany has com-mented, "since discovery is more important than creation, 'found beauty' more than cre-ated beauty." The medium of *décollage* reached its apogee in the work of Mimmo Rotella around 1955, and that of Hains, Villeglé and Dufrêne at the first Biennale de Paris (1959). An echo of the poetic freedom that manifested itself in the publi-cation of *Hépérile éclaté* (the transposition of a sound poem by artist Camille Bryen that was designed to "explode speech into ultra-words that no human mouth could ever utter"), *décol-lage* is, beyond the links con-necting word and image, like taking a photograph—it makes it possible, as Hains has mis-chievously quipped, to "take the motif away with you."

The movements treated in this chapter, which drew on Cubist collage, Futurism, Dada, the various incarnations of the Surrealist method and Lettrism, all strove to fuse art with everyday concerns, to operate, as Robert Rauschenberg put it, "in the gap between art and life."

Pop art, although it became synonymous with American culture, was born in England. The word itself was coined as early as 1947 by one of its most significant future exponents, the painter and sculptor Eduardo Paolozzi, but the movement derived from the concept of "popular culture" outlined by critic Lawrence Alloway. Paolozzi was a founder member of the London-based Independent Group, along with artist Richard Hamilton, historian Reyner Banham, and architects Alison and Peter Smithson. A whole series of events such as "Parallel of Life and Art" (1953), "Collages and Objects" (1954), "Man, Machine and Motion" (1955), and above all "This is Tomorrow" (1956) brought to light the recurrent themes of what soon transmuted into the Pop art scene. In 1958, Lawrence Alloway published *The Arts and the Mass Media;* Richard Smith, Peter Blake and Peter Phillips (all linked to the Royal College > > >

> > > of Art, London) were followed by a new generation that included David Hockney, Allen Jones, Patrick Caulfield, Ronald B. Kitaj and Pauline Boty.

But it was in New York, in a climate otherwise dominated by Abstract Expressionism, that Jasper Johns and Robert Rauschenberg, aided and abetted by musician John Cage and choreographer Merce Cunningham, reintroduced art to the imagery and physical presence of everyday objects. The result was an unqualified public success, but Pop art's position in relation to the avant-garde—did it go with or against its grain?—remains an open question. As early as 1960, Pop art's meteoric rise was consecrated by events such as the staging in Martha Jackson's gallery in New York of the "Environment, Situation, Space" show, as well as developments around the art dealers and collectors Leo Castelli, Ileana Sonnabend, Richard Bellamy and numerous critics such as Max Kozloff, Leo Steinberg and Robert Rosenblum. Jasper Johns and Rauschenberg themselves, together with Andy Warhol, Roy Lichtenstein, James Rosenquist, Tom Wesselmann, Claes Oldenburg, Larry Rivers, Jime Dine and Robert Indiana, were the early exponents of a trend which, as Rosenberg stressed, marked the professionalization of American art. A rather different strand, exemplified by Ed Kienholz, Lucas Samaras, Richard Stankiewicz, George Segal, Robert Watts, Red Grooms and Richard Artschwager, as well as Californians Billy Al Bengston, Mel Ramos and Edward Ruscha, was also to play a crucial role.

Although stylistically distinct, all these currents shared a view of the contemporary world epitomized most recognizably by Andy Warhol, a megastar in a society gripped by the worship and consumption of images. Critic Pierre Restany, emphasizing the fact that the European way of 'staging' modern life was displaced by a distinctively American approach, also went on to bring out most usefully the antecedents of Nouveau Réalisme, the movement he himself founded in October 1960. "New Realists," he > > >

"Color becomes pure and utter sensibility"

YVES KLEIN
Monochrome (IKB 3)
1960. Pure pigment and resin on canvas glue-mounted on panel, 199 x 153 x 2.5 cm. Centre Pompidou, MNAM, Paris. Photo Centre Pompidou.

"Blue has no dimension, it lies outside dimension, whereas all other colors have one. They are pre-psychological spaces... All other colors entail the association of some concrete idea... but blue reminds us at the most of the sea and sky, everything that is most abstract in tangible, visible nature." These words record the birth of Klein's *epoca blu,* a "Blue Period" during which the artist would refer floridly to the philosopher of sensation, Gaston Bachelard. "First of all, there is nothingness, then a deep nothingness, then a blue depth." Klein, aiming at a fullness at which "color becomes complete and pure sensibility... noticed that the public... always reconstitutes elements of decorative polychromy [and] cannot just be in the presence of the 'COLOR' of a single picture." In 1957, after two years devoted to monochromes of various colors, Klein finally decided to exhibit works in a single shade of blue—International Klein Blue, or IKB. This "'specialization' of sensitivity as a raw material into stabilized pictorial sensitivity" led him in 1958 to the white room *(Le Vide)* installation at Iris Clert's gallery.

"The dignity and the gravity of destiny"

JEAN TINGUELY
Homage to New York
New York, MoMA,
March 17, 1960.
Left: fragment, Museum of Modern Art, New York. Gift of the artist. Right: Photo D. Gahr, New York. All rights reserved.

The work of Jean Tinguely is amusing, almost comical. Stuttering into motion and jiggling as if indulging in some *danse macabre,* it has provided one of the most acute, if tenderly anarchic, parodies of the world of the machine, whose pointless, laughable hustle and bustle Tinguely, in the way of Chaplin in *Modern Times,* condemned. A number of series have been described by his faithful accomplice Pontus Hulten: *Métamatics, Rotozazas, Baloubas* —absurdly entitled "spare parts" that powered "drawing machines"; *Cyclograveurs,* ironic twists on the abstract trends of the 1950s; *Ballet for the Poor, Studies for an End of the World,* and *Homage to New York* that blew up in MoMA's courtyard just as the finishing touches were being put to the building itself. In Tinguely's oeuvre—a kind of *Praise of Folly* or an excuse for an archaic and primitive festival—one can hear the distant clamor of the carnival and the rattle of ghost trains. *Hon* (Woman), mounted with Niki de Saint Phalle and Utveldt in Stockholm in 1966, as well as the *Cyclopes* that he built with his assistants in the 1970s, remain *Gesamtkunstwerken* of a kind that, as Hulten has stressed, "in spite of their burlesque side, preserve all the dignity and the gravity of destiny."

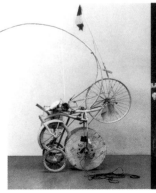

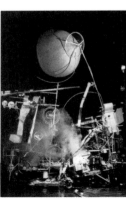

"NICÉPHORE NIÉPCE MET

"Where the bullets should go"

JASPER JOHNS
Target with Plaster Casts
1955. Mixed technique,
130 x 111.8 x 8.9 cm.
Private collection, New York.

NIKI DE SAINT-PHALLE WITH JASPER JOHNS
Untitled 1961. Mixed
technique, 120 x 58.5 x 24 cm.
Private collection, Paris.

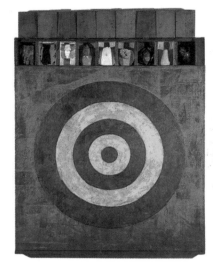

"In the series of large paintings dating from the spring and summer of 1961," explains Pontus Hulten, "Niki de Saint-Phalle decided to do a 'Rauschenberg' and a 'Jasper Johns,' a homage tinged, as it were, with a certain amount of love and agressivity. She carefully imitated a picture by Jasper Johns, both in terms of size and spirit. She included all of Jasper Johns' pictorial elements of the period: the target, the pot with the paintbrushes, the coat hanger, the light bulb and the beer can. The lower part was painted in the master's characteristic gray. The object of this homage liked the result very much. He studied it for a long time to work out where the bullets should go, because it was he of course who was to shoot the work. After considering the matter for two or three hours, he finally placed a certain number of bullets which made a white run (dirty), then an orange that was subsequently applied (with the finger?) on the targets..." Artistic creativity thus made short shrift of the split between Nouveau Réalisme and Pop art.

"Critical and political content"

CHRISTO
Iron Curtain
June 27, 1962.
A wall of oil drums set up
in rue Visconti, Paris.
Photo J.-D. Lajoux.

Christo Javacheff (known by his first name alone) executed his earliest urban works shortly after his arrival in Paris in 1958. The *Iron Curtain,* a wall of 204 oil drums that barricaded rue Visconti, and which he maintained was a protest against the

erection of the Berlin Wall the previous year, is strikingly reminiscent of the rear courtyard of the Martha Jackson Gallery that Allan Kaprow filled with automobile tires in the same year. Like Kaprow's Happenings, Christo's works had a political and critical dimension. Subsequent projects can be seen today as forerunners of Land art. Christo's works (made with the assistance of his wife Jeanne-Claude) constitute a permanent challenge to the nature of the sites chosen and defy material constraints of every kind. Their utopian projects have been installed in both urban and natural sites, and include monuments and open spaces that over time have become increasingly vast. Ephemeral pieces, they counter over-ambition and media saturation through the lasting memory their intervention leaves on sites that they both reveal and transform.

129

"Trap paintings"

DANIEL SPOERRI
Ben's Table
1961. Assemblage,
85 x 237 x 42 cm.
Private collection, Cologne.
Photo K. Igniatiadis/Centre
Georges Pompidou, Paris.

After working as principal dancer with the Bern Opera (1954–57), Spoerri was assistant director at the Darmstadt Landstheater (1957–59). In 1959 in Paris, he completed his first *tableau-piège (trap painting, Fallenbild),* which he explained in a text entitled *Topographie anecdotée du hasard* (Anecdotal topography of chance, 1962). Close to Tinguely and Yves Klein, he also signed Nouveau Réalisme's "aesthetic declaration." The following year, he transformed the "J" gallery into a restaurant, serving meals and carefully preserving the leftovers. Two years later, Spoerri opened a restaurant of his own in Düsseldorf, following this with the EAT gallery in which he exhibited works of culinary art by his friends Beuys, Niki de Saint Phalle, and German-born American satiric painter Richard Lindner. "The most radical concept to be introduced by Nouveau Réalisme," according to Raymond Hains, Spoerri's *tableaux-pièges* underwent numerous variations, from *tables-pièges* (trap tables) to *Détrompe-l'oeil,* from the *Collections* to *Word Traps* made in collaboration with Robert Filliou, from *Conserves de Magie à la Noix* to *Musées sentimaux.* These zero-gravity games of sense and nonsense were creations by an artist concerned with celebrating the "reliefs in the leftovers of our daily lives."

HIS WIFE AGNÈS IN NICE" Hains

> > > continued, "consider the world as a painting, as the 'Opus Magnum' from which they appropriate fragments invested with universal significance… And, through the mediation of what are objective images, they conjure up reality as a whole, the common store of human activity and of twentieth-century Nature—its technology, industry, advertising and city life."

From 1958, the distinctive art form of the Happening cropped up sporadically in various places, although the fact that its "material" was so difficult to pin down meant that it long went unrecognized. The first Happenings took place in New York and initial impetus was provided by Allan Kaprow (another student of Hans Hoffmann), Meyer Schapiro and John Cage, who were soon to be followed by a posse of fellow conspirators. Happenings relied on audience participation and, in terms of technique, fostered unconstrained freedom of action.

The Happening arose from a rejection of hackneyed styles and of the imperialism of American cultural ideology vehicled by Pop art. It offered an alternative view, with a ritual dimension that revolved around a fetish for human activity. In their search for an overall synthesis of the arts, Jim Dine and Claes Oldenburg (who soon rallied to Pop), and, a few years later, Dick Higgins and Jean-Jacques Lebel (a figure instrumental in bringing the Living Theater to France), transformed the Happening into a fundamental poetical and critical form of expression. The ramified and international scope of the Fluxus movement created by George Maciunas in 1961-62 propagated globally the radically uncompromising practice of figures such as George Brecht, Dieter Roth, Nam June Paik, Joseph Beuys, Wolf Vostell, Emmet Williams, Robert Filliou, Ray Johnson, Jackson MacLow, Ben Patterson and Robert Watts.

Transcending boundaries and disciplines, Happenings and Fluxus instilled the power, the inventiveness of a state of mind that their practitioners themselves refused to see "recuperated" by the art scene. <

"Colères!"

ARMAN
Chopin's Waterloo
1962. Pieces from a broken piano mounted on wood panel, 186 x 300 x 48 cm.
Centre Georges Pompidou, MNAM, Paris. Photo Centre Georges Pompidou.

From *Cachets* (1955) to *Allures* (before 1959), the early work of Arman (born Armand Fernandez) displayed a dual focus: the object itself and a rejection of abstract art. His subsequent series, such as *Accumulations*, *Poubelles* (dustbins), *Coupes*, *Colères* (rages), *Combustions* and *Inclusions*, demonstrate the significance of entropy in a career in which destruction and reinvention are interdependent. Throughout his career, Arman has combined—"without the desire to arrange aesthetically"— notions of quantification and repetition. His method, with its inherent physical and psychological violence, was a reaction against the "hedonism of action painting." He explores a "domain of refuse, of rejects, of manufactured articles put out to grass—in short, of the unused." On October 25, 1960, two and a half years after Yves Klein's *Void*, Arman assisted Martial Raysse in producing *Plein* (Full). According to Yves-Alain Bois, it is a dialectic that implies both that "man is drowning in what he has produced and that is gradually destroying him," and that "all activity, and above all communication, can only end up as shapeless detritus."

"The logic of the material"

CÉSAR
Sunbeam Compression
1961. Automobile compression, 156 x 75 x 62 cm.
Galerie Beaubourg, Vence. Marianne and Pierre Hahon. Photo J.-C. Mazur/Centre Georges Pompidou.

Expansion no. 5
1969. Expanded, stratified and lacquered polyurethane foam, 206 x 120 x 107 cm.
Galerie Beaubourg, Vence. Marianne and Pierre Hahon. Photo J.-C. Mazur/Centre Georges Pompidou.

From 1947, César—by way of works made out of scrap metal—was engaged in a far-reaching critique of matter itself. With the three *Compressions* exhibited at the Salon in May 1960, he presented what was sensed as an act of defiance by Lucy Lippard —although in common with many American critics she has been generally reticent about acknowledging the antecedents and originality of Nouveau Réalisme. These were followed by the earliest *Expansions* and *Empreintes* (Imprints) that provided an essential paradigm for the unfolding language of contemporary sculpture. In his long career, César often retraced his steps and returned to earlier techniques. This tendency hinders a purely linear reading of his work and has resulted in his being misunderstood and feted by critics uniquely because of the obviously radical nature of his pieces. This principle of discontinuity and his constant questioning of the sculptor's craft through his extraordinary long-term series *Fers* (Irons) gave rise to a much more complex oeuvre than he is given credit for in some quarters. Whether in classic mode, with his arc-welded bestiaries, idols and other atavistic humanoid figures, in the hydraulic-pressed *Compressions*, in the polyurethane foam *Expansions* (which can also be seen as precursors of Performance art), or in the *Empreintes* of various parts of the human body, César was always concerned above all with asserting the "presence" of form.

"POP ART IS POPULAR, TRANSIENT, EXPENDABLE, LOW-COST, MASS-PRODUCED,

new, antiseptic, pure world"

MARTIAL RAYSSE
Tableau simple et doux
1965. Collage, paint, neon light
and cut-out photo, 195 x 130 cm.
Private collection, Paris.

To those critics intent on acquiring a global view of his entire career, Martial Raysse appears in the puzzling if striking guise of a contemporary hero. From the height of his meteoric rise to fame, Raysse soon realized that it is perilous to try to second-guess the world to avoid its pitfalls. His participation in the "Dylaby" show at the Stedelijk Museum, Amsterdam, in 1962 and his exhibitions at the Dwan Gallery, Los Angeles, and the Iloas Gallery, New York, assured him overnight international fame. At the height of his renown in the beginning of the 1970s, Raysse abandoned his research into materials and into the images of our materialistic society, and started a methodical, solitary exploration of the future of painting and of the conditions under which such an art is still tenable. The early assemblages and the *étalages* (display racks) *Hygiène de la vision,* views of a "new, antiseptic, pure world," the acrylic and fluorescent stereotypes and other idols were followed by hallucinogenic cycles, such as *Coco Moto.* Raysse started exploring an archaic, wondrous realm in which gods of the ancient world and modern tractors, monsters and everyday objects rubbed shoulders. The latent danger of nostalgia was always under control, thus, obvious to those with eyes to see, the approach to the plastic and to style inherent in Raysse's early works was converted into a complex allegory of "time regained."

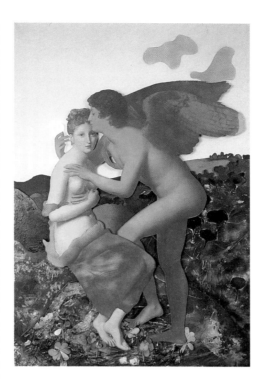

"This is Tomorrow"

RICHARD HAMILTON
*What Is It That Makes
Today's Homes So Different,
So Appealing?*
1956. Collage, 26 x 25 cm.
Edwin Janss Jr. Collection,
Thousand Oaks, California.

Between 1954 and 1957 in London, in response to an exhibition organized by artist Eduardo Paolozzi, photographer Nigel Henderson and architects Alison and Peter Smithson, the term Pop art began to be applied to mass-media products and to the collective investigations of urban culture undertaken by members of the Independent Group in London. In 1956, at the "This is Tomorrow" show arranged in the form of a twelve-part maze that confronted viewers with the motley textures of the street, Richard Hamilton presented a collage which is of itself an image-bank for English Pop art. Lawrence Alloway summed up the context in which Pop art was rooted: "Mass production techniques, applied to

131

"A cemetery for uniforms"

GÉRARD DESCHAMPS
Pilot Ink
1961–64.
Fabric assembled on stretcher,
182 x 206 x 40 cm.
Centre Georges Pompidou,
MNAM, Paris.
Photo Centre Georges
Pompidou.

Although a devotee of Nouveau Réalisme by 1961, Deschamps only joined the group in 1962. Rags, fabrics and women's underwear had by then already ousted paint as his preferred media. Starched, sewn, knotted, draped or laid in every imaginable arrangement and variation, these works extend the bounds of assemblage, and confer upon it a domestic and intimate form of (perhaps not particularly elevated) nobility. The war in Algeria led Deschamps to appropriate military vocabulary in what was a "cemetery for uniforms," mixing American army marker-tarpaulins with ribbons and medal-bars hijacked and recycled into garish parodies of painting. Highly skeptical about the sheer diversity of objects and works his contemporaries were turning out, Deschamps gradually retired from the Paris art scene in the 1970s. Several more recent exhibitions (notably in Gilles Peyroulet's gallery in 1990 and at the Fondation Cartier in 1999) have shown the powerful and still relevant impact of his wry critique of contemporary society. Today Deschamps has opted for a mythology of visual material (that the artist, like Roland Barthes, sees as capturing the "color scheme" of our modern world), instead of the recycled off-cuts and rag merchant's tat of his earlier years.

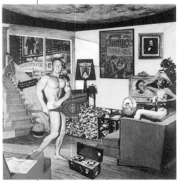

accurately repeatable words, pictures and music, have resulted in an expendable multitude of signs." In England, Pop art ran counter to the disinterested contemplation of Roger Fry, the theoretical positions of Sir Herbert Read and Clement Greenberg's contention that mass media could only produce ersatz culture. It quickly opened the door to a new awareness of reality and renewed engagement on the part of artists with political, economical and social structures.

YOUNG, WITTY, SEXY, GIMMICKY, GLAMOROUS AND BIG BUSINESS" Hamilton

"Urban nature"

JEAN PIERRE RAYNAUD
Corner 806
1967. Assemblage. Polyester, metal, enameled sheet-metal, paint, 400 x 75 x 75 cm.
The Museum of Modern Art, New York.
Photo Denyse Durand-Ruel Archives.

Early on in his career, Jean-Pierre Raynaud produced a series of assemblages that centered on the "urban nature" of our contemporary world, leading in 1962 to the symbolic gesture of setting a pot of flowers in concrete and painting it red. These were followed by the famous *Psycho-Objects* (1964–67). Raynaud was subsequently associated with other "objectors," such as Daniel Pommereulle and Tetsumi Kudo, who took up with the Nouveaux Réalistes. By 1965, Raynaud had neutralized the symbolic charge of his earlier pieces, creating installations based on series and repetition with obsessive themes. His *Corners, Walls* and *Containers*, like the *Espaces Zéros* (beginning in 1965), all covered in identical white tiling, convey a chilly fascination for the immutable face of death. The goal of this demanding body of work is a profound immersion in meditation. His *House* at Celle-Saint-Cloud, its public opening in 1974 and destruction in 1988, appear as allegories of the effect of time on creativity.

132

OYVIND FAHLSTRÖM
The Cold War
1963–65. Tempera on steel and plastic with magnets, 245 x 308 cm.
Centre Georges Pompidou, MNAM, Paris.
Photo P. Migeat/Centre Georges Pompidou, MNAM/CCI.

On occasion, Oyvind Fahlström could be heard lamenting his incapacity for either understanding or elucidating life and the world in the face of the propaganda, mass communication and language of our age. Fahlström was a multifaceted figure whose complex and interesting ideas have only recently begun to gain the recognition they deserve. From the 1950s to his death, he worked in theater, Happenings, poetry, journalism and the visual arts. In 1962, with *Sitting...Six Months Later,* he began to

"Image machines"

develop the method of "variable pictures" using magnet-backed elements. These culminated in his "Monopoly games": "My Monopoly game paintings consist of 200–230 painted magnetic elements on a painted metal board. They deal with world trade, world politics, the left and the right in USA, Indochina, and CIA vs. Third World liberation forces. They can all be played, according to the rules written on the paintings, as variants of the classical Monopoly game, which is of course the game of capitalism: a simplified, but precise presentation of the trading of surplus value for capital gains." Fahlström's art is both an image-making machine and a bitter critique of the mechanisms that regulate the world.

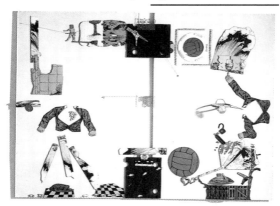

"For the Birds"

ROBERT RAUSCHENBERG
Monogram
1955–59.
Combine. Oil, paper, fabric, metal, newspapers and reproductions, wood, rubber sole, tennis ball on canvas, with paint on angora goat and tire,
106.7 x 106.7 x 163.8 cm.
Moderna Museet, Stockholm.

Robert Rauschenberg began developing what he

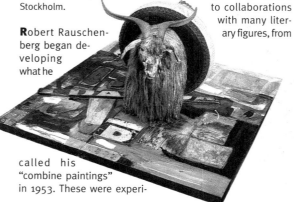

called his "combine paintings" in 1953. These were experimental works that drew on various practices from very different aesthetic communities. The painting was no longer an end in itself, but instead had become a source of elements, a toolbox for making a "device" that combined diverse types of representation and ways of perceiving reality. Over the years, Rauschenberg's desire to experiment has led to collaborations with many literary figures, from William Burroughs to French novelist Alain Robbe-Grillet, as well as with dancers such as Merce Cunningham and Trisha Brown. In the 1960s, after the collective event *For the Birds* at Black Mountain College, he started collaborating with research technicians of various kinds, and set up projects such as "Experiments in Art and Technology" (EAT), as well as the more recent Rauschenberg Overseas Culture Interchange (ROCI, opened in 1984), which arranges exhibitions of work made with the help of artists and craftspeople from all over the world. Although clearly a forerunner of Pop art, Rauschenberg is an artist who has rejected formalist classifications and for whom openness and incompleteness are intrinsic to his work. For him, there is already no real distinction between art and its apparent destruction.

"EVERYTHING I DO

"I want to be a machine"

ANDY WARHOL
One of the 32 Cans of Campbell's Soup
1962. Acrylic on canvas,
50.8 x 40.6 cm.
Museum of Modern Art,
New York.
Photo K. Igniatiadis/Centre
Georges Pompidou, Paris.
© Andy Warhol Foundation.

A media animal and, just like many of his subjects, a Pop art icon, Andy Warhol explicitly declared his intention to propel his life and his art into the "star system." Half collaborator with, and half critic of, a world whose behavior and attitudes he inventoried and parroted, Warhol sarcastically offered his artwork to the highest bidder in a system whose disillusion and decline he could—not without a certain satisfaction—see coming. A successful graphic and advertising artist

until the mid-1950s, his earliest acrylics dating from 1960 took as their models American comic-book heroes or banal advertising material lifted from magazines. These were followed by series such as *American Dollars, Coca-Cola, Brillo Boxes, Campbell's Soups* and other mass-produced images that were screenprinted on canvas and aligned in rows, the entire picture resembling a shelf of products in a store. By 1962, he was turning out series after series of Hollywood stars, street murders, disasters and other daily news events. The following year, he installed his studio and offices in a space he christened "The Factory," and surrounded himself with "counter-culture" celebs and hangers-on who were "famous for fifteen minutes." Meanwhile, in the hundred or so films he produced—and which

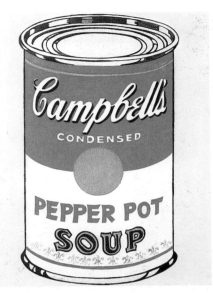

filmmaker Jonas Mekas sees as one of the major triumphs of his work and as landmarks in American indie cinema—he made countless others into ephemeral stars.

"I'm a deeply superficial person"

ANDY WARHOL
*Most Wanted Man, no. 2.
John Victor G.*
1964.
Silkscreen on canvas,
two panels, 123.2 x 97.5 cm;
122.8 x 93.9 cm.
Dia Art Foundation, New York
(The Menil Collection,
Houston).
© Andy Warhol Foundation.

Co-opting the production and distribution principles of a consumer society whose operations he mirrored, Warhol

exploited and reworked news items, thereby converting mass media into art. "I started as a commercial artist and I want to finish as a business artist." As Jean Baudrillard has written in reference to the artist's work, "Confronted by the modern challenge of the commodity, art is ill advised to seek salvation in critical denunciation... but should exaggerate [its] formal and fetishistic abstraction and the magic of exchange value —and become more like a

commodity than commodities themselves." Before he was shot by a founder of the feminist movement SCUM (Society for Cutting Up Men) in an attack that left him at death's door for two months, Warhol took on the role of "producer" with the intention of delegating the execution of his pieces to teams of co-workers so as to be able to devote more of his time to the performing arts. The "business of art" then became inextricably linked to the "art business." Manager of the rock group Velvet Underground and founder of the magazine *Interview*, which went on to trail a long line of programs and talk shows he made in the 1980s, Warhol was always turning up in untoward places or at unexpected times. Trapped in his paranoia and anxiety, he continued to perform at the "wake" for a culture in which he was indubitably a major player—and an anti-hero.

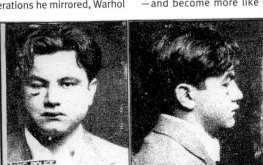

"I am anti-experimental"

ROY LICHTENSTEIN
Big Painting VI
1965.
Oil and ink on canvas,
327.6 x 235 cm.
Kunstsammlung Nordrhein-Westfalen, Düsseldorf.

To his detractors who claimed that his art made no changes and that he was doing no more than enlarging the comic strips and adverts he had started utilizing in 1961, Lichtenstein replied: "I think my work is different from comic strips—but I wouldn't call it transformation... What I do is form, whereas the comic strip is not form in the sense I'm using the word, but there has been no effort to make them intensely unified. The purpose is different, one intends to depict and I intend to unify." The two essential advances of Pop art and Mec art (mechanical art), invented by Alain Jacquet, Mimmo Rotella and Pol Bury in 1964, were the adaptation and elevation of the multiple to the status of an orig-

133

inal, and the conflict between canvas and screen. Unlike them, and unlike Warhol, however, Lichtenstein painstakingly transposes the marks of reproductive techniques, mimicking the raster of mechanical printing on the support. The artist confessed to being anti-experimental, and "anti-contemplative, anti-nuance... anti-paint-quality, anti-Zen, anti all of those brilliant ideas of preceding movements which everyone understands so thoroughly."

IS CONNECTED WITH DEATH" Warhol

"Waiting for Ben is an art"

BEN VAUTIER
Le Magasin
1958–73. Various elements originally from the Magasin de Nice, approx. 500 x 300 x 350 cm. C. Pompidou, MNAM, Paris. Photo P. Migeat/C. Pompidou.

"Live for a fortnight in a shop window… Each time an artist dies, send the others a little card inscribed 'Oooh! One less!'… make an appointment with someone, make them wait and send them a note 'Waiting for Ben is an art,' kill myself October 8, 1992 (date picked at random)," and then sign stains, everyday actions, "living sculptures," sign something missing, death, holes, epidemics, time, God and, in February 1960, sign Everything. "The idea of the Whole is created through awareness." The list of Ben's *Idées* and *Gestes* is endless. An apostle of art as attitude, his work is rooted in his personality and in the city of Nice where he has lived since 1949. In 1958, with other artists belonging to Nouveau Réalisme, to non-art, or to Supports/Surfaces, he

opened a store, "Le Magasin," complete with records and books, which centered around the complementary themes of "for" and "against." Ben is an agitator who has spent the best of his energies putting notions of art, artist, and ego through the mill. A moralist in his way, Ben, as well as being a disturbing presence in an art world he both represents and rejects, is an artist who can be relied upon to track down new things, in addition to being the figure through whose career Fluxus entered and flourished in France.

"Hard, soft and ghostly"

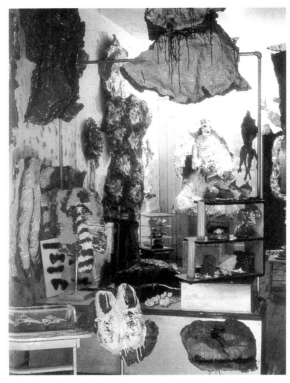

CLAES OLDENBURG
The Store
107, East Second Street, December 1961

In 1956 Oldenburg moved to the Lower East Side, where he improvised Happenings in which he attempted, as in his drawings and sculptures at the time influenced by Dubuffet, to highlight both the abstract and primitive characteristics of the urban fabric. A series of six such Happenings under the umbrella title *Ray Gun Spex* (in Swedish, the word "spex" evokes "parody") involved artists like George Brecht, Jim Dine, Red Grooms, Tom Wesselmann and Rauschenberg, who were to grow into the Judson Group. *Snapshots from the City* showed Oldenburg and his first wife in a cycle of 32 dream-like sketches satirizing American life. With the creation of the Ray Gun Company, Oldenburg established

the general principles underlying his art. Environments like *The Street* (a simile for poverty), *The Store* (a metaphor for wealth), *The Home* and *Mouse-Museum* are all parodic and critical environments, glossaries of forms with plaster and papier mâché models of everyday objects—hard, soft, even ghostly—that constitute an oblique, baroque and erotic look at American consumer society. Since the mid-1960s, intrigued by the possibilities of outsized objects in landscape, he has collaborated with his second wife Coosje van Bruggen on many large-scale public projects that subvert the environment with a mix of social provocation and collective collaboration. He is "for an art that is political-erotical-mystical, that does something other than sit on its ass in a museum… I am for an art that embroils itself with everyday crap and still comes out on top."

"It is art that makes life more interesting than art"

ROBERT FILLIOU
The Permanent Creation.
Tool Box no. 1.
1969. Tool box and neon lights, 70 x 40 cm. Private collection, Paris.

Filliou was a member of the Resistance, student of economics in Los Angeles, and Coca-Cola employee. His work resembles a highly intelligent game. He based his oeuvre on three fundamental concepts: "Permanent creativity—eternal network—permanent celebration." In the manner of an anthropologist, he founded the "Genial Republic" and its "territory," *Cucumberland*—a special place where genius could prosper—and followed it in 1963 with the *Poïpoïdrome* in collaboration with his accomplice, the architect and city-planner Joachim Pfeuffer. From summer of 1965 on, at Villefranche-sur-Mer, he created (with the assistance of George Brecht) a studio-store

that he euphoniously christened *La Cédille qui sourit*. "There, we invented, and 'disinvented' objects… we made poems that finished in the air and rebuses we sold by mail order." A solitary figure, he gradually shifted from provocation to a more meditative attitude. In 1985, he decided to retire with his wife for "three years, three months and three days" to a Tibetan Buddhist community in the Dordogne. He died two years later. Like

teh nineteenth-century social theorist Charles Fourier, Filliou, in an effort to reconcile art and life, was determined to extricate creativity from the economic system. This resulted in a number of basic principles, such as the axiom that the three possibilities "well done," "badly done" and "not done at all" were all equivalent. Filliou exalts creativity because, in his opinion, it carries with it universal values of freedom and liberation.

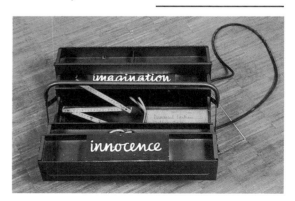

"I AM FOR AN ART THAT EMBROILS ITSELF

134

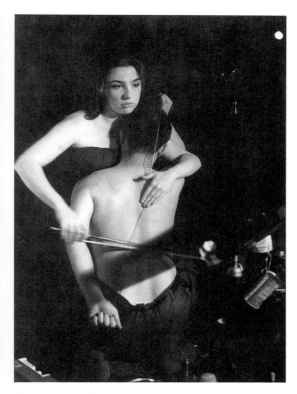

"Fluxus"

NAM JUNE PAIK AND CHARLOTTE MOORMAN
Human Cello
**Café Au Go Go, New York,
1965.** Performance on a human cello of *26' 1.1499 for a String Player*, by John Cage.
Photo P. Moore.

As Charles Dreyfus brought out in the catalogue to the exhibition "Happenings et Fluxus"—organized in Paris jointly by the galleries 1900–2000, the Galerie du Poche and the Galerie du Génie—the "flux planet" was already spinning away by 1952, before its founding in 1961. Neither French, nor American, nor German, nor Japanese, Fluxus proper, set up in the spring of that year through the good offices of George Maciunas, was "nomadic and international." It derived from a "necessity to discover new connections BETWEEN the visual arts, poetry, dance and theater: it is aleatoric music (as advocated by John Cage); simultaneous and concrete poetry (Jackson MacLow, Emmett Williams); Happenings

(Allan Kaprow, Red Grooms, Dick Higgins, Al Hansen, Claes Oldenburg, Jean-Jacques Lebel); phenomenal correspondences (Bob Watts); "Permanent Creation" (Robert Filliou); auto-destructive art (Gustav Metzger, Jean Tinguely); "Eternal Music" (La Monte Young); Event (George Brecht); Conceptual art (Henry Flynt); musical Performance art (Nam June Paik, Wolf Vostell, Philip Corner, Ben Patterson...); the "Théâtre du Vide" (Yves Klein); Action painting (Pollock, Gutai); multiple art (Daniel Spoerri); social sculpture (Joseph Beuys); total art, Appropriation art (Ben Vautier); behavioral art (Piero Manzoni); dance (Ann Halprin, Merce Cunningham, Simone Forti...); mail art (Ray Johnson); Environment (Walter de Maria, Christo...); experimental cinema (Robert Breer, Jonas Mekas): BETWEEN ART AND LIFE." Fluxus is "conscious raising... an example of another way of seeing, hearing and living," as Jean-Jacques Lebel himself puts it in a superb text printed in the catalogue to the exhibition mentioned above.

Chronology 1955–1970

This chronology is largely devoted to events in Europe and the United States. Sections in bold refer to artists mentioned in the main text and captions. For further information concerning this period, reference should be made to the two previous chapters.

1955
London: ICA, "Man, Machine and Motion." **Yves Klein: *Orange Monochrome* refused at the Salon des Réalités Nouvelles.** Kassel: first documenta. Osaka: Gutai, Action paintings. Paris, bookshop-cum-gallery L'Escalier: François Dufrêne, *Crirythmes ultralettristes.*

1956
Paris, Galerie Colette Allendy: first exhibition by Yves Klein, prefaced by critic Pierre Restany. Paris, Galerie du Haut-Pavé: first Arman exhibition. ICA, London: "This is Tomorrow" group exhibition.

1957
• Düsseldorf: Zero group set up. **Milan: Yves Klein, "Proposte Monocrome, Epoca Blu." Paris: Pierre Restany invites Yves Klein to show at the Galerie Iris Clert ("Yves le monochrome") and at the Galerie Colette Allendy ("Pigment pur").**

1958
• Bernard Aubertin: first red monochromes, followed by nail- and fire-paintings. **Paris, Galerie Iris Clert: Klein, "Le Vide." Nice: Ben opens his "store," Laboratoire 32. New York: Allan Kaprow, *The Legacy of Jackson Pollock*. Earliest happenings.** Lawrence Alloway, "The Arts and the Mass Media" *(Architectural Design,* February; "Pop art" coined). Christo produces *Empaquetages* (packaging) and wrappings, followed by *Vitrines* (1963).

1959
Paris, Galerie Rive droite: Jasper Johns exhibition. New York, Reuben Gallery: 18 Happenings in 6 Parts. First Biennale de Paris: Dufrêne, J. de la Villeglé, Rauschenberg, Hains, Tinguely, Yves Klein. Paris: Yves Klein's lecture at the Sorbonne on the evolution of art toward the non-material. Arman, *Accumulations* and *Poubelles* (trash cans), followed by *Coupes* and *Colères* (1961), and *Combustions* (1963). Paris, Galerie Iris Clert: Klein and Tinguely, "Vitesse pure et Stabilité monochrome." Daniel Spoerri: Éditions MAT established.

1960
Paris, 16th Salon de Mai: César, *Compressions*. Paris, Galerie Iris Clert: Arman, *Le Plein;* Klein, *Anthropométries of the Blue Period.*

New York, MoMA: Tinguely, *Homage to NY.* Milan: Pierre Restany publishes the *Manifeste du nouveau réalisme* (April 16), followed by an exhibition in Paris, at the Galerie Apollinaire. Paris, October 27: founding charter of Nouveau Réalisme. New York, Martha Jackson Gallery: "New Forms, New Media." **Venice: Alain Jouffroy and Jean-Jacques Lebel, *Antiprocès*, first Happening to be staged in Europe.**

1961
• Paris: Galerie J. opens with "À 40° au-dessus de Dada." • New York, MoMA: "The Art of Assemblage." • Robert Malaval: first *Aliments blancs*. • John Cage, *Silence* soundless music. **Paris, Galerie Rive Droite: "Le Nouveau Réalisme à Paris et à New York." Galerie Daniel Cordier: Rauschenberg exhibition. Nice: first festival of Nouveau Réalisme. New York, Wiesbaden: George Maciunas, Fluxus.**

1962
• Paris, Musée des Arts Décoratifs: "Antagonismes 2." • London, Gallery One: "Festival of Misfits." • Vienna: first Body actions by Hermann Nitsch. Otto Muehl, *Blood Organ.* **Spoerri, *Topographie anecdotée du hasard.* Jean Pierre Raynaud: first *Pot*, followed by the *Psycho-Objets* (1964–67) and *Walls* (1968–71). Paris, Galerie Daniel Cordier: Fahlström exhibition. June 6: death of Yves Klein. Galerie du Cercle: Alain Jouffroy and Robert Lebel, "Collages et Objets." Paris, American Center: "Festum Fluxorum." New York, Sidney Janis Gallery: "International Exhibition of the New Realists."**

1963
• London: Archigram, "Living City" exhibition. **Paris, Galerie Sonnabend: "Pop art américain." Biennale de Paris presents English Pop art and what will become Figuration Narrative. Mimmo Rotella: first Mec art works. Jean-Michel Sanejouand, *Charges-objets,* followed by *Organisations d'espaces* (1967). Galerie J.: exhibition of Spoerri as "chef at the stove." Nice: "Nice Fluxus Festival," organized by Ben, Brecht, La Monte Young, Nam June Paik and Maciunas. Wuppertal, Galerie Parnass: Paik, "Exposition of Music."**

Chronology 1955–1970

1952.
Isidore Isou.
Portrait of Isidore Isou. Gouache on photographic print, 39 x 28.5 cm. Letailleur Collection, Paris.

1961.
Allan Kaprow. *Yard.* Premiere presentation in the rear courtyard of the Martha Jackson Gallery, New York, in the context of the "New Forms New Media."

February 8, 1964.
François Dufrêne.
Public reading of the telephone directory at a Lettrist evening at the Théâtre de l'Odéon, Paris.
Photo Harry Shunk.

1964.
Wolf Vostell. *You.* Great Neck, New York, at the Yam Festival organized by George Brecht and Robert Watts.
© Happening Archive, Malpartida.

1966.
Jean-Jacques Lebel.
120 Minutes Dedicated to the Divine Marquis. Happening on the occasion of the Festival de la Libre Expression, Paris.

1964

• Paris, Musée d'Art Moderne de la Ville: Mythologies quotidiennes," organized by Gérald Gassiot-Talabot.
Paris: first Libre Expression festival.
Galerie Daniel Cordier shuts its doors: public publication of a letter explaining the decision.
New York, Alexandre Iolas Gallery: Alain Jacquet, *Le Déjeuner sur l'herbe.* Invention of Mec art.
Venice Biennale: Rauschenberg wins Grand Prix.
Nam June Paik makes his first use of camcorders.

1965

• Paris, Galeries Creuze and Europe: "La Figuration narrative."
Paris: Galerie J.: "Hommage à Nicéphore Niépce" (Alain Jacquet, Mimmo Rotella, Gianni Bertini, Warhol, Rauschenberg, etc.).
Paris, Galerie J.: Alain Jouffroy, "Les Objecteurs."
Exhibitions by Raynaud (Galerie Jean Larcade), Daniel Pommereulle (Galerie Ranson), Arman, Spoerri and Kudo (Galerie J.).
Amsterdam, Stedelijk Museum: first Klein retrospective exhibition.
Stockholm, Moderna Museet: Niki de Saint-Phalle and Tinguely, *Hon.*
New York, Jewish Museum: retrospective exhibitions of Nicolas Schöffer and Tinguely.

1966

• New York, Jewish Museum: "Primary Structures: Younger American and British Sculptors."

1967

• Paris, Musée des Arts Décoratifs: "Bande dessinée et Figuration narrative."
Montreal, Expo 67: *Fantastic Paradise* and *Nanas* by Saint-Phalle and Tinguely's *Machines.*
Galerie J. Ranson: "La Cédille qui sourit."
Rauschenberg and Klüver create Experiments on Art and Technology (EAT).

1968

• The review *Chroniques de l'art vivant* is established.
Amsterdam, Stedelijk Museum; Stockholm, Moderna Museet; and Paris, CNAC: Jean Pierre Raynaud retrospective exhibition.
New York, MoMA: "The Machine as Seen at the End of the Mechanical Age."
New York, Paris: "Art of the Real."
Avignon Festival: J.-J. Lebel and the Living Theater organize numerous Happenings.
Pierre Restany, *Les Nouveaux Réalistes* published.

1969

• New York, Metropolitan Museum of Art: "New York Painting and Sculpture: 1940–1970."

1970

• Stockholm, Amsterdam, Paris: Kienholz exhibition.
Paris, Galerie M. Fels: "Nouveau réalisme, 1960–1970."
Milan: tenth anniversary of Nouveau Réalisme.
Cologne: "Happening & Fluxus, 1959–1970."

Studies on Pop art, Nouveau Réalisme, Fluxus and Happenings

Catalogues

1977, Paris. *Paris-New York.* MNAM/Centre Pompidou.

1990, Venice. *Ubi Fluxus ibi Motus 1990–1962.* Biennale di Venezia.*

1991, London. *Pop Art.* Royal Academy of Art.*

1995, Marseille. *L'Esprit Fluxus.* MAC/Musées de Marseille.*

1986, Paris. *1960, les Nouveaux réalistes.* Musée d'Art Moderne de la Ville de Paris.*

1997, Paris/Nice. *De Klein à Warhol, face à face France-United States.* Centre Pompidou-RMN/Musée d'Art Moderne et Contemporain, Nice.

1998, Los Angeles. *Out of Actions, Between Performances and the Objects, 1949–1979.* The Museum of Contemporary Art.

General Works

L. Alloway. *American Pop Art.* New York, 1974.

J. P. Ameline, *Les Nouveaux Réalistes.* Paris, 1992.

C. Dreyfus. *Happenings and Fluxus.* Paris, 1989.*

C. Francblin. *Les Nouveaux Réalistes.* 1997, Paris.*

Hand-painted Pop: American Art in Transition 1955–1962. New York, 1993.

J. Hendricks. *Codex Fluxus: the Gilbert and Lila Silverman Fluxus Collection.* Detroit and New York, 1988.*

A. Jouffroy. *Les Pré-voyants.* Brussels, 1974.

M. Kirby. *Happenings, an Illustrated Anthology.* New York, 1966.

T. Kellein. *Fluxus.* London, 1995.

U. Kultermann. *Art & Life.* New York and Washington, 1971.

J.-J. Lebel. *Le Happening.* Paris, 1966.

L. Lippard. *Pop Art.* New York, 1966.

M. Livingstone. *Pop Art: A Continuing History.* New York, 1990.*

S. H. Madoff. *Pop Art, a Critical Anthology.* Berkeley, Los Angeles, and London, 1997.*

D. Mahsun (ed.). *Pop Art: The Critical Dialogue.* Ann Arbor, 1989.

L. Meisel. *Photorealism.* New York, 1989.

F. Pluchart. *Pop Art & Cie, 1960–1970.* Paris, 1971.

P. Restany. *Le Nouveau Réalisme.* Paris, 1978.*

J. Russell and S. Gablik. *Pop Art Redefined.* London, 1969.

P. Taylor (ed.). *Post-Pop Art.* MIT Press, Cambridge, Mass., 1989.

D. Waldman. *Collage, Assemblage and the Found Object.* New York, 1992.

* Essential reading

SCULPTURE
"between form and gesture"

"Writing in space"

ALEXANDER CALDER
Nageoire
1964. Painted steel,
450 x 510 x 610 cm.
Private collection.
Photo J.-C. Mazur/Centre
Georges Pompidou.

As early as the late 1930s, soon after the emergence of the "mobile" (a term coined by Marcel Duchamp in 1932) — an assembly of colored metal struts and steel plates erected in unstable equilibrium — there appeared what Hans Arp suggested calling "stabiles." By this time Alexander Calder had already achieved a certain recognition. His "circus" and other sculptures in wire had earned him the admiration of many of his contemporaries. His interest in the world of the performing arts and his penchant for sketching cartoons culminated in what was dubbed "writing in space" — the expression of movement through the use of motors or wind power. By 1940, Calder had abandoned mechanical contrivances, preferring the unrestricted motion of chance to that created by

"repetitive machines." Many mobiles and stabiles followed, taking their inspiration as much from the outside world as from abstraction. "Imagination," as Jean-Paul Sartre wrote, "rejoices in these pure forms... at once free and calculated... a tangible symbol of the nature... that wastes pollen and then promptly throws up a flight of a thousand butterflies." After the constellation he made during the war, Calder worked on slim, graceful forms emanating sheer physical presence. At this time, his work was close to that of Miró. His large-scale stabiles of the 1950s demonstrated his rare ability to reconcile the demands of outside space and architecture.

In 1990, a seminal exhibition at the Whitney Museum of American Art, New York, entitled "The New Sculpture," revealed two opposing trends in sculpture: one devoted to continuing the formal investigations of the avant-garde and the other intent on undermining the whole modernist process. While works by Anthony Caro, Eduardo Chillida, Max Bill, Robert Jacobsen, Berto Lardera and even David Smith remained linked to the fundamental principles of modern sculpture, Tony Smith's projects on the other hand marked a new and highly individual turning point. In *Black Box* (1962) and, above all, in the ambivalently >>>

> > > christened *Die*—a black steel cube measuring 182.4 cm along the side that he had industrially manufactured—the artist introduced a new parameter in his refusal to intervene in the *execution* of the work. At the very time when minimally inclined art was emerging, Tony Smith thus showed an unwillingness to embrace monumental or object-centered ambitions. Although, as Jean-Pierre Criqui noted, with "their formal analogy or rather their 'pseudomorphosis'" they are not directly linked with the notion of Minimal art per se, they do foreshadow both the questions Minimalism poses and a number of its later developments.

The word "minimal" itself was simultaneously co-opted by Barbara Rose and Richard Wolheim, who were in fact recycling a term already employed by John Graham in 1937. Opposing Abstract Expressionism—whose three-dimensional equivalent was to be found in the 1950s work of David Smith—the sculptors Carl Andre, Donald Judd and Robert Morris, as well as painters such as Robert Ryman, Robert Mangold and Brice Marden, rejected out of hand not only figuration but also lyricism. In conjunction with a sculptor of the same generation, Mark di Suvero, they adumbrated geometrical systems that they termed "Primary Structures." Trying to achieve what critic Michael Fried defined as greater "control," Minimalism proposed critical models that contrasted with the formalist myth of modernism. Nonetheless, if Minimal art went against modernist teleology, it did nonetheless signal a return to a preexisting paradigm: the Constructivist ideal of abstraction. Although Minimalist artists espoused the collectivist and productivist ideals of earlier avant-garde tendencies, they perpetuated the production of one-off bourgeois objets d'art.

This was something that Conceptual art (which emerged around 1967) in its turn sought to eliminate. Two essays by Sol LeWitt, "Paragraphs on Conceptual Art" and, a couple of years later, "Sentences on Conceptual Art," explain the approach: "In Conceptual art the idea or > > >

138

"Suspension in time and space"

DAVID SMITH
Australia
1951. Painted steel, 200.6 x 272 cm. The Museum of Modern Art, New York. Gift of William Rubin. Photo Centre Georges Pompidou.

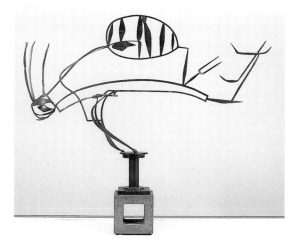

As with Louise Bourgeois, the source of David Smith's works of the 1940s can be found in the Surrealist object and fetish, but his earliest sculptures also demonstrate a desire to analyze the formal principles of the totem in addition to its symbolic content. With his passionate interest in psychoanalysis, Smith refused to see the totem as an archaic object. His later sculptures centered around a void that seems to push all details and narrative elements to the edges of the structure. As they are treated frontally, these loose forms give the impression, when viewed from the side, of being attempts at self-concealment. The notion of "suspension in time and space"—suspension of action and mass—highlights the effects of gravity, and is just one of the recurring qualities of Smith's work that can be compared to certain precepts of Action painting. Smith later started producing painted or burnished steel sculptures (*Cubi* series), their monumentality, combined with the brutalism of their masses, harking back to the violence of his early works.

"Antagonism between painting/sculpture"

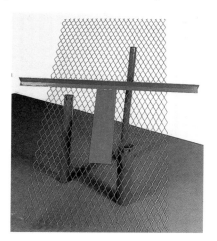

ANTHONY CARO
Paris Green
1966.
Steel and aluminum painted green, 133 x 85 x 140 cm. Private collection. Photo B. Hatala/Centre Georges Pompidou.

Anthony Caro's earliest sculptures were influenced by Picasso and Henry Moore's free-standing pieces, as well as the work of David Smith and Jacques Lipchitz during his American years. As Michael Fried has noted, however, the concepts of weight and pressure, of void and plenitude quickly ousted figurative forms. In 1962, adopting tenets derived from the work of Picasso and Tatlin, Caro's work evolved from "sculpture" into "structures" and "constructions." Elements such as metal girders, tubes and grills were articulated so they lost all trace of representation. His sculptures were often painted in acidulous colors, as if to emphasize the crucial difference between the confines of painting and the unlimited space of sculpture. Monochrome color schemes, however, if they unify and underscore the antagonism between painting and sculpture, also transform structure into image. The *Table Pieces* of 1967 were a further turning point in which the instability and seesaw motion of the form analyzed gravity and equilibrium still more profoundly.

"MY IDEA OF A PIECE OF

"The physical manifestation of an idea"

SOL LEWITT
Serial Project AI/O
1966. White-painted aluminum, 80 x 80 x 2.5 cm; 203 x 203 x 2.5 cm.
Private collection.

The debut appearance of LeWitt's work at a group show in New York in 1963–64 betrayed the Bauhaus and De Stijl influences that he, with Judd, Flavin, Ryman and Robert Mangold, were promulgating in America. Two manifestos on Conceptual art that came out in 1967 and 1969 ("Paragraphs on Conceptual art" and "Sentences on Conceptual art") give an account of the theoretical bases of his work. Ten years later, together with Lucy Lippard, LeWitt founded an artists' book publishers, "Printed Mat-

ter." LeWitt saw his artworks as physical manifestations of ideas. He adopted a formula, a standard procedure, based on the iteration of a single volume followed by the repetition of the resulting series, ensuring the transformation of form and its modular combinations. Aiming for a synthesis between Minimalist and Conceptual ideas, LeWitt

acknowledged the element of chance inherent in both his sculptures and his *Wall Drawings*. He began working on the latter in the late 1960s, providing designs which are executed by others. Impressed by the frescoes of Italy where he now lives, he has recently even introduced the colorful decorative dimension that his early works disavowed.

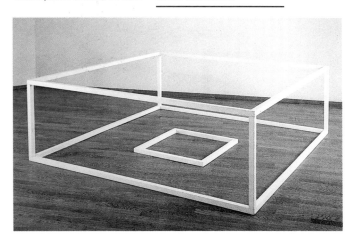

"Art can exclude superfluity"

CARL ANDRE
37 Pieces of Work
1970. Aluminum, copper, lead, zinc, magnesium, steel, 0.9 x 1097 x 1097 cm. Foyer of the Solomon R. Guggenheim Museum, New York. Private and public collections.

Early in his career, Carl Andre (together with his childhood friend the photographer and filmmaker Hollis Frampton)

was impressed by the writings of Ezra Pound on Brancusi and Gertrude Stein, as well as the megalithic site at Stonehenge. To Andre, the *Black Paintings* of Frank Stella, whose studio he shared in New York, seemed to be a prime example of how art could exclude superfluity. Between 1960 and 1964, when circumstances led him to work as a brakeman on the Pennsylvania Railroad, Andre

wrote poems and constructed assemblages out of diverse materials which have since been destroyed. Around 1960, he decided to abandon direct carving and, amplifying serial principles based on repetition, began using untreated materials to break up space. In 1965, he staged an "invasion" of Tibor de Nagy's gallery with the aid of modular structures made from industrial plastics. Andre said he wanted "to seize and hold the space." In 1967 he began making his floor pieces: flat sculptures in various metals. These mark an important turning point in the history of contemporary art. Their horizontal format and the fact that it is possible to walk over a surface which offers what Andre has termed an infinite number of viewpoints present a synthesis which seeks to redefine the status of twentieth-century sculpture as it appears from Rodin's *Burghers of Calais* to Brancusi's *Endless Column*.

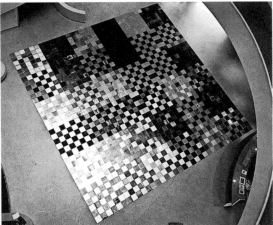

"Specific objects"

DONALD JUDD
Untitled
1965. Orange-tinted Plexiglas, four tensioners,
51 x 122 x 86.2 cm.
C. Pompidou, MNAM, Paris.
Photo C. Pompidou.

A central figure and a major theorist of American sculpture, Donald Judd countered Abstract Expressionism with a radical corpus of work that was nourished by the European Constructivist avant-garde. A philosophy graduate of the University of Columbia and a student of Meyer Schapiro, Judd wrote criticism for journals such as *ArtNews* and *Arts Magazine*. In 1964, following his debut exhibition at the Green Gallery, he published *Specific Objects*. "Actual space is intrinsically more powerful and specific than paint on a flat surface," he recalled. An artwork is thus a three-dimensional "specific object" that is inscribed in real space, a structure in which color, form and volume are perfectly integrated and whose order is non-relational. Rejecting entirely the dynamism and gesturality of Expressionism, and foster-

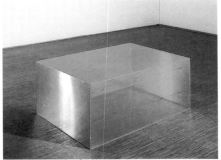

ing instead notions of proportion and combination, of arrangement and progression, Judd tackled the problem of the relationship between sculpture and painting, and between artist and the actual producer of the piece. He had his works industrially manufactured and stipulated systemic and deductive production processes that resulted in an equilibrium between difference and repetition.

SCULPTURE IS A ROAD" Andre

> > > concept is the most important aspect of the work... all planning and decisions are made beforehand and the execution is a perfunctory affair. The idea becomes the machine that makes the art." A distant echo of the way Duchamp took issue with art, Conceptualism remained sufficiently broad to embrace Robert Barry, Mel Bochner, On Kawara, Joseph Kossuth, Sol LeWitt and Lawrence Weiner in the United States, Art & Language and the early work of Barry Flanagan in Great Britain, Bernar Venet and the first events organized by B.M.P.T. in France, as well as Germany's Hanne Darboven. Rather than serving to convey or define either a specific practice or even a medium, Conceptualism asked questions of both, contributing to their eventual demise. Staging-posts in a critical endeavor that sought to undermine the imperious laws of formalism, the notions of "anti-form" and Process art (headings meant to embrace the work of Vito Acconci, Chris Burden, Eva Hesse, Bruce Nauman, Dennis Oppenheim, as well as the exponents of Arte Povera) featured in Harald Szeemann's 1969 traveling exhibition, "When Attitudes Become Form." Minimalist and Conceptual ideas also underpin pieces by emblematic figures such as Yves Klein, Claes Oldenburg or Joseph Beuys, whose "social sculpture" project was born in 1958. "The desire to construct a process activity based on practices integrated with the requirements of everyday life and implicated in a political and ideological context," to quote Germano Celant, was, in its rejection of a *single* object, further evidence of the broadening of sculpture to include activities uniting theater, dance, music and performance. At the same time, the notion of Land art questioned the very basis of sculpture, in both its definition and status. In the context of what was a new-found syntax, thinking about form in space now boiled down to furnishing new vocabularies which, from Installation and Environment to the notion of the "contraption," would forge new paradigms for contemporary art. <

140

"Total living-space"

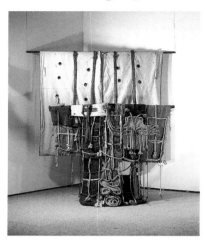

ÉTIENNE-MARTIN
Le Manteau (Demeure 5)
1962. Fabrics, haberdashery, rope, leather, metal, tarpaulin and leather wrap,
160 x 200 x 30 cm.
Centre Georges Pompidou, MNAM, Paris. Photo Centre Georges Pompidou.

Difficult to categorize (as is that of his contemporary Dodeigne), Étienne-Martin's work developed at a time when Nouveau Réalisme, Pop art, Minimalism and Arte Povera were flourishing. Indifferent to art movements, gripped by strange ambitions fed by the exploration of memory and childhood, Étienne-Martin is nonetheless a major figure in contemporary sculpture, one for whom Harald Szeemann, for example, has always professed the highest regard.

The theme of the "dwelling" appeared in his work in the 1950s as a symbol of an original, uterine locus, and as a path of initiation that leads to knowledge. In general, Étienne-Martin's work takes the form of vast sculpture pieces (which the artist has sometimes had cast in bronze) that can be walked into ("penetrables"). *Demeure 5* (Dwelling 5), however, subtitled *Le Manteau* (Coat or Cloak) is one of a handful of works (the others are *Passementeries, Abécédaire,* and *La Marelle*) that are essential for an understanding of the relevance of his oeuvre today. Often compared to a cloak with fetishistic powers belonging to some tribal chief, *Le Manteau* is at once "a house, a mother, a wrap, and a total living-space." It was one of the first pieces in the early 1960s to be recognized as a tool in a singular and personal ritual, and that therefore is more profitably seen in the light of the innovative ideas and practices that were to follow.

"Minus Objects"

MICHELANGELO PISTOLETTO
Minus Objects
1965–66. Mixed media. Installation at the Galleria Nazionale d'Arte Moderna, Rome. All rights reserved.

Michelangelo Pistoletto occupied an important place in an Italian art scene that had become a crucial link between Pop imagery and Conceptual art (another key figure, before his untimely death in 1968, was Pino Pascali). At the end of the 1950s, Pistoletto embarked on a series of works which addressed the way art has mirrored Western civilization as a whole. He paid little heed to divisions between categories and styles, counterbalancing a radical heterogeneity of form with an

extremely coherent artistic focus. In 1962, for example, he exhibited what he called "mirror paintings" that allowed the "image to be penetrated by the order of objective reality." The singularity of Pistoletto's ideas and the peculiar nature of his theories and work can be seen most clearly in the *Minus Objects* that he first presented in his Turin studio in 1965. Accompanied by written texts ("Photo of Jasper Johns," "Structure for Talking Standing," "Burnt Rose," "Pear-shaped Body"), they give an account of various perceptive experiences which "occur once and once only," and demonstrate the artist's total liberation from formalist constraints. He went on to combine sculpture and street

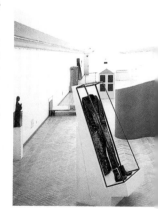

theater in an existential mode close to that of the Living Theater (Zoo group founded in 1967). With his *Azioni povere* (poor actions), his work continued to center on the *Progetto arte,* a tendency which anticipated developments in Arte Povere that Germano Celant was trying to define at the time.

"A FORM IS LIKE AN IDEA.

"Intellectual instability"

JANNIS KOUNELLIS
Untitled
January 1969. Twelve live horses. Galleria l'Attico, Rome. All rights reserved.

Undifferentiated impacts"

MARIO MERZ
Untitled (Che fare?)
February 1969.
Mixed media. Galleria l'Attico, Rome. All rights reserved.

Presented only a month apart, and in the same year that Harald Szeemann staged the pioneering "When Attitudes Become Form" show in Bern and elsewhere, these two installations by Kounellis and Merz gave special impetus to the new language that both

artists were instrumental in developing. In a gallery space that had originally been a garage, Merz installed a few of the recurrent themes of his vocabulary—the igloo, the sheaf of straw, neon lights—and, like novelist and diarist Cesare Pavese, asked "Che fare?": "What is there to do?" For his part, Kounellis, in a quest for intellectual, emotional and sensorial instability, transformed the gallery space into a stable in which live horses were exhibited. The entrenched frontier between the theater and the visual arts was thus crossed; art and life merged through the animal kingdom. Merz, a "spiritual and magnetic witness," with great sensibility to living and fragile materials, "aimed," in the words of Celant, "to express a way of perceiving reality that does not derive from a series of contrasting objects, but from

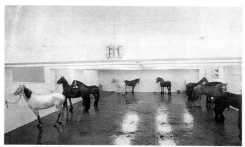

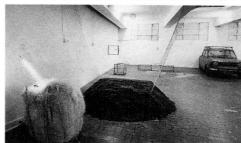

a sequence of undifferentiated shocks." Merz's is a "savage mind," hovering somewhere between what is termed scientific knowledge and updated mythology.

"Physical energy"

GIOVANNI ANSELMO
Untitled
(Structure That Eats Itself)
1968.
Granite, copper wire, lettuce, and sawdust, 70 x 23 x 37 cm. Centre Georges Pompidou, MNAM, Paris.
Photo Centre Georges Pompidou.

Blending the unutterable and the tangible, Giovanni Anselmo's works from 1965 lie on the edge of a kind of phenomenology, or poetics, of perception. Constructed from unsophisticated materials such as stone, water, cotton and iron, and making use of words that are projected onto the object, Anselmo's pieces establish spatial and temporal links between areas of

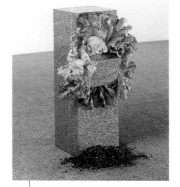

141

abstract thought, such as the finite and the infinite, the whole and the detail. Guided primarily by intuition, he converts his body (and that of the viewer) into a tool and a measure of introspective enquiry. For Anselmo, the sculptures and structures he created at the end of the 1960s represent essentially a "physical energy." These projects in plasticity have nothing to do with an imaginary fictional narrative, but are instead physical, organic and living realities in themselves. In this untitled piece, a lettuce, attached to the block of granite by a length of copper wire, withers, putting the equilibrium of the whole construction in jeopardy.

"Total work of art"

JOSEPH BEUYS
Object from "32nd Movement of the Siberian Symphony 1963. Eurasia"
Action, October 31, 1966.
Mixed technique,
183 x 230 x 51 cm.
Private collection, Germany. All rights reserved.

A charismatic artist, teacher and political activist in Germany, Joseph Beuys remains one of the most ambitious artists of our time. He was living proof of his country's relationship to memory as catharsis and therapy. In 1961 he was appointed professor of sculpture at the Düsseldorf Academy, becoming a pivotal influence on the thought and work of two generations of artists. The careful control he exerted over his biography, his political opinions and Green activities, and his original visual syntax that sought to redefine the finality of the creative act coalesced into a "Beuys myth"

during his own lifetime. A pilot in the Luftwaffe, his aircraft was brought down in the Crimea in 1943. The wounds he sustained were treated by nomadic Tartars from the steppes. This episode, and the controversial account Beuys gave of it, became the founding event of what developed into the symbolic order structuring his entire oeuvre. Freed in 1946, he studied in sculptor Ewald Mataré's studio until 1951. From his earliest drawings, he developed, in addition to other obsessive themes, a bestiary of a mythical Eurasia. His work drew on the most diverse traditions, from Christianity to Nordic myth, from shamanism to Paracelsus's alchemy, from Rudolf Steiner's anthroposophy to Dostoevsky. By the 1960s, he had acquired a vocabulary of characteristic materials—felt, copper, wood, sulfur, honey, fat, bones, batteries and other devices—that he arranged into a highly

metaphorical sculptural language conveyed through environments and mechanisms that conjoined real and symbolic energy. Beuys's theory of "social sculpture" demonstrated his belief in a Romantic and idealist conception of the "total work of art" functioning as both paradigm and power source for an evolving world.

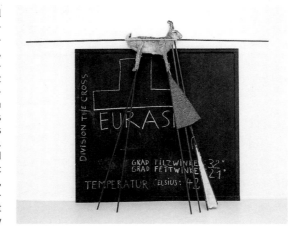

ANTIFORM IS AN ENERGY" Beuys

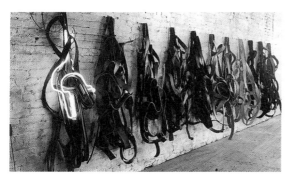

"Physical properties"

RICHARD SERRA
Belts
1966–67. Vulcanized rubber and blue neon lights, 214 x 752 x 51 cm. The Solomon R. Guggenheim Foundation, New York. Collection Panza di Biumo. All rights reserved.

Born in San Francisco, Serra studied art in Californian universities, then at Yale, where he was taught by Josef Albers. In Europe, he spent much time in Brancusi's rebuilt studio at the Musée National d'Art Moderne in Paris and befriended Minimalist composer Philip Glass. In 1966 in Rome, Serra exhibited *Animal Habitats, Live and Stuffed*, a curious environment containing animals in both states which some commentators saw as a forerunner to Arte Povera. Settling in New York, where he became associated with Robert Smithson and Joan Jonas, Serra's early works in rubber and neon sought to combine sculptural and pictorial principles. During the same period, Serra drew up a list of one hundred verbs ("roll," "fold," "tidy," etc.) that he intended as pointers to future work. Between 1968 and 1970, works such as *Splash Pieces* (molten lead squirted on to gallery walls), the precarious card-castles or heaps of metal rolls leaning against a wall, various pieces incorporating materials strewn across the floor, and his videos and films, such as *Hand Catching Lead* (1969), gradually forged a vocabulary for what was a challenging and original type of Minimalism. In this new language, danger and instability became tools. "It is impossible to separate," wrote Gregoire Müller in 1972, "the physical properties of a piece from the psychological conditions of its perception. The materials, the processes, the mechanisms of thought, time, horizontality, verticality, composition, weight, disorder, knowledge, the structures of material... form a complex system." From 1970, Serra's works became ever larger, which was in itself a critique not only of monumentality but of the most basic tenets of sculpture.

"Limit experiences"

BRUCE NAUMAN
From Hand to Mouth
1967.
Wax on canvas,
76.2 x 25.4 x 10.2 cm.
Private collection,
United States.
Courtesy Joseph A. Helman.
All rights reserved.

Impossible to pigeonhole, Nauman has produced a body of work which, in its sheer diversity, is one of the most

ambitious of the past thirty years. Intent on reintroducing feelings and sensations into modern art, Nauman (like his contemporaries Vito Acconci, Chris Burden and Robert Morris) started using his body (as well as that of the viewer) in a series of physical, physiological and psychological experiments or ordeals that explore space through all five senses. In his work, definitions and art forms blur and overlap. Classical materials, metal cages, objects suspended in space, fiberglass, wax or rubber, neon lights, video and film installations, and performances put on in the private space of the studio amount to an ongoing reinvention of the language of art and its purpose, leading to veritable "limit experiences" of time and space. The piece is not an end in itself but a probe, a proactive stimulus, a language that the artist composes and decomposes, and in which, as for Beckett whom he so admires, the impossibility of communication between human beings remains one of the dominant themes.

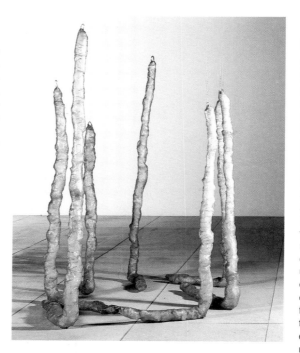

EVA HESSE
Untitled (Seven Poles)
1970. Seven elements: aluminum wire, polyethylene, resins and fiberglass, approx. 272 x 240 cm. Centre Georges Pompidou, MNAM, Paris. Photo P. Migeat/Centre Georges Pompidou.

In 1964, after gouaches and paintings out of which strange shapes were precipitated, Eva

"Chaos can be structured"

Hesse exhibited linear drawings incorporating organic and mechanical-looking forms and reliefs built out of industrial waste. Returning to New York in 1965, she produced her first sculptures redolent of vaguely biological forms, employing unusual, unsophisticated or fragile materials, such as rope and wire. Like Richard Tuttle and Joel Shapiro in the following years, Hesse opted for work on an altogether more modest scale than most of her contemporaries. From 1967 until her untimely death, she exploited the ductile qualities of latex, polyester resin and fiberglass to make sculptures that explored material properties in delicate figures and uncomplicated, confidential forms. In a career that showed up Minimalist art as ensnared in its own formalism, Eva Hesse repeatedly demonstrated that "chaos can be structured, just like non-chaos." Such strict observance of the logic of materials, combined with particular attention to space in its psychological and cultural as well as political dimensions, led to the emergence of what became known as Process art.

"EVERY SITE HAS AN IDEOLOGY

"Et in Utah Ego"

ROBERT SMITHSON
Spiral Jetty
1970.
Black rock, earth and salt
crystals, 457.2 x 3.81 m.
Great Salt Lake, Utah.

Land art was intended to take creativity out of the enclosed confines of the gallery and release it into the wide open spaces beyond. Be it ephemeral or permanent, tentative or interventionist, Land art is a distant echo of certain activities at Black Mountain College in the 1950s. These were designed to bridge the gap between genres and throw out the established categories, and thereby extend artistic practice beyond its accustomed frontiers, returning to a world free from social constraint. Robert Smithson's early career, like that of Hamish Fulton, Michael Heizer, Richard Long, Walter de Maria and, to a more limited extent, Christo and Jeanne-Claude— marked the onset of art directly in and on nature. From 1964, Smithson began producing works which combined sculpture, landscape and architecture. In a first series of works in steel and mirror-glass made between 1964 and 1968, the notion of "presence" on which Minimalist sculpture relies was physically dissolved. The same process was at work in other avatars of Minimalism entitled *Earth-*

works and *Non-Sites*, where remnants of experience announce a "metaphysical archeology" that Smithson adopted as his own. His desire to "put land into the work of art," the quality and the breadth of his vision, the centrality of the notion of entropy, the extreme diversity of his work, the continuous exploration of the fault lines of history, and, last but not least, his commitment to experimentation and analysis have made Smithson's career appear increasingly significant. The *Spiral Jetty*, a 457-meter-long embankment of earth, rock and salt crystals, embodies the elementary and symbolic aspirations of Smithson's Land art. As the water level rises and falls due to evaporation, the form emerges then retreats, serving as an allegory of the Creation. Through his muscular, intransigent, and often polemical writings, Smithson, who died in a plane crash while surveying a work in progress, also endeavored to supply a conceptualization of his artistic activity. He invented ideas and practices that can be seen as critical of the illusory power and utopian visions to which today's artists are susceptible. His own works transcend boundaries, conventions, and categories: "The artist seeks... the fiction that reality will sooner or later imitate."

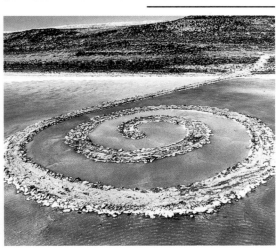

Chronology 1939–1970

This chronology is largely devoted to events in Europe and the United States. Sections in bold refer to artists mentioned in the main text and captions. For further information concerning this period, reference should be made to the two previous chapters.

1939
• Giacometti reduces his sculptural figures.

1941
Jacques Lipchitz settles in New York.

1942
• Death of Julio González.

1943
• Isamu Noguchi: *Monument to Heroes.*

1944
• Picasso: *Man with Sheep;* retrospective exhibition of his work at the Salon d'Automne, Paris.

1945
New York, MoMA: Calder retrospective.
New York, Bertha Schaefer Gallery: debut exhibition by Louise Bourgeois.

1947
• First sculptures in plaster and iron by César, followed by his *Compressions* (1960), *Thumbs* and *Expansions* (1965).
• Lucio Fontana develops his concept of "concetto spaziale."
Robert Jacobsen settles in Paris.

1950
• Richard Stankiewicz's earliest sculptures.
• Louise Nevelson's large-scale constructions.
First abstract sculptures by Eduardo Chillida.

1953
• Jean Tinguely makes his first *Méta-Matics.*
• First São Paulo Bienal.

1954
• Death of sculptor Henri Laurens.
• Paris, Galerie Arnaud: first exhibition by Tinguely.
Etienne-Martin: *Demeures* **cycle started.**

1955
• Rauschenberg, Jasper Johns and Twombly begin making sculptures.

1957
• Death of Brancusi.
• John Chamberlain's debut exhibition.

1958
• Takis produces his first magnetic sculptures.
• Yves Klein: first sponge-sculptures.
• Nice: Ben opens "Magasin" (his "store" in Nice).
Beuys begins to devise his creative language.

Christo produces his first *empaquetages* (packagings).

1959
• Arman, the first *Accumulations* and *Poubelles* (trash cans) followed by *Coupes, Colères* (1961) and *Combustions* (1963) series.
Donald Judd publishes critical pieces in *Art News* **(to 1965) then in** *Art in America.*

1960
• New York: Tinguely, *Homage to New York.*
• Jesús Rafael Soto: first "Penetrables."
• Raymond Mason: earliest works on the theme of the crowd.
Caro: earliest works in metal.

1961
• Erik Dietman: *Objets pensés* and *Sparadraps.*
• Piero Manzoni: *The Base of the World.*
• George Segal: first plaster-cast sculptures.
• Richard Artschwager: objects that mimic furniture.
• Claes Oldenburg makes *The Street* (1960), *The Store* (1961) and *The Home* (1965).
• New York, MoMA: "The Art of Assemblage."
• Addi Köpcke Gallery, Copenhagen: first exhibition by Robert Filliou.

1962
• Jean Pierre Raynaud creates the earliest *Pot,* followed by *Psycho-Objets* (1965).
• Panamarenko's earliest experiments.
Tony Smith makes *Die.*
Paris: Christo, *Iron Curtain,* **rue Visconti.**
Beuys meets Fluxus activists Nam June Paik and Maciunas.

1963
• Edward Kienholz produces first environments.
• Jean-Michel Sanejouand: first *Charges-Objets.*
• Hans Haacke: first works on glass and condensation.
• Barnett Newman begins work on the *Broken Obelisk* (completed 1967).

1964
• Andy Warhol: *Brillo Boxes.*
• Marcel Broodthaers publishes *Pense-bête* and begins to work on object pieces.

1965
• Pino Pascali: first *Armi,* followed by *Finte Sculpture* (fake sculptures).
• Joseph Kosuth: *Definitions.*
• Barbara Rose writes on "ABC art," Richard Wolheim on Minimal art.
• New York, Tibor de Nagy Gallery: first Carl

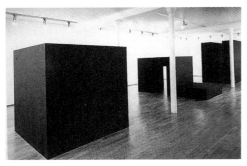

1961–63. Tony Smith. *Die* (foreground). Steel, 183 x 183 x 183 cm. 1962. Exhibited at the Galerie Daniel Templon, Paris, 1986. Courtesy Daniel Templon.

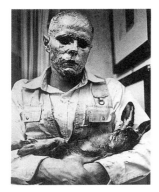

1965. Joseph Beuys. *How to Explain Pictures to a Dead Hare*. Action, Schmela gallery, Düsseldorf. All rights reserved.

1967. Robert Morris. *Untitled* (1986 version). In the background, works by Serra, LeWitt, Flavin, Fabro, Hesse and Zorio. Exhibited at the Centre Pompidou, Paris, 1986. Photo B. Hatala/Centre Pompidou.

1968. Bruce Nauman. *Dance or Exercise on the Perimeter of a Square* (16mm sound film, 10 minutes).

1966–67. Helio Oiticica. *Tropicalia: Penetrable PN 2 ("A Purita é um Mito")*. Remounted at the Galerie Nationale du Jeu de Paume, Paris, 1996. Photo P. Y. Brest/Centre Georges Pompidou.

Chronology 1939–1970

Andre exhibition.
Michelangelo Pistoletto begins work on the *Minus Objects* series.
Judd publishes *Specific Objects*.

1966
• Death of Arp.
• Stockholm: Niki de Saint-Phalle designs *Hon* (Woman), the first giant *Nana*.
• Ian Hamilton Finlay begins designing his philosophical garden, to be built at Stonypath, Scotland.
Rome: Richard Serra exhibits *Animal Habitats Live and Stuffed*.
New York, Jewish Museum: "Primary Structures" exhibition.
Land art begins to appear.

1967
Genoa, La Bertesca gallery: Celant organizes the exhibition "Arte Povera/In Spazio" and develops the idea of *arte povera* (poor art).
Sol LeWitt's first manifesto, "Paragraphs on Conceptual Art" (*Art Forum,* June), expanded in "Sentences on Conceptual Art" (*Art-Language,* May 1969).
Michael Fried publishes *Art and Objecthood*.

1968
• France, Neuilly: death of M. Duchamp; discovery of *Étant donné...* in New York.
• Bernard Pagès's formative sculptures.
• New York, Fischbach Gallery: "Eccentric Abstraction" exhibition.
Robert Morris publishes "Antiform" (in *Art Forum,* April).
Richard Serra: first *Splash Pieces*.
Nauman exhibits for the first time.

1969
• De Kooning: first sculptures.
• Leverkusen, Städtisch Museum: "Konzephon/Conception" exhibition.
• Body art begins to appear.
New York, Whitney Museum: "Anti-Illusion: Procedures/Materials."
Smithson develops *Non-Sites*.
Bern: "When Attitudes Become Form" exhibition organized by Harald Szeemann.

1970
• Toni Grand begins a "deconstructive reading" of traditional sculpture.
• Daniel Dezeuze realizes "Ladders in Plaited Wood" after *Châssis*.
• New York, MoMA: Kynaston McShine curates "Information."
• André Cadéré's first "mises en situations."
Giuseppe Penone begins creating works in nature and on his body.
Robert Smithson: *Spiral Jetty*.
Turin, Galleria Civica d'Arte Moderna: Giacomo Celant organizes the exhibition "Conceptual Art, Arte Povera, Land Art."

Studies on Sculpture Dictionaries and General Works

G. Battcock. *Minimal Art, a Critical Anthology*. New York, 1968.*

J. Beardsley. *Earthworks and Beyond: Contemporary Art in the Landscape*. New York, 1984.

G. Celant. *Arte povera*. Villeurbanne, 1989.*

C. Gintz. *L'Art conceptuel, une perspective*. Paris, 1989–90.*

J. Kastner and B. Wallis. *Land and Environmental Art*. London, 1998.

R. Krauss. *Passages in Modern Sculpture*. Cambridge, 1977.

L. Lippard. *Six Years: The Dematerialization of the Art Object from 1966 to 1972*. London, 1973.*

E. Lucie-Smith. *Sculpture Since 1945*. New York, 1987.

G. A. Tiberghien. *Land art*. Paris, 1993. *

Monographs and exhibition catalogues on the sculpture and sculptors mentioned

1967, Los Angeles. *American Sculpture of the Sixties*. Los Angeles County Museum of Art.

1969, Bern. *When Attitudes Become Form*. Kunsthalle.*

1990, New York. *The New Sculpture 1965–75: Between Geometry and Gesture*. Whitney Museum of American Art. *

1996, Krefeld, Wolfsburg. *Carl Andre, Skulptor*. 1996.

1994, Paris. *Joseph Beuys*. MNAM/Centre Georges Pompidou.

1998, Washington, D.C. *Alexander Calder*. National Gallery of Art.

1988, New York. *Donald Judd* (ed. Barbara Haskell). Whitney Museum of American Art.

1993, Paris. *Eva Hesse*. Galerie Nationale du Jeu de Paume/RMN.

1978–79, New York. *Sol LeWitt, Retrospective*. MoMA.

1994, Minneapolis. *Bruce Nauman, Catalogue Raisonné*. Walker Art Center.

1990, Rome. *Michelangelo Pistoletto*. Galleria Nazionale d'Arte Moderna.

1998–99, Los Angeles. *Richard Serra Sculpture 1985–1998*. Museum of Contemporary Art, 1987–88.

2000, Vienna. *Robert Smithson*. Kunsthalle.

J. C. Ammann, D. Le Buhan, M. Ragon, and H. Szeemann. *Étienne-Martin*. Paris, 1991.

R. E. Krauss. *The Sculpture of David Smith*. Cambridge, Mass., 1971.

Diane Waldman. *Anthony Caro*. Oxford, 1982.

* Essential reading

ARCHITECTURE
"after modernism"

"Architecture of the future"

LE CORBUSIER (CHARLES-ÉDOUARD JEANNERET, KNOWN AS)
Unité d'Habitation (Housing unit), la Cité Radieuse, Marseille
1945–52.
© From left to right and from top to bottom: P. Cook/Archipress; F. Eustache/Archipress; Y. Lion/C. Pompidou; M. Babey/Artephoto.

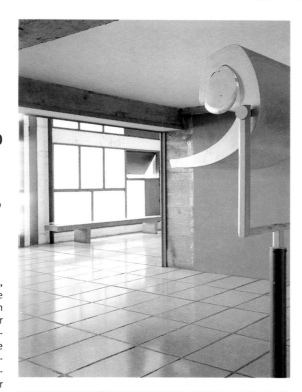

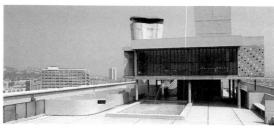

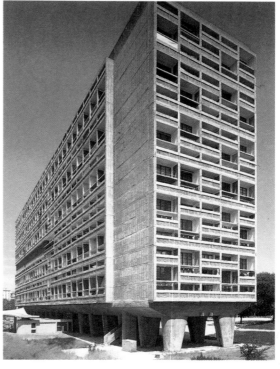

As Gérard Monnier has written, the state commission for the Marseille Unité d'Habitation (1945–52) offered Le Corbusier a chance to "put his typological interpretation of living-space into practice, as well as allowing for new plastic and figurative opportunities." Four other designs of a similar type had a more or less checkered history: Rèze-les-Nantes (1948–55); Berlin-Tiergarten (1957–58); Briey-en-Forêt (1956–63); and Firminy (1959–67), completed after the architect's accidental death. Today the considerable impact of this project, in which Le Corbusier gave concrete form to concepts of function, hygiene and unconstrained movement, is obvious. The building, 165 meters long and 150 high, and nicknamed "La Maison du Fada" (the loony's house), only saw the light of day after countless vicissitudes. It contains 337 duplex apartments and displays considerable technical mastery: so as to aid sound-proofing and conserve the individual characteristics of the dwellings within a collective housing project, the dwelling units are inserted into the carcass like separate individual boxes. All the requirements of everyday living are localized in one place: businesses, communal amenities, childcare facilities, school and hotel, as well as the leisure center almost the size of a sport's stadium on the roof. In 1950, as part of his drive to synthesize the arts, Le Corbusier devised the Modulor, a system for standardizing the dimensions of architectural space. The numerous plans which followed, the projects for an "architecture of the future," combined elements from his early projects with the plastic and sculptural inventiveness of his mature years.

The postwar period was inevitably characterized by reconstruction. American liberalism spawned skyscrapers, while collective housing projects were foisted on the USSR. The 1943 Athens Charter set out overarching principles for modern architecture and city planning that remained in force until the mid-1950s. These were contested at the tenth CIAM in Dubrovnik (1956) by Alison and Peter Smithson, Aldo van Eyck and the trio of Candilis-Josic-Woods who

> > >

> > > made up Team X. They each proposed contrasting solutions that lay between organic-based principles and "Megastructural" mechanisms.

As early as 1944, the French government was making moves to house the homeless and to construct the city of tomorrow. Auguste Perret at Le Havre and Le Corbusier in Marseille were establishing rules for social housing. Once the city center was rebuilt, concentration switched to the outskirts. Jean Prouvé, following on from Eugène Beaudouin and Marcel Lods, also drew up emergency housing schemes. According to Nikolaas Habraken, "man no longer dwells; he is housed." The suburbs were soon filled with straight-edge lines against which Émile Aillaud proposed curved prefabricated forms, while in 1958 at rue Croulebarbe, Paris, Édouard Albert constructed the country's first high-rise block.

In northern Europe, it was the humanism of Alvar Aalto and Arne Jacobsen that won the day, while Aldo van Eyck fostered "architectural structuralism." Mies van der Rohe returned to rebuild in Germany, while Walter Gropius, Hans Scharoun and Frei Otto suggested new typologies for reconstruction. British and Dutch models countered the isolated architectural object with a consciousness of the urban and social context. In Italy (which espoused the INA-Casa system from 1949) very different projects were being underwritten. In the 1950s, historicist sirens got the better of a modernist such as Giuseppe Terragni (a figure often identified with Fascism), just as a policy of rehabilitating historical sites was being applied in France with laws equivalent to those on national heritage and listed buildings elsewhere (1963).

Outside Europe, city planning and architecture could evolve in directions independent of Old World constraints. In Mexico City, Caracas, Santiago, Lima, Rio and Bogota, as well as in Asia, models derived from Le Corbusier, Mies van der Rohe or Gropius became paradigms of the modern spirit. New capitals, new conurbations arose: Chandigarh, Brasília and Dacca were each the work of a single visionary. Others, for instance in Africa, advocated a return to vernacular schemas, whereas architects > >

146

"Monumental structures of the past"

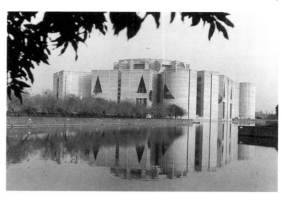

LOUIS I. KAHN
Governmental Center, Dacca, Bangladesh
1962–83 (completed by Wisdom & Associates).
© S. Alam.

Initially indebted to the International Style, Louis Kahn was attracted to the "monumental structures of the past," the only ones that seemed to him to possess the requisite universal characteristic of "grandeur" on which the architecture of the future should be based. In 1950, he discovered the buildings of Rome, Greece and Egypt, and stopped off in Marseille where Le Corbusier's Cité Radieuse was being constructed. After this trip, Kahn introduced a fresh approach to volume that was expressed in travertine and brick monumental forms and figures of an extreme sparseness. An architect whose work called for meditation and immanence, Kahn yearned for silence and for the light that makes objects present. Together with Niemeyer and Costa's Brasília, and Le Corbusier's Chandigarh, the Dacca project is one of the few schemes in which contemporary architecture was directly involved in the birth of a nation. Louis Kahn exerted an influence on Aldo Rossi, Mario Botta, Tadao Ando and Rafael Moneo. In 1972, two years prior to his mentor's death, however, his former associate Robert Venturi published *Learning from Las Vegas*, the eclecticism and Postmodern tenets of which were totally at odds with Kahn's monumental and monastic spirituality.

"Less is more"

LUDWIG MIES VAN DER ROHE
Seagram Building, New York (with Philip Johnson)
1954–58. Photo E. Stoller Associates. © Esto.

Farnsworth House, Plano, Ill.
1945–50.
© P. Cook/Archipress.

The theme of the individual glass dwelling first appeared in Mies van der Rohe's work in the 1920s. Present in the Barcelona Pavilion (1929), the Tugendhat House at Brno (1928–30), as well as in numerous unrealized plans, the principle of the glass box standing on steel stanchions only attained its full potential in the United States in 1945, however, with the construction of the Farnsworth House. The concept was quickly taken up by many of Mies' successors. In the Lake Shore Drive Apartments, which foreshadow the famous Seagram Building (1954–58), Mies was at last able to exploit the device of exposed metal latticework on the scale of a skyscraper. The overall glass-and-steel aesthetic and the three-to-five proportion selected for the window openings led to the option of single, prismatic block erected on stanchions. The resulting uniform

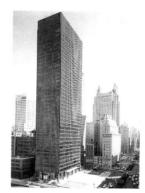

network structure, broken up by rhythmic elements, became a symbol of the industrial world which, before it became adulterated, was the tangible expression of Mies' famous dictum: "Less is more."

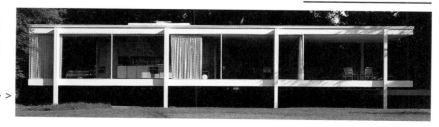

"GOD IS IN

"A futuristic image of take-off"

EERO SAARINEN
The TWA Terminal Building, Kennedy International Airport (formerly Idlewild), New York
1956–62. © TWA/E. Stoller Associates, New York.

Born in Finland, Saarinen and his parents emigrated to the United States in 1923. After graduating from Yale, he worked with his father Eliel, becoming a partner in 1941. In 1948 he won the design competition for the Jefferson National Expansion Memorial in St. Louis. The enormous steel-clad arch was less a technical tour de force than a general reflection on the commemorative monument as a place where sculpture and architecture can be fused. The TWA terminal at Kennedy International Airport, whose concrete curves and counter-curves create a "futuristic image of take-off," fuses form and function in an embodiment (like the contemporary airport at Washington) of the modern ideal of a liberated and dynamic architecture, divorced from the stylistic and technical constraints of International Style models.

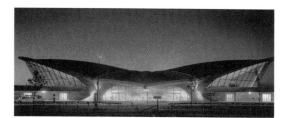

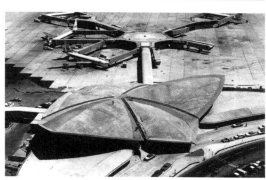

"Only beauty is functional"

KENZO TANGE
Broadcasting and Press Center, Yamanashi, Tokyo
1962–66.
© O. Murai.

Tange was fascinated by the figure of Le Corbusier, whose work he refused to see as a dogmatic offshoot of the International Style. By the 1940s, he was already demonstrating his inability to combine on a grand scale a novel stylistic language with imagery taken from traditional Japanese architecture. The Peace Park and Center, Hiroshima (1949–55), with which his career started, led to contact with the 1951 CIAM, where he was invited to present his plans. Tange's intention was to forge a "new tradition" lying midway between international architecture and a redefinition of the essential components of Japanese style. To this end, he developed a synthesis of two historic poles of his culture, Yayoi and Jomon. The Kagawa Prefectural Office (1955–58), the Sports Center at Takamatsu (1962–64) and the Broadcasting and Press Center, Yamanashi, are examples of Tange's rejection of "boring modern architecture," and show a willingness to breathe new life into the celebrated functionalist axiom: "Only beauty is functional." Jointly with Kisho Kurakawa, the initiator of the Metabolism movement, Tange

147

"A temple to non-objective art"

FRANK LLOYD WRIGHT
Solomon R. Guggenheim Museum, New York
1943–59.
© F. Eustache/Archipress.

Frank Lloyd Wright's seventy-year career, with its wealth of architectonic ideas and forms by turn elitist and socially conscious, was shot through with utopian visions that were sufficiently individual as to render the formation of a "Wright school" practically impossible. In contradistinction to the Enlightenment philosophy fostered by Mies van der Rohe, Wright's work embodies the American myth of a pioneering spirit determined to conquer uncharted lands. The motif of the spiral had surfaced in Wright's work by 1925, becoming a reality in the highly complex site of the Solomon R. Guggenheim Museum, New York, completed just months after his death. An icon of 1950s architecture, the building itself and the shallow incline of its ramp that takes visitors down to the museum below is a symbol of the continuous line of a modernist movement that saw itself as purposeful yet open-ended. With its obvious references to the Mesopotamian ziggurat, this "temple to non-objective art" is a tour de force of architectural sculpture to be reinterpreted in diluted form by Frank O. Gehry at the Guggenheim Museum in Bilbao.

"Spatial environment"

CARLO SCARPA
Brion-Vega Cemetery, San Vito d'Altivolte, near Treviso
1969–78.
© Y. Lion.

He set up his practice in Venice in 1927 and taught drawing and commercial interior design in the city until 1972. Carlo Scarpa was attracted to Art Nouveau and to the Vienna Sezession. In 1942, he began an extended collaboration with the Venice Biennale, for which he acted as a consultant and exhibition space designer. His close links with the contemporary creative arts and his work in museums resulted in an unusual approach to the history of forms and objects. Scarpa's architectural development unfolded in the form of a reasoned critique. He was particularly attentive to detailing and to the elements that lie at the intersection of one space with another, and he had a theater director's eye for light and color. Scarpa evolved the concept of "spatial environment," which he envisioned in a cognitive or tangible form that would extend beyond the enclosed space. This he has applied to various public areas, such as this cemetery at Brion-Vega, near Treviso.

presented an analysis of the contemporary city as biological structure. In 1960, he published a redevelopment plan for Tokyo that remained at the theoretical stage in which mega-structures are connected by vast rapid-transit systems.

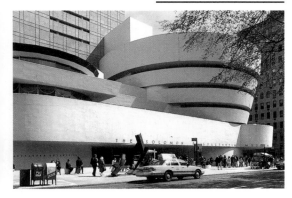

THE DETAIL" Mies van der Rohe

> > > such as Buckminster Fuller (with his geodesic dome), Paul Rodolph and Yona Friedman ("moving cities"), the Archigram group ("living cities"), the Japanese "Metabolists" (at Expo 70 at Osaka), the Italians (those belonging to Superstudio) and Constant (in the midst of the Situationists' urban "wanderings") all promulgated a utopian vision of the cityscape that mitigated against Functionalism. In the critical climate of a large-scale revisionist history of the century, architects such as the members of the Group of Five, Tadao Ando in Japan and Henri Ciriani in France reaffirmed their belief in what had become termed the "modern tradition" and in the neo-Corbusian movement. On the other hand, after the 1970s Postmodernism held sway as the only spectacular cultural product of the time. Anglo-Saxon critics and architects such as Charles Jencks, Charles Moore, Robert Venturi, Philip Johnson, Michael Graves, James Sterling, Japan's Arata Izosaki, Aldo Rossi in Italy and Bernard Huet in France were vociferous in their desire to reinstate architecture into the history of the city. Parodies and pastiches abounded, decorating edifices or piazzas of the most eclectic and archetypal styles. From the Ticino to Portugal, the critical "Neo-Regionalism" of Mario Dona and Alvaro Siza attempted to meld a universal modernist approach with local references. Simultaneously, high-tech developments attained an extreme level of sophistication which (from Norman Foster and Richard Rogers to Renzo Piano) conveyed a fascination with architecture rooted in the "arts of engineering." The notion of deconstruction, meanwhile, derived its theoretical models from contemporary philosophical thought. Subjectivity thus ousted dogma: it would seem that the architect is no longer called upon to invent new typologies but instead has to think about the site and the reality that confront him. In the wake of the avatars of postmodernism that followed on from Japanese eclecticism, the Western city presents us with practices that, though contemporaneous, are divergent: a reminder that, in the words of Antoine Grumbach, "architecture without constraints is an imposture." <

148

"Living space and form"

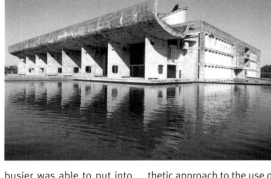

LE CORBUSIER (CHARLES-ÉDOUARD JEANNERET, KNOWN AS)
Chandigarh Parliament, India
1951–57.
© F. Eustache/Archipress

Chapel of Notre-Dame-du-Haut, Ronchamp, Jura
1951–55.
© F. Eustache/Archipress.

It was in Ahmedabad, India, where he designed the museum (1953–56), the house (headquarters) of the Mill Owners' Association (1954–56), Sarabhai House (1955–56), and the Villa Shodan (1956) that Le Cor-

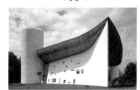

busier was able to put into practice his synthesis of architectural and urban ideas. In Chandigarh, the capital of the Punjab founded in 1947, the city plan was laid out in collaboration with Maxwell Fry and Jane Drew. The sector of the Parliament Building and the High Court of Justice, built between 1952 and 1964, gave Le Corbusier the opportunity of presenting a coherent aes-

thetic approach to the use of reinforced concrete that was in keeping with traditional Indian architecture. An inimitable way of "living space and form"—an expression that Le Corbusier used in connection with the Pilgrimage Church of Notre-Dame-du-Haut at Ronchamp—is superimposed over the rational engineering techniques he had absorbed earlier.

"A new city"

OSCAR NIEMEYER
Cathedral of Our Lady of Fatima, Brasília, Brazil
1958–70.
© M. Moch/Archipress.

During the association he built up with Le Corbusier and the French-born architect Lucio Costa during the construction of the Ministry of Education and Health at Rio de Janeiro in 1936, Oscar Niemeyer had learnt to see architecture as a vehicle for a specific aesthetic. Between

1943 and 1944, in association with Juscelino Kubitschek de Oliveira, mayor of Belo Horizonte and future president of Brazil, he completed the overall plan for the suburb of Pampulha. This project won him international renown and established him as the leading architect of a rapidly expanding Brazil. Brasília's huge site offered Niemeyer and his associate Lucio Costa the opportunity to devise a large-scale architectural and urban plan in

a style of unadorned classicism involving an elegant and masterly use of reinforced concrete in complicated or irregularly curved surfaces. With its hyperbolic curves sweeping up like a crown of thorns, the Cathedral of Our Lady of Fatima located on the new capital's central square is a suggestive example of the marriage between architectural and sculptural principles that Niemeyer was to exploit throughout his career.

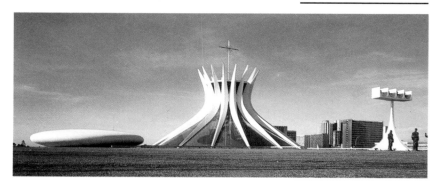

"WITHIN A LARGE STRUCTURE

"Architectural structuralism"

ALDO VAN EYCK
Municipal Orphanage, Amsterdam
1955–60. Preliminary project: sketch. Colored pencil and lead pencil on translucent layout paper, 40.5 x 31.5 cm. Photo C. Pompidou, MNAM-CCI.

A free spirit and an inquisitive mind, Aldo van Eyck never stood still during his fifty-year career; neither, as Jean-Claude Garcias has brought out, did he ever lose "his respect for certain values: social commitment, an obsessive attention to practicalities, a belief in participation, a rejection of hierarchy, a concern with the Third World, an almost child-like taste for color." He studied in The Hague and

Zurich, and made numerous voyages, including one to the Dogon in Africa. He settled in Amsterdam in 1945, where he set out to work in state-sector architecture, specializing in sports facilities. He was a member of Team X and had links with Cobra and the Situationists. He lent his voice to the challenge to CIAM and to the dogma of modernism, and saw his plans integrated into a particular social and cultural context. The Amsterdam orphanage scheme on which he worked until 1960 was an early project based on "architectural structuralism," and represented a completely new way of thinking. Standing out against the metropolis, this house-sized "city" built from a series of domes around patios and interior courtyards, signals, as Jean-Claude Garcias has again emphasized, "a radical

break with the institutional image of an unhappy childhood, if not with the institution itself." Other projects based on this same architectural ethic included the Hubertus House for unmarried mothers, the rebuilding of the Nieuwmarkt quarter in the capital and the Padua psychiatric clinic at Boekelo.

"City as event"

ARCHIGRAM
Plug-in-City
1964. Cross-section: print and plastic film on cardboard, 58.8 x 121 cm. Centre Georges Pompidou, MNAM-CCI, Paris. © J. Planchet/Centre Georges Pompidou.

The fanzine was a typical product of 1960s counter-culture. When Warren Chalk, Peter Cook, Dennis Crompton, David Green, Ron Herron and Michael Webb started to publish one, the aim was to provide clear information on innovations in architecture. After issues about flux and movement, extension and change, and "throwaway architecture," number 4, entitled *Zoom! Amazing Archigram,* published in 1964, arrived by way of a manifesto for a style of thought and life that would be informed by historic references and by an awareness of many innovative forms. Archigram emerged in the context of the emerging Pop art scene and saw itself as having its finger on the pulse of the times, amalgamating the lessons of the Smithsons and of Situationist theory with the indeterminate urbanism of Yona Friedman. At the 1963 "Living City" exhibition in London, Archigram presented a vision of the city as "permanent event." For a decade, the members of Archigram continued to design projects that got no further than the planning stage. They wedded a fascination for anarchic

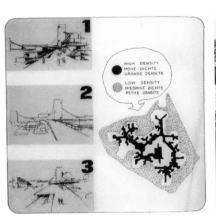

"A society of the greatest number"

GEORGES CANDILIS,
PAUL DONY,
ALEXIS JOSIC,
SHADRACH WOODS
Centre linéaire, Toulouse-le Mirail
1961–62. India ink on translucent layout paper, 27 x 26.5 cm. C. Pompidou, MNAM-CCI, Paris (Fonds Candilis). Photo C. Pompidou.

GEORGES CANDILIS,
PAUL DONY,
ALEXIS JOSIC,
SHADRACH WOODS,
MANFRED SCHIEDELM
Freie Universität, Berlin

1963–74. Photo Cardot-Joly/ Documentation générale, Centre Georges Pompidou.

Georges Candilis, Alexis Josic and Shadrach Woods met on the site of the Unité d'Habitation, where their work was overseen by Le Corbusier. Until 1955, they worked in Morocco, constructing social housing projects for ATBAT (Ateliers des Bâtisseurs), an organization which served as a center for interdisciplinary studies. Back in Paris, they collaborated on projects by Team X, and were among the few architects in France to situate

their activities within the context of the wider international debate. Occupied on vast social-housing projects, they designed numerous out-of-town projects, winning the competition for the Toulouse-Mirail ZUP (priority city redevelopment plan) in 1961 and the competition for the Berlin Freie Universität. They developed principles of urbanism that amounted to a revision of the guidelines enshrined in the Athens Charter and presented a forward-looking and utopian approach to the problems facing a "society of the greatest number."

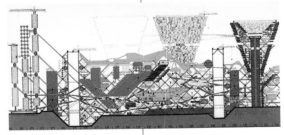

and ramified machinery, a libertarian vision of the city and a linguistic inventiveness that bequeathed to the future a vast number of plastic, theoretical and social models.

ALMOST ANYTHING CAN HAPPEN" Archigram

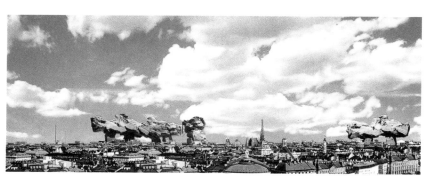

HANS HOLLEIN
Urban Structure Vienna,
1960.
Photomontage, 13.2 x 32.7 cm.
Centre Pompidou, MNAM-CCI,
Paris.

"Everything is architecture"

Hans Hollein adopted an approach that marked a return to the spirit of Austrian modernism. In the early 1960s, he started teaching in Europe and the United States. He followed the guiding principle "everything is architecture" and his critical models and concepts stemmed from an interest in urban situations and in "collage" projects, such as *Stadt-struktur* (urban structure; 1962) and the *Flugzeugträgerstadt* (aircraft-carrier city; 1964). Using precious materials, Hollein's intricately detailed early works incorporated references and quotations of every kind. The Schullin Jewelry Store (1972–74 and 1981–83) and the head of the Austrian Tourist Office in Vienna (1976–78), where the artificial palms recalled John Nash's Royal Pavilion in Brighton, took the visitor on a journey. The more recent Haas Haus in Vienna (1990), the Städtisches Museum, Abteiberg, Mönchengladbach (1972–82) and the modern art museum at Frankfurt (1991) with its prow-like façade, on the other hand, exemplify a distinctive outlook on the environment. The "Reiner Raum" (pure space) in the Santander bank in Madrid (1993) and Vulcania, the "European Volcanism Park" combine the utopia of underground cities of the 1960s with an investigation into the relationship between the arts that redefines architecture in terms of ritual practice.

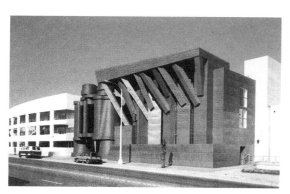

150

"No-Rule Architecture"

**FRANK O. GEHRY
(WITH CLAES
OLDENBURG)**
*Chiat-Day Building,
Venice, California*
1991.

Born in Toronto, Gehry studied on the American West Coast as well as at Harvard University. He opened a practice in Los Angeles in 1962. In accordance with his precept of "No-Rule Architecture," Gehry completed a number of single-family houses, including his own house at Santa Monica (1977–78), using the kind of unexceptional materials that are his trademark. Receptive to many forms of cultural creativity and to the rehabilitation of a sculptural approach in architecture, Gehry undertook projects for Disneyland at Marne-La-Vallée and Los Angeles, in Barcelona (Vila Olympica, 1989–92), at Weil-am-Rhein (Vitra museum and factory, 1987–89) and in Paris (the American Center, 1993). Free of the ambitions and social constraints characteristic of European architecture, Gehry has forged his own idiom from a process of improvisatory sketching, the results of which he would make up into maquettes that fuse a taste for free form with, as Alain Guiheux has put it, an "almost choreographic" approach. More recent projects, such as the Guggenheim Museum in Bilbao (1995–97) and a plan for the Guggenheim Museum on the Hudson River, New York, provide clear evidence of Gehry's desire to make architecture into a public spectacle, into a significant, if not necessarily dominant, feature beating at the heart of the city.

"Body, Memory and Architecture"

CHARLES MOORE
*Piazza d'Italia,
New Orleans*
1975–78.

Since 1962, Charles Moore has been producing a hugely various body of work in collaboration with various partners. His work is hard to categorize, however. Awash with souvenirs from the past and quotations, Moore's sculptural language often borders on parody. His most notable projects include: his own Moore House at Orinda, California (1962), where the living space "overflows" into baldacchino-like wooden canopies; the Faculty Club of the University of California at Santa Barbara (1966–68); the numerous and deliberately diverse social-housing schemes at Kresge College at the University of California at Santa Cruz (1973–74), where a "rural Acropolis" cites from the Antique Forum; the Piazza d'Italia (New Orleans, 1975–76), built in the spirit of the prop room from some Graeco-Roman theater; and the Tegeler Hafen in Berlin (1980). Though less intellectual in his approach than Robert Venturi, Moore is determined to openly flout the "Puritanism" of the orthodox modernist idiom. In *Body, Memory and Architecture,* published in 1977, Moore defended the space of memory dear to regionalism and to rational architecture and, together with Charles Jencks, Robert Venturi, Aldo Rossi and Michael Graves, exemplified the doubts of Postmodernism in the modern consciousness.

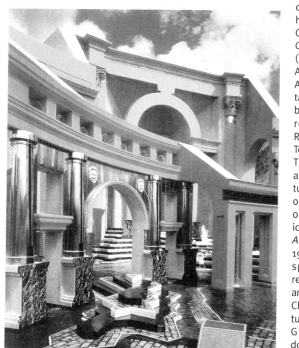

"THE MODERN MOVEMENT

"A dialectic between image and meaning"

JAMES STIRLING (WITH JAMES GOWAN)
Engineering Building, Leicester, Great Britain
1959–64.

Born in Glasgow, James Stirling grew up in Liverpool, where he absorbed, in addition to the monumental and naval architecture of the city, the philosophy of the theoretician Colin Rowe. In London, he met James Gowan, with whom he realized several projects, including the Engineering Building of the University of Leicester in the Midlands. From 1963 to 1971, Stirling's taste for using materials sculpturally and, as Catherine Slessor has put it, for a "dialectic between image and meaning" grew stronger. The History Fac-

ulty at Cambridge University (1964–67), Runcorn new town (1967–76) and the Olivetti offices at Haslemere (1969–72) are all characterized by a heightened sense of the spectacular. Stirling exploited many sources of imagery, from greenhouse to battleship, from Russian Constructivism to the eighteenth-century English interior or the launchpads at Cape Canaveral. Commissions became less forthcoming in the 1970s, a decade that saw Stirling edging surprisingly close to Postmodernism. He did complete a number of projects, such as the Wallraf-Richartz Museum, Cologne (1975), and the Neue Staatsgalerie in Stuttgart (1977–83), as well as the new Turner Wing at the Tate Gallery (now Tate Britain), London (1984–88). His final plan for the Braun factory at Melsungen, Germany, completed the year of his death, is full of eclectic references and forms of extreme theoretical refinement.

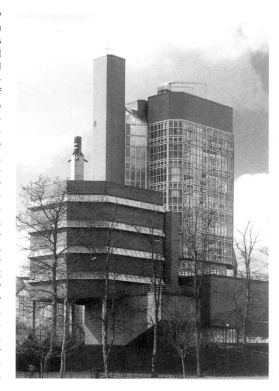

"A metaphor for technology"

NORMAN FOSTER
Reliance Controls Factory, Swindon, Great Britain
1965–67.

Hong Kong and Shanghai Bank, Hong Kong
1979–85.
© R. Bryant/Archipress/Arcaid.

In London in 1963, Norman Foster founded Team 4 with his first wife Wendy Cheeseman, Richard Rogers and George Wolton. In 1965, they designed the Reliance Controls Factory, Swindon, for the French car firm Renault. Built up from a set

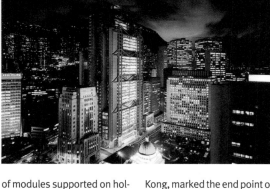

of modules supported on hollow prestressed-steel masts from which are suspended steel girders in the form of pointed arches, the structure was intended to be indefinitely expandable. Coming after the Smithsons' Brutalist approach, the design reinforced Team 4's belief in an architecture preoccupied by contemporary technology. From 1968, Norman and Wendy Foster joined Buckminster Fuller on a number of projects, though these all remained on the drawing board. The tower of the Hong Kong and Shanghai Bank, Hong

Kong, marked the end point of a prolonged redefinition of the typology of the skyscraper undertaken with the engineer Ove Arup. Moreover, it demonstrates a capacity for escaping from both dogmatism and Meccano. It is a telling example of design development in a building symbolic of end-of-the-century high tech. In many more schemes that followed Hong Kong—such as the Carré d'Art at Nîmes (1984–92)—Foster engaged perceptively with the relationship between contemporary building and historic city.

"Anti-monument"

RENZO PIANO AND RICHARD ROGERS
Centre Georges Pompidou, Paris
1971–77. Photo G. Meguerditchian/C. Pompidou.

In 1971, two young architects, the Italian Renzo Piano and the Briton Richard Rogers, won the international competition for the Centre National d'Art et de Culture that Georges Pompidou intended as his legacy to France. On the flat Beaubourg precinct in the heart of Paris, they proposed to erect a giant "urban toy," an "anti-monument" that would embody the culture-for-all aspirations of the period. The critical reaction to this piece of pop architecture is well documented, since it was soon recognized as both an emblematic piece of high tech and the epitome of the machine as symbolic model derived from Functionalism, from Archigram, from the Metabolists, from Peter Rice and of course from the work of Jean Prouvé, president of the competition jury for the center. Renzo Piano's subtle approach, steeped in a reflection on ecological, planning and social questions, was to develop further at the De Menil Foundation, Houston (1982–86), Kansai airport (opened 1995), the Beyeler Foundation in Basel (1997) and the Centre Culturel Jean-Marie Tijbaou, Nouméa (1992–96). Rogers' admiration for Charles Eames, Louis Kahn and Mies van der Rohe's open-plan system found its expression in the Lloyd's Building in the City of London (1978–86),

the Inmos Microprocessor factory in Newport, Wales (1982), and the Channel Four offices in London (1990–94).

151

WAS (ALMOST) RIGHT" Venturi

"An extraordinary maelstrom"

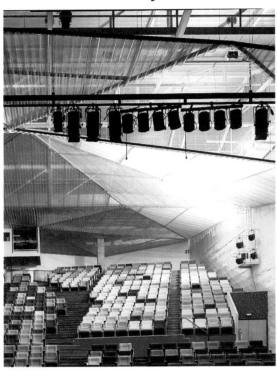

REM KOOLHAAS
Palais des Congrès,
Euralille, Lille, France
1988–95.
© Left: P. Cook/Archipress.
Above: F. Eustache/Archipress.

Initially a journalist and scriptwriter, Rem Koolhaas studied architecture at London between 1968 to 1972, a period marked by two theoretical and speculative projects inspired by Superstudio and Archizoom. In 1975, he moved to the United States for a while and published *Delirious New York*, a kind of retroactive Manhattan manifesto in which he provided a paradigm for the exploitation of "density." Back in Europe, Koolhaas founded the Office for Metropolitan Architecture (OMA) in Rotterdam, with the aim of defining new models for the "strategic" relationship between architecture and the city. Koolhaas worked on numerous published but unrealized designs and tackled, in a series of speeches and written texts, the crucial question of the role of modern architecture in the context of the historical European city. The Nederlands Dans Theater at The Hague (1987) and private residences at Rotterdam (1988), Saint-Cloud (1991) and Floirac (1997), housing projects in Amsterdam (1989) and Fukuoka (Japan, 1991), the Rotterdam Kunsthalle (1992), the redevelopment scheme for Melun-Sénart new town and the master-plan for Eura-Lille (characterized by Jacques Lucan as an "extraordinary maelstrom... of interconnecting and intersecting infrastructures") each present solutions and adventures in planning which have made a great impression on contemporary architecture.

"Wind architecture"

TOYO ITO
Tower of Winds
1986. Maquette.
Centre Georges Pompidou,
MNAM-CCI, Paris.

Having graduated in 1965, Toyo Ito worked in the agency of Kiyonuri Kikutake, a member of the Metabolist movement. In 1971, he established his own practice, Urban Robot, in Tokyo, producing early projects strongly influenced by Arata Isozaki and Kazuo Shinohara. The various residences he designed engaged in a critique of formalism, and offered a redefinition of the function of architecture through an analysis of contemporary society and lifestyle. Chantal Béret has described his agenda as "elaborating a concept of nomadic life adapted to the fragmented, fluid, dynamic, ephemeral, intangible city, from which all idea of the 'genius of the place' has been expunged." He used the phrase an "architecture of wind" to sum up his work and the shining example of this is the Silver Hut (Tokyo, 1983–84). The Tower of Winds was built in accordance with technical rules that allowed Ito to adapt his projects in keeping with the environment and site. The tower was the first of a long line of designs produced in the 1990s, which included the Egg of Winds (Tokyo, 1989–91), the City Museum (Yatsushiro, 1988–91), the Japanese Cultural Center in Paris (not built; 1990). It was the tangible expression of an art that is directed toward immateriality, contrasting with the bombastic theatricality and heroic gestures of some of his contemporaries. It opened the way to a Japanese architecture which reached its apogee in Kazuyo Sejima.

152

"A Minimalist parti pris"

DOMINIQUE PERRAULT
Bibliothèque
François Mitterand, Paris
1989–97.
© M. Denance/Archipress/
BNF/D. Perrault architect, Paris.

Dominique Perrault graduated in 1978. Following a competitive tender, he designed the École Supérieure d'Ingénieurs at Marne-la-Vallée (1984–87), a deeply sober and technically perfect piece that was to serve as a springboard for larger projects. His major works include the Hôtel Industriel Jean-Baptiste Berlier (1986–90)—constructed as a vast glass roof placed on concrete open-plan floors offering the contrast of a diaphanous veil with the intricate urban texture around it—the SAGEP factory at Ivry-sur-Seine (1987–93), the Archives de la Mayenne in Laval (1989–93), the Berlin Velodrome and Olympic pool (1992–99), and the recent Aplix factory Nantes (1999). Perrault's work, like that of Jacques Herzog and his associate Pierre de Meuron, is sensitive to the idea of the "skin" of a building, adopting a keenly "Minimalist" style and addressing the nature of the connections between architecture and the most advanced manifestations in the visual arts today. The last of President François Mitterand's large-scale projects, the French National Library is a formidable example of Perrault's tellingly simple conception. Its moderation and the symbolic clarity of its structure are in marked contrast to the designs of his contemporaries, the effacement and elimination of the architectural object being rejected in favor of sheer presence.

"BY DEFINITION, ARCHITECTURE

"The Spirit of the Times"

JEAN NOUVEL
Fondation Cartier, Paris
1991–95. © Archipress.

*Centre de Culture et de
Congrès, Lucerne, Switzerland*
1995–2000. © P. Ruault.

A multifaceted figure on the contemporary architecture scene, Jean Nouvel set up his first practice with Gilbert Lézénès and François Seigneur. His early projects showed debts to both Claude Parent and Paul Virilio. There followed an energetic series of winning entries to competitions which remained for the most part on the drawing board: the Collège at Anthony (1978–80), an extension at the Clinic, Bezons, with Lézénès (1978), the renovation of the Municipal Theater, Belfort, with Lézénès and Dominique Lyon (1980–83), and the "Nemausus 1" housing project in Nîmes, with Jean-Marc Ibos (1985–87), the last displaying a sensitive appreciation of real living conditions. With the Institut du Monde Arabe, designed in collaboraton with Lézénès, Pierre Soria and Architecture Studio (Paris, 1981–87), Nouvel created one of the most talked about French buildings of recent times. The Fondation Cartier (1991–95), the Stade de France competition (1994), the Tour sans Fin project (1988), and the Centre de Culture et de Congrès, Lucerne (1998–2000), are also highly individual, even provocative projects. They all display a sensitivity to the site and to the "spirit of the times," exemplifying Nouvel's concern with the social and critical context that he also pusued in his opposition to the destruction of the Paris covered-markets (Les Halles) and of the Ile Séguin at Billancourt.

Chronology 1944–2000

This chronology is largely devoted to events in the field of architecture, mostly in France. Sections in bold refer to architects mentioned in the main text and captions. The dates indicated refer to the completion of projects.

1944
Jean Prouvé: folded sheet-metal structures.

1945
• Finland: Alvar Aalto, Raniemi village.
• Denmark: Arne Jacobsen, houses at Soholm.
• Bruno Zevi, *Towards an Organic Architecture.*
Auguste Perret: Le Havre city plan.
Marseille: Le Corbusier project for the first five *unités d'habitation.*
Plano: Mies van der Rohe, Farnsworth House.

1948
• Turin: Pier Luigi Nervi, exhibition hall for the car show.
Le Corbusier devises the Modulor.
Chicago: Mies van der Rohe's plans.

1949
• Santa Monica: Charles Eames, Eames House.
Hiroshima: Kenzo Tange, Peace Center.

1951
Ahmedabad, India: Le Corbusier's plans.
Yale: Louis Kahn, University Museum.

1952
Neuilly: Le Corbusier, Maisons Jaoul.

1953
Aix-en-Provence: ninth CIAM.
Team X formed.

1954
• Royan: Guillaume Gillet, Church of Notre-Dame.
Jean Prouvé: houses for Abbé Pierre.

1955
• Pantin: Émile Aillaud, Courtillières housing project.
• Milan: Gio Ponti, Pirelli Tower.
Ronchamp: Le Corbusier, Notre-Dame-du-Haut.

1956
• Bazoche: Aalto, plan for the Maison Carré.
• Orly Airport by Henri Vicariot.
• Berlin: Hans Scharoun, concert hall.
Bagnols-sur-Cèze: Candilis, Josic and Woods, plans for Toulouse-Le-Mirail.
Dubrovnik: tenth CIAM. Team X's radical proposals.
New York: Eero Saarinen, TWA Terminal, Kennedy International Airport. Mies van der Rohe and Philip Johnson, Seagram Building plans.
Brasília: Niemeyer organizes the competition for the new city (winner: Lucio Costa).

1957
• Algiers: Fernand Pouillon, the "200 Columns."
Paris: Le Corbusier and Lucio Costa, International City at the Brazil pavilion.

1958
• Paris, La Défense: Robert Camelot, Jean De Mailly Bernard Zehrfuss, Centre National des Industries et Techniques (CNIT).
• Paris: Marcel Breuer, Pier-Luigi Nervi and B. Zehrfuss, Unesco headquarters.
• Paris: Édouard Albert, tower block on rue Croulebarbe.
• Yona Friedman, *L'Urbanisme spatial.*
Brussels: international exhibition with French pavilion (Guillaume Gillet and Jean Prouvé) and Philips pavilion (Le Corbusier with composers Iannis Xenakis and Edgar Varèse).

1959
• Marly-le-Roi: Marcel Lods, the Grandes Terres.
New York: death of Frank Lloyd Wright.
Guggenheim Museum completed.

1960
• Le Havre: Raymond Audigier and Lagneau Dimitrijevic-Weill Studio, Maison de la Culture (program set up by André Malraux).
• Flaine: Marcel Breuer, winter sports resort.
London: Archigram group founded.

1961
Chandigarh, India: Le Corbusier's scheme.

1962
Dacca, Bangladesh: Louis Kahn, Parliament Building.

1963
• Saint-Paul-de-Vence: José-Luis Sert, Fondation Maeght.
Paul Virilio and Claude Parent: group and review *Architecture principe;* **Sainte-Bernadette Church, Poitiers.**

1964
Leicester: James Stirling and James Gowan, Engineering Building.

1965
• Sydney: Jørn Utzon, Sydney Opera House.

1967
• Helsinki: Aalto, Finlandia Hall.
Swindon: Foster and Rogers, Reliance Controls Factory.

1968
Berlin: Mies van der Rohe, Nationalgalerie.
Paris: Oscar Niemeyer, Communist Party headquarters.

1969
New York, MoMA: exhibition by the Five (Charles Gwathmey, Peter Eisenman, Michael Graves, John Hejduk, Richard Meier).

1970
• Osaka: Expo 70.

1971
• Paris: Les Halles demolished.
Évry: AUA-Bofill, competition for new town.
Riva-San-Vitale: Mario Botta, Bianchi House.

1972
Robert Venturi, *Learning from Las Vegas.*

IS A CHAOTIC AFFAIR" Koolhaas

1952–53.
Alison and Peter
Smithson. Systematic
Table for the CIAM,
Aix-en-Provence.
Mixed technique,
55 x 260 cm, detail.
Centre Georges
Pompidou, MNAM-
CCI, Paris.
All rights reserved.

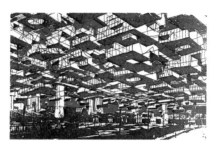

1958–59.
Yona Friedman.
*Study for a Spatial
City.* Perspective
view, felt-tip on
photocopy,
29.7 x 38 cm.

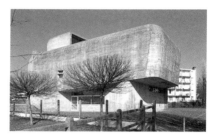

1963–66.
Claude Parent and
Paul Virilio
(Architecture
Principe group).
Sainte-Bernadette
Church, Nevers. All
rights reserved.

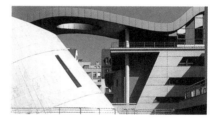

1984–90.
Christian de
Portzamparc. Cité
de la Musique
(west section),
Paris.
© N. Borel.

1991–98.
Bernard Tschumi.
Le Fresnoy (Studio
National des Arts
Contemporains),
Tourcoing.
© C. Richters.

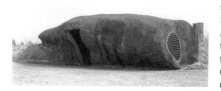

1997.
Nox/Lars Spuybroek.
Blow-Out Toilet Block (sani-
tary installation), Zeeland,
the Netherlands.
© Nox/Archilab 1999,
Orléans.

Chronology 1944–2000

1977
Paris: Piano and Rogers design the Centre Georges Pompidou.

1978
New Orleans: Charles Moore, Piazza d'Italia.

1979
• Paris: Claude Vasconi and Georges Pencreac'h, construction of the Forum des Halles.
Paris: Christian de Portzamparc, Les Hautes Formes.

1983
• La Défense: Otto von Spreckelsen wins the competition for the Grande Arche.

1985
• Montpellier: Ricardo Bofill, Antigone quarter.
Hong Kong: Norman Foster, Hong Kong and Shanghai Bank.

1986
London: Richard Rogers, Lloyd's Building.
Houston: Renzo Piano, De Menil Foundation.
Tokyo: Tadao Ando, Kidosaki House.

1987
• Los Angeles: Arata Isozaki, Museum of Contemporary Art.
Paris: Jean Nouvel, with G. Lézénès, P. Soria and Architecture Studio, Institut du Monde Arabe.

1988
• New York, MoMA: "Deconstructivist Architecture."

1989
• Berlin: dismantling of the Wall.
• La Défense: Johan Otto von Spreckelsen, Grande Arche and the "cloud," designed by Paul Andreu and Peter Rice.
• Paris: Paul Chemetov and Borja Huidobro, Finance Ministry.

1990
• Paris: Frédéric Borel, buildings on rue Oberkampf.
• Lille: Jean Marc Ibos and Myrto Vitart, extension of the Musée des Beaux-Arts.

1992
• Paris: Bernard Tschumi, Parc de La Villette.
• Bordeaux: Anne Lacaton and Jean-Philippe Vassal, Maison Latapie.
Nîmes: Norman Foster, Médiathèque.

1994
Osaka: Renzo Piano, Kansai Airport.
• Orléans: Dominique Lyon and Pierre du Besset, Médiathèque.
• Bernard Tschumi, *Architecture and Disjunction* (MIT Press).

1995
• Paris: Christian de Portzamparc, last section of the Cité de la Musique.

1997
• Tourcoing, Le Fresnoy: Bernard Tschumi, Studio National des Arts Contemporains.
• Bilbao: Frank Gehry, Guggenheim Museum.

1998
Caen: Dominique Perrault, redevelopment of the Unimetal industrial site.

1999
New York: Christian de Portzamparc, Tour LVMH.
Lucerne: Jean Nouvel, Centre de Culture et de Congrès.

Studies on Architecture
General Works

"1930–1990, 60 Années d'Architecture d'aujourd'hui," in *L'Architecture d'aujourd'hui* no. 272, déc. 1990.*
Archigram (exh. cat.). Centre Georges, Paris, 1994.*
M.-A. Brayer, and F. Migayrou. *Archilab.* Orléans, 1999.*
U. Conrads. *Programmes and Manifestos on 20th Century Architecture.* London, 1970.
C. Jencks. *Architecture Today.* New York, 1988
J. Lucan. *France, architecture 1965–1988.* Paris, 1989.*
P. Portoghesi. *Postmodern: The Architecture of the Post-Industrial Society.* New York, 1983.
J. Steele. *Architecture Today.* Oxford, 1999.*

Monographs on the
architects mentioned

Aldo van Eyck, Works. Basel and Boston, 1999.
R. Burnett. *Richard Rogers Partnership: Works and Projects,* New York, 1996.
Frank O. Gehry. *Album de l'exhibition.* Paris, 1991.*
Charles Moore. *Buildings and Projects, 1949–1986.* New York, 1986.*
Dominique Perrault, arquitecto. Barcelona, 1999.
P. Goulet, F. Pace, and P. Ruault. *Jean Nouvel.* Paris, 1994.*
T. Ito. *Blurring Architecture Toyo Ito, 1971–2005: Rethinking the Relationship Between Architecture and Media.* New York, 1999.
J. Joedicke. *Candilis, Josic, Woods.* Stuttgart, 1978.*
U. Kultermann. *Kenzo Tange.* Madrid, 1989.
Louis I. Kahn: The Complete Works, 1935–1974. Basel, 1977.*
V. M. Lampugnani. *Renzo Piano, 1987–1994.* Berlin, 1996.
J. Lucan, J.-L. Cohen, and H. Damisch. *Oma-Rem Koolhaas, Architecture 1970–1990.* New York, 1991.*
G. Mazzariol and F. Dal Co. *Carlo Scarpa.* Paris, 1984.*
W. Mitchell (et al.). *Frank O. Gehry: The Art of Architecture.* New York, 2001.
O. Niemeyer. *Oscar Niemeyer.* Belmont-sur-Lausanne, 1977.*
Richard Rogers. Complete Works. Vol. 1. London, 1999.
S. Roulet and S. Soulié. *Toyo Ito.* Paris, 1991.*
D. Treiber. *Norman Foster.* London, 1995.*
1995, Vienna. *Hans Hollein.* Historisches Museum der Stadt.*
D. Underwood. *Oscar Niemeyer and Brazilian Free-Form Modernism.* New York, 1994.
F. Wehrlin. *Kenzo Tange: 40 ans d'urbanisme et d'architecture.* Paris, 1987.*
M. Wilford (ed.). *James Stirling, Michael Wilford and Associates: Buildings and Projects, 1975–92.* London, 1994.*

* Essential reading

ART TODAY
"the situation and its risks"

"Manhood"

CHRISTIAN BOLTANSKI
Photo Album of the Family D.
1971. 150 photographs in tin-plate frames, each 22 x 30 cm. Detail. FRAC Rhône-Alpes. All rights reserved.

Store of Museum of Childhood
1989. Children's clothing, lighting, 55 black-and-white photographs, 50 x 60 cm. Detail. Musée d'Art Moderne de la Ville de Paris.

Rire aux larmes
Larmes (project for a poster for the series *Saynètes Comiques*)
1974. Pastel on photograph, 104 x 80 cm. Private collection. Courtesy Galerie Yves Lambert, Paris. All rights reserved.

Shadow Theater
1986. Puppets of various materials, metal and Plastiline structure, projector and transformer, ventilator (variable dimensions). National Museum, Seoul.

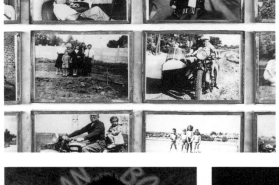

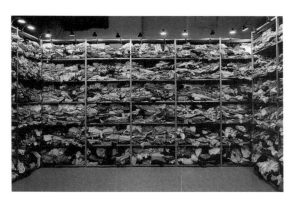

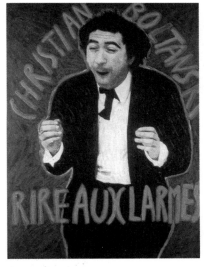

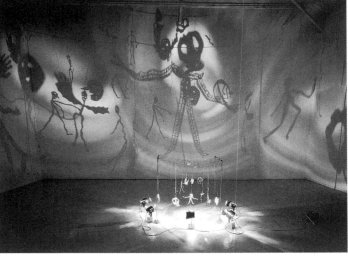

Four illustrations cannot do justice to the work of an artist who seems today to have abandoned the lightheartedness of his early work for an altogether more somber vision: the child C. B. and the storyteller who gave us the "laugh to tears" tales is now pursued by a cortege of funereal images in which death and pain join forces. The Holocaust has relegated "history painting and dramatic events" to the sidelines. The *Saynètes* ("comedy sketches") and nursery rhymes have vanished, making way for Schubert's *Winterreise*, while his "pretty color snaps" slip behind photos taken from Nazi albums. The *Vitrines of Reference* are obscured behind great tombs, while *Ombres* and the other wonders of his *danses macabres* are draped in shrouds, the Christmas decorations are replaced by nightlights. Irony leaves the stage—anguish makes its entrance. Not much left to smile about—and no time left to laugh. Is it because it was time to bear witness to life, and not just to the way we imagined it? Is it that the child C. B. has reached "manhood," and that he is asking us to grow up with him? No more "reconstituting childhood." No more make believe—that is, no more lying. No place this, for the idylls of *La Jeune Fille de Bois-Colombes,* of Michel D. or François C. Memories have no right to be vague—pain has its own story to tell. From life to death, like Georges Perec and his mirror-image drawn together in a single man, Boltanski is not one person, but many. Or like Beckett, hence profoundly alone. From the universal to the particular. Waiting for Godot—has Boltanski turned his hand to writing plays?

The real in all its forms took up where the conventions of illusion and representation had left off. It was now the material of "art." This was the case in Conceptual art, born in 1967 out of a preoccupation with the whys and wherefores of art in general; in Body art, which François Pluchart defined in 1968 as the "multiplicity of practices which use the body as material and photography as its main form of communication"; as well as in sociological art > > >

> > > and political agendas, as in the work of Forest, Haacke, Graham, or, as more loosely defined, in General Idea, Wodiczko, Thomas, or the Atelier van Lieshout. The Superrealism (or Photorealism) of Close, Estes, Hanson and Hucleux was paralleled by an appropriation of everyday imagery and signs recycled as "individual mythologies."

The Parisian scene between 1968 and 1972 that drew together Boltanski, Messager, Le Gac, Gette, Borgeaud and Sarkis preserves its iconic status for a number of reasons: these figures show that the 1970s were indeed "the decade of memory." In the same period, for Gasiorowski, Morley, Paul Thek, Richter and even Polke, begetting a canvas was no longer the goal in itself but served as a reflection on the contemporary image which, in an "age of mechanical reproduction," is designed to create "ways of painting." The 1980s for their part are often reductively and confusingly identified with the "New Spirit in Painting" exhibition in London that attempted to co-opt (as did the later "Zeitgeist" show in Berlin) the somewhat haphazard idea of the

"Transavantgarde" that had first been proposed in 1979 by the critic Achille Bonito Oliva and to apply it to other trends in painting of the time. Was it a process of reaction, or rather an overhasty and back-slapping analysis of the "Postmodern condition" when Jean-François Lyotard quipped that "invention arises from dissension"? Were the quotations from and parodies of models from myth and legend designed to sabotage the notion of progress and define the kind of "nomadic" and transitional system of thought that Lyotard himself advocated? The question is easy to answer if it is identified with the simple willingness to reinstate a profitable, if polarized, state of affairs. The situation is less clear-cut if one recalls that at the outset the work of a number of artists assimilated to what became a veritable trend. Artists such as Jean Michel Alberola, Gérard Garouste and of course Martial Raysse in France, Jörg Immendorf, Markus Lüpertz and even Alselm Kiefer, as well as those Wolfgang Becker gathered together in Cologne under the rather ambiguous label of > > >

"Art as Idea as Idea"

JOSEPH KOSUTH
One and Three Chairs
1965.
Wooden chair, two black-and-white photographs, the chair 82 x 40 x 37 cm; the photographs 112 x 79 cm and 50 x 75 cm.
Centre Georges Pompidou, MNAM, Paris.
Photo P. Migeat/Centre Georges Pompidou.

Kosuth is an American exponent and theorist of Conceptual art. He is a visual artist who has adopted as his own the tenets of Ad Reinhardt and Gertrude Stein, and he was one of the first in the mid-1960s to make the point that all artistic endeavor should be directed to calling art into question by investigating its very nature. His work, as he put it, is based on "the understanding of the linguistic nature of all art propositions." It "exists when it is conceived because the execution is irrevelant to the art... the art is for an art context only." Kosuth is fascinated by the logic and linguistic philosophy of Ludwig Wittgenstein, maintaining in effect that only tautologies can be indubitably valid propositions since, like art, they are incontrovertibly true. From the *Proto-Investigations* to *Investigations*, from *Blow Up*, *Art as Idea as Idea*, and *Cathexis* to *Hypercathexis*, and on to the later series, Kosuth's agenda has always been to enquire into and reinterpret the nature of art in the light of the fixation old Europe continues to exert on the American continent and in the context of the Platonic myth of *mimesis*.

"Words and Things"

MARCEL BROODTHAERS
Salle blanche
1975.
Replica of the artist's studio-house in Brussels.
Wood, photographs, light bulbs, and inscriptions, 390 x 336 x 658 cm.
Centre Georges Pompidou, MNAM, Paris.
Photo P. Migeat/Centre Georges Pompidou.

Under the dual aegis of Magritte and Mallarmé, Broodthaers art is based on the interaction between word and things. In 1964, his collection of *Pense-bête* were plaster-cast texts, while the invitation to his first exhibition carried the laconic inscription, "I got to wondering whether I couldn't sell something as well." Until 1968, Broodthaers was responsible for projects which took as their leitmotiv the peculiar characteristics of Belgian society and extrapolated them into an infinite geography full of images at once "poetical and political." La Fontaine's *Fables* and Mallarmé's typographic poem *Un coup de dés n'abolira jamais le hasard*, for instance, were turned into *Images* that Broodthaers returned to repeatedly. His films and books form an inextricable and infinite puzzle, while the concept of the museum served as a pretext for multiple environments in which Broodthaers intended to "separate the art from the ideology in objects." This is the case in his studio-cum-house in Brussels, in which, from September 27, 1968, to September 27, 1969, he opened his *Musée d'Art moderne, département des Aigles, section du XXIe siècle*, and which he transplanted wholesale in 1975 to a Paris exhibition entitled "Daumier's Angelus."

"I GOT TO WONDERING WHETHER

"Making is not an artistic act"

GERHARD RICHTER
Glenn
1983.
Oil on canvas, 190 x 500 cm.
Musée d'Art Moderne,
Saint-Étienne, France.
Photo Y. Bresson.

By imposing rules of his own making, Gerhard Richter has shown himself to be a major figure in modern painting whose impact has grown dramatically, to the point that he appears today as the artist who has best captured what Jean-François Chevrier calls the "conflict between the canvas and the screen." From his earliest works in 1962, Richter has painted in series, his agenda being to question, through the very diverse motifs he addresses, the nature of painting and the diversity and finality of the styles he adopts. Though resolutely heterogeneous and discontinuous, his work furnishes, in the words of Benjamin H. D. Buchloh, "a critique of the notion of originality through the multiplication of its potential." Richter is a highly methodical painter. Determined to "construct paintings in accordance with norms," he has totally excluded the element of chance from his art. Using every subject imaginable, he has turned his art into a lexicon of painting, an atlas of all the various styles his career has touched upon. His themes range from *Clouds*, *Alps*, *Cityscapes*, *Virgin Forests* and *Portraits*—definitions picked at random from the pages of a dictionary, or new items lifted from daily papers and then transposed—to *Candles* and *Skulls*, which, in a willfully contradictory manner, cohabit with *Gray Monochromes* and *Abstrakte Bilder*. Richter's subjects appear to originate in a private world and reintroduce into art a shift from the universal to the particular: residues of photography and reproduction do survive, but merely as visible guarantors of a pictorial originality that finds its sources in the multiple.

"Myth and reality"

MALCOLM MORLEY
Race Track
1970.
Acrylic and encaustic,
175 x 220 cm.
Múzeum Ludwig, Budapest.

Like that of his contemporary Gérard Gasiorowski, Malcolm Morley's work asks questions both of the subject and of the potential of painting in a climate dominated by the tyranny of the image. An exponent of Hyperrealism in the 1960s, a movement to which his work has all too easily been attached, Morley's pic-

south africa

157

tures (unlike the "raster" portraits of Close or the "photographic drawings" of Hucleux) hold the medium at a distance, never becoming bewitched by the power of illusion alone. Switching between past and present and between myth and reality, Morley recycles picture postcards from a modern-day world. Like Hockney, he was influenced by the New York School. He then went on to try his hand at a whole gamut of styles, marrying painstaking trompe-l'oeil to the impromptu virtuosity of a technique bordering on Expressionism. *Race Track* itself signals a break with the "perfect paintings" of the 1960s. The cross that slices across the image is not only a sign of the critical and political distance between artist and the acrylic-painted subject beneath; it is also a way of demonstrating that easel painting too can cause upheaval and appropriate "modulations" that reintroduce, through their violence and irony, moments of "indecision."

"Painting is in itself pure ignominy"

SIGMAR POLKE
Exhibition view. Center:
House of Potatoes.
1967. Wooden structure and potatoes (the artist recommending the "Ackersegen" variety—literal meaning, "blessing of the field"), 250 x 200 x 200 cm. Block Collection, Berlin.

Extreme left: *Modern Art*
1968. Dispersion paint on canvas, 150 x 125 cm. Block Collection, Berlin.

Extreme right: *Remingtons Museum-Traum ist des Besuchers Schaum.*
1979. Dispersion paint on canvas, 212 x 135.5 cm. Kunstmuseum Bonn.

"Unlike the modernist spirit of the 1960s," as Claude Gintz has explained, "Polke opened the door to 'sworn enemies' of painting such as the readymade and photography, and has used them as supports and source material for his pictorial practice." By 1963, with Konrad Lueg and Gerhard Richter, he had invented Kapitalistischer Realismus (capitalist realism) and started painting works teeming with parody and simulacra, and thus creating what Gintz has called, in the wake of Baudrillard's theories, an "art of seduction... that transgresses all laws and radiates in the void like an imaginary solution." For the insidious and provocative Polke, "painting is in itself pure ignominy." Art acts to transform individuals and, through its subversive action, has a cleansing effect. Inspired by banal if capricious imagery, Polke's take seesaws between the trivial and the tragic. In a mix of invention and casualness, he plays with a personal alchemy that makes apt metaphorical use of toxic substances, such as curare, in compositions that "put painting to the test to see what happens," in an attempt to grasp something of its instability. Polke thus sees the practice of art as an image of the unconscionable and derisory chaos of the contemporary world.

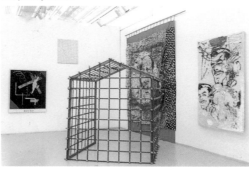

I COULDN'T SELL SOMETHING AS WELL" Broodthaers

> > > the Neue Wilde (New Wild Ones) and some of the exponents of what became known as "Bad Painting" in America (Salle, Schnabel and Morley) provide more in the way of an examination of the present through past forms than a "restoration" *per se*.

Such classifications also masked an inclination to appeal to national models and an abandonment of the dream of universality. Based on an amalgamation of nationalism and identity there arose "German painting," "English sculpture" and even a French "esprit" (as exemplified by Figuration Libre). The failure of the avant-garde in the political realm and the emergence of movements hoping to return to the norms and models of the past led to Simulationism and the Neo-Abstractionists in America and Europe who were often tangentially inspired by Structuralist theory. Once attention was drawn to non-Western models, the dawn of the "contemporary age" —and of its undermining—drew on apace. Since creativity in the Postmodern period had no truck with the sweeping narratives of the past, and, since it found itself equally appalled at the idea that the only alternatives lay in ever-increasing power or in knowledge viewed as a product marketed by information technology, it could only devise a pragmatism-based logic of its own, one that Lyotard has termed a "paralogy" for creative minds.

In our age of communication, artistic activities engage with a plethora of perspectives. Contemporary creative art responds to the world not so much inside a single discipline as within a heuristic that prefers the journey over the destination reached. Neither "video art" nor "installation," "multimedia art" nor "cells" (the word speaks volumes) exist as independent entities within a single practice.

What remains is a disturbing desire to categorize and to circumscribe something which aspires to extend the realm of thought. It is incumbent upon artists to find, if not necessarily ways of thwarting this ambition, then at least the strength for—and the forms appropriate to—the struggle. <

"Same Old Shit"

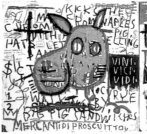

JEAN-MICHEL BASQUIAT
The Man from Naples
1982. Acrylic, pastel and collage on canvas,
123 x 265 cm.
Galerie Bruno Bischofberger, Zurich.
© Galerie Bischofberger.

The tragic hero of a society riddled with broken lives—like those that appear on prints by Andy Warhol, with whom he collaborated on many works— Basquiat was the living example of the "American prodigy," a man of Haitian-Porto-Rican stock with a drugs problem who came in off the street. SAMO—the acronym for "Same Old Shit"—the graffiti tagger who became the master of ceremonies for a pulsing underground and marginalized world, sprung from SoHo to become the Basquiat who first the United States then the whole world saw as offering a kind of guarantee of a rebellious freedom that, after first being channeled onto canvas, could then safely be reduced to the status of a saleable commodity. In concocting a symbiosis between American culture and that of his origins, however, Basquiat's career was exceptional. And if the graffiti we find in our "dehumanized" cities does indeed constitute a "social problem, it is at the same time," as Paul Ardenne has noted, "the expression of a social problem." Basquiat's agenda remains unique and— among the noisy crowd of those who add doses of free-flowing multi-culturism to the myth of a street steeped in violence, jazz, and drugs— untamable.

"The material is endless"

TONY CRAGG
Opening Spiral
1982. Installation: various materials, 152 x 260 x 366 cm.
Centre Georges Pompidou, MNAM, Paris.
Photo A. Rzepka.

Tony Cragg studied science and at various English art schools, including the Royal College of Art in London (1973–77). Along with artists such as Barry Flanagan, Richard Deacon, Bill Woodrow, Anish Kapoor and, more recently, Damien Hirst, he is a representative of a vague yet symptomatic movement known as "New English Sculpture" that appeared in the early 1980s, nurtured by a steady stream of skillfully orchestrated shows. Since his early works in the mid-1970s he has combined used materials with rejects from industrial civilization that he recuperated and classified for their symbolic as well as plastic value. Unlike contemporary Richard Long, Cragg has produced a corpus of work based on contemporary urban archeology, providing an ironic running commentary on the things and images that make up modern society. These early works, however, were followed from the 1980s by a proliferation of constructions and assemblages in just the kinds of classical materials and forms he seemed previously to be subjecting to a critique. Such pieces seem to rework technical treatments and traditional principles, and to present a fine-tuned, methodological, yet playful reflection on the style and history of the century's sculptural vocabulary.

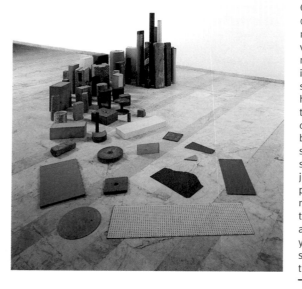

"OBJECTS HAVE A PHYSICAL EXISTENCE

"Unmediated aggression"

GEORG BASELITZ
Untitled
1982. Painted wood,
250 x 90 x 60 cm.
Private collection.
All rights reserved.

Born at Deutschbaselitz (Saxony, former East Germany) in 1956, Georg Kern was expelled from art college in East Berlin due to a "lack of political maturity." The next year saw him in the West, fully twenty years before his friend A. R. Penck. In 1961 and 1962 he published two Pandämonium manifestos under the influence of Antonin Artaud, in which he made a stand for expressive realism and against abstract art. Gestural and expressionist, Baselitz's oeuvre was from the outset symptomatic of a spiritual crisis in postwar Germany. The swollen bodies of his *Heroes* (1961–63) stand like hobos among the ruins—until 1966 haunting, flayed images embodying the history of his country. His "fracture paintings" (1966–68) and his upside-down canvases (1969 on) have become progressively simpler in terms of subject matter, although they have if anything gained in chromatic intensity. In 1980, in addition to his other work, Baselitz started producing engravings and wood carvings, in which, in a spirit of "unmediated aggression," he used an ax. Both his subjects and techniques were an uncompromising refutation of the dominant forms and themes of his contemporaries. Baselitz's career should thus not be seen in terms of its connection with and reversion to tradition, but more as a constantly accelerating enquiry into the confused relationship between aesthetic form and the "terror of history."

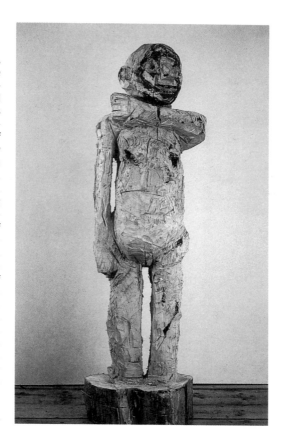

"Tired of that purity"

PHILIP GUSTON
Talking
1979.
Oil on canvas,
157.5 x 198.5 cm.
The Edward R. Broida Trust,
Los Angeles.
Photo D. McKee Gallery,
New York.

Guston's career was subject to violent upheavals that had significant impact on his work. He worked as a muralist on the Federal Art Project (1934–41). During the 1940s he took up easel painting and embraced abstraction, adopting a lyrical form of Abstract Expressionism. In the 1970s, he returned to figurative painting. "There is something ridiculous and miserly in the myth that we inherit from abstract art—that painting is autonomous and for itself." Guston embarked on a long, uninterrupted series of paintings of metaphorical import that conveyed the utter brutality and wretchedness of the modern world. He drew on imagery from

159

comic books and other elements in popular culture. "I do not see why the loss of faith in the known image and symbol in our time should be celebrated as a freedom. It is a loss from which we suffer, and this pathos activitates modern painting and poetry at its heart." Expressing his rejection of the modernist project and painting only what painting alone can express with its own devices, Guston's oeuvre opened a breach through which, after his death in Woodstock in 1980, for good or ill, a whole generation of artists have poured.

"History is a material"

ANSELM KIEFER
Parsifal II
1975. Oil on laid paper on muslin, 300 x 533 cm.
Kunsthaus, Zurich.
All rights reserved.

Kiefer initially studied law and literature. Between 1970 and 1972, about six years after taking up art, he studied with Joseph Beuys. He soon began to see artistic activity as representing a vast battlefield of individual and collective conflicts. In a way that transcends chronology proper, he addresses the Germany of the Romantic period, which, from Hölderlin to Rilke, from the *Niebelungen* to World War II, is conflated into a single, tragic and mythological whole. Melding exorcism and catharsis, from his late 1960s performances to the vast earthwork and ash installations he realized later, Kiefer delves deep into the memory of a country that he has chosen to leave, using it as a vessel for the strata of time and for the ruin time brings. Kiefer's Romantic night is inhabited by the hero Hermann, the great forests whence surge evocations of battles, wars, invasions, and devastation, and German cities scarred forever and in which appear, as if within "sacred places without a cult," the specters of Speer's architectural projects. These themes are presented as wounds in which sand congeals with tar and straw and wood with lead. Here a struggle is played out between a real and an imagined country that lives through history in a traumatic and ambivalent mode—which the artist's oeuvre, alive with words, texts and poems, with invocations and evocations, lays bare for all to see.

AND A METAPHYSICAL EXISTENCE" Cragg

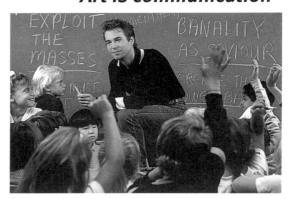

"Power and sarcasm"

"Memory of the recent past"

DAN GRAHAM AND JEFF WALL
Children's Pavilion
1989–91.
Mixed technique, large-scale wooden model, height 350 cm, diameter 600 cm.
Courtesy Galerie Roger Pailhas/ARCA Marseille.
Photo Dan Graham.

160

A joint project dating from 1989, the *Children's Pavilion* by Dan Graham and Jeff Wall encapsulates their thinking about the typologies of historical and modern architecture. It is a continuation of the much-touted *Homes of America* series, published in the review *Arts Magazine* in 1966, in which Dan Graham had undertaken a systematic inventory of various facets of the American habitat. A major artistic and intellectual figure in the post-

Pop art scene, and a contemporary of the Minimalist wave, Graham was able to create a symbiosis between various components in the creative arts, allying to his critical analysis a tireless exploration of every genre and discipline. Rejecting the idea that art can be an entirely autonomous entity, he commandeers every medium—from film to video, from music to performance, from plastic arts to design and architecture—for phenomenological and political investigations of "the historic memory of the recent past." The nine tondi-shaped lightboxes by Jeff Wall combine painting with photography and cinema, and show children of various racial origins. The work, as artist and critic Alain Sekula has said, harks back to a longing for a universal brotherhood of man exemplified by the exhibition "The Family of Man," organized by Edward Steichen in 1955.

THOMAS SCHÜTTE
Dreiakter
1982. Installation: acrylic on canvas, three elements, 227 x 305 cm; two wooden figures, 37 cm high; wooden balustrade, 20.5 x 65 cm.
Centre Georges Pompidou, MNAM, Paris.
Photo P. Migeat/Centre Georges Pompidou.

JEFF KOONS
Art Magazine Ads-Artforum
1988–89.
Advertisement published in the journal *Artforum* (detail) and lithography, 50 prints, 115 x 95 cm. © Jeff Koons.

"Art is communication—it's the ability to manipulate people. The difference with show business or politics is only that the artist is freer." Koons, the ex-stockbroker with the preppy face, takes great delight in his new incarnation as the American "golden boy" in all his glory (and wretchedness). " Don't divorce yourself from your true being," he wrote. "Embrace it. That's the only way you can move on to become a new upper class." In a period submerged beneath an "ecstasy of kitsch," in which, as Arthur C. Danto has pointed out, the commonplace has been transfigured, Koons has shown himself to be an artist with an uncommon gift for self-pro-

Student with Reinhardt Mucha and Thomas Ruff of Klaus Rinke at the Düsseldorf Academy, Thomas Schütte was influenced by the teaching of Joseph Beuys and Gerhard Richter, which for him opened up alternative paths to an otherwise all-pervasive Neo-Expressionism. His visual vocabulary derived from theater, architecture and decoration. He adapted the scale of his complex works to factor in a critical relationship between the piece and the surrounding site space. Schütte tackles the scope of art and its limits, as well as addressing the power apparatus and political and social superstructure on which the new Germany is founded. For Schütte, his maquettes, which are not necessarily intended for construction, represent an opportunity to ask questions about man's place at the heart of the urban space and give his ouevre a utopian dimension. By 1982, his wood cut-outs were replaced by more realistic depictions, which were reminiscent of Daumier's caricatures and F.-X. Messerschmidt's late-eighteenth-century character heads, and also of the figurines that psychiatric patients make as part of their therapy. Schütte's art addresses humankind's startled anguish in a schizoid contemporary world—showing it not waving but drowning.

"Art is communication"

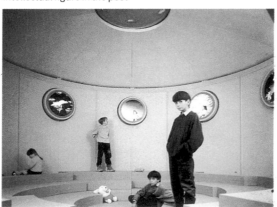

motion. Consumption and communication join forces to amplify a "Situationist" approach. His series included *The New* (1980), in which brand new vacuum cleaners stood gleaming in glass cabinets, *Total Equilibrium Tanks* (1985), in which basketballs floated, *Rabbit* (1986), with diverse garish objects in stainless steel, and the *Made in Heaven* series (1992), hovering somewhere between pornography and religious icon. At the peak of his fame, Koons married

Italian porn star Ilona Staller, better as "La Cicciolina." She provided the female component of his more sexually explicit works. The collective idyll was played out as a sitcom stuffed with knickknacks that turned into artworks, the dime-store trinkets promoted into stars of the auction room, and the galleries and museums morphed into sex shops. The contract ended in tears but, thanks to Koon's own talent and ambiguity, the work continued to flow.

"LET'S SAY THAT THESE OBJECTS ARE SCULPTURES,

"You should be ashamed"

MARTIN KIPPENBERGER
Transporter
1990. Installation. Galerie Luhring Augustine Hetzler, Santa Monica, California.

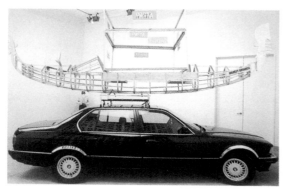

It is impossible to grasp the full import of Kippenberger's work without an understanding of the collective ambitions of projects such as Büro Berlin. Embracing impartially various forms and disciplines, Kippenberger, who was concurrently a member of other groups, such as Mülheimer Freiheit in Cologne (1979) and Disaster of Democracy in Hamburg, was joined by assistants and accomplices of every stripe hoping to bring about the dream of an artistic community. He created a resolutely hybrid and nomadic language that used every form available to undertake what, before his premature death, he saw as a much-needed re-eval-

uation of the whole history of art. Kippenberger represented a sort of antithesis to Jeff Koons in that every one of his projects was intended to combat a system he believed to be underhand and corrupt. A provocative figure, at the beginning of the 1980s Kippenberger produced *Lanterns for a Drunkard*, pictures that were intended to make the viewer wonder whether "we can really go on like this." He also produced self-portraits sporting underpants, and, in a further moment of self-castigation, railed against the

scourge of alcohol in *Face to the Wall, Martin, You Should be Ashamed of Yourself* (1989). Above all though, Kippenberger's agenda was utopian and poetic, as demonstrated by his *Metro-Net. Subway Around the World* (1993–97) and the dream he cherished of installing entranceways to an imaginary subway system—as in Kasper König's park for "Skulptur: Projekte" in Münster and another at documenta X (Kassel)—all part of the *Transportable U-Bahn Entrance* for a supposedly global underground system.

"Devil's advocate"

ALAIN SÉCHAS
Professeur Suicide
1995. Installation and video with soundtrack, polyester and various materials, 220 x 300 cm. FNAC, Paris. Photo E. Labenski/ The Solomon R. Guggenheim Foundation, New York.

The little-known works of Alain Séchas are, like those of Katharina Fritsch, perceptive and extremely singular. Instead of the knowing irony of most of his contemporaries, Séchas has opted for a heady brew of black humor. By 1982, his imagery, with its incongruous situations and bizarre source material, was already upsetting the aesthetic apple cart. His enigmatic *Bicycle* (1985) and

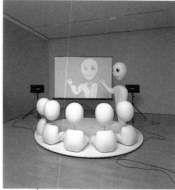

161

Mannequin (1985), for instance, succeeded in keeping a distance from the norms of representation, while simultaneously manipulating highly anachronistic situations. In 1988, Séchas began producing installations that resembled complex scenarios populated with statue-like figures and ideograms that appeared to have been lifted directly from a comic-strip world. The latent violence that came to the fore in *The Octopus* (1994), *Les Papas* (1995) and *Professeur Suicide* (1995)— somewhere between serenity and "passive contemplation"—leaves the spectator with the uneasy feeling he is somehow complicit in the scene. Patrick Javault has stressed that Séchas almost seems to be taking on the role of "devil's advocate," and is forcing us to re-evaluate our ways of engaging with artworks and thus with the ultimate purpose of art.

BERTRAND LAVIER

Walt Disney production
1984–98. Installation for the "Premises..." exhibition at the Solomon R. Guggenheim Museum, New York (1998–99). Mixed techniques, dimensions variable. Photo E. Labenski/The Solomon R. Guggenheim Foundation, New York.

Among the numerous "construction sites" that Bernard Lavier has opened over the past twenty-five years, it is his *Walt Disney Productions* (begun in 1984), presented in the form of a virtual environment for "a museum within a museum" in New York in 1998, that seems best to summarize the artist's basic intentions. In this work, Lavier has created, in as many pictorial and sculptural types as possible, all the diverse forms suggested to him by Walt Disney's 1947 cartoon *Very Abstract Lines*. In doing so, he has exploited every resource in terms of media and artistic discipline, and recycled signs

"A paradoxical method"

and images that originate in the stereotypes of our "age of mechanical reproduction." Moving from reproduction to original and from multiple to particular, Lavier's idea is to undermine the "rules of the genre," and devise new methods that he himself has characterized as "paradoxical." From the early over-painted household appliances which float in a no-man's-land between painting proper, sculp-

ture and image to his "superpositions" of one object on top of another (another form of "recovery"), Lavier proceeds by deliberate distortion. The "sites" that followed were testing grounds for a vast nomenclature of objects and signs that called into question, in a subtly ironic way, the paradoxes structuring the relationship between reality and its all various modes of perception and representation.

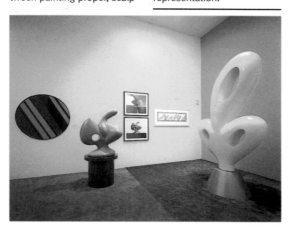

"AND EVERYTHING WILL BE ALL RIGHT" Lavier

"Lies, promises"

"Flying through the cosmos"

ILYA KABAKOV
The Man who Flew Away into Space from his Apartment
1988. Installation, mixed media, around 280 x 610 x 244 cm. Centre Pompidou, MNAM, Paris. Photos A. Rzepka and P. Migeat/Centre Pompidou.

In the USSR of the 1960s, Ilya Kabakov, with Erik Bulatov and Komar & Melamid, tackled the subject of Soviet history "after the utopia" in a style that became known as Sots art, a critical transposition of Socialist Realism promoted by an increasingly moribund Communist regime. By 1957, Kabakov was working as a book illustrator in Moscow and, in what he called *Albums*, begun a lengthy work starring fifty-five characters the narrative structure of which he later extended into a series of installations. At the beginning of the 1980s, a number of exhibitions gave him exposure in Western

Europe, and he eventually left to settle in the United States. Kabakov stressed that his work was designed to stimulate discussion. *The Man who Flew Away into Space from his Apartment* is along the lines of a total work of art. Constructed in the way of a story from a Russian fairy tale, the installation is an extended metaphor for his native country in the Perestroika period. Exalting liberation and liberty, the piece centers around a man who is

fired from a catapult out of the communal apartment block where he lives to "fly through the cosmos crisscrossed by the ascending energy flux." The project is at once political and poetical, addressing the collapse of the Soviet bloc, and mixing personal memories and metaphysical reflections. Kabakov's art was prominent at the 1993 Venice Biennale, where the artist represented the Community of Independent States in his "Red Pavilion."

ANNETTE MESSAGER
Mes Vœux
1989. Photographs under glass, string, approx. 150 cm in diameter. Centre Pompidou, MNAM, Paris. Photo P. Migeat/Centre Pompidou.

Messager, in connection with the various cycles she has produced during her thirty-year career, has adopted a series of pseudonyms, such as (on each occasion using the feminine form of the French noun) "Collector," "A Practical Woman," "Trickster," "Hawker" and "Artist." An uncompromising artist, her central concern is female identity and the female condition, blending themes from what are seen as "girls' duties" or "ladies' work" (i.e. needlework) with a subversive appropriation of the codes, rituals and practices of a daily existence that she transmutes into an "individual mythology" rich in "lies and promises." Under a veil of irony and cruelty—her methods lie somewhere

between taxonomy and taxidermy—Messager strips from the practice of art, from traditional pastimes or from fairy tales, the suffering and the anguish that form an integral part of the human condition. Incorporating not only childhood and magic spells, dreams and nightmares, but also human bodies and tattered animal remains, ritual and ceremony, Messager ransacks social history and all its struggles, its prohibitions and exploitations so as to force humankind—with its perversions, fantasies and humbug, with its despair and unease—to face the fact that many of its inventions are simply ways of coping with a distraught world. Since the 1990s, in many installations redolent of grottos or "penetrables," Messager has continued spinning her web and laying her snares in the form of environments or traps for the viewer, who is drawn into a literal and figurative maze that is both physical and mental.

"'One' in the midst of the universe"

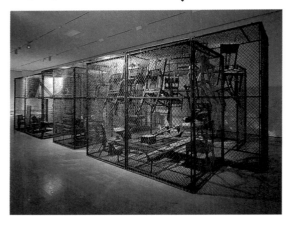

LOUISE BOURGEOIS
Dangerous Passage
1997. Mixed technique, 1200 x 250 x 200 cm. Artist's collection, New York. Photo E. Labenski/The Solomon R. Guggenheim Foundation, New York.

Haunted by her own past, Louise Bourgeois's singular

oeuvre is perhaps the first to have evolved entirely in the autobiographical mode. Eluding all aesthetic classification, oscillating between abstract geometry and organic form, the artist's lengthy career has been fed by childhood memories and by her self-imposed exile in the United States, where she married the art

historian Robert Goldwater in 1938. By 1945, a number of recurrent themes, such as the woman/house, were already in place, appearing in paintings, prints and numerous drawings. In 1949, she began to make sculpture, totemic wooden figures which she saw as "presences" that convey the "drama" of being "one" in the midst of the universe. Many works followed based on biomorphic imagery in which the themes of the nest, the refuge and the den combined with forms from an organic world to suggest a hybrid and thoroughly traumatized body. The performance works of the 1970s were followed in the 1980s by *Magic Chambers, Cells* and *Locus of Memory*—reconstructions of the self that express the complexity and permanence of emotion and desire through symbol and metaphor.

"MY CHILDHOOD NEVER LOST ITS MAGIC, NEVER LOST

"A space more mental than physical"

ABSALON
Left: *Cellule no. 2* (for Zurich).
1993. Inhabitable version.
Wood, white weatherproof paint, sanitary installations and domestic appliances.

Right: *Cellule no. 2* (for Zurich).
1992. Non-inhabitable prototype.
Wood, cardboard and white paint, 250 x 430 x 220 cm.
Exhibited at the Kunsthalle Zurich (1997). Collection Hauser & Wirth, Zurich (for both pieces). © A. Troehler, Zurich.

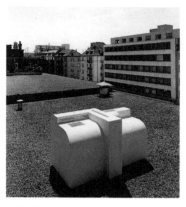

Compartiments, Cellules, Propositions d'objets quotidiens, Propositions d'habitations are the names given by Absalon to the enclosed "units" he constructed to separate himself off from the world around him, and to allow himself to adopt an entirely subjective and personal alternative—a real, self-imposed exile. Absalon's agenda, however, was also to resurrect in the context of formal history some of modernism's utopias—from Malevich to De Stijl and Le Corbusier's proposals for the *unité d'habitation*—which could respond to the constraints on daily life imposed by a world in which objects have been reduced to their aesthetic lowest common denominator. His project for the six *Cells* (realized between 1990 and 1993) that he proposed to install in various places and inhabit himself represents as much an approach to the teleology of sculptural form as a purely personal or individualistic gesture. Reminiscent of emergency housing and of survival shelters, Absalon's *Cells*—unlike the more utopian projects of Andrea Zittel or Joep van Lieshout, or Krysztof Wodiczko's *Vehicles*—provide a "space more mental than physical" that the artist scrutinized through a camera lens, filming the rituals of an everyday existence that he experienced as an ordeal.

"Discipline and punish"

ROBERT GOBER
Leg with Candle
1991.
Various materials,
34 x 18 x 96.5 cm.
Benedikt Taschen Collection.
Courtesy Paula Cooper Gallery, New York.
All rights reserved.

Reactivating a number of Surrealist processes for his own ends, Robert Gober presents viewers with situations that confront them directly with a society prone (as a famous book by Michel Foucault put it) to "discipline and punish." In fact his projects, beneath their sens-

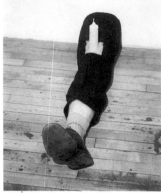

163

itive and emotional use of images from childhood, treat—like those of Felix Gonzalez-Torres, Charles Ray and Matthew Barney—of repression and suppression, and of the unending struggle of all minorities. Gober's work is akin to a long course of analysis at the core of which lie scenes from the artist's own life story. It is also symptomatic, in the age of AIDS, of the widely felt need for political activism to combat the oppression and repression the disease has brought with it. In an apparently domestic interior, complete with bridal dress and two bags of cat litter, the wallpaper is painted with two alternate watercolor motifs: a black man being hanged and a snoozing white weightlifter. A home is a "theater of cruelty"—none other than an Allegory of Reality, red in tooth and claw.

"A 'receiver'"

GABRIEL OROZCO
The DS
1993. Transformed automobile,
140 x 480 x 114 cm.
Fonds National d'Art Contemporain, Paris.
Photos Kleinefenn, Paris.

Sculptor and photographer, Gabriel Orozco is first and foremost an attentive observer of his environment and of the objects and shapes that punctuate the flux and dynamism of modern life. His own definition of his role is that of a "receiver," one who recomposes and repopulates the contemporary world with figures and objects he has transformed so their meaning is modified. The Citroën *DS* (1993), from which the middle third is "extracted" and reprofiled, appears as an inert object, but one which extrapolates to absurd limits the modern cult of the aerodynamic and the streamlined that Roland Barthes had analyzed in the 1960s in

Mythologies. In *Oval Billiard Table with Pendulum* (1996), a billiard table is adjusted to the shape of the place where it is to be installed—a process which obviously entails certain changes in the rules of the game. In *Elevator* (1994), a lift is removed from its customary place and set up as an object in itself, bereft of its function. The *Ferris Wheel* (1997) half-buried in the ground is a project in which the space situated midway between "hell below" and the "celestial realm" above represents, in our world gripped by the spectacle of itself, an experience no-one can possibly ever have. Gabriel

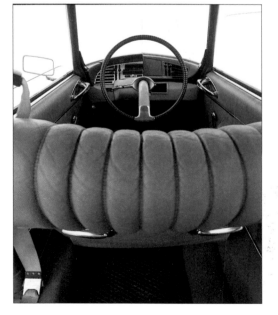

Orozco is the artful dodger our post-industrial period deserves, an "objector" who hijacks reality and reconfigures it into critical hypotheses.

ITS MYSTERY, AND NEVER LOST ITS DRAMA" Bourgeois

"The cinema as model"

DOMINIQUE GONZALEZ-FOERSTER, PIERRE HUYGHE, PHILIPPE PARRENO
Left: Dominique Gonzalez-Foerster, sequence from *Shadows II* (1998).
Right: Pierre Huyghe and Philippe Parreno, *Salle Anna Sanders* (1998).
Temporary mixed-media installation at the ARC, Musée d'Art Moderne de la Ville de Paris.
View of the rooms, 1998–99.
Photos M. Domage/Tutti.

In 1998, Dominique Gonzalez-Foerster, Pierre Huyghe and Philippe Parreno, having worked separately since the early 1990s, took the opportunity offered them by Suzanne Pagé at the Musée d'Art Moderne de la Ville de Paris to pool their resources and create a group piece. Although the individual character of each contributor remains perceptible, the intention of the exhibition was to urge viewers to reflect on its message and on the telltale signs by which it is communicated—that is to say on its style, in a period when aesthetics is based on the appropriation of methods and tools originating from different "communities" of form. The museum space here is transformed, not into a place for self-promotion, but into a collective environment, and the exhibition is given a "narrative" in the manner of a "script." The show brought out the importance of the film image, of cinema and its conventions, as a model in contemporary aesthetics.

"Psychosis"

MIKE KELLEY AND TONY OURSLER
The Poetics Project
1977–97. Mixed-media installation: paintings, objects/sculptures, video, audiovisual materials (variable dimensions).
C. Pompidou, MNAM, Paris.
Gift of the Société des Amis du MNAM. Photo Metro Pictures.

Far enough away geographically and intellectually from European models to have been able to forge its own individual vocabulary, the Californian scene—boasting forebears of the caliber of John Baldessari, Ed Ruscha, Gary Hill and Paul McCarthy—has evolved into a veritable breeding ground for creative art. Today Mike Kelley is one of the most recognizable figures of a culture that self-mockingly and joyously engages with Christian iconography and psychoanalysis, as well as with hippie culture, punk, trash and cari-cature—in short with the folklore of our times. *The Poetics Project,* that he made jointly with Tony Oursler over a twenty-year period, allies the psychological trauma and repression that dates from their time together in a punk band with an exploration of personal recollections. Their project also incorporates memories from a collective experience involving, among others, John Cale, Alan Vega, Kim Gordon, Genesis, Dan Graham, Tony Conrad and Laurie Anderson in the form of fragments reconstituted from notebooks, soundtracks, painted documents and elements of sculpture, in addition to interviews with critics and artists. The whole work amounts to a search for meaning and sensation, although one fully committed to the kind of subversive crosspollination that can offer an analysis of contemporary social psychosis and neuroses.

"Impure exchange"

FABRICE HYBERT
Hybertmarché
1995. View of the exhibition "1-1=2." Musée d'Art Moderne de la Ville de Paris.
Photo A. Morin.

Eau d'or, Eau dort, ODOR...
1997. Mixed-media installation. Venice Biennale, French Pavilion. Photo L. Lecat.

In *Hybertmarché*, and in the three identical syllables of *Eau d'Or, Eau dort, ODOR...*, Hybert presents two works focusing on the themes of consumerism and communication. By a process of duplicating his models, the artist is drawn into a functioning system, with his project organized in the way of a business enterprise operating under market economy conditions. With similar intent, in 1994 Hybert set up a limited liability company ironically named UR (Unlimited Responsibility) so as to, as the psychoanalyst and critic Jean-Michel Ribettes has explained, "foster 'impure exchanges,' to introduce marketing logic into artistic endeavor." UR soon turned its hand to publishing, making television programs and producing *POFS* (roughly, "Prototypes of objects in function"), "resulting from linguistic and material slippage in functional products," such as Bonbon très bon (Dandy Candy), *Balançoires à godemichés incorporés* (Swing with built-in Dildos) and the *String d'épaule* (Shoulder G-String). In *Hybertmarché* (Hybert-market), the artist diverts the museum process into "a political experiment that goes beyond the limits of politics," as Ribettes has again commented, "[and] a continuation of the erotic by other means."

"I DON'T BELIEVE IN HIGH-QUALITY ART,

"Take a seat"

FRANZ WEST
Moon Project
1997. Installation: six benches
in metal, foam and fabric, each
76 x 88 x 110 cm. The Museum
of Modern Art, New York.
Photo MOMA.

THOMAS HIRSCHHORN
Skulptur-Sortier-Station
1997. installation: video, wood,
plastic, adhesive tape, Plexiglas,
neon lights, aluminum foil and
cardboard, ten vitrines,
1000 x 240 x 280 cm. Exhibition,
"Skulptur. Projekte in Münster
1997." Centre Pompidou,
MNAM, Paris. Photo R. Mensing.

From the "adaptives" of the
early 1980s, to works that
documented, without forced
pathos, the Vienna Actionism
of Günter Brus, Hermann Nitsch,
Otto Mühl and Rudolf
Schwarzkogler in their most
uncompromising moments, the
often tongue-in-cheek work of
Franz West winds a path be-
tween aesthetic and more prac-
tical concerns. The seats and the
environment piece shown here

present an intermediate stage
between rapt contemplation
and an equivalent of Freud's
couch: the artist as mediator
has tried to create a specific
state in which he aims to invent
a "relational" formal language
and establish new physical and
intellectual bonds with the cre-
ative act. Since 1984,
Hirschhorn, foreswearing irony,
has been planning and exe-
cuting a political and social pro-
ject based on the notion of
exchange in an age of chronic
over-production. Marshaling a
wide range of signs, aphorisms
and dedications to figures who
embody a spirit of subversive
resistance to the barbarism of
our time (such as philosopher
Gilles Deleuze, anti-Nazi artist
Otto Freundlich and the apol-
ogist of "service," author Robert
Walser), Hirschhorn conveys
what is a demand on the artist
to be vigilant, energetic and
communicative through in-
stallations jerry-built out of fra-
gile materials, remnants and
stand-ins—rejects from our con-
sumer society.

"I like stupid things . . ."

Chronology 1971–2000

This chronology is largely devoted to events and a selection of exhibitions in Europe
and the United States. Sections in bold refer to artists mentioned in the main text
and captions.

1971
• Düsseldorf, Städtische Kunsthalle: "Prospect."
• New York, Whitney Museum of American Art:
"Contemporary Black Artists in America."
Gina Pane's first Body art performances.

1972
• Paris, Grand Palais: "1960–1972, 12 ans d'art
contemporain en France."
• Paris: *Art Press* begins publication.
**Kassel: documenta V, "Individual Myths"
(chief curator Harald Szeemann).**

1973
• Death of Picasso.
• London: "Photo-Realism," Serpentine Gallery.
• Geneva: Écart group forms around John M.
Armleder.
• Bordeaux: creation of the Capc.
**Paris, Cnac: "Hyperréalistes Americans,
réalistes européens."**

1974
• Paris: first Salon International d'Art
Contemporain.
**London: "Seven German Artists," Institute of
Contemporary Arts.**
**New York: Joseph Beuys week-long action with
a live coyote, *Coyote: I like America and
America likes me.***

1975
• Britain: David Hockney, sets for Stravinsky's *Rake's
Progress* at Glyndebourne.
• Paris: first issue of journal *Traverses*.

1976
• Venice: "Ambiente Arte."
• Los Angeles, Los Angeles Country Museum of Art:
"Women Artists: 1550–1950."

1977
• Kassel: documenta VI (chief curator M. Schneckenburger).
• Münster: "Skulptur: Austellung und Projektbereich,"
co-curated by K. Bussmann and K. König.
• Paris: opening of the Centre Georges Pompidou.
• United States: Walter De Maria, *The Lightning Field.*
• Chicago, Art Institute: "Europe in the Seventies:
Aspects of Recent Art."
• Washington D.C., Hirshhorn Museum and Sculpture
Garden: "Probing the Earth."

1978
• New York, Whitney Museum: "Art about Art."
• New York (Bronx): opening of "Fashion Moda."
• New York, New Museum of Contemporary Art:
"Bad Painting."

1979
• New York, Club 57: Keith Haring exhibition.
• Venice, Palazzo Grassi: "Art of Performance."
• New York, Solomon R. Guggenheim Museum:
Joseph Beuys retrospective.

1980
• New York, MoMA: major Picasso exhibition.
• London, ICA: "Women's Images of Men."

• New York, Metropolitan Museum: Clyfford Still
exhibition.
**Aachen, Neue Galerie Sammlung Ludwig:
"Les Nouveaux Fauves" (Neue Wilde).**

1981
• Cologne, Museen der Stadt Köln: "Westkunst."
• London, Royal Academy: "A New Spirit in Painting."
• Nice: Ben, first exhibition of Figuration Libre, followed
by B. Lamarche-Vadel, in Paris, with "Finir en beauté."
• New York, The New Museum: "Not Just for Laughs:
the Art of Subversion."

1982
• Amsterdam, Stedelijk Museum: "60'80
Attitudes/Concepts/Images."
• Modena, Galleria Civica: "Transavantguardia."
• Bern and Chambéry: "Leçons de choses."
• Kassel: documenta VII (chief curator R. H. Fuchs).
• Berlin, Martin Gropius Bau: "Zeitgeist."
• Zurich: Art journal *Parkett* set up.

1983
• Zurich, Kunsthaus: "Der Hang zum Gesamtkunstwerk."
• Bern, Kunsthalle: "Konstruierte Orte 6 X D + 1 X NY."
• Rotterdam, Boymans-Van Beuningen Museum:
Graffiti art exhibition.
• London, Tate Gallery: "The New Art."
Mary Kelly, *Post-Partum Document.*

1984
• New York, MoMA: "An International Survey of
Recent Painting and Sculpture."
• New York, MoMA: "Primitivism in 20th-Century Art."
• Schaffhausen: Hallen für Neue Kunst opens.
• Turin: Castello di Rivoli inaugurated.
• Stuttgart: Neue Staatsgalerie opens.
• London: Saatchi Gallery opens with "Art of Our
Time" (1985).
Paris, MAMVP: "Figuration Libre, France/USA."

1985
• Toronto, Art Gallery of Ontario: "The European
Iceberg. Creativity in Germany and Italy Today."
• New York: "The Knot Arte Povera at PS 1."

1986
• Paris, Palais Royal: Daniel Buren, *Les Deux
Plateaux.*
• Barcelona, Foundation Caixa de Pensiones:
"Art and its Double. A New Perspective."
• Madrid: Centro de Arte Reina Sofia opens.
**New York, Sonnabend Gallery: "Neo-Geo"
exhibition.**

1987
• New York: Van Gogh's *Irises* (1889) auctioned for
$53.9 million.
• Münster, "Skulptur. Projekte in Münster 1987."
• Paris, Centre Georges Pompidou: "L'Époque, la
Mode, la Morale, la Passion..."

1988
• London: "Freeze," exhibition of Young British Artists.
• New York, Solomon R. Guggenheim Museum:
"Refigured Painting: the German Image 1960–1988."
• Berlin, Berlinische Galerie: "Stationen der Moderne."

I BELIEVE ONLY IN ENERGY" Hirschhorn

1973.
Gina Pane, *Action sentimentale.* Galerie Diagramma, Milan. Panel with seven color photographs, 120 x 100 cm. Private collection. Photo F. Masson. Courtesy Anne Marchand.

1977.
André Cadéré carrying a *Stick* across the plaza in front of the Centre Georges Pompidou, Paris. Photo Ghislain Mollet-Viéville.

1982.
Jenny Holzer. *Truisms.* LED display sign, installation in Times Square, New York. All rights reserved.

1984.
Robert Combas. *The Hanged Man. The Man is delighted to be hanged and seems from afar to be nodding his head and walking over the ears of wheat. He hanged himself because he had it up to here, but on a canvas a hanged man is not too serious. It may even raise a laugh.* Acrylic on canvas, 204 x 154 cm. Private collection, Paris. Courtesy, Galerie Yvon Lambert, Paris. All rights reserved.

1996.
Jason Rhoades. *Un Momento/The Theatre in my Dick/A Look to the Physical/Ephemeral.* Mixed media. Installation, Kunsthalle Basel. Courtesy D. Zwirner, New York.

1997.
Carsten Höller and Rosemarie Trockel. *A House for Pigs and for Men.* View of an installation at the documenta X at Kassel. Photo VG Bild-Kunst, Bonn.

Chronology 1971–2000

1989
• London, Hayward Gallery: "Art in Latin America."
• Washington D. C.: Robert Mapplethorpe exhibition at the Corcoran Gallery is called off for "obscenity."
• Los Angeles, Museum of Contemporary Art (MoCA): "A Forest of Signs..."

1990
• New York, Solomon R. Guggenheim Museum acquires 310 works from the Panza di Biumo Collection.
• New York, MoMA: "High and Low, Modern Art and Popular Culture."
• Paris, Centre Georges Pompidou: "Art et Publicité, 1880–1990" (on art and advertising).

1991
• Berlin, Martin-Gropius-Bau: "Metropolis."
• Turin, Castello di Rivoli: "Medusa's Gaze."
• London, Serpentine Gallery: "Objects for the Ideal Home: the Legacy of Pop Art."
• Paris: opening of the Galerie Nationale du Jeu de Paume.

1992
• Paris, Centre Georges Pompidou: "Passages de l'Image."
• Bonn, Kunst und Austellungshalle, "Territorium Artist."
• London, Saatchi Gallery: "Young British Artists".
• Madrid: Museo Thyssen-Bornemisza opens.
• Los Angeles: "Helter-Skelter: LA Art in the 1990s."
• Kassel: documenta IX (directeur J. Hoet).

1993
• New York, Whitney Museum of American Art: "politically correct" Whitney Biennial.
• New York, Hirshhorn Museum Eva Hesse: retrospective.

1994
• Paris, MAMVP: "L'Hiver de l'Amour."
• London, Serpentine Gallery: "Some went mad, some ran away..." exhibition.

1995
• Paris, Centre Georges Pompidou: "Fémininmasculin: le sexe de l'art"; "Hors limites: l'art et la vie, 1952–1994."
• London, Tate Gallery: "Rites of Passage: Art for the End of the Century."

1996
• Paris, Centre Georges Pompidou: "L'Informe, mode d'emploi."
• Linz: Ars Electronica Museum opens.
• Humlebaek, Denmark, Louisiana Museum of Modern Art: "NowHere."

1997
• Paris, Centre Georges Pompidou: "L'Empreinte."
• London, Royal Academy of Art: "Sensation."
• Kassel: documenta X (curator C. David).
• Münster, Westfälisches Landesmuseum: "Skulptur. Projekte in Münster 1997."

1998
• New York, Guggenheim Museum: "Premises..."

1999
• Los Angeles, MoCA: "Out of Action, Art After Performance."
• Venice Biennale: 'dAPERTutto' (electronic art, installations, videos).
• Paris, Musée d'Art Moderne de la Ville: "ZAC 99."
• Berlin, Hamburger Bahnhof Museum: "Gegenwart: Collage-Montage."

2000
• London: opening of Tate Modern.
• New York, MoMA: "Open Ends (1960–2000)."
• Paris: Centre Georges Pompidou reopens.

General Works

M. Archer. *Art Since 1945.* London 1997.

Paul Ardenne. *Art, l'âge contemporain, une histoire des arts plastiques à la fin du xxe siècle.* Paris, 1997.*

G. Battcock. *New Artists' Video: A Critical Anthology.* New York, 1978.

M. Beaumont (et al.). *Sculpture Today.* New York, 1987.

P. Bourdieu and H. Haacke. *Libre-échange.* Paris, 1994.

L. Buck. *Moving Targets 2.* London, 1999.

M. Collins. *Blimey. From Bohemia to BritPop.* London, 1999.

J. Deitch (ed.). *Post Human.* Pully-Lausanne, 1992.

D. Hopkins. *After Modern Art.* Oxford, 2000.

J. Kastner and B. Wallis (eds.). *Land and Environment Art.* Oxford, 1997.

M. Lovejoy. *Postmodern Currents: Art and Artists in the Age of Electronic Media.* New York, 1997.

E. Lucie-Smith. *American Art Now.* Oxford, 1985.

E. Lucie-Smith. *ArtToday.* London, 1998.*

F. de Mèredieu. *Histoire matérielle et immatérielle de l'art moderne* 1994, Paris.

C. Millet. *L'Art contemporain en France.* Paris, 1987.

G. Mollet-Viéville. *Art minimal & conceptuel.* Geneva, 1995.

B. O'Doherty. *Inside the White Cube.* Santa Monica and San Francisco, 1986.

R. Pincus-Witten. *Postminimalism into Maximalism: American Art, 1966–1986.* Ann Arbor, 1987.

F. Pluchart. *L'Art corporel.* Paris, 1983.

J.-L. Pradel. *L'Art contemporain depuis 1945.* Paris, 1992.

B. Riemscheider and U. Grosenick *Art at the Turn of the Millennium.* Cologne, 1999.

R. Rochlitz. *Subversion et Subvention: art contemporain et argumentation esthétique.* Paris, 1994.

K. Ruhrberg (et al.). *Art of the 20th century.* Cologne, 2000.

C. Schlatter. *Art conceptuel, formes conceptuelles.* Paris, 1990.*

J. Stallabrass, *High Art Lite.* London, 1999.

B. Taylor. *The Art of Today.* London, 1995.

C. Tomkins. *Post to Neo: The Art World of the 1980's.* New York, 1990.

Catalogues

1981, London. *A New Spirit in Painting.* Royal Academy of Arts.

1991, Rennes. *Une scène parisienne, 1968–1972.* Centre d'Histoire de l'Art Contemporain.

1987, Paris. *L'Époque, la Mode, la Morale, la Passion, 1977–1987.* Centre Georges Pompidou.*

1995, Paris. *Masculin-féminin, le sexe de l'art.* Centre Georges Pompidou.*

* Essential reading

DESIGN
"things—a user's guide"

"Art Nouveau"

LLUÍS DOMÈNECH I MONTANER
View of the dining room, Casa Navas, Tarragona, Catalonia, Spain
1900.
Photo M. Loiseau/Archipress.

HENRY VAN DE VELDE
View of the dining room. Detail of the chandelier. Hohenhof House, Hagen, Germany
1900.
Photo M. Loiseau/Archipress.

FRANK LLOYD WRIGHT
Unity Chapel, Oak Park, Ill.
1905–8.
Photo P. Cook/Archipress.

CHARLES RENNIE MACKINTOSH
Hill House, Helensburgh, Scotland
1903.
Photo M. Loiseau/Archipress.

Between 1895 and 1905, Siegfried Bing's Galerie d'Art Nouveau in Paris acted "as an intermediary between purchasers, manufacturers and artists," growing to be a crucial influence on the development of the style that now bears its name. Henry van der Velde,

in his plea for the unity of the arts, *Déblaiement de l'art* (published 1894), rejected historicism and proposed that ornament become an integral part of the object. The Glasgow School around Mackintosh, the first Vienna Sezession centered around Josef Hoffmann, Belgian Art Nouveau with Victor Horta, Hector Guimard in France, Stile Liberty in Italy, German Jugendstil, the works of Gaudí, Russian Art Nouveau, and the American variety in the shape of Louis Comfort Tiffany, all formed part of a vast movement which reached its apogee at the Paris World's Fair in 1900, only to begin an immediate downward spiral soon afterward that gave fresh impetus to the Vienna Sezession. A victim of its own internal contradictions, that tendency itself was to flounder in 1905.

Although the word itself might appear inadequate, "design" is broad enough to be interpreted and used in widely differing ways and so has resisted all attempts to be absorbed into some other, pre-existent formal category. Design seems to go beyond the notions of the decorative and applied arts which are now accepted as belonging to a time in which the "invention" of daily life had without fail to make some appeal to (high) "art." Design is continually spreading into new areas, and our experience of it is as fast-paced as our lifestyle. For a long time France, unlike many other countries, treated design as something subordinate to the creative arts > > >

> > > proper. In a throwback to the genre hierarchy of the Classical age, it was consigned to the domain of ornament and was thus regarded as a superficial component of our surroundings. It should be stressed that members of the avant-garde, whose work was intended to be inseparable from the transformation of lifestyles, were each, in turn, confronted with a need to create a program centered on the redefinition of social forms and ways of being, which stood in for a promise of happiness. If comfort is undeniably part of the bourgeois order and trails behind it a host of conventions that endure to the present day, modern movements have associated the idea of revolution with that of a radical upheaval in customs and social practices, as well as in the signs that embody them. Such a utopia survives not only in the art of a given period, but also in the forms, images and objects that coexist with it. It is these significant elements which, as the epoch dictates, transform style and make it possible to create, for example, furnishings, typography and fashion and, with them, all the codes of social life.

Design—the word is as good as any other—is now welcomed with open arms into museums of modern and contemporary art. Moreover, it forms an integral part of a much needed reconfiguration of our (re-)reading of twentieth-century art. In France, the process was long overdue, since the Museum of Modern Art in New York opened a design department as early as 1932. The changes wrought and the obstacles overcome have become more obvious in France since the unveiling of a center for Création Industrielle in 1969 that lay at the heart of what has since become the Centre Pompidou. The setting up of a design collection proper in 1992 made it even harder to consider certain practices as subservient to the classic hierarchy of genres—a hierarchy which the creative arts, whenever they engage with life, tend to invalidate anyway. <

168

"The veritable application of the Stijl"

GERRIT THOMAS RIETVELD
Schröder House, Utrecht, Netherlands
1924.
Photo F. den Houdsten/ VG Bild-Kunst.

Rietveld joined De Stijl in 1918. In the same year, under the impact of the Nieuwe Bouwen (New Building) movement, he realized his famous Red-Blue Chair that was designed as a sculpture. In 1924, he built a house for Mrs. Schröder in Utrecht which was acclaimed by Theo van Doesburg as the only veritable application of De Stijl principles. Interested in the possibilities of industrial manufacture, by 1922 Rietveld was importing Scandinavian bentwood. In 1932 he designed another celebrated chair, the Zigzag, and began a collaboration with Metz & Co. and the Dutch company Artifort to produce wood and metal articles to an extremely high technical specification. The house designed for the interior decorator Truus Schröder-Schräder illustrates the application of typical De Stijl abstraction to three-dimensional space. Based on a formula of geometrical intersection, the ground floor is divided functionally, whereas the upper floor, for which Rietveld also created furnishings and fittings, remains essentially a uniform volume in which rhythm is imparted by integrated elements and sliding partitions.

"The USSR under Construction"

ALEXANDER RODCHENKO
Workers' Club, Soviet Pavilion, Exposition Internationale des Arts Décoratifs et Industriels, Paris.
1925. Documentation Générale, Centre Georges Pompidou, Paris.

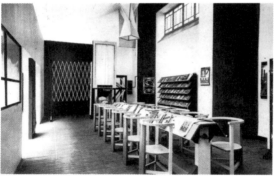

By 1916, Rodchenko was producing graphics of a geometrical character that he presented at the exhibition "The Store." These led to his first three-dimensional works (1917), culminating in the *Spatial Constructions* of the 1920s. General Secretary of the Society of Easel Painters from 1917, he also directed the IZO (Visual Arts Section) section of Narkompros (People's Commissariat for Enlightenment) from 1918 to 1922, was instrumental in the setting up of Inkhuk (Institute of Artistic Culture) and taught at the graphic design section of the drawing faculty in Vkhutemas (Higher Technical-Artistic Studios). A member of the commissariat for the synthesis of the arts, he produced numerous architectural designs and sketches for architectonic elements for the urban renewal of the modern city. His disagreements with Kandinsky in Inkhuk spurred him to set up the independent Group for Objective Analysis (1920) and join Vladimir Tatlin. In collaboration with his companion Varvara Stepanova, he created many projects in every discipline—from open-air cinema projection vans to "production" (or workers') clothing. He also explored photomontage and typography. In collaboration with the poet Mayakovsky, he enlarged the scope of his graphic work, applying it to every aesthetic domain. In addition to participating in the plans for the Russian Pavilion at the Exposition Internationale des Arts Décoratifs et Industriels in Paris in 1925, Rodchenko also designed adjustable and foldaway furniture for a workers' club which earned him first prize. The initiator behind the October Group in 1930, Rodchenko was the living embodiment of the title of a journal of the time: *The USSR under Construction.*

"BEAUTY IS A WEAPON

"Toward a housing program"

**LUDWIG MIES
VAN DER ROHE**
*German Pavilion,
International Exhibition,
Barcelona*
1929 (reconstruction 1986).
Photo F. Eustache/Archipress.

MARCEL BREUER
Wassily Chair
1926.
View of the Bauhaus School
(1925, architect: Walter
Gropius), Dessau.
Photo F. Eustache/Archipress.

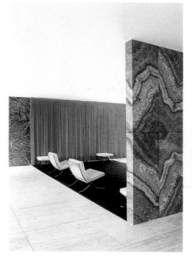

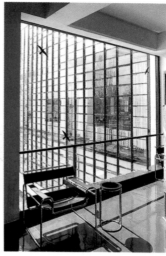

After a period which saw the completion of numerous projects such as the German Pavilion for Barcelona (for which he also designed the since famous furniture), the Tugendhat House (Brno, Czech Republic) and the "bachelor house," in 1931 Mies van der Rohe was appointed head of the Berlin Bauhaus, where he reinforced the teaching of the technical and professional aspects of architecture. In 1933, after the closure of the Bauhaus, he voted in favor of the appeal of intellectuals in support of Hitler, in the misguided hope that Nazism, as Fascism had to a limited extent, might prove receptive to modernist architecture. Mies then took part in the Paris Exposition Internationale of 1937 with the architect and designer Lilly Reich, formerly a teacher at the textile studios in the Bauhaus. In 1938, he left for the United States and opened a practice in Chicago. Gropius, for his part, took up the position of head of the Graduate School of Design at Harvard University. Marcel Lajos Breuer, who had been head of the furniture workshop in the Dessau Bauhaus, where he designed and constructed the school's tubular metal furniture, joined Gropius on the other side of the Atlantic and, thanks to his good offices, was appointed to the chair of architecture at the same institution.

**CHARLOTTE PERRIAND,
LE CORBUSIER
AND PIERRE JEANNERET**
*"Maison du Jeune Homme"
Brussels Exhibition.*
1935. Photo Vanderberghe/
Charlotte Perriand Archive.

At the end of the 1920s, Charlotte Perriand, a graduate of the École des Arts Décoratifs in Paris, persuaded Le Corbusier and Pierre Jeanneret to let her work with them. Her expertise in different disciplines culminated at the 1929 Salon d'Automne in a suite of furniture entitled "facilities for a habitation." Charlotte Perriand soon joined UAM, taking part in the CIAM IV (on the theme of the functional city) at which the Athens Charter was drafted. In 1935, with René Herbst and Louis Sognot, she unveiled the "house for a young man." The following year, she participated in the Salon des Arts Ménagers at the third exhibition of housing, at which she advocated a move from "all steel" to "all wood." In 1937, the "Refuge Bivouac" for the UAM pavilion, together with her association with Fernand Léger on the socialist Ministry of Agriculture's program, signaled the end of her collaboration with Le Corbusier. In 1940, with Pierre Jeanneret and Pierre Blanchon, she set up the Bureau de la Coordination and, while in Tokyo, experimented with an "all bamboo" aesthetic. Innumerable projects followed after the war, including co-collaboration with the architect Paul Nelson, participation in an important exhibition on utilitarian form and modern artefacts, and a four-

"Art of living"

teen-year stint on the construction of the winter sports facility at Les Arcs, as well as a number of collaborative projects with Jean Prouvé. In her efforts to promote a veritable "art of living," to synthesize the arts and further cross-cultural dialogue, Charlotte Perriand was, for seventy-five years, an untiring exponent of modernism.

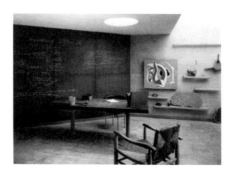

"Prestige functionalism"

**JACQUES-ÉMILE
RUHLMANN**
*Furniture for Paul Reynaud's
living room (wall paintings
by Louis Bouquet)*
1931. Musée National des Arts
Africains et Océaniens, Paris.
Photo Schormans/
Renaudet/RMN.

Interior and furniture designer Jacques-Émile Ruhlmann's roots lay in the construction industry and in paint, wallpaper and mirror manufacture. In 1913, encouraged by collector and dress designer Jacques Doucet and Frantz Jourdain, he exhibited various artefacts at the Salon d'Automne. In 1920, Ruhlmann became a member of the Société des Artistes Décorateurs. In collaboration with the architect Pierre Patout, he worked on the renowned "Hôtel du Collectionneur" at

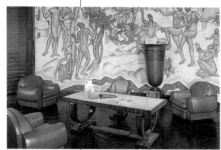

169

the 1925 Exposition Internationale in Paris. As his fame grew, he received an increasing number of commissions both in France and abroad. These included the interior of the debating chamber and the banqueting hall of the Paris Chamber of Commerce, a number of drawing rooms at the Palais de l'Élysée, and saloons on the liner *Île-de-France*. In 1929, he received a furniture order from the Maharajah of Indore, who at the time "was directing his style toward prestige Functionalism." At that time, Ruhlmann started employing metal in various projects, while simultaneously striving to retain something of the august tradition of French cabinetmaking through the use of exotic and precious woods that he combined with other rare materials.

AND THE MEANS IS REVOLUTIONARY" van de Velde

"A free spirit"

JEAN ROYÈRE
*Plan for a living
room in a chalet
in Mégève*
Around 1955.
Document, Galerie Jacques
Lacoste.
Photo Norma Éditions.

Jean Royère personifies a certain spirit in interior decoration. He studied in the 1930s with the period furniture manufacturer Pierre Gouffé. By 1934, he had won a City of Paris prize for a bistrot on the Champs-Élysées. Mobilized in 1940, he responded to General de Gaulle's appeal by joining the Resistance. After the war, Royère opened a number of

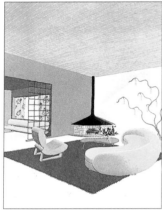

170

offices first in Africa and the Near East, then in South America, designing interiors for wealthy residences. Royère's use of unusual materials—from fake fur to the kinetic effects of raffia—and his preoccupation with strange forms were a real contribution to the design revival of the 1970s. He epitomized the free spirit with which so many in the upcoming generation identified. Élizabeth Garouste and Mattia Bonetti, for example, have presented their own special homage to his work: a design for the "Intérieur d'un Musicien" show at Galerie 1950 Alan and the Galerie Néotù centered around furniture by made Jean Royère for the singer Henri Salvador.

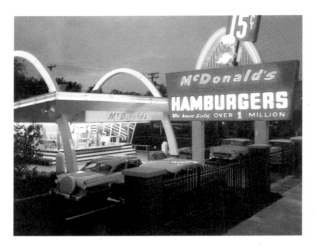

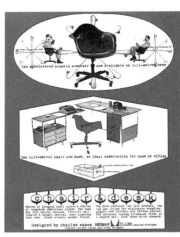

"Streamline"

STANLEY MESTON
*The First McDonald's
Restaurant, Des Plaines, Ill.*
1955. Photo McDonald's.

CHARLES EAMES
*Advertisement in Interiors
magazine for Herman Miller
featuring an armchair by
Charles Eames* **February 1954.**

At the beginning of the 1940s, Charles Eames and Eero Saarinen became famous overnight by winning two prizes at the Organic Furniture Competition organized by MoMA in New York (1940–41), at which they presented, among other things, a chair in molded plywood that only wartime restrictions prevented from going into mass-production. In 1941, Charles and his wife Ray moved to California. They perfected different techniques for bending plywood and manufactured various pieces for the US Navy and Air Force. With Herbert Matter and Herry Bertoia, they formed the Plyformed Wood Company and produced numerous articles for the firm of Herman Miller. Their approach to the use of plywood and fiberglass, together with an interest in the use of film for educational and publicity purposes, had a significant impact. They also designed many exhibition spaces, including the famous American National Exhibition Pavilion in Moscow in 1959. In 1948, the realization of molded chair shells in polyester and fiberglass for the Low-Cost Furniture Design competition run once again by MoMA was a milestone in the development of "Global Design" and in the streamline style. The first McDonald's restaurant was another example of streamlining, its arches providing the inspiration for the company's omnipresent logo, devised by the D'Arcy Agency in 1968.

"Free form"

CARLO MOLLINO
*Apelli & Varesio
Laboratory, Turin*
Around 1950.
Photo R. Moncalvo.

Carlo Mollino was a multifaceted, anti-conformist, and almost excessively individual-

istic figure on the Italian design scene. He kept alive the flame of Futurist and avant-garde research on form and movement. He was passionate about sports of all kinds, from automobiles and flying to skiing. By the 1930s, he was working at a frenetic pace, turning out projects that for the most part fused the Art Nouveau spirit from Mendelsohn to Aalto with mechanistic models. In addition to being an architect, Mollino was also an engineer and an inventor. He worked in close collaboration with many technicians producing articles of all kinds, from furniture and environments to whole buildings. Exuberant, whimsical, even bizarre—witness some of the projects executed in Turin in the 1940s and 1950s—his oeuvre paralleled his life and foreshadowed many innovative production methods and principles which have been interpreted as encapsulating the very essence of free-form style. His anthropomorphic and organic interiors and furnishings, strongly influenced by anatomical structures, provide ample evidence of his technical mastery and a constantly inventive approach to materials. The photograph shows the studio in which many of Mollino's most prestigious pieces were produced.

"DESIGN IS NOT DISAPPEARING;

ROGER TALLON
*Galerie Jacques Lacloche
with spiral staircase and
M440 cast-iron furniture*
1966. Exhibition in New York.
Roger Tallon Archives.

**QUASAR
(NGUYEN MAHN KHAN,
KNOWN AS)**
Aerospace Collection
1968. PVC.
Photo Norma Éditions. All
rights reserved.

VERNER PANTON
Fantasy Landscape
1970. Creation for "Visiona II,"
an event organized by
the firm of Bayer.
© Marianne Panton.

The diverse designs produced down the years by Roger Tallon closely parallel the history of design. Associating himself with numerous artists, including the Nouveaux Réalistes, he contributed to many projects, ranging from the design of everyday articles — Téléavia (1959 and 1966), M400 seats and stools for Sentou (1960), and the spiral staircase for the Galerie Lacloche — to the coaches for the Corail and TGV passenger trains with Alsthom for the SNCF. As a graphic designer, he also designed the review *Art Press* (1972) and produced graphics for the SNCF and the Moscow bus service. In 1969, he was invited to participate in the Centre de Création Industrielle's inaugural exhibition, "What is Design?" The previous year, Quasar had presented his inflatable PVC chair at another exhibition at the Musée des Arts Décoratifs. In the 1970s, the store on the rue Boissy-d'Anglas was the epitome of a "cool" lifestyle that, together with Marc Held and his plastic furniture, Quasar was to personify.

Between 1950 and 1952, the Danish-born Victor Panton collaborated with Copenhagen designer Arne Jacobsen. After a trip to Holland in the early 1960s, Panton set up a practice in Switzerland where a career that ranged from design proper to gallery installation flourished. An experimental figure, he undertook research into the properties of various materials such as cardboard and plastics and on the fluidity of forms. This culminated in the famous Panton chair (a reworking of the

171

"I make rooms in rooms"

PIERRE PAULIN
*Private apartment for
President and
Mme. Pompidou,
Palais de l'Élysée, Paris*
1971–72. Documentation,
Centre Georges Pompidou.
All rights reserved.

The renovation of the private apartments at the Palais de l'Élysée undertaken by Georges and Claude Pompidou in 1971 presented Pierre Paulin with a golden opportunity to celebrate the spirit of a glorious period in French design, the 1930s. An industrial designer by trade, Paulin designed his first pieces of furniture in the late 1950s for Artifort, among which the famous F560 (1960) and Ribbon armchairs (1969). Paulin was one of the first to make use of elasticated textiles. His collaboration with the Mobilier National climaxed in the large-scale environment in multicolored foam presented at Expo 70 in Osaka, an advance that left an enduring mark on the period. In 1975, Paulin founded the ADSA Group, which was soon joined by Roger Tallon and Michel Schreiber. Numerous designs for companies such as Calor, Allibert, Renault, Simca, and Saviem were followed by the much-lauded stackable Stamp chair. The latter, along with designs by Joe Colombo and Olivier Mourgue (Djinn series, 1964), appeared in Kubrick's film *2001 A Space Odyssey* (1968) and offered an alternative to the craft tradition in a period of mass-produced consumerism.

basic principle behind Rietveld's Zigzag chair), the first one-piece molded S-backed chair, sketched back in 1954 and issued in 1968 by Herman Miller. The Living Tower created in the same period is a modulated structure. The interior invites one to curl up, in contrast to the markedly rigorous external carcass. This highly unconventional space suggested new possibilites for relaxation. Panton also paid great attention to color. His Color System of the 1960s presented a chromatic code that could be applied to any surface. It lay behind the creation of the fantasy foam-rubber landscape presented by Bayer at the "Visiona II" exhibition, Cologne (above).

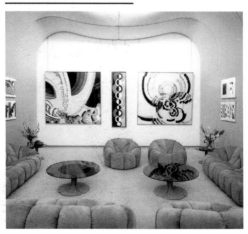

IT'S STYLES THAT ARE DISAPPEARING" Tallon

"Aesthetic pleasure"

**ETTORE SOTTSASS
(WITH MARCO ZANINI
AND MIKE RYAN)**
Zibibbo Bar, Kukuoka, Japan
1990. Photo Nacasa & Partners.

The son of an architect who had collaborated with Otto Wagner, Sottsass was a major figure in the reconstruction of northern Italy in the 1950s and became design consultant for the Olivetti company. In 1960 in Milan, he founded Studio Richerche Design, and made a trip to the Far East which had a significant impact on his outlook. Falling ill, he nonetheless published *Room East 128,* and brought out a magazine, *Pianeta Fresco,* with his wife Fernanda Pivano and Allen

Ginsberg. Something of an activist, Sottsass now entered a hectic and creative period. In 1970, he started his lengthy collaboration with Poltronova and Alessi, while three years later he founded the (anti-) school of architecture and design, Global Tools. From 1976, in association with the journalist Barbara Radice, his activities diversified still further. Exhibitions, collaborations with the Italian Studio Alchymia and the setting up of the international Memphis group in Milan, which he was to leave four years later, made him into one of the most newsworthy personalities on the design scene. Sottsass, never one to rest on his laurels, now devotes most of his time to architecture, which he sees as "a locus of aesthetic pleasure."

"Light and artifice"

SHIRO KURAMATA
*Tokio Kumagai Store,
Nagoya, Japan*
1986.
Photo Hiroyuki Hirai.

Shiro Kuramata was a leading Japanese designer of interiors and furniture. After studies in Tokyo, he worked with Japanese firms including the Matsuya department store. In 1965, he founded the Kuramata Design Office. Attracted by unusual formal devices, he went on to create household articles which contained an element of randomness and experimented with malleable materials. In his quest to bridge the gap between Japanese tradition and Western furniture, Kuramata dreamed up truly mind-boggling creations, such as the Ritz desk (brought out by Memphis, 1982), the Solaris chest (Cappellini, 1985) and the nickel-plated steel-mesh "How High the Moon" sofa and armchairs (Vitra, 1989). But the most significant example of the fusion of object and furniture was surely the acrylic fiber Miss Blanche chair (1986), which featured artificial roses embedded in the plastic and displayed a playful approach to light and the notion of artificiality. This design exemplified the poetical values peculiar to Kuramata's oeuvre, as well as a certain contemporary Japanese aesthetic that can also be seen in fashion design, notably in the work of Comme des Garçons or Issey Mikaye, whose interior refit Kuramata designed shortly before his death.

"Question time"

GAETANO PESCE
*Unequal Suite Collection.
View of the Sansone II
Table and the Cannaregio
Couch*
1986–87.
Photo B. Wulf, Hamburg.

The architect and designer Gaetano Pesce studied in Venice and was a cofounder of the Gruppo N in Padua, the first association to direct its research toward transformational and kinetic Arte Programmata. In the 1960s he experimented with new materials and explored other elements of expression, such as light and sound. Many of his projects were of a kinetic and serial nature. He wrote the *Primo Manifesto per un'Archittetura Elastica* and, in 1965, met with Cesare Cassina and Francesco Binfare, with whom he set up the Bracciodiferro company in Genoa. The company was dedicated to the realization of experimental objects out of, among other materials, polyurethane and jersey. In 1971, the project for an "underground city at a time of massive contamination: habitat for two people" was a deliberate mix of fantasy and reality that proposed a utopian and organic view of the world. Pesce has emerged as one of the chief proponents of an ongoing reflection on form and materials that also addresses the social and cultural role of the designer. As an architect, he has been responsible for some highly ambitious socio-political projects of an anthropomorphic nature (Manhattan skyscraper, 1978; an unofficial project for Les Halles, Paris, 1979; Vertical Loft, 1982). He is also one of the few designers to have tackled the creative function in a resolutely critical and utopian way, a vision that the exhibition "Le Temps des Questions," organized in 1996 by François Barré and Raymond Guidot at the Centre Pompidou, was to display in all its richness.

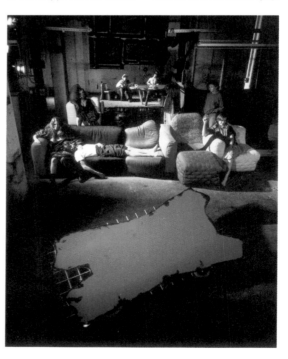

"THEY WANTED WARMTH, BUT NO

"Love is an endangered species"

PHILIPPE STARCK
*Café Costes, Paris
(view of the first floor)*
1984.
Photo P. Mardaga.
*Prefabricated house for
Les 3 Suisses*
1993. Photo J. Dirand.

Declaring that "love is an endangered species," Starck (a past master of the slogan) urges us to "think in the morning and work in the afternoon"—as he does himself. With clubbing haunts like the Main Bleue (1976) and the Bains-Douces (1978) to his credit, by his twenties this extraordinary figure had become one of the most feted interior architects of the decade. In 1979, his Easy Light ran off with the Oscar for best lamp. In 1982, he completed Mme. Mitterand's private apartments in the Palais de l'Elysée (with ceiling-paintings by Gérard Garouste). As a spin-off from that account, he went on to create the Richard III club armchair. The famous Café Costes in Paris (1984; demolished), together with innumerable international projects all over the world, have made Starck into a global star. As an architect, he has designed the Lagiuole factory (1988), numerous private residences, a number of blocks in Tokyo, and the plans for a Paris street which was to bear his name, no less. In the 1990s, projects came thick and fast, with designs for Alessi, Fluocaril, Vitra, Driade, Kartell, pasta for Panzani, motorbikes for Aprilia, XO, Thomson, Tim Thom, and a collaboration with the 3 Suisses mail-order company for whom he has even created a house in kit form. Starck, a man ever on the lookout for unexpected sources of inspiration, is a designer whose ambition is to be ready wherever life needs rethinking—one who combines a sense of enjoyment with a sincere commitment to the environment.

"Barbarian style"

**ÉLIZABETH GAROUSTE
AND MATTIA BONETTI**
*Haute Couture Showroom for
Christian Lacroix, Paris*
1987. Courtesy Christian Lacroix.

Since 1980, Élizabeth Garouste and Mattia Bonetti have been collaborating so closely on the creation of objects, furniture, exhibitions, and interiors that it is no longer relevant to know exactly who does what. Their joint restoration of the restaurant in the Palace, Le Privilège, was followed by their first household articles and furniture (Lune lamp, designed 1980; Rocher table, 1982). These were followed by wood and rope furniture for the VIA. In concept, these projects were diametrically opposed to the industrial aesthetic of the time. Their work marked a return to the principles of furniture designed from the standpoint of the interior decorator. A supreme example was the showroom they designed for fashion maestro Christian Lacroix (1987). With the eponymous chair that has since become notorious, the duo inaugurated the Barbare (barbarous) style, by no means exempt from sophistication, but based on composite forms often derived from nature. The hybridized work of Garouste and Bonetti, who are fond of all things theatrical, is the embodiment of a world and a way of thinking that goes against the grain.

"Écart and elegance"

ANDRÉE PUTMAN
*Bathroom, Morgans Hotel,
New York*
1982. Photo D. von Schaewen.

An attentive observer of the mutations of her time, Andrée Putman is above all associated in the public mind with the Prisunic store chain, for which she was invited to produce designs in 1960. There she embarked on a series of objects and lithographs in collaboration with her painter friends Pierre Alechinsky, Roberto Matta, Wilfredo Lam, Messagier and, Bram van Velde, whose most acute observer and exegete is Jacques Putman. Andrée Putman's faith in friends such as Didier Grumbach, Maïme Arnodin and Denise Fayolle has led her to participate on numerous collective projects. In 1978 she set up the firm of Écart in 1978, becoming its artistic director. The production of designs by creators such as Eileen Gray, Mallet-Stevens, Jean-

Michel Frank, Mariano Fortuny and Pierre Chareau met with great success, bearing witness to Andrée Putman's taste as well as her efforts to rediscover unjustly forgotten pieces. Yet Écart had an even greater impact in producing designs by younger hands. These have made Putman into one of the most important players in the field of design and one of its most active "facilitators." Interior designs for hotels, museums, showrooms and gallery spaces have since multiplied, her own personal creations going hand in hand with the collaborative efforts in which she delights.

173

RADIATORS, WATER, BUT NO TAPS" Starck

"Ruinist"

RON ARAD

Project for
Adidas Sport Café,
Toulon
1996. Synthetic image generation.
View of the bar with ceiling-
mounted screen (showing
broadcast relays and sports
results).
Photo Dis-Voir/Ron Arad.

Born in Israel, Ron Arad moved
to London in 1973. In 1981, in
collaboration with Peter
Keene and Tom Dixon, he
opened a showroom in
Covent Garden called One Off.
"Taking into consideration the
intrinsic qualities of techno-
logically advanced materials
and composites has led to a
conception of design that recy-
cles and re-utilizes pre-exist-
ing industrial elements... and
takes account of forms which
are intrinsically linked to the
unpredictable reactions of
substances when treated in
unusual ways." Raw concrete,
for example, served as the
basis for a stereo hi-fi (1985),
stainless steel appeared in

174

armchairs (Easy Vol. I and
Easy Vol. II, Well-Tempered
Chair, 1987) and lengths of
scaffolding were constructed
into a bedstead. By exploit-
ing recycling and appropria-
tions such as these, Ron Arad
was a dominant influence on
the growth of a "ruinist"
school analogous to Malcolm
McLaren and the Sex Pistols'
punk rock, offering a
decidedly "jump-cut" take on
the post-industrial world.
Although Arad maintains that
he is no angry young man,
his designs are surely influ-
enced by his avowed "aver-
sion" to convention.

"Sensibilized space"

SYLVAIN DUBUISSON

Inflatable structure for
presenting a collection of
objects designed for the
exhibition "Premises..."
at New York
1998. Synthetic image genera-
tion. Photo P. Caninacci/ Images
de Synthèse/Sylvain Dubuisson.

"Infiltrations"

MATALI CRASSET
Théo de 2 à 3
1998. Fold-out "power-nap"
mattress. Édition Domeau et
Pérès. Photo L. Nicolas.

RONAN BOUROULLEC
Model for soft infiltration:
the Donald Judd Foundation
at Cincinnati
1997. CAD image for Tarkett-
Sommer. © R. & E. Bouroullec.

In the wake of a generation for
whom the practice of design
voiced a genuine critical aware-

The architect and designer
Sylvain Dubuisson studied in
Belgium at the Saint-Luc
school of architecture in Tour-
nai. His pieces from the 1980s,
such as the Quasi una Fanta-
sia table, for Furniture (1982),
the Beaucoup de Bruit pour
Rien lamps that were issued
by Écart on the initiative of
Andrée Putman (1983), Le Cuer
d'Amour Épris (one-off, 1984),
and Tetractys (one-off for
Néotù, 1984), displayed great
refinement and sensibility in
a period gripped by Brutalism.
His numeropus projects
include the visitor's reception
center for Notre-Dame Cathe-
dral in Paris (1985), the Musée
des Tissus at Lyon (1988),
Flammarion bookstores
(1988), the Passage de Retz
(1993), the offices of politician
Jack Lang (1990) — centered
around the themes of theatric-
ality, light and culture — the
Panthéon (1995), the Château
at Fontainebleau (1996), as
well as the design schemes
for exhibitions such as "Les
Années Plastiques" (Cité des
Sciences, Paris, 1985) and "La
Magie des Plastiques" (École
des Beaux-Arts, Paris, 1996).
Sylvain Dubuisson's highly dis-
tinctive career has been char-
acterized by a search for the
clarity of a "sensibilized" and
"musical" space, and by a lit-
erary content that refuses to
stand mourning at the grave-
side of memory and culture.

ness, designers such as Vin-
cent Beaurin, Adrien Gardère,
Kristian Gavoille, Tony Dunne,
Fiona Raby, and the members
of Radi Designers have taken
up new positions. For them the
design profession is not sim-
ply a matter of turning out
objects but a question of manip-
ulating social codes and atti-
tudes. Matali Crasset, for in-
stance, who took part in the
Milan Triennale and worked
with Philippe Starck as director
of the Design Center for Thom-
son, creates articles and envi-
ronments that take everyday
lifestyle as their starting point
and arrive at new ways of imag-
ining living space. The same
might be said of Ronan Bouroul-
lec, who, having already pro-
duced highly adaptable objects,
developed (using CAD, among
other things) design formulae
intended to be "infinitely col-
lapsible," thus compelling us to
reflect on the use values and
exchange systems that regu-
late our every act.

"POST ALL AND

Chronology 1900–2000

This chronology is largely devoted to design, the applied arts and inventions, fashion being excluded except for a few reference points.

1900
Paris: Guimard, Metro entrances.
Paris, World's Fair: Josef Hoffmann, Sezession hall.

1901
• L'École de Nancy is formed into an association.

1902
• Josef Hoffmann and Kolo Moser found
the Wiener Werkstätte.
• Paris: creation of the Musée des Arts Décoratifs.

1906
• Milan: World's Fair.

1907
• Leo H. Baekeland invents bakelite.
• Muthesius and Henry van de Velde found the Werkbund.

1908
• Henry Ford produces the Ford T.
• Adolf Loos, *Ornament and Crime* first published in German.

1910
• Brussels: World's Fair.
• Peter Behrens' office gains international reputation.

1913
• United States: first refrigerator, marketed in 1918.
• Hans Geiger invents the Geiger radioactivity counter.
• Victor Courtecuisse invents the Wonder battery.

1915
• Alex Samuelson designs the Coca-Cola bottle.

1916
• Gabrielle Chanel founds her haute couture house.

1917
Holland: Theo van Doesburg founds De Stijl.
Moscow: Vkhutemas set up.

1919
Weimar: Walter Gropius establishes the Bauhaus.

1923
• Paris: Jules-Louis Breton, first Salon des Arts Ménagers.

1924
• Barker and Skinner invent Plexiglas.
Utrecht: Rietveld, Schröder House.

1925
• Paris: Exposition Internationale des Arts Décoratifs et Industriels.

1927
• Stuttgart: Werkbund exhibition.

1928
• Richard G. Drew invents Scotch adhesive tape.
• Jacob Schick invents the electric razor.
• Gio Ponti sets up *Domus*.

1929
• Raymond Loewy designs the Gestetner duplicating machine.
• Barcelona: World's Fair.
• Paris: foundation of the Union des Artistes Modernes.
• Second CIAM on low-cost housing.

1932
• Jean Mantelet invents the Moulinex blender and mixer.
• United States: Black Mountain College established.

1933
• Germany: Volksempfanger radio and Volkswagen prototype.
• Chicago: World's Fair, "A Century of Progress."
Bauhaus closed by the Gestapo.

1934
• UAM Manifesto: modern art as a stage for contemporary life.
• Pierre-Jules Boulanger and André Lefèbvre,
2CV automobile prototype.
• Brussels: World's Fair.

1936
• France: Le Printemps department store creates the Prisunic budget department store.

1937
• Wallace Hume Carothers applies for a patent for Nylon.
• Paris: international exhibition of art and technology.

1938
• Plastic and aerosol canisters developed.
• Lászlo Biro, the ballpoint pen.
• John Logie Baird, color television trials.

1939
• New York: World's Fair, "Building the World of Tomorrow."

1940
• United States: birth of commercial television.
• Raymond Loewy, Lucky Strike cigarette packet.

1942
• Paul Arzens, "Egg" electric car.

1945
• Hiroshima destroyed by atomic bomb.
• Percy Le Baron Spencer invents the microwave oven.
• Vélosolex (powered bicycle-cum-moped) invented.

1946
• Enrico Piaggio develops the Vespa scooter
(designed by C. d'Ascanio).
• New York: Charles Eames exhibition, MoMA.

1947
• Christian Dior launches the "New Look."
• Aluminum foil enters household use.

1948
• Denmark: Ole Kirk Christiansen creates Lego.
• United States: Bell Laboratories invent the transistor.
• Walter Bird designs the first inflatable architectural structures.

1949
• France: Formes Utiles movement.

1950
• Ralph Scheider develops the possibility of paying by credit card.

1951
• United States: supermarket cart enters general use.
• London: congress on industrial design.

1952
Raymond Loewy: "Ugliness doesn't sell."

1953
• IBM computer.
• Ulm: Hochschule für Gestaltung course developed.

1955
• Hans Gugelot: Braun industrial products launched.
• Flaminio Bertoni designs the DS19 Citroën car.
• California: original Disneyland opened.
Des Plaines (Illinois): first McDonald's restaurant.

1958
• Paris: Yves Saint-Laurent launches the Trapèze line.
• Sweden: Ingvar Kamprad opens the first IKEA store.

1959
• Mattel markets the Barbie Doll.
• Dante Jiacosa designs the Fiat 500.
• Alec Issigonis designs the Morris Mini Minor.

1960
• Liner *France* launched.

1961
• Berlin wall erected.
• USSR: Yuri Gagarin, first man in space.
• London: the journal *Archigram* begins publication.

1963
• First Philips cassette tape.
• United States: first holograms.

1964
• London: Terence Conran establishes Habitat.

1965
• First disposable cigarette lighter, Cricket, by Dupont.
• André Courrèges, fashion collections combining fabric and plastic.

1966
• Italy: beginnings of Archizoom and of Superstudio.

1967
• Montreal: Expo 67, "Terre des hommes."
• Christian Barnard, world's first heart transplant.

1968
Paris, Musée des Arts Décoratifs: "Les Assises du siège contemporain."

1969
• Concorde's maiden flight.
• Apollo 11 mission: man's first steps on the moon.
• U. S. Depart. of Defense sets up a feasibility study on computer networks which eventually leads to the Internet.

1970
• Osaka: Expo 70, first World's Fair in Japan.

1974
• Roland Moreno invented the microchip card.

NEO NOTHING" Arad

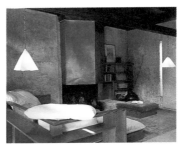

1921–22.
Rudolf Schindler.
The architect's house at
Los Angeles. Photo P.
Cook/Archipress.

1935.
Alvar Aalto.
The architect's practice,
Helsinki. Photo M.
Loiseau/Archipress.

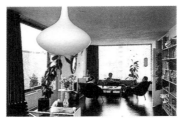

1961.
Interior of a house.
Federal Republic of
Germany. Photo AKG Paris.

1991.
Roger Tallon.
CAD impression for the
interior of the Méga TGV.
Roger Tallon
Archives/SNCF/CAV Photo
Library.

1998.
Martin Szekely.
CAD impression for
"Armoire," created for the
exhibition "Premises…,"
New York. Édition Kréo,
Paris. © Deis, Paris.

1999.
Radi Designers.
"Business Class"
briefcase.
© Pix/ Radi designers.

Chronology 1900–2000

1975
- Microsoft founded.
- Pierre Bourdieu establishes the journal *Actes de la recherche en science sociale.*

1976
- Photocopiers and Bic throwaway razors marketed.
- Italy: Studio Alchimia set up.

1977
- Bar codes developed.
- Centre Georges Pompidou opens.

1978
- Amoco Cadiz oil spill.
- France: Andrée Putman founds Écart and Écart International.

1979
- Akio Morita invents the Sony Walkman.
- Compact disc developed.

1980
- Alessi's first product designs.
- French Minitel telecommunications and Apple Macintosh developed.
Ettore Sottsass Jr. creates the Memphis group.

1981
French high-speed train (TGV) designed by Roger Tallon.

1982
- Paris: school of industrial design opened.

1983
- Professor Luc Montagnier identifies the AIDS virus.
- Switzerland: Swatch watches.

1985
- Computer-aided page layout available.
- First issue of the journal *Intramuros.*

1986
- USSR: Chernobyl nuclear accident. Beginnings of perestroika and glasnost.
- Superconductivity observed.

1989
- Sony camcorder and Nintendo Game Boy.
- Internet develops.
- Renault designs the Twingo.

1991
- Gulf War.
- Collapse of the Soviet bloc.

1992
- Seville: Expo '92.

1993
- Paris, Grand Palais: "Design, miroir du siècle" exhibition.
- Issey Miyake: "Pleats Please" polyester fashion collection.

1996
- Japan: launch of the digital videodisk (DVD).

1997
- Boulogne: "Design français: l'art du mobilier, 1986–1996."

1998
- Britain: Professor K. Warwick implants a microchip into a human body.

2000
- Paris, Centre Georges Pompidou: "Les Bons Génies de la vie domestique."

Studies on Design

A. Barré-Despond (ed.). *Dictionnaire des arts appliqués et du design.* Paris, 1996.*

J. Baudrillard. *The System of Objects.* New York, 1996.

S. Bayley, P. Garnier and D. Sudjic. *Twentieth Century Style and Design.* London, 1986.

L. Blackwell. *20th Century Type.* New York, 1992.

O. Boissière. *Streamline, le design américain des années 30–40.* Paris, 1987.

A. Bony. *Les Années 50 d'Anne Bony.* Paris, 1982 (and other works from the same series from 1910 to 1980).*

P. Bourdieu. *Distinction: A Social Critique of the Judgement of Taste.* Cambridge, Mass., 1987.

Y. Brunhammer and G. Delaporte. *Les Styles des années 30 à 50.* Paris, 1987.

Y. Brunhammer and M.-L. Perrin. *Le Mobilier français, 1960–1998.* Paris, 1998.

L. Burckhard. *Le Design au-delà du visible.* Paris, 1991.

G. de Bure. *Le Mobilier français 1965–1979.* Paris, 1983.*

C. Fayolle. *Le Design.* Paris, 1998.

C. and P. Fiell. *Design in the 20th Century.* Cologne, 1999.

P. Fossati. *Il Design in Italia, 1945–1972.* Turin, 1972.

R. Greenberg, B. W. Ferguson, and S. Nairne. *Thinking about Exhibitions.* London and New York, 1999.

R. Guidot. *Histoire du design, 1940–1990.* Paris, 1994.*

K. B. Heisinger and G. M. Marcus. *Landmarks of 20th-century Design.* New York, 1993.

S. Katz. *Les Plastiques, de la bakélite au high-tech.* Paris, 1985.

F. Mathey (ed.). *Au bonheur des formes, design français, 1945–1992.* Paris, 1992.

C. McDermott. *Street Style, British Design in the 80's.* London, 1987.

J. de Noblet. *Design, introduction à l'histoire de l'évolution des formes industrielles, de 1820 à nos jours.* Paris, 1974.*

J. de Noblet (ed.). *Industrial Design, Reflection of a Century.* Paris, 1993.

N. Pevsner. *The Sources of Modern Architecture and Design.* London, 1986.

S. Prendergast (ed.). *Contemporary Designers.* Detroit, 1997.

J. Soulillou. *Le Décoratif.* Paris, 1990.

P. Sparke. *An Introduction to Design and Culture in the 20th Century.* London, 1986.

J. Thackara, (ed.). *Design After Modernism: Beyond the Object.* London, 1988.

G. Vattimo. *La Fin de la modernité.* Paris, 1987.

R. Venturi (et al.). *Learning from Las Vegas.* Ann Arbor, 1985.

C. P. Warncke. *L'Idéal en tant qu'art, De Stijl 1917–1931.* Cologne, 1991.

H. M. Wingler. *The Bauhaus, Weimar, Dessau, Berlin.* Chicago-Boston, 1978.*

J. M. Woodman. *20th-Century Design.* Oxford, 1997.

* **Essential reading**

PHOTOGRAPHIES

"the memory of the gaze"

"A medium"

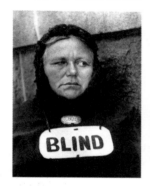

ALFRED STIEGLITZ
Flatiron Building, New York
1903. 16.8 x 8.2 cm.
Published full-size in *Camera Work* in 1903, Musée d'Orsay, Paris. Gift of M. de Gunzburg.
© Musée d'Orsay.

EDWARD STEICHEN
Flatiron Building, New York
1904.
Gum bichromate platinum print, 47.8 x 38.4 cm.
Published in *Camera Work* in April 1906. The Metropolitan Museum of Art, New York.
© The Metropolitan Museum of Art.

PAUL STRAND
Blind
1916. Gelatin silver print, 33.6 x 25.8 cm. Published in *Camera Work* in June 1917. Centre Pompidou, MNAM, Paris. © Centre Pompidou.

PIERRE DUBREUIL
Interprétation Picasso: le Rapide
Around 1911. Oil print, pencil highlights, mounted on paper, 23.8 x 19.4 cm. Centre Pompidou, MNAM, Paris.

At the end of the nineteenth century, the change from the refined aestheticism of Pictorialism—a movement that followed on from English Naturalism—to Edward Steichen and Alfred Stieglitz's creation in New York in 1902 of the Photo-Secession group (followed by the journal *Camera Work* in 1903) demonstrated the nature of the new vision that was gradually replacing the old world. An interest in the modern city and society slowly ousted visual effects that were misty-eyed with nostalgia. The photographic image turned toward the present. As early as 1905, the 291 Gallery in New York had already staged a number of exhibitions of avantgarde European art (from Rodin to Brancusi, from Cézanne to Picabia) and had also organized the earliest photography shows. In the last issue of *Camera Work*, in 1917, Paul Strand published works he entitled simply "Photographs," a gesture that heralded the birth of what became known as "straight photography," that is to say a technique which relied solely on light and centering to achieve its effects. Stieglitz and Steichen were to adopt the same style, soon followed by Charles Sheeler and, in 1935, by the founders of the F/64 group, Imogen Cunningham, Ansel Adams and Edward Weston, whose opinion was that a good photographer sees and thinks "with no allegiance to any other medium."

To write a history of a century of photography in a few lines is mission impossible in more senses than one. The creative arts, as we have seen, can no longer be addressed as separate media, and photography has been inextricably linked with nearly all art of the period. At once an addendum and a parallel, it is also, in the very intricacy of its definition, "contemporary art" itself. The task of the painter in the "age of photography" is a challenge artists have reflected on constantly throughout the century. In a celebrated essay *The Work of Art in the Age of Mechanical* > > >

> > > *Reproduction*, Walter Benjamin already warned us in 1931 that the point is not to wonder whether photography is an art form, but rather whether it has changed the overall character of art itself. The dilemma relates to an age-old Western quarrel between *ars* and *technè* that inevitably resurfaced when the movies were born and indeed comes to the fore whenever a new medium undermines the authority of time-honored systems and confronts a history of art in which attitudes are influenced by the predominant ideals of painting.

Photography *qua* photography is so important to us that even a brief synopsis should stress the fact that it concerns everyone, since it is omnipresent and readily available—as a document, as a fragment of the universal or of the particular, as a news item or as historical fact. Photography is nothing less than reality, in all its forms and myriad states. To refer generically to "photography" presupposes an adherence to the history of techniques and genres that in reality have proved far from immutable. It is in the very diversity of its applications that the means to evaluate photography's significance lies.

However, we should never lose sight of the fact that parallel to the official narrative there exists another, anonymous story which, in many aspects, supplements its history. The idea of "photography" requires a broader sweep; beyond the genre itself, it has to be realized that photography is a discipline which not only produces pictures but which has also given rise to new ways of seeing and of framing the real. Photography—or, as Michel Frizot has it, "photographies"—the photographic, in short the image, does not refer so much to a specific discipline or medium as to the permeability of the twentieth century to everything that catches its eye: these are the century's "grains of sand," as Michel Foucault calls them, hopes and experiences designed to keep time at bay, to transform and manipulate those things that no style can encapsulate and for which no history can provide closure. <

178

"A fatal blow to the old means of expression"

MAN RAY
Le Violon d'Ingres
1924. Gelatin silver print, Indian ink and pencil highlights, 28.2 x 22.5 cm. Centre Georges Pompidou, MNAM, Paris.
© Centre Pompidou.

ERWIN BLUMENFELD
Manina or *The Soul of the Torso*
1934. Gelatin silver print, photomontage, 29 x 22 cm. Centre Georges Pompidou, MNAM, Paris. Gift of Monty Montague. © Centre Pompidou.

GYULA HALASZ BRASSAÏ
The Statue of Maréchal Ney in the Fog
1932. Gelatin silver print, 56.7 x 40.5 cm. Centre Georges Pompidou, MNAM, Paris.
© Centre Pompidou.

From 1910, photography and the avant-garde became inextricably linked. The visual arts started drawing extensively on photography as a way of questioning what the Surrealists called the "principle of reality." Photography itself gave rise to countless inventions: from Man Ray's techniques to the quest for images "that either pre-existed their capture—or not," from Brassaï's night shots of the city, to other photographers who believed in the power of experiment. From Christian Schad's cameraless photography (Schadograph, developed in 1918) and Man Ray's 1922 rayograms to photomontage, it was a time when image and language were combined with great force. Breton stressed the possibility that photography might be able to establish "automatic" relationships between the expression of the unconscious and reality, and was to publish his findings in collaboration with J.-A. Boiffard, Man Ray and Brassaï. Through techniques such as the continuous exposures of solarization and the flame effects of *brûlage*, Man Ray and Raoul Ubac, among others, were creating a vision of a world that Georges Bataille approvingly qualified as "amorphous." "Surrealist woman"—from Claude Cahun to Dora Maar and Manina, whom Erwin Blumenfeld photographed with a statue's body—was at once model, artist and muse of what Breton had called "convulsive beauty," and played her part in breaking now obsolete taboos. In *Les Pas Perdus* (1924), Breton adjudged that photography had already dealt a "fatal blow to all the old means of expression."

HANS BELLMER
Photographs from the layout of **Les Jeux de la Poupée**
1938–49. 24 gelatin silver prints, aniline dyed on card, each 5.5 x 5.5. cm (detail). Centre Pompidou, MNAM, Paris. © Centre Pompidou.

In *Les Jeux de la Poupée* (The Doll's Games)—a long sequence of variations on the theme of the desired body he produced with the help of poet Paul Eluard—Hans Bellmer explained his position with respect to the magic and latent power of the object/subject he had fashioned: "Perhaps it is in the reality of the doll itself... that the imagination finds everything it was looking for in terms of joy, exaltation and fear."

"Joy, exaltation and fear"

 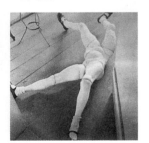

"THE CAMERA CAN MAKE THAT

"This century belongs to light"

LASZLO MOHOLY-NAGY
The City Lights
1926. Collage of magazine photos and tempera on cardboard, 61.5 x 49.5 cm. *Bauhaus Archiv*, no. 771. © Bauhaus Archiv/Éd. Carré.

ALEXANDER RODCHENKO
Staircase
1930. Gelatin silver print, 27.7 x 41.5 cm. Centre Pompidou, MNAM, Paris. © Centre Pompidou.

GERMAINE KRULL
Transporter bridge, Marseille
1935. Gelatin silver print, 8 x 5.5 cm. Musée Cantini, Marseille. © Musées de Marseille.

The productivist logic of the Russian Constructivists led them to consider photography and film as exemplary tools for the modern revolution. Rodchenko and El Lissitzky, observers and producers of a new world, and adopting as their own Tarabukin's contention that "art is fabrication, action... intentional function," published a series of images in the journal *Novi LEF* in which viewpoint, composition and photomontage were used to produce "impossible viewpoints [and] unimaginable moments." In 1922, the chief exponent of the "new photography," Moholy-Nagy (having expressed the view that "this century belongs to light") began to develop an independent and experimental visual language derived from geometry. A teacher at the Bauhaus, he continued to apply Gropius's program aimed at furthering the unity between art and technology. In 1925, he published *Malerei, Photographie, Film* (Painting, Photography, Film) and urged the art of photography to move on from "reproduction" to "production." In Marseille in the 1920s, in the footsteps of Sigfried Giedion, with Herbert Bayer, Germaine Krull, Florence Henri and Tim Gidal, he too saw the aerial ferry as the paradigm for a typology from which a "modernist vision" might be derived. Moholy-Nagy combined a keen sense of documentary with an interest in new visual techniques, which included photograms, photomontage and film. He wrote about his ideas in posthumously published books, such as *The New Vision* (1946) and *Vision in Motion* (1947).

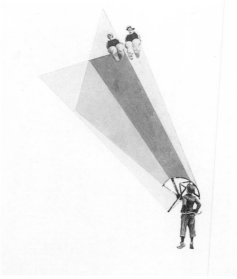

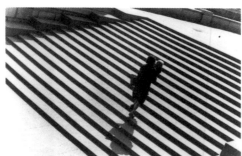

"Photography should be realistic"

ANDRÉ KERTÉSZ
Chez Mondrian
1926. Gelatin silver print, 24.6 x 19.8 cm. Centre Georges Pompidou, MNAM, Paris. Gift of the artist, 1978. © Centre Georges Pompidou.

In Paris, André Kertész was already earning his living as a professional photographer by 1925. A Montparnasse habitué, he attended many studios before working for various fledgling German and French magazines such as *Frankfurte Illustrierte*, *Die Woche,* and *Vu.* Some of his pictures were also published in the Surrealist *Minotaure*. His snapshots and experiments with form led to the series of *Distortions*, photographs taken in a funhouse mirror for the magazine *Le Sourire* in 1933. Kertész published numerous books, and then settled in New York in 1936, where he worked for *Harper's Bazaar* and *Vogue,* among others. However, he was little appreciated by *Life* magazine since he did not conform to its brave-new-world, seen-to-be-believed aesthetic. In 1949, Condé Nast offered him an exclusive contract from which he withdrew in 1962. A man of two cities, Kertész now seems to have been a photographer with an almost tactile eye, ever on the lookout for the right

179

"Readymade"

PAUL OUTERBRIDGE
Ide Collar
1922. Platinum print, 11.4 x 9.2 cm. Museum of Modern Art, New York. © Museum of Modern Art.

In 1929, the "Film und Foto" exhibition in Stuttgart provided photography with an opportunity to assert its new-found independence and show the results of its very diverse fields of research. "Photography," Bertolt Brecht was to remark, "possesses every privilege, every excellence." It is "the art of our time," and has a duty to "make artificial, fabricated things... since it is even

less the case than elsewhere that depicting reality says anything worthwhile about reality." Immune to propaganda, Outerbridge's work lies at the crossroads between the Surrealist and Constructivist imagination and is strongly infused by the sophisticated style of the 1930s. In the 1920s, he was already producing numerous photographs and his famous "Ide Collar" (an advert for shirts made by the Ide Company) was seen by Duchamp as a kind of readymade. In France, Laure Albin-Guillot, Florence Henri, François Kollar and René Zuber, among others, exemplified the fusion between a type of photography and photojournalism that absorbed elements from avant-garde aesthetics. As people consumed images, so they made images of consumerism.

moment and searching for a materialization of form in space. Refusing any theoretical view of his work, his opinion was "photography should be realistic."

OPTICAL INSTRUMENT KNOWN AS THE EYE PERFECT" Moholy-Nagy

"Documents for artists"

EUGÈNE ATGET
La Villette, rue Asselin, fille publique faisant le quart devant sa porte, 7 mars 1921
1921. Gelatin print,
22.3 x 17.7 cm.
Musée d'Orsay, Paris.
© Musée d'Orsay.

Although he is now a key figure in early-twentieth-century photography, Eugène Atget was initially a supplier of photographic "documents for artists." Until 1914, he sold photographs to Derain and Braque, as well as to the traders whose pictures he took as they posed before old-style storefronts that were fast disappearing. Crisscrossing Paris and the inner suburbs, Atget recorded a vanishing world. World War I left him in financial difficulties, forcing him to sell off a number of his archives to various institutions. In the 1920s, Man Ray

became captivated by Atget's work, and bought a number of prints, publishing several in *La Révolution surréaliste.* Berenice Abbott, Man Ray's assistant at the time, bought up many of Atget's plates and promoted his work in the United States after his death in Paris. In his *Short History of Photography,* Walter Benjamin saw Atget—with his vision of loss and his fascination with an archaic, pre-industrial world—as a radically unconventional artist, the first to look at objects in a truly modern way.

ALBERT RENGER-PATZSCH
Sempervivum abulaeforme crassulaceae
1928. Gelatin silver print,
23 x 16.8 cm.
Centre Georges Pompidou, MNAM.

AUGUST SANDER
Baker (Konditormeister), Cologne
1928. Gelatin silver, printed 1976, 30.4 x 22.3 cm.
Centre G. Pompidou, MNAM, Paris. © Centre G.Pompidou.

"Sociology with no text"

Whereas Atget's work is appreciated by modern eyes for the original way in which it saw a disappearing world, August Sander and Albert Renger-Patzsch embody the spirit of Neue Sachlichkeit (New Objectivity), with its social and anthropological approach to photography. In 1918, Sander began a typological inventory he entitled *Citizens of the Twentieth Century,* a documentary project designed to "see, observe and reflect." The first collection appeared in 1929 under the title "The Face of Our Time." Hitler put a stop to the project in 1933, after Sander had made 2,500 prints that were divided into 45 albums. Alfred Dödlin sees this project as "sociology with no text."

Unlike Karl Blossfeld or Helmar Lerski, Sander took each portrait full-length and face-on, all present and correct, a dignified figure in a uniform or other garment appropriate to their social position. Albert Renger-Patzsch, in his book *Die Welt ist Schön* (1928; A Beautiful World), preferred close-ups, centering the pictures in such a way as to maximize detailing. Renger-Patzsch, tried, as Wilhelm Kästner remarked in "Photography of the Present" (1929), to devise a "formal structure that is more readily assimilated than that of painting." He also maintained that "The secret of a good photograph—which can also possess aesthetic qualities just like a work of art—lies in its realism."

"The contemporary of our existence"

WALKER EVANS
Farmhouse, Westchester, New York
1931. Gelatin silver print,
12 x 22.5 cm. Centre Georges Pompidou, MNAM, Paris.
© Centre Georges Pompidou.

BERENICE ABBOTT
Mark Twain's House
1930. Gelatin silver print,
25.3 x 20.2 cm.
Musée Sainte-Croix, Poitiers.
© Musée Sainte-Croix.

Walker Evans is well known for the direct descriptive he produced during his participation in the government

sponsored Farm Security Administration set up to investigate rural conditions during the Great Depression. His importance in the history of photography nonetheless extends beyond his contribution to the development of the social documentary style. His influence over figures such as Robert Frank, Garry Winogrand and Lee Friedlander was crucial and is still perceptible thirty years later in Dan Graham's *Homes for America,* a project that follows a method comparable to his own. Walker Evans was the subject of the first photography exhibition

ever staged by the Museum of Modern Art, New York, in 1933, and his work, considered at once as a document and as an object of aesthetic value, was widely disseminated in journals such as *Time* and *Fortune.* Returning to New York from Europe in the late 1920s, Berenice Abbott undertook documentary work with the Works Progress Administration and taught for many years at the New School for Social Research. She thus developed a synthesis between the practice of photography, reportage and social commitment.

"ABOVE ALL, I KNOW THAT THE PHOTOGRAPHER

"History"

ROBERT CAPA
Death of a Loyalist Soldier
1936. Gelatin print, 24 x 34 cm.
Stedelijk Museum, Amsterdam.
© Stedelijk Museum.

HENRI CARTIER-BRESSON
Brussels
1932. Print 1980, 24 x 35.8 cm.
Centre Georges Pompidou,
MNAM, Paris. © Centre
Georges Pompidou.

Photojournalism emerged in
Germany with photographers
like Erich Solomon and Gisele
Freund, who worked using the
new lightweight cameras.
Thanks to the work of such
photographers as Kertész,
Walker Evans, Berenice
Abbott, Bill Brandt, Robert
Capa, Henri Cartier-Bresson

(who went on to found the
global photo agency Mag-
num), Marc Riboud and Ray-
mond Depardon, the genre
quickly developed into the
kind of "reportage" practiced
today, bearing witness to
dramatic historical events.
Expelled from Hungary, in 1936
Capa reported on the Span-
ish Civil War, publishing in *Vu,
Regards, Ce soir, Weekly Illus-
trated* and *Life* magazine. He
developed a conception of
journalism that "eschewed,"
as Françoise Ducros has re-
marked, "technical effects so
as to affirm the image's force
as a historical document."
Henri Cartier-Bresson, a tire-
less traveler and a witness to
all the great conflicts of the
time, captured reality by
means of the photographic
"shot": "We work in motion,
in a sort of premonition of life."

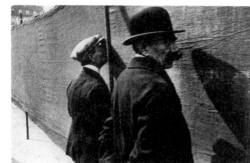

"Point blank"

ROBERT FRANK
Parade, Hoboken, New Jersey
1955. Gelatin silver print,
20.6 x 31.2 cm. The Museum of
Modern Art, New York.
© Museum of Modern Art.

WILLIAM KLEIN
Italian Quarter, New York
1954. Gelatin silver print,
30.6 x 43.3 cm. C. Pompidou,
MNAM, Paris. © C. Pompidou.

DIANE ARBUS
*Child with a Toy Hand
Grenade in Central Park,
New York*
1954. Gelatin silver print,
21.3 x 18.4 cm. The Museum of
Modern Art, New York.
© Museum of Modern Art.

After working for numerous
fashion magazines, Robert
Frank met Walker Evans and

received from the Guggenheim
Foundation and Robert Delpire
enough money to allow him to
travel around America in 1955
and 1956, photographing, as
Annick Lionel-Marie has writ-
ten, the "flow of everyday life
of apparently bored Americans
who seem determined to find
entertainment at any price, that
of gangs of teenagers whose
delinquency derives from not
having anything better to do.
Incisive manner, inexpressive
subjects, coarse-grained, out-
of-focus prints." Two years later,
Robert Delpire published the
anthology *Les Américains* in
Paris, which was translated the
following year with an addition-
al text by Beat poet Jack Ker-
ouac. In the United States, the
book was considered un-Amer-
ican and "gloomy." Today,
Robert Frank's work has—like

that of Weegee, Garry Wino-
grand, Lee Friedlander and
Diane Arbus—attained cult sta-
tus. It embodies the previously
unknown way in which pho-
tography can capture a real
world that has become
unhinged, and depict life in all
its chaotic diversity. The work
of William Klein, who has lived
in Paris since 1948 and whose
stated aim was to take "anti-
photographs"—point-blank
portraits of the anonymous
crowd—underscores the viol-
ence of the modern world
through a use of techniques
that might appear counter-
intuitive: blinding flash-guns,
off-kilter centering, visible cam-
era-shake. All are metaphors for
a permanent state of watch-
fulness that should, as Klein
sees it, be distinctive of mod-
ern photography.

"Emotional geography"

RICHARD AVEDON
Dovima with Elephants
1955. Gelatin silver print,
48.4 x 38.2 cm. The Museum
of Modern Art, New York.
© Museum of Modern Art.

Following in the footsteps of Horst
P. Horst, Cecil Beaton, Man Ray
and Erwin Blumenfeld, Richard
Avedon is one of the most remark-
able fashion photographers of
the postwar period. As early as
1945, he began producing a highly
individual series of works that
were published first in *Harper's
Bazaar,* then in *Life* magazine,
Look, Graphis, Egoist and *Vogue,*
for whom he became a contract-
ed contributor in 1966. He grad-
ually eliminated all traces of
narrative, preferring to take sub-
jects in his studio in front of a
white drape. "I always prefer to
work in the studio. It isolates peo-
ple from their environment. They
become in a sense... symbolic of
themselves." Compared to the
elegant sophistication of the ear-
lier pictures, the later clinically
taken photographs without back-
drop show how much Avedon
concentrates on the sitter, con-
veying a singularly intense "emo-
tional geography." These pictures
were the starting point for a con-
ception of photography that,
beyond its use in the fashion
world, was to be given highly per-
sonal twists in the careers of Guy
Boudin and Helmut Newton, as
the "Vanités" exhibition at the
Centre National de Photographie
in Paris in 1993 was to show.

181

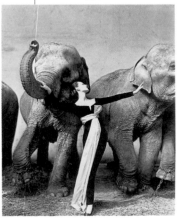

CANNOT ENVISAGE LIFE WITH AN INDIFFERENT EYE" Frank

"Terra Incognita"

HAMISH FULTON
Eyes of a Snake, an Eleven day Wandering Walk in Central Australia
1982. Gelatin silver prints, 96.5 x 250 cm. FRAC Lorraine Collection, Metz. All rights reserved.

As with Richard Long, photography occupies a central position in Hamish Fulton's work. Using it as an aid to exploring

terra incognita, a way of entering a natural world which he leaves totally undisturbed, Fulton choose to simply record his walks and journeys. Such a record might convey little more than a romantic dream were it not that the accompanying descriptions provide (as in David Tremlett's graphic surveys) details of Fulton's own physical and intellectual activities while on the site. He contends, however, that it is not the task of the artwork to furnish a commentary on experience since it is inherently unable to translate it. With the relevant location, date and specific context noted, the grand scale, the panoramic composition often consisting of a sequence of shots, the spacious white mounting board, the printed description of the walk undertaken, the simple wooden frame that stresses the factuality of the object—all these effects combine to supplement the absence of the landscape itself with what is its archetypal representation.

"A work of memory"

BERND AND HILLA BECHER
Mineheads No. 4
1966–73. Gelatin silver prints. Nine photographs, 117 x 85 cm in all. FRAC Rhône-Alpes Collection, Lyon.

The photographs Bernd and Hilla Becher began to take together in 1959 form the basis of a typological record of the symbols of a disappearing industrial world. The Bechers' impulse was to draw up an inventory that in part harks back to the taxonomies of the nineteenth century and Neue Sachlichkeit. Their black and white frontally taken photographs of water towers, silos, blast-furnaces, houses, gasometers and pitheads present us with the frozen vest-

iges of a now lost world. The Bechers have adopted a rigorously historical and scientific approach and the repetition and serial exposition heightens the wholeheartedly systematic character of their research. The similarity between each shot, however, serves to highlight the distinctions between the chosen typologies, while the analysis of reality gives rise to the uncanny sensation of an almost obsessive "work of memory" tinged with metaphysics. Teachers at the Academy of Fine Arts in Düsseldorf, the Bechers have paved the way for a new style of photography, whose exponents include Thomas Struth, Thomas Ruff, Candida Hofer and Andreas Gursky. Their work links art with the social, documentary and objective history of the postindustrial age.

"De-civilization"

JEAN-MARC BUSTAMANTE
Tableau T.45.82
1982.
Cibachrome, 103 x 130 cm. Private collection, Zurich. All rights reserved.

Since 1974, the best method of approaching the art of Jean-Marc Bustamante has been through photography. It is the linchpin upon which his projects hang. Photography, that is, in all its forms and all its styles: large-

scale color works showing almost nondescript sites from building plots to transitional areas that he calls *Tableaux*; black and white screenprints on Plexiglas derived from pictures snapped at abandoned sites *(Lumières)*; and object-sculptures that lie on the borderline of multi-disciplinarity and confront modernist museum architecture head on (entitled *Sites, Landscapes* or *Interiors*). Such works join forces with other procedures derived from photography to provide a method which probes a faltering and ephemeral side to the real world that Bustamante himself has termed "de-civilization." His work seeks to grasp no more than the emptiness and the absence of the world through which he passes. On the other hand, the objects and systems he devises appear as pointers to a way of recapturing lost space: they seem to await a viewer or a presence by which they might be apprehended.

"I'M TRYING TO MAKE PEOPLE RECOGNIZE

"Mythology of cinema"

CINDY SHERMAN
Untitled Film Still, # 48
1979. Photograph,
20.3 x 25.4 cm. Private
collection. All rights reserved.

From her early 1970s photographs, in which she played the role of both "actress" and director, to the "gore" images she has been producing since 1994, Cindy Sherman's work is defined by a reflection on the history of photography and film, and is based around various transformations her own body undergoes as it is appropriated by themes deriving from a feminist critique of stereotypes. The *Untitled Film Still* series produced between 1975 and 1986 addresses the artist's own imagination, alluding as it does so to the myth of film and the way each of us identifies with its heroes. "I am tying to make people recognize something of themselves rather than me." Since then, numerous other color sequences have followed in which photography directly confronts the television image. By 1982, however, she had abandoned these photonovels without a text and, made up and cross-dressed, she started constructing images whose color scheme and decor have become increasingly intricate: grotesque and monstrous characters sprouting artificial limbs disport themselves in interiors packed with detritus and the swill of science fiction. In her 1990s series, such as *Civil War, Sex Pictures* and *Horror Pictures,* in an attempt to force the viewer into reflecting on the nature of personal identity, Sherman herself seems to have abandoned the image and left the field open to a world of disjointed bodies and mannequins.

"Painter of Modern Life"

JEFF WALL
Picture for a Woman
1979. Cibachrome, fluorescent light and lightbox,
207 x 145 cm. Private
collection. All rights reserved.

In 1969–70, Jeff Wall created *Landscape Manual,* a series of photographs of the suburbs accompanied by texts. In 1977, he wrote a thesis on photomontage and cinema. He soon started making *Transparencies,* large-scale backlit photographs mounted in lightboxes. For Wall, these are a rereading of Baudelaire's *The Painter of Modern Life* larded with references to art history. At the crossroads between painting and film, Jeff Wall's work is like a framed still from a screen/painting. Each tableau is designed like a scenario, so enhancing the ambiguous status of the piece in this era of photography, while bringing out the equally complicated nature of a body of work that lies at the frontier between photography proper and other, more painterly genres. Jeff Wall's work achieves its effects by detecting the differences between the genres to which it refers. By reintroducing film into "pictures," he underlines (in much the same way as John Hilliard, Craigie Horsfeld, Urs Lüthi, Suzanne Lafont, Jean-Louis Garnell and Christian Milovanoff) the thought-provoking nature of the conflict between screen and canvas.

"A domestic world"

WILLIAM WEGMAN
Holiday Dance
1988. Polaroid photograph
Polacolor ER, 74 x 56 cm.
FRAC Limousin Collection,
Limoges. Courtesy W. Wegman
and Galerie Durand-Dessert.

William Wegman has been working in film and photography since the early 1970s. Beneath its humorous sit-com veneer, his work is a sustained and bitter critique of our social, cultural and

aesthetic codes. Arranging his cast of canine coworkers in pictures taken initially in black and white, and, since 1982, in oversized Polaroids, Wegman constructs an allegory of our artistic conventions, and replays, in the form of comic sketches, the customs and habits of everyday life. A teller of animal stories in the noble tradition of Grandville, the Brothers Grimm and La Fontaine, whom he has illustrated, Wegman replaces men with animals in scenes that use as many costumes and disguises as is necessary to recreate a complete domestic world in photographic form. His intention, however, is not confined to such games; the long line of canine stars—Man Ray, Fay Ray and their doggy progeny—also provides an excuse for a parodic recreation of the history of contemporary art forms. Beyond the simple parable of a beast in human fancy dress, beneath the animal skin which turns from living sculpture into a stylistic figure, the muzzle of avant-garde formalism can be seen peeking out.

183

SOMETHING OF THEMSELVES" Sherman

"Looking at people"

ROBERT MAPPLETHORPE
Self-portrait
1988. Gelatin silver bromide print, 60.6 x 50.5 cm. Maison Européenne de la Photographie, Paris. © Maison Européenne de la Photographie.

NOBUYOSHI ARAKI
Winter Day
1990. Gelatin silver bromide print, 35.4 x 43.2 cm. Maison Européenne de la Photographie, Paris. © Maison Européenne de la Photographie.

NAN GOLDIN
Self-Portrait in Bed, New York
1981. Cibachrome, 51 x 61 cm. Maison Européenne de la Photographie, Paris. © Maison Européenne de la Photographie.

From John Coplans to Robert Mapplethorpe and Nobuyoshi Araki, from Nan Goldin to Wolfgang Tillmans and George Tony Stoll, from Zoe Leonard to Andres Serrano, from Jack Pierson to Richard Billingham and Rineke Dijkstra, from Jenny Gage to Florence Paradeis and Delphine Kreuter, from Doningan Cumming to Martin Parr, a great deal of the photography of the 1990s depicted the body maimed and scarred, stripping bare its suffering and neuroses—some even going so far as to capture the moment of truth that is the instant of death. More than ever before, the purpose of taking a photograph is to mirror and to identify with life as it is really lived, exposing its intimacies and revealing the oppression and/or repression inherent in social identity. In an alienated world under 24-hour surveillance, with its documentary photographs and its increasingly sophisticated viewing audience, the photographic act samples from an array of portraits—some anonymous, some recognizable—and has transformed the artist into one who witnesses and exposes the disillusionment of the modern world. In these images of immediacy, on the borderlines of "reality cinema" and "theater of cruelty," the social conscience of the photographic subject wants us to accept that, as Andres Serrano has also confessed, we spend far too much time *not* looking at people.

184

"A Reconstruction of the self"

SOPHIE CALLE
Hotel, Room no. 28, February 16
1983. Two panels, color and black and white photographs, 102 x 142 cm each. Private collection, Paris. Courtesy Sophie Calle. All rights reserved.

From *Sleepers* (1979) to *Suite Vénitienne* (1980), from *The Hotel* to *No Sex Last Night* (a film made in collaboration with Greg Shepard, 1995), fiction and reality mix in Sophie Calle's life and work, to the point that they have become inextricable. The nature of her research and the situations in which she places herself, as incidental character or as heroine—observing and surveying a world that she explores in every direction and fills with projects and narratives of every kind—are symptomatic of a desire to reconstruct a life of her own by using the stories of others.

"Photography mirrors nothing"

PATRICK TOSANI
P. G.
1992. Color photograph, 175 x 162 cm. Private collection, Paris. Courtesy Galerie Durand-Dessert. All rights reserved.

Since the early 1980s, Tosani's work has revolved not so much around an extreme attention to detail but rather the enlarging of the photographed object so as to bring out the abstract nature latent within every image. Tosani was trained in architecture and has never lost his interest in it. From his first subjects encased in ice (1982), to *Talons* (1987), *Géographies* and *Cuillères* (1988), to *Circuits* (1989) and *Niveaux* (1990), the presence of the form derives from a "point of view" on "things" (in both the figurative and literal senses), which Jean-François Chevrier sees as relating to similar analyses by the poet Francis Ponge. Since 1990, Tosani has been working on a project to photograph different parts of the body: from *Nails* (1990) to the skull series (1992)—to which he refuses to give an overall title—his explorations of the body show the extent to which, from the early Braille portraits to more recent work, Tosani has kept on questioning the power and signification of the image. As Gilles A. Tiberghien has written in a piece on the artist: "Photography is not a mirror to anything—and certainly not to the real that it is meant to reproduce so perfectly."

"I NEVER SAID MY PHOTOS

Chronology 1900–1999

This chronology is largely restricted to the key inventions, discoveries and events in the field of photography in the twentieth century.

1900
• London, Royal Photographic Society: "The New School of American Photography."

1902
• Paris: Photo-club established.
New York: Alfred Stieglitz, Photo-Secession group set up.

1903
New York: Photo-Secession begins publication of *Camera Work.*

1904
• The Lumière Brothers invent the autochrome.

1905
New York: Stieglitz, 291 Gallery opens.

1907
• Edward S. Curtis begins the "North American Indian" photographic record.
Gabriel Lippmann wins the Nobel Prize for a method of reproducing color in photography.

1909
• Jacques-Henri Lartigue begins taking snapshots and autochromes.

1910
• Buffalo, Albright Art Gallery: "International Exhibition of Pictorial Photography."

1912
• Anton Giulio and Arturo Bragaglia, *Fotodinamismo futurista.*
• After the Brownie, George Eastman invents the pocket camera.

1916
New York, 291 Gallery: "Paul Strand."

1917
The journal *Camera Work* ceases publication.
• Alvin Coburn produces "vortographs."

1918
Zurich: Christian Schad invents sensitized paper, the Schadograph.

1920
• Berlin: Erste Internationale Dada Messe.

1921
• Lucerne: the journal *Camera* set up.
Man Ray begins taking rayograms.

1922
• Tristan Tzara, *La Photographie à l'envers, introduction aux Champs délicieux.*

1925
Moholy Nagy, *Painting, Photography, Film* **first published in German.**
• Flash and the 35-mm Leica launched.

1926
• New York, Metropolitan Museum of Art: photographic collections established.

1927
• Kodak-Pathé firm begins trading.
Rodchenko becomes a professional photographer.

1928
• Jan Tschichold: "New Typography."
Paris: Lucien Vogel creates *Vu.*

1929
• Essen, Folkwang Museum: exhibition of contemporary photography, "Fotografie der Gegenwart."
• Stuttgart, Deutscher Werkbund: "Film und Foto."

1931
• Paris: Florent Fels sets up *Voilà.*
Walter Benjamin, *Short History of Photography* **published in German.**

1932
• The French Communist Party starts publishing the journal *Regards.*
New York: foundation of the F/64 group.

1933
Paris: Charles Rado, Emile Savitry, Ergy Landau and Brassaï create the Rapho agency.
Henri-Cartier Bresson, *Paris la nuit.*

1934
• Zeiss produce the first camera with a photoelectric cell.

1935
• Leopold Mannes and Leopold Godowsky invent Kodachrome.
United States: Farm Security Administration starts photographically chronicling the agricultural situation nationwide.

1936
• New York: *Life* magazine set up.
Walter Benjamin, *The Work of Art in the Age of Mechanical Reproduction* **published in German.**

1937
• New York, MoMA: "Photography 1839–1937."
Chicago: Moholy-Nagy, the New Bauhaus School.

1938
• Paris: the picture magazine *Paris-Match* established.
• London: *Picture Post* starts publication.

1940
• New York, MoMA: photographic collections open.

1941
• Suisse: journal *Du* set up.

1943
• New York, MoMA: "Helen Levitt: Photographs of Children."

1944
• Kodacolor developed.

1946
New York, MoMA: Henri Cartier-Bresson retrospective exhibition.

1947
Paris: Robert Capa, Henri Cartier-Bresson, Georges

Rodger and David Seymour create the agency Magnum-Photos.
• United States: Edwin H. Land invents Polaroid film.

1948
• Japon: Nikon marketed.

1949
• Rochester, United States, George Eastman House: International Museum of Photography.
• Otto Steinert creates the Fotoform group.

1950
• Rank Xerox launches the first photocopier.
• Cologne: first "Photokina."

1951
• New York, MoMA: "5 French Photographers: Brassaï, Cartier-Bresson, Doisneau, Izis, Ronis."

1952
• New York: Minor White creates *Aperture.*

1955
• New York, MoMA: "The Family of Man."

1957
New York, MoMA: "Brassaï, Graffiti."
• Agence France Presse (AFP) set up.

1958
• New York, MoMA: "Abstraction in Photography."
Robert Frank, *The Americans.*

1959
• Essen, Folkwang Museum: Otto Steinert founds the photographic collections.
• Nikon launches a 35-mm reflex.
• The zoom lens is invented by the Austrian firm of Voigtlander.

1960
• New York, MoMA: "The Sense of Abstraction."

1963
• Kodak invents the Instamatic 50.

1964
• Cibachrome, paper and chemicals for permanent printing become available.

1966
• New York: Cornell Capa founds the International Center of photography (ICP).

1967
Gilles Caron and Raymond Depardon create Gamma.

1969
• Paris: Jean-Claude Lemagny sets up the photography collection of the Bibliothèque Nationale de France.
• Paris SIPA press agency established.
Photographs are taken on the moon by American astronauts.

1970
• London: opening of the Photographers' Gallery, Soho.

1971
• Larry Clark, *Tulsa.*

TOLD THE TRUTH" Araki

1934.
Robert Doisneau.
*Photographie
Aérienne.* Gelatin
silver print
(around 1981),
24.7 x 30.9 cm.
Centre Georges
Pompidou,
MNAM-CCI, Paris.

1962.
Edward Ruscha.
*Phillips 66, Flagstaff
Arizona,* from
*26 Gasoline
Stations.*
Courtesy Anthony
d'Offay Gallery.

1986.
Andy Warhol.
Self-Portrait.
Color Polaroid,
9.5 x 7.2 cm.
Centre Georges
Pompidou,
MNAM-CCI, Paris.

1996.
Richard Billingham.
Untitled.
Color photograph
glue-mounted on
aluminum,
120 x 80 cm.
Courtesy Galerie
Jennifer Flay, Paris.

1995.
Balthasar Burkhard.
Horse. Three gelatin silver
photographs, mounted on
stretcher; unique print,
2.3 x 2.88 cm.
Centre Georges Pompidou,
MNAM-CCI, Paris.

Chronology 1900–1999

1972
• Kodak invents the Pocket Instamatic and Polaroid the SX-70.
• Chalon-sur-Saône: Paul Jay creates the Musée Niépce.

1973
• Paris and New York: Sygma agency set up.
• John Szarkowski, *Looking at Photographs.*

1974
• Gisèle Freund, *Photography and Society* published in German.

1975
• Kassel: "Photography as Art–Art as Photography."
• Raoul Hausmann: "I am not a photographer."
**United States: The Center for Creative Photography is
established at the University of Arizona.**

1977
• Centre Georges Pompidou-MNAM: first Section de
Photographie established.
• Zurich, Kunsthaus: exhibition on the relationship between
painting and photography from 1840 to the present.

1978
• Lyon: Fondation Nationale de la Photographie.

1979
• Susan Sontag, *On Photography.*
• Jean-Luc Monteroso creates the Paris Audiovisuel association.

1981
• Paris, Centre Georges Pompidou: creation of the Cabinet
Photographique of the MNAM, director Alain Sayag.

1982
• France: Robert Delpire creates the National Center of
Photography.
• Arles: Alain Desvergnes sets up the École Nationale de la
Photographie.

1983
• Great Britain: The National Museum of Photography,
Film and Television opens in Bradford.

1984
• France: Bernard Latarjet and François Hers begin the
DATAR photographic project.

1989
**Japan: introduction of the electronic camera, which stores
pictures on magnetic disc instead of film.**

1989
• 150th anniversary of photography.
• Paris, Musée d'Orsay: "L'Invention d'un regard, 1839–1918."
• Paris, Centre Georges Pompidou: "L'Invention d'un art."

1990
• Paris, Centre Georges Pompidou: "Passage de l'image."
• Kodak: marketing of digital photography and the PhotoCD.
• Disposable cameras launched.

1996
• Paris: Maison Européenne de la Photographie opens.

1997
Bonn: "German Photography," Kunsthalle.

1999
• Paris, Maison Européenne de la Photographie: "Une
passion française. Photographies de la Collection Roger
Théron."

2000
**Madrid: "A Century of Photography in Spain," Centro de
Arte Reina Sofia.**

Studies on Photography

1989, Paris. *L'Invention d'un art.*
Centre Georges Pompidou.

1989, Paris. *L'Invention d'un
regard.* C. Pompidou/RMN.

1977, Zurich. *Malerei und
Photographie im Dialog, vom
1840 bis heute.* Kunsthaus.

1989, Paris. *Paysages
photographiés en France, les
années 80.* Mission DATAR.

R. Barthes. *Camera Lucida.* New
York, 1981.*

N. Beaumont Newhall.
*Photography 1839–1937. A Short
Critical History.* New York, 1937.

R. Bellour. *L'Entre-images.* Paris, 1990

R. Bolton. *The Contest of Meaning
Critical Histories of Photography.*
Cambridge, Mass., 1989.

P. Bourdieu (et al.). *Photography:
A Middle Brow Art.* Cambridge,
1990.

J.-F. Chevrier. *Une autre
objectivité.* Paris, 1989.

J.-F. Chevrier. *La Photographie,
10 ans d'enrichissement des
collections.* Paris, 1992 (RMN).

G. Deleuze. *L'Image-mouvement.*
Paris, 1983.*

G. Didi-Huberman. *Ce que nous
voyons, ce qui nous regarde.*
Paris, 1992.*

J. Enyeart (ed.). *Decade by Decade
Twentieth Century American
Photography.* Boston, 1989.

M. Frizot. *Photography from 1839
to the Present Day.* London, 1975.

T. Gidal. *Modern Photojournalism:
Origin and Evolution, 1910–1933.*
New York, 1972.

J. Green. *American Photography:
A Critical History, 1945 to the
Present.* New York, 1984.

A. Grundberg and K. Gauss.
*Photography and Art: Interactions
Since 1946.* New York, 1987.

E. Jaguer. *Les Mystères de la
chambre noire, surréalisme et
photographie.* Paris, 1982.

R. Krauss and J. Livingston.
*L'Amour Fou, Photography and
Surrealism.* New York, 1985.

J. Lemagny and A. Rouille. *A
History of Photography. Social
and Cultural Perspectives.*
Cambridge, 1968.

J. Liebling (ed.). *Photography —
Current Perspectives.* Rochester,
NY, 1978.

C. Phillips (ed.). *Photography in
the Modern Era: European
Documents and Critical Writings,
1913–1940.* New York, 1989.

N. Rosenblum. *A World History of
Photography.* New York, 1997.

J. M. Schaeffer. *L'Image précaire.
Du dispositif photographique.*
Paris, 1987.*

C. Squiers. *Over-Exposed: Essays
on Contemporary Photography.*
New York, 1999.

C. van Deren. *The Painter and the
Photographer, from Delacroix to
Warhol.* Albuquerque, 1996.

P. Virilio. *La Machine de vision.*
Paris, 1992.*

G. Walsh. (et al.). *Contemporary
Photographers.* New York, 1983.

*** Essential reading**

CINEMA, VIDEO

"the moving image: projections and installations"

PIERRE HUYGHE
L'Ellipse
1998. Installation, triple-part video projection,
13 min. PAL, color, soundtrack. Courtesy Marian
Goodman, New York/Paris.

JEAN-LUC GODARD
Histoire(s) du cinéma I, **1989.**
50 min. 20 sec. PAL, color,
soundtrack. © *Cahiers du cinéma.*

"Oh my friends, opium, the more shameful vices, the liqueur organ are all out of style: we have invented cinema!" Louis Aragon

Since the 1980s, a number of art shows have attempted to present and explore the complex relationship between the visual arts, film and video works. Thus exhibited, what philosopher Gilles Deleuze characterized as "image-movement" also reveals the diverse nature of practices that have become models and subjects for many forms of creative art on the contemporary scene. The links between the plastic arts (in the broad sense) and the cinema (and, since the beginning of the 1960s, video) crisscross the century. From Luis Buñuel to Germaine Dulac, from Viking Eggeling to Michael Snow, from Marie Menken to Marcel Broodthaers, from Hollis Frampton to Thierry Kuntzel down to more recent generations, these connections provide the material for a mutually beneficial yet perpetual tug-of-war between screen and canvas. However, the diverse approaches of film (and later of video) were for a long time regarded as separate, even marginal, forms by critics given to judging a work according > > >

> > > to standards rooted in the traditional fine arts model and whose sole repository is the museum. Under the impact of decades of creativity that have co-opted in every possible way the images of cinema and various forms of recording techniques and used them as models, any attitude to the status of "image-movement" within twentieth-century art has constantly to be reassessed. In the wake of historic avant-garde writings, texts by Gilles Deleuze, Raymond Bellour, Serge Daney, Pascal Bonitzer, Paul Virilio and Jean-Louis Schefer to cite only a handful of sources, have brought out the complex and fascinating nature of the cinematographic model in the context of the contemporary image. They have also highlighted the practical and theoretical chasm that has opened up in the move from the chemistry of the cinema to the electronics of the video recorder, from the old kinetoscope to the tape recorder and video disk. They have also highlighted the extent to which video as an intrinsically portable and democratic tool has established itself as a form in its own right just as television first penetrated then permeated everyday life. Many exhibitions and catalogues— "Projected Images" (Minneapolis, 1974), "The Luminous Image" (Amsterdam, 1984), "Peinture Cinéma Peinture" (Marseille, 1989), "Image World" (New York, 1989), "Passages de l'image" (Paris, 1990), "Halls of Mirrors" (Los Angeles, 1995), "Projections, les transports de l'image" (Le Fresnoy, 1998)—have gradually provided material for what is a long overdue reassessment of the relationship between film and the creative arts today. In spite of their varied concerns and many subdivisions, cinema in all its incarnations and video in all its diversity remain close neighbors, since both have provided forms through which twentieth-century art has explored uncharted physical and mental worlds, rolling back its frontiers and mapping a new geography.

There have been shifts in vocabulary, too. The concept of "centering" has had the better of "composition." Also, the language of the > > >

188

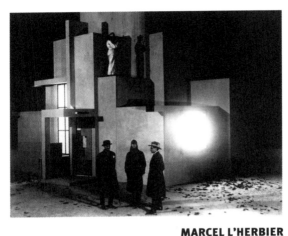

MARCEL L'HERBIER
The Inhuman, 1924.
66 min., sets by
Robert Mallet-Stevens
and Fernand Léger.
© *Cahiers du cinéma*.

HANS RICHTER
Rhythmus 21, 1921–24.
2 min. 10 sec, black and white,
soundtrack. Collection Centre Georges
Pompidou, Paris.

RENÉ CLAIR
Entr'acte
1924.
20 min., black and white,
soundtrack. Collection Centre
Georges Pompidou, Paris.

JORIS IVENS
Regen (Rain)
1929. 9 min. 40 sec., black and
white, silent. Collection Centre
Georges Pompidou, Paris.

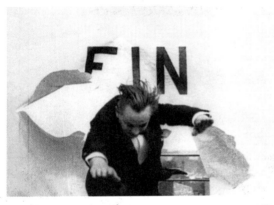

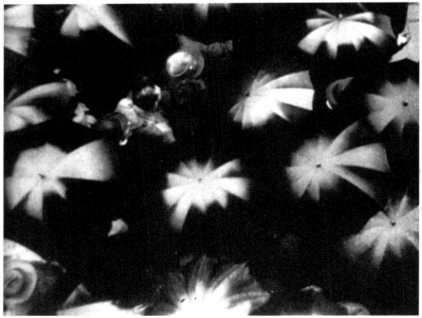

"EDITING ENABLES EVERY COMPOSITION

> cinema is essential in any account of the layout of a Dada or Surrealist image, of the use of the reverse shot in the Russian Constructivists, of the principles of the photogram, of the artwork of artists such as Warhol, of the highly cinematic nature of endless projects of Raymond Hains, John Baldessari and Ed Ruscha, of the panoramic designs of Jeff Wall and of all those who, following Bruce Nauman, Dan Graham and so many others, have pressed the medium and paradigms of film into the service of the structures they create. Since film of itself incorporates every technique and every genre, a reciprocal effect has been to invalidate distinctions between techniques and genres that then fall by the wayside. Hybrid by its very nature, it is also the ideal territory over which to claim an "inalienable right to enjoyment," as Jean-Louis Schefer terms it, as a counter to "its appropriation by specialists and historians, who have the all too prevalent tendency to adopt a rigid view of cinema as the last-born of the major art forms, always looking backward, always melancholic."

But film is not only an indispensable cognitive tool for the comprehension of the creative arts in the twentieth century; it is also the expression of the period's ambitions and of its most probing questions, of its stylistic and theoretical investigations into motion and motionlessness, into similarity and illusion, into reality and appearance, into perception and visibility. Above all, since it is, as Dominique Païni puts it, the "modern art" par excellence, it finds itself rooted in the *conflicts* of the time (and this is what links the history of film with ancient myth), into conflicts of every imaginable kind, even those between the very ideas, technologies and tools it enlists for its own existence and survival. Faced with the sheer variety of the questions being asked by artists and by the nature of the works being developed and created today, a necessarily reinvented museum is keen to incorporate the "image-movement" into any account of the history of the century it might propose. The Musée d'Art Moderne in Paris, > > >

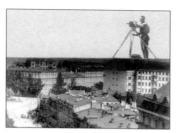

DZIGA VERTOV
Man with a Camera
1929. 70 min., silent.
© *Cahiers du cinéma.*

JEAN GENET
Song of Love
1948–50.
26 min., black and white, silent.
Collection Centre Georges
Pompidou, Paris.

RAYMOND HAINS
Penelope
1949–54/1980.
20 min., color, silent.
Collection Centre Georges
Pompidou, Paris.

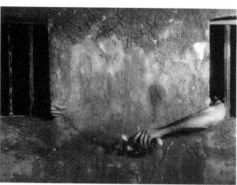

STAN BRAKHAGE
Reflections on Black
1955.
11 min., black and white,
soundtrack. Collection Centre
Georges Pompidou, Paris.

CHRIS MARKER
La Jetée, **1962.**
"Photo-novel" 16 mm, 29 min.
Collection Centre Georges
Pompidou, Paris.

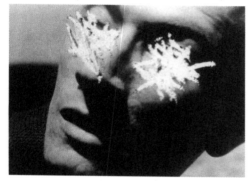

ANDY WARHOL
The Chelsea Girls
1966. Reels 11 and 12, 195 min., black
and white, color, soundtrack, split-
screen. Collection Centre Georges
Pompidou, Paris.

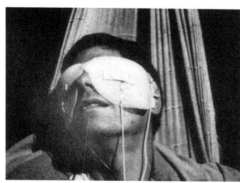

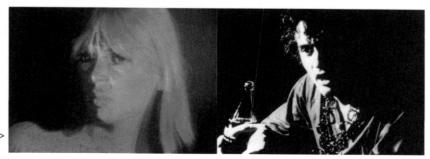

189

TO ATTAIN ORGANIC AND PATHETIC UNITY" Eisenstein

> > > for example, now variously exhibits Fernand Léger's *Ballet mécanique* next to René Clair's *Entr'acte*, *Pénélope* by Raymond Hains and *Ex-* by Jacques Monory, as well as Christian Boltanski's *L'Homme qui tousse*. It would never occur to the curators that the fact that projects intended to subvert or demolish formalist classifications by that token relinquish their right to exhibition. Beyond its documentary function, the film *Spiral Jetty* produced by Robert Smithson in 1970 serves as a paradigm of the "open work" in its relationship with the museum space—a welcome bout of dizziness at the core of the "white cube" which is but one object among all the others it houses. After practically forty years of creation, however, the rules have been rewritten. The showing of films that have punctuated the century-long relationship between the avant-garde and cinema, as well as the creation of a screening room permanently devoted to the viewing of videos on demand, are both responses to a body of work which appeals (both figuratively and literally) to the paradigms of film and video of every type. Film has gone from simply mirroring the various approaches of the time to becoming the archetype for all types of artistic endeavor. There is scarcely a single artwork, plan or project that fails to use it or that does not require its presence; there is hardly an exhibition space that does not feel the need to examine film in the very areas where it seems caught up in its own codes and seemingly incapable of asking pertinent questions of itself. This is true in spite of the heroic efforts of figures such as Chris Marker, Marguerite Duras, Jean-Marie Straub, Danièle Huillet and Jean-Luc Godard, who, with his *Histoire(s) du cinéma* (which was conceived in the 1980s), has probably begun the most important exploration in the form of a filmed essay ever proposed, one that is "sufficiently speculative in form and content," as Alain Bergala informs us, to be able to exert an enduring influence on future generations. Though film is indeed *the* model for creative art, it also poses of itself a number of problems > > >

190

MICHAEL SNOW
Wavelength, 1966–67.
16 min. 45 sec., color, soundtrack.
Collection Centre Georges Pompidou,
Paris. All rights reserved.

MARCEL BROODTHAERS
Figures of Wax (Jeremy Bentham), 1974.
16 mm, 15 min., color, soundtrack.
Courtesy Broodthaers estate.

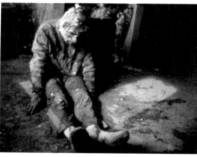

CHRISTIAN BOLTANSKI
L'Homme qui tousse, 1969.
3 min., color, soundtrack. Collection
Centre Georges Pompidou, Paris.
All rights reserved.

ROBERT FILLIOU
*And So On, End So Soon: Done 3
Times*, 1977. U-Matic, 32 min.,
PAL, color. © BORN Rodoreda/
Centre G. Pompidou, Paris.

THIERRY KUNTZEL
Nostos I, 1979.
45 min., PAL, color, silent.
Coll. Centre Pompidou,
Paris. All rights reserved.

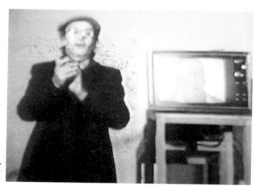

BILL VIOLA
Vegetable Memory, 1978–80. VHS-
NTSC, 15 min. and 13 sec., color, soundtrack.
© A. d'Offay & B. Viola. Photo K. Perov.

"SOMETHING LIKE THE FOLLOWING LUNATIC DESIRE:

> that it is rarely able to address unaided. See, for example, Cindy Sherman and Sophie Calle's fascination for the "wanabee" dream—in a critical and mutable mode—what Stanley Cavel has christened the "comedy of remarriage." Or the aesthetic approach of a Gary Wall or Bill Viola. Or else Pierre Huyghe's reflections on cinema as interpretation of a written score, or on the confrontation of an artwork with its model which underpins his *Remake*. Or the calculated soporific effects of structures that, in Warhol's wake, exploit the 24-frames-per-second illusion and extend the relationship between time and image, such as Douglas Gordon's *Feature Film*, itself a confrontation with another work of cinema that is constructed as an experience of remembrance, its soundtrack being continuously associated with the memory of a now absent image. The same goes for Pierre Bismuth, whose structures work with soundtrack and image, with reading and language, thereby exposing our obsession with "original cinema." And for the exhibitions compiled in the manner of a script or rushes staged by Pierre Huyghe, Philippe Parreno and Dominique Gonzalez-Foerster collaborating in the manner of a film crew. And for Johan Grimonprez, whose *Dial H.I.S.T.O.R.Y* with a soundtrack by David Shea samples the terrors and terrorism emitted by the cathode-ray tube. Or, working on the borderline of reportage, Eija-Liisa Ahtila, who blends narration with a fictional component that situates her films and videos as a system within a more general visual art context. Hence, too, Doug Aitken whose uncompromising approach (leaving aside his adverts) recycles images from a contemporary world that violence and speed are threatening to engulf. Or Sharon Lockhart's stills which, following John Cassavetes and Larry Clark, employ amateur actors and instill a dichotomy between visible surface and psychological content at the heart of the exhibition space. Hence also Matthew Barney's *Cremaster* series, wordless dialogues and elaborate metaphors for (re)production techniques. Hence the > > >

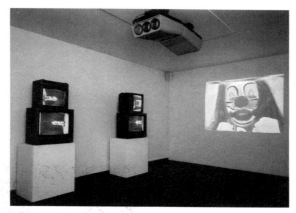

BRUCE NAUMAN
Clown Torture, 1987. Installation, VHS-NTSC, color, soundtrack, four monitors and two video projectors. Courtesy Donald Young Gallery, Chicago.

CHRIS MARKER
Zapping Zone (Proposals for an Imaginary Television), écran du Hérisson-lumière 1990–92. Multimedia installation. Collection Centre Georges Pompidou, Paris. All rights reserved.

PIERRICK SORIN
Réveils **1988.** PAL, color, soundtrack. Collection Centre Georges Pompidou, Paris. All rights reserved.

191

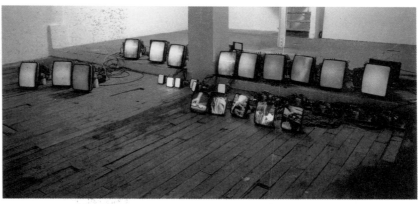

GARY HILL
Between Cinema and a Hard Place **1991.** Video installation, VHS-NTSC, color, soundtrack. Courtesy of the Bohen Foundation, New York.

STAN DOUGLAS
Hors Champs, 1992. Two video projectors, 13 min. 20 sec., PAL, black and white, soundtrack. Collection Centre Georges Pompidou, Paris. All rights reserved.

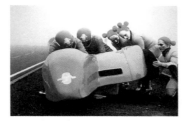
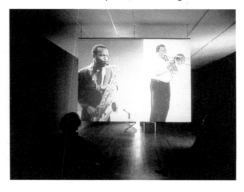

MATTHEW BARNEY
Cremaster 4: Triple Option (detail), 1994. 35 mm, 42 min. 16 sec., color. Fondation Cartier pour l'Art Contemporain, Paris.

MAKE LIGHT VISIBLE" Kuntzel

> > > relationship between identity and sexuality that Gus van Sant sets up in a *Psycho* remake that implicitly vehicles reflections on the B-movie. Models from cinema are thus replayed, transgressed or repositioned in a substantial portion of today's art that works with and against film—*with,* for what it offers, but *against,* for all those things it cannot (or will not) say.

If film (that is, all film and everything in film) now operates as the basic model for the visual arts, it is because it combines, incites and stimulates all the senses: sight, of course, but also others—think of the music in *Le Mépris, India Song, Naked Island, Vertigo* or *Pulp Fiction.* The motion picture serves as a parable for all our expectations: a fearsome, implacable presence between "purity and impurity," set around with countless traps, it imposes its own laws. In working "against cinema," a cultural theorist like Guy Debord *(Hurlements en faveur de Sade,* 1952), a poetic thinker such as Isidore Isou *(Traité de bave et d'éternité,* 1951), or experimenters such as Maurice Lemaître *(Le Film est déjà commencé,* 1951) or Andy Warhol *(Chelsea Girls,* 1966) interfere with the projected image with scratches, collages on the reel itself, thus steering clear of the pitfalls of narrative and producing effects that necessarily maintain a critical distance between image and text.

Cinema enters into all the genres from which it takes its material; it has to come to terms with all kinds of conflict; it is a collective enterprise and an industry; it is a catalyst for what Paul Virilio calls "the war of images"; it is popular in a way that the plastic arts seem reluctant to become; it is witness to life in all its richness; it is both an object and an inexhaustible tool, and, finally, it is a "young art." The cinema, then—like video, which further increases freedom of use and the appropriation of the image on a private and immediate scale—serves as a digest of all contemporary issues and addresses every subject in every form. It is this fact that has understandably to be stressed in an afterword to any history of twentieth-century art. <

192

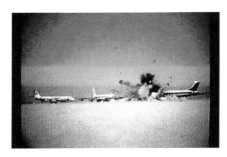

JOHAN GRIMONPREZ
Dial H.I.S.T.O.R.Y.
1997. Beta, 68 min., PAL, color, soundtrack. Collection Centre Georges Pompidou, Paris.

EIJA-LIISA AHTILA
Anne, Aki and God
1998. Video installation. Courtesy Anthony Reynolds, London. © Crystal Eye Ltd.

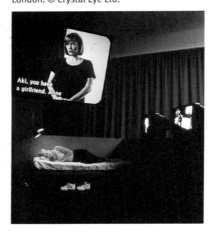

STEVE McQUEEN
Drumroll, 1998.
Three-screen video projection (left-hand image). Courtesy Anthony Reynolds, London and Marian Goodman, New York/Paris. © Steve McQueen.

DOUG AITKEN
Eraser
1998. Video installation. Courtesy 303 Gallery, New York.

DOUGLAS GORDON
Feature Film
1999. Beta, 75 min., PAL, color, soundtrack. Collection Centre Georges Pompidou, Paris.

"VAGUE IDEAS HAVE TO BE APPROACHED

Chronology 1895–1999

This brief chronology is intended to provide a few reference points in the history of cinema, video, and film in the twentieth century.

1895
- Edison, Kinetoscope acquires sound and color.
- The Lumière Brothers' patent (February 13) and first public showing (December 28).
- Louis Lumière, *La Sortie des Usines*.

1898
- Edison begins the "war" of the patents.

1899
- Georges Méliès, *L'Affaire Dreyfus* (first feature-length film).

1902
- Georges Méliès, *Le Voyage dans la lune*.
- Vincennes: Studio Pathé constructed.

1906
- Kinemacolor developed.

1908
- V. Jasset, *Nick Carter*.
- Hollywood: first movie studios.

1911
- Thomas H. Ince, *Renegade*. First western.

1913
- Chaplin, *Kid Autoraces at Venice*.
- Louis Feuillade, *Fantômas*.

1914
- Giovanni Pastrone, *Cabiria*: first sword-and-sandals epic.
- Paul Wegener, *The Golem*.

1915
- D. W. Griffith, *Birth of a Nation*.

1916
- D. W. Griffith, *Intolerance*.

1919
- Robert Wiene, *The Cabinet of Dr. Caligari*.

1920
- Victor Sjöström, *The Phantom Chariot*.
- Robert Flaherty, *Nanook* (first documentary film).

1921
- Fritz Lang, *Der Müde Tod*.
- Chaplin, *The Kid*.
- Hans Richter, *Rhythmus 21*.
- Victor Eggeling, *Diagonal Symphony*.
- Walter Ruttmann, *Opus 1*.

1922
- F. W. Murnau, *Nosferatu the Vampire*.
- M. L'Herbier, *Eldorado, the Wheel* (with Léger).
- G. Kozintsev and L. Trauberg set up the "firm of the eccentric actor" (FEKS).

1923
- Erich von Stroheim, *Greed*.
- René Clair, *Paris qui dort*.
- Man Ray, *Return to Reason*.

1924
- L'Herbier, *Inhuman*.
- René Clair, *Entr'acte*.
- Léger, *Ballet mécanique*.

1925
- Sergei Eisenstein, *Battleship Potemkin*.
- Chaplin, *The Gold Rush*.
- G. W. Pabst, *Freudlose Gasse*.
- M. Duchamp, *Anemic Cinema*.
- J. Painlevé produces his earliest scientific films.

1926
- F. W. Murnau, *Faust*.
- Fritz Lang, *Metropolis*.
- A. Cavalcanti, *Only the Hours*.

1927
- Jean Epstein, *La Glace à trois faces*.
- Abel Gance, *Napoléon*.
- Eisenstein, *October*.
- Alan Crosland, *The Jazz Singer* (first full-length talkie).
- Walter Ruttmann, *Die Symphonie der Grossstadt*.
- G. Dulac, *The Seashell and the Clergyman*.
- Hollywood: Oscars devised.

1928
- E. Sedgwick, *The Cameraman*.
- Victor Sjöström, *The Wind*.
- G. W. Pabst, *Lulu*.
- C. T. Dreyer, *The Passion of Joan of Arc*.
- Luis Buñuel and Dalí, *Un Chien andalou*.

1929
- D. Vertov, *Man with a Camera*.
- Man Ray, *Les Mystères du château de dé*.
- Joris Ivens, *The Bridge*.
- L. Lye, *Tusalava*.
- L. Moholy-Nagy, *Marseille Old Port*.
- Walt Disney and Tex Avery, early cartoons.

1930
- J. von Sternberg, *The Blue Angel*.
- Jean Vigo, *About Nice*.
- Jean Cocteau, *The Blood of a Poet*.
- Luis Buñuel, *L'Âge d'or*.

1931
- Jean Renoir, *The Bitch*.
- Lang, *M*.
- Murnau (with Robert Flaherty), *Taboo*.

1932
- C. T. Dreyer, *Vampyr*.
- Howard Hawks, *Scarface*.
- René Clair, *À nous la liberté*.
- A. Medvedkin: Agitprop "Film-Train."

1934
- Jean Vigo, *L'Atalante*.

1935
- Rouben Mamoulian, *Becky Sharp* (first Technicolor).
- Renoir, *Le Crime de M. Lange*.

- Alfred Hitchcock, *The 39 Steps*.

1936
- Chaplin, *Modern Times*.
- Duvivier, *La Belle Équipe*.
- Henri Langlois sets up the Cinémathèque Française.

1937
- Jean Renoir, *La Grande Illusion*.
- Frank Capra, *Lost Horizons*.
- George Cukor, *Le Roman de Marguerite Gautier*.

1938
- Leni Riefenstahl, *Olympia*.
- Marcel Carné, *Quai des Brumes*.
- A. Cauvin, *Memling and the Mystic Lamborn*.
- Howard Hawks, *Bringing Up Baby*.

1939
- Jean Renoir, *La Règle du Jeu*.
- Ernst Lubitsch, *Ninotchka*.
- John Ford, *Stagecoach*.
- Victor Fleming, *Gone with the Wind*.
- Marcel Carné, *Le Jour se lève*.

1940
- Chaplin, *The Great Dictator*.
- Luciano Emmer, *Il Dramma di Cristo*.

1941
- John Huston, *The Maltese Falcon*.
- Orson Welles, *Citizen Kane*.

1942
- Marcel Carné, *Les Visiteurs du soir*.
- Luchino Visconti, *Ossessione*.

1943
- Robert Bresson, *Les Dames du Bois de Boulogne*.
- Maya Deren, *Meshes in the Afternoon*.

1944
- Otto Preminger, *Laura*.

1945
- Marcel Carné, *Les Enfants du paradis*.
- Roberto Rossellini, *Rome, Open City*.
- René Clément, *Battle of the Rails*.

1946
- Jean Cocteau, *Beauty and the Beast*.
- Frank Capra, *It's a Wonderful Life*.
- Howard Hawks, *The Big Sleep*.
- Foundation of the Cannes Film Festival.

1947
- Kenneth Anger, *Fireworks*.

1948
- Jacques Tati, *Jour de Fête*.
- Vittorio de Sica, *The Bicycle Thief*.
- Roberto Rossellini, *Germany Year Zero*.
- Powell and Pressburger, *The Red Shoes*.
- Jean Genet, *Song of Love*.

193

WITH CLEAR PICTURES" Godard

1915.
D. W. Griffith,
Birth of a Nation.
© *Cahiers du cinéma.*

1922.
Robert Flaherty,
Nanook of the North,
© *Cahiers du cinéma.*

1922–23.
Friedrich W. Murnau,
Nosferatu the Vampire.
© *Cahiers du cinéma.*

194

1925.
Sergei M. Eisenstein,
Battleship Potemkin.
© *Cahiers du cinéma.*

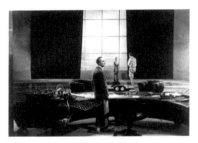

1927.
Fritz Lang,
Metropolis.
© *Cahiers du cinéma.*

1926.
Jean Renoir,
Nana.
© *Cahiers du cinéma.*

1950
- Akira Kurosawa, *Rashomon.*
- Billy Wilder, *Sunset Boulevard.*
- John Huston, *Asphalt Jungle.*
- John Ford, *Rio Grande.*
- Carol Reed, *The Third Man.*
- R. Hains, early sketches for *Pénélope.*
- First video recorders appear.

1951
- Elia Kazan, *A Streetcar Named Desire.*
- John Mankiewicz, *All About Eve.*
- Roberto Rossellini, *Europe 51.*
- Isidore Isou, *Traité de bave et d'éternité.*
- Marcel Lemaître, *Le Film est déjà commencé?*
- John Huston, *The African Queen.*

1952
- Luis Buñuel, *Los Olvidados.*
- Jean Renoir, *The Golden Coach.*
- Jacques Becker, *Casque d'or.*
- Cecil B. De Mille, *The Greatest Show on Earth.*
- Guy Debord, *Hurlements en faveur de Sade.*

1953
- Sacha Guitry, *Poison.*
- Jacques Tati, *Monsieur Hulot's Holiday.*
- Kenji Mizoguchi, *Ugetsu Monogatari.*
- Chris Marker and Alain Resnais, *Les Statues meurent aussi.*

1954
- C. T. Dreyer, *Ordet.*
- Elia Kazan, *On the Waterfront.*
- Federico Fellini, *La Strada.*
- Vincente Minnelli, *The Band Wagon.*
- Nicolas Ray, *Johnny Guitar.*
- Akira Kurosawa, *The Seven Samurai.*
- Yasujiro Ozu, *Tokyo Monogatari.*
- R. Breer, *Image by Image.*

1955
- Jean Resnais, *Night and Fog.*
- Nicolas Ray, *Rebel Without a Cause.*
- Charles Laughton, *The Night of the Hunter.*
- Orson Welles, *Mr. Arkadin.*
- Max Ophuls, *Lola Montes.*
- Billy Wilder, *The Seven Year Itch.*
- Satyajit Ray, *Pather Panchali* (first of the *Apu* trilogy).
- Elia Kazan, *East of Eden.*

1956
- Cecil B. De Mille, *The Ten Commandments.*
- Jacques-Yves Cousteau, *Le Monde du silence.*
- Henri-Georges Clouzot, *Le Mystère Picasso.*

1958
- Alfred Hitchcock, *Vertigo.*
- Ingmar Bergman, *Smultronstallet/Wild Strawberries.*
- Jean Rouch, *Moi, un noir.*
- P. Kubelka, *Arnulf Rainer.*

1959
- Howard Hawks, *Rio Bravo.*
- Billy Wilder, *Some Like it Hot.*
- Robert Bresson, *Pickpocket.*
- François Truffaut, *Les 400 Coups.*
- Jean-Luc Godard, *À bout de souffle.*
- Alain Resnais, *Hiroshima mon amour.*

1960
- Alfred Hitchcock, *Psycho.*
- Federico Fellini, *La Dolce Vita.*
- Michelangelo Antonioni, *L'Avventura.*
- L. de Heusch, *Magritte ou la Leçon de choses.*

1961
- Pier Paolo Pasolini, *Accatone.*
- John Huston, *The Misfits.*

1962
- Federico Fellini, *8 1/2.*
- Michelangelo Antonioni, *Eclipse.*
- Eric Rohmer, *The Girl at the Monceau Bakery.*
- Yasujiro Ozu, *An Autumn Afternoon.*
- Chris Marker, *La Jetée.*

1963
- Jean-Luc. Godard, *Le Mépris.*
- Joseph Losey, *The Servant.*
- Andy Warhol, *Sleep.*
- J. Smith, *Flaming Creatures.*

1964
- Shohei Imamura, *Akai Satsui.*
- C. T. Dreyer, *Gertrud.*
- Jacques Demy, *The Umbrellas of Cherbourg.*
- G. Markopoulos, *The Illiac Passion.*
- Jonas Mekas begins *Walden* (1964–69).

1965
- Jean-Luc Godard, *Alphaville; Pierrot le fou.*
- M. Menken, *Mood Mondrian.*
- Jean-Christophe Averty, *Ubu Roi.*

1966
- Ingmar Bergman, *Persona.*
- Jacques Rivette, *La Religieuse.*
- Eric Rohmer, *La Collectionneuse.*
- Andy Warhol, *The Chelsea Girls.*

1967
- Jacques Tati, *Play Time.*
- Michelangelo Antonioni, *Blow-Up.*
- Jean-Pierre Melville, *The Samurai.*
- Jean-Marie Straub and Danièle Huillet, *The Chronicle of Anna Magdalena Bach.*

1968
- Luis Buñuel, *The Milky Way.*
- Stanley Kubrick, *2001, A Space Odyssey.*
- Jacques Monory, *Ex-.*
- Gina Pane, *Solitrac.*
- Daniel Buren, *La Partie de Cartes.*
- Richard Serra, *Hand Catching Lead.*

1969
- Andrei Tarkovsky, *Andrei Rublev.*
- Pier Paolo Pasolini, *Pigsty, Theorem.*
- Dennis Hopper, *Easy Rider.*
- Glauber Rocha, *Antônio das Mortes.*
- M. Raysse, *Camembert Martial extra-doux.*
- Christian Boltanski, *L'Homme qui tousse.*
- Bruce Nauman, *Pulling Mouth.*

1970
- Bernardo Bertolucci, *The Spider's Strategy.*
- H. Frampton, *Zorns Lemma.*
- Michael Snow, *The Central Region.*

1971
- Luccino Visconti, *Death in Venice.*
- Stanley Kubrick, *Clockwork Orange.*
- Ken Loach, *Family life.*

"MOREOVER, CINEMA

1928.
Edward Sedgwick,
The Cameraman.
© *Cahiers du cinéma.*

1928.
Carl Theodor Dreyer,
The Passion of Joan of Arc.
© *Cahiers du cinéma.*

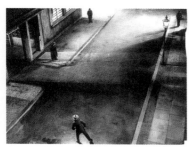

1931.
Fritz Lang,
M.
© *Cahiers du cinéma.*

1936.
Charlie Chaplin,
Modern Times.
© *Cahiers du cinéma.*

1941.
John Huston,
The Maltese Falcon.
© *Cahiers du cinéma.*

1941.
Orson Welles,
Citizen Kane.
© *Cahiers du cinéma.*

1972
- Bernardo Bertolucci, *Last Tango in Paris.*
- Ingmar Bergman, *Cries and Whispers.*
- J. Van der Keuken, *Diary.*

1973
- Marco Ferreri, *La Grande Bouffe.*
- Jean Eustache, *La Maman et la Putain.*
- R. Laloux, *Wild Planet.*
- E. De Antonio, *Painters Painting.*

1974
- Marguerite Duras, *India Song.*
- Marcel Broodthaers, *Voyage en Mer du Nord.*
- George Matta-Clark, *Splitting.*
- Y. Rainer, *Film About a Woman Who.*

1975
- Carlos Saura, *Cría Cuervos.*
- Chantal Akerman, *Jeanne Dielman, 23, quai du Commerce, 1080 Bruxelles.*
- M. Lakhdar Hamina, *Chronicle of the Burning Years.*

1976
- Nagisa Oshima, *In the Realm of the Senses.*
- Eric Rohmer, *The Marquise of O.*
- Milos Forman, *One Flew over the Cuckoo's Nest*
- Martin Scorsese, *Taxi Driver.*
- Godard, *Six fois deux (sur et sous la communication).*

1977
- George Lucas, *Star Wars.*
- Alain Resnais, *Providence.*
- Paolo and Vittore Taviani, *Padre Padrone.*
- Wim Wenders, *Alice in the City.*
- Robert Filliou (and George Brecht), *And So On, End So Soon.*
- Paris. César awards begin.

1978
- Rainer Maria Fassbinder, *The Marriage of Maria Braun.*
- Raul Ruiz, *L'Hypothèse du Tableau Volé.*

1979
- Francis Ford Coppola, *Apocalypse Now.*
- Victor Schlöndorff, *The Tin Drum.*
- Woody Allen, *Manhattan.*

1980
- John Cassavetes, *Gloria.*
- Akira Kurosawa, *Kagemusha.*
- David Lynch, *The Elephant Man.*
- Sony demonstrates first consumer camcorder.
- Andrzej Wajda, *Man of iron.*

1982
- Ingmar Bergman, *Fanny and Alexander.*
- Jean-Luc Godard, *Passion.*
- Ridley Scott, *Blade Runner.*
- Steven Spielberg, *E.T.*
- Wim Wenders, *The State of Things.*
- Chris Marker, *Sans soleil.*

1983
- Maurice Pialat, *To Our Loves.*
- François Truffaut, *Finally Sunday.*
- Shohei Imamura, *Narayama-Bushi-ko/Ballad of Narayama.*
- Raymond Depardon, *Reporters.*

1984
- Jacques Doillon, *La Pirate.*
- Terry Gilliam, *Brazil.*

1985
- Jim Jarmusch, *Down by Law.*
- Agnes Varda, *Sans toi ni loi.*
- Emil Kusturica, *When Father Was Away on Business.*
- Hector Babenco, *Kiss of the Spider Woman.*
- Claude Lanzmann, *Shoah.*
- Peter Fischli and David Weiss, *The Way Things Go.*

1986
- Léos Carax, *Bad Blood.*
- Derek Jarman, *Caravaggio.*

1987
- Wim Wenders, *Wings of Desire.*

1988
- L. Moulet, *Beyond Justice.*
- Pierrick Sorin, *Réveils.*

1989
- Dai Sijie, *China, My Sorrow.*
- Steven Soderbergh, *Sex, Lies and Videotape.*
- Chris Marker, *Zapping Zone.*
- Jeffery Shaw, *The Legible City.*

1990
- C. Denis, *S'en fout la mort.*
- J.-M. Straub and D. Huillet, *Cézanne.*

1991
- Jacques Rivette, *La Belle Noiseuse.*
- Joel and Ethan Coen, *Barton Fink.*
- Philippe Garrel, *I Can No Longer Hear the Guitar.*
- Hal Hartley, *Trust Me.*

195

1992
- Michael Haneke, *Benny's Video.*
- P. Rist, *Pimple Porno.*

1993
- Tim Burton, *The Nightmare Before Christmas.*

1994
- Quentin Tarantino, *Pulp Fiction.*
- Atom Egoyan, *Exotica.*
- Jean-Luc Godard, *JLG/JLG.*
- Nanni Moretti, *Caro Diario.*

1995
- Joao Cesar Monteiro, *A Comedia de Deus.*
- Theo Angelopulos, *To Vlemma tou Odyssea/Ulysses' Gaze.*
- Sophie Calle, *No Sex Last Night.*

1996
- David Cronenberg, *Crash.*

1997
- Abbas Kiarostami, *Ta'ame-gilas/A Taste of Cherry.*
- Takeshi Kitano, *Hana-Bi.*
- Cindy Sherman, *Office Killer.*

1998
- Lars von Trier, *The Idiots; Festen.*
- T. Ming-Liang, *The Hole.*
- Jean-Luc Godard, *Histoire(s) du cinéma.*

1999
- Harmony Korine, *Gummo.*
- J.-M. Straub and D. Huillet, *Sicilia!*

IS AN INDUSTRY" Malraux

1942.
Marcel Carné,
Les Visiteurs du Soir.
© *Cahiers du cinéma.*

1963.
Jean-Luc Godard,
Le Mépris (Disdain).
© *Cahiers du cinéma.*

1945.
Roberto Rossellini,
Rome, Open City.
© *Cahiers du cinéma.*

1967.
Michelangelo Antonioni,
Blow-Up.
© *Cahiers du cinéma.*

1950.
Max Ophuls,
La Ronde.
© *Cahiers du cinéma.*

1969.
Marcel Ophuls,
Le Chagrin et la Pitié.
© *Cahiers du cinéma.*

1955.
Charles Laughton,
The Night of the Hunter.
© *Cahiers du cinéma.*

1971.
Stanley Kubrick,
Clockwork Orange.
© *Cahiers du cinéma.*

1958.
Jacques Tati,
Mon Oncle.
© *Cahiers du cinéma.*

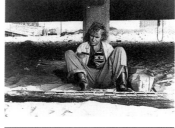

1974.
Wim Wenders,
Alice in the City.
© *Cahiers du cinéma.*

1958.
Alfred Hitchcock,
Vertigo.
© *Cahiers du cinéma.*

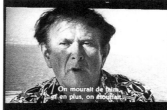

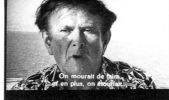

1985.
Claude Lanzmann,
Shoah.
© *Cahiers du cinéma.*

1959.
Robert Bresson,
Pickpocket.
© *Cahiers du cinéma.*

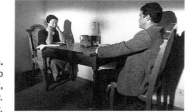

1999.
Jean-Marie Straub
and Danièle Huillet,
Sicilia.
© *Cahiers du cinéma.*

196

Studies on cinema and video

E. Barnouw. *Documentary: A History of the Non-Fiction Film.* Oxford, 1993.

R. M. Barsam. *Non-Fiction Film: A Critical History.* New York, 1973.

G. Battcock. *New Artists Video, A Critical Anthology.* New York, 1978.*

R. Bellour. *L'Entre-Images.* Paris, 1990.*

R. Bellour and A. M. Duguet (eds.). *Vidéo,* Communication no. 48. Paris, 1988.

D. Bordwell and K. Thompson. *Film Art: An Introduction.* New York, 1997.

D. Bordwell and N. Carroll (eds.). *Post Theory: Reconstructing Film Studies.* Madison, 1996.

J. M. Bouhours (ed.). *L'Art du mouvement, collection cinématographique du MNAM,* 1919–96. Paris, 1996.*

D. Boyle. *Video Classics: A Guide To Video Art and Documentary Tapes.* Phoenix, 1986.

G. Breteau. *Abécédaire des films sur l'art moderne et contemporain, 1905–1984.* Paris, 1985.*

A. Bushby. *A-Z of Film, Television, and Video Terms.* London/New York, 1994.

S. Cavel. *À la recherche du bonheur, Hollywood et la comédie du remariage.* Paris (Cahiers du cinéma 19).

M. Chion, *Le Son au cinéma.* Paris, 1982.

Cinéma du Réel. (Festival international de Films ethnographiques et sociologiques, Centre Pompidou/Bibliothèque Publique d'Information: 22 publications since 1978.)*

A. Easthope (ed.). *Contemporary Film Theory.* London, 1993.

C. Gledhalle and L. K. Williams. *Reinventing Film Studies.* London, 2000.

R. Goldberg. *Performance Art from Futurism to the Present.* New York, 1988.

G. Hennebelle and A. Gumucio-Dagron (eds.). *Les Cinémas d'Amérique latine.* Paris, 1981.

J. Hill and P. C. Gibson. *Oxford Guide to Film Studies.* Oxford, 1998.

Image World. Whitney Museum of American Art, New York, 1989.*

T. Johnson, M. Klonaris, and K. Thomadaki. *Technologies et imaginaires, Art cinéma, Art vidéo, Art ordinateur.* Paris, 1990.*

P. R. Klotman and G. Gibson. *Frame by Frame II: A Filmography of the African American Image 1978–1994.* Bloomington, 1997.

D. McClelland. *The Golden Age of B Movies.* New York, 1981.

J.-C. Masséra. *Amour, Gloire et Cac 40 (esthétique, sexe, entreprise, croissance, mondialisation et médias).* Paris, 1999.

G. Mast, M. Cohen and L. Braudy. *Film Theory and Criticism: Introductory Readings.* Oxford, 1999.

M. McLuhan. *Understanding the Media.* New York, 1964.*

J. Mitry (ed.). *Le Cinéma des origines.* Paris, 1976.

J. Monaco (ed.). *The Encyclopedia of Film.* New York, 1991.

J. Monaco. *How to Read a Film.* Oxford, 1981.

D. Noguez. *Éloge du cinéma expérimental.* Paris, 1987.*

G. Nowell-Smith (ed.). *The Oxford History of World Cinema.* Oxford, 1996.

D. Païni. *Le Cinéma, un art moderne.* Paris.

1990, Paris. *Passages de l'image.* Centre Georges Pompidou.*

J.-L. Passek (ed.). *Dictionnaire du cinéma.* Paris, 1995 (2 vols.).

Z. Pick. *The New Latin American Cinema. A Continental Project.* Austin, 1993.

Peinture, Cinéma, Peinture. Marseille and Paris, 1989.

H. H. Prinzler, *Chronik Des Deutschen Films, 1895–1994.* Stuttgart, 1995.

Projections, les transports de l'image. Le Fresnoy-Tourcoing, 1999.

M. Rush. *New Media in Late 20th-Century Art.* London, 1999.

J.-L. Schefer. *Du monde et du mouvement des images.* Paris.

C. Solomon. *The History of Animation.* New York, 1989.

R. Stam, R. Burgoyne, and S. Flitterman-Lewis. *New Vocabularies in Film Semiotics: Structuralism, Post-Structuralism, and Beyond.* London, 1992.

D. Thompson. *A Biographical Dictionary of Film.* London, 1994.

J. Tulard. *Dictionnaire des films.* Paris, 1990.

C. van Assche (ed.). *Vidéo et après.* Paris, 1992.*

C. van Assche (ed.). *Encyclopédie nouveaux médias Internet.* 1998 (www.newmedia-arts.org).

P. Virilio. *Guerre et Cinéma.* Paris, 1984.*

B. Wallis (ed.). *Art After Modernism: Rethinking Representation.* New York, 1984.*

R. Williams. *Technology and Cultural Form.* London, 1997.

G. Vincendeau. *Encyclopedia of European Cinema.* New York, 1995.

G. Youngblood. *Expanded Cinema.* New York, 1970.

* Essential reading.

revolutionary artists): 91
(Alvar): 99, 101, 102, 146, 153, 176
lie (Daniel): 120
tt (Berenice): 180, 181
lon: 163
ract Expressionism: 11, 103, 106, 110, 114, 159
raction (abstract art): 10, 44, 56, 8, 59, 60, 78, 84, 85, 88, 90, 91, 111, 112, 114, 116, 118, 119, 120, 121, 125, 144, 185
raction Lyrique: 118, 125
raction-Création: 84, 85, 90, 91
nci (Vito): 12, 140, 142
on painting: 123
ns (Ansel): 177
r (Dankmar): 54
A Group: 171
m (Yaacov): 122
la (Eija-Liisa): 191, 192
gon (Jean-Jacques): 13
ud (Émile): 146, 153
ud (Gilles): 126
en (Doug): 191, 192
rman (Chantal): 195
n-Fournier (Henri): 30
erola (Jean-Michel): 156
ers (Josef): 83, 88, 142
ert (Édouard): 146
n-Guillot (Laure): 179
chinsky (Pierre): 173
en (Woody): 195
ndy (Colette): 121, 125, 127, 135
oway (Lawrence): 127, 128, 131,
eline (Jean-Paul): 124, 136
erican Abstract Artists: 109
derson (Laurie): 164
do (Tadao): 146, 148, 154
dre (Carl): 110, 138, 139, 144
dreu (Paul): 154
drews (Michael): 126
ger (Kenneth): 193
selmo (Giovanni): 141, 144
tonioni (Michelangelo): 194, 196
ollinaire (Guillaume): 23, 24, 26, 27, 29, 30, 31, 33, 34, 35, 36, 37, 38, 66, 67, 68, 78, 90
pel (Karel): 118
ad (Ron): 174
agon (Louis): 10, 28, 64, 66, 68, 73, 7
aki (Nobuyoshi): 184
bus (Diane): 181
chigram: 135, 148, 149, 153, 154, 175
chipenko (Alexander): 37, 43, 46
chitecture principe: 153, 154
chitecture Studio: 153, 154
chizoom: 152, 175
rdenne (Paul): 158, 166
rensberg (Walter): 104
rgan (Giulio Carlo): 120
rman (Pierre Fernandez Armand, nown as): 130, 135, 136, 143
rmleder (John M.): 165
rnodin (Maïmé): 173
p (Hans or Jean): 62, 65, 66, 85, 88, 4, 111, 137, 144

Arroyo (Eduardo): 126
Art and Language: 140, 165
Art Brut: 117, 120, 125, 158
Art concret: 88, 125
Art Deco: 97, 98
Art Informel: 118, 123
Art Nouveau: 21, 47, 59, 167
Arte Povera: 12, 140
Artaud (Antonin): 70, 73, 74, 79, 80, 125, 159
Arts and Crafts: 9, 48, 53, 96
Artschwager (Richard): 128, 143
Arup (Ove): 151
Arzens (Paul): 175
Atget (Eugène): 180
Atlan (Jean-Michel): 118
Aubert (André): 100
Aubertin (Bernard): 135
Audigier (Raymond): 153
Auerbach (Frank): 126
Averty (Jean-Christophe): 194
Avery (Fred, known as Tex): 193

B

BMPT (Buren Mosset Parmentier Toroni): 120, 125, 126
Baader (Johannes): 66
Baargeld (Johannes Theodor): 62
Babenco (Hector): 195
Bachelard (Gaston): 128
Bacon (Francis): 115, 118, 120, 125, 126
Bad Painting: 158
Bakst (Lev Rosenberg, known as Léon): 29, 30
Baldassari (Anne): 123
Baldessari (John): 189
Ball (Hugo): 61, 62, 66
Balla (Giacomo): 35, 46
Baltard (Victor): 153
Balthus (Balthasar Klossowski de Rola, known as): 78, 79, 120, 126
Banham (Reyner): 127
Barney (Matthew): 163, 191
Barr (Alfred H.): 65
Barré (François): 172, 175, 176
Barré (Martin): 120, 122
Barrès (Maurice): 21, 64
Barry (Robert): 140, 158
Barthes (Roland): 110, 125, 131, 163, 186
Baselitz (Georg): 159
Basilico (Gabriele): 186
Basquiat (Jean-Michel): 158
Bataille (Georges): 70, 73, 118, 125, 178
Baudelaire (Charles): 68, 73
Baudot (Anatole de): 53
Baudrillard (Jean): 133, 157, 175, 176
Bauhaus: 10, 51, 54, 66, 80, 82, 83, 84, 86, 87, 88, 96, 98, 101, 102, 118, 122, 169, 175, 176, 179, 185
Bayer (Herbert): 83, 179
Bazaine (Jean): 118, 125
Bazile (Bernard): 165
Baziotes (William): 106, 113
Beaton (Cecil): 181
Beaudouin (Eugène): 102, 146
Beauffet (Jacques): 117
Beaumelle (Agnès de la): 93
Beaurin (Vincent): 174
Becher (Bernd and Hilla): 182
Becker (Jacques): 194

Becker (Wolfgang): 158
Beckett (Samuel): 123, 125, 142, 155
Beckmann (Max): 77, 78
Behrens (Peter): 50, 51, 54, 175
Behrens (Timothy): 126
Bellamy (Richard): 128
Bellmer (Hans): 72, 74, 94, 178
Bellour (Raymond): 188, 196
Belmondo (Paul): 125
Belvaux (Rémy): 195
Ben (Ben Vautier, known as): 129, 134, 135, 143, 165
Bengston (Billy): 128
Benjamin (Walter): 89, 178, 180, 185
Benton (Thomas Hart): 104
Béret (Chantal): 152
Bergala (Alain): 190
Berger (Patrick): 154
Bergman (Ingmar): 194, 195
Bergson (Henri): 26
Berlage (Hendrik Petrus): 11, 54
Berlewi (Henryk): 87, 94
Berlin Sezession: 60
Bernadac (Marie-Laure): 29
Bernanos (Georges): 80
Bertini (Gianni): 136
Bertoia (Harry): 170
Bertoni (Flaminio): 175
Besset (Pierre du): 154
Bertolucci (Bernardo): 194, 195
Beuys (Joseph): 129, 130, 135, 140, 141, 143, 144, 159, 160
Bijvoet (Bernard): 97
Bill (Max): 122, 125, 137, 158, 181
Billingham (Richard): 184, 186
Binfare (Francesco): 172
Bing (Siegfried)21, 167
Bird (Walter): 175
Bismuth (Pierre): 191
Bissière (Roger): 76, 118, 120
Black Mountain College: 88, 110, 113, 143, 175
Blake (Peter): 128
Blanchon (Pierre): 169
Blanchot (Maurice): 124
Blaue Reiter (der): 9, 18, 29, 30, 56, 57, 58, 60, 65, 95
Blauen Vier (die): 83, 87
Bloc (André): 43, 117
Bloesch (Hans): 59
Blok (group): 87, 91, 94
Blossfeldt (Karl): 180
Blumenfeld (Erwin): 178, 181
Boccioni (Umberto): 37, 38, 40, 44, 46
Bochner (Mel): 140
Böcklin (Arnold): 57, 71
Bodiansky (Vladimir): 102
Body art: 12, 114
Bofill (Ricardo): 154
Boiffard (Jacques-André): 73, 178
Bois (Yves-Alain): 130
Boissel (Jessica): 59
Boissière (Olivier): 174, 176
Boltanski (Christian): 12, 155, 156, 190, 194
Bonfand (Alain): 116, 126
Bonitzer (Pascal): 188
Bonnard (Pierre): 17, 21, 108, 115
Bordier (Roger): 122
Borel (Frédéric): 154
Borgeaud (Bernard): 156
Botta (Mario): 146, 148, 153
Boudin (Eugène): 19
Bouguereau (William): 15, 27

Boulanger (Pierre-Jules): 175
Boulenger (Marcel): 44
Bouquet (Louis): 169
Bourdelle (Antoine): 40, 45, 46, 51, 70
Bourdieu (Pierre): 176
Bourdin (Guy): 181
Bourgeois (Louise): 138, 143, 162
Bourliouk (Vladimir): 36
Bouroullec (Ronan): 174
Bozo (Dominique): 43, 92
Bragaglia (Anton Giulio and Arturo): 185
Brakhage (Stanley): 189, 194
Brancusi (Constantin): 9, 10, 18, 27, 40, 43, 44, 45, 46, 90, 93, 94, 111, 129, 139, 142, 143, 177
Brandt (Bill): 181
Braque (Georges): 8, 19, 21, 22, 23, 25, 26, 27, 28, 29, 30, 31, 32, 34, 37, 38, 115, 125, 180
Brassaï (Gyula Halasz): 94, 117, 178, 185
Brauner (Victor): 72
Brecht (Bertolt): 80, 179
Brecht (George): 130, 134, 135, 136
Breer (Robert): 135, 194
Breker (Arno): 125
Bresson (Robert): 193, 194, 196
Breton (André): 10, 63, 64, 66, 67, 68, 69, 70, 71, 72, 73, 74, 92, 93, 94, 103, 117, 123, 124
Breton (Jules-Louis): 175, 178
Breton-Collinet (Simone): 73
Breuer (Marcel): 102, 153, 169
Broodthaers (Marcel): 143, 156, 187, 190, 195
Brossa (Joan): 120
Brown (Trisha): 132
Brücke (die): 9, 18, 22, 29, 41, 46, 55, 56, 57, 58, 59, 60
Bruhnes (Jean): 185
Brun (Jean-François): 165
Brus (Günter): 165
Bryen (Camille): 127
Buchheister (Carl): 88
Buchloh (Benjamin H. D.): 40, 157
Buckminster Fuller (Richard): 99, 101, 148, 151
Buffet (Bernard): 118
Bulatov (Erik): 162
Buñuel (Luis): 73, 187, 193, 194
Burden (Chris): 140, 142, 155
Buren (Daniel): 125, 165, 194
Burgess (Gregory): 25
Burke (Edmond): 109
Burkhard (Balthasar): 186
Burn (Ian): 165
Burnham (Daniel): 54
Burri (Alberto): 120, 121, 125
Burroughs (William): 103, 114, 132
Burton (Tim): 195
Bury (Pol): 122, 133, 137
Bustamante (Jean-Marc): 165, 182

C

Cadéré (André): 144, 166
Cage (John): 110, 113, 114, 128, 130, 135
Cahun (Claude): 178
Caillebotte (Gustave): 21, 45
Calder (Alexander): 88, 92, 94, 122, 125, 137, 143, 144
Calle (Sophie): 165, 184, 191, 195

Camelot (Robert): 153
Camoin (Charles): 21, 22
Candilis (Georges): 145, 149, 153, 154
Capa (Cornell): 185
Capa (Robert): 181
Capra (Frank): 193
Carax (Leos): 195
Carco (Francis): 17
Carné (Marcel): 193, 196
Caro (Anthony): 137, 138, 143, 144
Caron (Gilles): 185
Carothers (Wallace Hume): 175
Carrà (Carlo): 37, 71, 76
Carré (Louis): 125
Cartier-Bresson (Henri): 181, 185
Casorati (Felice): 78
Cassavetes (John): 191, 195
Cassina (Cesare): 172
Cassirer (Ernst): 60
Cassirer (Paul): 55, 56
Cassou (Jean): 32, 93, 116
Castelli (Leo): 113, 128
Cattelan (Maurizio): 7
Caulfield (Patrick): 128
Cauvin (A.): 193
Cavalcanti (Alberto): 193
Cavel (Stanley): 191, 196
Cazals (Henri de): 43
Chekov (Anton): 21
Celant (Germano): 140, 141, 144
Céline (Louis-Ferdinand): 73, 80
Cendrars (Blaise): 27, 32, 34, 36, 38
Cercle et Carré: 84, 85, 88
César (César Baldaccini, known as): 130, 135, 143
Cézanne (Paul): 8, 18, 19, 20, 21, 22, 23, 24, 25, 26, 27, 29, 30, 32, 34, 37, 41, 59, 79, 84, 103, 108, 119, 177, 195
Chagall (Marc): 29, 36, 37, 82, 115
Chaissac (Gaston): 117, 120
Chalk (Warren): 149
Chamberlain (John): 143
Chaplet (Ernest): 41
Chaplin (Charles Spencer, known as Charlie): 73, 193, 195
Chappey (Marcel): 96
Char (René): 73
Chareau (Pierre): 97, 101, 102, 173
Chaslin (François): 12
Cheeseman (Wendy): 151
Chekov (Anton): 21
Chemetov (Paul): 154
Chevreul (Eugène): 32, 33
Chevrier (Jean-François): 157, 180, 184, 186
Chia (Sandro): 156
Chillida (Eduardo): 125, 137, 143
Chomon (Segundo de): 30
Christo (Christo and Jeanne-Claude): 129, 135, 143
CIAM (Congrès Internationaux d'Architecture Moderne): 96, 98, 101, 145, 147, 149, 153, 154, 169, 175
Ciriani (Henri): 148, 154
Clair (Jean): 10, 80, 91, 106
Clair (René): 186, 188
Clark (Larry): 185, 191
Claudel (Paul): 22, 30, 80
Clay (Jean): 122
Clément (Gilles): 154
Clément (René): 193
Clemente (Francesco): 105, 156
Clergue (Lucien): 185
Clert (Iris): 121, 125, 128, 130, 135

Cloisonnism: 58
Close (Chuck): 82, 156, 157
Clouzot (Henri-Georges): 194
Cobra: 116, 118, 120, 125, 149
Coburn (Alvin): 185
Cocteau (Jean): 80, 193
Coen (Joel and Ethan): 195
Cohl (Émile): 29
Colombo (Joe): 171
Combas (Robert): 158, 166
Conceptual art: 12, 140, 166
Conrad (Tony): 164
Conran (Terence): 175
Constant (Constant Nieuwenhuis, known as): 118
Constructivism: 10, 64, 66, 76, 82, 84, 86, 87, 90, 92, 94, 95, 96, 98, 116, 138, 139, 151, 179, 189
Cook (Peter): 149
Cooper (Douglas): 30, 32
Cooper (Paula): 163
Copeau (Jacques): 29
Coplans (John): 184
Coppola (Francis Ford): 195
Cordier (Daniel): 116, 124, 126, 135, 136
Cormon (Fernand): 18
Corneille (Corneille Guillaume van Berverloo, known as): 118
Corner (Philip): 135
Costa (Lucio): 146, 148, 153
Courrèges (André): 175
Courthion (Pierre): 19
Cousseau (Claude): 117
Cousteau (Jacques-Yves): 194
Cragg (Tony): 158
Crasset (Matali): 174
Cravan (Arthur): 61, 66
Criqui (Jean-Pierre): 138
198 Crompton (Denis): 149
Cronenberg (David): 195
Crosland: 193
Cross (Henri Edmond Delacroix, known as): 21
Cubism: 8, 18, 20, 23, 24, 25, 26, 27, 28, 29, 30, 31, 32, 33, 35, 36, 37, 38, 41, 42, 46, 43, 46, 70, 71, 75, 78, 87, 89, 90, 99, 104, 127
Cubo-Futurism: 36, 44
Cucchi (Enzo): 156
Cueco (Henri): 126
Cukor (George): 193
Cumming (Doningan): 184, 193
Cunningham (Imogen): 177
Cunningham (Merce): 110, 113, 128, 132, 135, 177
Curtis (Edward): 185

D

Dachy (Marc): 65, 66
Dada: 9, 10, 61, 62, 63, 64, 65, 66, 68, 70, 74, 77, 80, 86, 87, 110, 113, 126, 127, 135, 178, 185, 189
DAH (Die Abstrakten Hannover): 88
Daix (Pierre): 28, 30, 34, 78
Dalbet (Louis): 97
Dalí (Salvador): 70, 71, 73, 74, 93, 193
Daney (Serge): 188
Danto (Arthur): 114, 160
Darboven (Hanne): 140
Dastugue (Marcel): 100
Dau al Set: 116, 120, 125
Daum (Antonin): 21, 53
Daumier (Honoré): 156, 160
Davis (Stuart): 104
De Antonio (Emile): 195
De Chirico (Giorgio): 65, 67, 68, 73, 76, 78, 79

De Kooning (Willem): 106, 107, 108, 110, 113, 114, 144
De Maria (Walter): 135, 143, 165
De Mille (Cecil B.): 194
De Sica (Vittorio): 193
Deacon (Richard): 158
Debord (Guy): 126, 192, 194
Debré (Olivier): 118
Debussy (Claude): 21, 29, 30
Degand (Léon): 118, 125, 126
Degand (Odile): 126
Degas (Edgar): 8, 34, 39, 40, 46
Degottex (Jean): 123
Delaunay (Robert): 27, 32, 33, 34, 35, 36, 37, 38, 58, 60, 66, 84, 88, 119, 125
Delaunay (Sonia): 32, 34, 37 38
Deleuze (Gilles): 165, 186, 188
Delpire (Robert): 181, 186
Delteil (Joseph): 119
Demuth (Charles): 103, 104
Demy (Jacques): 194
Denis (Maurice): 16, 17, 21
Depardon (Raymond): 181, 185, 195
Derain (André): 17, 18, 19, 20, 21, 22, 29, 30, 37, 38, 45, 78, 125, 180
Deren (Maya): 193
Dermée (Paul): 98, 101
Derouet (Christian): 59, 78
Deschamp (Gérard): 131
Desnos (Robert): 70, 73
Despiau (Charles): 125
Desvergnes (Alain): 186
Dewasne (Jean): 126
Dezeuze (Daniel): 144
Di Suvero (Mark): 138
Diaghilev (Sergei): 29, 30, 58, 75
Dietman (Erik): 135, 143
Dieuzaide (Jean): 186
Dijkstra (Rineke): 184
Dine (Jim): 128, 130, 134
Dior (Christian): 175
Disney (Walt): 193
Divisionism: 17, 18, 19, 57
Dix (Otto): 77, 78
Dixon (Tom): 174
Documenta: 125, 161, 165, 166
Dodeigne (Eugène): 140
Dödlin (Alfred): 180
Doillon (Jacques): 195
Doisneau (Robert): 126, 185, 186
Domela (César): 88
Domènech i Montaner: 53, 54, 167
Dondel (Jean-Claude): 100
Dony (Paul): 149
Dotremont (Christian): 118, 120
Douglas (Stan): 195
Dove (Arthur): 103
Dreier (Katherine): 63, 66, 104
Drew (Jane): 148
Dreyer (Carl Theodor): 193, 194, 195
Dreyfus (Charles): 135, 136
Drieu La Rochelle (Pierre): 80
Drouin (René): 117, 118, 125
Dube (Wolf-Dieter): 57, 60
Dubreuil (Pierre): 177
Dubuffet (Jean): 110, 116, 117, 118, 120, 125, 126, 134
Dubuisson (Sylvain): 174
Duchamp (Marcel): 9, 30, 34, 35, 40, 42, 45, 46, 61, 63, 64, 66, 70, 88, 90, 92, 94, 104, 113, 114, 122, 126, 137, 140, 144, 156, 179, 186, 193
Duchamp-Villon (Raymond): 32, 44, 46
Ducros (Françoise): 181
Dufrêne (François): 121, 127, 130, 135, 136
Dufy (Raoul): 19, 21, 22, 80
Dulac (Germaine): 187, 193

Dunne (Tony): 174
Dunoyer de Segonzac (André): 78
Dupin (Jacques): 69
Duras (Marguerite): 190, 195
Duthuit (Georges): 19, 22, 123
Duvivier (Julien): 193

E

Eames (Charles): 151, 170, 175
Eames (Ray): 170
Eastman (George): 185
Écart: 173, 176
École de Fontainebleau: 33
École de Nancy: 21
École de New York: 113
Eggeling (Viking): 187, 193
Egoyan (Atom): 195
Einstein (Carl): 46, 70
Eisenman (Peter): 153
Eisenstein (Sergei M.): 193, 194
Eliade (Mircea): 93
El Paso (group): 116, 125
Eluard (Paul): 68, 71, 72, 73, 74, 178
Emmer (Luciano): 193
Ensor (James): 57
Epstein (Jacob): 41
Epstein (Jean): 193
Ernst (Max): 41, 53, 56, 60, 61, 62, 65, 66, 68, 70, 71, 72, 73, 74, 178
Estes (Richard): 156
Estienne (Charles): 118, 123, 125, 126
Étienne-Martin (Martin Étienne, known as): 140, 143, 144
Eustache (Jean): 195
Evans (Walker): 180, 181
Expressionism: 9, 20, 55, 57, 60, 83, 95
Exter (Alexandra): 87

F

F/64 (group): 177, 185
Fabro (Luciano): 144
Factory: 114, 133
Fage (Jean and André): 185
Fahlström (Oyvind): 132, 135
Falla (Manuel de): 80
Famiglia Artistica: 37
Fassbinder (Rainer Werner): 195
Faulkner (William): 80
Faure (Élie): 80
Fautrier (Jean): 116, 118
Fauves (Fauvism): 8, 15, 16, 17, 18, 19, 20, 21, 22, 23, 24, 38, 42, 55, 56, 57, 58, 60, 66, 78, 80, 158, 165
Fayolle (Denise): 173, 175, 176
Feininger (Lionel): 83
Fellini (Federico): 194
Fénéon (Félix): 57
Ferreri (Marco): 195
Ferriss (Hugh): 97, 101
Feuillade (Louis): 30, 193
Figuration Libre: 158, 165
Figuration Narrative: 135, 136
Filliou (Robert): 129, 130, 134, 135, 143, 190, 195
Fischli (Peter): 195
Five (Group of): 148, 153
Flaherty (Robert): 193, 194
Flamel (Nicolas): 73
Flanagan (Barry): 140, 158
Flavin (Dan): 113, 139, 144
Flechtheim (Alfred): 31
Fleming (Jan): 193
Fluxus: 11, 114, 127, 128, 130, 132, 134, 135, 136, 143
Flynt (Henry): 135
Focillon (Henri): 80, 118
Fontana (Lucio): 116, 121, 125, 143

Forces Nouvelles: 80
Ford (John): 193, 194
Forest (Fred): 156, 165, 166
Forman (Nicolas): 195
Forti (Simone): 78, 135
Fortuny (Mariano): 71, 173
Foster (Norman): 148, 151, 153, 154
Foster (Wendy): 151
Fotoform: 185
Foucault (Michel): 126, 178
Four, The: 48
Frampton (Hollis): 139, 194
Frampton (Kenneth): 102, 148
Francis (Sam): 108
François (Édouard): 154
Frank (Jean-Michel): 167, 173
Frank (Robert): 180, 181, 185
Frankenthaler (Helen): 111
Freud (Lucian): 126
Freud (Sigmund): 68, 80, 71, 74
Freund (Gisèle): 181, 186
Freundlich (Otto): 117, 165
Fried (Michael): 111, 114, 138, 141, 144
Friedlander (Lee): 180, 181
Friedman (Yona): 148, 149, 153, 154
Friesz (Othon): 21, 22
Fritsch (Katharina): 161
Frize (Bernard): 165
Frizot (Michel): 178, 186
Froment (Jean-Louis): 165
Fry (Edward): 26, 27, 30
Fry (Maxwell): 148
Fry (Roger): 131
Fuchs (Rudi H.): 165
Fuller (Loïe): 45
Fulton (Hamish): 143, 182
Functionalism: 50, 99, 147, 148, 151, 169
Futurism: 29, 30, 35, 37, 38, 42, 44, 46, 52, 54, 76, 127, 147, 170

G

Gabo (Naum): 82, 87, 90, 92, 94
Gage (Jenny): 184
Gallé (Émile): 21, 53
Gance (Abel): 80, 193
García Lorca (Federico): 80
Garcias (Claude): 149
Gardère (Adrien): 174
Garnier (Tony): 21, 50, 53, 54, 176
Garouste (Gérard): 156, 173
Garouste and Bonetti (Élizabeth and Mattia): 170, 173
Garrel (Philippe): 195
Gasiorowski (Gérard): 156, 157
Gassiot-Talabot (Gérald): 136
Gatepac (Group of Catalan Artists and Technicians for the Progress of Contemporary Architecture): 101
Gaudí (Antoni): 47, 48, 54, 167
Gaudier-Brzeska (Henri): 41
Gauguin (Paul): 15, 16, 18, 19, 20, 21, 22, 30, 40, 41, 43, 45, 55, 57
Gavoille (Kristian): 174
Geddes (Patrick): 54
Gehry (Frank O.): 147, 150, 154
General Idea: 156
Genesis: 164
Genet (Jean): 189, 193
Geometrical abstraction: 90
George (Waldemar): 185
Gérôme (Léon): 27
Gette (Paul Armand): 156
Giacometti (Alberto): 70, 73, 74, 78, 79, 93, 94, 107, 110, 120, 126, 143
Gidal (Tim): 179
Gide (André): 17, 21, 29, 66, 79
Giedion (Siegfried): 179

Gilbert (Cass): 54
Gilioli (Émile): 126
Gillet (Guillaume): 153
Gilliam (Terry): 195
Ginsberg (Allen): 172
Gintz (Claude): 114, 144, 157
Giraudoux (Jean): 80
Girault (Charles): 53
Glasgow (School of): 9, 167
Glass (Philip): 142
Gleizes (Albert): 30, 31, 32, 36, 37, 89, 90
Gober (Robert): 163
Godard (Jean-Luc): 187, 190, 194, 195, 196
Godowsky (Leopold): 185
Goldin (Nan): 184
Goldwater (Robert): 46, 162
Goll (Yvan): 73
Goncharova (Natalia): 30, 36, 38
Goncourt (Edmond de): 21
González (Julio): 10, 80, 92, 94, 143
Gonzalez-Foerster (Dominique): 164, 191
Gonzalez-Torres (Felix): 163
Goodrich (Lloyd): 79
Gordon (D. E.): 46, 60
Gordon (Douglas): 191, 192
Gordon (Kim): 164
Gorky (Arshile): 103, 106, 113
Gottlieb (Adolf): 106
Gouvion-Saint-Cyr (Agnès de): 186
Gowan (James): 151, 153
Gracq (Julien): 70
Graham (Dan): 156, 160, 164, 180, 189
Graham (John): 106, 138
Grand (Toni): 138, 143, 144
GRAV (Groupe de Recherche d'Art Visuel): 122
Graves (Michael): 148, 150, 153
Gray (Eileen): 102, 173
Greenberg (Clement): 11, 106, 107, 108, 110, 111, 113, 114, 131
Greene (Charles and Henry): 54
Greene (David): 149
Griffith (David): 193, 194
Grimault (Paul): 195
Grimonprez (Johan): 191, 192
Gris (Juan): 22, 24, 33, 34, 37, 38, 76
Grooms (Red): 128, 134, 135
Gropius (Walter): 50, 51, 54, 83, 84, 87, 88, 98, 101, 102, 146, 169, 175, 179
Grosz (George): 62, 66
Group for Objective Analysis: 168
Groupe Panique: 126
Gruber (Francis): 118
Grumbach (Antoine): 148
Grunbach (Didier): 173
Gruppo N: 172
Gruppo Toscano: 100
Guéguen (Pierre): 125
Guggenheim (Solomon R.): 88
Guichon (Françoise): 176
Guidot (Raymond): 172, 174, 176
Guiheux (Alain): 54, 150
Guilbaut (Serge): 106, 144, 166
Guimard (Hector): 21, 48, 49, 53, 54, 167, 175
Guitry (Sacha): 194
Gursky (Andreas): 182
Guston (Philip): 159
Gutaï (group): 126, 135
Gwathmey (Charles): 153

H

Haacke (Hans): 143, 156, 166
Habraken (Nikolaas): 146

aftmann (Werner): 117
ains (Raymond): 127, 128, 129, 135, 89, 190, 194
alley (Peter): 158
alprin (Ann): 135
als (Frans): 57
amilton (Richard): 127, 131
amilton Finlay (Ian): 144
aneke (Michael): 195
ansen (Al): 135
anson (Duane): 156
antaï (Simon): 120, 124
appening: 11, 127, 129, 130, 132, 35, 136
aring (Keith): 165
artley (Hal): 195
artung (Hans): 118, 118, 119, 125, 126
ausmann (Raoul): 62, 64, 178, 186
awks (Howard): 193, 194
eartfield (John): 178
eckel (Erich): 41, 56, 60
eidegger (Martin): 73, 80, 120
eizer (Michael): 143
ejduk (John): 153
eld (Marc): 171
élion (Jean): 85, 88, 120
énard (Eugène): 54
enderson (Nigel): 131
ennebique (François): 53, 54
enri (Florence): 179
epworth (Barbara): 87, 94
erbin (Auguste): 85, 90, 125
erbst (René): 169
ernandez (Miguel): 195
erron (Ron): 149
ers (François): 186
erzfelde (Wieland Herzfelde Helmut, nown as): 66
erzog (Jacques): 152
esse (Eva): 140, 142, 144
eusch (Luc de): 194
iggins (Dick): 130, 135
ill (Gary): 164, 191, 196
illiard (John): 183
irschhorn (Thomas): 164, 165
irst (Damien): 158
itchcock (Henry-Russell): 98, 101, 02
itchcock (Alfred): 196
öch (Hannah): 178
ockney (David): 128, 157
odler (Ferdinand): 57
offmann (composer): 72
offmann (Hans): 113, 130
offmann (Josef): 18, 22, 48, 49, 54, 7, 167, 175
ölderlin (Friedrich): 80, 159
ollein (Hans): 150, 154
öller (Carsten): 166
olzer (Jenny): 166
ood (Raymond): 101
oog (Michel): 34
opper (Edward): 78, 79, 104
opper (Denis): 194
orsfield (Craigie): 183
orst (Horst P.): 181
orta (Victor): 48, 53, 54, 167
oward (Ebenezer): 53
owells (John Mead): 101
ucleux (Jean-Olivier): 156, 157
uet (Bernard): 148
ugnet (Georges): 74
uidobro (Borja): 154
uillet (Danièle): 190, 194, 195, 196
ulten (Pontus): 122, 128, 129
usserl (Edmund): 26
uston (John): 193, 194, 195
uszar (Wilmos): 85

Huyghe (Pierre): 164, 187, 191
Huysmans (Joris-Karl): 39
Hybert (Fabrice): 164
Hyperrealism: 114, 165

I

Ibos (Jean-Marc): 153, 154
Immendorff (Jörg): 156
Impressionism: 8, 16, 19, 21, 27, 30, 35, 39, 40, 45, 58, 59, 108
Inamura (Shoei): 195
Ince (Raymond): 193
Incohérents (group): 64
Independant Group: 127
Indiana (Robert): 128
International Style: 11, 97, 98, 101, 102, 146, 147
Internationale Situationniste (IS): 125, 148, 149
Isou (Isidore): 125, 127, 136, 192, 194
Isozaki (Arata): 148, 152, 154
Ito (Toyo): 152, 154
Ivens (Joris): 188, 193
Izis (Israël Bidermanas, known as): 126, 185

J

Jackson (Martha): 128, 129, 135, 136
Jacob (Max): 75, 92
Jacobsen (Arne): 146, 153, 171
Jacobsen (Robert): 122, 126, 137, 143
Jacquet (Alain): 133, 136
Janco (Marcel): 62
Japonaiserie: 48, 49
Jarman (Derek): 195
Jarmusch (Jim): 195
Jarry (Alfred): 21, 22, 27, 64
Jasset (Victorin Hippolyte): 193
Javault (Patrick): 161
Jay (Paul): 185
Jean (Marcel): 71
Jeanneret (Pierre): 101, 169
Jencks (Charles): 148, 150
Jiacosa (Dante): 175
Johns (Jasper): 108, 110, 111, 113, 128, 129, 135, 140, 143
Johnson (Philip): 98, 102, 114, 46, 148, 153
Johnson (Ray): 130, 135
Jonas (Joan): 142
Jones (Allen): 128
Josephson (Hannah and Matthew): 66
Josic (Alexis): 145, 149, 153, 154
Jouffroy (Alain): 132, 135, 136
Jourdain (Frantz): 22, 45, 54, 169
Journiac (Michel): 12
Jouve (Pierre-Jean): 37, 79, 80
Joyce (James): 80
Judd (Donald): 113, 114, 138, 139, 143, 144, 174
Judson Group: 134
Jugendstil: 48, 167
Jung (Carl Gustav): 104

K

Kabakov (Ilya): 162
Kafka (Franz): 73, 80
Kahn (Albert): 185
Kahn (Louis I.): 146, 151, 153, 154
Kahnweiler (Daniel Henri): 22, 25, 26, 29, 30, 31, 37, 45, 70
Kandinsky (Wassily): 58, 59, 60, 66, 80, 82, 83, 84, 87, 88, 90, 94, 103, 125, 168
Kapitalistischer Realismus: 157
Kaplan (Jonathan): 194

Kapoor (Anish): 158
Kaprow (Allan): 113, 129, 130, 135, 136
Kassovitz (Matthieu): 195
Kästner (Wilhelm): 180
Kawara (On): 140
Kazan (Elia): 194
Keene (Peter): 174
Kelley (Mike): 164
Kelly (Ellsworth): 111
Kerouac (Jack): 113, 181
Kertész (André): 179, 181
Kiarostami (Abbas): 195
Kiefer (Anselm): 158, 159
Kienholz (Ed): 128, 136, 143
Kikutake (Kiyonuri): 152
Kilian (Lucienne): 126
Kinetic art: 122
Kippenberger (Martin): 161
Kirchner (Ernst Ludwig): 41, 43, 46, 56, 60
Kitaj (Ronald B.): 128
Kitano (Takeshi): 195
Klee (Paul): 60, 83, 84, 87
Klein (Robert): 122
Klein (William): 181
Klein (Yves): 120, 121, 125, 128, 129, 130, 135, 136, 140, 143
Klimt (Gustav): 53, 54
Kline (Franz): 106, 114
Klossowski (Pierre): 80
Klüver (Bernd): 136
Kobro (Katarzyna): 91, 92, 94
Kollar (François): 179
Komar and Melamid: 162
König (Kasper): 161, 165
Koolhaas (Rem): 152, 154
Koons (Jeff): 160, 161
Korine (Harmony): 195
Kosnick-Kloss (Jeanne): 117
Kosuth (Joseph): 140, 143, 156
Kotera (Jan): 53
Kounellis (Jannis): 141
Kozloff (Max): 128
Krafft-Ebing (Richard von): 71
Krauss (Rosalind): 44, 46, 92, 144
Kreuter (Delphine): 184
Krull (Germaine): 179
Kubelka (Peter): 194
Kubrick (Stanley): 171, 194, 196
Kudo (Tetsumi): 132, 136
Kuntzel (Thierry): 187, 190, 196
Kupka (Frantisek): 85
Kuramata (Shiro): 172
Kurokawa (Kisho): 147
Kurosawa (Akira): 193, 194, 195
Kusturica (Emir): 195
Kysela (Ludvik): 101

L

La Fresnaye (Roger de): 37
La Monte Young: 135
Lacan (Jacques): 93, 126
Lacaton/Vassal (Anne and Jean-Philippe): 154
Lafont (Suzanne): 183, 186
Lagneau-Dimitrijevic-Weill: 153
Lakhdar Hamina (Mohamed): 195
Laloux (René): 195
Lam (Wilfredo): 173
Lamarche-Vadel (Bernard): 165
Lambert (Yvon): 110, 165
Land (Edwin H.): 185
Land art: 129, 140, 143, 144
Landau (Ergy): 185
Lang (Fritz): 73, 101, 193, 194, 195
Lang (Jack): 174
Langlois (Henri): 193
Langner (Johannes): 59
Lanzmann (Claude): 195, 196

Lardera (Berto): 137
Larionov (Mikael): 29, 36, 37, 38
Lartigue (Jacques-Henri): 185
Lassaigne (Jacques): 19
Latarjet (Bernard): 186
Laude (Jean): 24, 30, 75, 116, 118
Laughton (Charles): 194
Laurens (Henri): 30, 94, ,143
Lautréamont (Isidore Ducasse, known as): 66, 67, 68, 73
Lavier (Bertrand): 160, 161
Lavirotte (Jules): 54
Lawless (Catherine): 124
Le Corbusier (Charles-Édouard Jeanneret, known as): 50, 96, 97, 98, 100, 101, 102, 145, 146, 147, 148, 149, 153, 163, 169
Le Fauconnier (Henri): 37
Le Gac (Jean): 156
Le Moal (Jean): 118
Le Parc (Julio): 47, 126
Lebel (Jean-Jacques): 130, 135, 136
Lebel (Robert): 63
Lebensztejn (Jean-Claude): 112
Lechner (Odon): 53
Lefèbvre (André): 175
Léger (Fernand): 30, 31, 32, 33, 34, 36, 37, 38, 97, 115, 116, 188, 190, 193
Leiris (Michel): 69, 70, 73, 80, 94, 115
Lemagny (Jean-Claude): 185, 186
Lemaître (Maurice): 192, 194
Lemoine (Serge): 62, 66, 88
Leonard (Zoe): 184
Lepage (Jacques): 133
Lerski (Helmar): 180
Letrosne (Charles): 99
Lettrism: 121, 125, 127, 127, 136
Lewis (Duncan): 154
LeWitt (Sol): 114, 138, 139, 140, 144
Leymarie (Jean): 20, 22, 25, 116
Lézénès (Gilbert): 153, 154
L'Herbier (Marcel): 101, 188, 193
Lhote (André): 37, 78
Liberty (style): 48, 167
Libre Esthétique: 18
Libre Expression: 21, 45, 136
Lichtenstein (Roy): 114, 128, 133
Liebermann (Max): 57
Limbour (Georges): 70
Lindner (Richard): 129
Lionel-Marie (Annick): 181
Lipchitz (Jacques): 138, 143
Lippard (Lucy): 114, 130, 136, 139, 144
Lissitzky (Eliazar, known as El): 82, 84, 87, 88, 94, 179
Living Theater: 113, 130, 136, 140
Llods (Marcel): 102
Loach (Ken): 194
Lockhart (Sharon): 191
Loeb (Édouard): 123
Loewy (Raymond): 175
Long (Richard): 143, 158, 182
Loos (Adolf): 18, 49, 50, 52, 53, 54, 175
Losey (Joseph): 194
Louis (Morris): 111
Lubitsch (Ernst): 193
Lucan (Jacques): 152, 154
Lucas (George): 195
Luce (Maximilien): 45
Lueg-Fisher (Konrad): 157
Lumière (Louis and Auguste): 21, 22, 185, 193
Lüpertz (Markus): 158
Lurçat (André): 102
Lüthi (Urs): 183
Lye (Len): 193
Lynch (David): 195
Lyon (Dominique): 153, 154

Lyotard (Jean-François): 156, 158

M

Maar (Dora): 178
MacCarthy (Paul): 113, 164
MacCollum (Allan): 158
MacDonald-Wright (Stanton): 104
Maciunas (George): 114, 130, 135, 143
Macke (August): 58, 60
Mackintosh (Charles Rennie): 48, 53, 54, 167
MacLow (Jackson): 130
MacNair (Herbert): 48, 53
MacQueen (Steve): 192
MacShine (Kynaston): 144
Magritte (René): 66, 69, 73, 74, 156, 194
Mahler (Gustav): 29
Mail art: 135
Maillol (Aristide): 39, 40, 45, 46
Mailly (Jean de): 153
Majorelle (Louis): 21, 53
Malassis (Coopérative des): 126
Malaval (Robert): 135
Mâle (Émile): 118
Malevich (Kasimir): 36, 38, 81, 82, 87, 88, 91, 92, 95, 101, 163
Mallarmé (Stéphane): 21, 30, 33, 45, 156
Mallet-Stevens (Robert): 97, 101, 102, 173
Malraux (André): 74, 80, 116, 123, 125, 153
Mamoulian (Rouben): 193
Man Ray (Emmanuel Rudnitsky, known as): 63, 66, 71, 73, 104, 178, 180, 181, 183, 185, 193
Manessier (Alfred)): 118, 126
Mangold (Robert): 138, 139
Manet (Édouard): 22, 29, 111
Manguin (Henri): 21, 22
Mankiewicz (Herman J.): 194
Mann (Thomas): 60, 73, 80
Mannes (Leopold): 185
Manzoni (Piero): 121, 135, 143
Mapplethorpe (Robert): 184
Marc (Franz): 58, 60
Marden (Brice): 108, 112, 138
Mare (André): 101
Maré (Rolf de): 66
Marinetti (Filippo Tommaso): 29, 35, 37, 44, 66, 121
Marker (Chris): 189, 190, 191, 194, 195
Markopoulos (Gregory): 194
Marquet (Albert): 18, 19, 21, 22
MARS (Modern Architectural Research Group): 102
Martel (Jan and Joël): 97
Mason (Raymond): 143
Massenet (Jules): 30
Masson (André): 70, 73, 103, 106
Mataré (Ewald): 141
Mathey (François): 175, 176
Mathieu (Georges): 117, 123, 125, 126
Matisse (Henri): 8, 15, 16, 17, 18, 20, 21, 22, 23, 25, 26, 33, 38, 40, 42, 44, 45, 46, 58, 59, 60, 74, 111, 112, 115, 124, 125
Matta (Roberto): 74, 103, 173
Matta-Clark (Gordon): 195
Matter (Herbert): 170
Mayakovsky (Vladimir): 168
Mec art: 11, 133
Medunestsky (Konstantin): 94
Medvedkin (Alexandre): 193
Meier (Richard): 153
Meissonier (Jean Louis Ernest): 71, 74

199

Mekas (Jonas): 133, 135, 194
Méliès (Georges): 21, 193
Melnikov (Constantin): 87, 95, 96, 102
Melville (Jean-Pierre Grumbach, known as): 194
Memling (Hans): 27
Memphis (group): 172, 176
Mendelsohn (Erich): 11, 95, 101, 102, 170
Menken (Marie): 187, 194
Mercereau (Alexandre): 37
Merleau-Ponty (Maurice): 123
Merz (Mario): 141
Mesens (Edouard L. T.): 69, 73
Messager (Annette): 156, 162
Messagier (Jean): 173
Messerschmidt (Franz Xavier): 160
Meston (Stanley): 170
Metabolist (movement): 147, 148, 151, 152
Metken (Gunter): 77
Metzger (Gustav): 135
Metzinger (Jean): 26, 30, 31, 33, 36, 37
Meuron (Pierre de): 152
Meyer (Adolf): 51, 66
MIAR (Movimento Italiano per l'Architettura Razionale): 102
Michaux (Henri): 116
Michelucci (Giovanni): 100, 102
Mies van der Rohe (Ludwig): 50, 97, 98, 101, 102, 146, 151, 153, 169
Miller (Herman): 170, 171
Milovanoff: (Christian): 183, 186
Ming-Liang (Tsai): 195
Minimalism (Minimal art): 11, 12, 103, 104, 106, 108, 110, 112, 114, 136, 138, 139, 140, 142, 143, 152, 160
Minnelli (Vincente): 194
Miró (Joan): 69, 70, 71, 73, 74, 88, 93, 94, 103, 115, 137
Miyake (Issey): 172, 176
Mizoguchi (Kenji): 194
Modern Style: 47, 69
Modigliani (Amedeo): 22, 43, 45, 46, 66
Moholy-Nagy (Laszlo): 83, 84, 87, 88, 91, 92, 94, 178, 179, 185, 193
Moles (Abraham): 160
Mollet-Viéville (Ghislain): 165, 166
Mollino (Carlo): 170
Mondrian (Piet): 30, 34, 37, 82, 84, 85, 86, 87, 88, 93, 111, 113, 179, 194
Moneo (Rafael): 146
Monet (Claude): 17, 18, 22, 59, 108, 111
Monfreid (Henri de): 15
Monnier (Gérard): 145, 166
Monory (Jacques): 190, 194
Monteiro (João Cesar): 195
Monterosso (Jean-Luc): 186
Moore (Charles): 148, 150, 153, 154
Moore (Henry): 94, 138
Moorman (Charlotte): 135
Moreau (Gustave): 18, 21, 22, 68
Morellet (François): 111, 122, 126
Moretti (Nanni): 195
Morice (Charles): 15, 16, 18, 23
Morise (Max): 71, 73
Morley (Malcolm): 156, 157,158
Morris (Robert): 138, 142, 143, 144
Mortensen (Richard): 126
Moser (Koloman, known as Kolo): 48, 53, 54, 175
Mosset (Olivier): 125
Motherwell (Robert): 105, 106, 113, 114
Moullet (Luc): 195
Mourgue (Olivier): 171
Movimento Nucleare: 121

Movimento spaziale: 125
Mucha (Reinhardt): 160
Mueller (Otto): 57, 60
Mühl (Otto): 135, 165
Müller (Gregoire): 142
Munch (Edvard): 45, 55, 56, 60
Münter (Gabriele): 58, 59
Murnau (Friedrich Willhem): 193, 194
Murphy (Gerald): 104
Muthesius (Hermann): 48, 50, 54, 175

N

Nabis (group): 8, 16, 21, 57
Nadar (Félix Tournachon, known as): 29
Nam June Paik: 130, 135
Nash (John): 150
Nauman (Bruce): 140, 142, 143, 144, 189, 191, 194
Naville (Pierre): 66, 73
Nelson (Paul): 169
Neo-Abstractionists: 158
Neo-Classicism: 96
Neo-Dada: 110
Néo-Humanistes: 80
Neo-Impressionism: 8, 16, 21, 59
Neo-Plasticism: 80, 82, 86, 87
Neo-Primitivism: 36
Neo-Regionalism: 148
Nerval (Gérard Labrunie, known as Gérard de): 68
Nervi (Pier Luigi): 153
Neue Künstlervereinigung (New Artists' Association): 29
Neue Sachlichkeit (New Objectivity): 180
Neue Wilde: 158, 165
Neutra (Richard): 99, 101
New Bauhaus: 88, 94
Newman (Barnett): 106, 108, 109, 113, 114, 143
Newton (Helmut): 181
Nicholson (Ben): 87, 94
Niemeyer (Oscar): 146, 148, 153, 154
Niepce (Nicéphore): 128, 136, 185
Nietzsche (Friedrich): 56
Nieue Bouwen (New Building): 168
Nijinsky (Vaslav Fomich): 29, 30
Nitsch (Hermann): 135, 165
NKVM (Neue Künstlervereinigung München): 58, 60
Noguchi (Isamu): 143
Noland (Kenneth): 111
Nolde (Emil): 56, 57, 58, 60
Nouveau Réalisme: 11, 121, 126, 127, 128, 129, 130, 131, 132, 134, 135, 136, 140, 171
Nouvel (Jean): 153, 154
Novembergruppe: 98
Nox (Lars Spuybroek): 154
Nozière (Violette): 74
Nuove Tendenze: 52

O

Obrist (Hans Ulrich): 56
October (group): 168
Oiticica (Helio): 144
O'Keeffe (Georgia): 103
Olbrich (Joseph Maria): 53, 54
Oldenburg (Claes): 113, 128, 130, 134, 135, 140, 143, 150
Oliva (Achille Bonito): 156
Op art: 125
Ophuls (Marcel): 196
Ophuls (Max): 194, 196
Oppenheim (Denis): 140
Oppenheim (Meret): 94
Orlan: 165

Orozco (Gabriel): 163
Orozco (José Clemente): 104, 105
Oshima (Nagisa): 195
Otto (Frei): 26, 27, 146
Oud (Jacobus Johannes Pieter): 85, 86, 101
Oursler (Tony): 164
Outerbridge (Paul): 179
Ozenfant (Amédée): 88, 96, 98, 101
Ozu (Yasujiro): 194

P

Pabst (George Wilhelm): 193
Pach (Walter): 44
Pacquement (Alfred): 109
Pagé (Suzanne): 164
Pagès (Bernard): 144
Païni (Dominique): 189, 196
Panamarenko: 143
Pane (Gina): 155, 166, 194
Panofsky (Erwin): 80, 109
Panton (Verner): 171
Paolozzi (Eduardo): 127, 131
Paradeis (Florence): 184
Parent (Claude): 153, 154
Parmentier (Michel): 125
Parr (Martin): 184
Parreno (Philippe): 164, 191
Pascali (Pino): 140, 143
Pasolini (Pier Paolo): 194
Pasqualini (Dominique): 165
Pastrone (Giovanni): 193
Patout (Pierre): 169
Patterson (Ben): 130, 135
Paulhan (Jean): 30, 117, 125, 126
Paulin (Pierre): 171
Pavese (Cesare): 141
Paz (Octavio): 116
Pechstein (Max): 56, 57, 60
Péguy (Charles): 29, 30
Peignot (Lucien): 185
Penck (Ralf Winkler, known as A. R.): 159
Pencreac'h (Georges): 154
Penn (Irving): 181
Penone (Giuseppe): 144
Perec (Georges): 155
Péret (Benjamin): 66, 73, 74
Perrault (Dominique): 152, 154
Perret (Auguste): 21, 51, 54, 96, 98, 101, 102, 146, 153
Perriand (Charlotte): 97, 169
Pesce (Gaetano): 172
Pevsner (Anton): 82, 87, 90, 92, 94
Peyroulet (Gilles): 131
Pfeuffer (Joachim): 134
Phalanx (group): 45, 59, 60
Phillips (Peter): 128
Photo-Secession: 21, 177, 185
Piacat (Maurice): 195
Piano (Renzo): 148, 151, 153, 154
Piaubert (Jean): 126
Picabia (Francis): 34, 35, 61, 62, 63, 64, 65, 66, 73, 177
Picasso (Pablo): 7, 8, 9, 10, 17, 18, 20, 21, 22, 23, 24, 25, 26, 27, 28, 29, 30, 31, 32, 33, 34, 37, 38, 40, 41, 42, 43, 45, 46, 60, 66, 71, 74, 75, 78, 80, 90, 92, 94, 103, 105, 106, 115, 118, 119, 120, 124, 126, 138, 143, 165, 177, 194
Picon (Antoine): 54
Picon (Gaëtan): 71, 74, 116
Pictorialism: 177
Pierson (Jack): 184
Pincemin (Jean-Pierre): 123
Pirandello (Luigi): 80
Pissarro (Camille): 21
Pistoletto (Michelangelo): 140, 144
Pivano (Fernanda): 172

Pleynet (Marcelin): 124
Pluchart (François): 136, 155, 166
Poe (Edgar): 73
Poiret (Paul): 29, 80
Poirier (Anne and Patrick): 156
Poliakoff (Serge): 126
Polke (Sigmar): 156, 157
Pollock (Jackson): 104, 105, 106, 111, 113, 114, 124, 135
Pölzig (Hans): 11, 101
Pommereulle (Daniel): 132, 136
Pompidou (Georges and Claude): 171
Ponge (Francis): 19, 184
Ponti (Gio): 153, 175
Pop art: 11, 108, 127, 128, 130, 131, 132, 133, 134, 135, 136, 140, 149
Popova (Liubov): 87
Portzamparc (Christian de): 154
Post-Impressionists: 21
Postmodernism: 148, 150, 151
Pouillon (Fernand): 153
Pound (Ezra): 139
Praesens (group): 91, 94
Preminger (Otto): 193
Prévert (Jacques): 71, 73
Primitivism: 57, 72, 117
Process art: 140, 142
Proust (Marcel): 30
Prouvé (Jean): 102, 146, 151, 153, 169
Prouvé (Victor): 21
Puccini (Giacomo): 21
Puni (Ivan): 87
Punk: 164, 165, 174
Purism: 96, 101
Puteaux group: 34, 46
Putman (Andrée): 173, 174, 176
Putman (Jacques): 123
Puvis de Chavannes (Pierre): 21, 79
Puy (Jean): 21, 22

Q

Quasar (Nguyen Manh Khan, known as): 171
Queneau (Raymond): 117

R

Raby (Fiona): 174
Radi Designers: 174, 176
Radice (Barbara): 172
Rado (Charles): 185
Ragon (Michel): 54, 88, 108, 144, 153, 116, 117, 126
Rainer (Arnulf): 194
Ramos (Mel): 128
Rationalism: 48, 49, 50, 51, 67, 88, 92, 95, 96, 98, 99, 100, 102
Ratton (Charles): 93
Rauschenberg (Robert): 108, 110, 113, 114, 127, 128, 129, 132, 134, 135, 136, 143
Ravel (Maurice): 21, 29
Ray (Charles): 163
Ray (Nicholas): 194
Ray (Satyajit): 194
Ray Gun Company: 134
Raynal (Maurice): 38, 92
Raynaud (Jean Pierre): 132, 135, 136, 143
Rayonism: 34, 36, 37, 38
Raysse (Martial): 130, 131, 156, 194
Read (Herbert): 46, 74, 131
Readymade: 9, 10, 39, 40, 41, 42, 43, 44, 45, 46, 63, 89, 94, 144, 156, 157, 165, 179
Réalités Nouvelles: 80, 88, 90, 121, 123, 125, 126
Reboux (Paul): 27
Redon (Odilon): 34, 45

Reed (Carol): 194
Regionalism: 79, 98, 99, 101, 102, 148, 150
Reich (Lilly): 169
Reich (Wilhelm): 114
Reinhardt (Ad): 109, 113, 114
Renard (Jules): 29
René (Denise): 122, 125, 126
Renger-Patzsch (Albert): 180
Renoir (Jean): 193, 194, 195
Resnais (Alain): 194, 195
Restany (Pierre): 127, 130, 135, 136
Reverdy (Pierre): 66, 78
Rhoades (Jason): 166
Ribettes (Jean-Michel): 164
Riboud (Marc): 181
Rice (Peter): 151
Richier (Germaine): 143
Richter (Gerhard): 156, 157, 160
Richter (Hans): 188, 193
Riefenstahl (Leni): 193
Riestelhueber (Sophie): 186
Rietveld (Gerrit Thomas): 87, 101, 168, 171, 175
Rilke (Rainer Maria): 79, 80, 159
Rimbaud (Arthur): 16, 64, 68, 73, 11
Rimsky-Korsakov (Nicolaï): 30
Ring (Zehnerring): 98
Rinke (Klaus): 160
Riopelle (Jean-Paul): 125
Rist (Pipilotti): 195
Rivera (Diego): 74, 105
Rivers (Larry): 128
Robbe-Grillet (Alain): 125, 126, 132
Roché (Henri-Pierre): 117
Rodger (Georges): 185
Rodin (Auguste): 9, 21, 39, 40, 44, 45, 46, 90, 139, 177
Rodchenko (Alexander): 82, 84, 87, 91, 92, 94, 168, 179, 185
Rogers (Richard): 148, 151, 153, 154
Rohmer (Éric): 194, 195
Rolland (Romain): 21
Romanticism: 40, 47, 49, 68, 70, 99, 99, 141, 159, 182
Ronda (La): 80
Ronis (Willy): 185
Rose (Barbara): 107, 114, 138, 143
Rosenberg (Harold): 106, 107, 113, 114
Rosenblum (Robert): 30, 128
Rosenquist (James): 128
Rossellini (Roberto): 193, 194, 196
Rossi (Aldo): 146, 148, 150
Rosso (Medardo): 40, 46
Rostand (Edmond): 21
Rotella (Mimmo): 127, 133, 135, 136
Roth (Dieter): 130
Rothko (Mark): 106, 108, 112, 113, 11
Rouault (Georges): 17, 18, 115
Rouch (Jean): 194
Rouillard (Dominique): 149
Rouquette (Jean-Maurice): 185
Rousseau (Henri, known as l Douanier): 22, 27, 29, 33, 46
Roussel (Raymond): 29
Rowe (Colin): 151
Rowell (Margit): 41, 46
Roy (Louis): 27
Royère (Jean): 170
Rubin (William): 30, 41, 66, 72, 74, 11 138
Rudolph (Paul): 148
Ruff (Thomas): 160, 182
Ruhlmann (Jacques-Émile): 169
Ruiz (Raúl): 195
Ruscha (Edward): 128, 164, 186, 189 194
Ruskin (John): 48

200

ussel (Morgan): 104
ussolo (Luigi): 37
utault (Claude): 165
uyters (André): 29
yan (Marc): 172
yman (Robert): 108, 112, 138, 139
yout (Denis): 104, 107, 114

S

aarinen (Eero): 147, 147, 153, 154, 70
ade (Donatien Alphonse François, nown as the marquis de): 68, 73
aint Phalle (Niki de): 128, 129
aint-Laurent (Yves): 175
alle (David): 156, 158
alles (Georges): 116
almon (André): 25, 38, 92
alomon (Erich): 181
amaras (Lucas): 128
amuelson (Gabrielle): 175
ander (August): 180
andler (Irvin): 113, 114
anejouand (Jean-Michel): 135, 143
artoris (Alberto): 100, 102
artre (Jean-Paul): 74, 80, 117, 120, 5, 137
atie (Erik): 66, 80
aura (Carlos): 195
auvage (Henri): 54
avitry (Émile): 185
ayag (Alain): 186
carpa (Carlo): 147, 154
chad (Christian): 77, 178, 185
chamberg (Morton): 104
charoun (Hans): 146, 153
chefer (Jean-Louis): 188, 189, 196
chiedelm (Manfred): 149
chindler (Rudolph): 101, 1776
chinkel (Karl Friedrich): 98, 50
chlemmer (Oskar): 83, 84, 87, 88, 94
chlichter (Rudolf): 66
chlöndorff (Volker): 195
chlumberger (Jean): 29
chmidt-Rottluff (Karl): 41, 56, 60
chnabel (Julian): 158
chneckenburger (Manfred): 165
chneider (Rudolf): 46, 125, 126
choenberg (Arnold): 26, 60
chöffer (Nicolas): 136
chreiber (Michel): 171
chütte (Thomas): 160
chwarzkogler (Rudolf): 165
chwitters (Kurt): 64, 65, 66, 88, 93,

ott (Ridley): 195

chas (Alain): 161
ection d'Or: 31, 32, 34, 35, 38
edgwick (Edward): 193, 194
egal (George): 128, 143
eigneur (François): 153
eitz (William): 103
jima (Kazyo): 152
ekula (Allan): 160
min (Didier): 72, 117
emper (Gottfried): 11
erra (Richard): 142, 144, 194
errano (Andres): 184
rt (José Luis): 101
uphor (Michel): 85, 87, 88, 125, 6
urat (Georges): 18, 21, 22
x Pistols: 174
ymour (David): 185
zessionstil: 48
ahn (Ben): 104, 105
apiro (Joel): 142

Shapiro (Meyer): 109, 139
Sharits (Paul): 194
Shaw (Irwin): 195
Shea (David): 191
Sheeler (Charles): 104, 177
Shepard (Greg): 184
Sherman (Cindy): 183, 191, 195
Shinohara (Kazuo): 152
Signac (Paul): 16, 21
Sijie (Dai): 195
Simulationism: 158, 160
Siqueiros (David Alfaro): 104, 105
Sironi (Mario): 78
Siza (Alvaro): 148
Sjöström (Victor David): 193
Slessor (Catherine): 151
Smith (David): 137
Smith (E. Lucie): 166
Smith (Jack): 194
Smith (Richard): 128
Smith (Tony): 137, 138, 143, 144
Smithson (Alison and Peter): 127, 131
Smithson (Robert): 114, 142, 143, 144, 145, 149, 151, 154
Snow (Michael): 187, 190, 194
Sobrino (Francisco): 126
Soby (James Thrall): 74, 79
Sots art: 162
Société Anonyme: 66
Société des Artistes Indépendants: 61, 66
Sociological art: 155
Soderbergh (Steven): 195
Sognot (Louis): 169
Solier (René de): 119
Sonnabend (Ileana): 128, 135
Sontag (Susan): 186
Soria (Pierre): 153, 154
Sorin (Pierrick): 191, 195
Soto (Jésus-Rafael): 122, 143
Sottsass (Ettore): 172, 176
Sougez (Emmanuel): 127, 185
Soulages (Pierre): 106, 118, 119, 125, 126
Soupault (Philippe): 64, 66, 68, 73
Souza Cardoso (Amedeo de): 46
Speer (Albert): 98, 102
Spielberg (Steven): 195
Spoerri (Daniel): 129, 135, 136
Staël (Nicolas de): 118, 119, 120
Stankiewicz (Richard): 128, 143
Starck (Philippe): 172, 173, 174
Starobinski (Jean): 123
Stazewski (Henryk): 87
Steichen (Edward): 46, 160, 177
Stein (Gertrude): 18, 25, 42, 139, 156
Stein (Joel): 126
Stein (Leo): 26, 42, 104
Steinbach (Haim): 158
Steinberg (Leo): 110, 114, 128
Steiner (Rudolf): 11
Steinert (Otto): 185
Stella (Frank): 108, 110, 111, 113, 114, 139
Stenberg (Vladimir and Georgii): 94
Stepanova (Varvara): 82, 87, 168
Stieglitz (Alfred): 21, 46, 61, 103, 177, 185
Stijl (De): 10, 82, 84, 85, 86, 87, 97, 98, 139, 163, 168, 175, 176
Still (Clyfford): 106, 108, 113, 183
Stirling (James): 148, 151, 153, 154
Stoll (George Tony): 184
Stoullig (Claire): 111
Strand (Paul): 177, 185
Straub (Jean-Marie): 190, 194, 195, 196
Strauss (Richard): 29
Stravinsky (Igor): 29
Structuralism: 146, 149, 158
Struth (Thomas): 182

Strzeminski (Vladislav): 87, 91, 94
Sturm (der): 58, 60, 65, 84
Style nouille: 48
Style des Vingt: 48
Süe (Louis): 101
Sullivan (Louis): 48, 49, 53, 54
Sully-Prudhomme (René): 21
Superstudio: 148, 152, 175
Supports/Surfaces: 12, 120, 124, 126, 134
Suprematism: 10, 34, 36, 38, 81, 82, 87, 89, 98
Surrealism: 10, 65, 66, 67, 68, 69, 70, 71, 72, 73, 74, 76, 78, 79, 84, 90, 92, 93, 94, 103, 104, 117, 118, 119, 120, 124, 127, 138, 163, 178, 179, 180, 186, 189
Sylvester (David): 115
Symbolism: 8, 16, 18, 40, 48, 49, 55, 57, 58, 68, 95
Szarkowski (John): 186
Szeemann (Harald): 140, 141, 144, 165
Szekely (Martin): 176
Szenes (Arpad): 125

T

Tabart (Marielle): 93
Tachism: 118, 122, 125, 126
Taeuber (Sophie): 65, 88
Takis (Vassili): 143
Tallon (Roger): 170, 171, 176
Tange (Kenzo): 147, 153, 154
Tanguy (Yves): 71, 73
Tapié (Michel): 118, 123, 125
Tàpies (Antoni): 120, 125, 126
Tarabukin (Nikolaia): 76
Tarantino (Quentin): 195
Tarkovsky (Andrei): 194
Tati (Jacques): 193, 194, 196
Tatlin (Vladimir): 10, 46, 84, 87, 88, 89, 91, 92, 94, 95, 101, 168
Taut (Bruno): 11, 95, 101
Taviani (Vittorio and Paolo): 195
Team 4: 151
Team X: 146, 149, 153
Terragni (Giuseppe): 100, 102, 146
Thek (Paul): 156
Théron (Roger): 186
Thomas (Philippe): 165
Thoreau (Henry): 63
Tiberghien (Gilles A.): 144, 184
Tiffany (Charles Lewis): 167
Tillmans (Wolfgang): 184
Tinguely (Jean): 113, 122, 128, 129, 135, 136, 143
Tobey (Mark): 125
Tolstoy (Leo): 29
Toroni (Niele): 124, 125
Torrès-Garcia (Joaquin): 85, 88
Tosani (Patrick): 184
Toulouse-Lautrec (Henri de): 8, 21
Tournier (Michel): 185
Townsend (Charles): 53
Transavantgarde: 156
Tremlett (David): 182
Trianon (Henri): 39
Trockel (Rosemarie): 166
Truffaut (François): 194, 195
Trülszch (Holger): 186
Tschichold (Jan): 185
Tschumi (Bernard): 154
Turner (Joseph): 21, 151
Tuttle (Richard): 142
Twombly (Cy): 110, 143
Tzara (Tristan): 62, 64, 65, 66, 185

U

UAM (Union des Artistes
Modernes): 101
Ubac (Raoul): 178
Union des Artistes Modernes: 101
Union of Soviet Architects: 102
Unism: 87
Unovis: 83, 87

V

Valéry (Paul): 66, 80, 101
Vallotton (Félix): 27, 56
Valori Plastici: 76, 80
Van Alen (William): 97
Van Bruggen (Coosje): 134
Van de Velde (Henry): 51, 53, 54, 167, 168, 175
Van der Keuken (Johan): 195
Van der Leck (Bart): 85, 87
Van Doesburg (Theo): 66, 82, 84, 85, 86, 87, 88, 168, 175
Van Dongen (Kees): 18, 21, 22, 56, 57, 60, 125
Van Eyck (Aldo): 118, 145, 146, 149, 154
Van Gindertael (Roger): 119
Van Gogh (Vincent): 18, 21, 22, 30, 55, 56, 57, 60
Van Lieshout (Joep, Atelier): 156, 163
Van Sandt (Gus): 191
Van Velde (Bram): 120, 122, 123, 125, 173
Vantongerloo (Georges): 85, 111
Varda (Agnès): 195
Varèse (Edgar): 113, 153
Vasarely (Victor): 122, 125, 126
Vasconi (Claude): 154
Vauxcelles (Louis): 18, 20, 22, 23, 26, 27, 31
Vega (Allan): 164
Velvet Underground: 133
Venet (Bernar): 140
Venice Biennale: 21, 80, 125, 126, 136, 162, 164
Venturi (Robert): 146, 148, 150, 153, 176
Vereinigte Werkstätten: 50
Verlaine (Paul): 21
Vertov (Dziga): 188, 189, 193
Vesnin (Leonid, Victor, Aleksandr): 87, 102
Viallat (Claude): 124
Viard (Paul): 100
Viatte (Germain): 118
Vicariot (Henri): 153
Vieira da Silva (Maria Helena): 119, 125
Vienna Actionism: 165
Vienna Sezession: 21, 147, 167
Vigo (Jean): 193
Villeglé (Jacques de la): 127, 135
Villon (Jacques): 44, 46
Viola (Bill): 190, 191
Viollet-le-Duc: 11, 47, 51, 98
Virilio (Paul): 153, 154, 186, 188, 192, 196
Visconti (Luchino): 193, 194
Vitart (Myrto): 154
Vitrac (Roger): 73
Vkhutemas: 84, 96, 168, 175
Vlaminck (Maurice de): 20, 21, 22, 45, 125
Vogel (Lucien): 185
Vollard (Ambroise): 21, 23, 26
Von Hofmannsthal (Hugo): 29
Von Jawlensky (Alexei): 58, 60, 83, 87
Von Kanodt (Alexander): 58
Von Spreckelsen (Johan Otto): 154
Von Sternberg (Josef): 73, 80, 193
Von Stroheim (Erich): 193
Von Trier (Lars): 195
Von Werefkin(Marianne): 59, 60
Vordemberge-Gildewart (Friedrich):
88
Vorticism: 30
Vostell (Wolf): 130, 135, 136

W

Wagner (Otto): 48, 49, 50, 52, 53, 54, 172
Wajda (Andrzej): 195
Wall (Jeff): 160, 183, 189
Wallis (Brian): 138, 144
Walser (Robert): 165
Warhol (Andy): 114, 128, 132, 133, 136, 143, 158, 186, 189, 191, 192, 194
Watts (Robert): 128, 130, 135, 136
Webb (Michael): 149
Wedekind (Frank): 60
Weegee (Arthur): 181
Wegener (Paul): 193
Weiner (Lawrence): 140
Weiss (Peter): 195
Welles (Orson): 193, 194, 195
Wenders (Wim): 195, 196
Werkbund (or Deutscher Werkbund): 29, 48, 50, 51, 54, 96, 98, 101, 175, 185
Wesselmann (Tom): 114, 128, 134
West (Franz): 165
Weston (Edward): 177
Whistler (James Abbott): 21
Whitman (Robert): 135
Whitman (Walt): 63
Wiene (Robert): 193
Wilde (Oscar): 48
Wilder (Billy): 193, 194
Williams (Emmett): 130, 135
Williams (Owen): 101, 102
Williams (Tennessee): 121
Winogrand (Gary): 180, 181
Wittgenstein (Ludwig): 156
Wodiczko (Krzysztof): 156, 163
Wolheim (Richard): 138, 143
Wols (Wolfgang Schulze, known as): 117, 125
Wolton (George): 151
Wood (Grant): 104
Woodrow (Bill): 158
Woods (Shadrach): 145, 149, 153, 154
Worringer (Wilhelm): 56, 60, 76
Wright (Frank Lloyd): 49, 53, 54, 86, 89, 98, 99, 102, 147, 153, 167

X

Xenakis (Iannis): 153

Y

Yvaral (Jean-Pierre): 126

Z

Zadkine (Ossip): 43
Zanini (Marco): 172
Zehrfuss (Bernard): 153
Zero group: 121, 125, 135
Zervos (Christan): 24, 94
Zittel (Andrea): 163
Zola (Émile): 21, 29, 45, 50
Zoo group: 140
Zorio (Gilberto): 144
Zuber (René): 179
Zweig (Stephan): 71

Printed in France by CLERC S.A.